THE

Political

Companion

TO

American

FILM

★★★★★THE★★★★★
Political
Companion
★★★★★TO★★★★★
American
FILM

Edited by Gary Crowdus

Foreword by Edward Asner

Lakeview Press

Library of Congress Cataloging in Publication Data

A Political Companion to American Film / edited by Gary Crowdus.
 p cm
 Includes bibliographical references and index.
 ISBN 0-941702-37-5 : $60.00
 1. Motion pictures—Political aspects—United States.
I. Crowdus, Gary, 1945-
PN1995.9. P6P66 1994
791.43'658—dc20 93-41593
 CIP

Contents

FOREWORD BY EDWARD ASNER...IX

PREFACE...XI

AFRICAN-AMERICAN FILMMAKERS..3

ALLEN, WOODY...9

ALTMAN, ROBERT..13

AMERICAN FILM CRITICISM ..17

ANTI-COMMUNIST FILMS...26

AUTEUR THEORY...31

BIG BUSINESSMEN IN AMERICAN CINEMA..34

BLACKS IN AMERICAN CINEMA..41

CAPRA, FRANK...50

CHAPLIN, CHARLES SPENCER ...54

CHILD ACTORS ...60

CIMINO, MICHAEL...64

THE COMMUNIST PARTY IN HOLLYWOOD ..66

CONGLOMERATES IN THE FILM INDUSTRY...71

CONTEMPORARY FILM THEORY...74

COPPOLA, FRANCIS FORD...85

CRIME MOVIES...94

DE ANTONIO, EMILE...103

DE PALMA, BRIAN..108

DISNEY, WALTER ELIAS...110

DIXON, THOMAS...115

THE DRIVE-IN THEATER...118

EASTWOOD, CLINT..123

FAIRBANKS, DOUGLAS ..129

FARMER, FRANCES ...131

THE FILM AND PHOTO LEAGUE ...134

FILM NOIR ...137

FLAHERTY, ROBERT JOSEPH ..144

FORD, JOHN ...147

FOREMAN, CARL..153

FRANKENHEIMER, JOHN ..155

FRONTIER FILMS ..160

FULLER, SAM..164

GARFIELD, JOHN...167

GAYS AND LESBIANS IN THE CINEMA ..171

GENRE..177

GILLIAM, TERRY ...185

GRIFFITH, DAVID WARK...190

THE HOLLYWOOD BLACKLIST..193

THE HOLLYWOOD STUDIO SYSTEM ...199

THE HORROR FILM...205

JEWS IN AMERICAN CINEMA...214

JUVENILE DELINQUENTS...224

KAZAN, ELIA..232

KRAMER, STANLEY ...235

KUBRICK, STANLEY...237

LARDNER, JR., RING..241

LAWSON, JOHN HOWARD..243

LEE, SPIKE ...245

LEROY, MERVYN...249

LOSEY, JOSEPH...252

LUMET, SIDNEY..255

MALTZ, ALBERT ...258

MARRIAGE IN THE MOVIES..261

THE MARX BROTHERS...267

MENTAL ILLNESS IN THE MOVIES ...270

MILIUS, JOHN...274

THE HOLLYWOOD MUSICAL..278

NATIVE AMERICANS IN HOLLYWOOD FILMS..292

PECKINPAH, SAM..300

PENN, ARTHUR...304

POITIER, SIDNEY ..307

POLITICAL ASSASSINATION THRILLERS...310

POLITICAL THRILLERS...319

POLITICIANS IN THE AMERICAN CINEMA ...322

POLLACK, SIDNEY...330

POLONSKY, ABRAHAM ..333

POTAMKIN, HARRY ALAN ..336

PRISON FILMS ..338

REBEL HERO ..342

RITT, MARTIN ..347

ROAD MOVIES ..349

ROBESON, PAUL ..355

SAYLES, JOHN ..359

SCHRADER, PAUL ..362

SCHULBERG, BUDD ..365

SCIENCE FICTION FILMS ..369

SCORSESE, MARTIN ..385

SILENT FILMS ..389

THE SMALL TOWN IN AMERICAN CINEMA ..395

SPIELBERG, STEVEN ..402

SPY FILMS ..408

STALLONE, SYLVESTER ..413

STONE, OLIVER ..417

STRAND, PAUL ..423

STURGES, PAUL ..426

TRUMBO, DALTON ..429

TELEVISION AS SEEN BY HOLLYWOOD ..432

THE UNFRIENDLY HOLLYWOOD 19 ..437

VAN PEEBLES, MELVIN ..441

VIDOR, KING ..443

VIETNAM WAR FILMS ..447

THE WAR FILM ..455

WAYNE, JOHN ..463

THE WESTERN ..469

WEXLER, HASKELL ..476

WILDER, BILLY ..478

WILSON, MICHAEL ..480

THE WOMEN'S FILM ..483

WORLD WAR II ANIMATED PROPAGANDA CARTOONS496

ZANUCK, DARRYL ..501

NOTES ON CONTRIBUTORS ..503

INDEX, NAMES ..506

INDEX, FILM TITLES ..516

Foreword
by Edward Asner

I f you picked up this book—and I, for one, am glad you did, for it's a wonderful assortment of essays—then you and I are probably in agreement on two points. First, a good movie is not objective. A story done without personal conviction, on whatever level—political, social, or moral—is not worth doing and certainly not worth watching.

(True, there are movies not worth watching that *do* have conviction, but bad artistry shouldn't be confused with the merit of the message itself.) Films with a message don't have to be turgid and heavy. After all, even *The Wizard of Oz* had messages about family values and about leaders being corrupted by power! So we agree. Even if you may not personally like a film's point of view, it's important that there *is* one.

Our second point of agreement is that American film—in fact, the entire entertainment industry—has great power and influence. Cecil B. DeMille once said, "It's a sobering thought that the decisions we make at our desks in Hollywood may intimately affect the lives of human beings throughout the world."

If that sounds self-important, please note that the entertainment industry is America's second largest export—second only to military aircraft. A successful film is seen by maybe 10,000,000 people in theaters, then millions more when it shows up on cable, then again in foreign markets. Not only is there a proliferation of cable and satellite channels, but video rentals are booming. Studies show that upwards of seventy-five percent of Americans are influenced by what they see on TV and in the movies. That puts a tremendous responsibility on the entertainment industry to be accountable for what we produce.

Most actors—and probably most producers and writers—would be happy if their responsibility was just to "entertain." Just entertain the fans, collect the money and go home. I suppose that's because most of us got into the business as a means of escape—we can "become" fictional people in our acting, or write about fictional people—thereby avoiding the realities of our lives. Which is, truthfully, the same reason people *watch* movies and TV. But if you're in the industry long at all, you soon realize the bigger picture—the influence we have on others accords us a responsibility beyond just entertaining.

I had that realization when a fan wrote me about *The Gathering*, a film in which I played a terminally ill man who gathers his estranged family together for the holidays. The fan wrote me that the movie inspired him to contact

his father, to whom he hadn't spoken in years. They'd had a tearful reunion and, a few months later, his father died suddenly. The man wrote to thank me for influencing him to reconcile with his father in time.

Sometimes you reach just one person with your work; sometimes, your work will cause a whole nation to act. After *JFK*, in which I was proud to play a small part, public outcry triggered the declassification of the Kennedy assassination files. Movies on subjects of crime, abortion, and AIDS have helped shape public opinion *and* legislation. Celebrities will often give testimony in Congressional hearings. I myself was a panel member after a *Lou Grant* episode on the subject of "orphan drugs." My testimony, along with that of Jack Klugman—*Quincy* had also featured the problem—helped pass legislation to make little-used "orphan" drugs accessible and affordable to the public.

There are rewards in doing projects that educate as well as entertain, but the risks are there as well. Actors risk being blackballed or considered "political liabilities." Writers must constantly fight the diluting of their work by networks, sponsors, studios, and distributors. The minute you do a project about a controversial subject, or use your "celebrity" to speak out as a concerned citizen, you become a target for those who prefer the status quo.

I know of jobs I've lost as a result of my own speaking out. As a producer, I've had good projects rejected because they were too controversial. And for every instance I know of, there are probably another five I don't.

I believe the words of Pablo Casals:

> *I know there are those who believe artists should live in an ivory tower, removed from the struggles and suffering of their fellow men. That is a concept to which I have never been able to subscribe. An affront to human dignity is an affront to me; and to protest injustice is a matter of conscience. Are human rights of less importance to an artist than to other men? Does being an artist exempt one from his obligations as a man? If anything the artist has a particular responsibility, because he has been granted special sensitivities and perceptions, and because his voice may be heard when other voices are not. Who, indeed, should be more concerned than the artist with the defense of liberty and free inquiry, which is essential to his very creativity?* (Pablo Casals, *Joys and Sorrows*)

To me, Casals's words are the best definition of what it means to be an American citizen and a creative artist. My work—and the work of those in my industry—helps determine what we become. I applaud all those—many of whom are recorded in this book—who accept that responsibility.

Preface

All films are political. In most countries, that's not a particularly contentious statement, but here in America, the home of Hollywood, it's a surprising notion to many people. Hollywood's usual attitude to politics is best characterized in such film industry clichés as "Politics is poison at the box office" or "If you've got a message, send it Western Union." "Political films" are usually thought of as constituting some sort of separate genre—liberal social conscience movies à la Stanley Kramer, political thrillers by Costa-Gavras, anti-war films, satires on the American political system, and the like. Other films, despite the fact that they clearly illustrate some sort of social or political context, are nevertheless considered to be "merely entertainment."

Filmmakers are social beings, however, just like the rest of us. They have been shaped and influenced by the society and historical period in which they live and their social and political views are expressed—whether consciously or unconsciously, as firm convictions or unexamined assumptions—in their films, no matter how seemingly innocuous. Quite simply, then, all filmmakers—and therefore all films—have a point of view. Even a filmmaker's conscious effort to avoid any political expression is in itself a political statement. And today "political" no longer refers only to those films dealing with politicians, international affairs, or government scandals. One of the key lessons of feminism and other consciousness-raising movements of the last few decades is that "the personal is political," too. Indeed, in its broadest and most meaningful definition, politics involves any aspect of human and social relations.

Thus, even though a film may not have been motivated by any conscious political intentions on the part of the filmmaker, it may nevertheless be rich in political implications—implications that may have little to do with the filmmaker's ostensible artistic aims. That old critical watchword, "Trust the tale, not the teller," is especially relevant in light of the film industry's frequent pronouncements about the political innocence of its films. Indeed, it can be argued that the political "messages" in Hollywood films are all the more influential in that they come cloaked in the guise of "entertainment." A clearly polemical film like Oliver Stone's *JFK* will stir controversy and charges of political bias or even "propaganda," but the most insidious propaganda, which almost always goes unremarked or unchallenged, is often that which attempts to pass itself off as "entertainment."

For successive generations of Americans since the turn of the century,

Hollywood has been a potent political force in the sense that its films—especially popular genre films such as Westerns, war films, science fiction, or crime films, whether artistically accomplished works or mediocre programmers—have helped to shape public attitudes in myriad ways. The sheer cumulative power of the American genre film is especially noteworthy in this regard. No moviegoer is likely to be politically radicalized by viewing one of Costa-Gavras's political thrillers or even seeing several of the most militantly Marxist-Leninist of Jean-Luc Godard's films, but growing up on a steady diet of Hollywood Westerns, for example, can subtly but significantly influence one's attitudes toward women and Native Americans, not to mention provide powerfully suggestive notions of male behavior and some rather sanitized versions of American history.

Not all viewers, of course, respond to movies in the same way. The moviegoing audience is by no means a blank slate on which Hollywood movies "imprint" their messages. We all bring our own emotional, cultural, and ideological baggage to the movies which accounts for our varied and sometimes divergent responses to the same film. While many critics would contend that the best individual examples of political films come from abroad, there is also no question that in terms of the highly prolific and proficient nature of its studio production system, its perennial ability to generate formulaic popular entertainment, and its powerful marketing and distribution system which reaches audiences worldwide, Hollywood produces the most political cinema in the world.

The Political Companion to American Film is designed as a collection of critical essays focusing on the American genre film, from silent films to the present day. Several essays examine the work of documentary filmmakers, and some of the genre essays include references to key foreign works, but the focus throughout remains on American narrative feature films which receive mainstream distribution in theatres, on television, and in homevideo formats. The essays examine not only the work of filmmakers (directors, producers, writers, performers, and others) but also genres (Westerns, musicals, crime films, horror and science fiction, war films, etc.), subgenres (prison films, road movies, spy films, etc.), racial and ethnic representations (blacks, Jews, Native Americans, etc.), social characterizations (politicians, businessmen, juvenile delinquents, rebel heroes, etc.) and relevant issues in film criticism and theory.

The Political Companion to American Film grew out of our efforts with *Cineaste*, a quarterly film magazine which for over twenty-five years now has specialized in providing a social and political perspective on the cinema. While many of the authors featured in this volume have also contributed previously to *Cineaste*, each was chosen because of his or her special expertise. Some of them have literally "written the book" on their subject. As with *Cineaste* contributors, we have asked *The Political Companion* authors to write clearly and colorfully, to avoid jargon of any sort, and as much as possi-

ble to deal with both the art and politics of their respective topics. While we make no claims for comprehensiveness with *The Political Companion to American Film*—it is not intended as a reference book—we hope this selective collection of essays will serve as a stimulus for further reading (many of the essays conclude with recommended bibliographies) and, in particular, for further viewing. The printed word, no matter how evocative, is no substitute for the viewing experience.

We do believe, however, that criticism which attempts to situate films in their broader social and political context does not have to, like so much theoretical or academic writing on film today, "explain away" the intellectual and emotional pleasures of the cinema in a hyperintellectualized fog of rhetoric, but can, at its best, make movies a richer and more rewarding experience. We hope that *The Political Companion to American Film* will demonstrate that it's possible to seriously examine social and political issues in the cinema and yet still be able to love the movies as a popular art form. An informed political perspective is an important aspect of a truly relevant and insightful film criticism because, no matter what Hollywood tells you, there's more than "merely entertainment" going on at the movies.

Gary Crowdus

Acknowledgements

Thanks, first of all, to André Schiffrin, Tom Engelhardt, and David Sternbach, my former editors at Pantheon Books, where this project originated some years ago. Thanks to Paul Elitzik, both a contributor to this volume and a committed independent publisher, who revived and reconceived this project at a crucial moment. Thanks to Delia Kurland for her work on the bibliographies. And thanks, above all, to each of the talented (and patient) authors whose contributions make up this book.

Note on the Editor

Gary Crowdus is the Founder and Editor-in-Chief of *Cineaste: America's Leading Magazine on the Art and Politics of the Cinema.*

The Political Companion to American FILM

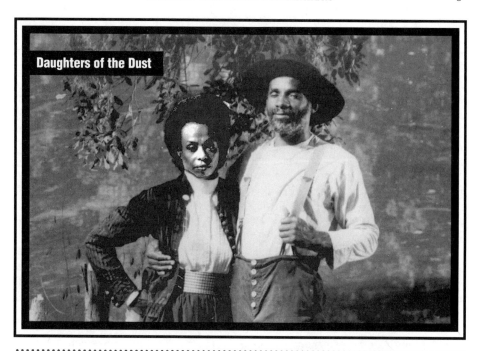

Daughters of the Dust

African-American Filmmakers

As early as 1912, Will (Juli Jones) Foster founded the first African-American film company, the Foster Photoplay Company of Chicago. Foster produced and directed such film shorts as *The Railroad Porter* (1912), a sexual comedy, *The Butler* (1913), a detective film, and *The Grafter and the Maid* (1913), a melodrama.

Similar to the entrepreneurial interests of his white contemporaries, Will Foster entered the filmmaking business to make a profit. Foster argued that African-Americans should produce black-oriented films for the black market because he believed that the production of black films would be a profitable undertaking. Unlike most of his white contemporaries, however, he chose to entertain the racially segregated black moviegoers with black-oriented films, commonly referred to as "race" movies. Thus, the importance of Foster's films, though few in number and limited to shorts, lies in their broad presentation of

black types which did not consist merely of chicken thieves, coons, and servants. From a political perspective, Foster's films indirectly contested the one-dimensional black stereotypes portrayed in such popular productions as the Lubin Company's "Rastus" series.

By 1916, Noble Johnson, an African-American actor employed by Universal Studios, founded the Lincoln Motion Picture Company of Los Angeles. Later, George Johnson, Noble's brother, took over the company's management when Universal forced Noble to leave Lincoln or lose his job. Unlike Foster Photoplay,

which had its roots in black theater, Lincoln was owned by a middle class group of blacks. These men used the Protestant work ethic and rugged individualism as the main ingredients for their melodramas which portrayed black protagonists realizing some middle class dream.

Lincoln's first production, *The Realization of a Negro's Ambition* (1916), is an example of the black bourgeois sentiment which prevailed in most Lincoln productions. *The Realization* begins as a Tuskeegee graduate leaves his family, his girl, and the rural South. He ventures west with intentions to become rich by finding oil. When he attempts to secure an oil concession, he encounters racist obstacles, which he overcomes through sheer fortune—he saves the life of the daughter of an oil magnate, in reward for which he receives an oil concession. Through hard work and unflinching determination, he discovers oil which brings him wealth. The Tuskeegan has realized the middle class dream, a sort of holy grail, which permits him to return to his home in the South where his family and his fiancée await him.

Lincoln films also portrayed a protagonist's recovery from a slothful or an immoral life. Films like *The Trooper of Company K* (1916) and *The Law of Nature* (1917) dramatize the redemption of a shiftless soldier and an adulterous mother, respectively. These films were Christian in their portrayal of an individual's moral capacity for self-betterment. Rather than present a character's moral fall, as in tragedy, Lincoln films presented uplifting images of the race which were circumscribed by a middle class morality.

The significance of the Lincoln films lies in their earnest attempts to dramatize the middle class dreams of a southern black community whose dreams had not yet been seriously portrayed on film. Unfortunately, the contemporary struggles and socioeconomic reality of blacks in the urban North were absent from Lincoln films.

Foster Photoplays, Lincoln Motion Pictures, and the Micheaux Book and Film Company were African-American owned and controlled companies. All three distributed their films through a makeshift circuit of theaters which scheduled racially exclusive screenings for their black clientele. But Oscar Micheaux was the first African-American to direct, produce, and write a feature length film—*The Homesteader* (1919), a melodrama about a mistaken mixed marriage.

Unlike the films of Lincoln Motion Pictures, Micheaux films treated controversial issues and rarely had morally uplifting denouements. They spoke to the sociohistorical currents of the Twenties, a period when black audiences required dramatizations of the politically important as well as the socially decadent. For example, *Body and Soul* (1924) portrayed a preacher who preys on his congregation. Many Micheaux films made a spectacle out of acts of violence, such as *The Brute* (1920) which dealt with a black man fighting off a southern lynch mob. Interestingly, this picture was banned in Chicago, where the infamous 1919 riot had just terrorized the city. *Birthright* (1924), another action film without an uplifting end, portrayed a black Harvard graduate who settles in a small southern town only to encounter racism and violence from both black and white communities.

Portrayals of unredeemed acts of violence and immorality were not appreciated by the tastemakers of either the white or the black middle class. Nevertheless, Micheaux films attracted more of a black mass audience and secured more bookings in white-owned theaters than did the films of Foster or Lincoln. True, Micheaux had better distribution and exhibition networks, but this alone would not continually attract his loyal following. Micheaux films featured spectacular entertainment, thereby attracting black audiences and assuring theatrical bookings for his subsequent productions.

Micheaux's independently produced films lasted throughout the Harlem

Renaissance (1919–1929). His films spoke to the "New Negro" who had fought in World War I, who had been introduced to Marcus Garvey's black capitalism, who had migrated north for economic betterment, and who had discovered that freedom from racist assaults requires continued struggle. Many African-Americans found their urban life reflected in Micheaux films which dramatized themes other filmmakers had neglected.

By 1931, African-American film companies had totally disappeared. Oscar Micheaux filed for bankruptcy in 1928, and that same year the Micheaux Film Corporation was founded by Micheaux through securing an uneven partnership with Leo Brecher and Frank Shiffman, who owned several theaters in the black communities of New York, Philadelphia, Washington, D.C., Baltimore, and Norfolk.

Micheaux's importance in black American film is twofold—he was a successful businessman and a significant director of black popular entertainment. In addition, Oscar Micheaux was the first African-American to successfully make the transition from black independent cinema to a corporate partnership with white financiers of African-American theaters in the "chitlin' circuit" (comparable to Jewish theaters in the "borscht belt"). Micheaux continued to make black-oriented films until 1948.

The films of Foster Photoplays and the Lincoln Motion Picture Company are lost, as are most of Micheaux's early films. While myths and legends can easily be constructed around the films of these three pioneers of black cinema, one cannot so easily build myths around Williams's directorial work since his films are still in distribution. Williams's films are thus valuable sources for the study of prewar African-American cinema. One critic has already pronounced Williams's *The Blood of Jesus* (1941) as "an exemplar of Southern black fundamentalism untrammeled by white intrusion—even by Sack who provided only money and distribution." Other critics can assess the value of this observation and also its utility for comparative studies of other religious films.

Spencer Williams is the last important African-American filmmaker before Hollywood studios began hiring black directors in the Seventies. Throughout his directorial career, he remained employed by white film companies. Considering the lost work of black filmmakers before 1940, his films might present examples of how a black filmmaker, whose films were produced by white businessmen, may have enjoyed a discernible amount of creative control over the cinematic portrayal of black culture.

THE DOCUMENTARY TRADITION AND THE AFRICAN-AMERICAN FILMMAKER

The revitalization of African-American filmmaking has rarely been confined within the infrastructure of the Hollywood studio system. Most recent advancements, in fact, have occurred only after African-Americans have acquired the technical skills and business acumen necessary for the development of black independent filmmaking.

Most of the new crop of African-American filmmakers found access to filmmaking skills and financing within institutional frameworks such as the film and television industry, film schools, and government agencies. Some of these filmmakers remained in the institution that first offered them opportunities to work in film, while others returned to the community armed with a new weapon to aid in the liberation of African-American people. During the civil rights movement, for example, several African-American documentary filmmakers—including William Greaves, St. Clair Bourne, Woodie King, Jr., William Miles, and Madeline Anderson—played important roles.

William Greaves is considered by many to be the father of the black social documentary. His initial position as the executive director of the Public Broadcasting

Service's *Black Journal* (1968–1971), the first nationally televised African-American current affairs program, permitted other blacks their first opportunities in documentary filmmaking. Greaves has also directed sociopolitical documentaries such as *Still A Brother: Inside the Negro Middle-Class* (1968), *In The Company of Men* (1969), and *Power Versus the People* (1970).

St. Claire Bourne received his first directorial assignments in 1968 while he was on the staff of *Black Journal*. Since his departure from *Black Journal*, he has directed *Let The Church Say Amen* (1973), *Big City Blues* (1982), *The Black and the Green* (1982), and *Langston Hughes: Dream Keeper* (1986). Bourne's *The Black and the Green* manifests his interests in the matrix of international oppression. This particular film deals with five African-Americans who travel to Northern Ireland and seek the common elements between the Irish situation and the African-American experience in the United States.

Madeline Anderson is the earliest African-American woman to work in documentary. Like St. Claire Bourne, she was initiated into documentary filmmaking while working as a film editor and producer at *Black Journal*. Anderson's documentaries include *A Tribute to Malcolm X* (1969), *I Am Somebody* (1970), *Being Me* (1975), and *The Walls Come Tumbling Down* (1975). Madeline Anderson has gained a following among both feminists and trade unionists for *I Am Somebody*, a reportage covering a strike by hospital employees who are black, female, and underpaid. The narration and perspective of a black female organizer is central to the documentary's construction of a black feminist point of view. According to one critic, the major themes of this film—sexist discrimination, racism, and antiunionism— "anticipate later developments in feminist documentaries."

Woodie King, Jr. works within a similar national context as Greaves but focuses on particular individuals whose efforts have changed modern black urban culture

and/or politics. For example, *The Black Theatre Movement* (1978) chronicles, through the use of personal interviews with major figures, the development of black theater from 1959 to 1978. King's *The Torture of Mothers* (1980) documents, through the account of Truman Nelson, the 1964 experience of The Harlem Six and their mothers' failed efforts in dealing with the Manhattan criminal justice system. His eulogy to Malcolm X, *Death of a Prophet* (1981), is a docudrama which uses personal interviews and documentary footage to recreate the day of Malcolm's assassination.

Finally, the documentaries of William Miles, *Men of Bronze* (1977) and *I Remember Harlem* (1980), offer comprehensive historical studies—his *Men of Bronze* uses newsreel footage and interviews with soldiers to portray African-American participation in World War I, while *I Remember Harlem* documents African-American sociocultural and political participation between World War I and the beginning of the Depression.

The first generation of black documentary filmmakers, like their white colleagues, were predominantly male, except for the singular presence of Madeline Anderson. As African-American women documentary filmmakers increasingly graduated from university film programs, however, many of these women expanded the scope of the black documentary to include serious treatment of African-American feminist issues.

Many of these filmmakers have focused on the lives of black artists rather than sociopolitical struggles. Carroll Blue directed *Varnette's World* (1979) on a black woman artist and *Conversations With Roy de Carava* (1984) on photographer Roy de Carava and his photographs of Harlem in the Fifties. Ayoka Chenzira's *Syvilla: They Dance To Her Drum* (1979) chronicles the life of Syvilla Fort, one of the first of a generation of black modern dancers. Michelle Parkerson's *But Then, She's Betty Carter* (1980) treats the life of jazz singer Betty

Carter, a woman who succeeded in a traditionally male occupation. Parkerson's work reflects an interest in women's issues as well as the issue of gender roles. For example, in Parkerson's *Storme: The Lady of the Jewel Box* (1987), she uses archival footage to document the career of Storme, a former big band singer, who took up a career as a male impersonator and M.C. of the Jewel Box Revue in Washington, D.C.

In the area of experimental or avant-garde filmmaking, several African-American directors deserve mention. Bill Gunn's direction of *Ganja and Hess* (1973) uses superimposition, interpolated narratives, Afro-Christian mythology, human sacrifice, and black sexuality to create one of the most provocative feature length horror films ever directed by an African-American. In shorter formats, Ben Caldwell's *I And I: An African Allegory* (1977), Barbara McCullough's *Water Ritual #1: An Urban Rite of Purification* (1979), and Zeinabu Irene Davis's *Cycles* (1989) use African mythology and ritualistic movements which invoke Afrocentric wholeness and/or a black feminist experience.

AFRICAN-AMERICAN FICTIONAL FILM: INDEPENDENT FILMMAKERS

Fictional film is the most productive area for African-American filmmakers in both the independent and commercial film industries. Kathleen Collins, the first African-American woman to direct a feature length film, made *Losing Ground* (1982), which portrays the experiences of a philosophy professor whose intellectual pursuits and marriage tend to restrict her self-realization. This film is a serious treatment of the problems encountered by the black middle class professional woman.

Similarly, Julie Dash's *Illusions* (1982), a short film, focuses on a professional black woman who has been passing for white to retain her executive position with a major film studio during World War II. Passing for white has not helped her escape from daily encounters with racist practices, but has actually enhanced these encounters because she is the assistant production supervisor. Dash's work shows a concern with black women in American history, and her most recent film, *Daughters of the Dust* (1991), focuses on women of the African-American Gullah community who lived on the various sea islands off the coast of Georgia and South Carolina.

Alile Sharon Larkin's short film, *A Different Image* (1981), creates a dialectic between the feminist consciousness of her protagonist and the sexist environment which surrounds her. Larkin also visually creates an African, woman-centered bodyscape through a collage of photographs which connects the character to her African sisters. Other African-American women filmmakers have also dramatized the double oppression of sexism and racism.

All of Haile Gerima's films, with the exception of *Harvest: 3,000 Years* (1975), dramatize African-American experiences, although many critics consider his work to be that of an Ethiopian rather than an African-American filmmaker. Gerima's *Bush Mama* (1975) portrays the daily trials of a welfare mother whose husband has been illegally imprisoned. His *Ashes and Embers* (1982) dramatizes the life of a Vietnam veteran who moves to Los Angeles to acquire an acting job in film. Both films experiment with the traditional dramatic narrative form by mixing fictive and documentary segments in a sort of counter-strategy which creates a dialectic between "real" and "false" modes of consciousness.

AFRICAN-AMERICAN FICTIONAL FILMS: MAJOR STUDIO PRODUCTIONS

When Gordon Parks, Sr. wrote and directed *The Learning Tree* (1969), an adaptation of his autobiographical novel, he became the first African-American to direct a major studio-financed picture. He later directed *Leadbelly* (1976), a fictional

biography of the blues singer Huddie Ledbetter, and, almost ten years later, he directed *Solomon Northrup's Odyssey* (1985), a fictional adaptation of Solomon Northrup's autobiography. The film tells the story of a free-black who, after having been kidnapped and enslaved, escapes and returns to his wife and children. Parks presents black characters who encounter southern racism and violence but survive through an accommodation that permits the maintenance of self-esteem. He also directed two black detective films, *Shaft* (1971) and its sequel, *Shaft's Big Score* (1972), in which he demonstrated his ability to film northern inner-city scenes with as much care for local color as presented in his southern pastorals.

Ossie Davis, who directed the black detective film, *Cotton Comes to Harlem* (1970), was the second African-American to direct a studio-financed film. Davis also directed *Black Girl* (1972), the cast of which consisted predominantly of African-American women. The film portrays a black teenager who wants to attend college and escape her impoverished existence. Conflict arises when her older sisters try to persuade her against such self-improvement. The screenplay was written by J. E. Franklin, an African-American woman who studied drama with Woodie King, Jr.

During the Sixties and early Seventies, three major occurrences helped promote black-directed, studio-financed feature films. Melvin Van Peebles is central to all three of these occurrences. The American film industry was embarrassed when Melvin Van Peebles, an African-American, attended the 1968 San Francisco Film Festival as a French-sponsored participant. His *Story of A Three Day Pass* (1967), a French entry, attracted the attention of both the press and the film industry. The necessity for Van Peebles to go to France to produce his first film highlighted the fact that the American film industry, like all major industries in America, continued racist policies which denied film direction

opportunities to African-Americans.

Second, although Van Peebles's subsequent ability to write, score, produce, and direct *Sweet Sweetback's Baadasssss Song* (1971) did not set a precedent—Gordon Parks had previously achieved a similar success with *The Learning Tree* (1969)—the singular value of Van Peebles's effort was that he did not depend on a major studio to produce his film. Van Peebles's financial acumen and rugged, African-American survival tactics established a role model for young black filmmakers like Spike Lee and Robert Townsend.

Third, Melvin Van Peebles recouped his expenditures, paid his debts, and made a handsome profit. In a capitalist system, no black filmmaker, especially those who disdain working for major studios, can disregard the importance of profits. The necessity of making a sufficient profit to produce another film is crucial to African-American filmmakers.

The Eighties brought African-Americans to the forefront of both independent and studio-distributed filmmaking. The names of Jamaa Fanaka, Spike Lee, and Robert Townsend are only a few of the filmmakers who will continue to produce well into the 1990s.

Jamaa (James) Fanaka is an MFA graduate of the UCLA film school. Unlike his colleagues Haile Gerima, Alile Sharon Larkin, and Charles Burnett, Jamaa Fanaka directed films which were distributed first by mini-major and later by major studios. Fanaka's most financially successful work has been limited to two sequels (1982 and 1987) of his 1980 prison film, *Penitentiary*.

Spike (Shelton Jackson) Lee received his MFA from the film school of New York University. He won an Academy of Motion Picture Arts and Sciences Student Academy Award for his MFA thesis project, *Joe's Bed-Stuy Barbershop: We Cut Heads* (1982). Three years later, Lee wrote, produced, and directed *She's Gotta Have It* (1986) whose production was characteristic of the "black-mode-of-produc-

tion" of *Sweet Sweetback's Baadasssss Song.* He has since gone on to direct five additional features—*School Daze* (1988), *Do the Right Thing* (1989), *Mo' Better Blues* (1990), *Jungle Fever* (1991), and *Malcolm X* (1992). (See separate essay.)

The appearance of Robert Townsend's *Hollywood Shuffle* (1987), a film which Townsend cowrote, produced, and directed, as well as the recent cycle of studio-distributed black urban action films such as Mario Van Peebles's *New Jack City* (1991), John Singleton's *Boyz N the Hood* (1991), Matty Rich's *Straight Out of Brooklyn* (1991), and Joseph B. Vasquez's *Hangin With the Homeboys* (1991) further substantiate the reality that the color of opportunity is green and its gender is male. Indeed, the struggle to racially integrate the film industry must also include African-American women.

The American film industry today will provide low budget resources for African-American male directors only as long as their films make enormous profits. The film industry has not liberalized its attitudes towards African-Americans, but in many ways remains just as racist as when Melvin Van Peebles made his American directorial debut at the 1968 San Francisco Film Festival.—Mark A. Reid

RECOMMENDED BIBLIOGRAPHY

Bogle, Donald. *Toms, Coons, Mulattoes, Mammies, & Bucks: An Interpretive History of Blacks in American Films.* NY: Viking, 1973.
Cripps, Thomas. *Slow Fade to Black: The Negro in American Film, 1900–1942.* NY: Oxford University Press, 1977.
Guerrero, Ed. *Framing Blackness: The African American Image in Film.* Philadelphia, PA: Temple University Press, 1993.

Allen, Woody
(Alan Stewart Konigsberg)
(December 1, 1935 –)

Woody Allen is both a popular icon and one of the few genuine auteurs directing mainstream films in America today. He has directed, written, or cowritten, and often starred in nearly two dozen films in as many years.

His earliest works, like *Take the Money and Run* (1969) and *Bananas* (1971), developed from his career as gag writer and stand-up comic, and were static and ragged collages built around wild and imaginative vignettes which elicited a great many belly laughs. In the films that followed, *Sleeper* (1973) and *Love and Death* (1975), Allen struggled to develop a visual style and to create a narrative structure to help shape his wit and comic imagination. The pratfalls and one-liners, however, about subjects ranging from Allen's Jewish mother and his physical and psychological fears, to Charles de Gaulle and God (Allen has a special gift for comically linking literary references to Sartre's notion of "nausea," for example, with totally ordinary activities like shopping for bargains at a department store) continued to dominate

everything else that took place in the films.

Allen's films began to change their style and tone with the Academy Award-winning *Annie Hall* (1977), a film in which he succeeded in shedding his victim-schlemiel persona by playing a character, Alvy Singer, who was intelligent, serious, and capable of real suffering. In *Annie Hall*, Allen did not want to sacrifice the credibility of his characters for the sake of a laugh. He still constructed slapstick routines— Alvy at odds with lobsters, cars, and cocaine—used one-liners and engaged in word play on Jewish paranoia, life in California, and New York intellectuals. The relationship, however, between then death-obsessed, anxiety-ridden, hypercritical Alvy and the dizzy, insecure, and warm WASP Annie (Diane Keaton) transcends caricature and conveys a feeling of authentic pain and loss. Alvy's tendency to be a father-teacher in the relationship, his neurotic need for distance and fear of suffocation, are treated as more than comic conceits.

In *Annie Hall*, Allen also began to evolve a distinctive visual style: using cartoons, narration, flashback, and fantasy; creating a striking visual contrast between the gray New York cityscape and the bleached, bone white of California's suburban sprawl; and using a split screen, wittily juxtaposing Annie's ostensibly cool, gracious Midwestern WASP family with Alvy's agitated, sloppy Jewish one sitting down to dinner.

In his next film, *Interiors* (1978), he attempted to break totally from the comic tradition, and make an ambitious, Bergmanesque (all white walls and anguished close-ups) family drama. *Interiors* had severe problems—it was too stilted and lifeless, and Allen's need to make "serious" European films never overcame his penchant for self-consciously creating characters who sound like psychoanalytic case histories.

Many film critics attacked the new, somber Allen and expressed nostalgia for the unrestrained master of the one-liner of his earlier work. Despite its failings, however, *Interiors* was a necessary step for Allen in his aim to make films which were not utterly dependent on the seductiveness of his comic genius. It freed him to realize in his best film, *Manhattan*, (1979), a fusion of *Interiors*' moral seriousness with the comic pathos of *Annie Hall*. *Manhattan* is a romantic comedy that never permits a sight gag or bit of comic repartee to subvert its moral aspirations and sense of emotional desperation. Nevertheless, it remains a funny film.

Manhattan is set in the tense milieu of status-conscious, literate neurotics. Allen's alter ego is Isaac Davis, a successsful television comedy writer and witty moralist, who has a passionate commitment to New York City and to a number of self-defeating love affairs with women. *Manhattan* is a romantic work, opening—Gershwin pulsating on the sound track—with a voluptuous montage celebrating a mythicized, black and white Manhattan. This grand, sanitized vision of Manhattan and its icons has its roots in an older New York, whose traditional values no longer have much viability for Isaac's friends, who play meaningless intellectual games, are bogged down with their neuroses, and dissipate their talent in hack work.

Allen thoroughly knows how New York neurotics talk about their "relationships," and how absurd chic conversation about "the wrong kind of orgasm" sounds. Besides the pointed social satire, *Manhattan* genuinely evokes a sense of how elusive and fraught with trepidation expressions of feeling between men and women are. What is troubling here is Allen's capacity to share his character Isaac's self-deception that the intelligent but jejeune seventeen-year-old Tracy (Mariel Hemingway) is the right girl-woman for him.

Manhattan, of course, has other limitations. Allen's attack on modern decadence sometimes seems both too speechifying and intellectually sophomoric—no more than nebulous talk about the decline of cul-

ture and some facile cafeteria existentialism. Nevertheless, it remains the most subtle and luminous of Allen's works.

The films that folllowed varied in quality, but as a body of work can be matched by only two or three other working American directors. Allen made ambitious films like the Felliniesque, corrosive *Stardust Memories* (1980), which opens brilliantly with Sandy Bates (Allen) trapped on a silent train of suffering misfits, and seeing on a parallel track another train of well-dressed, handsome party-goers. Sandy yearns to join them, but is stuck on his train of sorrow. Allen, however, has no illusions: both trains end up in the same place—a New Jersey garbage dump. It's a powerful metaphor for Allen's vision of the ultimate absurdity of human aspirations.

Stardust Memories was a provocative work but a commercial and critical failure. Allen achieved greater critical success with his next six works: *Zelig* (1983), a technically gifted, gentle, overdetermined (fettered to a single idea) parody of a television documentary about a man who must assume other people's identities so he can exist; *Broadway Danny Rose* (1984), a sweet, comedy about a legendary theatrical agent who nobly gives his all to one-legged tap dancers, blind xylophone players, and other hapless clients; *The Purple Rose of Cairo* (1985), an imaginative, Pirandelloesque film about a wispy, pathetic, Depression-era movie fan, Cecilia (Mia Farrow), who literally escapes into movie fantasy by having a love affair with the handsome hero who steps out of the film she's watching; the commercial hit, *Hannah and Her Sisters* (1986), a novelistic-style, family comedy-drama about the relationships of a large group of intertwined characters; and the modest, carefully crafted, and nostalgic *Radio Days* (1987). The last two works evoke a more serene and happy mood, and take fewer emotional or intellectual risks than films like *Manhattan* or *Stardust Memories*.

Allen, however, did not sustain that tone in subsequent films. He returned to

making "serious" works with *September* (1988), a tedious psychodrama, and *Another Woman* (1988), a strikingly composed, overly calibrated reworking of Bergman's *Wild Strawberries*. The latter film's dialog tends to be self-consciously literary, and Allen, ironically, is unable to grant emotional life to a work which centers on a successful woman academic who fears intense feeling and lives an emotionally blind existence.

Allen's work continues to be unpredictable. In *Crimes and Misdemeanors* (1989) Allen returned to making films which satisfyingly played off angst and comedy. This time around, Allen operates on a whole new level of moral urgency, and made it viscerally come alive. The film is preoccupied with, on one level, issues as weighty as the existence of God and the nature of justice and morality, and on a mildly comic level, the nature of success and failure. The two levels are conveyed here by two separate narratives—represented by a pillar of the community, opthamologist Judah Rosenthal (Martin Landau), and a melancholy documentary filmmaker, Cliff Stern (Woody Allen)—that come together only at the film's conclusion.

Both characters and narratives are, with a vengeance, thrown into an empty, heartless universe where justice doesn't exist and the sleazy succeed while the decent flounder. It's a world that Allen can only try to vitiate by having one of his characters affirm, at the film's conclusion, human beings" remarkable capacity to keep on struggling.

Alice (1990) is a thin satire of the world of wealthy New Yorkers who spend their days extravagantly consuming and worrying about the state of their bodies. Centering around Alice Tait (Mia Farrow doing a female variation of a Woody Allen persona), the film strikingly uses flashback, dream, and fantasy to evoke her specious transformation from someone who leads a spoiled, empty life to a woman who works with the homeless.

Allen gives little primacy to politics in his films, although *Sleeper* contains one-liner put-downs of Al Shanker and Richard Nixon, and *Bananas* satirizes the Chicago Seven trial (Allen himself playing a version of a gagged Bobby Seale), sardonically uses a black actress to play J. Edgar Hoover, and portrays the Allen character constantly manipulated by both the American government and a Latin-American revolutionary regime. Though Allen's politics are never made explicit, running through his films is an inherent wariness of any institution that would delimit the freedom of the individual. Perhaps another example of Allen's political sympathies was his starring role with Zero Mostel in Martin Ritt's *The Front* (1976). It was a film sympathetic to the victimized actors, writers, and directors of the McCarthy period as it was totally critical of the television networks and corporate sponsors that blacklisted them.

Allen's latest film, *Shadows and Fog* (1992), is an ambitious pastiche, portentously evoking shades of Fellini, Bergman, Kafka, *The Cabinet of Dr. Caligari*, and even the Holocaust. It's a comic fable whose main strength is its expressionist sets—cobblestoned streets, isolated street lamps, looming shadows, and dense fog—but the film is not funny and Allen's usual existential angst about life's meaninglessness and flux fails to reverberate on either an emotional or intellectual level. Allen is adrift, too self-conscious about being profound and original, it seems, to make a film that works.

Allen is a director whose work has never remained fixed, either stylistically or in terms of subject matter, ranging from shtick-filled comedies like *Bananas* to almost surrealist films like *Stardust Memories* to straight dramas like *Another Woman*. Like the best comics, Allen both views the world from the vantage point of an outsider who can ridicule or satirize all he sees, and an insider who craves the world's approval and applause. Though his cinematic alter egos have moved up the class ladder from the inept, criminal hero

in *Take the Money and Run* to more successful, established figures in the arts or the media, to some extent they still remain at odds with society. Allen's skeptical, culturally conservative, Jewish heroes poke fun at religion ("The Vatican did so well in Rome, they opened in Denmark"), the media (sending up television programming by creating a panel show called *What's My Perversion?*), and the world of the hip, the modish, and the stylishly successful. It's that milieu, nevertheless, that one detects a genuine longing and hunger for on the part of Allen's heroes. Obviously, Allen could make a wonderful comic-pathetic film depicting the ambivalence of a solemn and despairing Jewish moralist who is both attracted to and repelled by a hedonistic, affluent WASP world.

Allen hasn't made that film yet, but the films he has produced are at their best touched with genuine yearning and sorrow (even if his desire to be a Bergman is misguided and pretentious) and create nuanced comic characters who are much more than mere cartoons. At moments, Allen can move beyond his keen satiric wit and fashionable intellectual chatter, evoking the emotional life of one of his characters, convincing us that his alter egos truly suffer from anxiety about death and the silence of the universe. Allen then achieves that difficult, ambitious synthesis of humor and despair that he so often struggles to realize in his films. Of course, that magical fusion rarely is accomplished, but even a weightless, evanescent Allen film like *Radio Days* is more literate, formally more imaginative, and funnier than almost any other Hollywood comedy made today.

—Leonard Quart

RECOMMENDED BIBLIOGRAPHY

Brode, Douglas. *Woody Allen: His Films and Career*. Secaucus, NJ: Citadel Press, 1987.

Hirsch, Foster. *Love, Sex, Death and the Meaning of Life: Woody Allen's Comedy*. NY: McGraw-Hill Publishing Co., 1980.

Lax, Eric. *Woody Allen: A Biography*. NY: Vintage Books, 1992..

Altman, Robert

(February 20, 1925 –)

R obert Altman's Hollywood career has been an erratic and tumultuous one. Two of his early films—*Countdown* (1968) and *That Cold Day in the Park* (1969)—were failures, but with *M*A*S*H* (1969) his films began to deservedly garner great critical acclaim. Hailed by critics as a cinematic visionary and risk taker, he is an auteur with an imaginative, improvisatory, and idiosyncratic style.

Altman deemphasizes plot and exposition, constructs striking, painterly compositions, utilizes overlapping dialog, and crams the film frame with overflowing, incidental, and elusive detail, with both foreground and background action carrying equal significance. Altman's films also often parody and invert Hollywood genre conventions, and inherent in his work is a contempt for American mainstream values and institutions.

*M*A*S*H, McCabe and Mrs. Miller* (1970), *Brewster McCloud* (1970), *The Long Goodbye* (1973), *Thieves Like Us* (1974), and his masterpiece, *Nashville* (1975), are populated with incompetent army officers, venal capitalists, hypocritical politicos, insidious psychiatrists, and manipulative and narcissistic entertainers. Though his films evoke a portrait of an absurd and corrupt America, they simultaneously convey great pleasure in its monumental foolishness and excess. Altman's America may be destructive and grasping, but it's also vital and bountiful, a richly alienated landscape that he also embraces for the dense, hyperreal stories that it spawns.

With *M*A*S*H*, Altman made an ironic, antiauthoritarian black comedy which is totally in tune with a great many films of the late Sixties. It is a seemingly anarchic but beautifully controlled collage of sounds and images, shot in a quasi-*ciné-ma-vérité* style, which uses its Korean War setting as camouflage for Vietnam. The behavior of the film's brilliant, hip surgeon heroes, Trapper John (Elliott Gould) and Hawkeye (Donald Sutherland), who carry out their own guerrilla war against the army bureaucracy, organized religion, and football, is clearly more in accord with the Sixties and Vietnam than Korea.

At moments *M*A*S*H* resembles a typical service comedy, complete with conventional sexism and slapstick routines. It succeeds, however, in evoking the madness of war by capturing, in a stylized fashion, the *abattoir*-like carnage of the operating room (i.e., amputated limbs, buckets of blood, and discarded corpses are everywhere). As a result, the surgeons' macabre practical jokes, offhand remarks, and incongruous songs become more than a straining for laughs. For Altman, their pot-smoking, martini-drinking sense of the absurd is the only way to maintain sanity in an insane world. Despite the film's subversion of the rhetoric and rituals of military life, the surgeons never really question or rebel against the war. They are masters of survival whose pleasure in the camaraderie and grotesque humor of the medical unit seems almost to balance out their revulsion with the war's murderous lunacy.

In his bleakly comic allegory, *Brewster McCloud*, Altman's hero is no

longer a cool, calmly detached surgeon, but a passive, melancholy dreamer who murders panting, racist cops, lecherous millionaires, and shrill, witch-like society ladies. The villains are facile cartoons who provide Altman with easy scores, especially for Sixties audiences. The film's action takes place in a Houston overrun with cars and pollution and dominated by the sterile Astrodome in which Brewster takes a doomed flight. Brewster shares with Trapper John and Hawkeye a commitment to an individualistic ethic which repudiates all that Altman sees as unnatural and repressive in American society—the church, family, politics, the military, and big business—although his actions are much more profoundly alienated than the surgeons' indulgence in dark humor.

Altman's revisionist Western, *McCabe and Mrs. Miller*—more an evocation of mood than an unfolding of narrative—is constructed around characters who, at first, we get only a glimpse of but who then emerge, almost unobtrusively, from the scenes of frontier communal life. The film's hero, McCabe (Warren Beatty), is a blustering, bumbling, uneducated gambler who is a business partner in a brothel with Mrs. Miller (Julie Christie), an opium-smoking madame. At its best, the film is a melancholy visual poem (filled with rich, warm colors and exquisite light) which sides with the losers and dreamers against the power of an insidious mining company and the empty oratory of a calculating, populist politician.

In Altman's alternately satiric, alternately serious *film noir*, *The Long Goodbye* (based on a 1953 Raymond Chandler novel), Marlowe (Elliott Gould) is depicted as a man living out of his era. He is an honest, independent, loyal, and fearless man trying to adhere to his moral code in the totally corrupt world of the Seventies. But he is also looser, sloppier, fuzzier, and a less mythic figure than Chandler or Bogart's Marlowe. Almost every character he encounters tends to be both morally treacherous and vicious. They range from

wife murderers to a stylish psychopathic racketeer who talks lovingly about his sons while slashing his "lover's" face with a Coke bottle. The L.A. that Marlowe drifts through is dominated by all-night supermarkets, drugged-out hippie girls, and luxurious, private Malibu developments. It's a city that is little more than a blinking constellation of lights, devoid of even the semblance of community.

In the midst of this vision of American fragmentation, Altman's films often contain communities that provide a possible alternative to conventional social structures: the medical unit in *M*A*S*H*; the obsessive gamblers of *California Split* (1974); the reconstructed female family in *Three Women* (1977); and the country and western performers of *Nashville* (1975). These communities have little social continuity or social hope, however. They are composed of either isolated groupings of people or of communities of ruthless competitors who share little connection beyond a profession. In a sense, Altman's communities are less social alternatives to the status quo (e.g., Vidor's Christian agrarian cooperative in *Our Daily Bread*) than groups of actors who are led by him to collaborate in making films that push beyond the constraints of Hollywood conventions and norms.

Altman's most striking and ambitious work, *Nashville*, involved a community of performers who were given a great deal of freedom to improvise their roles. The film is Altman's epic and ironic attempt at capturing Middle-American consciousness, as well as the perniciousness and life energy of American popular culture. In *Nashville*, Altman interweaves twenty-four characters who either participate in or dream of entering the world of country and western music. Using an open-ended style, the film is built around privileged, seemingly disconnected moments, filled with dazzling aural effects and images.

The world that is evoked is callous and grasping—a milieu in which everyone either gropes for stardom or lives off the

myths that popular culture creates. The country and western stars are manipulative, vain, and hysterical, obsessed with crowd applause and their career status, while their public's behavior towards them ranges from breathless adulation to petulance and rage. Among Altman's "Grand Hotel" of stars is a lead singer, Barbara Jean (Ronee Blakley), a childlike, fragile, and neurasthenic symbol of how media success can help victimize and destroy a performer. Another is the doyen of country music, Haven Hamilton (Henry Gibson), a self-important, tough, ambitious little rooster of a man whose song, "We Must Be Doing Something Right," embodies the soporific and saccharine values of the country music capital.

All the characters inhabit an alienated world where nobody is capable of listening to or caring about what another person is saying. Altman succeeds in turning the country music world into a metaphor for American life—a chaotic din where everybody is struggling for their version of a gold record.

In *Nashville* everything is packaged, including politics. It's a politics built around a canned voice and an invisible candidate; we never see the presidential candidate, Hal Phillip Walker, just his cool, quietly contemptuous advance man. And Phillip's Replacement Party, with its slogan, "New Roots for the Nation," seeks national moral renewal by selling nostalgia and bumptious iconoclasm (shades of Ross Perot). The party is one more image without substance: boosters and sound truck hawking the vagaries of the platform in the same way that the country and western record albums are hyped over the film's opening credits.

Through dynamic cutting and unrelenting movement within the frame, Altman creates a frenzied world whose apotheosis is the assassination of Barbara Jean at a benefit concert. In this vivid finale, a seemingly innocuous boy with a guitar, acting out of some Oedipal rage or possibly shaped by the violence which the film sees as permeating every pore of the society, shoots Barbara Jean. The act is an echo of all the Oswalds, Sirhan Sirhans, Arthur Bremers, and other assassins and psychopaths who menaced American politicians in the Sixties.

In the aftermath of the assassination, the crowd, stunned and milling about, begins to join in singing the chillingly ironic lyric "You may say I ain't free, but it don't worry me." What sounds at first like a stirring song of solidarity turns out to be a hymn to apathy and accommodation, a metaphor for an America which unthinkingly accepts its bondage to the media's plasticity and banality. Altman's vision of social culpability makes few class distinctions. Those who hold power usually elicit his contempt but, in their malleability, ordinary people are depicted as sleepwalkers who share responsibility for all that is repellent in American culture.

After *Nashville*, Altman's work began to decline. His *Buffalo Bill and the Indians, or Sitting Bull's History Lesson* (1976) treats Buffalo Bill as an insecure, vain figure whose reputation is purely a product of promotion and grandiose rhetoric. He is an empty shell—an apt symbol of an America whose reality is submerged in a mythology it has begun to believe. The film, like some of the others that followed—e.g., *A Wedding* (1978) and *Popeye* (1980)—had striking moments that either turned slack or were dissipated in the films' general chaos and lack of directorial control.

After a series of commercial and critical failures, Altman angrily left Hollywood for New York and Paris where he directed film versions of plays. Two of the best were David Rabe's *Streamers* (1983), an anguish-ridden play about three soldiers waiting to be shipped to Vietnam, and Donald Freed and Arnold M. Stone's *Secret Honor* (1984), one long ranting night with Richard Nixon in the Oval Office.

It was only with *The Player* (1992) that Altman made a successful return to

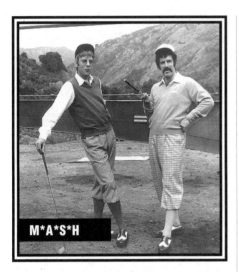

M*A*S*H

Hollywood. *The Player* is the tightest, most controlled work in his canon—a witty, formally accessible, entertaining film that shrewdly satirizes Hollywood mores and mannerisms. Altman's intent here is not to engage in savage jeremiads against Hollywood, but to dryly lampoon the industry's amoral, yuppified hustlers and the ludicrousness and utter lack of integrity of the institution they serve.

With *The Player*, Altman chose to make a Hollywood-style film, a masterly blend of film genres which playfully and self-reflexively mirrors the conventions of the industry while at the same time parodying them. The result, in its seamless, skillful manner, is a film perfectly tailored to a totally self-absorbed movie industry, and Altman—for one film, at least—has turned into a commercial director.

Despite the success of *The Player*, it's doubtful that Altman will suddenly turn into Steven Spielberg or John Hughes. He is an artist too wedded to taking formal risks and adhering to his own vision of the world to become a Hollywood mainstream director. Although his films lack the political sophistication and subtlety of a Resnais, Wajda, or Fassbinder, his works have sustained a consistent critique of American society.

That critique is sometimes no more than a Sixties counterculture sympathizer's contempt for American materialism and hypocrisy, and for those institutions, like the military and the church, which he sees as forces of repression and control. In fact, Altman usually portrays the representatives of these institutions as dolts or neurotics, providing little sense that institutions are intricate, powerful mechanisms characterized by explicit and implicit ideologies and subtle power relationships, and that their power is often greater than the foibles of individual personalities.

Of course, Altman is a director whose films are based on observation rather than exposition, intuition rather than analysis, and on the idea that society is based on chance rather than on some inherent logic or set of causes. Altman is a director in love with the complex texture of images, social surfaces, and behavioral tics, and he has an exceptional feel for an America that is ruled by appearances and hype. When his suggestive metaphors and images come alive, as they do in *Nashville*, they conjure up a monstrous, alienated America which is trenchant, resonant, and true.
—Leonard Quart

RECOMMENDED BIBLIOGRAPHY

Feineman, Neil. *Persistence of Vision: The Films of Robert Altman.* NY: Arno Press, 1978.

Karp, Alan. *The Films of Robert Altman.* Metuchen, NJ: Scarecrow Press, 1981.

Kass, Judith M. *Robert Altman: American Innovator.* NY: Popular Library, 1978.

Kolker, Robert Phillip. *A Cinema of Loneliness: Penn, Kubrick, Coppola, Scorsese, Altman.* NY: Oxford University Press, 1988 (revised).

McGilligan, Patrick. *Robert Altman: Jumping Off the Cliff: A Biography of the Great American Director.* NY: St. Martin's Press, 1989.

Wexman, Virginia Wright and Gretchen Bisplinghoff. *Robert Altman: A Guide to References and Resources.* Boston, MA: G. K. Hall, 1984.

American Film Criticism
(Postwar)

There hasn't been much in the way of noise from Andrew Sarris and Pauline Kael for some time. It wasn't so long ago that they could have been depended upon to enliven many a dull movie season with their legendary feuding, the nipping and biting at each other's heels that we came to know and love, and even expect.

But both have been more or less put out to pasture by their respective publications. Kael has retired from *The New Yorker*, and Sarris was rudely shoved from his perch at *The Village Voice* and has set up shop, modestly enough, at *The New York Observer*. Meanwhile, their protégés, scattered about America's newspapers and magazines, don't seem to have the old fire. Maybe it's just that there isn't much to argue about anymore; maybe, in fact, there never was.

Twenty years later, it's hard to imagine that the silent groves of movie reviewing were once agitated by gnashing and wailing, that two generations of readers watched closly to see which one would emerge from battle intact, which more bloodied. Although it is difficult to recall just what the sound and the fury was all about, it is clear what purpose they served. They created an illusion of intellectual ferment when there was none, and disguised the extent to which the dead hand of ideological conformity ruled popular film reviewing and academic scholarship. The *faux* warfare between Sarris and Kael also disguised the extent to which Sarris's auteurism and, for want of a better term, Kael's eclecticism, between them totally dominated the critical landscape. Even now, after academic film scholarship has inhaled the intoxicating fragrance of such exotic flowers of French culture as structuralism, semiotics, and Lacanian psycho-analysis, and auteurism has fallen into disrepute, we forget that to a remarkable degree it still determines the lay of the land, dictates which films will be examined from a semiotic, feminist, or psychoanalytic perspective, which directors will get monographs from the British Film Institute or will be included in the college curricula.

How did the world of postwar American film criticism come to be the way it is? Once upon a time, there lived a Frenchman called André Bazin. Bazin believed that the function of films was to "reveal reality." On these grounds, he broadly distinguished between two types of directors, those "who put their faith in the image and those who put their faith in reality" (*What Is Cinema?*, p. 24). The former embellished and distorted the object photographed either by means of editing or the manipulation of lighting, decor, makeup, acting, and so on. The latter left reality alone in order to bring out its "deep structure" and hidden meanings. Whereas German Expressionist directors tricked out the image with bizarre sets, weird costumes, and dramatic use of shadow, and the Russians altered the significance of the image by means of close-ups and "montage," the directors Bazin preferred just stared long and hard at the real world. "Take a close look at the world, keep on doing so" (*WiC?*, p. 27), Bazin advised. The best way to look at the world was by

employing the long take in deep focus. Montage and deep focus called forth different, contradictory responses in the viewer. Deep focus implied "both a more active mental attitude on the part of the spectator and a more positive contribution on his part to the action in progress. While analytical montage only calls for him to follow his guide, to let his attention follow along smoothly with that of the director who will choose what he should see, here he is called upon to exercise at least a minimum of personal choice" (*WiC?*, p. 36). The long take in deep focus presented a smorgasbord of objects and allowed the audience to pick and choose among them, decide for itself when and where to direct its attention. Montage, on the other hand, coerced the spectator's gaze, force-fed the audience a one-course meal. In short, deep focus was democratic, open, and pluralist; montage was totalitarian, closed, and monolithic.

Bazin's theory was tailor-made for the intellectual climate of postwar America, in which intellectuals of every stripe—historians like Daniel Boorstin, Richard Hofstadter, and Arthur Schlesinger, Jr.; sociologists like Daniel Bell and David Riesman; literary critics like Lionel Trilling—all agreed that the genius of America, as distinct from Nazi Germany and, more important, as it turned out, the Soviet Union, lay in its pluralism. In America, a variety of interest groups competed on a more or less equal basis for a piece of the pie. This competition was non-ideological (everyone agreed that it was "natural," "realistic," "commonsensical"), and was governed by compromise and the rules of fair play. The enemies of pluralism were political fanatics of the right and left, "extremists" who attacked the practical and pragmatic "center" in the name of ideology. Pluralists of the center defended "culture" from "primitives," who attacked it in the name of "nature"; in the psychobabble that characterized postwar discourse, they privileged "adulthood" and "maturity"

against the infantilism of "children.'

Bazin's long take in deep focus was a perfect prescription for the pluralist style in film. (In the Fifties, it would take other forms as well, particularly CinemaScope.) His emphasis on realism disguised and suppressed not only the ideological dimension of film, but the ideological dimension of criticism as well. And it just so happened that the practitioners of deep focus were American directors like Welles and Wyler, while the practitioners of montage were Soviet directors like Eisenstein. Before Bazin, Eisenstein's montage theory was the theory of film; Soviet cinema of the late Twenties, the films of Eisenstein, Pudovkin, and Dovzhenko, were generally regarded as the pinnacle of film art. As the chill of the Cold War settled over East-West relations, Bazin put the skids under Eisenstein's reputation.

Needless to say, Bazin's ideological distinction between deep focus and montage didn't hold up. As Raymond Durgnat wrote many years later, in films like Wyler's *The Little Foxes* (1941) and *The Best Years of Our Lives* (1947), "Wyler had effectively determined which characters the spectators would be interested in, by the moral and emotional traits with which he endowed them, and which he balances against the other with just as much care and control as do such shallow-focus films as *Johnny Guitar* or *This Island Earth*" (*Films and Feelings*, p. 30). What we look at in the deep-focus long take is influenced by lighting, the composition of the frame, who's talking and who isn't, and numerous other factors. "The spectator is no freer," concluded Durgnat, "no more 'democratic,' in Wyler's films than in the others." But he appeared to be. Bazin was partly right. In the movies, as in society, pluralist techniques of control created the illusion of freedom; they manipulated, rather than coerced.

As the political spectrum in both postwar France and America moved right, French and American film criticism moved with it. Bazin roughly played the role in

France that critic Robert Warshow played in America. As Annette Michelson acutely observed, "One can speak of Bazin's critical and theoretical work as providing an aesthetics of postwar Christian Democracy, and of Warshow's as both reflecting and reinforcing American liberalism in its Eisenhower phase." If Bazin was infatuated with "facts" and "reality," Warshow valued the "immediate experience" (the title posthumously given to his collection of essays).

In the late Forties, when Warshow started writing (his articles appeared in *Commentary* and *Partisan Review*), American film reviewing was still dominated by men of the Thirties and Forties, of the Popular Front and New Deal, like John Grierson, Lewis Jacobs, Paul Rotha, Richard Griffith, Jay Leyda, Dwight Macdonald, Bosley Crowther, and James Agee. These men believed that film was Art, but what they had in mind were not Hollywood "movies," but the Soviet classics, the German Expressionists, and the films of D. W. Griffith and Charlie Chaplin.

The reputation of Charlie Chaplin was always a political bellwether. Agee considered Chaplin a true genius of the cinema. When *Monsieur Verdoux* came out in 1947, it was greeted with a storm of abuse, and its director hounded out of the country shortly thereafter by the witch hunt. Agee, in a celebrated trilogy published in *The Nation*, sprang to the defense of the film, calling it "one of the greatest movies ever made," but Warshow, in an exquisite exercise in ambivalence and victim-bashing— of which he was a master—at once compared Chaplin to Swift, and also suggested it was all his own fault—for not making *Monsieur Verdoux* more of a feel-good movie. "There was even an organized campaign against the movie which...could be successful only because *Monsieur Verdoux* was so forbidding," he wrote. "When this campaign culminated some years later in the Attorney General's suggestion that Chaplin, then in Europe, might not be permitted to re-enter the country, there were

suprisingly few Americans who cared. We can say easily enough that this is a national shame: once again America has rejected one of her great artists. And Chaplin, no doubt, is only too ready to say the same thing; he has said it, in fact, as crudely and stupidly as possible, by his recent acceptance of the "World Peace Prize." But for him, who has asked so insistently for our love, there must be more to it than that; there must be the possibility that he has given himself away" (*The Immediate Experience*, p. 166).

Then there was the not unexpected revisionism on the subject of Soviet film. In Agee's opinion, writing in 1946, "Men like Eisenstein and Dovzhenko and Pudovkin [made] some of the greatest works of art in this century"(*Agee on Film: Reviews and Comments*, p. 195). He regarded Eisenstein as both a great artist and a victim of Stalinism. When Eisenstein died the following year, Agee wrote, "For years, as everyone knows, Eisenstein has been working as if in a prison, under the supervision of jailers who are...peculiarly dangerous and merciless...Everything that is meant by creative genius and its performance, and everything that that signifies about freedom and potentiality in general, is crucified in Eisenstein, more meaningfully and abominably, than in any other man I can think of..." (*AoF*, p. 250).

By 1955, however, Eisenstein was no longer a genius and victim of Stalinism, but a fraud and apologist for Stalinism. In "Re-Viewing Russian Movies," Warshow, making an invidious distinction between Dovzhenko's *Earth* and Eisenstein's *The General Line*, called the latter "the work of a skilled hack and philistine" (*TIE*, p. 211). But more interesting than the downward mobility of Eisenstein's reputation were the terms in which it was derided. Whereas for Agee, one of his strengths was his antirealistic stylization (in *Ivan the Terrible*, Agee praised him for "go[ing] boldly and successfully against naturalism and even simple likelihood" [*TIE*, p. 249]), this stylization, for Warshow, following

Bazin, was a weakness, worse, a lie, confounded by the higher truth of "reality." "How utterly vulgar art and belief [read "ideology'] can be, sometimes, when measured against the purity of the real event," wrote Warshow. "There are innumerable examples of such vulgarity in the Russian cinema, moments when the director, taken up with his role as an artist who controls and interprets—few artists have put a higher value on that role than the early Soviet film directors—forgets what is really at stake and commits an offense against humanity" (*TIE*, p. 210). Again, attacking the celebrated montage by which Eisenstein evokes the awakening workers in *October* (three stone lions in the process of standing up), Warshow wrote, "This is another example of montage that is mentioned with honor in the textbooks, usually with the information that the three lions were not even photographed in the same city, a fact which is supposed to cast light on the question of whether the cinema is an art. The use of the stone lion is, indeed, a clever and 'artistic" idea, but it is also fundamentally cheap, and in both respects it is characteristic of Eisenstein, and of the Soviet cinema generally. What we want most, that cinema rarely gives us: some hint of the mere reality of the events it deals with. The important point about the lions is that all the "art" of their use depends on the fact that they are not alive" (*TIE*, p. 204).

In attacking artfulness in favor of "reality," Warshow echoed Bazin, and moved the French critic's esthetic into the American mainstream. But what was the "pure reality," the "immediate experience" that Warshow employed to batter Eisenstein? In *The Liberal Imagination*, Lionel Trilling wrote that the future historian of the decade "will surely discover that the word reality is of central importance in his understanding of us." Trilling was right; it became a key concept in the ideological tug of war between pluralists and their enemies, and pluralists expended considerable energy attempting to secure

the term for their own ends. Like them, Warshow was fairly clear about what reality was not, but somehow he never bothered to define exactly what it was, preferring to leave the impression that it was self-evident, or, if not, sufficiently "complex" to be in need of interpretation by experts like himself. Yet Warshow, who portrayed himself in his writing as something of a moral tuning fork, preternaturally sensitive to the crimes of Stalin, apt to quiver with pain at the slightest tremor of Zhdanovism, turned out to be, unlike Agee, astoundingly oblivious to the Soviet persecution of Eisenstein, and strangely unconcerned by the virtual expulsion of Chaplin from the U.S.

Warshow didn't attack the pre-Cold War, left-liberal, Popular Front critics directly; he shared many of their assumptions and spoke the same language, but nevertheless, he successfully undermined many of their assumptions, particularly the criteria of social significance, seriousness, and good taste they used to judge movies. He not only began the downward revaluation of Eisenstein and Chaplin, but he also had a taste for mass culture, and wrote well on the lowly Hollywood genre movies—Westerns and gangster films—which had hitherto been beneath contempt. In so doing, he made the old arthouse gang look stuffy and foolish.

Warshow provided a bridge between Agee and Sarris, and when he died, suddenly, in 1955 (the same year Agee died), Sarris was just beginning his career. Drawing on the new generation of young critics and novice directors gathered around *Cahiers du cinéma* in Paris—François Truffaut, Jacques Rivette, Jean-Luc Godard, and Eric Rohmer—Sarris turned them to his own purposes. In their hands, Bazin's theory became a club with which to bludgeon the "Tradition of Quality," France's "official" film culture. This was a version of our old friend, Popular Front culture, and after the war, when *Cahiers*' Young Turks turned on their elders, they were turning on the left.

Taking a hard line in France's cinematic cold war, Truffaut wrote in January 1954 that "peaceful co-existence between this 'Tradition of Quality' and the *"cinéma d'auteurs"* was impossible." Attacking the films of France's most celebrated prewar and postwar directors—Claude Autant-Lara, Henri Clouzot, René Clement, René Clair, and Yves Allegret—"He found them," as John Hess put it, "anti-bourgeois, anti-military, anti-clerical, opposed to all sorts of linguistic and sexual taboos, and full of profaned hosts and confessionals."

By the time Sarris began to write, the pages of American newspapers and magazines had been made safe for democracy. The lefties, radicals, fellow travelers, independents, anarchists, pacifists, and general riffraff who had infected the press with their pink prose in the Thirties and Forties had been flushed out by almost a decade of witch hunting. It was all quiet on the Western front, save for the click-clack of Westbrook Pegler or George Sokolsky goose-stepping across the pages of the Hearst press. All Sarris had to do was to conduct a mopping-up operation, and he saw to it that auteurism would play the same role in America that it had played in France; the American "Tradition of Quality" that it was used to demolish was precisely the Jacobs, Rotha, Griffith, Macdonald, Agee group that Warshow had already softened up. More so than Warshow, Sarris saw them as a "tradition," and attacked them directly. His strategy, borrowed from the French, was to dump the silents, whether Russian or American, the "art films" so dear to the old guard, and privilege "movies" instead, claiming they were true "art." "The sociologically oriented film historians, Jacobs, Grierson, Kracauer," Sarris wrote, "looked on the Hollywood canvas less as an art form than as a mass medium. Hollywood directors were regarded as artisans rather than artists...Film historians have been misled by the sociological veneer of [*Birth of a Nation* and *Potemkin*] into locating the

artistic essence of cinema in its social concerns. Realism and social consciousness thus became the artistic alibis of socially conscious film historians, and genre films without a sociological veneer were cast into the dustbins of commercial entertainments" (*The American Cinema*, p. 15; *The Primal Screen*, p. 58).

If Hollywood films were Art, not artifacts, they could be detached with impunity from the social and cultural context, from the circumstances of production and consumption. According to Sarris, sociological critics had a bad habit of "singling out the timely films and letting the timeless ones fall by the wayside" (*TAC*, p. 25). He intended to put a stop to that, substituting "timeless" for "timely." Arguing with Bazin about the impact of capitalism on film, he wrote, "I still find it impossible to attribute X directors and Y films to any particular system or culture...If directors and other artists cannot be wrenched from their historical environments, aesthetics is reduced to a subordinate branch of ethnography" (*TPS*, p. 45).

Sarris's 1962 auteurist manifesto veered wildly from the obvious to the obscure, but what it all boiled down to was that the films were judged on the basis of who directed them, and directors were judged on the basis of the presence or absence of personal style: "The distinguishable personality of the director [is] a criterion of value." He ranked some 150 directors from the "Pantheon" to "Others." The worst film of a permanent Pantheon pensioner like John Ford was more interesting than the best film of a director like Kazan for whom the Pantheon was full up. (As Dwight Macdonald remarked at the time, "This kind of grading is appropriate to eggs but not works of art" [*On Movies*, p. 305].)

Sarris led a one-man counterrevolution in film scholarship. He followed up on Warshow's attack on Chaplin by elevating Buster Keaton to the spot of #1 Silent Comic. Now it was the turn of "serious" films like *The Informer* to be carted out to

the dustbin of social consciousness, while films once disdained like *Baby Face Nelson, Seven Men From Now,* or *El Dorado* were firmly ensconced in the Pantheon's bridal suite. *Potemkin* became the butt of dumb Cold War jokes ("What is black and white and Red all over?"—even Warshow would have turned over in his grave), and Sarris pretended to find (let's give him the benefit of the doubt) Ford's *Steamboat "Round the Bend* "more interesting" than Ford's *The Grapes of Wrath.* Meanwhile, Ford's *The Man Who Shot Liberty Valance* became the subject of lyrical adulation: It "must be ranked along with *Lola Montes* and *Citizen Kane* as one of the enduring masterpieces of that cinema which had chosen to focus on the mystical processes of time" (*TPS,* p. 152).

This shift in the criteria by which films were judged had seismic consequences. Hollywood movies had always lagged embarrassingly far behind New York painting, Jewish and Southern fiction, and jazz as evidence of American superiority in the cultural Cold War with the Soviet Union. After Sarris, it was no longer necessary to apologize for "movies." Whereas Agee was a fierce critic of Hollywood, Sarris was a fervent admirer. Whereas the "sociological" critics and film historians once valued the German Lang, the English Hitchcock, and the French Renoir over the American films of the same directors, which were considered empty, glossy, and commercial, now the worm had turned, and the American Lang, Hitchcock, and Renoir were suddenly as good if not better than their European films. The stock of directors like Aldrich, Fuller, Siegel, Hawks, Walsh, and even Karlson, whom no one aside from bleary-eyed cultists had ever heard of, shot up and off the scale. Auteurism marked the triumph of nationalism in film studies. Dismissing Murnau, Lang, Pabst, Renoir, Vigo, Cocteau, Rossellini, Visconti, De Sica, Bergman, Dreyer, Mizoguchi, Kurosawa, Ozu, Satyajit Ray, and Wajda, not to mention the Russians, Sarris grandly declared, "Film for film, director for director, the American cinema has been consistently superior to that of the rest of the world from 1915 through 1962" (*TPS,* p. 48).

"Sociological" became an obscenity in the auteurist lexicon, a code word for "left" or "liberal," and was replaced by "aesthetic" as in "the criteria of selection for [the Pantheon] are aesthetic rather than social or industrial" (*TAC,* p. 16). Aesthetic was defined as "a committment to formal excellence" (*TPS,* p. 69) and its use appeared to initiate a new era of formalism. But not quite. Sarris liked Walsh better than Wilder, Hawks better than Huston (whom Agee championed), Cukor better than Kazan, Gregory La Cava better than Wise, Wyler, or Zinnemann. Why? On closer inspection it turned out that Sarris's criteria weren't esthetic at all; they were ideological. The adoration of American film meant the adoration of American ideology. The action films auteurists liked were clean, mean, tough, and generally right wing. The films they didn't like were "liberal."

Take Sarris's review of Sidney Lumet's *Dog Day Afternoon,* written in the Seventies. He was outraged that "once the robbery gets started Pacino and Cazale begin more and more to resemble lovable non-conformists held at bay by a hostile, unfeeling society," and he pined for the movies of "the forties and fifties [when] the story would have been told in such a way as to make the audience root for the bank manager, his employees, the police, and the FBI...Under the aegis of Freud and Marx the perpetrator [*note the law enforcement lingo*—RTW] is transformed into a Problem we all should have solved a long time ago" (*Politics and Cinema,* pp. 35 and 33). After hundreds of column inches flailing liberals, he finally gets around to the "aesthetic value," seven lines from the end of the review, writing that *Dog Day Afternoon* "is not a bad job of moviemaking" (*TPS,* p. 36). But it was too little, too late. This was "sociological" criticism pure and simple. It suddenly became clear that

there was good sociological criticism and bad sociological criticism. Good sociological criticism wasn't sociological at all; it was redefined as "aesthetic," and it was practiced by "us"; bad sociological criticism was practiced by "them." "Us" in this case meant centrists like Sarris. "My own political position," he wrote, is "rabidly centrist, liberal, populist, more Christian than Marxist...I believe more in personal redemption than social revolution...The ascending and descending staircases of Hitchcock are more meaningful to me than all the Odessa Steps...I never wept for Spain or Chile" (*TPS*, p. 61, etc.).

Despite his own oft-proclaimed "pluralistic" esthetic, "them," simply meant the left, with which Sarris conducted a career-long polemic, flinging about epithets like "the idiot left" with abandon. When Sarris looked left, he saw red; when he saw red he saw Stalin, and reached for his dog-eared copy of George Orwell. Sarris's rhetorical strategy followed the well-worn path trod before him by pluralist pioneers like Bell, Schlesinger, and Riesman. With a flourish of mock bathos, he portrayed the center as a helpless "muddled middle" beset on all sides by "extremists," a delicate flower set aflutter by the sound of approaching jackboots. He was a firm subscriber to the centrist doctrine that the left and right were essentially the same. "As a Centrist," he wrote in the Sixties, "I am uncomfortable with both the Buckleys and the Berrigans. They are cut from the same absolutist cloth, and they would exclude the middle if they could."

Filled with paranoia himself, Sarris followed the lead of Richard Hofstadter's centrist classic, *The Paranoid Style in American Politics*, and called others paranoid, particularly his *bêtes noires*, the socially conscious critics of the Thirties. Writing about what he calls the "forest" critics, he said, "It is the system that he blames for betraying the cinema. This curious feeling of betrayal dominates most forest histories to the point of paranoia" (*TAC*, p. 21). Following Bell's celebrated

essay, "The End of Ideology," his enemy is "ideology," which becomes, like "sociology," a dirty word. In a characteristic attack, he wrote of "the ever mounting pile of idiotically ideological cinema" (*PaC*, p. 81).

The great beauty of pluralism was that it was indeed pluralistic, up to a point. Not everyone bought auteurism. One critic who didn't was Pauline Kael. In a witty and stinging demolition job called "Circles and Squares," published in 1963 in *Film Quarterly*, she attacked Sarris's devotion to "distinguishable" personal style as the primary criterion of value: "The smell of a skunk is more distinguishable than the perfume of a rose; does that make it better?" (*I Lost It at the Movies*, p. 268). And she also attacked his attempts to isolate movies from their social context. "When is Sarris going to discover that aesthetics is indeed a branch of ethnography," she wrote. "What does he think it is—a sphere of its own, separate from the study of man in his environment?" (*ILIatM*, p. 280). But although Kael and Sarris went at it hammer and tong, they were both rocking, not tipping, the same boat. If you didn't like Hertz, you could try Avis, to change metaphors in midstream, and still be assured of a smooth ride down the middle of the road.

Kael indeed attacked Sarris, but she did so in pluralist terms. Like him, she had scores to settle with the old-guard lefties, and in settling them, she used his techniques. When Richard Griffith, a noted film historian and curator of film at the Museum of Modern Art, praised *La Grande Illusion* for its attempts to "influence" events, she complained that "the standard film histories still judge movies by the values of the 'Resistance'" (*ILIatM*, p. 255). Siegfried Kracauer, the left-leaning "sociological critic" whom Sarris savaged, fared no better in Kael's hands. Nastily reviewing Kracauer's book, *The Theory of Film*, in a pun worthy of Sarris's worst, Kael attacked the "Odessa-steeped film critics [who] tell us that Eisenstein's 'goal, a cinematic one, was the depiction of col-

lective action, with the masses as the true hero'—and this battle hymn has become the international anthem of film criticism" (*ILIatM*, p. 254). Kracauer had a neorealist-influenced esthetic very much like Bazin's (and Warshow's)—he liked nonactors in real locations—and in attacking Kracauer, she was attacking Bazin, the granddaddy of auteurism. Despite her distaste for Eisenstein, she used him as a club against Kracauer, accusing the latter of disdaining "art" and artfulness in favor of "nature," defined as "a belief in progress," (p. 257) or "reality," defined as "poverty and mass movements" (p. 256). She draped Kracauer with all the unhappy qualities pluralists habitually attributed to extremists. He was guilty of "primitive ...thinking" (p. 247), an adherent of a "monomaniac theory." "Siegfried Kracauer is in the great lunatic tradition" (pp. 244–45), she wrote, comparing him to a "religious zealot," and contrasting him to "relaxed men of good sense," presumably like herself, "whose pluralistic approaches can be disregarded as not fundamental enough" (p. 245).

When Kael turned to Sarris himself, she employed the same strategy against him she used against Kracauer and the others. Sarris was guilty of applying a "single theory" (by which she meant abstract preconceptions that get in the way of the "experience" of film), that overran the pluralist garden like a beserk "lawn mower" (p. 279). Auteurists were essentially loonies "united by fanaticism in a ludicrous cause" (p. 280). Worse, and this was the ultimate weapon in the pluralist arsenal, auteurists were implicitly totalitarian. Their esthetics were "an aesthetics for 1984" (p. 283). Sarris-the-Stalin-slayer was himself, implicitly, a Stalinist. His constant harping on directorial style convicted him of the crime of the "cult of personality" (p. 272).

Kael's prose in the Fifties and Sixties was full of echoes of Riesman (she called auteurists "inside dopesters"); like him (and Bell, Schlesinger, Trilling, et al.),

she saw not only the democratic process, but also reality itself in terms of the give and take of interest group politics. She spoke of "the real world of conciliation and compromise" (p. 295). Filmmakers she didn't like were not only bad, but undemocratic (un-American?). (She didn't use "reality" as a criterion of value; she couldn't, after flaying Kracauer for doing it, but she tended to substitute "experience," as in "art is an expression of experience." Just what "experience" was, she, like Warshow, never quite said, falling back instead on the pluralist cant about "complexity.") Those who flouted reality were "neurotic" or infantile, allowing her to switch over to the derogatory psychologizing fashionable at the time. Thus, like Sarris, she was fond of calling her enemies "paranoid," as in "the accusatory, paranoid style of [Jonas] Mekas" (p. 285). (Mekas first published Sarris's auteur theory in his magazine, *Film Culture* in 1962–'63.) And in the same way that Sarris opposed his "balanced" centrism to the paranoia of the extremists on the right and (especially) the left, so Kael opposed her calm, sane, "balanced" pluralist approach to the frenzies of auteurism. "I believe that we respond most and best to work in any art form (and to other experience as well) if we are pluralist, flexible, relative in our judgments, if we are eclectic" (p. 278). In fact, her own matter-of-fact, brilliantly colloquial, down-home conversational style went a long way towards establishing the ideology of the center as just plain common sense.

Kael misconstrued Sarris as a cultural radical. True, he first published in *Film Culture*, and then in *The Village Voice*, and it is also true that he affected a kind of populism, championing lowbrow commercial fare and baiting "coterie" arthouse taste in "cinemah," as he was fond of calling it. But he turned on the avantgarde as soon as it became expedient, and it quickly became clear that he didn't want to demolish "cinemah" so much as

redefine it to include the movies he liked best.

Both Sarris and Kael were, needless to say, entitled to their political views. Both had a keen eye for the weaknesses of Soviet cinema, the fatuousness of the "message" movies of the Thirties and Forties, and the hollowness of the progressive film scholars who made themselves easy targets with their windy and sententious Popular Front rhetoric, labored Americanism, and sentimentalization of the "masses." Auteurism performed a real service in deflating the pretensions of the "montage maniacs," as Sarris called them, and making Hollywood movies respectable. Kael in particular played a key role easing the way for the New American Cinema of the Seventies. Without her, the determined campaigns carried on in *The New York Times* and *Time* magazine against pictures like *Bonnie and Clyde* and *Clockwork Orange* might have been successful. But both Sarris and Kael were beneficiaries of the witch hunt that cleared away the left-wing underbrush so that centrist growths like their own might flourish. The last chapter of Kael's *I Lost It at the Movies* is entitled "Morality Plays Right and Left," and, in it, Kael paid her ideological dues. First she dispatched an anti-Communist film, *Night People*, and then she joined the hue and cry against *Salt of the Earth*. She called it "Communist propaganda" (p. 298) and proceeded to chide *The New York Times* and *Los Angeles Daily News* reviewers for not spotting the Commie line when it was being unreeled right before their very eyes. "There are Americans," she asked in amazement, "who have not learned that Communist propaganda concentrates on local grievances?" (p. 298). Maybe these reviewers were themselves Red agents? Kael didn't say so; she was a centrist, so she only loaded the gun and aimed it, leaving it to others to pull the trigger.

Salt of the Earth may have been awash in Popular Front bathos as Kael charged, but she went further. At a time (1954) when the U.S. government had deported the film's Mexican star, Rosaura Revueltas, when Hollywood labs refused to process the exposed footage, when IATSE projectionists struck the movie, Kael delivered a blow for movie McCarthyism. Let-a-hundred-flowers-bloom centrist critics celebrated the variety and plenitude of the pluralist garden, but they were confined to the Hollywood mainstream, and nurtured in a climate of ideological conformity that would have made Stalin blush. And while they were busy pruning away the troublesome weeds on the American right and left, a whole new world of cinema sprang up with which they were totally unequipped to deal. It had become a jungle out there.—R. T. West

ADDITIONAL RECOMMENDED BIBLIOGRAPHY

Murray, Edward. *Nine American Film Critics.* NY: Frederick Ungar, 1975.
Kauffmann, Stanley, ed. *American Film Criticism.* NY: Liveright, 1972.

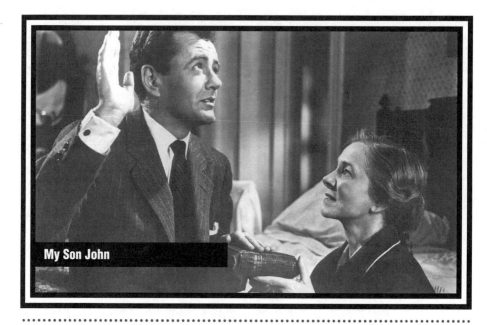

My Son John

Anti-Communist Films

The anticommunist films produced by the American film industry during the late Forties and the Fifties were a product of the Cold War and the near-hysterical anti-Red witch hunt of that period.

The production of these films had little to do with either the economic motivations or ideological convictions of the movie industry's leaders. To be sure there were among the studio bosses a few dedicated if overly zealous anticommunists: Howard Hughes, who controlled RKO, went so far as to have all the credits of that studio's reissues scrutinized and to have the names of any suspect personnel excised (e.g., musical composer Hanns Eisler's name disappeared from the 1950 reissue of the 1945 release *The Spanish Main*).

None of Hollywood's anticommunist films did well at the box office, and many of them did not even recover their costs. The paranoia which swept the U.S. during these years notwithstanding, moviegoers voted with their feet against such films. What most likely gave rise to the production of

these films was the fear-inspired attempt to combat, in *Variety*'s words, "the ill-will against the film industry" resulting from Congressional hearings on subversion in Hollywood. The production of the first batch of these films seems to have been triggered by the 1947 hearings held by the House Un-American Activities Committee, and the HUAC hearings held in 1951 resulted in another spate of such films. The industry, albeit in significantly reduced numbers, continued to produce such films into the Sixties.

The precise beginnings of the Cold War remain a matter of dispute among historians, but there can be no doubt that by the late Forties Hollywood had enlisted for the duration. The industry took its lead from such Cold Warriors as Winston Churchill, who already in 1946 had charged the

Russians with having drawn an "Iron Curtain" across Europe and with using Communist parties in various countries as "fifth columns" for the purposes of internal subversion.

In Cold War Hollywood, no film genre proved immune—not even Westerns or science fiction. These genres, like the cinema in general and like most American culture, resonated with Cold War overtones of one sort or another. The titles of just a few representative films tell a great deal about their content and level of sophistication: *Walk a Crooked Mile* (1948), *Conspirator* (1950), *Invasion, U.S.A.* (1952), *No Time for Flowers* (1952), *The Fearmakers* (1958).

In the mid-Fifties, Dorothy B. Jones, a respected film analyst, undertook a study of the films dealing relatively directly with communism that were produced during the late Forties and early Fifties, and her findings about content hold true for the whole era. She concluded that overall these films could be categorized as follows: l) formula spy melodramas which followed "the familiar timeworn pattern"; 2) movies which attempted to deal with communism in the U.S. and to explain "the way in which the party recruits and holds its membership, and the tactics" by which it operates; 3) dramatizations of Cold War events "which had taken place abroad." Obviously there is an overlapping within these categories, but, whatever the category, all these films emphasize the supposedly overwhelming attractiveness of American values and way of life, and condemn the evil, atheistic heartlessness of communism and the drab quality of life in countries under its brutal sway.

The spy melodramas were naught but a reworking of formula plots in which the communists (whether the domestic variety or Soviets) were up-to-date villains. The Reds replaced the Hun of World War I, the Axis agents of World War II, and the unnamed foreign enemy of the interwar years. The plot devices around which these movies revolved may have varied, but it usually involved something the Soviets

dearly wanted and which they went to great lengths to obtain, and frequently involved the Communist parties or fifth columns to which Churchill had referred. Naturally the Reds were always foiled by one or another branch of the American government.

In *Diplomatic Courier*, a 1952 Twentieth Century Fox film, Tyrone Power, as a Foreign Service officer aided by some friendly MPs, is able to keep the Russians from recovering a microfilm containing their detailed timetable for the invasion of Yugoslavia. In the course of so doing he finds out that the cosmopolitan American woman to whom he was attracted actually was working for the other side. *Walk East on Beacon*, a 1952 Louis de Rochemont production for Columbia release, deals with Soviet efforts through the use of disloyal American to penetrate "FALCON," a top-secret U.S. project. The credits inform viewers that the film is "A Drama of Real Life Suggested by "The Crime of the Century" by J. Edgar Hoover... produced...with the cooperation of the Federal Bureau of Investigation," and, just in case the audience failed to read this message, a narrator during the film's opening minutes reports that the FBI is dealing with a Soviet "worldwide conspiracy" which "through subversion" is trying to "destroy established governments everywhere."

Night People, a 1954 Twentieth Century Fox production, is more complex. A young American corporal is kidnapped from the West Berlin streets and taken East. Why? Because the Russians need a hostage in order to force an exchange with the American authorities in West Berlin for an elderly German couple. This couple, it turns out, is an upper-class Englishwoman married to a former German general involved in the plot against Hitler—both are now wanted by former S.S. officials working with the Russians and anxious to settle past accounts. Within less then forty-eight hours an energetic, strongwilled U.S. Army colonel rescues the GI and saves the

German couple. While doing so, he finds out that one of his informants is actually an unscrupulous double agent who betrayed a Russian friend planning to defect. The double agent is dealt with by being framed in such a manner that the Russians will dispose of her.

The Nazi connection in *Night People* (1954) points up a fascinating aspect of the anticommunist films. As critic Pauline Kael put it: "The filmgoer who saw the anti-Nazi fims of ten years ago will have no trouble recognizing the characters in *Night People*...the bit players who once had steady employment as S.S. guards are right at home in their new Soviet milieu." And it was not just bit players. The primary Soviet agent in *Walk East on Beacon* was portrayed by Karel Stepanek who during World War II played Nazis in such films as *Escape to Danger* (1944). Nor was this recycling of villains limited to a contemporary time frame, as can be seen from films like the 1952 Universal-International production, *The World in His Arms*, an adventure yarn set in Gold Rush San Francisco, Russian Alaska, and the seas in-between. In this film a Yankee seal hunter wooes and wins a Russian countess fleeing from a forced marriage to a cruel, autocratic, snobbish Russian prince. Car Esmond played that prince in his best polished Nazi villain manner, for he, like Stepanek, and many other actors, had been effectively recycled from Nasty Nazi to Rotten Russian.

The movies that dealt with communism in the U.S. were lurid, simplistic, and formulaic. They also highlighted the nefarious activities of the Communist Party as fifth column. These films spotlighted sabotage, espionage, and subversion, but they also presented Hollywood's melodramatic view of American communists. "Better dead than Red" sums up the industry's approach. The leadership is presented as violent in the best gangster tradition. The male membership, when not prone to violence, is shown as a bunch of simpering bookish types, woolly do-gooders, or naive dupes. The women are either starkly unpretty (and probably frigid) or blond seductresses given over to free love, luring innocents through sexual means fair or foul. The Party, from which it was difficult, nigh impossible, to resign, took precedence over everything else, including patriotism, God, family, or love. The director Karel Reisz, in 1953 a young film critic, found the following exchange in one form or another, took place in a number of these films:

Party girl: (in love and therefore deviating) "Don't worry about my private life."

Party boss: "You *have* no private life."

These films maintained that the CP paid only lip service to its announced ideals and the equality it preached. The Party was portrayed as being anti-Semitic and anti-Negro as well as undemocratic and elitist. In *The Red Menace* (Republic, 1949), a Party official discussing a Negro snarls, "We're wasting our time on these African ingrates," an Italian is written off as "a Mussolini-spawned Dago," and a Jewish poet is hounded to suicide. In the Warner Bros. 1951 film *I Was a Communist for the FBI*, after a meeting in the CP's Freedom Hall at which he rabbleroused a black audience, the CP functionary discussing the results with his comrades refers deprecatingly to the audience as "niggers." That same film also includes a stock scene to be found in many such films in which there is a small private champage and caviar supper during which one CP leader asserts, "Better learn to get used to it...this is how we are all going to live once we take the country over."

One of the crudest of the films dealing with domestic communist activities was *The Woman on Pier 13*, in which the party tries to capitalize on a San Francisco docks labor dispute. Released by RKO in June 1950 after a long gestation period and after the finished film had been withheld from distribution for months, it had begun life as a project called "I Married a Communist." The studio's belief that such a marriage had melodramatic implications is an excellent indication of the film's quack level of

political sophistication. The communist bridegroom in the title of the original screenplay actually had left the party and had risen to executive level in a San Francisco shipping concern. He is blackmailed by Communist leader Vanning who wishes to foment unrest on the docks for the party's ends—ends which have nothing to do with the workers. The portrayal of Vanning as a physically unattractive, thug-like, hardline Communist was (to use one recent critic's words) "a savage smear on Harry Bridges," the controversial but extremely effective West Coast labor leader. Overall, the party leadership is shown to be operating on the lowest level of villainy, including murder.

On the same crude level was the meretricious 1952 Warner Bros. release *Big Jim McClain,* which eulogized HUAC for whom the eponymous hero and his martyred buddy work as investigators and subpoena servers. McClain was played by John Wayne (whose company produced the film) in his usual heroic style as he helped to expose Communist activities in Hawaii, especially on the waterfront (another slap at Harry Bridges). The CP murderers of McClain's associate are brought to justice, and, although HUAC exposes the Red infiltrators, they are able to find shelter behind the Fifth Amendment. The film barely pays lip service to the rights guaranteed by the Constitution, and the implication is clear: only those subversive of the true Americanism expostulated by groups such as HUAC hide behind constitutional guarantees—all others have nothing to fear and are willing to bare all. In a simpleminded but enthusiastic way, *Big Jim McClain* was a rousing endorsement for the McCarthyism then sweeping the country. Given the film's storyline and Wayne's well-known conservative reputation, it would be unfair to regard the production as cynical exploitation; it is, alas, a sincere but misguided effort typical of the attitudes (to use critic Bosley Crowther's words) that "it is painful to think too deeply and the fist is

mightier than the brain."

A much more earnest and insidious effort was the 1952 Paramount release *My Son John* which postulated similar points of view, including staunch, unquestioning Roman Catholicism, emotional patriotism, and (especially) antiintellectualism. All these elements in one form or another are to be found in various anticommunist films but not to such a degree nor presented with such intense, sermonizing pretentiousness. The film was very much the creation of the versatile Hollywood veteran Leo McCarey, who coproduced, coscripted, and directed it. An avowed anticommunist, he allowed his beliefs to get the better of his filmmaking instincts, which in the past had served him very well in fashioning commercially successful, award-winning films.

John (Robert Walker), a federal government functionary, is exposed as a Communist tied to an espionage ring, thanks to the patience and fortitude of the FBI, who through his mother get him to repent before he is murdered in front of the Lincoln Memorial. John's last words are offered on tape to the graduating class of his alma mater and they are both a confession (about being a Communist) and a warning (that intellectualism can lead from the path of righteousness as exemplified by parents and church). Indeed, the exposure of John is the discrediting of intellectuals. McCarey's hero is John's father, a proud American Legionnaire, who calls the Reds "scummies," hits his son over the head with a Bible, and sings songs that begin, "If you don't like your Uncle Sammy, then go back to your home o'er the sea…" John's mother tells her husband that "you've got more wisdom than all of us because you listen to your heart." There is no question about the antiintellectualism of *My Son John.* Critic Robert Warshow called it "an affirmation of "Americanism" that might legitimately alarm any thoughtful American, whether liberal or conservative."

The dramatization of Cold War events "torn from the pages of today's headlines,"

as the movie companies' ads went, made extensive use of Churchill's Iron Curtain metaphor. There was something nasty going on behind that curtain, something from which good people tried to flee, and flight is the motivating force in a number of such films. MGM's *The Red Danube* (1949) dealt with the forcible repatriation of refugees from Russia back to their homeland. Unfortunately the genuine horror of this situation was lost in an undistinguished movie which centered on a love story between a British junior officer and a young ballerina who accepts death in Vienna rather than return to the U.S.S.R., and included hollow and clichéd conversations about God, man, and duty between the young man's superior officer and the head of the convent where the ballerina temporarily found refuge.

Hollywood also failed to treat adequately the defection of Igor Gouzenko, the Soviet diplomat whose decision to stay in Canada led to the exposure of Russian espionage activities there. Twentieth Century Fox's *The Iron Curtain* (1948), although making use of Canadian locations, was a drab and uninspiring affair. Much more exciting if less believable was that company's 1953 film *Man On a Tightrope*, which recounted in somewhat exaggerated form the flight of an entire circus troupe, including animals, from Czechoslovakia to West Germany. The film more than adequately sketched the desperation which motivated the dash across the border.

However banal the propaganda in *Man On a Tightrope*—stern-visaged, machine-gun-wielding guards on the Red side, gum-chewing, easygoing GIs on the German side—the film had pace and style. Most of the films dramatizing the headlines did not. They were poor movies, no matter how interesting the subject matter. Americans, for example, were not at this time used to the seizure of U.S. citizens as spies. *Assignment Paris*, a 1952 Columbia release dealing with such an arrest, failed even as stark melodrama, although it treated such inherently interesting aspects of the subject as brainwashing.

The anticommunism of these films led Hollywood to revise its interpretation of recent history. Thus, *Operation Secret*, a 1952 Warner Bros. melodrama, is set during World War II, but while the Germans are the enemy, the prime villain is a French Communist who even deceives his Resistance friends. Such Frenchmen, according to the film, assisted the Allied cause only as long as that aid furthered the Soviet cause. When it did not, as in 1940 during the Nazi-Soviet Pact, such subversives helped to bring France to its knees. Their commitment to a cause or to another person was always seen as subject to the dictates of their Soviet masters.

Trial, set just after World War II, deals harshly and crudely with the American CP's use of what are described as liberal dupes and innocent martyrs. In its contention that the CP undertakes the defense of seemingly lost causes mainly to raise funds which are siphoned off to the party's coffers, the film is only another slice of Cold War propaganda. But *Trial* is of more than passing interest, not for its unoriginal treatment of Communists, but because it is symptomatic of changes to come. It makes a stab at evenhandedness and allows the liberal dupe to achieve a standoff (in what admittedly is a minor subplot) with a publicity-seeking legislator who is using anticommunism as a vehicle to further himself.

Anticommunist movies continued to be made into the Sixties, as can be seen from the partial output of just one studio. In 1960 Columbia released Louis de Rochemont's film version of Hollywood veteran Boris Morros's account of being a counterspy. *Man On a String* was clichéd, unimaginative, and harped on the well-worn theme that the Kremlin was out to undermine the American way of life, as did the studio's 1962 release *We'll Bury You*, an uninspiring compendium of still photographs and newsreel footage held together by an exaggerated narration.

By the beginnings of the Sixties these films and their earlier counterparts had

become out-of-date propaganda. *Trial* did not mark a turning point, but, as the real world began to change, so too did the reel one. Detente and the lessening of McCarthyism led to a new enemy on-screen—still Red but now Yellow as well. The Russians were replaced as the bogeymen by the Chinese, and in effect there was a revival of the "Yellow Peril," as racism and politics entwined.

The noted documentary filmmaker John Grierson once defined propaganda as "the art of public persuasion." For the makers of the anticommunist Cold War films of the late Forties and Fifties, however, persuasion was too mild. They figuratively hit audiences over the head with a hammer and sickle.—Daniel J. Leab

RECOMMENDED BIBLIOGRAPHY

Barson, Michael. *Better Dead Than Red: A Nostalgic Look at the Golden Years of Russiaphobia, Red-Baiting, and Other Commie Madness.* NY: Hyperion, 1992.

Sayre, Nora. *Running Time: Films of the Cold War.* NY: The Dial Press, 1982.

White, David Manning and Richard Averson. *The Celluloid Weapon: Social Comment in the American Film.* Boston, MA: Beacon Press, 1972.

The Auteur Theory

The auteur theory refers to a critical approach which emerged in the postwar period, especially in France, and which was formulated most notably by André Bazin in France and by Andrew Sarris in the United States.

In a 1975 article, *"La Politique des Auteurs,"* Bazin summarized auteurism as "choosing in the artistic creation the personal factor as a criterion of reference, and then postulating its permanence and even its progress from one work to the next."

Although auteurism came into vogue in the Fifties, the idea itself was in some ways a traditional one. The characterization of the cinema as the "seventh art" implicitly compared film artists to painters or writers. Directors like Griffith and Eisenstein compared their own cinematic techniques to the literary devices of writers like Flaubert and Dickens. American journals of the late Forties, meanwhile, anticipated the auteurism discussion by debating the relative importance of the diverse collaborators on the filmmaking team. Lester Cole defended the scriptwriter, Joseph Mankiewicz the scriptwriter-director, while Stanley Shofield

compared the collaborative art of filmmaking to constructing a cathedral.

It was in postwar France, however, that the auteurist metaphor became a key structuring concept in film criticism and theory. Alexandre Astruc in "The Birth of a New Avant-Garde: The Camera-Pen" (1948) suggested that the filmmaker should be able to say "I" like the novelist or poet. With its first issue in 1951, *Cahiers du cinéma* became a key auteurist organ. The *Cahiers* critics saw the director as the person generally responsible for a film. In keeping with the theory, *Cahiers* wrote about and interviewed both French (Renoir, Cocteau, Bresson) and American auteurs (Hawks, Hitchcock, Welles). They defended the American films of Lang against the prejudice that his work declined in Hollywood. In the case of Hitchcock, *Cahiers* not only supported his American films but two of its members,

Eric Rohmer and Claude Chabrol, also wrote a book arguing that Hitchcock was both a technical genius and also a profound metaphysician.

The "scandal" of the auteur theory lay not so much in glorifying the director as the equivalent in prestige of the literary author but rather in exactly *who* was granted this prestige. Filmmakers like Renoir and Welles had always been regarded as auteurs because it was known that they had artistic control over their productions. The novelty of the auteur theory was to suggest that studio directors like Hawks and Minnelli were also auteurs. They argued, in other words, that intrinsically strong directors will exhibit, over the years, a recognizable stylistic and thematic personality, even when they work in Hollywood studios.

In his landmark 1957 article, Bazin summarized the auteur theory but also warned against any esthetic "cult of personality" which would erect favorite auteurs into infallible masters. Bazin also pointed out the necessity of complementing auteurism with other approaches—historical, sociological, technological. Great films, he argued, arise from the fortuitous intersection of talent and historical moment. Occasionally a mediocre director—Bazin cites Curtiz and *Casablanca*—might vividly capture a historical moment, without qualifying as an authentic auteur. The quality control guaranteed by the Hollywood film factory system, furthermore, virtually assured a certain competence and even elegance.

"*La Politique des auteurs*" translates literally as "the auteur policy" rather than "theory." In France, auteurism formed part of a strategy for opening the way to a new kind of filmmaking. Critic-directors like Truffaut and Godard were dynamiting a place for themselves by attacking the established system with its rigid production hierarchies, its preference for studio shooting, and its conventional narrative procedures. They were also defending the rights of the director vis-à-vis the produc-

er. Godard's *Contempt*—pitting the humane and cultivated auteur Fritz Lang against the vulgar and illiterate producer Prokosch—filmically encapsulates this "director's lib" side of auteurism.

Auteurism took on a very different thrust when it was introduced in the United States by Andrew Sarris in his "Notes on the Auteur Theory in 1962." In Sarris's hands, the auteur theory became an instrument for asserting the superiority of American cinema. Sarris declared himself ready to stake his critical reputation on the notion that American cinema had been consistently superior to what Sarris arrogantly called "the rest of the world." Sarris proposed three criteria for recognizing an auteur: 1) technical competence; 2) distinguishable personality; and 3) interior meaning arising from tension between personality and material. Pauline Kael debunked the three criteria in her response article "Circles and Squares" (1963). Technical competence, she argued, was hardly a valid criterion since some directors, like Antonioni, were *beyond* competence; they questioned and probed the very idea of technical competence. "Distinguishable personality" was meaningless since it favors repetitive directors whose styles are recognizable because they rarely try anything new. The distinctive smell of skunks, she analogized, does not make that smell pleasant or superior to that of roses. "Interior meaning," finally, she dismisses as impossibly vague and favoring "hacks who shove style into the crevices of plots."

Now that auteurism no longer triggers violent polemics, it is perhaps easier to attempt a lucid evaluation. Auteurism has clearly made a substantial contribution to film criticism and methodology. Auteurism is now widely practiced even by those who have reservations about the "theory." Museums show retrospectives in the works of directors, film courses revolve around the names of directors, and the general public increasingly tends to choose films on the basis of auteurs rather

than of stars or genre. Auteurism, further-more, clearly represents an improvement over the critical methodologies, if one can dignify them with that name, that preced-ed it, notably impressionism (a kind of neuro-glandular response to films based solely on the critic's sensibility) and sociol-ogism (an evaluative approach based on a reductive view of the progressive or reac-tionary political qualities of the characters or storyline).

Auteurism introduces a kind of system which consists in seeking out and con-tructing an authorial personality where perhaps none had been detected before. This systematic side of auteurism made it reconcilable with a certain kind of struc-turalism, resulting in a hybrid called auteur-structuralism, exemplified by Geoffrey Nowell-Smith's *Visconti* and Peter Wollen's *Signs and Meaning in the Cinema*. The auteur-structuralists put the director's name in quotation marks, to emphasize the idea of an auteur as a criti-cal construct rather than solely a flesh-and-blood person. Auteurism also performed a rescue operation for neglected films and genres. They discerned authorial personal-ities in surprising places—especially in the American makers of B-films—Samuel Fuller, Nicholas Ray, Douglas Sirk. Auteurism combatted the prejudice that directors automatically declined in Hollywood, valorizing the American films of Lang, Hitchcock, and Renoir. They res-cued entire genres—the thriller, the Western, the horror film—from literary high-art prejudice against them. Finally, auteurism forced attention to the films themselves and to *mise-en-scène* as the styl-istic signature of the director.

Auteurism has also been criticized on a number of grounds. Critics point out that auteurism underestimates the importance of production conditions. The filmmaker is not an untrammeled artist. While the poet can write poems on a napkin in prison, the filmmaker requires money, camera, film. Auteurists also underestimate the impor-tance of the collaborative nature of film-making, confusing the pseudo-descriptive proposition that "directors *do* control films" with the normative "directors *should* control films." Structuralists and poststruc-turalists score auteurism for formulating the theory in such a way as to make the cinema the last outpost of a romanticism long discarded by other arts. The expres-sive view of art attributes successful films to a mysterious "élan" or "genius," a view which is ultimately magical and quasireli-gious. Postauteurist criticism highlights all the ways a director's work is mediated by genre, by technology, and by the shared codes of the cinematic medium. Partisans of the avant-garde censure auteurism for its exclusive devotion to commercial cine-ma, leaving little room for experimental or militant cinema. Auteurism falters when confronted with a Michael Snow or Hollis Frampton and breaks down completely with the Newsreel Collective or the Grupo Cine de la Base. Marxists criticize auteur-ism's ahistorical assumption that talent will eventually "out" no matter what politi-cal or economic conditions obtain. Third World critics, finally, give auteurism a mixed reception. Glauber Rocha wrote in 1963 that "if commercial cinema is the tra-dition, auteur cinema is the revolution." But Fernando Solanas and Octavio Getino reject "second cinema" (auteur cinema) as easily cooptable by the establishment, in favor of a "third cinema" which is collec-tive, militant, and activist.—Robert Stam

RECOMMENDED BIBLIOGRAPHY

Caughie, John. ed. *Theories of Authorship*. NY: Routledge, 1981.
Sarris, Andrew. *The American Cinema: Directors and Directions 1929–1968*. Chicago, IL: University of Chicago Press, 1968.

The Devil and Miss Jones

Big Businessmen in American Cinema

F rom Douglas Fairbanks's indefatigable go-getter of the early silent cinema to Orson Welles's Charles Foster Kane, from Walter Huston's Lincolnesque Depression banker in *An American Madness* to Al Pacino's corporate gangster in the *Godfather* films, the big businessman has been a central figure in American cinema.

If the image of the big businessman has varied significantly with the times—in the prosperous Twenties and Fifties he was a hero, while in the Depression and post-Vietnam-Watergate era he was vilified—the terms by which he has been judged have remained constant. Virtually every Hollywood film about big business is linked by an obsession with the success ethic and the American Dream, by the quintessentially American belief that hard work, honesty, and fair play are the best and surest way to succeed in the land of opportunity. The businessman who respects the ethic is lauded by Hollywood as the type of man who brought the country prosperity, while the businessman who violates its rules is judged as a threat to prosperity and democracy itself. Only rarely have films about big business questioned the Protestant work ethic itself. The system which is supposed to let the best man win is a good system; it is only a few corrupt individuals who make things bad for everyone else.

According to Lewis Jacobs's *The Rise of*

the American Film, this emphasis on the success ethic was present in American cinema from its very beginnings. Films of the pre-WWI era glorified the rugged individualist who worked his way to the top from humble beginnings (such evocatively titled films as *The Best Man Wins, From Cabin Boy to King, A Self-Made Hero, The Stuff Americans Are Made Of*). At the same time, those who tried to "get rich quick," ignoring the principles of fair play, were soundly condemned in films like *A Corner in Wheat* (based on Frank Norris's story), *Crooked Banker*, and *Miser's Fate*.

In 1917 Douglas Fairbanks allied with Anita Loos and John Emerson to produce a series of comedies which established a new screen hero, the "self-made man," who was unbeatable and unfazed, whose "quick intelligence and indefatigable energy always won him success in terms of money and the girl" (Jacobs, p. 276). The energetic Fairbanks became the prototype for the big businessman in Hollywood films through the "jazz age." During a period when big businessmen were seen as gods or "titans of industry" by a prosperous and contented public, Fairbanks epitomized the American Dream come true.

With the exception of James Cruze's satire on the *nouveau riche, Beggar on Horseback* (1923), and King Vidor's brilliant *The Crowd* (1928), virtually no film criticized big business until the Wall Street Crash brought prosperity to an abrupt end. As America entered the Depression, the image of big business did an abrupt turnabout and the once-vaunted tycoons were now scapegoated as the cause of the breakdown. In film after film, big businessmen were portrayed as crooks and charlatans who would go to any lengths to achieve wealth. *Hell's Highway* (1932) condemns building contractors who exploit chain-gang prisoners as a source of cheap labor while *Cabin in the Cotton* (1932) shows how wealthy landowners exploit tenant farmers. In a number of pacifist war films, such as *All Quiet on the Western Front* (1930) and *Broken Lullaby* (1932),

big business is indicted for the tragedy of World War I. The "Great War" is viewed as an unnecessary conflict brought on by greedy politicians and manufacturers who made a fortune from arms sales. In *The President Vanishes*, a cabal of businessmen and politicians plot to start another profitable conflict, cynically commenting that the last war may have cost us "a few million casualties. But it also brought us the greatest era of prosperity this nation has ever seen."

Though all of these films portray big business in a negative light, few of them question the success ethic itself. Even the radical gangster films of this period follow this pattern. Films such as *Little Caesar* (1930) and *Public Enemy* (1931) portray characters reminiscent of the Douglas Fairbanks go-getter, the difference being that because of the Depression they had to go outside the law to achieve their success. According to Hollywood, all red-blooded Americans are instilled with the success-ethic mandate. Indeed, Edward G. Robinson's Rico in *Little Caesar* is a true believer in the American Dream, carefully following Andrew Carnegie's step-by-step formula for success, starting at the bottom of the gangster world and working his way to the top through hard work and a single-minded determination to succeed. Rico typifies the hardworking businessman except that his corporation is the gang and his main business tactic is murder. In Rowland Brown's *Quick Millions* (1931) and *Blood Money*, the heroes likewise succeed by applying big-business techniques to their rackets. In *Blood Money* (1933), the hero bluntly states the underlying thesis of the early Thirties' films—"Crime is a business like any other."

Rowland Brown's films are probably as radical as Hollywood got on the subject of big business and the success ethic. After the initial anger over the Crash subsided, Hollywood began to temper its view of the business titans, suggesting that it was only a corrupt few who were to blame for the Depression. Frank Capra's *An American*

Madness (1932) contrasts the socially conscious bank president (Walter Huston) with his tightfisted board of directors which will not lend money to anyone without collateral. Other films such as *The Power and the Glory* (1933), *The World Changes* (1933), and *A Modern Hero* (1930) portrayed the industrial magnate as a tragic hero who worked his way to the top honestly but along the way alienated himself from friends and family. The children of the honest tycoons, coddled by their mothers and neglected by their fathers, become spoiled, immoral brats who, when called upon to take over the family business, bring it to the brink of bankruptcy. In *The Working Man* (1933), shoe manufacturer George Arliss refuses to blame the Depression for bad sales: "Now, don't go blaming the Depression. People are still wearing shoes." Arliss believes that competition is the life-blood of America and when he sees his old rival's children squandering their father's hard-earned millions, Arliss joins the firm incognito, teaching them to have pride in their business and to work hard for success. In all of these films the success drive is seen as a positive force, but wealth and power, when placed in the wrong hands, spell economic disaster.

During this period, Hollywood offered a number of screwball comedies that showed how the corrupt, unhappy rich are humanized through contact with the common man. In *You Can't Take It With You* (1938), Edward Arnold portrays Anthony P. Kirby, a ruthless Wall Street tycoon who tries to buy out a middle-class neighborhood in order to build a munitions factory. He is opposed by the residents who are led by Papa Vanderhoof (Lionel Barrymore), a former tycoon who one day decided he "wasn't having any fun" and left his office, never to return. Vanderhoof convinces Kirby that there are more important things than mergers and millions, and soon Kirby forgets about tearing down the neighborhood to join his newfound friends playing harmonica duets of "Polly-Wolly Doodle."

Other films of this genre include *Holiday* (1938) in which Cary Grant, a "man of the people" and self-made millionaire rejects the business world to go on a permanent holiday, and *The Devil and Miss Jones* (1941), in which a rich and miserable department store owner played by Charles Coburn becomes a shoe clerk in his own store in order to discover the source of labor unrest there. Coburn is quickly won over by the honesty and kindness of his employees and soon joins them in picketing his own store.

With the rise of Hitler in Germany and the specter of another World War, the big businessman who violates the principles of fair play came to be viewed as a menace to democracy. In Frank Capra's *Mr. Smith Goes to Washington* (1939) and *Meet John Doe* (1941), Edward Arnold portrays far more malevolent figures than Anthony Kirby. In the former film, he plays Jim Taylor, a big businessman who controls an entire Midwestern state's industry, press, and government. Taylor's power extends into the United States Senate and he is now grooming his "favorite" senator for the presidency. It is only through the intervention of a naive and idealistic young senator (Jimmy Stewart) that Arnold's plans are foiled. Where Arnold's goals are more financial than political in *Mr. Smith* (he is trying to pass a bill that will allow him to sell land back to the government at a huge profit), in *Meet John Doe* Arnold is nothing less than an American would-be Hitler. Armed with a private police force and motor guards, with control over the nation's press and most of its politicians, D. B. Norton tries to catapult himself to the presidency. When Norton announces his political intentions, he speaks in a tone which clearly indicates that he will neither gain power through democratic means nor exercise it democratically: "These are daring times...We're coming to a new order of things. There's too much talk going on in this country. Too many concessions have been made. What the American people need is an iron hand." Norton is the

frightening projection of betrayal of the American Dream—a potential fascist dictator. He is also the precursor to the most complex and power-hungry of all American film businessmen, Orson Welles's *Citizen Kane.*

Where Capra's businessmen are purely evil, opposed by heroes who staunchly defend democracy, Charles Foster Kane is a curious combination of hero and villain, a businessman who upholds the rights of the common man at the same time as he tries to manipulate him. When newspaper publisher Kane runs unsuccessfully for governor, he crusades against business trusts, polititical bosses, and slum landlords. His platform to protect "the underprivileged, the underpaid and the underfed" seems sincere, but his quest for power is at the same time an ego-gratifying attempt to prove that he is more powerful than the political machine that controls his party. Kane's progressivism is clearly self-centered. He magnanimously offers the people token reforms to placate their discontent, but is unwilling to part with his own wealth or power over them— "If I don't look after the interests of the underprivileged, maybe someone else will—maybe somebody without money or property." Kane soon forgets his earlier liberalism when he finds the working classes demanding genuine reforms. His final betrayal of his "friends" comes when he publicly endorses Hitler—the ultimate enemy of those he once defended. Yet Welles's portrayal is a sympathetic one— like Anthony Kirby, Kane is temporarily humanized by the down-to-earth honesty of "commoner" Susan Adams, and his desperate discontent in later life is pitiable.

With America's entry into the war, the need for national unity improved the big businessman's Hollywood status. King Vidor's *An American Romance* (1944) was reminiscent of the earliest films, a glowing portrait of an immigrant who comes to America and works his way to the top as an automobile magnate. A traditional individualist, the immigrant opposes unioniza-

tion of the working man, but labor and management resolve their differences and the car plant is transformed into a factory to produce bombers that will win the war. This new sympathy extended into the postwar period with *The Best Years of Our Lives* (1946), in which Fredric March plays a banker sympathetic to the underprivileged. Like Walter Huston in *An American Madness*, March believes that his bank should make loans to the undeserving poor, opposing his superiors who fail to understand that the war was fought to provide everybody with an equal opportunity.

The success ethic remained sacred in Hollywood throughout the Forties with a few notable exceptions. Just prior to the blacklist that temporarily destroyed the cinema as a vehicle of social protest, *Monsieur Verdoux* (1947) and *They Live by Night* (1949) posed some radical questions about the American Dream. Although neither is a film about big business (*Verdoux* is a black comedy about a wife-murderer, *They Live by Night* a retelling of the Bonnie and Clyde saga), both films suggest that big business and crime are one and the same. As Chaplin's Bluebeard comments, there's little difference between his murdering women for profit and the arms manufacturers who slaughter millions. "Wars, conflict—it's all business. One murder makes a villain, millions a hero. Numbers sanctify."

Nicholas Ray's *They Live by Night* likewise raises serious questions about greed and the American Dream. American society is portrayed as corrupt and venal. There are two kinds of thieves here, the protagonists who are labelled "enemies of society" and the more legitimate crooks, the businessmen who don't steal but merely exploit others to make their profits.

Postwar prosperity and McCarthyism together ushered in the most sympathetic screen treatment of big business since the pre-Depression years. While some films continued in Thirties' tradition with crooked big businessmen getting their comeuppance from the common people—

most often represented by Judy Holliday: see *Born Yesterday* (1950) and *Solid Gold Cadillac* (1956)—a whole series of films showed audiences what went on behind the closed doors of the boardrooms and bedrooms of America's corporate powers. In films like *Executive Suite* (1954), *The Man in the Grey Flannel Suit* (1946), *The Power and the Prize* (1956), *Woman's World* (1954), and *Cash McCall* (1960), executives jockeyed for position in the corporation, struggling to reconcile the demands of their personal and business lives. As always, the hardworking Horatio Alger-type was contrasted with the unscrupulous villains who would use any means to gain power, with the hero almost always winning out. In *Executive Suite*, the members of the board of directors of a large corporation are revealed as adulterous, neglectful, frustrated, and frightened. And yet the film's final confrontation conforms to the success-ethic steretoype. After the beloved company president drops dead in Wall Street, a boardroom battle to succeed him ensues, which eventually boils down to two candidates. One is a finance officer (Fredric March), cold, unfeeling, interested only in raising dividends. The other is a young industrial designer (Wiliam Holden), creative, sensitive, interested not only in profit but also in pride and producing a quality product. March's character is not against "stepping on a few toes" on the way up, while Holden believes in a fair shake for everyone, even the most lowly plant worker. Holden is the success ethic personified—hardworking, devoted, honest, fair, and, as a bonus, a man with a vision for the future of the company. These characters are the stuff big business is made of—personal problems only add to the pressures of their work. Again, the system of success is a good one, and in this case, the best man (Holden) wins a unanimous vote for the top spot.

This period also saw a revival of the working-girl-meets-millionaire comedies. Films like *All in a Night's Work* (1961),

How to Marry a Millionaire (1953), *That Touch of Mink* (1962), and *Let's Make Love* (1960) all portrayed suave millionaires who have everything in life except the right woman. In *Let's Make Love*, an angry billionaire (Yves Montand) gets wind of a planned Off-Broadway revue satirizing him. Incognito, he visits the audition, is mistaken for an actor, and lands up getting the lead role in the show. Naturally, he falls in love with his bohemian leading lady, Marilyn Monroe. She learns that he isn't the ogre she thought he was and he realized that there's more to life than big business.

The best and most cynical comedies of the period were Billy Wilder's *The Apartment* (1960) and *One, Two, Three* (1961). In the former film, Jack Lemmon tries to get ahead in the corporation by loaning his apartment out to executives who need a place to take their mistresses. When Lemmon falls in love with the boss's mistress, and refuses him access to the apartment, he clearly jeopardizes his future in the company. To Wilder, success and common decency are mutually exclusive. At the same time though, Wilder is clearly fascinated by success and the go-getter character. In *One, Two, Three*, an aging but seemingly inexhaustible Jimmy Cagney plays a successful Coca-Cola executive who takes Germany by storm. Paying little attention to the niceties of international law, Cagney makes a shambles of the Cold War, trying to sell the most American of all products to the communists and forcibly converting a young radical into the ideal capitalist husband for his boss's daughter. Despite the cynicism, Wilder is clearly no enemy of the American Dream—his worst barbs are saved for the eminently corruptible East Germans.

From the cynical humor of Wilder, big-business themes took a sharp left turn. Throughout the Sixties and Seventies films about big business became increasingly rare and increasingly hostile. The Sixties saw a flurry of pulp romances, a very different breed from the sympathetic soap

operas of the Fifties. In film adaptations of Harold Robbins and Jacqueline Susann novels—*The Betsy* (1977), *The Carpetbaggers* (1964), *The Adventurers* (1970), *The Love Machine* (1971)—the heroes are insatiable in their quest for sex, money, and power. In fact, it is difficult to distinguish hero from villain in these films. *The Love Machine*'s main character is a vain, selfless heel who will stop at nothing to gain his objectives—his boss's job and wife.

The *Godfather* films of the Seventies are reminiscent of the Thirties' gangster pictures, with the portrait of the young go-getter working his way up in the crime syndicate. Francis Coppola almost succeeds in romanticizing Don Vito Corleone's early days as a small-time hood and his rise to Mafia chieftain. Don Vito's view of his work is essentially the same as that of the hero in *Blood Money*—"Crime is a business like any other"—and, as an immigrant, he is a grateful and proud citizen of America. But Michael Corleone, who follows in his father's footsteps, is viewed as a cold and calculating monster, obsessed with his power within the family to the exclusion of human emotions. Vito Corleone is heralded as a believer in the American success ethic; his youngest son is a Hollywood example of the big businessman who abuses that ethic and the power it has brought him.

Equally malevolent are the big businessmen in films like *The Formula* (1980), *Chinatown* (1974), *Winter Kills* (1979), *Cutter's Way* (1981), and *True Confessions* (1981). Murderers and rapists, they use their wealth and power to conceal their crimes, destroying anyone who tries to thwart them. In *Cutter's Way*, a murderous businessman is opposed by a beach boy and a crippled Vietnam veteran, while a crooked cop takes on his murderous ex-employer in *True Confessions*. In both cases, the forces of "good" triumph, but the victories are tainted. In *Cutter's Way*, victory destroys the heroes' lives, while in *True Confessions* the arrest of the businessman is meaningless (he is already dying of cancer) and ruins the careers and

lives of numerous others.

Similarly, the victories over big business obtained by the heroes of *North Dallas Forty* (1979), *Norma Rae* (1979), and *Wall Street* (1987) are pathetically small. In the latter film, Charlie Sheen's would-be tycoon sees the light in time to bring down his evil mentor, a corporate raider convincingly played by Michael Douglas. But Sheen, like Douglas, has already been implicated in an insider trading fraud, and is headed for jail. *Wall Street* offers the hope of Sheen's personal redemption, but there is no guarantee that Douglas will not resurface in the future, as powerful as ever. The football front office forces a rebellious star (Nick Nolte) out of the game in *North Dallas Forty*, while Norma Rae's tiny union triumph is offset by the death of her father, almost literally at the hands of the company. In *Network* (1976), the lunatic Howard Beale sets out against the evil forces of the network and ends up a TV idol with his own show. His "victory" is in the awareness he instills in his adoring public, but typically, it's at the cost of his own life.

Most films dealing with big business in the last decade exude a feeling of futility absent from earlier movies. The *Godfather* films draw the same parallels between big business and crime as the Thirties films. But by the time Michael Corleone is ready to pass the mantle of Godfather on to his nephew, Vincent (Andy Garcia), in *The Godfather Part III* (1990), the mob is so heavily involved in legitimate enterprises, it is impossible to separate the businessmen from the hoodlums. The heroes of *Cutter's Way* and *True Confessions* are societal outcasts—a far cry from the dignified businessmen portrayed by Walter Huston or Jimmy Stewart in the Thirties. The most honorable big businessmen of recent years, Jeff Bridges's visionary *Tucker* (1988), is destroyed trying to buck the automobile establishment and manufacture his own car. The one way Michael Caine can set things right in the rat race of *A Shock to the System* (1990) is to murder his nasty boss.

The only new films to suggest that the forces of good can still legitimately triumph in the world of big business are two highly successful romantic fantasies, *Working Girl* (1988) and *Pretty Woman* (1990). In the latter film, Richard Gere's coldhearted corporate raider is warmed up by Julia Roberts's earthy, working-class prostitute. In *Working Girl*, scrappy, sexy secretary Melanie Griffith improbably rises to the top of her Wall Street firm through ingenuity and pluck. Along the way, she also manages to attract and humanize big-time broker Harrison Ford, and affect the defeat of her egocentric, idea-stealing boss, Sigourney Weaver.

But without the influence of the sweet yet strong female who baffles her big businessman into a new appreciation for ideals,

the tycoon is presumably lost. When *Network*'s Howard Beale—perhaps Hollywood's ultimate loser-hero—declares, "I'm mad as hell and I'm not going to take it anymore," he voices the desperation of recent heroes, and personifies the hope that will inevitably be dashed. Big business, from the Seventies through the early Nineties, is more powerful than ever before. Hollywood seems to be warning us of what can happen in these times when power is not tempered by fair play and the principles of the American success ethic.

—Peter Roffman and Beverly Simpson

RECOMMENDED BIBLIOGRAPHY

Roffman, Peter and Jim Purdy. *The Hollywood Social Problem Film.* Bloomington, IN: Indiana University Press, 1981.

Wall Street

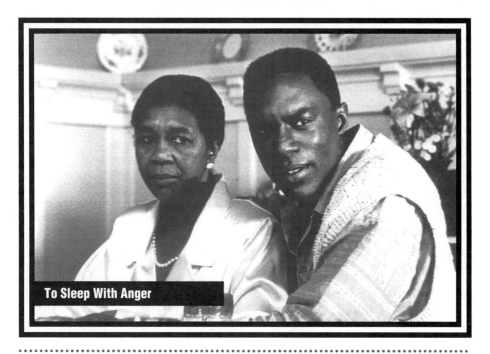

To Sleep With Anger

Blacks in American Cinema

U ntil recently the movie image of the black has been a "Sambo" image. "Sambo," to quote the historian Stanley Elkins, "was docile but irresponsible, loyal but lazy, humble but chronically given to lying and stealing."

Just about everything traditionally held to be of some value in the United States was absent from this stereotype. The movies presented black men and women as subhuman, simpleminded, superstitious, submissive people who exhibited qualities of foolish exaggeration, and who were always willing to take what did not belong to them.

The 1904 Biograph movie, *A Nigger in the Woodpile*, is a primitive early film example of how the black was stereotyped. Because wood is being stolen from the farmer's shed, he places dynamite among the kindling. The black thief, a deacon, is shown huddling in front of the stove with a group of blacks. The stolen wood is put in the fire and there is a terrific explosion.

The farmer thus finds the culprit who has been stealing his wood. The blacks are not hurt by this explosion, however, because even then they were portrayed as subhuman, as incapable of being hurt, of being amoral, of being Sambo figures.

A Nigger in the Woodpile accurately reflects the racial prejudices and beliefs of pre-World War I America, although the movies treated blacks less viciously than some other ethnic groups. The movie industry's changing treatment of immigrant ethnic groups over the years reflected their gradual assimilation into American society, but black men and women remained outsiders to that society. For decades, except for a few notable instances, the industry either ignored

blacks or used the Sambo image.

Motion pictures were initially produced in the United States for commercial purposes beginning in the mid–1890s, and between then and 1915 the movies became one of the most important forms of mass entertainment. This period was not a happy one for black Americans. As historian C. Vann Woodward has pointed out, it was an era in which "the extremists of Southern racism probably reached a wider audience, both within their own region and in the nation, than ever before." Newspapers and magazines, for example, used the words "negro," "nigger," "darky," "colored," and "coon" indiscriminately and often interchangeably.

The movies drew images from the popular culture of the day, and that culture had succeeded in fixing in the American consciousness a particularly unfortunate image of the black as a ludicrous figure. Black women were either fat, asexual, servile, and dark, or promiscuously attractive and lightskinned. Black men were, as one show business history puts its, supposedly born "hoofing on the levee to the strumming of the old banjo." The movies drew on such stage stereotypes of the black man as the faithful retainer, the comic stooge, the brute, or the intelligent mulatto (white blood makes all the difference).

Black performers, even the most talented, found it almost impossible to escape the fantastic artificiality of the caricatures in which they had been imprisoned. Bert Williams, for instance, was a star of the *Ziegfeld Follies of 1910* and had an extraordinary career lasting into the Twenties. But in the theater and on screen, this gifted, erect, light-skinned, distinguished-looking man appeared as a slouching, dialect- speaking, inept shuffler wearing a blackface mask that he hated.

Indeed, most performers playing blacks did so in makeup, since whites primarily played these roles, even Uncle Tom. Whether or not portrayed by whites, black characters appeared only in certain kinds of films among the hundreds of motion pictures produced between the mid-1890s and 1915. The stereotypes developed so strong and so fast that, in the first version of *Uncle Tom's Cabin* (1903), in order to make use of the dancing-fool image, one scene begins with a long cakewalk by black men, women, and children that has absolutely nothing to do with the preceding or following action.

As far as blacks were concerned, patterns were set in these early motion pictures that with few exceptions remained unbroken on screen for decades. Black author John Oliver Killens over a half century later accused the American movie industry of being "the most anti-Negro influence in this nation" and called *The Birth of a Nation* "Hollywood's first big gun in its war against the Black American." The castings for that gun were forged in the movies made between the mid-1890s and 1915.

If ever a single movie can be said to have played a unique role in the American film industry's treatment of the black, that movie was *The Birth of a Nation*—a decidedly pro-South melodrama of the Civil War and Reconstruction glorifying the Ku Klux Klan. Although the film had more than its share of what a title called "faithful souls," including the overdrawn "mammy," the movie stressed the black as menace. The black man is presented as lusting sexually for white women, grasping greedily for white property, and unwilling to accept his preordained station at the bottom of the social order. The black was presented as a serious danger to the established order of American society unless checked by a white force such as the Ku Klux Klan.

This view of the black was all the more pernicious because of the extraordinary artistic impact of the film. D. W. Griffith's work is almost universally recognized as a milestone in the development of world cinema, and clearly demonstrated the tremendous potential of the motion picture. Griffith was pained by the charge that he was antiblack, but for him the black was

either an Uncle Tom or a menace to white society. Although Griffith, as he claimed, may well have had genuine feelings for what he called "the colored people," his film was viciously racist.

The Birth of a Nation very quickly became the subject of much controversy. Although the new National Association for the Advancement of Colored People, other black groups, and their white allies tried to have the film banned in its entirety or to have the more objectionable scenes cut, they failed despite much heated protest. It goes without saying that black self-esteem was hurt by this film, but one of its more important consequences was what happened thereafter to the black image in film. As film critic Andrew Sarris has stated, "The outcries against *The Birth of a Nation* served merely to drive racism underground."

The result was that menacing blacks, except for jungle savages, were eliminated from American-made movies, but the more demeaning caricatures continued to be presented, more one-dimensional than ever. For the remainder of the silent period, blacks in American films were incidental to plot development and served simply as a means of comic relief. The laughs most often came at the expense of the black male character who was presented as fearful, as an emasculated comic object.

The period from the advent of sound at the end of the Twenties to the United States' entry into World War II in 1941 has often been referred to as the "Golden Age of American Cinema," but for blacks it was more of the same old dross. Although it was at this time (1939) that Hattie McDaniel became the first black performer to win an Oscar, she did so for portraying a Mammy in the distinctly Southern-oriented *Gone With the Wind*. During these years the movies produced by the American film industry, when they bothered to recognize the existence of blacks at all, continued to caricature and denigrate the race, even in cartoons. Slavery, as shown in *Gone With the Wind*

and other films made under the influence of the Margaret Mitchell novel which revived great interest in the Civil War era, was shown as a happy time for blacks. They were shown on screen as in the past—cleaning, cooking, or carrying for whites—and were placed either in the fields, the kitchen, the stable, or the train station. Director Fritz Lang recalls that MGM head Louis B. Mayer "was convinced that Negroes should be shown only as menials of some description." The other studio heads obviously shared this view. The only casting call blacks received for Warner's 1940 football epic, *Knute Rockne—All American*, was for six performers to play porters in a depot scene.

One alternative was a condescendingly sentimentalized white view of blacks which found full expression in the screen version of Marc Connelly's Pulitzer Prize winning play, *The Green Pastures*, which was filmed by Warner Bros. in 1936. Connelly used as his inspiration a collection of short stories that supposedly visualized what was in the minds of black children being taught about the Creation in a back country Louisiana Sunday School by an old black preacher. The play and the movie told about "Eve an' dat Snake" and "De Flood." Connelly showed Heaven as a fish fry where "De Lawd" enjoyed his "ten cent seegars." The movie, which Connelly codirected, heightened the play's one-dimensional view of blacks. Another alternative view of the black was one which set him down in the jungle. He was an ignorant, often irrationally hostile savage who was not equal to the white, no matter what the blacks' numbers. But it must be remembered that these stereotypes found their way into only a small number of the hundreds of films produced annually in Hollywood. In the main, blacks were still almost nonexistent in movies dealing with the American scene, past, present, or future. This meant that even the more important and well-known black performers were hampered.

The exuberant Bill Robinson achieved

great success in a number of movies, notably those in which he performed with Shirley Temple. Their joint appearances received enormous publicity and elicited much favorable domestic comment about opportunities for blacks in the United States. Despite such commentary as well as Robinson's personal popularity in Hollywood, he made only a few movies there because, according to one black source, "he did not fit the Hollywood stereotype." His vital personality shone through even when he played servant roles.

Even so well-known and talented a performer as Paul Robeson (see essay on Robeson) found it difficult to find proper vehicles. Between 1929 and 1942 he played important roles in nine features, but it is doubtful that he ever fully realized his ambition to present the black moviegoer with an image that could replace the usual stereotypes. Perhaps his best role came not in Hollywood but in *Song of Freedom*, a movie he helped to produce in England in 1936. Robeson played a dock worker in London who achieves great success as a singer, but, fascinated by his African heritage, he gives up everything to help the tribe from which his forebears stemmed generations ago. Well-meaning, sincere, and earnest, *Song of Freedom* is also heavy-handed and occasionally silly.

Blacks gained little from the introduction of sound to movies. Some additional work was available for those performers who could sing and dance or play jazz. A few blacks, such as Robinson, Robeson, and Stepin Fetchit did achieve a kind of second-class standing in the industry, but this limited distinction came in stereotyped roles. The image of the black remained a composition of caricatures, so much so that in 1935 the black newspaper, *The New York Age*, in a despairing editorial asked when the motion picture industry would have the "guts and moral courage" to stop pandering to society's "prejudices and fanaticism."

A very limited answer to that editorial came during the war years in the Forties. The people of the United States were shown on screen to be heroically fighting a democratic war for the "four freedoms" and against Axis aggression. Yet for all this preaching, even while American propaganda castigated Nazi racism, many wartime movies showed blacks in the traditional way. The titles of some cartoons, such as *Boogie Woogie Bugle Boy of Company B* and *Coal Black and De Sebben Dwarfs*, illustrate this continued caricaturing.

The exception came in a handful of war movies in which the black was an integral part of a unit fighting the Axis. In *Sahara* (1943), for example, the black soldier Tambul was a noncom in one of the Allies' colonial units. This character was one of a small band of Americans, British, and a Frenchman who have banded together to get through the Axis lines. Tambul even gets the chance to die heroically.

In most films during this period, however, the old caricatures persisted. Whatever her talents, Lena Horne was given no chance to display them except in song numbers which were not related to the plot, and which could easily be excised to meet the requirements of censors, especially those in southern states. By the end of the Forties, however, the coarser, more debasing caricatures were being muted by the industry which understood that race relations were changing in the United States. An important milestone in the film industry's more sympathetic approach to the black found expression in a number of key productions in 1948–1950 which were known as "racially aware films.'

In part these movies were produced as postwar America's response to the shifting legal and social response to blacks, although the studios were also responding to a situation summed up by the *Variety* headline, "More Adult Pix Key to Top Coin." The topic of race seemed an ideal choice for controversial box office fare. The number of these films was very limited—less than ten in three years—but they

did push their message hard. *No Way Out*, for example, a 1950 Twentieth Century Fox production dealt with what happens when the first black intern at an urban hospital treats the injured brother of a "Negro-hating psychopath." This black man is placed on a pedestal: he is shown to be conscientious, hardworking, and intelligent. He takes enormous abuse during the course of the movie without losing his composure, eschewing violence to the extent of not shooting his chief tormentor when he has the chance but instead treating his wound. This character was the precursor of an important new black movie stereotype which would develop during the later Fifties and the Sixties: the Ebony Saint. Neither Uncle Tom nor militant, he remains nonviolent.

For all the commercialism which motivated the production of these films, they did represent a change of diet from the usual swill about blacks until then fed the American moviegoing public. For that reason, films such as *Pinky* (1949) and *Lost Boundaries* (1949), which dealt very gingerly with "passing for white," have often been singled out for praise, even though they now seem somewhat embarrassing and naive.

The production of these films also signaled the end of the all-black cast film. Hollywood has produced many stinkers over the years, but few have been as bad as the ghetto-oriented all-black films turned out by both independent white and black filmmakers. Both technically and artistically, these cheaply produced, quickly made Jim Crow films remained true to their beginnings in the silent period and never rose above mediocrity. The heyday for these quickies was the period stretching from the late Thirties to the mid-Forties when about a dozen a year were produced. The genre persisted into the Fifties, notwithstanding its overall shabbiness and technical imperfections.

The movie industry's attitude towards blacks changed more significantly during the Fifties and Sixties. In the Forties

Woody Strode played the third native from the right; in the Sixties he was one of the eponymous leads in Richard Brooks's film, *The Professionals* (1966). If, as the historian Thomas Carlyle has postulated, "History is the essence of innumerable biographies," then much of the changing image of blacks in the Fifties and Sixties resides in the careers of some of the more important black performers, most notably Sidney Poitier and Jim Brown.

For a decade, beginning in the late Fifties, Poitier (see separate essay) personified the black man on screen (black women by then really had no identity since the Mammy figure was being phased out and nothing was replacing it). A standard joke in Hollywood at the time was, "If you can't get Sidney Poitier, rewrite the part for a white man." Moreover, among black performers who to that point had achieved prominence in the movies, Poitier was unique, for as an *Ebony* article made clear in 1959, "Poitier unlike other Negro stars did not carry to Hollywood a name as an entertainer. He did not sing or dance. His calling card reads Actor."

Poitier was the first black to achieve and maintain star status within the industry; he was the first black superstar in film. He achieved these distinctions because he is a first-rate actor who worked at his craft, and because he played an Ebony Saint in his most popular films. Poitier's movie roles varied enormously but, prior to 1967, they almost all had in common the fact that, as one commentator said, he dealt with whites "in areas of conscience, not sex." His roles generally set him apart from everyday life. The human dimension remained very one-sided. Sniping at Poitier is easy, especially in retrospect, but it means forgetting what preceded him. In 1967 Poitier reached the peak of his popularity, and one of his three films released that year was *Guess Who's Coming to Dinner*, a Stanley Kramer film that dealt with intermarriage chastely and in Technicolor. The movie is pleasant enough, did very well at the box office, but

took a critical beating. One angry black critic called it "warmed over white shit."

This last comment is indicative of the black revolution in America which peaked in the late Sixties and whose screen persona first found expression in Jim Brown. He also projected a cool character, but his coolness on screen was far different from that of Poitier. He usually played strong-willed men of action—sure of themselves, aggressive, self-disciplined—and in many of these films Brown was paired with white actresses. Now there was no question about interracial coupling, nor was there any question of Brown's characters eschewing violence or being self-effacing.

Brown's films—such as *100 Rifles* (1969) and *El Condor* (1970)—paved the way for the veritable avalanche of productions with black superheroes that descended on American movie screens in the early and mid-Seventies. These "blaxploitation films," as they were dubbed, were filled with sadistic brutality, sleazy sex, venomous racial slurs, and the argot of the streets. Important issues such as racial discrimination of the basest sort, police brutality, and economic exploitation of ghetto blacks were touched on but social commentary was kept to a minimum.

"Sambo" gave way to "Superspade" (with rare exceptions women were adornments or bedmates, not independent participants in any kind of action). Superspade was a violent man who lived a violent life in pursuit of black women, white sex, quick money, easy success, and a cheap joint, among other pleasures. In these films white was synonymous with every kind of conceivable evil and villainy. Whites were moral lepers, psychotically antiblack, whose vocabulary was laced with the rhetoric of bigotry. Films such as *Superfly* and the *Shaft* series (which dealt with a black private detective named John Shaft) made no concessions to good taste. Writing about the portrayal of whites in these movies, an angry Pauline Kael charged that "except when we were at war, there has never been such racism in American films." And she was right....up to a point. These films, after all, were only a mirror image of how blacks had been treated on screen for years. In its search for box office dollars, the movie industry just carried the reversal even further than the original.

Not all the movies dealing with black themes during these years were simply exploitative. Some films abandoned stereotypes in order to present another kind of picture. *Sounder* (1972) presented a stirring portrait of black rural family life in the South and included a splendid portrayal of a black mother and wife by Cicely Tyson. That same year Bill Cosby starred in *Man and Boy*, a low-key Western about black homesteaders in the post-Civil War era, and Ossie Davis movingly dealt with contemporary black family life and a girl's attempt to escape from the ghetto in *Black Girl*. But such films were exceptions which in the main did not win wide distribution.

With the end of the "blaxploitation" cycle in the mid-Seventies the situation became desperate for most black actresses as black women almost disappeared from the screen. True, the integration of blacks into American life manifested itself in a minor way on screen and afforded some opportunities for a few black actresses. Pam Grier, who had attained a kind of B-picture stardom as a female action star in films like *The Big Doll House* (1971) and *Foxy Brown* (1974), managed to sustain a career as a lesser character actor in films like *Fort Apache, the Bronx* (1981), and *The Package* (1989). There also were occasional star turns, which were flashy, but did not lead to other parts: black women dead-ended in the industry on screen just as in real life. Good examples are Lisa Bonet (*Angel Heart*, 1987), Lonette McKee (*The Cotton Club*, 1984), and Tina Turner (*Mad Max Beyond Thunderdome*, 1985).

The one movie during the Eighties that dealt significantly with the role of black women aroused enormous controversy. *The Color Purple* (1985) was based on black writer Alice Walker's Pulitzer Prize-

winning novel about the travail and abuse suffered for much of her life by an uneducated southern backwoods black woman. The director Steven Spielberg softened much of the novel's harshness and tempered other aspects as well, such as the lesbian relationship between the woman and her husband's mistress. The movie celebrates the wife but is harsh in its treatment of black men, who are depicted as brutish, violent, and oversexed. The NAACP as well as others in the black community condemned this depiction. Whoopi Goldberg was nominated for an Oscar as Best Actress for her touching portrayal in the lead role.

Goldberg was the only black actress to star in Hollywood films in the second half of the Eighties. But for all her talent she could not overcome the stereotyping which cast her in foolish oddball roles in films such as *Jumpin' Jack Flash* (1987) and *Fatal Beauty* (1987), which were critical and commercial duds.

Various black actors also had problems finding suitable roles. Poitier, after nearly a decade during which he worked only behind the camera, attempted a comeback in 1988 with *Shoot to Kill* and *Little Nikita* but without notable success. Performers like Brown or Richard Roundtree (who had portrayed Shaft) who had based their career on action roles in black-oriented films found themselves almost unemployable and worked on the fringes of the industry. Some black actors had occasional success but found it difficult to sustain, and often that success came in roles that had very little to do with their race. Louis Gossett, Jr., after a spotty career in films, landed a role in *An Officer and a Gentleman* (1982) as a tough drill sergeant and won an Academy Award as Best Supporting Actor. But Gossett soon found himself cast as half of interracial buddy teams, once even with martial-arts champ Chuck Norris in *Firewalker* (1986).

Such pictures utilized a number of black actors. Carl Weathers went from being an antagonistic opponent to a friend of the eponymous hero in the *Rocky* films—*Rocky* (1976), *Rocky II* (1979), *Rocky III* (1982), *Rocky IV,* (1985). Other actors who notably served as buddies or sidekicks to whites in various pictures included Billy Dee Williams, Gregory Hines, Danny Glover, and Yaphet Kotto. As the civil rights movement waned, and as racism again became noticeable if not fashionable, the movie industry hedged its bets by appealing to white and minority audiences through buddy films in which the lead role was always taken by whites.

During the late Seventies and the Eighties, however, a number of films were made which dealt with black themes. These films did so intelligently if not always commercially, attractively if not always to the satisfaction of the black community. The film version of E. L. Doctorow's complex novel *Ragtime* (1981) culminated in an ill-fated attempt by black revolutionaries to use their seizure of the Morgan Library in early twentieth-century New York City for political ends. Howard Rollins, Jr. won an Academy Award nomination as Best Supporting Actor for his portrayal of the musician turned into a revolutionary by events. Rollins later had a lead role in *A Soldier's Story* (1984) as an army officer investigating the murder of a black army noncom at a Louisiana military post for black troops in 1944. This screen version of Charles Fuller's Pulitzer Prize-winning play dealt marvelously and incisively with the tensions black soldiers created for themselves as a result of racism. *The Bingo Long Traveling All-Stars and Motor Kings* (1976) was a nostalgic look at the heyday of all-black baseball in the Thirties. A filming of Richard Wright's *Native Son* (1986), though weak, raised important issues. *The Brother From Another Planet* (1984) was a pleasing if ineffectual allegory.

Black men (and to a much lesser extent black women) were presented in these films in ways that were not always attractive, that built on the less appetizing stereotypes of the past, and that exploited

a variety of black themes. The black performers, moreover, had little control over their roles, or much else, in these films. Blacks did not profit economically from the "blaxploitation" cycle or from the films that followed. Whites packaged, financed, and sold these films. Richard Roundtree got only $12,500 for playing Shaft in the first movie of the series. Black directors, with a few notable exceptions such as Sidney Poitier and Michael Schultz, had a very hard time finding work. And the technical unions, despite pressure brought to bear by black groups and by the government, kept blacks out of their ranks in any but the most minuscule numbers. What changes did take place came as a result of the activities of two new stars (Richard Pryor and Eddie Murphy) and an energetic director (Spike Lee).

Richard Pryor, who one historian has described as "The Crazy Nigger as Conquering Hero," was an unlikely choice to become a black superstar. Quite different in character onscreen from Poitier's Ebony Saint, Pryor was foulmouthed, apparently uncontrollable, and ethnically street smart. He had a checkered screen career initially in a variety of movies such as *Wild in the Streets* (1968), *Dynamite Chicken* (1972), *Hit!* (1973), and *Adios Amigo* (1975). His comic-relief role as a kind of streetwise Sancho Panza paired with white lead Gene Wilder in *Silver Streak* (1976) brought him stardom. Films of Pryor appearing in concert as a stand-up comic (1979, 1982, 1983) built on that persona and were extremely successful, as was a second pairing with Gene Wilder in *Stir Crazy* (1980). But Pryor was unable to build his career successfully and, in a succession of awful movies—including *The Toy* (1982), *Brewster's Millions* (1985), and *Moving* (1988)—dissipated his stardom.

Eddie Murphy, building on the image presented by Pryor, made it his own in a series of box office hits that in the main received critical acclaim. Already a TV star in his late teens, as a result of his appearances on *Saturday Night Live*, Murphy's first movie, *48 Hours* (1982), won him acclaim for his role as a hip jail inmate given a two-day pass in order to help a white cop catch a killer. That box office smash was followed by another, *Trading Places* (1983), in which he again worked with a white performer, this time in a comedy dealing with the breaking of two racist, aging commodities market swindlers. Superstardom came with *Beverly Hills Cop* (1984), in which Murphy portrayed a hip, street-smart Detroit policeman who goes to Los Angeles to find the killers of a friend. The megahits continued—*The Golden Child* (1986), *Beverly Hills Cop II* (1987), *Eddie Murphy Raw* (1987)—but, for all his hipness and obscene street smarts, Murphy in character was desexualized and detached from any social context. This situation changed with *Coming to America* (1988), in which he played an African prince from a mythical kingdom in search of the ideal mate. He relates to black American society and in doing this the film made no concessions to white sensibilities. Subsequently his career stalled with films like *Harlem Nights* (1989), which was unprofitable as a result of exorbitant production costs in part resulting from demands made by Murphy.

Spike Lee moved on a different track. Born Shelton J. Lee, he has created black-oriented movies dealing with different aspects of the black community. *She's Gotta Have It* (1986), shot on a shoestring budget and commercially quite successful, dealt with a female black graphic artist and her three boyfriends, all contemporary and not unattractive urban black characters. *School Daze* (1988), less successfully but with a certain amount of humor, dealt with the touchy subject of rivalry at an all-black college between the "Wanabees" and the "Jigaboos." *Do The Right Thing* (1989) is a startlingly prescient film about urban racism which ends in a riot. *Jungle Fever* (1991) is a startlingly tough interracial romance drama which makes no concessions to the usual liberal sentimentalities.

All these films were commercially successful. The multitalented Lee—actor, writer, director—is the moving force behind his films and responsible for their inner-city rhythm; he is artist and activist.

Others tried to follow Lee's route. Robert Townsend's *Hollywood Shuffle* (1987) was a marvelous, quirky, episodic parody of the trials faced by black performers who are offered only stereotyped roles. But Townsend for some years was unable to follow up this achievement. His more adult *The Five Heartbeats*, a 1991 view of the ups and downs of a black doo-wop group, fared poorly. *To Sleep With Anger* (1990), an interesting drama starring Danny Glover about a black working-class family in Los Angeles, made by MacArthur fellow and veteran independent filmmaker Charles Burnett, died at the box office despite exceptional reviews.

Yet the movie industry, faced at the beginning of the Nineties with declining box office returns, once again turned to black-themed films in the hopes of retaining a black audience that represented one out of four U.S. moviegoers. During 1991 an unprecedented nineteen black-directed films were released. Critic Roger Ebert declared "a new Black cinema" was being developed. But like the blaxploitation films of the early Seventies the range of themes was limited. Yet the films offered not only performers but also directors and writers unusual opportunities.

Whatever the quality of these inexpensively made films, the bulk (as one black critic put it) tended "to urbanize and to criminalize." Such films included *New Jack City* (directed by Mario Van Peebles as an exercise in urban mayhem), *A Rage in Harlem* (a comedy-thriller by TV director Bill Dukes centered on a two-dimensional sex symbol), *Straight Out of Brooklyn* (nineteen-year-old Matty Rich's debut as a director which dealt intensely with teen life in a Brooklyn housing project), *Boyz N the Hood* (a coming-of-age story set in the tough Los Angeles ghetto; it was director-writer John Singleton's debut), and *Livin'*

Large (a heavy-handed satire, directed by Michael Schultz, about a ghetto black who loses his way when he achieves success as a TV newscaster).

Stereotyping continued to mark the appearance of blacks onscreen. In 1984 *Cineaste* magazine declared that most black performers in the movies "were restricted to comedy roles or to background roles as sidekicks or villains." Despite the new wave of blaxploitation films and despite the fact that some actors such as Danny Glover had in his buddy films with Mel Gibson moved to the foreground, the situation was reminiscent of the Thirties when blacks on screen were comic relief, musical entertainers, or peripheral characters. During 1990 Whoopi Goldberg appeared in two hits (*Soapdish* and *Ghost*); in neither did she play a leading role.

Except for a few notable exceptions the film image of the black has for generations been condescending and defamatory. Movies are entertainment but they are also symbols, and behind every shadow on the big screen is the struggle to impose definitions upon what is and what should be. The power of any single movie to influence one's viewpoint permanently is limited, but obviously repetition has its effect. Constant repetition which emphasizes certain topologies, as has been the case with the black presence on screen since the 1890s, is overpowering. Although on television shows and in movies made for TV an accommodation has been achieved that places blacks in a more favorable light, in the films made for theatrical release that image remains cloudy or nonexistent—even in the films stemming from a black consciousness. Movies have played an important part in the American Dream. Almost from the American film industry's beginning the black on screen has been left out of that dream, either by being ignored or by being presented as a flawed people who are somehow unable to partake of what is available to all other Americans.—Dan Leab

RECOMMENDED BIBLIOGRAPHY

Bogle, Donald. *Blacks in American Film and Television*. NY: Simon and Schuster, 1988.

——*Toms, Coons, Mulattoes, Mammies and Bucks: An Interpretive History of Blacks in American Films*. NY: Continuum Publishing Co., 1989.

Friedman, Lester. *Slow Fade to Black: The Negro in American Film 1900–1942*. NY: Oxford University Press, 1977.

——*Unspeakable Images: Ethnicity and the American Cinema*. Urbana, IL: University of Illinois, 1991.

Leab, Daniel. *From Sambo to Superspade: The Black Experience in Motion Pictures*. Boston, MA: Houghton Mifflin Company, 1976.

Null, Gary. *Black Hollywood: The Negro in Motion Pictures*. Secaucus, NJ: The Citadel Press, 1975.

Woll, Allen L. *Ethnic and Racial Images in American Film and Television: Historical Essays and Bibliography*. NY: Garland, 1987.

Capra, Frank

(May 18, 1897 – September 3, 1991)

In the Thirties and early Forties, Frank Capra was the master at manipulating an audience's feelings and fantasies, at constructing archetypal figures and images guaranteed to make them feel that it was their own lives, selves, and dreams that appeared before them on the screen.

Capra could convince an audience that America was a country filled with small towns radiating Christmas cheer and harmony; of gray-headed moms offering simple sweetness and sympathy; of heroic ordinary men whose characters were blessed with courage, compassion, and intelligence; and of icons—historical monuments, the flag, the Constitution—that were still capable of stirring the most profound patriotic and reverential emotions.

Capra's fables were especially suited to the psychological and social mood of the Thirties, and he embraced the role of mass entertainer without ever sacrificing his personal vision in the process. He believed in making films which were "songs of the working stiffs, of the short-changed Joes, the born poor and the afflicted," films which were self-admittedly sentimental, but, in a time of economic dislocation and breakdown, offered the simplistic hope that good neighborliness and Christian charity would suffice to purge injustice and corruption from American society.

Capra's films had few ideas, and the intellectual commitments he did make—Christianity, humanitarianism, and a nebulous sort of egalitarianism—were shallow and lacked any semblance of a coherent social and economic perspective. His vision of society was moral rather than political, reducing social conflict to a struggle between the humane and moral and the greedy and cynical. In Capra's terms, there was no genuine class base for this struggle; he viewed it merely as a folksy fight between a "bankful of money" and "a houseful of love." Capra also personalized social evil, so the actions of his villains (e.g., Edward Arnold) never reflected on the capitalist system that shaped them, and the public could complacently leave the theatre believing that America would be transformed once a just man would rise to throw the rascals out.

Though Capra had no political ideology or program, he held a populist faith in the

importance of each ordinary individual. Of course, his "ordinary" heroes (Deeds and Smith) were extraordinary—men of superior talents and leadership. They were individuals who were not only truly decent and humane, but who were also made more attractive by being whimsical and eccentric. They were men who, though attacking venal politicians, sneering journalists, and shyster lawyers, could never be accused of being radicals. Capra placed them squarely within what he felt was best in the American tradition. His heroes invoked and embodied the innocence of boyhood, the mores of the mythic small town, and the redemptive power of traditional romantic relationships. (Capra's heroines, who were often independent, tart-tongued, career women, were always shown the error of their ways and domesticated by his less sophisticated heroes.) Most important, they were committed to a supposedly socially responsible form of individualism, which was suspicious of big government, labor, and business, and sanguinely put its trust in individual initiative rather than governmental or collective action. The society could be made more humane, but its basic tenets would be left untouched.

If Capra's heroes were extraordinary, his ordinary folk—that classless "collection of free individuals" for whom Smith and Doe were to provide charismatic leadership—sometimes proved fickle and destructive. For despite Capra's optimism there lurked in his films a consciousness of the dangers of mass conformity—his "little people" forgetting their usual good cheer and warmth and turning into a barbaric mob—although Capra never allowed that dark, self-critical strain to take over. Smith, Deeds, Doe, et al. could face self-doubt, despair, and betrayal, but the people would ultimately return to the just path and no enduring tragedy would be permitted to disrupt his fabulist world.

Capra's career began in the silents as a gagman for Hal Roach and Mack Sennett in 1921. It was an experience which he put to good use later on, for it taught him how to balance off some of his more saccharine moments with brilliantly timed bits of comic business. In his first film, *The Strong Man* (1926), Harry Langdon plays a common man, a saintly fool who continually survives misfortune—a role which prefigured later Capra heroes. From there Capra moved on to Columbia, where he made drawing-room melodramas and romances until he found his way back to comedy, collaborating with scriptwriter Robert Riskin (they made nine films together) on *Platinum Blonde* in 1931.

There were stronger hints of Capra's future political tone in *American Madness* (1932) in which a decent, small businessman-banker (Walter Huston) fights for running the bank on the principle of character over collateral, and triumphs over the impersonal and callous machinations of big business. In *The Bitter Tea of General Yen* (1933), Capra, in a treatment which was to become characteristic, both took on and muffled the subject of miscegenation (a sexual relationship between an Oriental man and a white woman) by raising the taboo issue without upsetting conventional beliefs. Even in Capra's classic romantic comedy, *It Happened One Night* (1934), the spoiled, petulant heiress (Claudette Colbert) receives a lesson in democracy and equality, without her place in the class structure ever being upset. In fact, the mentor who leads her to see how warm and endearing "the people" are is a macho newspaper reporter (Clark Gable) who ultimately marries her. Gable not only acquires wealth and joins his energy to the upper class, but also acts out the male-chauvinist fantasy of taming the flighty heiress.

It wasn't really until *Mr. Deeds Goes to Town* (1936) that Capra began to consciously make films on social themes and construct his own version of America. In *Deeds, You Can't Take It With You* (1938), *Mr. Smith Goes to Washington* (1939), and *Meet John Doe* (1941), Capra expressed the need for his films to say something about routing the "mass predators." In *Deeds*, the

innocent, shrewd hero (Gary Cooper) is a small-town writer of greeting cards whose honest, democratic, and egalitarian values triumph over the pretensions of New York sophisticates.

Mr. Deeds was a softer, more buoyant work than most of the films that followed. Nevertheless, Capra was capable of inserting a touch of Depression reality without destroying the basically warm and whimsical tone of the film. Deeds has inherited a fortune, and wants to give money to the poor to buy land. Of course, there were no workers or blacks among Capra's poor. They were sturdy Jeffersonian yeoman who through a series of close-ups (capturing their impoverished state) could evoke social feelings in Capra's audience without excessively disturbing them. And in Deeds, Capra's political solution—a commitment to a paternalistic form of capitalism—did little to disturb the status quo.

Mr. Smith Goes to Washington was a darker, more complex film than Deeds. The political forces that the idealistic young Senator Jefferson Smith (Jimmy Stewart) must struggle against were far more dangerous than those of Deeds. Although the film eschewed the economic conflicts of the Depression for political conflicts which invoked early twentieth-century Progressivism, Capra clearly meant the film's exaltation of free speech to demonstrate to Nazi and fascist dictatorships the strength of the American democratic tradition.

Smith's politics were no more complicated than a Quixotic quest for common rightness and "liberty," and a commitment to a boy's camp to be built by government loans. Smith's actions were almost divinely inspired by the prime emblems of American democracy. For Capra there was still too much power and virtue left in the Capitol Dome and the Lincoln Memorial to allow the political bosses and foreign fascists to take over. Consequently, at the film's climax, a seemingly defeated, broken Smith is magically saved by a last-minute confession, and once again folksiness, morality, and Christian decency had triumphed.

In Meet John Doe, Capra set out to prove that he could deal with "hard-nosed brutality with the best of them." Conscious of the continuing economic depression and a totalitarianism which threatened Western Europe, Capra decided to abandon his wholesome hero for a drifter (Gary Cooper), a man susceptible to the temptations of money and willing to become a newspaper's idea of the common man, John Doe. The Doe persona is then manipulated by D. B. Norton, Capra's most sinister villain, as a base for constructing an indigenous fascism. And in this film the prime power groups are all greedily ready to join up with Norton and sell out American democracy.

It was in Meet John Doe that Capra's faith in the virtue and humaneness of "the people" meets its greatest test. Most of the film's characters succumb for a time to the seductions of money or the mindless bleatings of the crowd. Of course, Capra cannot allow the contemptible Norton to triumph, and contrived his usual transformations to stymie him. By 1941, however, Capra was filled with self-doubt and filled the film with images (i.e., the cynical Colonel) which questioned his own genius for manipulating the public with paeans to the "ordinary folk." He began to understand in some part of himself that the same "little people" that applauded and were the core of his benign vision could be as easily susceptible to the seductive rhetoric of native fascists, that sentimental, egalitarian talk could be used by totalitarians as well as democrats.

After adopting Broadway plays like Arsenic and Old Lace (1944) to the screen and producing and directing the jingoistic antifascist documentary series, Why We Fight, during WWII, Capra directed his last big film, It's a Wonderful Life (1946). It's a moving, Christmas carol type of film whose overflowing sentiment is laced with a sense of despair. The film's hero, George Bailey (Jimmy Stewart), is a Mr. Smith whose ambitions are eternally deferred, and whose life is built on service to his family

and community. Bailey has to confront a small-town tyrant (Lionel Barrymore), but this time the villain is a much less forbidding figure than Edward Arnold's power wielders.

In fact, Capra has moved the film's prime focus from the political and social world to George Bailey's internal conflicts. George Bailey is the most psychologically complex of Capra's common-man heroes, for coupled with the usual Capra virtues—decency, altruism, and courage—George has feelings of resentment and rage. Bailey has lived a life in perfect accord with Capra's principles, but feels that he's a failure, a man capable of snarling at his children, bursting into tears, and contemplating suicide.

By the Forties, Capra's confidence in the power of people to provide salvation had eroded to the point that he had to contrive a homely guardian angel to point out to George the values of an "ordinary" life. And he does it by creating a *film noir* nightmare of George's hometown which is much more vivid than the supposed reality. In fact, although George is ultimately returned to the bosom of family and friends, the image of George in anguish and the fantasy of a small town filled with angry, desperate, and real people is hard to erase. In *It's a Wonderful Life*, Capra made his most personal film, and underneath the often oversweet and jaunty surface lay anxieties and insecurities he had difficulty ever admitting to or dealing with.

None of Capra's subsequent films was either memorable or commercially successful. It was obvious that Capra had difficulty adjusting his vision of a unified, caring, and optimistic America to the growing complexity, fragmentation, and violence that began to characterize postwar existence. His vision lacked bite and toughness, and in the America of the Fifties, the audience had begun to demand a different set of myths and fables.

Capra's best work, however, was not time bound. For all his patriotic and humanitarian hokum, Capra's genius was for making his moral values skirt that thin line between artful simplicity and outright banality. Capra may have simplistically divided the world into heroes and villains, and in traditional American fashion substituted ideals and instincts for ideas and systematic thought, but he was a perceptive enough filmmaker to grant his sentiments an almost universal appeal. A case could probably be made for Capra as a liberal, a conservative, a Jeffersonian, a Populist, even a Popular Fronter, for, in his intuitive way, he shared values and commitments with all these political strains.

In fact, it was his lack of definition, his political and intellectual ambiguity that was part of the secret of his success. He could attack popular enemies like double-chinned tycoons and cynical political bosses with a politics built primarily on a belief in charismatic personality and moral conversion. He instinctively perceived that Americans were uninterested in a political commitment built on painstaking organization and the refining of ideological principles. Their desire was for one built on the form and content of Hollywood films—glamor, sensation, and the illusion of immediate change—and Capra had a genius for packaging it. For all his mawkishness and lack of political profundity, however, Capra could make his audience believe that life in America was truly a luminous and wonderful thing.

—Leonard Quart

RECOMMENDED BIBLIOGRAPHY

Bowman, Barbara. *Master Space: Film Images of Capra, Lubitsch, Sternberg and Wyler*. Westport, CT: Greenwood Press, 1992.

Capra, Frank. *The Name Above the Title: An Autobiography*. NY: Vintage Books, 1971.

Carney, Raymond. *American Vision: The Films of Frank Capra*. NY: Cambridge University Press, 1986.

Lourdeaux, Lee. *Italian and Irish Filmmakers in America: Ford, Capra, Coppola and Scorsese*. Philadelphia, PA: Temple University Press, 1990.

McBride, Joseph. *Frank Capra: The Catastrophe of Success*. NY: Simon and Schuster, 1992.

Chaplin, Charles Spencer

(April 16, 1889 – December 25, 1977)

Charlie Chaplin, at one time a worldwide celebrity unrivaled in popularity, ended his filmmaking career in exile, after years of government and right-wing attacks finally left him unable to live and work in the United States and kept his films out of movie theaters throughout the country.

Much of this history has been forgotten, his attackers dismissed as hysterical witch hunters and many of his defenders shrugging off his politics as safely liberal or irrelevant to understanding his films. In 1972 he was officially rehabilitated when his name was added to the Los Angeles Walk of Fame and he was given a special Oscar at the Academy Award ceremonies in Hollywood. Chaplin the subversive had been replaced in history by a canonically sanitized figure acceptable even to the original targets of his satire.

A different idea of Chaplin's art and place in history emerges if the government case against him is credited. Certainly Chaplin, who at various times called himself an anarchist, humanist, or individualist, did not fit the pattern of the orthodox left and its fellow travellers, either in his work or opinions. Yet his public pronouncements and personal associations, while innocuous by today's standards, were an outspoken challenge to Cold War politics and culture, and a closer look at his films shows them permeated with politics genuinely "subversive" in their challenge to the values of American society.

While it is only Chaplin's later work which editorialize on controversial political questions, his films consistently identify with the poor and ridicule their social betters. One source of these sympathies was Chaplin's early years of poverty on London's East End. Deserted by his father, his mother was in and out of the work house and suffered periodic episodes of insanity. Chaplin, along with his older brother Sidney, was more than once left to the poor-law orphanages and the London street, exposed to the wide experience of the city from which he drew material for his films. The art form which most closely reflected this life, the music hall, provided Chaplin both an escape from poverty and training with the masters of the pantomime comedy he would bring to the American screen.

His technique and gags in his earliest films, at Keystone and Essanay (1914–1916), distinguished him from other film comics; he was from the start recognizably Chaplin, with a novel elegance in his characteristic interplay of movement and objects. His films could target anyone with a rear end, but almost from the start his individualist attack on the social order was clear; his characters were a principle of disorder interfering with the social routine, subversive in that mild way of most good comedy. While Chaplin often did not play the tramp, he was, as a menial job-holder, a square peg in a round hole in such films as *The Pawnshop* (1916) or *The Rink* (1916). Early in the year following his first film, he created his familiar comic persona in *The Tramp* (1915), and in the shorts which followed he was the first filmmaker to create a fully developed comic character, drawing on pathos as well as pratfalls.

With this pathos Chaplin wins the audience's sympathy to a character standing for those shut out of the American dream,

a character defined in his antagonistic relation to the police and his social betters, whether the American middle class or the aristocracy of the wealthy. This artistic choice of sympathies and targets was by no means obvious or routine. The other great silent comics—Harold Lloyd, Buster Keaton, Laurel and Hardy, Harry Langdon—made choices more in keeping with the media's less threatening image of America as a middle-class and egalitarian society.

As Chaplin mounts his comic assault on society in the more fully realized tramp films made at Mutual (1916–1917) and First National (1918–1923), the tramp emerges as not just the poor man or the unemployed hobo. Even more, he is the anarchist spirit who does not have it in him to maintain a respectable job. The social structure conflicts with his very being, but in a way that is presented as more a comment on society than on him. It becomes clear that to identify with the down-and-out tramp is to laugh at his social betters and enjoy their shock and discomfort in his presence. Even more, it is to compare respectable society to the poorer but nobler Charlie. The Kid represents the culmination of the politics and art of these early films and a transition to his later masterpieces. An unwed mother is driven to abandon her baby; Charlie adopts him, and they become father and son. Social authority is the police and orphanage officials who take the kid away from Charlie. The film ends tragically, after Charlie rescues the kid. He is again taken away, this time not to an orphanage, but to the home of his mother, now successful and able to provide a home for him. The grief is only partly relieved when the police arrest Charlie and take him not to jail, but to the mother's house.

The way Chaplin adapted the forms of romantic melodrama to his purposes shows the coherence with which his films express his social outlook. When Charlie meets the beauty in one early film, The Fireman (1916), the love is little more than a device to advance the plot; in the next film, The Vagabond (1916), the tramp appears and the romance at the center of the story is full of poignant possibilities. Can a tramp win the beauty or will he lose her to a more socially suitable prospect? Will his low station alone make the match impossible? This sad question, to which Chaplin repeatedly returns, is at the heart of the conception of the tramp. The Kid ended as the tramp enters the mother's house, the door closing behind him. Charlie is inside with the kid, but the impossibility of a continuing relationship with the kid has been strongly suggested. When the film refuses to overwhelm the audience with the sad reality of the class difference now separating Charlie and the kid, the refusal is an assertion of the need for compassion and fantasy in a society of inequality and loss. The filmmaker's compassion for the tramp and the kid is powerful partly because it is a recognition of the right of such people to happiness also, even if they will never enjoy it.

One of Chaplin's least overtly political films, The Gold Rush (1925), is in reality a most intense development of the politics of the tramp films. The subject is not merely survival, but, as in a A Dog's Life (1918) and The Immigrant (1917), it is the dream of America itself—the mythical land where even the poor and outcast can become wealthy, or at least own a home and win the girl. The Gold Rush, the ultimate promise of opportunity, is the backdrop, as the tramp begins the movie lost in the wilderness and lost also in the rush of other tramps for the same gold. The search for wealth becomes a desperate struggle to survive, and the loneliness always a part of the tramp's life reaches more than social dimensions as he becomes pitted against the elements, struggling against nature as well as society for survival. Hunger and loneliness, food and love are inseparable; the killing of a bear in the wilderness cements his partnership with prospector Big Jim, and the table set for the dance hall girl who makes

fun of him succeeds in touching her and finding honest feelings in her to draw on. The tramp strikes it rich and the dance hall girl is redeemed, and they meet in a fantasy ending which redistributes wealth and love to the most needy and deserving.

City Lights (1931) begins a period of more pointedly political filmmaking. Like *Modern Times*, it is set in the city and reflects the impact of the Great Depression. The opening of the film warns of the sustained social stir to come. In a public ceremony, a statue of Justice is unveiled, revealing, to the consternation of the rich and the mayor, the tramp asleep in its lap. As he tries to get out of the picture, he first becomes impaled on the sword of Justice, and then the camera shows the statue's thumb saluting the audience form the tramp's nose.

The action of the film, as well as the sight gags with which it begins, neatly embodies the social antagonisms which lie behind the society the film depicts. In a familiar fantasy of upward mobility, Charlie is adopted by the rich drunk he saves from suicide. Suddenly Charlie has a palatial home, fine clothes, a car, money, anything he needs—until his benefactor wakes up sober the next morning. The rich man no longer recognizes Charlie, returned to social reality by convenient social amnesia, he looks at Charlie, sees a tramp, and has him kicked out. In this Chaplinesque mix of fantasy and sober reality, the rich can befriend the poor only when drunk, and it is a joke to think class antagonisms can be overcome.

The contrast between the humanity of the tramp and selfishness of the rich is more intense than in any earlier film. Charlie is vital, always hopeful, in love and compassionate; the rich man is depressed and suicidal, leading an empty life, unable to love. The love story, as in many Chaplin films, follows the logic of the social commentary. The rich man gives Charlie money, Charlie gives it to the blind girl for an operation to restore her sight, then is imprisoned for stealing the money. They meet again when the girl, now owner of her own flower shop, can see her "rich" benefactor for the first time. Reality has dissolved her romantic dreams as quickly as it had dissolved Charlie's fantasy of wealth, and the films ends here with some of the most complex emotions ever conveyed by visual means and acting alone. The close-up of the tramp and flower girl, seeing each other for the first time as they really are, mixes joy and sorrow, pity and love, fantasy and reality, and, most of all, unresolved confusion, framing a relationship that no longer makes any social sense.

Modern Times (1936) is a more direct refection of social developments than any of his earlier films. Chaplin again broadens the scope of the subject matter of the cinema with startling images of factory workers, machines, crowds massing for the chance at a job, and even a street demonstration. Yet the film distances itself from the left-wing movements of those years in a scene which says a great deal about Chaplin's film politics. The tramp picks up and tries to return a red warning flag dropped by a street repair crew and follows them, waving it to get their attention. Immediately a mass demonstration appears behind him, and, as his innocent flag-waving takes on an unintended political meaning, he is set upon by police. The tramp is a political being without wanting or intending to be, or even knowing that he is.

This ironic politics is the essence of the tramp, and *Modern Times* brings the tramp to his fullest realization before Chaplin abandons him in the sound films to follow. When the tramp works on an assembly line, he is the first to lose his humanity. After turning bolts with a pair of wrenches all day, he runs, wrenches in hand, wildly after anything resembling bolts—buttons on fellow workers' overalls or the nipples on a heavily built lady. In a manic assertion of feral freedom, he poses with the wrenches on his head like a Pan's horns. He is by his very nature unassimilated into

industrial society.

When Charlie and his female counterpart, the gamine (Paulette Goddard), turn a hovel into the American dream of marriage and home, this idyllic fantasy cannot last. Charlie soon takes to the road and waddles into the horizon, this time not alone, but with the gamine; yet the road is still the natural place of this misfit anarchist, love is possible only because the road is the gamine's natural place as well.

During the Thirties Chaplin became associated more and more with left-wing causes, and his next film was his first self-confessed political statement. *The Great Dictator* (1940), a comic protest against fascism and war, was one of Hollywood's first anti-Nazi films, made at a time when a Gallup poll showed ninety-six percent opposition to U.S. entry into the war. In Chaplin's first sound film he faced the problem of adapting the character of the tramp to a medium for which he was not created. The solution is right. Charlie is again an outcast and a "little man" standing for "downtrodden humanity," but this time not because he is a tramp, but because he is a Jew. This new conception of "the little man" and the exploitation of his resemblance to Hitler allows Chaplin to develop some of his finest comedy. In Charlie's person, as the barber, we see a very characteristic Chaplin style. But there is a very new element in the way the slapstick of the earliest tramp films is used to express the power-mad grandiosity of the dictator Adenoid Hynkel; to characterize this outrageous fascist misfit, Chaplin combines grandiose visuals of his fantasies of world conquest with grotesquely childish behavior.

The Great Dictator was the first of a series of sound films, each responding to the new problems of dialog form with a marked departure in style and conception and yet, at the same time, different in treating the material characteristic of Chaplin's films as a whole. *Monsieur Verdoux* (1947), his next film, is perhaps his strangest and most remarkable political statement.

Chaplin found a new way to scandalize the bourgeois society he always targeted with his sympathetic portrayal of a mass murderer, a Bluebeard who amasses a small fortune by marrying and then killing wealthy women. There was something in this film to offend everyone, not least of all right wingers and moral uplifters who had for years attacked Chaplin for sexual immorality. Fans who wanted another sentimental Charlie were startled to find instead a cynic who kills without passion, as a simple matter of good business. The only offenses of the victims are esthetic and cultural—their vulgarity or lack of physical and emotional appeal.

Yet this highly bizarre comedy, its "sick humor" completely out of place in the Hollywood of its time, was perhaps Chaplin's most fundamental criticism of bourgeois society. The target was not only war profiteers, but also capital itself, which admits only one calculation of means and ends—profitability. Chaplin asks the audience to see the similarity between the condemned murderer Verdoux and munitions manufacturers; if they are different, it is because the mass murders of the arms dealers are big business and therefore the criminals are respectable businessmen. Verdoux's real crime in this hypocritical society is that he is a small businessman and far less effective.

It cannot be said that Chaplin's audience turned against him, because the film was not given a chance at the box office. The opening of this film, after Cold War politics had already made its impact, was met by a media assault, right-wing protests, and boycotts of such intensity that theaters would not book the film. *Limelight* (1952), which followed, was in many ways a retreat from politics. A very personal film, like the neglected masterpiece *The Circus* (1928), it was concerned with the comedian's ability to be funny and to keep his audience. Chaplin plays Calvero, the great music-hall performer who has lost his audience and, he believes, his art. He befriends a suicidal young

woman, a ballerina who has also lost her art. Together they regain their will to perform and ability to create. The film repeatedly signals that Calvero, "the tramp comedian," is meant to be Chaplin. When Calvaro dies, it is after nostalgia for his successful years becomes an affirmation of the vitality of the old world he represents and the old art which succeeds again in animating an audience.

Limelight was the last film Chaplin made in the U.S. When he left for its premiere in London, the Justice Department used Chaplin's departure to force him out of the country as an undesirable alien. There are over 15,000 pages of government documents on Chaplin, thousands of them destroyed or unreleased, which reveal the government's determination to destroy his career and popularity and, at the same time, their fear that they could not. In this crusade the FBI was joined by military intelligence agencies, the CIA, the State Department, the IRS, and the Postal Service.

FBI files on Chaplin go back as far as 1922, but government interest intensified during World War II when he publicly supported Russian War Relief and advocated a second front. When the actress Joan Barry brought a paternity suit against him, newspapers smeared him for immorality and, after he was exonerated by a blood test, the FBI launched a vigorous investigation to convict him of violating her civil liberties and the White Slavery Act of 1910.

Chaplin's popularity and international stature placed some limits on the persecution. The House Committee on Un-American Activities subpoenaed Chaplin in 1947, but withdrew it after he accepted their invitation in a defiant public attack, privately threatening to appear in the tramp costume and turn the tables on them. In all this period of Cold War anticommunism, Chaplin was one of the few Hollywood personalities who did not retreat an inch; he continued his open opposition to the persecutions, continued to associate with known and suspected communists, and reasserted his opposition to the Cold War and support of peaceful coexistence.

Chaplin's response to his forced exile was his most outspoken attack on the social order, *A King in New York* (1957), a film which could not be shown in the U.S. until years later. Bitter lampoons of Cold War persecutions of dissenters are made part of a critique of the vulgar commercialism of American society. The film is uneven, sometimes embarrassingly awkward, but is always interesting and often very funny. What remains most significant about the film is not its artistic merits, but the unrestrained fury of its attack on the government, unprecedented and rarely matched in later Hollywood films. The cruelty and bigotry of the government are represented in its shocking attack on a small boy, played by Chaplin's son Michael; the king himself is Chaplin thinly disguised.

This intrusion of Chaplin's increasingly well-known and notorious offscreen personality is a remarkable feature of the later films. He repeatedly crosses the border between fiction and personal statement, as he himself stood in for the tramp persona he had left behind. *The Great Dictator* ends with Chaplin's famous plea for justice and brotherhood. In *Monsieur Verdoux*, the Chaplin who was smeared through the media as immoral and a white slaver, comes on screen as a Bluebeard, the director defiantly turning the tables on society by making the audience care more about the murderer than the victims. In *Limelight*, the story of the aging performer losing his audience and art is impossible to watch without seeing Calvero as Chaplin himself, reproaching the faithlessness of his public; in *A King in New York*, the parallel is so immediate that Chaplin has Charlie the King appear before HUAC. Separating the real Chaplin from the screen roles becomes impossible for the viewer who has any sense of who Chaplin was and what he had done; Chaplin had become part of our culture. The films become the personal statement

of a filmmaker with such an intimate relation to the history of his time that his films exercise the complex fascination and emotional impact of history itself, with its tragic overtones.

A King in New York was the first clear artistic failure since Chaplin created the tramp. Perhaps it failed because, unlike the other dialog films, Chaplin was unable to incorporate into his overtly political attack on the government the tramp through whom he expressed his ironic politics and outlook. His choice of persona, Shahdov, a refugee king ousted by a revolution, reflects his ambivalence toward his customary comic target; in the film Chaplin both loves and hates the wealth he always attacked. Though the tramp was at heart democratic, he always asserted the elegance of the wealth in his tattered clothes. Chaplin was quite happy to enjoy wealth and very clever at amassing it—to the point that he converted all his equities to gold six months before the crash of 1929, and his autobiography shows he was fascinated by the rich and powerful people who lionized him. At the same time he espoused the causes of the left-wing enemies of the rich.

Chaplin's politics have often been downplayed, first by Chaplin himself who denied his films were political statements, then by apologetic critics following Chaplin's own example, or eager to paint government officials as paranoid or idiotic. But the government can't be faulted for seeing him as a political threat at a time when public figures were called upon to denounce the Communist Party and the Soviet Union and to attack anyone who refused to go along. He was tolerable during the Popular Front period, when there was widespread support for the communist movement and left wing causes, but, when it was government policy to create a Cold War anticommunist consensus, Chaplin could be tolerated no more than Paul Robeson. There was no room for public opposition by a vastly popular fimmaker whose works seemed guaranteed to reach the widest possible film audience, and who set an example of resistance by his refusal to make the least compromise in his public politics and personal life. Chaplin's politics were always too individualistic to conform to any left-wing model. When he did claim a position, he described himself as anarchist and humanist. This remains an accurate summary description of the politics of his films. He created comic characters who represent individual freedom and the worth of the individual over the society which seeks to regiment them or who enter into irreconcilable conflict with the social order and target its symbols.

Chaplin began by opposing the middle-class image of America presented by Hollywood with his comic images of poverty, exploitation, and conflict between the propertyless and the propertied, the bum and respectable society. He ended with an outspoken cry of outrage and frustration at the society which would no longer tolerate the freedom of the tramp in the public arena.—Paul Elitzik

RECOMMENDED BIBLIOGRAPHY

Chaplin, Charles. *Charles Chaplin's Own Story.* Bloomington, IN: Indiana University Press, 1985.

——— *My Autobiography.* NY: Simon and Schuster, 1964.

Epstein, Jerry. *Remembering Charlie: A Pictorial Biography.* NY: Doubleday and Co., 1989.

Geduld, Harry M. *Chapliniana: A Commentary on Charlie Chaplin's 81 Movies, Vol. I: The Keystone Films.* Bloomington, IN: Indiana University Press, 1987.

Haining, Peter. *Charlie Chaplin: A Centenary Celebration.* Philadelphia, PA: Trans-Atlantic Publications, Inc., 1989.

Maland, Charles J. *Chaplin and American Culture: The Evolution of a Star Image.* Princeton, NJ: Princeton University Press, 1989.

Robinson, David. *Chapln: His Life and Art.* NY: McGraw-Hill, Inc. 1989.

——— *Chaplin: The Mirror of Opinion.* Bloomington, IN: Indiana University Press, 1985.

Child Actors

March 4, 1951. A feature in *Parade* magazine, headlined "Smart Boys...," reports, "It is estimated that the 15 youngsters who today are established 'names' (as boy child stars in Hollywood) earn over a million dollars a year.

Trust funds keep their earnings secure; studios provide tutors and medical care; State laws prevent them from overwork. It's nice work, if a boy can get it." Captioned under a photo of a pair of smiling youngsters is the following: "YOUNG DISNEY STAR, Bobby Driscoll, takes Kathryn Beaumont (she's Alice-in-Wonderland) sightseeing. Bobby is 14, has won an Academy Award, tops the list of American child actors."

July 25, 1961. A one-paragraph UPI news item out of Los Angeles is buried in *The New York Times*. Headlined "Ex-Child Star Admits Forgery," the copy reads, "Bobby Driscoll, 24 years old, one-time child actor, pleaded guilty in Superior Court today to forging an endorsement on a stolen check. Sentencing was set for Sept. 6."

The transition of Bobby Driscoll from pampered celebrity to petty criminal is not unique among child actors. Studio hype, as exemplified by the piece in *Parade*, was that Driscoll lived a cotton-candy life as a pint-sized contract player. He was not just another wide-eyed moppet: he was acclaimed as an *actor*. Allegedly, those around him were sincerely concerned for his welfare and his future.

For decades, however, child actors have been abused by the adults in whose care they are entrusted. The "Coogan Law," passed in 1938, is a California statute that controls what happens to a minor's earnings. It is named for Jackie Coogan, Chaplin's costar in *The Kid* (1921), whose parents frittered away the $5 million he had made in the movies.

Kids have been exploited as fantasy objects. In the name of "realism," Jodie Foster and Brooke Shields, themselves barely into their training bras, were cast as teenage hookers in *Taxi Driver* (1976) and *Pretty Baby* (1978). Foster's performance provided John Hinckley's inspiration for attempting to become a presidential assassin; Shields soon after appeared nude opposite George Burns in *Just You and Me, Kid* (1979).

Or they can be exploited to achieve a certain special effect. At the age of two, Baby Peggy, a star of silent films, was wired to a goat and cast out of a speeding truck. Darla Hood, of the *Our Gang* comedies, had to hang from the back of a dog catcher's wagon for half a day, take after take. Eventually, she was felled by carbon monoxide fumes. More recently, there have been the well-publicized deaths of two Asian youngsters with actor Vic Morrow while shooting *Twilight Zone: The Movie* (1983).

What are successful, identifiable actors of all ages if not commodities, pieces of merchandise placed in film after film to sell tickets and earn profits? Unfortunately, cute, precocious children often grow into gangly, pimple-faced adolescents. The fact that, in the movie business, you're only as good as your last picture is difficult enough for many adult actors to accept. For a five-year-old, or a fifteen-year-old, the result could be devastating.

A fan magazine once headlined, "Baby LeRoy Washed Up at 6." George "Spanky"

McFarland, another *Our Gang* alumnus, was at age twenty-four broke. He worked at a soda plant and hamburger stand. He made popsicles, sold wine and appliances. Edith Fellowes, who appeared in *Mrs. Wiggs of the Cabbage Patch* (1934), *Black Fury* (1935), and *Pennies from Heaven* (1936), became a switchboard operator. Tommy Rettig, of television's *Lassie*, sold men's wear, worked in an electronics shop and real estate office. "Nobody outside the profession has any idea what it's like," says Darryl Hickman, who appeared in films during the Forties and Fifties, quoted in Leonard Maltin and Richard W. Bann's *Our Gang: The Life and Times of the Little Rascals.* "To survive in Hollywood you've got to have a shaft of steel right up your back. It must be flexible enough to bend but not brittle enough to break. Jackie Cooper has got it. He's tough and he survived. Most of the others didn't. None of our stories is very pretty."

Some young actors do maintain or reclaim stardom. But at what price? The tragedy of Judy Garland is now Hollywood legend. Robert (Bobby) Blake, Little Beaver in Republic's *Red Ryder* Westerns and a supporting player in *Humoresque* (1946) and *The Treasure of the Sierra Madre* (1948), remains extremely bitter about his treatment as a youngster, a fact he has often expressed on television talk shows. Mickey Rooney and Elizabeth Taylor each seem to have been married a dozen times—and still counting. Natalie Wood's accidental drowning may be unrelated to her stardom, but her early, tragic death is symbolic of the plight of her pint-sized peers.

Not all child actors end up on skid row or in an early grave. Jackie Cooper and Shirley Temple are a couple of glaring exceptions. But the percentage is alarmingly high. Matthew "Stymie" Beard, a Little Rascal, began abusing drugs before finishing high school, became a heroin addict and petty criminal, and spent many of his adult years in jail. Carl "Alfalfa" Switzer, a Little Rascal, was shot to death

at age thirty-one, in a dispute over fifty dollars, after allegedly having threatened his adversary with a knife. Scotty Beckett, a Little Rascal, was over the years arrested for drunk driving, assault, drug possession, disturbing the peace, passing a bad check, and carrying a concealed weapon. He died at thirty-eight after having suffered a severe beating.

Marcia Mae Jones, of *The Champ* (1931), *These Three* (1936), and *The Life of Emile Zola* (1937), became an alcoholic, while Tommy Rettig and Billy Gray ("Bud" on *Father Knows Best*) were busted for drugs. Lauren Chapin, "Kitten" on the latter TV series, chronicled in her autobiography her plight as a prostitute. Anissa Jones, pigtailed star of TV's *Family Affair*, died at age eighteen after overdosing on Quaaludes and liquor. In the early Nineties, the sordid plights of *Diff'rent Strokes* stars Gary Coleman, Dana Plato, and Todd Bridges were fodder for the tabloids. It was reported in an August 23, 1991 Associated Press story that "former child actor Danny Bonaduce, known for his co-starring role in *The Partridge Family*, was spared jail time when he was sentenced Friday for an attack on a prostitute. Bonaduce, 32, pleaded guilty in July to endangerment and pleaded no contest to misdemeanor assault charges."

In *The Complete Directory of Prime Time TV Stars*, Tim Brooks writes of Rusty Hamer, Danny Thomas's TV son for over a decade on *The Danny Thomas Show*, "Since the show left the air in 1964, Rusty has been seen only in a short-lived 1970 revival and a later nostalgia special or two. Without much income from any of these, he worked for a time as a house painter and a messenger and at last report had settled in Louisiana, where he never mentions his background and is hardly ever recognized." Not long after the book's publication in 1987, Hamer committed suicide.

And Bobby Driscoll, who once had "nice work, if a boy can get it," died of occlusive coronary arteriosclerosis—hard-

ening of the arteries—before his thirty-first birthday. His films earned millions: the check he admitted forging in 1961 was for forty-five dollars.

The events in Driscoll's life comprise a contrast in irony and hypocrisy. His career came about by chance. When he was five, he moved with his parents to California because of his father's sinus condition. A barber, whose own boy acted in films, was impressed by Bobby's ebullient personality. He referred Driscoll to his son's agent and the result was a bit in *Lost Angel* (1943) with Margaret O'Brien.

Bobby's charm, his turned-up nose, brown eyes, freckles—and his talent—immediately captivated audiences, and he quickly appeared in a succession of films. He was the youngest Sullivan brother as a child in *The Sullivans* (1944); director Lloyd Bacon dubbed him "the greatest child find since Jackie Cooper played *Skippy*." He had parts in *The Big Bonanza* (1945) and *Identity Unknown* (1945), a couple of Republic quickies with Richard Arlen, and was one of the children in a poor, parentless family who prepared a *Sunday Dinner for a Soldier* (1945). He was a nephew of Joan Fontaine and Mark Stevens in *From This Day Forward* (1946); the son of Don Ameche and Myrna Loy in *So Goes My Love* (1946); and the son of Eddie Cantor and Joan Davis in *If You Knew Susie* (1948). He even aided Alan Ladd in outwitting the Nazis in *O.S.S.* (1946).

A press release hyping *So Goes My Love* announced that "Bobby Driscoll, eight years old, promises to be the Jackie Coogan, Jackie Cooper or Shirley Temple of this era. He has worked in nine pictures, three of which have not been released, and is already headed for starring status. In fact, in Walt Disney's *Uncle Remus,* yet to be released to the public, he will get that recognition."

"He has a fabulous memory and an innate ability to hold his own in scenes with established stars," commented director Frank Ryan. "He has so much charm," said Myrna Loy. "If Don Ameche and I aren't on our toes all the time, we know that the audience will be looking at the youngster and ignoring us. That's bad in our business." Added Don Ameche, "He's got great talent. I've worked with a lot of child stars in my time, but none of them bore the promise that seems inherent in young Driscoll. Moreover, he works at his job, doesn't loaf and disappear between scenes. I think he will go far."

Driscoll and Luana Patten became the first actors ever signed to long-term contracts by Walt Disney. Uncle Walt referred to the youngsters as the "sweetheart team," and featured them in *Song of the South* (1946—the "Uncle Remus" referred to in the press release). A feature detailing the film's Atlanta opening, from the March 1947 *Silver Screen*, prophesized, "Nine-year-old Bobby Driscoll and eight-year-old Luana Patten will probably turn out to be the Van Johnson and Ingrid Bergman of the next generation and attend premieres of their pictures in the capitals of the world."

But 1949 was Driscoll's year. He had top billing in Disney's *So Dear to My Heart* (actually released in December 1948), a live-action/animated feature, the nostalgic tale of a country lad growing up in 1903 Indiana. *The New York World-Telegram* reported, "Bobby Driscoll impetuously swarms through his share of the picture and fills it with the eager charm of an idealized childhood." He then displayed his versatility with a bravura performance in *The Window*, in which he stars as a little boy who cries wolf once too often and who then accidentally observes his upstairs neighbors kill a man. Thomas M. Pryor aptly began his *New York Times* critique, "The mounting terror of a young boy who lives in mortal fear for his life is projected with remarkable verisimilitude by 12-year-old Bobby Driscoll in *The Window*...the striking force and terrifying impact of this RKO melodrama is chiefly due to Bobby's brilliant acting, for the whole effect would have been lost were there any suspicion of

doubt about the creditability of this pivotal character." For his performances in these films, Driscoll was presented with a special Academy Award, a miniature statuette for being the "outstanding juvenile actor of 1949." He also won *The Film Daily* Critics' Award for *Song of the South, So Dear to My Heart,* and *The Window* and *Parents Magazine* dubbed him the "most talented juvenile star" of the year.

But Driscoll's stardom was tragically brief. As he reached his mid-teens, he lost the uniqueness which had endeared him to moviegoers. Star parts, and soon even featured roles, became scarce. "I was carried on a satin cushion," he told Bob Thomas in a 1958 interview, "and then dropped into the garbage can."

Driscoll began experimenting with drugs in 1953. By the following year, when he was seventeen, he allegedly was addicted to heroin. In July 1956 he was arrested in his Pacific Palisades home on a felony narcotics charge. He had reportedly been under surveillance, according to a newspaper report, "on the basis of confidential information that he was dealing in drugs." The charges later were dropped when the district attorney's office refused to issue a complaint. Driscoll was nineteen at the time. He was employed as a parking lot attendant.

By 1958, though, he was hoping for a comeback. He joined the Drama Study Group, changed his billing to a more adult-sounding "Robert Driscoll," and appeared in *The Party Crashers*, a programmer about teenage gangs. At the time, he revealed to Bob Thomas, "The other kids didn't accept me (when I was younger). They treated me as one apart. I tried desperately to be one of the gang. When they rejected me, I fought back, became belligerent and cocky and was afraid all the time." During this period, Driscoll married and became a father, but the relationship foundered and his wife eventually divorced him.

Driscoll soon was back in the headlines, but not because of any accolades for *The Party Crashers*. In October 1959 he was arrested with two companions on "narcotics charges." He was carrying a hypodermic kit, and police noted needle marks on his arms. Driscoll was booked on suspicion of violating the state narcotics code, and jailed as an addict. He gave his occupation as "unemployed."

In April 1961, when he was twenty-four, he and Mrs. Suzanne Stansbury, a thirty-four-year-old waitress, were arrested in Malibu on burglary charges. According to police, a car identified as Stansbury's was observed leaving the scene of a $450 robbery of the Palisades Animal Clinic. Driscoll reported that he was employed as a construction laborer.

That October, he was held in lieu of $3,675 bail pending psychiatric determination of whether he was an addict. Eventually, he spent over a year in California's Chino Penitentiary in a drug rehabilitation program. He worked as a carpenter until 1964, when he completed his parole, and then set off for New York. His mother later explained that he had "washed his hands of his family and the movie industry and left for New York in hopes of getting work."

Driscoll apparently was unable to find employment on the New York stage, and rarely phoned his parents. He died in early 1968, and his body was discovered by children playing in an abandoned tenement. He was penniless. At his side were some religious material and a couple of empty beer bottles. As Driscoll was without identification, no one was able to claim his body. His identity was later determined through his fingerprints.

Bobby Driscoll, winner of an Academy Award, was buried in New York City's Potter's Field in an unmarked grave.
—Rob Edelman

RECOMMENDED BIBLIOGRAPHY

Cary, Diana Serra. *Hollywood's Children: An Inside Account of the Child Star Era.* Boston, MA: Houghton Mifflin, 1978.

Darvi, Andrea. *Pretty Babies: An Insider's Look at the World of the Hollywood Child Star.* NY: McGraw Hill, 1983.

Cimino, Michael

(1938(?) –)

The story of writer-director Michael Cimino's spectacular rise and fall reads like a slick Hollywood screenplay, a contemporary morality pageant in which overweening Ambition is resoundingly punished.

Flushed with acclaim and Oscars for *The Deer Hunter* (1978), his second film, Cimino plunged into *Heaven's Gate* (1980), the most delirious example of megalomania in American movies, a work of profligate wastefulness that not only exposed the Emperor's nudity but also toppled a moviemaking empire: Cimino's $36 million clinker caused the downfall of United Artists.

The excesses of *Heaven's Gate*—languorous pacing, overstuffed *mise-en-scène*, improvisational pauses, and stammerings that masquerade as dialog—are apparent in both *Thunderbolt and Lightfoot* (1974) and *The Deer Hunter;* only in the postdisaster *Year of the Dragon* (1985) does a chastened Cimino tighten his pace and create characters who speak in quick full sentences. With his remake of *Desperate Hours* (1991), William Wyler's taut 1955 thriller starring a wonderfully deadpan Humphrey Bogart, Cimino's career has come to a crashing halt—his overwrought, declamatory style, a terminally self-parodying performance by Mickey Rourke, and a grotesquely mannish turn by Lindsay Crouse as a sheriff, decapitate what could have been a still-tense story about criminals invading the home of a bourgeois family.

Despite its flaws, *The Deer Hunter* has a cumulative impact that *Heaven's Gate* never achieves; and where the characters' muteness in *The Deer Hunter*, their inability to form a verbal response to the events that inundate them, is purposeful, inarticulateness—the writer's as well as the characters'—sabotages *Heaven's Gate*. After the flabby first hour of *The Deer Hunter*, a prolonged introduction to the working-class characters and their milieu in which Cimino's wanton self-indulgence ought to have been a warning to the producers of *Heaven's Gate;* the film is filled with startling set pieces—the choked, steaming streets of Saigon, a line of refugees straggling along a jungle road, a circle of sweaty onlookers around a suicidal game of Russian roulette—that demonstrate Cimino's skill in choreographing crowd scenes and that created the illusion (at the time) of directorial genius.

Eager to claim the last word on the caper movie (*Thunderbolt and Lightfoot*), the war drama (*The Deer Hunter*), the Western (*Heaven's Gate*), and the police thriller (*Year of the Dragon*), Cimino attempts to transfigure generic conventions. But his lush, painterly visual style and his self-consciously literary structures in which the action is divided into separate "acts" are at odds with his coarse-grained thieves and cops, his beleaguered soldiers and peasants. In Cimino's would-be epics "culture" fights with crudeness as the director drenches his proletarian characters in a series of inappropriately "artistic" pictures.

Each of his overscaled fables features a maverick hero played by actors who project an idealized man-of-the-people aura. Bucking the Establishment, more loyal to male bonding or to the pursuit of their heroism than to romantic alliances, the stubborn Cimino loners—from Clint Eastwood's clever con man in *Thunderbolt and Lightfoot* to Robert De Niro's soldier

who tries to salvage his buddies from the wreckage of Vietnam in *The Deer Hunter* to Kris Kristofferson's Wyoming marshal defending immigrant farmers against cattle barons in *Heaven's Gate* to Mickey Rourke's cop locked in battle with both the Chinese Mafia and a corrupt police force in *Year of the Dragon*—are ruddy survivors. In the context of the social and political traumas into which Cimino thrusts his characters, mere endurance is a kind of victory.

In Cimino's movies the enemy is typically a monolithic, remote, and fatally contaminated political establishment that tramples over the common man: in *The Deer Hunter* a blind and inexorable war machine destroys the lives of a representative group of working-class victims, as in *Heaven's Gate* the Association of cattle barons, in league with the federal government, slaughters masses of immigrant peasants. Cimino's paranoid political vision is cynical as well as defeatist—there is a masochistic strain in the director's politics that is as voluptuous and ultimately as spurious as his visual grandiosity.

If his bruised and disillusioned rebels can't change the system they can at least fight back. And indeed their heroism is measured by their use of violence to combat violence, their willingness to break the law in order to attack the greater lawlessness of the entrenched political powers. In setting up scenarios in which the heroes' use of brute force is cathartic both for themselves and for the audience, Cimino converts his democratic sympathies for the folk into reactionary fables. (His populism is also compromised by his ambivalence about his earthy characters, whom he regards with an unstable mixture of condescension and camaraderie.) Cimino's vigilante heroes have more in common with Rambo and Dirty Harry than with Marxist revolutionaries; it isn't capitalism that Cimino is against, it's the *bad* capitalists like the Association in *Heaven's Gate* and the Mafia in *Year of the Dragon* that he is gunning for.

Finally, though, Cimino's overriding commitment seems not to be to the political issues his films raise but to their visual possibilities. In *Heaven's Gate* he is continually distracted from the political and economic conflicts between the rampaging capitalists and the dispossessed immigrants by visual set pieces. More footage is devoted to atmosphere and weather than to clarifying the historical circumstances of the Johnson County War which presumably attracted Cimino to the material in the first place. Political statement is submerged, indeed rendered inarticulate, by the director's insistent exquisiteness: sunlight slanting through shutters; moonlight shimmering on a lake; dancers swirling gracefully in a huge room that looks like a set designer's feverish fantasia; whores and their clients gamboling in sepia-toned interiors. Unlike the use of ritual and ceremony in the films of John Ford, Cimino's communal celebrations seem ornamental rather than thematic. Even when the imagery is relevant—factories belching smoke in *The Deer Hunter*, peasants in *Heaven's Gate* pulling a plow in tortured low angle against a panoramic horizon—the overstated virtuoso compositions are more picturesque than political. Just as Cimino's elaborate multilayered sound tracks often, perversely, emphasize background noise at the expense of dialog, his visual monumentality overpowers sense with sensibility.—Foster Hirsch

RECOMMENDED BIBLIOGRAPHY

Bliss, Michael. *Martin Scorsese and Michael Cimino*. Metuchen, NJ: Scarecrow Press, 1985.
Gallagher, John Andrew. *Film Directors on Directing*. NY: Greenwood Press, 1989.

The Communist Party in Hollywood

T he Hollywood branches of the Communist Party (CP), contrary to Cold War accusatory rhetoric, never controlled, subverted, or determined in a direct way any other political organization, any labor union, any movie studio, or any movie.

Hollywood Communists did not spy, sabotage, or deliver American secrets to Russian agents. The Communist screen employees played active roles in the talent guilds (most notably, the Screen Writers Guild), antifascist organizations, and progressive political coalitions, and, as a result of the reformist tenor of the era, helped in the victory of liberal measures and candidates and the defeat of conservative measures and candidates. But the Communist Party in Hollywood, as the Communist Party in the rest of the country, "triumphed" only when its interests directly coincided with the liberal Democratic position, as occurred during the height of the antifascist Popular Front (1936–'39) and World War II (1941–'45). Whenever the Communist line dictated opposition to the liberal position, however, as occurred between 1939 and 1941, and again in the post-1945 era, redbaiting, schism, and purges resulted. In sum, even during the vocal heights of the "Red Menace" chorus, studio bosses, knowledgeable liberals, and militant conservatives all knew that the Communist Party, for all its impressive organization and discipline, controlled very little in Hollywood.

Nevertheless, as an integral part of the radical political and cultural wave of the Thirties, Hollywood Communists influenced the behavior and thought of many non-Communists, while breeding a heightened social consciousness and providing channels for dedicated political activity among its own membership. In the decade 1936–1945, the CP made itself nearly synonymous with serious political commitment in Hollywood. Ironically, in terms of its revolutionary past, and tragically, in terms of its hoped-for socialist future, the CP achieved this stature only by downplaying to the point of invisibility the militant class conflict, workers" state, and separatist rhetoric that dominated its propaganda during the Twenties and early Thirties. Instead, party spokespeople trumpeted defense of democracy and the Soviet Union by means of a broad-based coalition of progressive forces—the Popular or People's Front.

Prior to 1933, and Hitler's rise to power in Germany, intellectuals and artists were not attracted to the CP in impressive numbers, nor did the CP seem to care. It preferred to develop its own type of intellectual and artist by means of the John Reed Clubs and the Film and Photo League. Some writers supported the Communist-backed miners' strike in Harlan County, Kentucky, in 1931, while others backed the presidential effort of William Z. Foster in 1932, but it was not until 1935, when non-Communist labor leader John L. Lewis launched the Committee for Industrial Organization, and Communist International Chairman, Georgi Dimitrov, approved the formation of People's Fronts against Fascism, that the political expertise and activism offered by the CP finally meshed with the organizational needs of progressive-thinking intellectuals and artists in America.

In Hollywood, although individual Communists had been active agents in the formation of the Screen Writers Guild (1933) and the campaign to elect Upton

Sinclair (a Socialist turned Democrat) to the governorship of California (1934), the Communist Party, as an organized collective force, did not play a significant role until 1936. The efforts of its trade union front, the Trade Union Unity League, to introduce industrial unionism to the backlot and sound stage workers foundered on the rocks of an entrenched union, the International Alliance of Theatrical Stage Employees, and the craft union orientation of studio workers. It was only when a large bloc of members of the Screen Writers Guild, the most militant labor group in Hollywood, came to see the CP as the principal protector of progressive social values and political ideals, that a breakthrough occurred. The CP's unstinting support for blacks deprived of their civil rights, migrant agricultural workers, and California longshoremen, combined with its clarion call to resist fascism by means of a Popular Front and its newly Americanized political vocabulary, convinced many Hollywood writers that the CP had become the best means of defending democratic values in the United States.

Hollywood writers, both present and future, helped organize the first, and one of the most important, Popular Front organizations: the League of American Writers. This group, and a similar one formed for American artists, signalled the party's perception of the value and prestige of intellectuals and artists and its striving to develop forums designed to attract America's cultural elite. The Hollywood front of this new campaign, however, did not take shape immediately. The basic party structure—neighborhood clubs and shop branches—did not fit the needs of Hollywood artists or the nature of their work and private lives. In early 1936, therefore, V. J. Jerome, the party's "Commissar of Cultural Affairs," and Stanley Lawrence, one of its most experienced organizers, arrived on the West Coast to weld the growing number of party film members into homogenous talent branches—writers, directors, and actors. The

adherents to these branches were freed from most of the normal demands of party membership—regular payment of dues, selling *The Daily Worker*—so that they could make maximum use of their professional positions and skills to advance party goals and raise money for party causes, primarily the Loyalist (antifascist) side in the Spanish Civil War. The party's flexibility was rewarded: the Hollywood branches, during the period 1936–'39, were the largest contributors to Popular Front causes.

In addition, the younger screenwriters—Richard Collins, Budd Schulberg, Ring Lardner, Jr., and Paul Jarrico, among others—were allowed to form a special branch, one in which they could explore how to communicate their radical political and social ideas in scripts and where they could discuss revolutionary theories and techniques of moviemaking. The men and women in this branch viewed films from Europe and the Soviet Union, read Marxist esthetics, and fiercely debated their creative role within the Hollywood movie industry.

In matters of political doctrine, however, no flexibility was granted. No deviation from the established party line was permitted any Communist, anywhere. But the Hollywood Communists, convinced that they had found an effective channel for their social ideals and political goals, did not outwardly chafe against this restraint. Inner doubts and questions stayed hidden.

By 1937, then, the Hollywood branches of the CP were in a healthy state of adolescence. Although precise membership totals are difficult to establish, somewhere between 250 and 300 movie employees (or about one percent of the studio worker population) joined the party at one time or another. Screenwriters predominated, 145 joining between 1936 and 1946. There were approximately sixty actors, twenty directors and producers, and fifty backlot, sound stage, and front office workers enrolled in party ranks for varying lengths of time.

There were, at any given time, depend-

ing on the popularity of the party, between five and seven talent branches in Hollywood, containing ten to twenty people each. The branches met at least once a week, in a home of one of the members. There the members were presented with the latest party directives, Marxist theory, current political tactics, and the fine points of an advanced social consciousness through "educationals" that focused on the "women's question" or the "minority question." Only a very few took to the basic Marxist texts with relish and considered themselves Marxist-Leninists. The vast majority either did not understand or were bored by the finer points of doctrine.

Hollywood Communists also participated in regular "fraction" meetings—meetings of Communists who belonged to the same non-Communist organizations (Screen Writers Guild, Anti-Nazi League, etc.). There they discussed the strategy and tactics they would pursue in the larger group. It was through the fractions that the policies and ideals of the party were transmitted most effectively to the public and party strength magnified beyond its actual strength in numbers.

Even though regular party functionaries spoke admiringly of the commitment and activity of the movie Communists, something of a distance remained between them. Albert Maltz has said "that there was a distinct theoretical narrowness among party leaders and they exhibited a limited tolerance for debate and criticism from the intellectual and artistic members." And a Los Angeles party "educator" noted that "there was always a great deal of suspicion between the party and its creative types."

Hollywood Communists were an unusual element within the party, distinguished by the glamorous aura of the movie business and the distinctive nature of the employment categories within it. Movie Communists were uniquely valuable to the party, not because it was believed that they could influence moviemaking, but because of their access to the fame of Hollywood and the huge salaries of Hollywood employees. The party, therefore, had no incentive to "proletarianize" its Hollywood cadres; on the contrary, it needed their "bourgeois" names, fame, and life style. Moreover, Hollywood writers, actors, and directors puzzled party bureaucrats; they were hybrids—at once workers on an industrial assembly line and craftspeople. They fit none of the party's categories.

The complete agreement between the party and its Hollywood adherents on the issue of resistance to fascism thus hid a knotty tangle of differences which were not resolved and barely even confronted. Many of the screen artists who joined the party during the Thirties hoped that membership would provide a workable synthesis between political activity and artistic output. But the idealistic nature of the movie members" goals repeatedly clashed with the principal nature of the party's. On the one hand, the main political goal of the movie Communists, antifascism, was only provisionally a top priority for the party's national and international leadership. On the other hand, the party simply did not care about the frustrations and disappointments that bedeviled most Communist movie people, few of whom managed to combine political views and vocational demands in a satisfying manner.

In the realism which most concerned artists and intellectuals—development of a link between the world of political and social action and that of artistic and literary expression—the party and its creative members found little common ground. party leaders had little understanding of the artistic or literary process and little patience with it. They simply wanted famous literary names and well-written political tracts. Not only did the party "aestheticians" and literary commissars fail to provide creative solutions to the problems writers faced, they clumsily and dogmatically wielded critical sledgehammers on the efforts of Communist writers to achieve artistic social realism.

Even if the party had been more helpful—even if it had pushed Hollywood

Communists toward a more advanced theoretical position on movies and moviemaking—the impact of politicized screen artists on commercial films would have remained meager. Even without party support, a small number of Hollywood Communists evidenced skill and determination and an understanding of what constituted progressive film content and technique. The studio bosses, however, were more skilled and more determined, and they exercised complete control over the form and style of Hollywood movies.

For the most part, then, movies written, directed, or produced by Communists are not politically or stylistically distinguishable from those by non-Communists. In the world of moviemaking, as in the world of politics, Communists only made their influence felt when they wrote or acted as liberals, and when the times were propitious for liberal ideas. They did try to approach their subject matter more objectively than was the norm; they endeavored to add realism and delete racial distortions and ethnic stereotypes; and they tried to accentuate the real elements of story material they found in their assignments. The progress they made on those fronts must have been fulfilling, for very few Communist movie people left Hollywood of their own volition; none opted to found an independent film company.

The magnetic force of Hollywood—its cultural product, its production system, its salaries, life-style, and values—held all its employees firmly in place. Communists were a special, but not distinct, species within the movie genus. As a group, they stood for progressive ideas, for selfless charitable work, for professional, social, and political improvements, and for more realistic movies. They did not realize their cinematic ideals, however, and their political ideals were crushed between the implacable forces that confronted each other during the Cold War.

The Cold War destroyed the marriage of convenience between the Communist Party and Hollywood artists. Even though a mass exodus did not occur in 1945 or 1946, events during those years augured a severe tightening of the reins of party discipline and a severe hardening of its political line in ways that might have proved incompatible to the Hollywood cadres. First, Earl Browder's effort to "Americanize" the party and make it a more open organization was declared an error and Browder, who had headed the party for over fifteen years, was expelled. Then, Albert Maltz, as the result of an article he wrote criticizing the party's literary criticism, became the unexpected and unwilling symbol of the party's need to close ranks and stifle criticism in the face of the chill winds of the brewing Cold War. Finally, during the election of 1946, the CP and its liberal allies both began to support their respective visions, policies, and candidates in a pugnacious manner reminiscent of the 1939–'41 period. The result was schism in the ranks of the reformed left-wing coalitions that had grown out of the Grand Alliance of World War II. This time, however, there was no German invasion of the Soviet Union to provide a foundation for still another Popular Front against reaction.

Rather, the increasing hostility between the United States and the Soviet Union left the American Communist Party a vulnerable and inviting target to those groups in America, notably the business community and conservative congressmen, armed and primed to roll back the tide of New Deal reform. Congressional investigations and United States Chamber of Commerce battle plans emerged as early as 1946, but the event that symbolized and publicized the onslaught was the hearings into "Subversion in the Motion Picture Industry" held by the House Committee on Un-American Activities.

Even though fifteen of the nineteen "unfriendly" witnesses subpoenaed to appear in Washington in October 1947 were Communists, the party could not

offer much assistance. Between 1946 and 1956, thousands of Communists were to be subpoenaed before Congress, state legislative committees, and administrative tribunals, hundreds were to be indicted under the Smith Act, dozens were to be jailed, and party membership totals were to decline by seventy-five percent. Except for a few months in 1947, the Hollywood movie community sat back and watched ten of its members go to jail and hundreds lose their jobs simply for refusing to discuss their political pasts.

During those years of investigations, hearings, trials, blacklists, and shattered lives, then, Hollywood Communists basically relied on their own resources to survive. About one-third of them found the going too rough and turned informer. The remainder rallied and fought back, but the opposing forces proved too strong and the party and its social network disintegrated. The hardy few who clung to the Hollywood branch of the CP were dealt one final, shattering blow—a blow so strong that it shook even those who were living in Mexico and Europe, those exiles who had been forced to leave Hollywood to gain employment as writers. Word of Nikita Khrushchev's speech exposing the crimes of Josef Stalin and news of Soviet tanks entering Budapest combined to sever the final links between Hollywood artists and the Communist Party of the United States.

Although the Hollywood branches of the CPUSA failed to endure beyond the Cold War, failed to transform its adherents into Marxist-Leninists, and failed to revolutionize Hollywood or Hollywood films, the party experience left an indelible imprint on those who stuck with it and fought the repression engendered by the Cold War. The party experience of those who came under attack helped them collectively to rise to the occasion to display personal resources of solidarity, courage, honor, decency, integrity, and transcendence of which any group could be proud. Moreover, as a result of their party experience, the majority of Hollywood Communists better understood the nature of repression, more clearly perceived its purposes and consequences, and more systematically and enduringly resisted it than did any other radical or liberal entity in America.

The Hollywood branches of the CPUSA also did much more for Hollywood than that community realized. In their absence, not only did the entire progressive movement in Hollywood collapse before the wave of reaction, but movements to ban the bomb, support the Rosenbergs, fight McCarthy, lobby for peaceful coexistence, march for civil rights, or demonstrate against the Korean and Vietnam wars failed to materialize. Furthermore, without a radical backbone, the frightened studio bosses turned resolutely away from the occasional populist or socially critical or realistic film and began producing hundreds of movies ignoring minorities, debasing women, extolling American imperialism, and caricaturing the Communist menace.

In sum, communism in Hollywood made a mark, but it did not spread wide enough or endure long enough to have a lasting impact, except on the individuals who were part of it. They remain as exemplars of courageous behavior in a time of political crisis—and their behavior attests to the quality of the political ideals that motivated them to join the Communist Party in the first place.—Larry Ceplair

RECOMMENDED BIBLIOGRAPHY

Ceplair, Larry and Steven Englund. *The Inquisition in Hollywood: Politics in the Film Community, 1930–1960*. NY: Doubleday/Anchor, 1980.

Conglomerates in the Film Industry

D uring the Sixties and Seventies conglomerate corporations took control of the Hollywood film industry. Gone were the traditional movie moguls, lording over single-line moviemaking empires.

Instead, if one examined the corporate hierarchy of these new conglomerate powers, one found MBAs and attorneys not so much interested in making movies as raising the share values of their stock.

A conglomerate is defined as a large modern corporation not confined to making and distributing a single product, but embracing a varied line of businesses, tendered both in the continental United States and throughout the world. The conglomerate form was rare until the extraordinary merger movement which took place during the Sixties. With the coming of ITT, Litton Industries, and Textron, one had to pay close attention to figure what types of operations a conglomerate was peddling.

The initial wave of conglomerate formation concentrated on the "pure" conglomerate in which totally unrelated businesses were grouped together. The pure conglomerate form embraced the U.S. film industry in 1966 when Gulf+Western Industries acquired Paramount Pictures. Gulf+Western had begun as a producer of automobile bumpers, and then spread into harvesting sugar cane, manufacturing cigars, electrical wire and cable, clothing and musical instruments, mining zinc, and selling insurance. Founder Charles Bludhorn also purchased Famous Players, the largest movie circuit in Canada, the book publisher Simon & Schuster, the Madison Square Garden arena in New York City, the New York Knickerbockers professional basketball team, the New York Rangers professional ice hockey club, and the International Holiday on Ice skating show. In all,

Gulf+Western, in its heyday before its founder's death in the early Eighties, represented more than sixty diverse businesses under one corporate umbrella.

In response, the remaining Hollywood movie companies initiated or accelerated recently commenced diversification efforts. But, unlike their pure conglomerate cousins, they tended to execute product extension takeovers, involving businesses which were fundamentally related, so-called media-entertainment products.

By the late Eighties these media conglomerates focused on a set of related leisure-time and information-generating businesses, and they held considerable economic power. Thus, in the late Eighties and into the Nineties, the most powerful of these media conglomerates merged into bigger corporate units.

Time Warner stands as the prototypical media conglomerate. The motion picture part of this corporate empire grew out of a 1969 merger between Kinney National Services, Inc. (which dealt in parking lots, construction, car rental, and funeral homes) and the then-struggling Warner Bros. Pictures, Inc., a maker of both movies and television programs. In 1971 Warner Communication was formed when Kinney National was spun off to handle the construction, automobile, and funeral businesses. In 1989 Warner merged with Time. The new Time Warner empire now includes popular music, publishing, cable television as well as the core Warner Hollywood operations. Steven J. Ross, originally of Kinney, remains the corporate godfather of Time Warner while Robert Daly supervises

operations in Hollywood.

But Time Warner was hardly alone in its creation of a media conglomerate which held powerful positions in all forms of the media and leisure time worlds. Universal Studios is controlled by the conglomerate MCA, Inc. The Music Corporation of America was founded in 1924 as a booking agent for popular swing bands of the era. MCA soon spread to representing all talent, including Hollywood actors and actresses, probably its most famous examples being Ronald Reagan and Jane Wyman. Late in the Fifties, MCA purchased the ailing Universal studios. Faced with a governmental suit because it then both employed and represented the same talents, MCA shrugged off the original talent business and soon thereafter added television production, theme parks, a chain of gift shops, book publishing, and a popular music division to its original movie studio. In 1986 Universal brought half interest in Cineplex-Odeon movie theatres, and became a giant in the movie theater business in both the United States and Canada. In 1990 the huge Japanese electrical company, Matsushita, purchased MCA for more than $7 billion.

Other Hollywood corporations strove to follow the successful examples of Time Warner and MCA. In 1985 the Australian Rupert Murdoch desperately sought to make his name in Hollywood. Even with a successful string of newspapers and television stations in Australia and Great Britain, Murdoch could not afford (or risk) to start a studio from scratch. The power of a Warner or MCA could easily have crushed such an upstart operation. Instead Murdoch brought the then ailing Twentieth Century Fox film studio, hired manager extraordinaire Barry Diller away from Paramount, and began to create his own media conglomerate.

Murdoch saw Hollywood extending more and more into the American home through television, and so in 1986 Fox took control of the Metromedia television stations and launched the Fox Broadcasting Network. To make sure the public did not ignore this challenger, Murdoch purchased *TV Guide* for more than a billion dollars. With his other worldwide matrix of magazines and publishing enterprises, Murdoch, from a base at Hollywood's Twentieth Century Fox, had equalled the media power of his rivals Time Warner and MCA.

Hollywood's other two major studios, Disney and Columbia Pictures, have undergone their own mini-versions of media conglomeratization. During the early Eighties, with the corporate management of Michael Eisner and Jeffrey Katzenberg moving over from Paramount, Disney took bold steps by making R-rated adult films and opening theme parks in Japan and France. By the late Eighties Disney was the equal of any media conglomerate, with new book-publishing and television-syndication arms.

Columbia's experience of the Eighties proved media, not pure, conglomeration was the correct road to longrun riches. In 1981 the mighty Coca-Cola corporation took over Columbia, expecting to ride the wave of entertainment prosperity. Columbia floundered under strict controls of Coke's Atlanta-based MBA cost accountants. In 1988 Coke sold Columbia and thereafter Columbia struggled to find the proper mix of media products. In 1990 Sony purchased Columbia Pictures to gain access to the corporate "software" (movies and TV shows). Sony expects to build a media powerhouse in the final decade of the twentieth century.

Media conglomerates, whoever their owners are, present a host of effects not seen in past Hollywood corporate expansion. First, through a wide array of accounting and tax gimmicks, conglomerate managers can produce profits in the short run even when no real growth has taken place. In popular business parlance, this "synergism" has turned the focus of the Hollywood movie companies from moviemakers into holders of "film

libraries" and real estate, particularly in the Los Angeles area.

In the longer run, business conglomeration permits two lines of corporate behavior not readily available to single-product firms: cross-subsidization and reciprocity. Cross-subsidization enables a media conglomerate with interests in a number of markets to take profits from one area to subsidize activities in another business line to undercut the competition. Single-line corporations rarely have the resources to effectively fight back. Indeed, Hollywood has not seen the emergence of a new major movie producer in decades, with the way littered with such failures as Cannon Pictures, De Laurentis Films, and New World Pictures.

Reciprocity means media conglomerates maximize their already apparent advantages by selling only to firms which cooperate with other parts of the enterprise. For example, MCA might not sell movies to Time's HBO unless that same company's cable franchises book MCA's USA Cable Channel. More and more frequently, media conglomerates have become vertically integrated, so they produce, distribute, and present (in print, on television, or on film) the same product over and over again, making more and more profits.

Thus, only the Paramounts, Warners, and Universals are able to thrive and prosper by fully exploiting blockbuster attractions such as *Star Wars* and *E.T.* They alone can concentrate their movie ventures into a handful of productions; they know that, since there are only six competitors which can put forth rival blockbusters, only the media conglomerates can fully exploit the potential riches of the media leisure-time marketplace.

Moviemaking is concentrated in a very few companies. Their formulas are predictable. This system closes down opportunities for all but a handful of writers, directors, actors, and other creative talent. Six men have the sole power to push the buttons necessary for making a feature film which, in 1991, cost on average nearly $25 million to make and $15 million more to market and distribute in arenas from multiplexes to cable TV to home video.

To those who champion film as an art form, the coming of media conglomerates has meant that corporate chieftains prefer safe, formulaic films to even the most elementary experimentation. To those who look to film to help with ideological struggle, media conglomerates have effectively strangled the marketplace and kept alternative means of expression marginalized. Expectedly, media conglomerates spend whatever they need to maintain their enormous control over the market for movie entertainment. Cases of bribery and illegal political activity continue to be common occurrences. The prospect is that, as the motion picture industry moves into the twenty-first century, it will be as a small part of a handful of giant media conglomerates probably named Paramount, Time Warner, Matsushita-MCA, Twentieth Century Fox (with a new name?), Disney, and Sony Columbia Pictures.

—Douglas Gomery

Contemporary Film Theory

W hile there had always been sporadic attempts, by filmmakers and critics, to theorize the cinema—one thinks of the work of Sergei Eisenstein, Siegfried Kracauer, and André Bazin—it was only in the Sixties that film theory emerged as a powerful and comprehensive movement.

Previously, film writers had simply consumed films, made judgements about their quality or social impact, without feeling the need for an all-encompassing theory. In the Sixties, writers began to "get serious" about film, assuming that it deserved as much sustained theoretical reflection as any other art. Contemporary film theory emerged from French auteurism, from the intellectual movement called structuralism, and from the mingled influences of Althusserian Marxism, Saussurean linguistics, Lacanian psychoanalysis, and feminism. In the first postauteurist state, Saussurean linguistics provided the dominant model, followed by a second phase in which Marxism and psychoanalysis became the preferred conceptual tools. The feminist movement, meanwhile, displayed its own autonomous development, even as it both incorporated and critiqued the other theories and schools.

The wave of film theory had its most immediate roots in the intellectual currents of postwar France, where there was a strong preoccupation with the idea of *écriture* (writing). Carried over to film, it became the metaphor of "film-writing," which from Astruc's *"camera-stylo"* camera-pen) to Metz's prolonged discussions of cinema and *écriture*, dominated film criticism in France. The French New Wave directors were especially fond of this graphological trope, hardly surprising given that many of them began as writer-critics who saw writing articles and making films as simply two forms of expressive *écriture*. The film-writing trope was also implicit in the notion of the "film-auteur." André Bazin defined "Auteurism" in *"La Politique des Auteurs"* (1957) as the analytical process of "choosing in the artistic creation the personal factor as a criterion of reference, and then postulating its permanence and even its progress from one work to the next." While auteurism occasionally had the effect of making the cinema the last refuge of a romanticism discarded both by the other arts and by the most advanced theory, its project of seeking out and constructing authorial personalities did introduce a kind of system, however problematic, into the realm of film studies. Thanks to the film-writing metaphor, interest was progressively displaced from realism to textuality, from the situation or characters depicted to the act of writing itself. Since the concept of writing is performative, rather than one of mere transcription, it implicitly undermines the mimetic view which regards the work as a mirror-like reflection of preexisting reality. Film came to be seen as text, utterance, speech act, not the depiction of an event but rather an event in itself, one which participated in the production of a certain kind of subject-spectator.

It is impossible to speak of film theory over the last three decades without speaking of the movement called structuralism. For our purposes, we can define structuralism as a theoretical grid through which behavior and institutions are seen as analyzable in terms of an underlying network

of relationships, the crucial point being that the elements which constitute the network have no inherent meaning apart from the relations that hold between the elements. Common to most varieties of structuralism and semiotics was an emphasis on the underlying rules and conventions of language rather than on the surface configurations of speech exchange. In film, this meant that film analysts were to look for the underlying rules and conventions of film, the systems that made possible their meaning. Film semiotics emerged, in the early Sixties, as part of this structuralist euphoria, leading to short-lived dreams of a total scientificity, dreams which were to be undone both by the political developments summed up in the phrase "May '68," by internal self-questioning, and by the attraction of other methodological models.

The emergence of "film theory" in the Sixties calls for a multileveled explanation. On one level, this efflorescence of film theory forms part of overall intellectual history, the long-range impact of the revolution in thought evoked by such names as Marx, Freud, and Nietzsche, and the more immediate influences called up by such names as Saussure, Lévi-Strauss, Lacan, and Derrida. That is why it is ultimately silly to rail against theory, as if it were the serpent in the garden of film, for to do so is simply to rail against the major intellectual currents of our epoch. It is legitimate to question specific theories, of course, but to reject the theoretical enterprise as a whole in the name of "common sense" is simply to be antiintellectual, nostalgic for a time when people simply "went to the movies" and bathed in their pleasures with simple-minded enjoyment. On another level, the emergence of film theory as a "growth industry" has more immediate institutional causes, to wit, the inauguration of cinema studies as a discipline in major universities, alongside such "new disciplines" and "area studies" as women's studies, ethnic studies, and popular culture studies. Without this institutional

home base, film theory would have never acquired the importance and dissemination that it did.

Although it is a nearly impossible task in the space available here to comprehensively survey developments in film theory over the last few decades, we can examine the key questions being asked by film theory, and to weight the political import of these questions. Since the Sixties, film theory has been preoccupied with what film theorists, following Althusser, like to call "problematics," i.e., constellations of crucial issues and questions. For the film semioticians, such as Umberto Eco, Pier Paolo Pasolini, and Christian Metz, the issue had to do with the nature of "film language." Is film a language? What kind of language is it? How are linguistic methods relevant to the study of film? Although the cine-semiologists did not invent the notion of "film language"—one finds the metaphor in the Twenties' writings of Riccioto Canudo in Italy and Louis Delluc in France, in the Russian Formalists, and, implicitly, in the many "Grammars" of Cinema—it was only with the advent of structuralism and semiotics in the Sixties that the film-language concept was explored in depth. The key figure among the filmo-linguistic pioneers was Christian Metz, whose goal, as he himself defined it, was to "get to the bottom of the linguistic metaphor," by testing it against the most advanced concepts of contemporary linguistics. Metz took the linguistic metaphor seriously, but also skeptically, in order to discern its quantum of truthfulness. Metz looked for the counterpart, in film theory, to the conceptual role played by *langue* in the Saussurean schema. And much as Saussure concluded that the rightful purpose of linguistic investigation was to disengage the abstract signifying system of a language—i.e., its key units and their rules of combination at a given point in time—so Metz concluded that the object of cine-semiology was to disengage the cinema's signifying procedures, its combinatory rules, in order to see to what extent these

rules resembled the doubly-articulated systems of "natural languages."

The question which oriented Metz's early work was whether the cinema was *langue* (language system) or *langage* (language) and his well-known conclusion to his own question was that the cinema was not a language system but that it was a language. Although film texts cannot be conceived of as a *langue* generated by an underlying language system, then, they do nevertheless manifest a language-like systematicity. Cinema is a language not only in a broadly metaphorical sense but also as a set of messages grounded in a given matter of expression (i.e., the five tracks—moving image, phonetic speech, noises and music, and written materials) and as an artistic language, a discourse of signifying practice characterized by specific codifications and ordering procedures. This apparently technical question of whether film is a language seems apolitical, yet the very fact of approaching film as a language meant approaching it as a shared, social entity, not merely as entertainment, as a commercial industry would have it, and not solely the product of individual creative personalities, as a romantic auteurism would have it, but rather as a social product collectively produced and collectively consumed.

In *Language and Cinema* (first published in English in 1974), Metz develops the notion of textual system—the undergirding organization of a film text considered as a singular totality. Every film has a particular structure, a network of meaning around which it coheres—even if the system chosen is one of deliberate incoherence—a configuration arising from the diverse choices effectuated among the diverse codes available to the filmmaker. The concept of the textual system helps Metz define the task of the film analyst as opposed to that of the theorist. Just as cinematic language is the object of cine-semiological theory, so the text is the object of film-linguistic analysis. What the cine-semiologist studies is not the filmmaking

milieu, or the lives of the stars, or the technological supports of the cinema, or their reception, but the text as a signifying system. (This New Critical-style "ghettoizing" of the text would be questioned subsequently, even by Metz himself.) The publication of *Language and Cinema* was followed by a kind of deluge, in many countries, of textual analyses of films. Such analyses investigated the formal configurations making up textual systems, usually isolating a small number of codes such as camera movement, framing, point of view, and then tracing their interweavings across the film. Among the more ambitious textual analyses are Kari Hanet's analysis of *Shock Corridor*, Stephen Heath's of *Touch of Evil*, Pierre Baudry's of *Intolerance*, Thierry Kuntzel's of *The Most Dangerous Game*, and *Cahiers du cinéma*'s of *Young Mr. Lincoln*. Rene Gardies, meanwhile, concentrating on pertinent binary oppositions having to do with character, myth, and *mise-en-scène*, offered an extended analysis of the films of Glauber Rocha as a "plurifilmic textual system."

Although most of the analyses generated by this wave belonged, broadly speaking, to the general semiotic current, not all of them were rigorously based on Metzian categories or assumptions. Historian Pierre Sorlin's textual analyses of films like *October* and *Muriel* formed part of a sociological project largely inspired by the work of Pierre Bourdieu and Jean-Claude Passeron. Marie-Claire Ropars Wuilleumier's extremely intricate insights with a more personal project concerning filmic "writing" partially inspired by Derridean grammatology. Many other analyses were influenced by literary textual analyses such as Roland Barthes's *S/Z*, an elaborate analysis of Balzac's novel *Sarrasine*. (Julie Lesage, for example, explored the exegetical relevance of Barthes's "five codes" to Renoir's *Rules of the Game*.) Still other analyses were inspired by Proppian narratological methods—Peter Wollen on *North by Northwest*—or by other theoretical currents such as feminism or deconstruction.

While some textual analyses sought to construct the system of a single text, others studied specific films as instances of a general code informing cinematic practice, but even here the distinction is far from clear; Raymond Bellour's analysis of *The Birds* offers both a microcosmic textual analysis of the Bodega Bay sequence of the Hitchcock film and an interrogation of broader narrative codes shared by a larger body of films—to wit, the constitution of the couple as the telos of Hollywood narrative.

Since textual analysis finds its historical antecedents in Biblical exegesis, in hermeneutics and philology, in the French pedagogical method of close reading (*explication de texte*) and in New Critical "immanent" analysis, it makes sense to ask what exactly was new in the semiotic approach to textual analysis? First, the new method demonstrated, in comparison with antecedent film criticism, a heightened sensitivity to the filmic signifier and to specifically cinematic formal elements as opposed to more traditional "literary" elements such as character and plot. Second, the analyses tended to be methodologically self-aware; they were at once about their subject—the film in question—and about their own methodology. Each analysis thus became a sample of a possible approach to be extrapolated for other films. In contrast with journalistic criticism, the authors of these analyses saw it as their obligation to cite their own critical and theoretical presuppositions and intertext. (Many analyses began with quasiritual invocations of the names of Metz, Barthes, Kristeva, or Heath.) These analyses also presupposed a radically different approach to studying a film. The analyst had to abstract him/herself from the "regressive" conditions imposed by conventional moviegoing. Rather than a single screening, the analyst was expected to study the film shot by shot, preferably on a flatbed editing table (the existence of VCRs has to a certain extent democratized the practice of close analysis). Analysts

such as Marie Claire Ropars and Michel Marie developed elaborate schemas for notation, registering such codes as angle, camera movement, movement in the shot, offscreen sound, and so forth. Finally, these analyses eschewed the old evaluative terms of film criticism in favor of a new lexicon drawn from structural linguistics, narratology, psychoanalysis, and literary semiotics.

Semiotics always had what might be called a right (liberal) wing and a left wing. The right wing tended to use semiotics as an apolitical scientistic instrument, while the left wing deployed it for the demystification, the "denaturalizing" of conventional cinematic representations, exposing them as constructed systems of socially-informed signs. At times, for immature minds, semiology became a pretext for snobbism, and words like "code" and "signifying practice" were wielded like magic wands designed to turn garbled criticism into "scientific analysis." Metz criticized what he called "delirious semiotizations" and "pseudo-Lacanian approximations," deriding the "sausage-link semiology" which would feed all texts into a semiotic machine, laboriously transforming theme into syntagmas, lexies, and articulations. At its best, however, semiology, like Marxism, was deeply subversive of commonsense ways of thinking. It scrutinized social and artistic phenomena in order to discern the cultural and ideological codes operative within them, performing the work of a subversive denaturalization. It challenged conventional notions of history, society, signification, and human subjectivity, notions on which conventional criticism was surreptitiously based.

In the early and mid-Seventies, cine-semiologists began to turn their attention away from linguistic issues to psychoanalytic ones. The linguistically-based model, it was found, was somewhat narrow, failing to account for the psychic effects of the cinema on the spectator. The theoretical questions now had to do with the relation between film and its spectator. What is our

investment in film? Why do films affect us so strongly? What is the relevance of psychoanalytic concepts such as voyeurism, fetishism, regression to the filmic experience? What is the nature of the cinematic apparatus? In what ways is film experience comparable to dream? Theorists such as Metz and Raymond Bellour psychoanalyzed their own critical and theoretical practice. Thus Metz, in "The Imaginary Signifier," spoke of the diverse ways in which theorists can "love films," and scrutinized his own "investment" in film and in film theory. Both Metz and Jean-Louis Baudry, meanwhile, stressed the metapsychological aspects of the "desire for film," the way in which the combination of cinematic representationalism and a fantasy-inducing spectatorial situation conspire to project the spectator into a dreamlike state where interior hallucination is confused with real perception. Metz and Baudry explored the analogies between cinema and diverse psychic phenomena such as dreams, daydreams, and hypnosis, in order to explain cinema's power over the spectator.

Much has been made of the "faddish" nature of the shift of interest from linguistic semiotics to psychoanalysis. But in fact this change forms part of a coherent trajectory toward the "semio-psychoanalysis" of the cinema. Linguistics and psychoanalysis were not chosen for arbitrary voguish reasons but because they are the two sciences that deal directly with signification as such. Psychoanalytic questions, while not in the surface political, could be easily pushed in a political direction, either by eliding politics and reducing everything to the Oedial tensions, in short to the Freudian master-schema of "Mommy, Daddy and Me," or, in contrast, by attempting to link psychoanalytical questions to political ones. How does Hollywood, for example, exploit the spectator's voyeuristic and regressive tendencies in order to maintain itself as an institution. In "The Imaginary Signifier," Metz came close to integrating social consciousness with psychoanalytic method. He distinguished two "machines" operating within the cinematic institution: first the cinema as industry, making commodities whose sale as tickets provides a return on investment, and second the spectatorial psyche, which experiences film as a pleasurable "good object." One economy, involving the generation of profit, is intimately linked to another, involving the circulation of pleasure. Metz in this context psychoanalyzed the sources of cinematic pleasure—identification, voyeurism, fetishism, narcissism. In other essays, Metz explored the parallels between film and dream; he was hardly the first to do so, of course, but he faced the task with extraordinary rigor. He displaced interest from the fantasy embodied in the film—the particular wish-fulfilling stories told by the cinema—to the fantasy involved in the filmgoing experience.

Marxist approaches, meanwhile, which became especially strong in the late Sixties and early Seventies, became intermingled with these other approaches. Marxist film theory asked such questions as what are the social determinants of the film industry? What is the ideological role of the cinema as an institution, and of specific films? What style and narrative structures should politicized filmmakers adopt, and what strategies should critics deploy to analyze film politically? Linking Althusser's idea that the primary function of ideology is to reproduce subjects who will support the values necessary to maintaining the existence of an oppressive social order with Lacan's ideas about subject-construction, the more politicized theorists (notably Stephen Heath, Colin MacCabe, Jean-Louis Comolli) emphasized the ways in which the cinema "positioned" subjects in ways congenial to the capitalist system. Addressed by the film, it was argued, the spectator accepts the identity assigned and is thus fixed in a position where a particular mode of perception and consciousness appears natural. The spectator is locked into a structure of misrecognition, into an imaginary relationship to the real condi-

tions of his or her actual social existence.

For theorists such as Marcelin Pleynet, Jean Louis Baudry, and Jean-Louis Comolli, bourgeois ideology was inherent in the cinematic apparatus itself. As defined by traditional Marxism, ideology referred to a distortion of thought which both arises from and conceals social contradiction. As defined by Lenin, Althusser, and Gramsci, bourgeois ideology refers to that ideology generated by class society so that the dominant class provided the general conceptual framework for a society's members, thus furthering the economic and political interests of that class. For Louis Althusser, ideology was "a system (possessing its own logic and rigor) of representation (images, myths, ideas or concepts as the case may be) existing and having a historical role within a given society." Ideology was, furthermore, as Althusser expressed it in a widely-quoted definition, "a representation of the imaginary relation of individuals to the real conditions of their existence," insofar as it interpolates individuals and constitutes them as subjects who unthinkingly accept their role within the system of production relations. The more radical of the film theorists called for a deconstruction of the ideology produced by the camera. Jean-Louis Baudry argued in "The Ideological Effects of the Basic Apparatus" that the apparatus must be examined in the context of the ideology which produced it as an effect. Pleynet pointed out that the technology of the camera was conditioned by the code of Renaissance perspective, a convention of pictorial representation developed by the Renaissance painters of the Quattrocento, who observed that the perceived size of objects in nature varies proportionally with the square of the distance from the eye. The Quattrocento painters simply incorporated this code, which characterizes the retina, into their paintings, thus planting the seeds of illusionism in painting, resulting in the impression of depth and ultimately leading to impressive *trompe-l'oeil* effects. As

absorbed into the camera, this code functioned, as Marcelin Pleynet put it, "to 'rectify' any anomaly in perspective, so as to reproduce in its full authority the code of specular vision as it was defined by Renaissance humanism." The code of perspective, furthermore, produces the illusion of its own absence; it "innocently" denies its status as representation and passes off the image as if it were actually a kind of "piece of the world."

Subsequent commentators were quick to point out that such a view was monolithic and ahistorical, a formula for total paranoia regarding a cinematic apparatus conceived as an overwhelming "influencing machine." The Althusserian view, as transposed into film theory, tended to treat cultural products as if they were completely exempt from contradiction, the fruit of a unified and self-aware bourgeoisie capable of forseeing subsequent centuries with total clairvoyance, constructing its codes of representation with the single goal of defending its class interests. Some of the theoretical texts, especially those influenced by Althusser, seemed to equate perception itself with ideology, falling into a kind of puritanical condemnation of the apparatus as a kind of all-powerful machine against which all resistance was necessarily in vain. (The despair of subverting the apparatus, it should be added, mirrored a certain decline and defeatism on the left during the period—the early Seventies—in which the theories were being formulated.) Coming from an anti-semiotic perspective, Noel Carrol argued in *Mystifying Movies* that the Lacanian-Althusserian equation of ideology with subject positioning led to an impasse. By identifying ideology with subject construction, Carrol argued, the concept became roughly coextensive with that of a culture as a whole, thus losing its critical force. The concept, Carrol argued further, was superfluous for political-ideological analysis. The subject's subordination to the reigning social order was better explained by what Marx called the "dull compulsion

of economic relations" than by any hypothesis concerning subject-construction.

Given what were seen as the sinister effects of the illusionist esthetic, many theorists called for what Peter Wollen labeled a "counter cinema," best exemplified by the work of Godard, a cinema characterized by openness, by systematic disruption of the flow of narrative, by estrangement rather than identification, and by displeasure instead of pleasure. Such conceptions were obviously very much indebted to the dramaturgical conceptions of Bertolt Brecht, and it was no accident that many film analysts in the late Sixties and Seventies turned with enthusiasm to the theories of the German dramatist. Brecht's Epic Theatre was in many respects diametrically opposed to classical realism. Its mode was argumentation rather than evocation. The spectator was to remain outside of the drama rather than to be drawn in. The dominant narrative strategy was one of montage, the juxtaposition of self-contained units rather than the organic growth and evolution of a homogenous structure. Character was seen as an epiphenomenon of social process rather than a question of individual will and desire. With Brecht, the issue of distantiation was always closely tied to a dialectical analysis of alienation—the process by which human beings, in a Marxist perspective, lose control of their labor power, their products, their institutions, and their lives. Apart from the general goals of Brechtian theater—laying bare the causal network of events, the cultivation of an active, thinking spectator, the defamiliarization of alienating social realities, and the emphasis on social contradiction—Brecht also proposed specific techniques to achieve those goals. In terms of mythos (plot), Brecht proposed his own "epic" theater, i.e., a theater whose narrative structure was interrupted, fractured, digressive. In terms of acting, Brecht argued for a double distantiation, i.e., a reflective critical relation both between the actor and the part, and between the actor and the spectator. Brecht also proposed a theater productive

of alienation effects, i.e., devices by which the spectator is deconditioned, by which our lived social world is "made strange" as a way of getting rid of the false representations that we make of ourselves and of our society. Brecht believed that bourgeois normality numbs human perception and masks the contradictions between professed values and social realities; whence the need for an art which would free socially conditioned phenomena from the "stamp of familiarity," and reveal them as striking, as calling for explanation, as other than "natural." Brecht argued, finally, for the use of gestus, i.e., the "mimetic and gestural expression of social relationships beween people in a given period," by which a play might evoke domination, submission, arrogance, humility, and self-deprecation based on social position. These Brechtian proposals were taken up not only by film theorists such as Colin MacCabe, Peter Wollen, and Stephen Heath, but also by innumerable filmmakers such as Jean-Luc Godard, Tomás Gutiérrez Alea, Alain Tanner, and Herbert Ross.

THE POLITICS OF REFLEXIVITY

Brecht argued as well for a thoroughgoing reflexivity, i.e., the principle that art should reveal the principles of its own construction, to avoid the "swindle" of suggesting that fictive events were not "worked at" but simply "happened." Indeed, reflexivity formed a key term in all these debates. Borrowed from philosophy and psychology, the term as applied to the arts referred originally to the mind's capacity to be both subject and object to itself within the cognitive process, but is here extended to the capacity for self-reflexiveness of any medium or language. In the broadest sense, reflexivity refers to the process by which texts foreground their own production, their authorship, their textual procedures, their intertextual influences, or their reception. The penchant for reflexivity must be seen as symptomatic of the methodological self-scrutiny of contemporary thought, its tendency to exam-

ine its own terms and procedures. Many polemics have revolved around the issue of what might be called the political valence of reflexivity. While Anglo-American literary criticism has often seen reflexivity as a sign of the postmodern, a point at which an "art of exhaustion" has little left to do except contemplate its own instruments or render homage to past works of art, the left wing of film theory, especially that influenced by Althusser as well as Brecht, came to regard reflexivity as a political obligation. The major thrust of the Althusserian movement in cultural studies was the critique of realism, and the tendency, in the early phase, was simply to equate "realist" with "bourgeois" and "reflexive" with "revolutionary." The terms "Hollywood" and "dominant cinema" became code words for all that was retrograde and passivity-inducing. The identity of "reflexive" and "revolutionary," meanwhile, led in the pages of journals such as *Cinethique* to the rejection of virtually all cinema, past and present, as "idealist." But both of these equations call for close examination. First of all, reflexivity and realism are not necessarily antithetical terms. A novel such as Balzac's *Lost Illusions*, and a film like Godard's *Tout Va Bien*, can be seen as at once reflexive and realist, in the sense that they illuminate the everyday lived realities of the social conjunctures from which they emerge, while also simultaneously reminding the readers-spectators of the constructed nature of their own mimesis. Realism and reflexivity are not strictly opposed polarities but rather interpenetrating tendencies quite capable of coexisting within the same text. It would be more accurate to speak of a "coefficient" of reflexivity or realism, while recognizing that it is not a question of a fixed proportion. Godard-Miéville's *Numero Deux*, for example, displays a simultaneously high coefficient of both realism and reflexivity. Illusionism, furthermore, has never been monolithically dominant even in the mainstream fiction film. The coefficient of reflexivity varies

from genre to genre (musicals like *Singin' in the Rain* are classically more reflexive than social-realist dramas like *Marty*) from era to era (in the contemporary postmodernist era reflexivity is very fashionable, even de rigueur), from film to film by the same director (Woody Allen's *Zelig* is more reflexive than *Another Woman*), and even from sequence to sequence within the same film. Even the most paradigmatically realist texts—as Barthes's reading of *Sarrasine* and *Cahiers'* reading of *Young Mr. Lincoln* demonstrate—are marked by gaps and fissures in their illusionism. Few classical films perfectly fit the abstract category of transparency often taken to be the norm in mainstream cinema. Nor can one simply assign a positive or negative value to realism, or reflexivity, as such. Marx's debt to Balzac suggests that realism is not inherently reactionary. What Jakobson calls "progressive realism," i.e., the deployment of realist fictional strategies in order to present the perspective or explain the oppressive situation of subaltern groups, has been used as instrument of social criticism in favor of the working class *(Salt of the Earth)*, women *(Marianne and Juliane)*, and emergent Third World nations *(The Battle of Algiers)*. Brecht's theories pointed the way beyond the false dichotomy of realism and reflexivity, since Brechtian theater (and film) clearly attempts to enlist self-referential narrative procedures to Marxist revolutionary aims. Brecht demonstrates the compatibility of reflexivity as an esthetic strategy and realism as an aspiration. His critique of realism centered on the ossified conventions of the nineteenth-century novel and naturalist theatre, but not on the goal of truthful representation. Brecht distinguished between realism as "laying bare society's causal network"—a goal realizable within a reflexive, modernist esthetic—and realism as a historically determinate set of conventions.

The generalized equation of the reflexive with the progressive is also problematic. Texts may foreground the work of their

signifiers or obscure it; the contrast cannot always be interpreted as a political one. Jane Feuer speaks, in conjunction with the musical, of "conservative reflexivity," i.e., the reflexivity characterizing films such as *Singin' in the Rain* which foreground cinema as an institution, which emphasize spectacle and artifice, but ultimately within an illusionistic esthetic which has little to do with subversive, demystificatory, or revolutionary purposes or procedures. The reflexivity of a certain avant-garde, similarly, is eminently cooptable within art world formalism. One might speak, similarly, of the "postmodern" reflexivity of commercial television, which is often reflexive and self-referential, but whose reflexivity is, at most, ambiguous. The David Letterman show, or the Monty Python films, are relentlessly, even archly reflexive, but almost always within a kind of cynical, pervasively ironic stance, which looks with a jaundiced eye at all forms of political position-taking. Many of the distancing features characterized as reflexive in Godard's films would at first glance seem to typify many television shows—the designation of the apparatus (cameras, monitors, switches), the "disruption" of narrative flow (via commercials), the juxtaposition of heterogenous discourses, the mixing of documentary and fictive modes. Yet, rather than trigger "alienation effects," television often simply alienates. The commercial interruptions that disrupt fiction programming, for example, are not pauses for reflection but breaks for manipulation, intended not to make the television viewer think but rather to feel and to buy. The self-referentiality of parodic commercials, similarly, ultimately mystify rather than disenchant. The self-referential humor signals to the spectator that the commercial is not to be taken seriously, thus triggering a relaxed state of expectation which renders the viewer even more permeable to the commercial message.

FEMINIST FILM THEORY

At its height, film theory hoped for a creative amalgam of Marxism, linguistically-derived semiotics, and psychoanalysis. In an amicable division of labor, Marxism would provide the theory of society and ideology, semiotics would provide the theory of filmic signification, and psychoanalysis would provide the theory of the subject. But in fact it was not an easy task to synthesize Freudian psychoanalysis with Marxism, or Marxism with a largely ahistorical structuralism. The period of our discussion, furthermore, witnesses an overall decline in the prestige of Marxism and the emergence of the new politics of feminism, gay liberation, ecology, and the diverse Third World liberation movements. The decline of Marxism had to do not only with the transparent crisis of most socialist societies (a point sometimes exploited to obscure the fact that capitalism, too, is in crisis) but also with increasing skepticism about all totalizing theories, a skepticism sometimes summed up in the word poststructuralism. The move away from Marxism did not necessarily mean the abandonment of oppositional politics within film theory; it is just that the oppositional impulse now animated a different set of practices and concerns. Discussion now revolved around feminist issues, an interest first heralded by such popular books as Molly Haskell's *From Reverence to Rape* and further advanced by the work of theoretical journals such as *Women and Film* and *Camera Obscura*. The focus was both on practical goals of consciousness-raising, on denunciation of Hollywood's deformation of the image of women, but also on more theoretical concerns such as the nature of female spectatorship. Theorists such as Laura Mulvey, Kaja Silverman, Mary Ann Doane, Sandy Flitterman, and Teresa de Lauretis criticized the essentialism of early "naive" feminism, emphasizing gender as a social construct. Feminists partially took over, but always with modifications, the early amalgam of Marxism, semiotics, and psychoanalysis deployed by earlier (largely male) critics. Rather than focus on the "image" of women, these the-

orists focused on the constructed nature of vision itself, and the role of voyeurism, fetishism, and narcissism in the construction of a view of women. In the Seventies, many theorists called for a radical deconstruction of patriarchal Hollywood cinema, and the elaboration of an avant-garde feminist cinema exemplified by the work of Chantal Akerman, Yvonne Rainer, Marguerite Duras, and the Wollen-Mulvey films. In the Eighties, however, feminists turned their attention away from these hopes, spending more energy analyzing the alienated pleasures of mainstream cinema (not always in completely condemnatory ways, as, for example, in Tania Modleski's work on Hitchcock).

The feminists also pointed to the ideological limitations of phallocentric Freudianism, with its privileging of the phallus, of male voyeurism, and of an Oedipal scenario which left little place for the construction of female subjectivity. Mary Ann Doane argued that the overwhelming presence to itself of the female body made it impossible for women to establish the distance from the image necessary for voyeuristic pleasure and control. The whole concept of fetishism, Doane pointed out, had little to do with a female spectator, "for whom castration cannot pose a threat." Laura Mulvey, meanwhile, was criticized (and criticized herself) for forcing the female spectator into the mold provided by the male. Many feminist theorists became increasingly skeptical about the concept of an overpowering cinematic apparatus. The apparatus as conceived by Baudry and Metz, Constance Penley argued, was a "bachelor machine," while for Joan Copec it was a hysterical denial of sexual difference.

TOWARD A SOCIAL SEMIOTIC

One of the thrusts of the semiotic approach to film was to question realism by emphasizing the coded, constructed nature of the filmic artifact. The emphasis on realism characteristic of the film theory of the Fifties (for example in Bazin), gave

way to an attack on realism in the name of reflexivity and intertextuality in the late Sixties, Seventies, and Eighties. Art was a discourse, as Kristeva put it, responding not to reality but to other discourses. Kristeva was deeply influenced by Mikhail Bakhtin's theories of intertextual dialogism. Bakhtin defines dialogism as "the necessary relation of any utterance to other utterances." (An "utterance," for Bakhtin, can refer to any coherent complex of signs, from a spoken phrase to a poem, or song, or play, or film.) The concept of dialogism suggests that every text forms an intersection of textual surfaces where other texts may be read. In the broadest sense, intertextual dialogism refers to the infinite and open-ended possibilities generated by all the discursive practices of a culture, the entire matrix of communicative utterances within which the artistic text is situated, and which reach the text not only through recognizable influences but also through a subtle process of dissemination. Dialogism operates within all cultural production, whether it be literate or nonliterate, verbal or nonverbal, highbrow or lowbrow. The film artist, for example a Jean-Luc Godard or a Raul Ruiz, becomes the orchestrator, the amplifier of the ambient messages thrown up by all the series—literary, painterly, musical, cinematic, publicitary, and so forth.

The Bakhtinian reformulation of the problem of intertextuality can provide a corrective to the purely intrinsic formalist and structuralist paradigms of semiotic film theory, as well as to vulgar Marxist paradigms interested only in extrinsic ideological determinations. Any art, for Bakhtin, must be seen as an inseparable part of culture and must be understood within what Bakhtin calls the "differentiated unity of the epoch's entire culture." One of the major failures of film theory, after all, was to integrate the semiotic model with a clearly conceived sense of history. Both structuralism and poststructuralism had in common the habit of

"bracketing the referent," i.e., of insisting more on the interrelations of signs than on any correspondence between sign and referent. In their critique of realism, both structuralism and poststructuralism occasionally went to the demagogic extreme of detaching art from all relation to the "real." The very term "reality," under the semiotic onslaught, acquired a suspect air. Derridean deconstruction, in its more extreme formulations, posited a world that was nothing but text. The artistic text, in this perspective, was not a thing in itself but rather a relation to other texts which were themselves nothing but sets of relations. The text was cut off from the author, the world and the reader-spectator. But to reject all relation between film and reality is to suggest that verisimilar fiction would allow for a cartoon-like fictional world where apples fall upward and characters survive two hundred-degree fevers. The constructed, coded nature of artistic discourse does not preclude all reference to physical reality or social existence. Many theorists saw Bakhtin as the theorist who had anticipated the structuralist insight concerning the coded nature of artistic discourse without ever falling into the structuralist and poststructuralist trap of completely severing the link between text and context, between art and social world. In books such as *The Formal Method in Literary Scholarship* and *The Dialogic Imagination*, Bakhtin reformulates the question of artistic realism in ways which reconcile semiotics and historical materialism. Human consciousness, and artistic practice, Bakhtin argues, do not come into contact with existence directly but rather through the medium of the surrounding ideological world. Art does not so much refer to or call up the world as represent its languages and discourses. Art is not the reflection of the real, or even a refraction of the real, but rather a refraction of a refraction, i.e., a mediated version of an already textualized socioideological world. By bracketing the question of "the real" and instead emphasizing the artistic representation of languages and discourses, Bakhtin relocates the question so as to avoid the "referential illusion," i.e., the idea that films "refer back" to some preexisting truth. Bakhtin's formulation has the advantage, then, of avoiding a naively "realistic" view of artistic representation, without acceding to a "hermeneutic nihilism" whereby all texts are seen as nothing more than an infinite play of signification. Bakhtin rejected naive formulations of realism while never abandoning the notion that artistic representations are at the same time thoroughly and irrevocably imbricated in the social, precisely because the discourses that art represents are *themselves* social and historical. Indeed, for Bakhtin artistic texts are incontrovertibly social, first as utterances (that is, addressed by a person or group to another person or group), and second as situated, contexted, immersed in historical circumstance.

Under the combined pressure of radical feminism, Bakhtinian dialogism, Derridean deconstruction, and Baudrillardian postmodernism, semiotics as a project of methodological unification has entered into what is probably its final agony. Theory now is somewhat more pragmatic, less inclined toward overarching systems, drawing on a plurality of theoretical paradigms. Theory is now undergoing a kind of rehistoricization, partially as a reponse to the elision of history by both the Saussurean and the Freudian-Lacanian models. Theorists are also now paying attention to the spectator as multifarious, as a social product transected by issues of gender, race, class, and nation, thoroughly immersed in history and circumstance. But even if some of the initial scientific claims of semiotics have come to be regarded with great skepticism, the postsemiotic era remains rich in the traces, the vestiges, the conceptual vocabulary, and the methodological presuppositions of semiotics. While semiotics may no longer be the fashionable phenomenon it once was, all the intellectual movements that

are currently fashionable owe a good deal to it and would probably not exist had semiotics not paved the way. The project now is to forge a critical practice which combines the interdisciplinary thrust of first-phase semiology with the critique of mastery of poststructuralist currents, all combined with the political consciousness characteristic of a translinguistic "social semiotic."—Robert Stam

RECOMMENDED BIBLIOGRAPHY

Andrew, Dudley. *Concepts in Film Theory*. NY: Oxford University Press, 1984.

Burch, Noel. *Theory of Film Practice*. Lane, Helen R., translator. Princeton, NJ: Princeton University Press, 1981.

Carroll, Noel. *Mystifying Movies: Fads and Fallacies and Contemporary Film Theory*. NY: Columbia University Press, 1991.

Doane, Mary Ann. *Femmes Fatales: Feminism,* *Film Theory, and Psychoanalysis*. NY: Routledge, 1991.

Gentile, Mary C. *Film Feminisms: Theory and Practice*. Westport, CT: Greenwood Publishing Group, 1985.

Henderson, Brian. *A Critique of Film Theory*. NY: Dutton, 1980.

Lapsley, Robert and Michael Westlake. *Film Theory: An Introduction*. NY: St. Martin's Press, 1988.

Mast, Gerald. *Film, Cinema, Movie: A Theory of Experience*. Chicago, IL: University of Chicago Press, 1983.

Mast, Gerald, Marshall Cohen, and Leo Braudy, eds. *Film Theory and Criticism: Introductory Readings*. NY: Oxford University Press, 1992.

Rodowick, David. *The Difficulty of Difference: Psychoanalysis, Sexual Difference, and Film Theory*. NY: Routledge, 1991.

Rosen, Philip. *Narrative, Apparatus, Ideology: A Film Theory Reader*. NY: Columbia University Press, 1986.

Coppola, Francis Ford

(April 7, 1939 –)

Francis Ford Coppola was the first of the film school graduates of the Sixties to break into commercial filmmaking. In many ways he served as a role model for filmmakers who followed.

Beginning as a screenwriter, moving into directing and then, finally, producing, he showed it was possible to gain artistic control over production within the commercial constraints of Hollywood filmmaking.

Coppola made his first film at the age of ten, charging admission to neighborhood kids for a 16mm home movie. After some earlier experience in school theatricals, he entered Hofstra College, editing the theatrical and musical columns of Hofstra's *World*, writing short stories, acting, lighting, staging, and finally directing in the student theater. Impressed by Eisenstein's films, he decided on filmmaking rather than theater, enrolling in the UCLA film school in 1960. Unable to get hands-on experience in filmmaking at school, he directed three "nudie" films, including *Tonight for Sure* (1961), and then was hired to work as assistant to Roger Corman. After working to prove his all-around utility to Corman, he was given a chance to direct *Dementia 13* (1963), a barely comprehensible but suitably gruesome story of a family complete with a murdered child and an axe-murderer. The

film's visually striking moments received some praise from reviewers.

Submitted as his MFA thesis at UCLA, *You're a Big Boy Now* (1966) is a coming-of-age film in which a young man struggles to break out of a family and social world that stifles both sexual expression and creative spontaneity. The comic style, based on grotesque caricature and fantasy, is defeated by poor writing, but at the same time the film's few well-visualized moments were enough to bring Coppola's first "respectable" directorial effort to critical attention for his attempt at personal filmmaking. The film was also notable for Coppola's successful maneuver to gain control of the property, to which Seven Arts could claim title, since he wrote it while under contract with them. He told Seven Arts his screenplay was based on a similar novel, for which he had bought the screen rights; claiming that he and Seven Arts each had partial ownership, he persuaded them to let him direct the film with their money.

Finian's Rainbow (1968) was Coppola's first major production, a multimillion-dollar version of a twenty-year-old Broadway musical. Despite the huge investment, the film was a box office failure. It is now memorable only as the film in which Fred Astaire dances with his feet cropped out of the frame.

Coppola returned to personal filmmaking in *The Rain People* (1969). Here, before the feminist movement had made an impact in Hollywood, Coppola followed Natalie (Shirley Knight), stifled by her role as housewife as she leaves her husband, decides upon an abortion, and takes to the road for freedom. Killer Kilgannon (James Caan), a childlike innocent after suffering brain damage in a college football game, is also on the road; with no one willing to take responsibility for him he confronts Natalie, who repeatedly tries to abandon him and, in the end, holds him in her arms as he dies. *Rain People* is a moody film of estranged outsiders cut off from each other in a hostile world. The

outsiders struggle aimlessly and in conflict with the few characters who represent society. The world is a detached spectacle, like the people whose lives the little girl spies on, looking through the windows of the trailer park. The drama of Natalie accepting responsibility for Killer only as he dies is less poignant than the film's many visually striking moments, such as Killer freeing the animals in the animal farm or the opening sequence, early morning rain in the suburban street.

The first two *Godfather* films have been widely recognized as among the outstanding achievements of American popular filmmaking, showing, better than any of Coppola's later work, the possibilities for the film artist within the limits of Hollywood economics. These films were also an important personal breakthrough for Coppola. Based on his earlier work, no one could reasonably have expected such an achievement. Not even Coppola's screenplay for *Patton* revealed a talent that could create an epic with such mythic resonance, with a canny sense of audience needs, with the power to draw into a powerful emotional experience even film students able to see the manipulations of genre and formula.

The Godfather is an accomplished adaptation of Mario Puzo's best-selling novel, a mix of trashy characterization, clever plotting, and good writing. While both film and book are heroic immigrant and family sagas, both Mafia crime stories, the film makes a decisive break from the sentimentality of the novel, reaching more consistently for the tragic. *The Godfather* becomes the tragedy of Don Vito Corleone, the Sicilian immigrant whose fundamental aspiration was conventionally American—respectability for his family and its social acceptance through the success of his college-educated son Michael. But when Vito dies, Michael takes his place as an old-world Godfather, destroying Mafia enemies with the Sicilian vengeance that his father had forgone. Coppola ends the film with this

vengeance, which he presents not merely as self-defense, but as *infamia*. He cross-cuts between the sacred baptism of Michael's nephew and the bloody murders of his enemies, including the infant's father, closing on Michael's betrayal of his promises as he lies to his wife, denying his murders.

The film revealed an authorial mastery Coppola was never to surpass. The screenplay, which he coauthored with Mario Puzo, shows the economy of *The Conversation;* but Coppola also forced crucial decisions on the producers, including the casting of Brando and Pacino, and the location shooting in Sicily.

It is ironic that the film which presents the Italian immigrant story as a Mafia crime drama has become the Italian-American epic. The film romanticizes organized crime by casting it in the form of a heroic immigrant saga. The Corleones hurt only those who deserve it, and hurt either in pursuit of some justice for the powerless or in self-defense against the wicked. They have redeeming family integrity, but their violence is directed against thoroughly unredeemed Mafiosi who are depicted as brutal, treacherous, even racist, and without the sense of honor which enobles Don Vito. The only representatives of respectable society are presented as corrupt and vicious, justifying Michael's cynical defense to Kay that there is no real difference between the politicians who run the country and the Corleone family, who in any case only want integration into respectable society.

The Godfather was the tragedy of Vito Corleone, that he was unable to protect his family, saw one son die, another incompetent, and, sadder yet, the most loved Michael succeed him. *The Godfather, Part II* is the tragedy of Michael Corleone, who, in trying to become like his father, debased his memory. Both were outsiders, the impoverished immigrant bereft of his Sicilian family and his son, who rejects his own family

for American ways. Michael becomes the American success in a caricature of power, respectability, and alienation from self only when he rejoins and vindicates his crime family. In the words of his own question to his mother, in trying to be strong for the family, he lost it. As *Godfather II* ends, his parents are dead, he has been betrayed by his wife and his brother, and he has murdered his sister's husband for another betrayal. His final *infamia* is the murder of his brother Fredo, after Fredo renounces ambition, accepts his inability to live in the Mafia world, and spends his time caring for Michael's son. When Michael murders him for yet another betrayal years before, he murders also his last hope of family closeness and his last pretension that what he did was for family.

A key moment in the first film was Vito's announcement that he forgoes vengeance for the sake of family; the film ends and the sequel begins with Michael taking up vengeance and following it to the end, until he is left without family and alone with power. The focus of *The Godfather* is the illusion that the Corleone gangster empire was built on family and respect, on the offer of friendship and services, more than on compulsion; *The Godfather, Part II* replaces family with fear, respect with compulsion.

Coppola wanted the first two *Godfather* films to be seen as an allegory of the American experience, in which ethnic and family solidarity disintegrate, with the individual left alone in society, without even personal integrity—Americanization as spiritual disintegration. The allegory is made more plausible by movies than by life, finding its argument less in the realities of American history than in the tradition of Hollywood's bitter commentaries on the "American Dream" from *Citizen Kane* on, the tycoon with the taste of ashes in his mouth. This allegory is a convincing partial truth, the lament of the more successful parts of the middle class, whose heroes have too often found suc-

cess a hollow disapointment. The allegory flatters power by leaving out most of the American reality—the losers and the powerless, whose experience is mostly not for Hollywood.

The Godfather, Part III (1990) is an entertaining but disappointing variation on the themes of the earlier films. Michael begins with an unexplained change of character, now regretting all of the things which made *Godfather II* a great movie. His efforts to buy respectability and confine himself to legitimate business ends with his abdication in favor of the illegitimate child of his brother Sonny, a reversion to mob brutality and murder after manipulation has failed. The most respectable business, even the Vatican bank, turns out to be a sanctuary for corruption and murder, with one honest priest becoming Pope only to be murdered by an alliance of businessmen and Mafiosi. Reconciliation with his son and wife is offset when assassins, shooting at him, accidentally slay his daughter. The film loses the tragic dimension of the Godfather narrative, as the family becomes more a figment of melodrama than the experience of generations of an immigrant and Americanized family. The unexplained mellowing of Michael is a poor sequel to the intensity of his personal tragedy, and the internationalization of his business affairs and the Vatican intrigues obscure the mythic American point of reference, without gaining any serious religious or metaphysical resonance. The deliberate narrative echoes of the earlier films say it all, ending with murder during an opera instead of during a religious rite.

The Conversation (1974) is, in form, a thriller, but it is less about a crime than it is about the observer of a crime, surveillance expert Harry Caul (Gene Hackman). Coppola is fascinated by the technology of sound, and sound surveillance, and creates a character who is a function of that fascination. Caul becomes as obsessive in his attempts to penetrate the lives of his subjects, as he is in his attempts to avoid penetration of his own life by others. The only way he can relate to people is by spying on them, but the spy is always hiding, and his need for intimacy is frustrated by his fear that intimacy will rob him of his privacy.

The success of this obsessively limited focus is such that many implausibilities of detail, enough to spoil any thriller that moves so slowly, are forgotten as Caul's inner conflict becomes the real drama of the thriller, and his spiritual death becomes the real murder. The images left with the audience are not of the murder and the corpse, but of Caul hunched behind a toilet bowl with his ear pressed to the hotel-room wall, or the empty spaces of his warehouse-workshop. The film ends with images of his life laid bare. After a phone call warns him that he is under surveillance because he knows too much, he guts his apartment in search of hidden microphones. We see him sitting among lathe and floorboard and the shambles of his life.

The film is a tour de force. With an economy Coppola never equalled, every resource of the filmmaker is directed to the same end, the creation of one mood and one character.

The *Godfather* films proved Coppola's early conviction that it is possible to make a film which is an artistic as well as a commercial success. The blockbuster successes and Coppola's shrewd contractual dealings freed him to act on his earlier ambitions to create an economic base for complete artistic freedom. The grandiose expenditures of money and time for *Apocalypse Now* (1979) became possible. Coppola's fascination with power and absolute freedom in *Patton* and the *Godfather* films laid the basis for this new film about the journey to the mad god Kurtz, which was presented in the media during the years of the film's production as if it was Coppola's own mad journey upriver. Years in the making and costing over $30 million, *Apocalypse Now* overwhelms the viewer with a cinematic experience representing the sensory overload of the war itself. Sound and image leave a

conception of the war as a monstrous threat to the soul in powerful images such as the Do Lung Bridge or the first view of Kurtz's compound.

The film is divisible into two parts. In the first, Captain Willard (Martin Sheen) is instructed to proceed to the base of Colonel Kurtz (Marlon Brando). Willard is to "terminate" Colonel Kurtz, who has gone mad with power and makes war unconstrained by any moral limits. Willard's journey upriver is a journey into madness, with increasingly surreal episodes, representing the "madness" of the war. The second part begins with Willard's arrival in Kurtz's compound and, after much deep symbolism and murky anthropology, ends with Willard's ritualistic slaughter of Kurtz.

It is difficult to say to what extent *Apocalypse Now* is a success or a failure. It remains an awesome cinematic achievement, still controversial for its pretensions, but it is nevertheless an awkward product of an unresolved artistic conflict. The film suffers from Coppola's impulse to make an antiwar statement and a conflicting impulse to draw away from political filmmaking and present the war as a metaphysical spectacle, a drama of the human soul. But this conflict which so damaged the film is an interesting one, with an interesting history. In this conflict, Coppola is true to his source in Conrad's novel of Belgian colonialism in the Congo, *Heart of Darkness,* with its most particular attack on Belgian colonialism, and most general attack on human nature. Conrad's Africans are presented as primitive savages, but the Europeans are in the end seen as no better and no different. Coppola's Kurtz, too, is presented as mad and savage, but his madness crystallizes the madness of normal military thinking and practice, the routine conduct of war revealed in its essence as unspeakable, lunatic carnage.

Coppola makes an appeal to both liberals and reactionaries in his approach. Right-wing screenwriter John Milius (see separate essay), who did the initial adaptation, contributed Kurtz's anecdote about Viet Cong who cut off the arms of village children after a U.S. team inoculates them, but Milius was upset with Coppola's inclusion of a scene in which the U.S. patrol boat, in a routine search of a Vietnamese craft, panics and massacres an entire family. This muddy appeal across the political spectrum is the familiar way the film industry blunts the edges of controversial subject matter. But, in the end, the antiwar impulse dominates the film, with its unforgettable images of a maniacal war, of a Vietnamese village destroyed, of GIs fighting a pointless battle over a bridge, and the surreal and bestial warfare of Kurtz, called a lunatic and an assassin by more routine lunatics and assassins.

The completion of *Apocalypse Now,* like the completion of the *Godfather* films, led Coppola to more ambitious projects. Again he tried to realize his ambition of becoming a counter-mogul, creating a center for a community of talented filmmakers who would be given the resources of a studio that would respect creativity and the energy of creative collaboration. They would produce art films that would rival commercial Hollywood. Coppola bought Hollywood General Studios in 1980 for $7 million, renaming them Zoetrope Studios. Zoetrope signaled its commitment to cinema art by its reconstruction and rerelease of Abel Gance's *Napoleon* and support for Kurosawa's *Kagemusha.* It also brought to America Syberberg's *Our Hitler,* and Godard's *Every Man for Himself.* It was less successful with its own productions, however, beginning with Wim Wenders's *Hammett,* which Coppola took out of the director's hands to finish shooting himself, and then Coppola's own *One from the Heart* (1982), his most disastrous failure.

It is hard to understand how the thin story of *One from the Heart* could have become the vehicle for such grandiose ambitions and disproportionately extrava-

gant production values. An exceptionally uninteresting couple loses and refinds their love in Las Vegas, finally leaving their fantasy lovers to return to their marriage. It never becomes clear why they shouldn't separate, why they go back to each other, what they see in each other, and what they want. The premises of the film are a preposterous pretension—a variation on Goethe's *Elective Affinities* set in a mythical Las Vegas. Las Vegas is presented as a symbol for "life and luck," a decidedly simple idea of Sucker City, even more romantically unreal than Coppola's idealization of the Mafia in *The Godfather*.

The characters are excuses for showing off the camerawork, music, and set design, a grandiose conception of Las Vegas built on a studio lot with ten miles of neon and 125,000 light bulbs. These are certainly worth showing off, but the film is so beautiful to watch and listen to that the inadequacy of the story is the more disturbing. Coppola was disheartened by the hostile critical response and the box office failure. His fascination with set design and avant-garde electronic cinema had produced a museum piece.

By the time he finished *One from the Heart,* Coppola said, he was $50 million in debt. At that point he began a series of, for him, low-budget films, which, unlike *One from the Heart,* were based upon other people's screenplays, and which he completed roughly on schedule and at budget.

The first two of these were adaptations of S. E. Hinton's short novels, *The Outsiders* (1982) and *Rumblefish* (1983). *The Outsiders* is the more interesting, less pretentious, of the two films about romanticized gang members of the Fifties. The high school world is divided into lower-class "greasers," the "outsiders," and upper-class "socs," who come together in the playgrounds and parks for rumbles. Everyone in this society is either a "greaser" or a "soc"; and the film expresses a powerful longing for a society where there is neither, a longing which wraps up the angry hurt of the deprived and the angry

arrogance of the privileged. The unfairness of privilege becomes a fantasy representation of inequality and class struggle. As in Marx, there are just two classes—in the world of high school students, the socs are the bourgeoisie and the greasers the proletarians. The unfairness resonates with the death of Johnny (Ralph Macchio), who is not only poor, but is also without parental love, the truest capital of children. The class conflict is only momentarily transcended when Ponyboy (C. Thomas Howell) and Randy (Darren Dalton) see each other as two guys, not as greasers or socs; but Randy expresses the futility of wishing away class. Whoever wins the street fight, he says, Ponyboy and the greasers will still be on the bottom and the socs still on top.

The only comfort is the moral and esthetic superiority of the greasers— Johnny, dying, tells Ponyboy to "stay gold," and they indeed are innocently golden; but the socs are portrayed as drunk and corrupt, or, in the case of Cherry (Diane Lane), the girl who likes Ponyboy, unwilling to maintain a friendship outside of her class. "If I see you in school and I don't say Hi, don't take it personal," she tells Ponyboy. The rigid class roles are left behind only by the greaser heroes. They suffer more, each escaping his rigid class role as greaser—Johnny, thinking it worthwhile to die for the children he saves from the fire; Dallie (Matt Dillon), dying in anger and bitterness for Johnny's death; and Ponyboy, living on to "stay golden" because they died for him.

In *The Outsiders,* the feeling of alienation was anchored in economic deprivation but had its deeper moorings in the lack of social capital, deprivation of the parents. In *Rumblefish,* however, neither kind of deprivation is clear, as if the alienation of Motorcycle Boy were due to the human condition and not to family or society. In *Rumblefish* the conflict is between Motorcycle Boy (Mickey Rourke) and the cop—a representative of society and maybe also something larger and more

obscure. The cop who shoots down Motorcycle Boy is not like the cops who shot down Dallie; he represents not social law, but order of some metaphysical kind. In *The Outsiders,* Dallie dies in frustration and incomprehension of the unfairness of his lot; but in *Rumblefish,* Motorcycle Boy meets his death not because he cannot come to terms with all this, but because of his insight into his situation, an insight shared in the movie only by his equally spaced-out drunk of a father (Dennis Hopper). In keeping with this higher order of pretension, the film is as beautiful to look at as the characters are difficult to care about.

The problems of *The Cotton Club* (1983) began before Coppola became involved. It was originally a star vehicle for Richard Gere. But Dixie Dwyer (Gere) is far less interesting than the minor characters and the setting itself, the Cotton Club, where the best black talent of the Twenties and Thirties performed for all-white audiences. Coppola turned what could have been a period romance with a period backdrop into an ambitious film on an epic scale with stories and characters shifting in and out of focus—the Cotton Club itself, more than a setting, was put forward as if it represented the times. Individual destinies tell the story of the coming of jazz and the movies, the rise of the black performer, America at the end of one gangster era and the beginning of another. Organized crime is again at the center, a dream of wealth and freedom, violence and corruption; the gangster is both producer and enemy to the singers, dancers, and musicians, as they struggle for personal and creative independence. The white performers, Dixie and his lady Vera (Diane Lane), achieve it, Dixie leaving the cornet to become a movie star, joined by Vera, Dutch Schultz's mistress, who leaves the gangster after taking his nightclub; the black performers are left to wait for another era. The screenplay suffers from an overload of ideas, and the picture from an overload of sound, color, and

motion, but the lasting impression is of a film teeming with energy, and a use of music and dance that brings the thin stories to a high pitch of drama.

Peggy Sue Got Married (1986) is a sweeter return to the Fifties high school world of *The Outsiders* and *Rumblefish.* Peggy Sue (Kathleen Turner), the cheerleader and most popular girl who married her high school sweetheart (Nicolas Cage), is voted queen of her high school reunion. But her marriage has fallen apart, and, overwhelmed by grief and memories, she faints and wakes up back in her senior year. Seemingly conventional, when she is sent back to her past she has become an outsider in her high school, whom no one can understand, who can talk to no one and get help from no one. This is the basis of the comedy and sadness, the sense of regaining the past and losing it forever, and regaining the present with possibilities of a future informed by the past.

Peggy Sue Got Married is essentially nostalgia—use of an imagined past to escape from a bitter present, as Peggy Sue, shaken and hurt to pieces when her husband leaves her, finds herself in her own teenage years able to have feelings besides her despair, enjoy her life, love her family, herself—and even the husband (Nicolas Cage) who betrays her years later. ˝ emotional cleansing she undergoes magically, as if an emotional cleansing for both of them, enables them to come together again when she returns to the present.

In some ways, Coppola's next film, *Gardens of Stone* (1987), was also an attempt to cope with the past, but a past more hostile, with divisions unlikely to come together, betrayals unikely to be forgiven. *Gardens* is more of a return to Hollywood than any of the previous "made to hire" films. At the same time, it is a very personal film, as were almost all Coppola's more commercial efforts. He saw this film as a tribute to the military, in which he wanted to break down the

stereotypes of the lifer and professional soldier, a film which was at the same time antiwar and proarmy. While there were antiwar elements there for the liberals, they were ambiguous enough to meet army standards; Coppola was here given the assistance denied *Apocalypse Now*— uniforms, equipment, training for actors, technical advice, and hundreds of extras.

Clell Hazzard (James Caan) is the war hero reduced to a curator in a ghastly war museum, a sergeant in the honor guard which buries the Vietnam War dead in a precision ceremony. He is torn between his bitter rejection of the war because it is unwinnable, not because it is unjust, and the need to stand by his "family," the army; in the end he wins a transfer to a combat unit where, at least, he will have a chance to save a few lives through benefit of his experience. He is a man in conflict, and the conflict is one which invites viewer identification. Loyal to the military and at the same time antimilitary—disgusted with the empty ceremony he presides over, as the unwinnable war goes on, he loves the men who die in it and sees them as part of a tradition that is his "family.'

This is a safely patriotic film—showing the treacherous and cynical colonel who sees the war as "a boon for R & D," the bitter war hero who sees the war as a tragic defeat and waste of America's young, and, at the same time, his lover, a *Washington Post* reporter (Anjelica Huston), who mentions in passing that she sees the war as "genocide." In this film, however, the only vigorous opposition to this war overwhelmingly rejected by the American people is the drunken lawyer who baits the hero as a baby killer. You love to see Hazzard beat him up, but, in the film's spirit of reconciliation, the lawyer apologizes from his hospital bed for his insensitivity.

Although the film revives the powerful emotions of the war years, the film works better the less you think about it. *Gardens* is Coppola's patriotic effort, his contribution to healing the wounds he salted in

Apocalypse Now. Coppola unites the American political spectrum in one imaginary family: the antiwar reporter in love with the professional soldier who thinks her demonstrators are betraying the GIs, the true victims of the war, and the surrogate son, a gung-ho lieutenant ready to die in battle. The family creates an image of reconciliation between the old enemies, the hawks and the doves, but neither are real. Even the army itself, loved like a family, large enough to contain conflicted heroes like Clell Hazzard, is a surrogate for a divided America. After *Apocalypse Now,* it is astonishing to find the film's only vigorous opposition to the war put into the mouth of a drunken boor. Coppola's apology is a political howler, a patriotic film about a war that *Apocalypse Now* envisioned as a reduction of patriotism to absurdity. Coppola enobles the military as if it can be dignified without consideration of what it has done and is doing; he creates photo opportunities and images of heroism and sacrifice, a plea for reconciliation between the antiwar and the dogs of war, as if the horrors can all be put behind us with love and trust for all. It is a shame to see the American victims of the war, represented by soldiers Coppola's art invests with real tragic stature, used in this moving film to make an illusory peace with an imagined mainstream.

This peacemaking with establishment America was followed by a shout—or song—of defiance, *Tucker: The Man and His Dream* (1988), another apparently unambitious film, but one which clearly had personal meaning. Coppola had wanted to make the film since 1967, fascinated since childhood by Tucker's challenge to the Big Three automakers with an innovative car. Tucker (Jeff Bridges) becomes a mythical figure, an archetypal American, the populist Edison whose car was defeated by the establishment but whose dream was not—an upbeat ending defying the tragic story. Coppola lived his own dream of becoming a counter-mogul, setting up a studio which was an artistic community to

rival the industry's commercial establishment. Zoetrope Studios failed in 1984, after falling $50 million in debt, like Tucker a victim of an economic system which locks out the creativity of the smaller players.

After *Tucker,* Coppola became concerned in lesser efforts. *Life Without Zoe,* his contribution to *New York Stories* (1989), was a self-indulgent family effort written with his daughter Sofia. His vampire movie may have been called *Bram Stoker's Dracula* (1993) because Universal owned the rights to just plain *Dracula,* but the odd title is in keeping with the movie's almost academic absorption in folklore, film history, and cinematic technique. · It is, however, unfair to the author of *Dracula,* whose tale of horror has only superficial characteristics in common with Coppola's eroticized version of the legend. Prince Vlad easily competes with the boring, thin-blooded Victorian males, awakening the sexually ravenous beast in Mina and Lucy, both starved for the romance of the consensual exchange of infected body fluids. Visually spectacular scenes and clever details are tied together with an over-complicated narrative. This Count Dracula is the construct of an intellectual for an audience of movie-lovers, not a figure of horror worthy of comparison with the archaic Nosferatu, let alone Freddy or Jason. Coppola may have made the story into a more convincing romance—certainly more erotic—than his more serious *One from the Heart,* but in the end it too is overcome by flamboyant style.

One of the most delicate problems in *Tucker* had been finding an ending to relieve the intolerable defeat of the dreamer. Tucker triumphed despite the loss of his plant and his financial backing, but at the end the screen filled with a line of Tuckers surrounding the courthouse, as if it is the dream alone which counts.

Tucker's defeat describes Coppola's more grandiose dream, becoming a counter-mogul with his own rival studio where the bottom line was art, not bucks. Although his attempts to create an independent studio failed, the film industry not only welcomed most of his films, but also his influence, which extends beyond them. The film industry proved far less hostile to Coppola than the Big Three Automakers had to Tucker. Coppola first became influential when the old studio system had fallen, and it was in part his energy that contributed to the new status of the director. Through his patronage he introduced new directors, actors, and screen technicians, and new technologies of electronic filmmaking which may yet make their mark on Hollywood's future.

—Paul Elitzik

RECOMMENDED BIBLIOGRAPHY

Chown, Jeffrey. *Hollywood Auteur: Francis Coppola.* NY: Praeger Publishers, 1988.

Coppola, Eleanor. *Notes.* NY: Simon and Schuster, 1979.

Cowie, Peter. *Coppola.* NY: Macmillan Publishing Co., Inc., 1990.

Goodwin, Michael. *On the Edge: The Life and Time of Francis Coppola.* NY: Morrow, 1989.

Lourdeaux, Lee. *Italian and Irish Filmmakers in America: Ford, Capra, Coppola and Scorsese.* Philadelphia, PA: Temple University Press, 1990.

Pye, Michael and Lynda Miles. *The Movie Brats.* NY: Holt, Rinehart and Winston, 1979.

Zuker, Joel Stewart. *Francis Ford Coppola: A Guide to References and Resources.* Boston, MA: G. K. Hall, 1984.

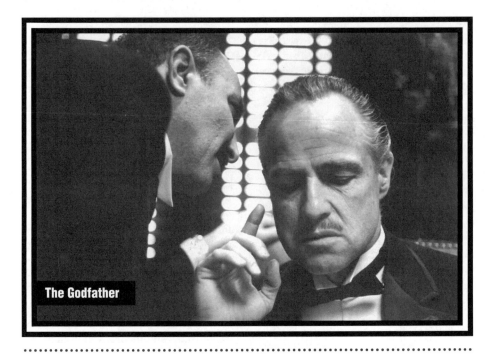

The Godfather

Crime Movies

Gangster characters have been audience favorites throughout cinema history. Before the movies learned to speak, criminal lifestyles were portrayed in films from Griffith's *The Musketeers of Pig Alley* (1912) through von Sternberg's *Underworld* (1927).

But the gangster film genre was not born until after the advent of sound. At that time, as an outgrowth of Prohibition, gangsterism had taken an unrelenting stranglehold on America. Audiences then were especially primed for the excitement and escapism inherent in movies featuring hoodlums as heroes.

Crime is supposed to be bad, and criminals are supposed to be bad guys. After all, they are antisocial. They rob, maim, and murder; operate numbers rackets; deal in illegal liquor, drugs, and prostitution. They even stuff grapefruits into the faces of their molls. Yet the prototypical racketeer hero was first portrayed on screen as glam-orous, colorful: an outlaw living a life of unrestricted violence and thrills.

Most genre films of the period are set in the big city, with the average gangster protagonist an immigrant who grew up in the slums, on the streets. He exists in a forbidden and alluring environment replete with double crosses and intrigues, screeching cars and blazing machine guns, fancy nightclubs and flashy dames. If his surname is ethnic, it will more often than not be Italian; he is surrounded by underlings with such descriptive nicknames as Gimpy, Midget, Bugs, Bull, and Nails; a typical moniker for a gangland rival would be Big Louie. More often than

not, the film in which he committed his mayhem was produced by Warner Bros.

In his landmark essay, "The Gangster as Tragic Hero," first published in *Partisan Review* in 1948, Robert Warshow writes that "for the gangster there is only the city; he must inhabit it in order to personify it; not the real city, but that dangerous and sad city of the imagination which is so much more important, which is the modern world. And the gangster—though there are real gangsters—is also, and primarily, a creature of the imagination. The real city, one might say, produces only criminals: the imaginary city produces the gangster: he is what we want to be and what we are afraid we may become."

Some films depicting lawbreakers, like *I Am a Fugitive from a Chain Gang* (1932) and *Wild Boys of the Road* (1933), are social conscience dramas that moralize about the conditions that spawn crime. In the former, a classic and influential film that spurred prison reform, an innocent, down-on-his-luck drifter is brutalized by a harsh, uncompromising justice system; the latter portrays Depression-era teenagers who are unable to find work and who ride the rails, panhandle, and steal. *I Am a Fugitive from a Chain Gang* is essentially a prison film, however, while *Wild Boys of the Road* is a youth picture. The typical gangster genre scenario simply presents its gangster hero in all his glitz and glory, with little if any moralizing.

Our mobster hero, incidentally, will rarely if ever be opposed by a cop or district attorney portrayed by an actor with billing or status equal to that of a Cagney, Robinson, Raft, or Muni—the stars who are synonymous with Hollywood gangsterism early-Thirties style. The one exception may be the racketeer's best friend from childhood (usually played by Pat O'Brien), who has grown up to be a priest or a policeman. Despite their relationship, the memories they share of their past, and the fondness the O'Brien character may have for his old pal, they are on opposite sides as adults. In the end, O'Brien may prevail, but the Cagney or Robinson character is by far the more interesting.

This character will talk a tough, private language. "We gotta stick together," Edward G. Robinson warns his cronies in *Little Caesar* (1930), the initial feature to significantly define the genre. "There's a rope 'round my neck right now, and they only hang you once. If anybody turns yellow and squeals, my gun's gonna speak its piece." Robinson achieved stardom here as Caesar Enrico Bandello, a small-time thug who becomes king of the underworld. "Til I say different, nobody's gonna plan for this mob but me," Sam the Gang Boss tells Rico when he's a young upstart. Rico gives Sam a hard, defiant stare, and stomps out of the room. "He'll learn," laughs one of Sam's underlings. But soon it is Rico who is doing the ordering, and the laughing, when he gets to inform Sam, "You're through."

Rico dispenses with a macho philosophy for survival: "When I get in a tight spot, I shoot my way out of it. Why, sure! Shoot first and argue afterwards. You know, this game ain't for guys that's soft." As he is done in at the finale, Rico dramatically gasps one of the most often-quoted lines in gangster film lore: "Mother of mercy," he asks, "is this the end of Rico?"

Little Caesar was followed by a pair of equally influential features: *The Public Enemy* (1931) and *Scarface, The Shame of the Nation* (1932). In the first, James Cagney charismatically exudes sexual tension and energy as Tom Powers, a hood who rises and falls during Prohibition. Paul Muni plays the title role in *Scarface*. He is Tony Camonte, a vulgar, primitive, Capone-like bootlegger who, despite the presence of a mistress, has a yen for his sis; she, in turn, falls for his coin-flipping cohort, "Little Boy," played by George Raft. The latter film was shot in 1930, but its release was delayed two years until some scenes were deleted (for instance, one depicting an elected official as a paid collaborator

with the mob), and others added (a news-paper publisher attempting to convince some public-spirited citizens to halt the gang menace).

Still, Scarface and his cinematic com-rades remained heroes to audiences, even though they died in the final reel and even when their stories contained such implied "crime doesn't pay" messages. Robert Warshow notes that "the experience of the gangster *as an experience of art* is univer-sal to America. There is almost nothing we understand better or react to more readily or with quicker intelligence....In ways that we do not easily or willingly define, the gangster speaks for us, expressing that part of the American psyche which rejects the qualities and the demands of modern life, which rejects 'Americanism' itself."

Gangster heroes most certainly realized the dreams of Depression-era audiences. Scarface Tony Camonte, Tom Powers, and Caesar Enrico Bandello were powerful and successful; they lived exciting lives; they carried large wads of money, with which they freely parted. So what if those dollars were illegally earned? So what if they came to sorry ends? And what melodramatic ends they were. At least, for a while, they had money to spend, power to wield. Gangsters, and not the cops out to get them, were the characters audiences idol-ized, idealized—and paid to see.

Hollywood has always been an industry where the most important consideration is the bottom line. When *Little Caesar* direc-tor Mervyn LeRoy brought Darryl F. Zanuck a copy of the W. R. Burnett book on which the film is based, the mogul per-ceptively responded, "This guy is no good at all. It'll go over big." The industry saw that the public was willing to shell out its money for films glorifying bootleggers and killers, so it swiftly set out to supply prod-uct for that demand. Even average, work-ing-class guys could be depicted as aspir-ing to the gangster lifestyle: in the aptly-titled *Quick Millions* (1931), Spencer Tracy plays a truck driver who makes it big in the rackets. Meanwhile, gangsters could yearn

for respectability: *Ladykiller* (1933) features Cagney as a mobster who becomes a Hollywood actor; *The Little Giant* (1933) stars Robinson as a bootlegger who attempts to crash high society.

Although the spotlight was on male characters, and all the classic films of the period focused on men, women were not completely cast as subservient molls or mobsters' long-suffering mothers. In *Paid* (1931), Joan Crawford plays, with authority and conviction, a woman wronged, who serves a term in the slammer from which she emerges "all wised-up...wised up but good." She seeks revenge by initiating a breach-of-promise scheme against the son of the man who caused her imprisonment. She's befriended by a hood (Robert Armstrong) who is clearly the supporting character. He may be hotheaded, but he's ultimately presented as a good-hearted lug whose transgressions result from his pro-tectiveness of the woman; his actions in the film are related not to his own place within the scenario, but to that of the main charac-ter. Meanwhile, the real villains are the cops and district attorneys. They connive, manipulate, and lie; they entice criminals to break the law as they attempt to entrap Crawford and her cronies.

It was just this sort of disrespect for authority that resulted in protests against Hollywood's glorification of mobsters by such groups as the American Legion and the Daughters of the American Revolution. This, coupled with the repeal of Prohibition and the implementation of the Production Code, resulted in a rearranging of priorities in gangster films. Now, the cops, and not the robbers, would be the characters earn-ing audience sympathy.

"Instead of the glorification of gang-sters, we need the glorification of police-men," reads President Hoover's statement at the beginning of *The Beast of the City* (1932). This film features a vicious hood, named Sam Belafonte (Jean Hersholt), but the main character is dedicated, coura-geous, resourceful cop Walter Huston. James Cagney went over to the other side

of the law as one of the *G-Men* (1935); interestingly, his character is raised by an underworld figure but joins the FBI when a friend is murdered by mobsters. Edward G. Robinson portrays a lawman who goes undercover in *Bullets or Ballots* (1936), and a district attorney who battles a corrupt urban government in *I Am the Law* (1938).

These films constitute a variation on the gangster film, rather than mark the emergence of a new genre. Cops and lawyers as heroes were really not depicted in any significant way until their presentation on television in the Fifties and Sixties. But detectives were: Humphrey Bogart, after years of playing supporting roles as hoods (often as the "bad" gangster to Cagney or Raft's "good" one), starred as Sam Spade in *The Maltese Falcon* (1941), the film which, with due respect to Charlie Chan, *The Thin Man*, and even the two earlier versions of the Dashiell Hammett story, is the bellwether of all detective films. *The Maltese Falcon* signalled the emergence of detective heroes who were not clear-cut good guys; rather, they were tough and cynical losers existing on their own, working outside the system, often themselves at odds with the law. So "cop" and "detective" films from this period may be differentiated, with the former linked to the gangster genre and the latter making up one all their own.

Despite any attempts to depict them otherwise, robbers generally are more interesting characters than cops. In fact, the most memorable cinematic policemen are the ones, like Dirty Harry Callahan or Popeye Doyle, who ignore the rules as they collar criminals. In any case, by the late Thirties, the pressure had subsided enough for the classic gangster actors to be recast as hoods. Because of the Production Code, the films were not as raw and unrelenting as *Little Caesar, The Public Enemy,* and *Scarface,* but this next cycle of cinema hellraisers did in no way discredit their predecessors.

The two most representative films of the period, *Angels With Dirty Faces* (1938) and *The Roaring Twenties* (1939), feature James Cagney back in peak form. In the first, he's cast as a hood idolized by the Dead End Kids, in the latter a big-time Prohibition racketeer. Edward G. Robinson spoofs his gangster persona in both *A Slight Case of Murder* (1938) and *Brother Orchid* (1940). He respectively plays a mobster who goes straight and rents a house littered with corpses, and a racketeer who retires to a monastery. Bogart also appeared on the scene, creating his first memorable gangster characterization in *The Petrified Forest* (1936). Film buffs may recall that he played Duke Mantee, yet how many remember the name of good guy Leslie Howard's character? (It was Alan Squier.) Bogart's Roy Earle, in *High Sierra* (1940), is a notorious killer, but he's also misunderstood, an outcast with a soft heart, attributes which enabled the audience to relate to him and root for him. In this film, Warner Bros. pays fitting tribute to the legendary American gangster. Earle is aging, and graying; his old cohorts are, as one character explains, "all either dead or doing time now in Alcatraz." He is told, "Remember what Johnny Dillinger said about guys like you and him; he said you're just rushing toward death—that's it, you're rushing toward death."

Again, who can immediately recall the names of Earle's moll and the lame girl he befriends? (They are Marie and Velma.) Or even the actresses cast in these roles? (Ida Lupino, Joan Leslie.) When we think of gangster films, we first think of the actors, and only the actors, who created the seminal gangster characterizations. For this reason, they, and not their directors, are the true auteurs of the genre. The makers of *Little Caesar, The Public Enemy,* and *Scarface*—respectively Mervyn LeRoy, William Wellman, and Howard Hawks—are themselves not specifically linked to the genre. Actors like Cagney, Bogart, Raft, and Robinson (but not really Muni, who is more noted for his roles in biographies) may have worked in other genres, but their names are immediately associated with gangster films.

The few hoods who appeared on screen during World War II were, in the name of national unity, presented as misguided rather than incorrigible. The characters were softened considerably from those depicted just a few years before. In *Bataan* (1943), Lloyd Nolan plays a gangster type who is the adversary of hero Robert Taylor but who also battles the Japanese and dies for his country. *Mr. Lucky* (1943) features Cary Grant as a gambler (a gentlemanly version of a gangster) who dodges the draft but in the end is converted into a moral, upright citizen. Both these characters were not bad guys after all. In the early Forties, the only bad guys were Japanese, Germans, and Italians; heavies who were native-born American could be redeemed, and recruited into the war effort.

The genre reappeared in all its glory after the war, with the release of *White Heat* (1949). This is the key gangster film of its period in that it serves as a link between the Thirties genre titles and the postwar *film noir*. An older but no less mellower James Cagney stars as gang leader Cody Jarrett, a cold-blooded killer cloned from the same mold as Camonte, Powers, and Bandello. "I told you to keep away from the radio," he warns a disobedient underling. "If that battery is dead, it'll have company." His unfaithful wife declares, "It ain't just like waitin' for some human being who wants to kill you. Cody ain't human. Fill him full of lead, and he'll still come at you." Yet there is the *noir*-like addition of psychosis to Jarrett's character. He suffers from excruciatingly painful headaches; his temper may best be compared to a firecracker; and he has an Oedipal relationship with his mother. In the classic finale, Jarrett battles police from the top of an oil storage drum. He fires his gun into the drum, yelling, "Made it, ma. Top 'o the world." Then he literally explodes, along with the drum. And, so, *White Heat* marks the entrance of the gangster film into the age of the atom bomb.

This period does have its share of classic gangster characterizations. After Cody Jarrett, grinning, giggling gunman Johnny Udo, the role that made Richard Widmark a star, is the most memorable; the sequence in *Kiss of Death* (1947), in which he hurls a wheelchair-bound old woman down a flight of stairs, is now part of cinema lore. Additionally, the use of on-location shooting throughout New York City makes *The Naked City* (1948) an otherwise routine police-on-trail-of-killer story, a high point in the development of the look and feel of the gangster film.

For the most part, *film noir* thrillers and detective stories now replaced the pure, generic mobster melodrama. Humphrey Bogart's classic portrayals of the detectives Sam Spade and Philip Marlowe typify the dark, cool, postwar period. Bogie's legacy has been the rise in popularity throughout the past four decades of the more complex detective or cop character and, until the end of the Eighties, the general decline of the gangster as protagonist: sandwiched in between *Al Capone* (1959) and *Dillinger* (1973) may be found *Harper* (1966), *Gunn* (1967), *Tony Rome* (1967), *P. J.* (1968), *Marlowe* (1969), *Shaft* (1971), and *Dirty Harry* (1971).

There were other changes. In the postwar era, real-life mobsters were becoming organized, functionaries of crime syndicates. Such activities were uncovered in government investigations similar to the one depicted in *On the Waterfront* (1954). Scenarios focusing on lawbreakers began to highlight the caper, rather than the personality and character development of the criminal. *The Asphalt Jungle* (1950) and *The Killing* (1956) are two of the better examples of this caper film subgenre. Films with gangsters also dealt with topical concerns and controversies. In *No Way Out* (1950), Richard Widmark portrays a bigoted criminal who instigates a race riot. In *Pickup on South Street* (1953), he's a wiseguy pickpocket plying his trade on a tramp (Jean Peters), who unknowingly is passing military secrets to the "commies" (as they were generically known during the reign of Joseph McCarthy). In the B-movie sleeper

Gun Crazy (1949), Peggy Cummins plays a hard-boiled "bad broad" who leads confused, "gun-crazy" John Dall down a crime-laden path to hell. The film serves as a revealing reflection of the alienated, younger, postnuclear generation of Americans, soon to be depicted in such films as *The Wild One* (1954) and *Rebel Without a Cause* (1955).

The cops (or other key characters), however, were now regularly being portrayed by actors of equal or greater stature than those playing the robbers. Some of the great postwar gangsters are not even the main characters: Widmark, after all, earned a Best *Supporting* Actor Oscar nomination for his role as Johnny Udo. Edward G. Robinson recreates his classic mobster icon in *Key Largo* (1948), but the main role is played by hero Humphrey Bogart, a disillusioned veteran forced to take action against Robinson's hooliganism. Lee J. Cobb's Johnny Friendly, in *On the Waterfront,* is one of the most vivid hoods of the Fifties, but the center of the film, its focus and force, is the moral dilemma of young Terry Malloy (Marlon Brando). Cobb also plays a gang leader in *Party Girl* (1958), but the star of the film is Robert Taylor, cast as a crippled mob mouthpiece attempting to break free from the life-style. George Raft rehashes his mobster role in *Some Like It Hot* (1959), but the film is a comedy and the featured players are Jack Lemmon, Tony Curtis, and Marilyn Monroe.

Actually, *Bonnie and Clyde* (1967) is the next significant highpoint in the evolution of the genre. There are similarities to the gangster films of old: the male lead is played by a charismatic star, Warren Beatty; he has no good-guy counterpart; the rural outlaw innocents-on-the-lam scenario, a variation on the genre, has been depicted as far back as *You Only Live Once* (1937), *They Live by Night* (1949), and *Gun Crazy.*

But *Bonnie and Clyde* features several major innovations. There are, appropriately, scenes that are shockingly harsh and violent, but there also are ones that are charming and comedic: a trend-setting juxtaposition of melodrama with humor. The gunplay is explicitly graphic; when the hero and heroine meet their end, they do so not bloodlessly and antiseptically but in a slow-motion ballet of death. In this regard, *Bonnie and Clyde,* along with the Western, *The Wild Bunch* (1969), has for better or worse influenced the manner in which violence is presented on screen in a variety of genres. The male gangster is also joined by an aggressive female cohort, one who is just as tough and ruthless. In fact, Clyde even commits his first law-breaking in response to Bonnie's dare. Faye Dunaway's Bonnie Parker is equal to Beatty's Clyde Barrow as they rob banks and become legends.

Bonnie and Clyde was appealing to audiences—especially younger ticketbuyers—because it is nostalgic and romantic, with its vintage cars, fashions and settings, and its folk ballad style. The title characters are, like so many young people during the late Sixties, nonconformists. Bonnie and Clyde are like the rock idols Janis Joplin, Jimmy Hendrix, and Jim Morrison: they live their lives to the hilt, and die young. They will never live to be thirty (and so they can be trusted implicitly), let alone grow fat, middle-aged and middle class, and be coopted by the Establishment. Two films that further add to the evolution of the celluloid gangster are *The Godfather* (1972) and *The Godfather, Part II* (1974). Originally, the cinema mobster was a street punk who scaled to the zenith of the underworld on his own. Robert Warshow observes that the "gangster's whole life is an effort to assert himself as an individual, to draw himself out of the crowd, and he always dies *because* he is an individual; the final bullet thrusts him back, makes him, after all, a failure." In *The Godfather* saga, however, he has evolved into a corporate entity: the ultimate, shrewd capitalist who has built for himself a great American empire.

By the Seventies, a sustained individual

enterprise had become almost obsolete in a complex, rapidly changing society. The corner grocery store would be outgrossed by the all-purpose supermarket; the successful small business would be gobbled up by the large conglomerate because, financially speaking, its owners would be "made an offer they couldn't refuse." Even movie studios were no longer controlled by the Louis B. Mayers and Harry Cohns but had become divisions of corporations. During World War II, the Japanese were depicted as soulless, slimy vermin in dozens of American movies. Back then, Japan could not conquer America militarily, but one might argue that, today, Japan is conquering America economically. We now drive Japanese-made cars, dine in Japanese restaurants, and sell our real estate and our businesses—including our movie studios—to Japanese firms.

Society had become more computerized, more impersonal, and so the Seventies gangster was no longer an individual rising and falling by himself, but a spoke in a wheel, a part of a greater whole. The Corleone clan, as presented in *The Godfather* films, essentially is a family of successful entrepreneurs, a corporate entity not unlike the Fords and Rockefellers. They are businessmen who conduct their affairs with machine guns rather than telexes, and who have succeeded simply by outsmarting (as well as outshooting) their rivals. At the end of *The Godfather, Part II*, Michael Corleone (Al Pacino) may have become isolated and alienated, a prisoner of his success as a mobster among mobsters. But the business—a gift, an heirloom—that has been passed on to him by his father, the Don, thrives as never before.

The initial two *Godfather* films depict a social system wallowing in corruption. There are crooked New York cops, and crooked United States senators, and famous entertainers who owe their careers to mobsters. Organized crime has its foothold in Las Vegas, in Hollywood, in New York—everywhere. Furthermore, the definition here of "family" and "loyalty"

translates into a travesty of traditional moral values and familial responsibilities. These films accurately reflect their era—a time of Vietnam and Watergate—in that, by promoting crime as a corporate entity, they serve as a metaphor for the decline of America. And they mirror the upheavals then occurring within the nuclear family: Michael Corleone ultimately destroys his own family as he conducts the business that will supposedly secure its future.

These films may even be taken as full-length promotional pieces for organized crime. Sure, there's violence, but the racketeers kill only their own; the inference is that the average, law-abiding citizen has nothing to fear as long as he does not cross organized crime. Respect it, revere it, these films preach. If you don't, you are liable to wake up one morning next to the decapitated head of a horse.

The propaganda in such films is ever so fascinating. Frank Sinatra (who has himself been linked to organized crime) made his television movie debut in *Contract on Cherry Street* (1977). He's cast as a deputy New York City police inspector, an honest cop; there are hints that his superiors are not so scrupulous, and the ultimate villain of the piece is no racketeer but a deluded, trigger-happy detective (Harry Guardino). This serves to remove the focus from the evils of the mob: cops, who are supposed to have the public trust, can break the rules. At least the criminals are honest in their criminality.

The two mob families in the scenario war only against each other (so the public need not dread them). One is run by a Jew, the other by Italians, and there are a couple of gunman brothers who are Greek. Nonetheless, the first sympathetic character who dies (a police captain, played by Martin Balsam) is blown away by a psychotic who happens to be African-American. There's a message here, one that is particularly insidious. At a time when rising crime rates had Americans alarmed, the implication is that the roots of lawlessness extend no further than the

young black junkie on the street—certainly not the Mafia don who may be his supplier, and who is actually the real profiteer of crime.

In the Eighties the model gangster film is neither *Once Upon a Time in America* (1984), which pays homage to the cinematic mobster of old; *Prizzi's Honor* (1985), a black comedy so successful that it spawned a number of "Mafia comedies," including *Married to the Mob* (1988) and *Spike of Bensonhurst* (1988); nor *The Untouchables* (1987), whose focus is on an honest law enforcement official's steadfast pursuit of a gangland dictator. But even here, Robert de Niro's flamboyant Al Capone is a far more interesting character than Kevin Costner's stiff-collared, super-serious Eliot Ness.

It is, instead, *Scarface* (1984), an updating of the 1932 classic, which most accurately reflects the "Me Decade": its title character is preoccupied by his greed, his lust for having it all, his need for quick highs, quick orgasms, and violence. In Eighties style, this Scarface (Al Pacino) has been recast as a Cuban refugee who calls himself Tony Montana. He's a reckless, obscenely outrageous hoodlum who deals (as well as does) cocaine. As in *Bonnie and Clyde*, the violence is graphic, but it's not realism for any esthetic purpose. The blood that flows is excessive to the point of nausea. There's an infamous sequence in which Tony and his partner have been double-crossed by some Bolivian drug dealers and Tony, with a gun at his throat, watches as his cohort is cut to pieces with a chain saw. Blood sprays over him, and the scene is so pointlessly and repulsively gory that it is unwatchable.

Critics almost uniformly dismissed *Scarface,* even a universally lauded film like *Prizzi's Honor,* which chronicles the relationship between hitman Jack Nicholson and hitwoman Kathleen Turner, is not lacking in gratuitous bloodletting. The grotesquely graphic close-up of Turner's death near the finale seems shockingly inappropriate in a film that's supposed to be a comedy, black or otherwise.

This shot might have been lifted from any of the gangster films that came to movie screens in 1990, which will go down in celluloid annals as the year of the genre's full-fledged resurgence. All of the key characters were mobsters (or their mates and offspring) in two of the five Best Picture Academy Award nominees: *GoodFellas* and *The Godfather, Part III.* There were gangsters who were British (in *The Krays,* a British film that enjoyed a healthy run outside the foreign film art house ghetto); Irish and Jewish *(Miller's Crossing);* Irish and Italian *(GoodFellas* and *State of Grace);* and just plain Italian *(The Godfather, Part III).* Just to show that this is an equal opportunity genre, there were African-American along with white gangsters (in *King of New York*). This revival continued in the first half of 1991 with the release of *New Jack City* and *Mobsters.*

How these films are most importantly linked is that, collectively, they offer an unrelentingly violent, grim depiction of modern society. They are crammed with characters who wear violence on their sleeves; as the sister of a pair of "Irish muscle" brothers in *State of Grace* observes, "Every time we turn around, somebody's dead." In sequence after sequence, this film offers blazing guns and bloody brawls in broad daylight, on city streets. There are no cops on the scene, no outraged citizens. The bloodletting is accepted as an everyday aspect of urban survival.

As in every Nineties gangster film, the characters in *State of Grace* are casually profane. "I had this pit bull, right," remarks one of the film's minor characters. "Joe. Joe the dog. I go to feed the fuck, right. I put his bowl down. He goes nuts. Bites my fuckin thumb off. Nineteen stitches. I'm in the hospital three days. I get out. I get my gun. I go to him. 'You like to bite things? Bite this.' I put the fuckin gun in his mouth. Bam. I blow him all over the fuckin apartment. You ever see a dog explode?"

State of Grace tells the story of Terry Noonan (Sean Penn), a graduate of New

York's Hell's Kitchen who returns to town as an undercover cop and infiltrates his old mob. During the Thirties, Noonan would be a clear-cut, nonpariel good guy, and would most likely be played by Pat O'Brien. Here, he's a confused, tormented soul, in what he describes as "a fuckin' fog," haunted by his guilt over being a "fuckin' Judas cop."

In *King of New York* (1990), good and evil become perversely intertwined: a white mobster (Christopher Walken), headquartered in the posh Plaza Hotel, sets out to corner the New York drug market. His goal: to rebuild a hospital in Harlem that will be a cornerstone of the community's rehabilitation. Bear in mind that this character is no Robin Hood. The emergency room of his hospital surely will be overflowing with addicts who've overdosed on the drugs he's responsible for putting on the street.

There's more irony to be found in *Miller's Crossing* (1990). Its central character is a thug (Gabriel Byrne) who is caught in the middle of a conflict between a pair of rival political bosses. In one extended sequence, an attempted gangland hit becomes an orgy of exploding machine guns, fire, and corpses that is played out to a lilting rendition of "Danny Boy." Here is a mixture of the civilized with the anarchic, music that is meant to soothe with visuals that are sure to repel.

In *The Godfather, Part III* (1990), the crime for which the Corleone family is responsible remains as organized as in Parts I and II. But now the tentacles of Michael Corleone and his ilk reach all the way into the upper echelons of Vatican City. The scenario proposes that Pope John Paul I, who in real life died scant weeks into his investiture, was in fact the victim of a hit. Today even the sacred cow of religion is not beyond finding itself weaved into the plot of a gangster film.

The middle-aged Michael Corleone is as alone here as he was at the finale of *The Godfather, Part II*. But this purveyor of violence, who now wishes to retire into

respectability, suffers a fate that is, for him, literally worse than death: the bloody demise of his daughter, who dies in his arms after catching a bullet.

By far the most original and honestly ambitious of the new gangster films is *GoodFellas*, an American success story about Henry Hill (Ray Liotta), a young fellow from the dregs of Brooklyn who doesn't want to be a working stiff like his father. His fantasy is not to be a movie star, president of a corporation, or president of the United States. Henry's American Dream is to be a gangster. And become a gangster he does.

Throughout the film, director Martin Scorsese doesn't moralize about Henry and his cohorts (among them hoodlums played by Robert De Niro and Joe Pesci). He just portrays them for who they are. *GoodFellas* is, naturally, quite violent. As in all of these films, the violence is an integral part of the story because it is an integral part of the time in which it is set.

Yet Scorsese does offer a final word on these characters. As the film ends, he chooses to fill the sound track with a version of "My Way"—sung not by Frank Sinatra, but by Sid Vicious.

Up to now, gangster films have accurately, and often acutely, reflected our society, and how our attitudes and values have evolved. More relevant to the business of motion pictures, they offer excitement and thrills; they feature characters who live outside the law, who have money and power (and act out the viewers' fantasies). All of this translates into box office appeal. Clearly, there will be mobsters and crime in movies for as long as there are mobsters and crime dominating the evening news.

—Rob Edelman

RECOMMENDED BIBLIOGRAPHY

Bookbinder, Robert. *Classics of the Gangster Film*. Secaucus, NJ: Citadel Press, 1985.
Clarens, Carlos. *Crime Movies: From Griffith to The Godfather—and Beyond*. NY: Norton, 1980.
Shadoian, Jack. *Dreams and Dead Ends: The American Gangster/Crime Film*. Cambridge, MA: MIT Press, 1977.

De Antonio, Emile

(May 14, 1919 – December 15, 1989)

I t is never easy to measure the effect of political films upon the hearts and minds of the audience. But for a director who chooses to act as a political gadfly, it may be reassuring to learn one has aroused the enmity of those in power.

In that light, Emile de Antonio's position as the only filmmaker on the Nixon "enemies list" was more than a sign of danger, or skullduggery at work: it represented a special kind of tribute.

De Antonio came to filmmaking late. He was educated at Harvard, where he joined the Young Communist League, and later engaged in a variety of jobs ranging from college philosophy professor to longshoreman. Before making his first film, he had not shown any great concern with film culture; he once described his film interests in terms of an admiration for the Marx Brothers, W. C. Fields, and the early Soviets. That offhand remark, suggesting equal parts anarchy, comedy, and a political cinema obsessed with editing, is actually not a bad guide to de Antonio's filmmaking.

De Antonio's debut came with *Point of Order* (1963, made with Dan Talbot). Though it looked back to the Fifties by focusing on the Army-McCarthy hearings, it was intended as a film not so much about McCarthy as McCarthyism, a warning to the Sixties about the continuing presence of the Radical Right. From the start, therefore, de Antonio showed an interest in using history for didactic and polemical purposes. The film also demonstrated de Antonio's distance from traditional documentary practice. *Point of Order* was created after the fact: it did not involve gaining access and shooting film, but rather used editing—"the heart of political film" for de Antonio—to shape the original 188 hours of kinescope recordings into a greatly reduced yet coherent form. In presenting the conflict between the antagonists, above all McCarthy, Roy Cohn, and the counsel for the Army, Joseph Welch, de Antonio showed that a documentary could match the drama of the best fiction films. Though rejected by the New York Film Festival on the silly grounds that it was not a film, *Point of Order* immediately became a classic of independent political documentary in America.

In his later films de Antonio refined upon what he calls his "radical scavenging" by adding interview footage to the compilation of historical material. He followed up *Point of Order* with *Rush to Judgment* (1966), made with Mark Lane, the author of the best-selling book of the same title criticizing the Warren Commission Report on the Kennedy assassination. Here, through simple juxtaposition, the prosaic denials of seemingly ordinary people—"I can't hardly believe that..." and "I can't buy that right now"—undercut the testimony of the authorities. Sections with Lane behind a desk reviewing the evidence in a straitlaced, legalistic fashion also challenge the official findings. The film's "moral" is delivered in its final speech by a small-town newspaper editor: "I think all of us who love our country should be alerted that something is wrong in the land."

De Antonio's next attack on an "authorized" version of history was in *In the Year of the Pig* (1968), about the war in Vietnam. It remains the outstanding example of de Antonio's brand of compilation documentary. The movie is unapolo-

getically partisan: Ho Chi Minh is its obvious, if unproclaimed, hero. Thus conservative Republican Senator Thruston Morton acknowledges that Ho Chi Minh is considered by the people of Vietnam as the George Washington of his country, while the French scholar Paul Mus remarks, "Every time Ho Chi Minh has trusted us, we betrayed him." But the film goes beyond simple agitprop, and not only because of de Antonio's skill in selecting archival material and conducting interviews. In the Year of the Pig did something that was simply not being done adequately by the television networks or anyone else: it provided an in-depth view of the conflict, with American involvement set in the context of the long history of imperialism in Southeast Asia, and in particular French colonialism.

Right from the start, with Point of Order, de Antonio had deliberately avoided voice-over narration, his pet peeve. Instead, as Bill Nichols has noted, de Antonio deploys voices representing a range of points of view to develop a sense of counterpoint and establish an overarching textual voice not identified with any individual speaker. For de Antonio, this is a more democratic, less passive kind of filmmaking, with the viewer forced to choose between competing points of view. The play between voices may not really be so open-minded as de Antonio seems to believe: his films are always clearly tilted in a particular political direction, even if his point of view is communicated not directly, through narration, but more subtly, through selection and arrangement. In the Year of the Pig, for example, incorporates the notorious footage of George Patton III calling his men "a bloody good bunch of killers," as well as a statement by General Westmoreland that Viet Cong prisoners are not being mistreated—played over a shot of a prisoner being kicked in the groin, and followed by a veteran saying that soldiers were routinely told to kill prisoners. De Antonio has said, "Only God is objective, and he doesn't

make films." He scores points in his running verbal gun battle with the proponents when he asked, "Whose vérité?" But de Antonio's insistence that his films show "prejudice" without falsifying the facts is a questionable distinction from a one-time philosophy professor, even if he has remarked that "mirrors don't really interest me all that much."

America is Hard to See (1970) traced the ill-fated Eugene McCarthy campaign for president, in retrospect a highwater mark for the opposition to the war. McCarthy's challenge helped precipitate Johnson's decision not to run for reelection; yet with McCarthy's defeat and Humphrey's nomination came Nixon's presidency. The film's subject therefore became, according to de Antonio, "the failure of the liberal left." Because the interview segments were done in 1970, two years after the campaign, the film has a built-in historical perspective. Still, the uneasy combination of enthusiasm and disillusionment makes the film less than satisfactory.

De Antonio's next film, Millhouse: A White Comedy (1971), is more single-minded—a bitter, black-humored response to the outcome of 1968. Nixon is an easy mark: the film begins with mock heroic footage from a ceremony installing the Nixons—their wax mannequins, rather—at Madame Tussaud's. It also contains that most amazing of all American political performances, the Checkers Speech.

With Nixon, as with Joe McCarthy, de Antonio wished to go beyond a study of the man to larger issues, to the American political system of which the man is symbol and sympton. In the case of McCarthy that meant a study not only of demagoguery but also of complicity on the part of those willing to use the demagogue to further their own purposes and willing to tolerate him so long as he didn't threaten them. With both Nixon and McCarthy, de Antonio's concern was partly aimed at what he calls "technique," that is, skillful manipulation without any concern for

truth or morality. Implicit in both *Point of Order* and *Millhouse* is an indictment of the political system and the public for accepting such men and their methods. Thomas Waugh rightly calls de Antonio's work "a continuing Marcusean essay on the modern state and its manner of making its tyranny possible." Yet it is possible to read that "essay" as a series of case studies of political figures or situations regarded as aberrations not representative of the system. De Antonio neatly blows up Nixon, for example, by showing him denying any electoral ambition and then cutting to a shot of Nixon coming out for his nomination acceptance speech (in which he speaks of America in terms of "the revolution that will never grow old, the world's greatest continuing revolution"). Overall, however, the results do not go far enough beyond smirking satire. The more thoughtful, complex level of analysis, voiced in some interviews, remains secondary.

De Antonio indicts the mass media as "our greatest disease," for serving rather than exposing such individuals and such behavior; he has remarked that the true history of our time exists in television outtakes, those revealing but unused bits that show what politics and politicians are really like. In de Antonio's films, however, the critique of the media and "the system" is often visible only to those who look for it, for those who already share de Antonio's radical point of view. Because of de Antonio's desire to be popular among the left, from unreconstructed New Deal liberals to the most extreme Sixties radicals, an audience broad enough to support his films in theatrical distribution, he has made films more likely to amuse, shock, and rally those already converted than to transform more middle-of-the-road or conservative viewers. De Antonio has admitted that *Point of Order* is made more from a liberal than a radical point of view, because the film does not proscribe the liberal view of Welch as a hero righteously impugning McCarthy's lack of decen-

cy—as opposed to de Antonio's view that, considered carefully, the film exposes Welch as well as McCarthy.

Painters Painting (1973), on postwar American art, is at first glance an apolitical work, and therefore the odd film out in de Antonio's career. The director was close to the artists of the New York School long before they attained fame and fortune. In fact, he credits his friendship with the painters Jasper Johns and Robert Rauschenberg (and the composer John Cage) with giving him the ideas of using assemblage as the basic principle in *Point of Order*. (De Antonio says that he "loved making art out of junk"; for him the kinescopes were ugly blown up and projected as film, an ironic recycling from the mass media.)

De Antonio has acknowledged the seemingly incongruous subject and contradictions represented by *Painters Painting*. He has said that he simply had to get the subject out of his system, and that he believes "an art of quality" and "radical politics" are not incompatible. A case can be made that the rise of the New York School—described by de Antonio as "a cold art for a cold war" and "an art non-engagé" for the rich—was a sign of the new dominance of America in the world after World War II, and therefore a cultural extension of American political hegemony. A study of the New York School would then be a study in the politics of culture. This view is not really evident in the film, however, though de Antonio again offers a heterogeneous mix: artists, critics, curators, gallery owners, collectors. The characters are shrewdly sketched, and there are some droll moments, as when the dealer Leo Castelli says on the phone, "He's making a film like the McCarthy film but without McCarthy. About the art world." Yet neither the bits of Tom Wolfe-like social satire, nor the occasional criticism of the accomplishments of the New York School, really affects the celebratory tone of the film. *Painters Painting* nevertheless func-

tions extremely well as a kind of filmed oral history, a lively, informed look at the art world that goes far beyond the banal idolatry of the standard artist's profile.

De Antonio's next film, *Underground* (1976, made with Mary Lampson and Haskell Wexler), on the Weather Underground, was political with a vengeance, and offers the perfect illustration of de Antonio's special position as a director who made films literally no one else could, or would dare to, make. The subjects were at the time on the FBI's most wanted list, and the film became a *cause célèbre* when footage and other materials were subpoenaed—unsuccessfully—by the government before the film was released. *Underground* is, as de Antonio sensed, about endings. Punctuated by historical footage, it suggests a realization that the days of the New Left as an active force are over, even as the film turns back to beginnings by discussing the process of radicalization that led these children of the middle class to such actions as bombing the Capitol in Washington. The treatment of that incident comes complete with a typical de Antonio pair of responses: a Yippie saying, "We didn't do it, but we dug it," followed by Senator Mike Mansfield calling it "a sacrilege."

With *In the King of Prussia* (1982), the filmmaker takes an experimental tack. He combines footage of the actual events, shot (on video) with the cooperation of the Ploughshares 8, with footage shot during a staged reenactment of their trial for a protest at a General Electric plant in King of Prussia, Pennsylvania, where nuclear warheads are assembled.

In the King of Prussia neatly reflects the shift on the left as the antiwar movement of the Sixties and Seventies became the antinuclear movement of the Eighties; it also suggests some of the stylistic opening-up in recent political documentaries. The film uses professional actors such as Martin Sheen, who plays the judge, to complement individuals such as Daniel

and Philip Berrigan, the activist Catholic priests, who play themselves, that is, perform the roles for the camera they had already played in real life. Here there is no pretense of impartiality: the authorities are wrong, the protesters are right, and the give and take has little of the sense of questioning that characterized de Antonio's earlier work. Rather, *In the King of Prussia* permits a stylized, heightened version of the courtroom drama, a reading into the record of testimony not allowed in court, for instance, by individuals who would have been defense witnesses such as George Wald, David Dellinger, Robert J. Lifton, and Richard Falk, and a more close-up and partisan view of the defendants than would be possible in the mass media.

Point of Order has Welch asking McCarthy, "Have you no decency, sir?"; *In the King of Prussia* offers Daniel Berrigan, accused of destroying private property, complaining that language is serving "like a dance of death" and arguing that the use of word "property" for nuclear warheads is "a degradation and a disgrace...their right name...is murder, genocide, death." The defendants' "crime," he adds, is "that great and noble word...'responsibility.'" *In the King of Prussia* once again supports de Antonio's argument that "the best theater is politics"—not least in ironic moments such as when the judge remarks, "We're not playing first-run theater here."

De Antonio has said that his theme is always history. This is true of the films that deliberately adopted an historical (or biographical) approach to their subject, such as *In the Year of the Pig* and *Millhouse*. It is also true of the films that address contemporary events and movements of historic importance, such as *Rush to Judgment* and *Underground*. However loosely a work like *In the King of Prussia* falls within traditional documentary assumptions and practice, all de Antonio's works exploit the sense of actuality established when real people—even such unusual characters as McCarthy and

Nixon—are captured by the realistic yet unreal medium of film.

Mr. Hoover and Me (1989), de Antonio's final film, was a self-portrait made as a profile for the BBC. Like *La Petite Theatre de Jean Renoir*, it is a relatively slight work that fully reveals its maker's sensibility. De Antonio neatly connects his own story to that of his nemesis, J. Edgar Hoover, creating a biographical-historical sketch of America from the Depression through the Cold War. Applying his collage method with charm and skill, he uses footage from a post-screening talk, direct addresses to the camera, lighthearted sequences featuring John Cage baking bread and his wife cutting his hair, and a few oddities such as a ceremony where Nixon, as president, tries to butter up Hoover.

The film offers a good view of de Antonio the master raconteur as well as de Antonio the political analyst and moralist expounding his views on life and art. There is amusement over his despised adversary's skill in creating such bureaucratic masterpieces as "The Do-Not-File File." But the passion is there when de Antonio says, "I can't get over Hoover, ever" and goes on to explain what he values in America. Still, there is something sad as well as shrewd in the decision to review his life and times through the Hoover parallel, for de Antonio seems without a major contemporary issue to confront. It is as if he is sorry that he doesn't have the (live) Hoover to kick around—or be kicked around by—anymore. Speaking from the depths of the Reagan-Bush years, de Antonio concludes by saying, "I think we're on the verge of a new form of social change." The statement may sound too much like Ma Joad proclaiming that the people can't be licked, yet remains touching as a statement of faith, the final words of a dedicated radical.

De Antonio was clearly the most important political filmmaker in America in the Sixties and Seventies. He revived the spirit of the independent documentaries of the Thirties, and established a model for the documentary practice of a younger generation. His films still provide the best view of some extremely important subjects: Joe McCarthy, Vietnam, the Weather Underground, the artists of the New York School. De Antonio's films not only contributed to the historical record of his time, they also played a part in that history. De Antonio's films are personal films, filled with all his intelligence, anger, and humor. Without resorting to any diaristic self-indulgence, they neatly reflect one man's attitudes during a key period in American history. But those attitudes were not de Antonio's alone. His films offer a guide to the changing (as well as unchanging) beliefs of much of the American left from the Fifties and Sixties through the Seventies and the Eighties. Given de Antonio's achievement, a place on the Nixon enemies list seems a perfectly just reward.—Robert Silberman

RECOMMENDED BIBLIOGRAPHY

Rosenthal, Alan, ed. *The Documentary Conscience: A Casebook in Film Making.* Berkeley, CA: University of California Press, 1980.

———*New Challenges for Documentary.* Berkeley, CA: University of California Press, 1988.

De Palma, Brian

(September 11, 1940 –)

The son of a prominent orthopedic surgeon, Brian De Palma was raised in Philadelphia, and attended a Quaker high school there before matriculating at Columbia University in New York, from which he graduated in 1962.

While attending Columbia, the erstwhile physics major became "obsessed" with film and made various short films. He won an MCA writing scholarship and enrolled as a graduate student at Sarah Lawrence College. While there (1962–'64), he completed his first feature, *The Wedding Party*, a satirical look at the rituals accompanying a suburban wedding. Despite some favorable reviews, it remained on the shelf until 1969 when De Palma himself financed a limited distribution.

In 1968 he completed another feature, *Murder a la Mod*, which dealt with a murder as seen from three different points of view. It likewise failed to find a distributor. That same year, however, De Palma achieved a breakthrough with *Greetings*. A film very much of its time, *Greetings* dealt in satirical fashion with the Kennedy assassination, the draft, the war in Vietnam, and the sexual revolution. Made with wit, style, and energy, the film quickly attained a cult following as well as positive critical response (it won a Silver Bear at the Berlin Film Festival).

Hi, Mom! (1970) was a quirky follow-up to *Greetings*, using some of the same characters and themes, but with more emphasis on voyeurism. Less successful critically and commercially, the film remains most notable for a powerful sequence (presented as a pseudo *cinéma-vérité* documentary) in which a militant black theater group terrorizes and embarrasses its white liberal audience. That same year saw the release of *Dionysus in '69,* a filmed record of The Performance Group's Off-Broadway presentation of an avant-garde version of

Euripides' *The Bacchae.* De Palma made skillful use of a split-screen so that both the play's performance and the audience reaction to it can be seen simultaneously.

Although De Palma expressed a desire at this time to be the "American Godard," he went west to make his first Hollywood film, handling comedian Tom Smothers's film debut. Warner Bros. did not allow the director to finish *Get to Know Your Rabbit,* which on release in 1972 was a critical and box office bomb. Because of difficulties while shooting his first Hollywood film, De Palma could not find work for a period of time, but he persevered, and in the next five years he completed five films: *Sisters* (1973), *Phantom of the Paradise* (1974), *Obsession* (1976), *Carrie* (1976), and *The Fury* (1978).

Each of these films is excessively melodramatic and characterized by explicit violence and fancy camera techniques. The subjects included a Faustian view of rock culture, incest, voyeurism, the power of telekinesis, and the moral corruption of society. The critical response to them was mixed, especially as regard the director's avowed "borrowing" from Hitchcock (e.g., the story of *Obsession,* coauthored by De Palma, owed a great deal to Hitchcock's *Vertigo*). The box office response was also uneven, although *Carrie,* with its splatter-film emphasis on gore, was a solid commercial hit.

An interlude at Sarah Lawrence as "director-in-residence" resulted in *Home Movies* (1980), an uneven film parody made with college students and visiting film professionals such as actors Kirk

Douglas and Vincent Gardenia. De Palma then went on to make a series of films, most of which generated a highly negative critical response because of their treatment of women, excessive and unmotivated violence, lurid plots, and an unpleasant emphasis on voyeurism.

The most commercially successful of these films, *Dressed to Kill* (1980), dealt with a razor-wielding psychopathic transvestite psychiatrist and featured two shower scenes with women à la Hitchcock's *Psycho*. The murder of a political candidate in a Chappaquiddick-type incident was the subject of the cynical *Blow Out* (1981), a film which owed much to Antonioni's *Blowup*. *Scarface* (1983) was a vastly overblown remake of the classic 1932 gangster film, but so explicitly gory that it had to be recut in order to escape an X-rating. *Body Double* (1984) borrowed heavily from *Vertigo* but De Palma's direction, which emphasized the particularly nasty murder of a woman, failed to cover gaping holes in the plot which he coscripted.

Wise Guys (1986), a "buddy" film with comedians Danny De Vito and Joe Piscopo, marked the nadir of De Palma's career. He does not have a light touch and this attempt at comedy fell flat. De Palma made a remarkable comeback with *The Untouchables* (1987), a major critical and box office success. This straightforward reworking of Treasury Department agent Eliot Ness's bagging of gangster Al Capone was directed with flair by De Palma, who benefited from a well-constructed if not entirely logical script by playwright David Mamet. De Palma eschewed many of the tricks and traits associated with his previous films, which had increasingly turned off critics and moviegoers alike.

His misogyny surfaced again in *Casualties of War* (1989), which dealt with a Vietnam War incident: a member of a five-man U.S. Army patrol fails to prevent his fellow GIs from abducting, raping, and murdering a Vietnamese teenager. Scriptwriter David Rabe (noted for his work on the war and its effects) had a falling out with De Palma about the director's approach. The resulting film lacks a coherent political statement and garnered mixed results critically and commercially.

The Bonfire of the Vanities (1990), his next effort, was a critical and box office bomb. It was a spectacularly unsuccessful filming of Tom Wolfe's best-selling novel about Eighties yuppie life in New York City. Hampered by studio interference, De Palma proved unable to come to grips with the nuances and ideas inherent in Wolfe's biting satire. The "feel-good" ending of the film was generally judged a "cop-out."

De Palma knows movies. Over the years, he has proved to be one of the few Hollywood directors to have a genuine, almost intuitive grasp of the variegated possibilities of the film medium. He has demonstrated over and over again his grasp of the dramatic impact of the moving image. For better or for worse, his films move. They have energy. They are dynamic and, whatever their flaws, they invariably include scenes which are visually exciting.

Unfortunately, despite De Palma's obvious "feel" for the cinema, and despite the obvious artistry evidenced in individual scenes, his movies over the years have become less innovative and increasingly formulaic and mechanical. The violence he seems to enjoy graphically depicting had at least been an integral part of the plot in the films of the Seventies. But by the early Eighties it had become an end unto itself. Rather than offering any kind of artistic catharsis, the violence became nauseating, off-putting, and, in some instances (most notably in *Scarface*), downright silly.

His undeniable cinematic talents were exercised in ways that became increasingly unattractive and disturbing. His avowed efforts to pay "homage" to past masters of the cinema, especially Hitchcock, bordered on an unhealthy and sometimes less than successful copying. And most of De Palma's films, even his best ones, reek of a kind of voyeuristic contempt for women.

He does not just peddle or exploit sex (as does so much of the contemporary commercial cinema in a morally more permissive era); he seems obsessed by a sexuality that denigrates and demeans women, that verges on a disturbing and destructive misogyny.

De Palma's most recent films mark a break with the attitudes that marked much of his previous filmmaking. He claims, for example, that his obsession with Hitchcock is "finished." Today, the energy and style which graced so much of his early work has been diffused. While De Palma's earlier films had a kind of radical veneer that challenged the prevailing mores of society, that political orientation has given way to commercial slickness.
—Dan Leab

RECOMMENDED BIBLIOGRAPHY

Bliss, Michael. *Brian de Palma*. Metuchen, NJ: Scarecrow Press, 1983.

Bouzereau, Laurent. *The De Palma Cut: The Films of America's Most Controversial Director*. NY: Dembner Books, 1988.

Dworkin, Susan. *Double De Palma: A Film Study with Brian De Palma*. NY: Newmarket Press, 1984.

Mackinnon, Kenneth. *Misogyny in the Movies: The De Palma Question*. Newark, DE: University of Delaware Press, 1990.

Salamon, Julie. *The Devil's Candy: The Bonfire of the Vanities Goes to Hollywood*. Boston, MA: Houghton Mifflin, 1991.

Pye, Michael and Lynda Miles. *The Movie Brats*. NY: Holt, Rinehart and Winston, 1979.

Disney, Walter Elias

(December 5, 1901 – December 15, 1966)

W alt Disney, one of the world's most popular fantasists, built a twentieth-century entertainment empire on the animated antics of a cartoon mouse.

Disney's father, Elias, was a relentless pursuer of get-rich-quick schemes who relocated his wife and five children several times in the Midwest whenever the promise of a new opportunity glimmered brightly. A dour, demanding parent, Elias insisted his children contribute their labor to the support of the family, and he gave swift back-of-the-hand punishment at the least provocation. Years later, Walt Disney had a recurring nightmare stemming from the physical and psychological abuse he suffered as a child; he dreamed he was again nine years old and tardy in delivering a heavy load of newspapers in a Kansas City blizzard.

Considering Disney's burdensome relationship with his father, it is interesting to note that in many of his feature-length cartoons the father figure is absent, remote, or replaced by a surrogate. Snow White, for example, is an orphan adopted by seven substitute fathers—dwarfs—whom she in turn treats like children; Dumbo has an adoring mom, but apparently no dad; Bambi's father is glimpsed on distant mountain tops, while his mother rears him; Peter Pan wants Wendy to be an ersatz mother, but does not desire a father; Alice has no parental guidance at all through wild Wonderland; Pinocchio, whose papa must have been a pine tree, disobeys his surrogate dad, Geppetto the woodcarver, and grows up away from home.

From 1906 to 1910, Elias Disney tried to turn a profit by working a forty-five-acre farm in Marceline, Missouri. The toil and

stress proved so grueling that his two eldest sons ran away; after contracting typhoid and pneumonia, Elias was forced to sell the property for what he paid for it. Nevertheless, Walt's fondness for nature, the barnyard, and small towns, seen so often in his films, stemmed from his brief years in Marceline.

In Walt Disney's film world, the barnyard is sanitized and nature is tamed and idealized. Mickey Mouse behaves like a dirty rat in his earliest films, but he lives in a squeaky-clean environment.

Animation, which necessitates the manipulation of the content of each frame of film, is the perfect medium for one as obsessed with control as was Walt Disney. His compulsion to put a better face on reality extended beyond animation to the popular *True Life Adventure* nature film series of the late Forties and Fifties, which, through editing, narration, and music, anthropomorphized animals and their natural habits. Disney's ultimate statement of control is the gigantic amusement parks—Disneyland in California and Walt Disney World in Florida—totally controlled environments entered only through an idealized remembrance of Marceline's Main Street of long ago, now cleaned up and computerized.

Walt escaped the tyranny of his father by joining the American Ambulance Corps at the end of World War I. Although he did not participate in combat, he was sent to France where he claimed he "grew up." Returning to the states in the fall of 1919, Disney decided to turn a hobby of cartooning into a career. "Can you make a living from being an artist?," asked Elias, who never encouraged the artistic side of his son. "I don't know," came the honest reply from the young cartoonist whose work was regularly rejected by the humor magazines *Life* and *Judge*. In Kansas City, both the *Star* and *Journal* newspapers refused to hire him.

Disney found work at a commercial art studio roughing out ads for farm equipment for a monthly salary of $50. There he met another eighteen-year old, Ubbe (Ub) Iwerks, a talented illustrator and inventor who would, in time, make important contributions to the Disney films. By 1920, the two lads were employed by the Kansas City Film Ad Company, which made animated advertisements for local theaters. Walt's introduction to moving cartoons fascinated him and he immediately studied everything about the new medium, while, typically, attempting to improve upon the existing techniques.

By May 1922, young Disney headed a small corporation made up of local teenagers, formed to produce a series of animated fairy tales. *Puss 'n' Boots*, one of the surviving films, is stylistically mundane, but Disney's assured direction is already apparent.

Walt's earliest films failed to find distribution and in 1923 his small studio went bankrupt. He left for Los Angeles where he and his favorite brother, Roy, established the first cartoon studio on the West Coast. *Alice in Cartoonland* (1923), one of the Disney brothers' early series made in Hollywood, is as accomplished as the cartoon films produced in New York City, then the country's animation capital.

Roy O. Disney's fiscal conservatism often sparked friction between the brothers, but his resourcefulness allowed Walt enormous creative freedom. Working in tandem, the brothers managed to stay afloat during many lean times.

An early crisis involved the loss of Oswald the Lucky Rabbit, the star of a popular animated cartoon series. Walt presumed he owned the character but Oswald's copyright actually belonged to the film distributor. The incident strengthened Walt's resolve to remain independent in order to control all aspects of his company. It also led directly to the creation of Mickey Mouse, who was designed by Ub Iwerks, but belonged only to his inventor, Walt Disney.

Mickey Mouse catapulted to the top ranks of movie icons through an innovative use of technology: Disney's first pub-

licly released short, *Steamboat Willie* (1928), boasted the first imaginatively integrated sound track in cartoons. The canny promotion of Mickey's image on innumerable licensed products allowed the Disney studio to expand and develop dramatically during the Thirties.

The brief period starting with Mickey Mouse's 1928 debut to the 1937 premiere of the feature-length cartoon *Snow White and the Seven Dwarfs* represents a remarkable and unprecedented advance in the style and techniques of the animated film. Within a decade, Disney changed the look, content, and commerce of moving cartoons. Walt's vision was formed quickly, aided by the successful development of personalities in the Mickey Mouse shorts—besides Mickey, the cast of regulars included Minnie Mouse, Goofy, Pluto the Pup, and Donald Duck—and a series of music-oriented shorts called *The Silly Symphonies. The Sillies*, produced from 1929 through 1939 simultaneously with the Mickey Mouse shorts, experimented with motion, design, narrative, the synchronization of sound to action, and color—the use of three-toned Technicolor in *Flowers and Trees* (1932) garnered Walt his first Oscar.

Walt insisted his animated fantasies be based on reality ("I definitely feel that we cannot do the fantastic things, based on the real, unless we first know the real..."). He pushed his artists to develop the quality of their draftsmanship in order for the design and animation to create an illusion or caricature of life forces. He guided his writers and storypersons to create cohesive narratives starring appealing, strong personalities, like those in live-action comedies and melodramas. He spent thousands of dollars each year (starting in 1932) to run an animation school on the studio lot, obliging his staff to draw the nude figure and live animals, and to study a diversity of films frame-by-frame and scene-by-scene, such as Chaplin, Keaton, Laurel and Hardy comedies, German Expressionist horror tales, Oskar Fischinger/Len Lye abstract shorts, D. W.

Griffith epics, and the latest Hollywood melodramas and musicals.

He sent his artists to observe the performances of actors and dancers in the theater, and clowns and animals in circuses, and he brought experts in the fields of music, color, and fine art to lecture at the studio. This eclectic educational effort was in the hopes Disney's artists would borrow ideas and adapt them to their increasingly sophisticated filmmaking skills, and to conform to a vision Walt held in his mind's eye. He wanted his films to be somehow better, by which he meant more real and believable, more powerful and compelling, closer to the moviegoing public than any animated films ever had been.

During the Depression, it was said that Disney's films were one of the few things that visibly improved. "What? No Mickey Mouse?" was the disappointed cry from loyal fans to theater owners who neglected to book a Disney short. Walt cemented his growing audience appeal with the 1933 Silly Symphony, *The Three Little Pigs*. Its theme song, "Who's Afraid of the Big Bad Wolf?," became a national rallying cry, and demand for the short was so great that prints were bicycled between local theaters, where the film was often billed above the title of the feature.

Walt's films also found support during this period from film historians and critics, who favorably compared the filmmaker with screen geniuses such as Chaplin, Eisenstein, and Griffith. Although tightly synchronized to sound tracks, Disney's animations were free from the cumbersome machines and techniques that burdened live action "talkies." Instead of slavish imitations of theater and literature, Disney's cartoons seemed an extension of the creativity of silent movies, whose eloquence in motion and staging was destroyed when sound arrived in the late Twenties.

Walt ignored those who called his work "art," and he paid little heed to Hollywood cynics who dubbed his attempt to produce a full-length cartoon "Disney's Folly." The

production of *Snow White* stemmed from financial as well as artistic considerations; the short-film format constricted the development of complex stories and characters and frustrated the burgeoning talents of Disney's creative staff, and Roy Disney found Walt's continuing experimentations in the short films to be so expensive as to preclude a decent profit.

Snow White and the Seven Dwarfs is Walt's masterpiece, the culmination of his personal vision of animation as synthesis of motion, sound, color, narrative, and personality. The individuation of the characters, especially the dwarfs, set a standard by which all other examples of this specialized form—'personality animation"—must be measured. The script is a model of economy, and the melodic, operetta-like score develops the plot while defining the characters. There is a palpable freshness and energy about the film, a feeling of youthful daring that successful pioneering efforts in all art forms share. Disney's subsequent feature cartoons made small technical improvements based on the discoveries grandly exhibited in *Snow White*, but since 1937 neither the Disney studio nor imitators have progressed beyond the *Snow White* blueprint.

Around this time, several critics reassessed Disney's work and complained about his excessive interest in realism in animation. Caricaturist Al Hirschfeld wrote in *The New York Times* in 1938 that "the characters Snow White, Prince Charming, and the Queen are badly drawn attempts at realism...Disney's treatment of these characters belongs in the oopsy-woopsy school of art practiced by etchers who portray dogs with 'kute' sayings."

In the early Thirties, Disney abandoned the use of irrational abstractions in his animation in favor of logic; whereas Mickey's ears could pop off his head in fits of anxiety (*Plane Crazy*, 1928) or a fish's skeleton might contentedly swim in a fishbowl (*Mickey's Good Deed*, 1932), such illogical, surreal imagery was banned in later films. The witch's transformation

in *Snow White* is drug-induced, as is Dumbo's witnessing a wild metamorphic dance of pink elephants in *Dumbo* (1941), a vision conjured after he accidentally imbibes a quantity of liquor.

Other critics found fault with the bourgeois ideology and heavy-handed moralism evident in Disney's films. "Beginning with *Snow White*," wrote Dorothy Thompson in a review of *Fantasia* (1940), Disney films "developed a gloomy, fatalistic philosophy to record the Fall of Man and to record it with a sadistic relish...only the animals are in a state of grace."

Many of the cartoons contain behavioral propaganda, stressing unquestioning obedience to authority figures, conformity to long-established rules of social deportment, and following the "straight-and-narrow path." Problems are overcome through group effort and the work ethic; free sexuality is repressed, and marriage is elevated as the ultimate ideal. Male and female roles are stereotyped: men are active and women are either passive madonnas or out-of-control witches. Physical appearance defines good and evil as much as deeds: good is usually small, round, soft, and white, while evil is large, angular, black, and slinky.

A significant number of Disney characters suffer a death of some kind, then enjoy a resurrection to a newer, better life, thus touching on a basic human desire for survival and transcendence. Religious symbols and rituals borrowed from Christian mythology abound in the Disney oeuvre: Snow White, the seven dwarfs, and Geppetto kneel to pray; in *Melody Time* (1948), Johnny Appleseed confers with a guardian angel, who eventually leads him, after a selfless life, to heaven, and in the sequence "Trees," based on Joyce Kilmer's sappy poem, a tall oak transforms into a crucifix. In *Make Mine Music* (1946), Willie, a murdered operatic whale, finds a new audience amid fluffy clouds in a pink and puce heaven; Jiminy Cricket genuflects before the glow of the angelic Blue Fairy; angels and devils fight

for the souls and consciences of Pluto, Donald Duck, and Mickey Mouse in various short films. In World War II propaganda cartoons, God is clearly on America's side, judging from the heavy use of heavenly choirs, inspirational shafts of light from above, and "voice-of-God" male narrators; the enemy's horned machinery wallows in punishing hellish pits of flame and black smoke. The finale of *Fantasia* offers a menu of Christian kitsch ranging from the sight of a black devil shamed into Bald Mountain by church chimes, to an interminable procession of monk-like worshippers singing Schubert's "Ave Maria" while filing past a forest of trees shaped like stained-glass windows.

Snow White proved a huge box office success, and Disney pushed forward, investing all the profits into the production of four new features and the construction of an expensive new studio in Burbank. But 1941 brought profound changes that significantly altered his organization's future; first came an acrimonious strike by many of Disney's employees for improved salaries and job security. Journalists who mindlessly quoted Disney publicity blurbs describing the studio as a "magic workshop" were surprised to hear the term "sweatshop" chanted by strikers on picket lines in front of the new Burbank studio. Walt's paternalism was protested in a public and embarrassing way, and he took it as a personal affront led by a "Communist-backed" few, charges he would repeat as a "friendly witness" in the 1947 Hollywood HUAC hearings. Most significantly, the strike clouded Disney's interest in animation and its further development. "The spirit that played such an important part in the building of the cartoon medium has been destroyed," he wrote to newspaper columnist Westbrook Pegler in 1941. "I am thoroughly disgusted and would gladly quit and try and establish myself in another business."

With the war raging in Europe, more than half of the Disney studio's revenue was cut off. When America entered the war, Walt and Roy were saved from financial ruin by government contracts ordering literally hundreds of propaganda and training films. The urgent schedule to produce films for the war effort kept the studio afloat, but disrupted Disney's plans for future feature-length cartoons, which were either cancelled or delayed for years.

"After the war was over," said Roy Disney, "we were like a bear coming out of hibernation. We were skinny and gaunt and we had no fat on our bones. Those were lost years for us." In 1945, the Disney studio found itself more than $4,000,000 in debt and, as Bob Thomas put it, "out of tune with public tastes, financially depleted, confused about its own destiny."

The struggle to survive precluded any more innovations in animation, which would take a back seat in the production plans Walt now formulated. "I knew diversification of the business would be the salvation of it," he recalled years later.

Immediately after the war, Disney produced a number of compilation cartoon features based on popular music (e.g., *Melody Time, Make Mine Music*), features combining live action with animation (*Song of the South*, 1946; *So Dear to My Heart*, 1949), live-action nature films (the *True Life Adventure* series, i.e., *Seal Island*, 1948), and live-action features (i.e., *Treasure Island*, 1950). Not until 1950 was Disney able to begin again producing full-length animated fairly tales (i.e., *Cinderella*).

In the Fifties, the Disney studio developed from a small operation struggling picture to picture into a financially secure, wealthy entertainment conglomerate. Walt again seized upon new technology to gain advantage over competitors. In the past, it was sound and color; now it was television, a medium feared and shunned by other Hollywood film producers. Disney cut and pasted his huge backlog of features and shorts into low-budget TV programs. He used his popular television shows (*Disneyland* and *The Mickey Mouse Club*) to promote his new films and the giant

theme parks (Disneyland and Walt Disney World), which today constitute most of the Disney organization's income.

Walt Disney, a lifelong heavy smoker, died on December 15, 1966 of acute circulatory collapse in the hospital across the street from his Burbank studio. A recent Wall Street takeover attempt led to a much-needed housecleaning of Disney's corporate management. The success of the new team (Michael Eisner, et al.) in maximizing the enormously popular assets of the company would seem to assure Disney continuance as a major entertainment source into the next century. The house that Walt built remains popular and profitable, continuing to build upon his legacy of well-crafted films, pleasure palaces, and beloved characters.

Disney's dazzling technique, his famous "magic," blinds most audiences to the many regressive messages within his works. His simplistic ideology and idyllic visions continue to soothe and reassure people confused and alarmed by the chaos and insecurity of our times.

—John Canemaker

RECOMMENDED BIBLIOGRAPHY

Bailey, Adrian. *Walt Disney's World of Fantasy.* NY: Gallery Books, 1987.

Eliot, Marc. *Walt Disney: Hollywood's Dark Prince.* NY: Birch Lane, 1993.

Greene, Katherine and Richard Greene. *The Man Behind the Magic: The Story of Walt Disney.* NY: Viking Penguin, 1991.

Holliss, Richard and Brian Sibley. *The Disney Studio.* NY: Crown Publishers, 1988.

Maltin, Leonard. *The Disney Films.* NY: Crown Publishers, 1984.

Mosley, Leonard. *Disney's World: A Biography.* NY: Stein and Day, 1985.

Schickel, Richard. *The Disney Version: The Life, Times, Art and Commerce of Walt Disney.* NY: Simon and Schuster, 1985.

Dixon, Thomas

(January 11, 1864 – April 3, 1946)

Although Thomas Dixon, one of America's most controversial novelists, is perhaps best known for his contribution to D. W. Griffith's *The Birth of a Nation,* the writer-turned-filmmaker had his own film career over a period of more than twenty years.

Dixon was not only a true auteur of the cinema long before the word came into popular use, he was also among the first Americans to recognize the propaganda value of the motion picture. Some of Dixon's films were relatively unimportant, but others, particularly *The Fall of a Nation* and *Bolshevism on Trial,* were tremendously successful at the box office. That they did not always meet with critical approbation had as much to do with the content of the films as with their cinematic presenta-

tion.

Virtually all of Dixon's twenty-eight novels were concerned with social and political problems, and the author's answers to such problems seem far from palatable today. In his first novel, *The Leopard's Spots* (1902), Dixon made it perfectly clear that equality between the white and black races was impossible because of the natural superiority of the former. Three years later, in the year in which his best-known novel, *The Clansman,*

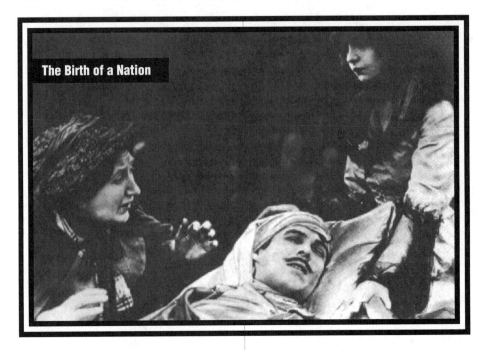

The Birth of a Nation

appeared, Dixon published an article in *The Saturday Evening Post* advocating the deportation of the Negro to Liberia as a solution to the race problem; in a 1911 interview with *The New York Dramatic Mirror*, Dixon noted, "Spain expelled the Moors. It took eight hundred years, but the deed was finally accomplished. On that basis, I reckon that we can expel the Negroes in two hundred years." Aside from the Negro problem, Thomas Dixon used his pen to attack socialism in *The One Woman* (1903), *Comrades* (1909), *The Root of Evil* (1911), and *The Way of a Man* (1919); feminism in *The Foolish Virgin* (1915); and communism in *The Flaming Sword* (1939), which also pointed out that the Negro was easy bait for communist propaganda.

In 1905, Dixon transformed *The Clansman* into a stage play, also utilizing elements from *The Leopard's Spots*. As early as 1911 Dixon had attempted to form a film company to produce the play, but it was not until 1913 that he was able to persuade Harry Aitken and D. W. Griffith to create the film which was to become known as *The Birth of a Nation*. Spurred on by the success and controversy which the film generated, Dixon moved to Los Angeles and set up his own studio, where he was determined to produce a film superior to *The Birth of a Nation*. The result was *The Fall of a Nation* (1916), which Dixon also created in novel form, and for which Victor Herbert composed the score. Intended to ridicule pacifists Henry Ford and William Jennings Bryan and to glorify Theodore Roosevelt and his staunchest advocate, *The New York Tribune, The Fall of a Nation* argued for a militant America to fight against certain European powers (i.e., Germany). The film depicted a feminist leader responsible for the downfall of America by her arguing against national defense. After the defeat of the United States by European forces, however, a loyalist legion of American women is formed, and its members seduce and kill their unsuspecting foreign escorts.

From the spectacle and war of *The Fall of a Nation*, Dixon turned to the dangers of socialism with *The One Woman*, which he coscripted for Select in 1918, from his own novel published fifteen years earlier. It told of a brilliant young clergyman who

becomes imbued with the spirit of social-
ism, is forced to resign from his church,
leaves his wife and moves in with a beauti-
ful, young socialist adventuress. The cler-
gyman becomes disenchanted with social-
ism when his colleagues vote against con-
scription and when his common-law wife
becomes the mistress of another socialist.
He kills the other man, but his former wife
comes to his rescue and the murder
charge is dropped. As *Motion Picture News*
commented, "The satisfaction it will give
depends on the political views of the indi-
vidual."

Neither *The Fall of a Nation* nor *The
One Woman* are extant, but Dixon's next
effort, *Bolshevism on Trial*, one of the "red
scare" cycle of films brought on by the
Russian Revolution and which depicted
the attitude of the majority of the
American public towards communism, has
survived. It was based on Dixon's novel,
Comrades, "a story of social adventure in
California," and was concerned with a
group of Americans who set up an "ideal
colony" experiment in a hotel on a small
Florida island. A Bolshevik is elected
leader of the group, and he promptly
divorces his wife and advocates "free
love." The heroine is menaced by the
Bolshevik leader but is saved by the
arrival of the U.S. Navy, which has come
to arrest the Bolshevik, who is considered
a dangerous anarchist by the government.
The similarity between the ending of *The
Birth of a Nation* and *Bolshevism on Trial*
is both obvious and disquieting, with the
white-uniformed, white-faced, all-American
Navy bearing a striking resemblance to
the white-robed Ku Klux Klan.

Dixon provided only the story for
Bolshevism on Trial. For *The Mark of the
Beast* (1923), he served as producer, direc-
tor, and author. A curious story of the dan-
gers of psychology, which causes a young
woman to marry a villainous brute, *The
Mark of the Beast* was poorly received by
both critics and public alike. *Photoplay*

described it as "A lot of pretentious bunk
about psycho-analysis. Poor story, poor
continuity, poor casting, poor direction—
poor public!"

Like Griffith, Dixon was no advocate of
the revived Ku Klux Klan of the Twenties;
his 1907 novel, *The Traitor,* has as its hero
a man who will fight to the death any
attempt to reorganize the Klan. In the
Thirties, Dixon's political views became
confused. A longtime Democrat, he was an
ardent speaker on behalf of the New Deal
who later turned against Roosevelt, whom
he viewed as a communist. Dixon's last
film, *A Nation Aflame* (1937), for which he
provided the story, indicates something of
the man's confusion. Produced by Victor
and Edward Halperin (and directed by the
former), *A Nation Aflame* illustrates the
danger of secret societies—in this case a
group called the Avenging Angels—who
don hooded robes and use their creed of
"Pure Americanism" to bring about the
downfall of democracy.

Thomas Dixon was one of the few men
of letters who early recognized the value
of film as a political weapon. In 1923, he
commented, "The moving picture man,
author and producer and exhibitor should
take himself more seriously. He is not
merely the purveyor of a form of entertain-
ment. He is leading a revolution in the
development of humanity—as profound a
revolution as that which followed the first
invention of printing."—Anthony Slide

RECOMMENDED BIBLIOGRAPHY

Cook, Raymond Allen. *Fire from the Flint: The
Amazing Careers of Thomas Dixon.* 1968.
———*Thomas Dixon.* NY: Twayne Publishers,
1974.
Dixon, Thomas. *Chesapeake and Ohio.* Carstens
Publications, Inc., 1984.
———*The Clansman: An Historical Romance of
the Ku Klux Klan.* Lexington, KY: University
Press of Kentucky, 1970.
———*The Leopard's Spots: A Romance of the
White Man's Burden.* Irvington, NY: Irvington
Publishers, 1979.

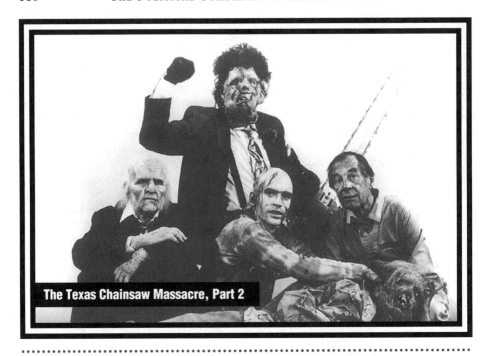

The Texas Chainsaw Massacre, Part 2

The Drive-In Theater

I n a class with neon signs, miniature golf courses, and glistening diners, the American drive-in theater is a colorful roadside artifact. Invented in 1933 by Richard M. Hollinshead, Jr. of Camden, New Jersey, drive-ins grew slowly during the Great Depression, due to the conflict over patent rights and opposition by owners of conventional 'hardtop' theatres.

The postwar economic boom brought them into a more auspicious climate. Between 1954 and 1963, their number increased from 2,000 to 6,000 nationwide, while hardtops declined by thirty-eight percent. In a 1950 study by *Theatre Catalog*, more than half the patrons brought their children with them in the family car, and a third said they attended *only* drive-ins.

What were the reasons for this popularity? What did these "ozoners" offer that hardtops did not? Novelty. Lured by promotional gambits (free baby-bottle warming, laundry service, kiddie playgrounds, even swimming pools) the public went outdoors, seduced by sheer convenience. Patrons never needed to dress up, hire a baby-sitter, worry about falling asleep, or obtain special access for the handicapped. They could talk, smoke, eat, drink, even make love in vinyl comfort without annoying their neighbors. To attract people in cooler weather, some drive-in owners installed individual heaters that could be hooked on the window next to the box speaker.

Movie viewing was different, too. Isolated patrons were spared collective reaction, especially to comedies. If they

missed a joke, they rarely felt embarrassed or inferior. As "atomized reception units," however, they did have one response in common—horn honking, which they used for two reasons: 1) to alert management to projection problems, and 2) to release anxiety during horror films. With their huge screens, drive-ins simultaneously distanced viewers from and immersed them in the horror films. *The Blob* (1958) may have been scary, but its horror diminished when viewed through a "protective" windshield, cut off from the screams and gasps of the audience. Because of this alienation, however, some viewers felt even *more* vulnerable in their cars, especially during lone maniac movies. One film even capitalized on this fear. In *Targets* (1967), a sniper is perched behind a drive-in screen, shooting people as they open their car doors. Because viewers are isolated, he hits several before the crowd realizes it is under attack.

The peak period of drive-in expansion coincided with television's rise. Both offered viewers private and interruptable viewing experiences (quadruple features at some drive-ins), with commercial breaks, and relatively easy access to snacks. In 1963 the enterprising owner of Albuquerque's "Autoscope" realized this affinity and projected his shows on individual three-by-five-foot screens located in front of each car.

Drive-ins and television also influenced the style of popular films, and then developed their own unique forms. The terms "Drive-In Movie" and "Made-for-TV-Movie" are now part of the lexicon, even though they are not the only—or lately, even the dominant—types that appear in each medium. The classic drive-in movie was a subgenre of the B-movie. It had low budget production values and was thrown together under the constraints of a short shooting schedule. But unlike B-movies, drive-in movies were more likely paired with each other than with A-features. They are also known as "exploitation films" because they have controversial, timely, or sensational subject matter designed to draw in audiences, although not necessarily to keep their attention. Three main types dominated the drive-in theatres from 1950 to 1980—the "teenpic," the slasher-zombie movie (known in the trade as "axploitation" or "slice and dice"), and the soft-core sex movie ("sexploitation"). Other styles featured black themes ("blaxploitation"), kung fu ("chop-socky"), swords and sorcery, and beach parties, but had even shorter popularity cycles.

In the Fifties, young people were the primary targeted audience. Thomas Doherty mentions in *Teenagers and Teenpics* that theatre owners often scheduled double bills with crude boy-girl pairings: *Sorority Girl* (1957) together with *Motorcycle Gang* (1957); *Diary of a High School Bride* (1959) with *Ghost of Dragstrip Hollow* (1959). Albert Zugsmith's *High School Confidential* (1958) appealed to both sexes by combining mixed elements. When first released, the film was doubly exploitative. It simultaneously manipulated the public fuss over juvenile delinquency and attracted the youth market with its lurid plot: a young undercover cop is sent to a high school to trap local drug dealers. He lives with his sexy, alcoholic "aunt" who tries to seduce him; he wooes a sweet, vulnerable high school girl; he participates in a drag race; finally, he defeats the drug dealers in a shootout at a local bar. Jerry Lee Lewis, controversial for marrying his thirteen-year-old cousin, sings the opening title song to stir the youthful crowd. Despite the movie's pretentious *Naked City*-style voice-over, Zugsmith was not interested in sparking debate about social issues; he intended only to produce a commercially successful but culturally disposable item. Although teen exploitation films were never meant to endure, many are now cult classics, like *Rock Around the Clock* (1956), *I Was a Teenage Werewolf* (1957), *The Cool and the Crazy* (1958), and *The Trip* (1967).

These films did not play exclusively at "open-air theatres," although exhibitors

preferred to show them there. The new "indie" production houses like American International Pictures or Filmgroup did not demand the same long runs as the more prestigious Warner Bros. or Paramount studios did. Embarking on lucrative schemes with their distributors, owners changed their billings fast, because their youthful audiences would return each weekend. Low-budget filmmaker Herschell Gordon Lewis summarizes the arrangement: "How could I convince [them] to set aside a week's playing time for my picture? Well, I could give them better terms: a sliding scale from twenty-five to fifty percent, instead of demanding a ninety-ten split in my favor...Economics [eventually] worked in favor of the low-budget producer."

Economics also influenced the style of drive-in movies. Producers avoided costume dramas or set-intensive Westerns. Beach films and low-cost monster films were popular for a while, then two new genres emerged in the mid-Sixties. Producers, alert to the topicality of serial killers, decided to turn out slash-and-gore features. It cost less to film a knife-wielding fiend in the woods than an elaborate space alien. Directors bought cheap cuts of meat from butcher shops and then recycled their plots with slight variations. Writers churned out hardware slice-and-dice movies that included saws (*The Texas Chainsaw Massacre*, 1974), power drills (*The Driller Killer*, 1979), meat grinders (*The Corpse Grinders*, 1972), even an assortment (*The Toolbox Murders*, 1978). Young working-class audiences liked these movies because they presented simple ways to deal with threatening or problematic situations. Rather than negotiate or capitulate—rules the audience must follow in daily life—the hero finds a weapon and "wastes the sucker." Slasher films are often underscored with sadomasochism. Youths are killed while copulating, the hypostatization of being caught *in flagrante delicto* by angry parents.

Zombie-slasher movies soon settled into a pattern. With fright scenes spaced fifteen to twenty minutes apart, audiences could visit friends or the refreshment stand without "missing anything." Owners profited by earning up to four times as much on concession sales as their hardtop counterparts did. Industry analysts calculated that every dollar spent at the ticket booth was matched by one spent at the concession stand. If a movie was well-paced, with generous sags in tension, profits doubled.

The Sixties' sexual revolution helped soft-core sex comedies flourish during the Seventies and early Eighties, but these films were not erotic or "blue"—they were only *about* sex, exploiting it as a topic of light humor. For many communities the local drive-in was the only place patrons could see movies like Alan Funt's *What Do You Say to a Naked Lady?* (1970) and *If You Don't Stop It You'll Go Blind* (1976). Funt's film used his hidden camera technique to create humorous sketches with burlesque sexual routines, such as an unwary man caught looking up a woman's skirt while she mounts a stepladder. *If You Don't Stop It You'll Go Blind* is filled with tasteless, but occasionally hilarious, renditions of classic dirty jokes, in a style similar to the Sixties' television show *Laugh-In*. In one scene (narrated as a TV commercial) nude male patrons make deposits in a sperm bank. Voluptuous tellers service them, "always willing to lend a helping hand." Since the film is soft-core, no sperm is actually shown (a sequel, *Can I Still Do It If I Wear Glasses?*, was released in 1980).

Soft-core films often parody larger-budget features. Unlike the shark in *Jaws* (1975), the mermaid in *Gums* (1979) grabs her victims to perform oral sex on them while swimming. The pubescent humor in *Screwballs* (1983) is similar to that in *Porky's* (1982); its band of satyric males, however, does nothing but get women to expose their breasts. Why were these movies ideal drive-in fare? Structure was an important factor. A movie was easy to watch if it had a thin (or nonexistent) plot,

insubstantial character delineation, and solid, predictable themes. It could also be viewed intermittently, conveniently entered and exited like the nearby concession stand, with no diminution of enjoyment. Second, soft-core comedies were ideal "hot date movies," especially for bashful couples. They served the useful social function of abating tension through laughter, and (hopefully) inspiring sexual activity. Their outrageous sequences even alluded to this function. In one of *Screwballs'* self-reflexive moments, petting couples watch a soft-core drive-in movie. As they throw their jeans and skirts onto a nearby car, a ten-year-old boy asks his father, "Is this movie 3-D?"

Not all drive-in fare is soft candy for the mind. Some exploitation directors injected satire or social commentary into their films. In George Romero's *Dawn of the Dead* (1978), a SWAT team is trapped in a shopping mall filled with zombies. One character maintains that the zombies return to the mall out of "memory of what they used to do [when alive]. This was an important place in their lives." Larry Cohen's films show corrupt officials trying to save face or profit from disasters; FDA bureaucrats market toxic white liquid in *The Stuff* (1985); city functionaries in *Q* (aka *The Winged Serpent*, 1982) frantically try to strike deals. Cohen feels that adding depth to characters makes a difference. "Sometimes the scenes that really make a movie work are the little scenes that have nothing to do with advancing the action, but just add a little *something*."

Something social? Romero and Cohen operate within a genre so standardized by gruesome effects that social criticism scarcely matters. Their antiauthoritarian outlook may be commendable but patrons may not separate it from the action. When they drive home, what do they remember—the anti-yuppie badinage or the spectacular decapitation? Do ambiguity, irony, and other complex devices distract them from the horrific special effects? But even within a context of blood and dismember-

ment, people *do* notice something. During a screening of the infamous *The Evil Dead* (1983) at the Route 114 Drive-In (Middleton, MA), the audience honked at the lead actor reacting implausibly to a zombie attack. Similar displays of disapproval have occurred at other drive-ins.

Debate hardly matters. Most exploitation movies are immune to film criticism, because they exist within their own bizarre context. Critics may correctly maintain that *Bloodsucking Freaks* (1983) contains excessive gore and degrades women, but they miss the movie's hyperbole. When *Student Bodies* (1981) periodically flashes its body count on the screen, audiences realize they are not watching a mainstream thriller. The constructs are too weird, too self-parodic.

Drive-in movies have their own aberrant standards. Their makers aim for the biggest shock or gross-out, unfettered by the constraints of decency or good taste. The genre even has its own critic. Joe Bob Briggs (pseudonym of John Bloom) began reviewing drive-in movies for *The Dallas Times Herald* in 1982, but is now a cable TV movie-show host. When he praises movies because they have "no plot to get in the way," he is evaluating them on their own terms—unseriously. In past years he has named his Drive-In Oscar Winners, presenting categories like "Best Psycho," "Best Gross-Out Scene," and "Breast Actress." Like the movies he reviews, he blends outlandish criteria with a persistent, tongue-in-cheek logic.

[In *Halloween III*] there is one fairly decent scene where this zombie puts a power drill through a nurse's ear, but there's not even any gurgles or gasps or anything. In other words, totally unrealistic. If you think about what would happen if somebody drilled you through the ear, it would probly be a kind of squishy sound after the steel popped through the skull, and then if he twisted it around inside like the zombie in the movie does, it would probly gush blood like one of those instant modern art twirling painter machines at

the state fair.

At the end of each review, he summarizes his evaluation:

Body count nine. Zombie body count fifteen. Two breasts. Not much kung fu, unless you count a little zombie kick boxing. Hands roll, arms roll, and yes, heads roll. Only two stars because it was made by Arabs. Joe Bob says check it out.

Feminists have reacted to Joe Bob's "crude and vulgar" remarks as "repugnant attitudes towards women," but Joe Bob sidesteps them with more parody of a shameless "good ol' boy." Of course, his above squib at Arabs is insensitive, but he never avoids stepping on toes during his Rabelaisian romps—he aims for them.

At the end of *Joe Bob Goes to the Drive-In,* he bemoans "dead drive-ins and drive-ins about to die." He offers to "come to your town and be obnoxious there," presumably to protest your local drive-in's closing. If the public accepts his offer, he may have to schedule frequent bookings years ahead. The drive-in has been quickly vanishing from suburbia. Developers are currently appraising land on which to build offices and condos. After giving theater owners lucrative settlements, they convert the twelve to fifteen acre areas into multiplexed hardtops or shopping malls. Surviving drive-ins are deteriorating, prey to vandalism, exposure, and inclement weather, particularly in the northern states. Most were poorly built, never designed to last more than twenty years. In the early Eighties, owners tried various schemes to recoup ticket sales lost to cable TV and VCR rental tapes. Massachusetts' Route 114 Drive-In turned into a triplex and rented itself out as a flea market on Sunday afternoons—ploys that kept it in operation only through 1988. Even their movies changed. In a desperate

bid for respectability, drive-ins began showing less exploitation fare and more second-run major releases. The Revere Drive-In (situated on a major expressway leading into Boston) showed soft-core horror films until the community complained they were causing "hazardous distractions to motorists" (it complied, but closed anyway in the early Eighties).

Demographic changes have contributed to the decline, with lower birthrates causing a drop in teen attendance. While changing sexual mores allowed teenagers more privacy, trips in the old convertible to the "passion pits" faded away. The novelty of seeing movies in a car clad in pajamas had a limited appeal. The Eighties also saw an increase in the popularity of X-rated films, which local authorities barred from even remote drive-ins, so viewers turned to renting videocassettes.

In the past five years, drive-ins have dwindled to about 2,000 nationally, with most remaining theaters clustered in warmer climates, where they can operate year-round. Perhaps New York's Dezerland admitted their passing when it opened "America's only indoor drive-in where you sit in real '60s convertibles and watch your favorite '50s movies." Like radio dramas and the 45 RPM jukebox, the drive-in has fallen victim to changing technology and public taste. For these media, nostalgia—not novelty or romance—attracts the remaining audience of the faithful.—Peter Bates

RECOMMENDED BIBLIOGRAPHY

Briggs, Joe Bob. *Joe Bob Goes to the Drive-In.* NY: Delacorte Press, 1987.
——— *Joe Bob Goes Back to the Drive-In.* NY: Delacorte Press, 1990.

Eastwood, Clint

(May 31, 1930 –)

In Hollywood's history of masculine attitude, Clint Eastwood is the heir and successor to John Wayne. Not only did Eastwood overtake Wayne at the box office and in the hearts of his countrymen, but he made good on the implicit threat in Wayne's persona as the outcast warrior of American society:

that such men, rejected by the community they had protected and cursed with a morally crippling skill at violence, would become totally unfettered instruments of chaos. A society patrolled by gunfighters and bounty hunters looks a lot like a frontier parody of a police state. Critics in the Seventies were always ready to attach the label fascist to Eastwood's work.

With Wayne, this threat remained implicit—in his films the hothead, the loner, the avenger is always brought back at least to the doorway (as in *The Searchers'* famous last shot) if not all the way in to the hearth.

Eastwood's long sojourn on the television Western *Rawhide* found him playing just such a part, as hotheaded Rowdy Yates, the second in command to actor Gil Fleming on a perpetual cattle drive, always learning to grow up and keep the herd in mind. The series was clearly modeled, at some remove, on *Red River*, a Wayne classic with Montgomery Clift in the son position.

But Eastwood became a movie star as the embodiment of the man who has entirely rejected Wayne's social contract; he made his name in Italian Westerns shot in Spain playing a man who is out only for himself, a skilled killer with no obligation to the community, to women, to sons, or to fathers—in short, as *A Fistful of Dollars* billed him, "the man with no name," i.e., with nothing to connect him to family or town.

The spaghetti Westerns of Sergio Leone were made with an affectionate nod to the conventions of their American forbears, but Leone and his collaborator (Eastwood claims he created his own distinctive costume and revised his dialog) also turned the Western inside out. In *A Fistful of Dollars* (1964) Eastwood is the stranger who moseys into a belligerent town not to clean it up, as Henry Fonda or Jimmy Stewart might, but to cast a pox on both warring houses and steal their money.

The plot was lifted whole, complete with camera sequences in some instances, from Akira Kurosawa's *Yojimbo*, but Leone forgoes the bedrock sentiment of Kurosawa's work; Leone's taciturn hero is unmistakably amoral, not a man trained to suppress his own emotions as Toshiro Mifune is, but a man unsullied by emotion, his words few and cryptic, his trigger finger quicker than the eye or reason, his motivation a distilled sense of self-preservation. Not for him the niceties of male confrontation hallowed by countless Westerns—none of this waiting for the other guy to draw first, but plenty of blows below the belt, cunning tricks, and ambushes, if that's what it takes.

American audiences found it exhilarating to see the old verities kicked off the screen by a figure clearly intended for adoration. In 1967, when *A Fistful of Dollars* and its sequel, *For a Few Dollars More*, hit American screens after a phenomenal success in Europe, Leone and Eastwood played into the antiauthoritarian fantasies

of the rebellious counterculture—with a storm trooper who answered to no higher power. It is just the sort of paradox that makes great and enduring myths. *For a Few Dollars More* followed a more familiar curve, providing a temporary partner for No Name, now a bounty hunter, in Lee Van Cleef, as a fellow mercenary whose real motive is very personal—revenge for the rape of his sister.

Eastwood has worked variations on No Name right up through *Pale Rider* (1985), but its purest and most portentous form materialized in *High Plains Drifter* (1973), the first Western Eastwood directed. Malevolent and mysterious, the unnamed Stranger comes to town in order to destroy it, just as the craven, scheming townspeople had once destroyed a young marshal, a whistle-blower who knew the shopkeepers were digging their gold out of government land. Possibly a ghost, an avenging angel, a relative of the murdered lawman (this last, Eastwood's own interpretation), the Stranger pumps up the self-righteous citizens' paranoia and then fulfills it lavishly and mercilessly. Employed to protect the town from three returning convicts the citizens had hired as murderers and then railroaded into prison, he orders the townspeople to paint the town Day-Glo red and then abandons them to the marauders, whom he ultimately kills one by one, in a midnight version of *High Noon*.

Gary Cooper's struggle addressed the question of what kind of town, state, nation we will have, but *High Plains Drifter* aims lower. The town, renamed Hell, is only there for burning, so that the murdered marshal will get his name on a grave marker, which comprises the last shot of the film. One hyperventilating French critic called the movie "a *Mein Kampf* for the West," and John Wayne was moved to write a letter to Eastwood. "That isn't what the West was all about," Wayne wrote. "That isn't the American people who settled this country." Eastwood says he replied to Wayne, "You're absolutely right. It's just an allegory."

The film's thorough misanthropy toward townies was in a direct line from the Leone Westerns, but a departure from Eastwood's first three American Westerns, *Hang 'Em High* (1968), *Two Mules for Sister Sara* (1970), and *Joe Kidd* (1972). *Two Mules* pitted Eastwood's Western hero against an actress who specialized in transcending masculine abuse—Shirley MacLaine. She spends most of the movie posing as a nun, and, in another popular Sixties trope (loner-joins-underdogs), recruits Eastwood to the peasants' cause. Both *Hang 'Em High* and *Joe Kidd* found Eastwood's characters struggling with the concept of rough justice on a frontier where a statutory system of law is just beginning to take hold. Eastwood ultimately concedes that law and community take precedence over a man's personal needs—a reversion to the John Wayne formula. Hollywood tried to tame its prodigal son come home, but *High Plains Drifter* plainly demonstrated a new agenda and new attitudes, which were erupting simultaneously in more pessimistic form in the films of Sam Peckinpah.

High Plains Drifter contains one of Eastwood's ugliest bits of misogyny. Shortly after the Stranger's arrival, a "respectable" woman (not a prostitute), who seems slightly hysterical, deliberately bumps into him on the street, slaps his cigar out of his mouth, and tells him he has the manners of a goat. He drags her into a barn and rapes her, and she likes it. Still, she tries to kill him later. "I wonder why it took her so long to get mad," he muses. His newfound sidekick replies, "Maybe because you didn't come back for more."

The overthrow of traditional courtesies (such as refraining from rape) was a crowd-pleasing feature in early Eastwood movies, as anyone visiting a packed theater could observe. Women played a marginal, decorative role in most of the Westerns, subjected to leering insult and injury, as the example from *High Plains Drifter*—not at all out of character—

demonstrates.

When Eastwood came to direct, he was almost preoccupied with women and their power. His first production was *Play Misty for Me* (1971), a sharper, less sociologically opportunistic rendering of *Fatal Attraction*, in which a disc jockey's one-night stand with a fan looses a homicidal maniac on him, his housekeeper, his best friend, and his girlfriend. Eastwood himself played the terrorized man. In the director's second film, a sentimental May-December romance called *Breezy* (1973), the teenaged flower child played by Kay Lenz teaches architect William Holden how to stop and smell the you-know-what.

Eastwood's most telling foray into the world of the female took place in *The Beguiled* (1971), a film directed by his favorite and most compatible director, Don Siegel. A wounded Yankee soldier in the deep South, Eastwood is conning women from the credits, as he sweet-talks a little girl ("old enough for kisses") who's picking mushrooms in the woods. She takes him to the Farnsworth Seminary for Young Ladies, an all-girl hothouse of repressed sexuality presided over by Geraldine Page. There his leg is bandaged and he's held virtual prisoner.

Even with his dysfunctional appendage, he has all the hens aflutter. Eastwood beguiles each woman according to her needs—or rather weakness—for what *he* needs. From the young nymphomaniac, sex; from the black slave, an unlocked door; from the tenderhearted spinster, emotional sustenance. Siegel and Eastwood defame women in this exquisitely misogynist film, but they cannot suppress the reverse thrust of the situation. The film discloses a sense of enmity that is only nominally North/South; national politics cannot match the bloodletting between male and female.

Clint runs afoul of Miss Farnsworth, who will not surrender her reigning position even for the pleasures of his bed (or rather, her bed). Found out in his perfidy and promiscuity, Eastwood suffers a bloody pseudo-castration, losing his fractured leg to Page's saw. He acquires a substitute—a loaded gun—but never counts on being undone by nefarious domesticity. In a rage he smashes the pet turtle of the little girl who first helped him. Immediate remorse and a marriage proposal to the spinster who sincerely loves him do not save him from the youngest of these furies. Her knowledge of mushrooms dispatches him at the evening table. His shroud provides the opportunity for a sewing lesson, and then the gates close safely again on Miss Farnsworth and her charges.

The Beguiled is a particularly savage film. In it women find and guard their independence in the absence of men, but their strength is presented as a feverish and unnatural state, undermined by unstable psychology and easily subverted by even a wounded, solitary male interloper. It's a far cry from *Tightrope* (1984). Eastwood did not direct that film but shaped it. He plays a morally compromised cop in pursuit of a psychotic woman-killer who shadows and in some ways doubles the policeman. Eastwood used the role to illuminate the confusion of violence with sex in our society. The cop plays out his own resentment about a failed marriage in his investigation among whores and the sexual underworld.

Tightrope also featured the most adult of Eastwood's "love interests," a psychologist given unusual interior depth by Genevieve Bujold, who must re-form the man she wants from the emotionally crippled man she first meets.

Eastwood's cinematic approach to women has matured, although it's hard to judge the years in which he insisted on casting his mate Sondra Locke, an unexpressive actress of narrow range who sued him for palimony after their 1989 split. None of his films vindicates the title of feminist filmmaker bestowed by *The Los Angeles Times* a few years ago. He's been far more probing in his protraits of men. Furthermore, with violence still his chief currency, Eastwood the performer

remains a man who always offers a (sometimes) veiled threat to women. The crime movie and the Western remain his undisputed territory; indeed, he presided over the death and transformation of one and the ascendancy of the other.

Coogan's Bluff (1968) spelled out the transition from Western to urban frontier. As an Arizona deputy sent to New York City for a prisoner, Eastwood indulged Hollywood's oldest polarization, city and country. He bests the slickers and gets his man, of course, and even wins the affections of a social worker (Susan Clark), something that would be a lot tougher for Eastwood to do once he planted the Western gunman firmly on city streets with his most famous alter ego, Harry Callahan.

The man with no name essentially acquired a moniker with *Dirty Harry*, along with a socially sanctioned occupation of maverick policeman in the flower-child city of San Francisco in 1970. Don Siegel's film marked the end of whatever lingering romance remained for Eastwood and liberal commentators. Harry made clear that Eastwood had prospered by giving voice and muscle to the white-male backlash against feminism, civil rights, and affirmative action, no matter what he might say in interviews about supporting equal rights for women and minorities. Pauline Kael attacked the film for its fascist medievalism. The Philippine police, on the other hand, wanted to use it for a training film.

The nominal villain of *Dirty Harry* is a psycho killer named Scorpio (Andy Robinson), who kills randomly and ultimately demands a ransom from the city to lay off its citizens. Harry catches him without benefit of due process, and the law lets him go. "The law's crazy," Harry says, and proceeds to dispatch the perp in his own inimitable fashion, chucking his badge into the bay after the killer's body, for good measure.

It was the same gesture that ended *High Noon*, one in which society's warrior finds the community he has defended

wanting in courage. But this time the thrust of the film was defiantly antisocial from the beginning, like the Leone Westerns, and in a milieu much closer to home than the fake frontier of Spain. It was particularly contemptuous of civil liberties and the law. The anti-Miranda message was inescapable, and the killer looked suspiciously like a leftover hippie, flaunting a peace symbol. As for Harry's methods, Eastwood himself said Harry "listens to a higher morality above the law." (So would Oliver North, according to Fawn Hall, two decades later.)

Eastwood was nevertheless stung by the furor over Harry's primitive code. In his next outing, *Magnum Force* (1973), which Eastwood thought his critics would take as a left-wing fantasy, Harry wiped out a neofascist death squad within the police department itself. They ask him to join; he replies, "I'm afraid you've misjudged me." But Harry's just as dirty as ever; only the perps are different. In *The Enforcer* (1975), Harry seemed to mellow; affirmative action stared him straight in the face in the person of Tyne Daly as a new partner, and he acquiesced reluctantly but gracefully. Of course, she did manage to take a bullet for him and die in the end (a privilege heretofore reserved for men of color in white boy adventures)—suggesting perhaps that the cost of equality might be higher than women were willing to pay. A similar mellowing can be seen in *The Outlaw Josey Wales* (1976), a counterculture Western that Eastwood directed and starred in in 1976. The farmer-turned-avenger makes his flight to Texas, reluctantly acquiring stragglers along the way—an old woman, a waif, an Indian chief—all of whom will set up communal housekeeping as Josey learns the value of detente with the natives.

By the time of the fourth Harry opus, *Sudden Impact* (1983), the vigilante mantle had been handed to Sondra Locke's avenging rape victim. Harry's fifth, *The Dead Pool* (1988), found Eastwood devoid of cogent political implications; the best he

can do is display his contempt for the entourage of an arty, violent filmmaker, a poor substitute for the bureaucrats and liberal journalists who have been Harry's real targets. In fact he meets a very nice television reporter in *The Dead Pool*, who knows a real man when she sees one. Harry doesn't hold it too much against her that she's a member of the press, though he does harangue her on the profession's thirst for blood. Times had changed and perhaps become more confusing; in 1986, when Sylvester Stallone was making his own neo-Eastwood crime movie called *Cobra*, Andy Robinson, the long-haired sleazo killer from *Dirty Harry*, could be seen playing for Stallone the real villain of all Harry's movies—a wimpy bleeding heart trying to muzzle a can-do cop.

As he's become a more accomplished actor in some forty films, and an ambitious director in fifteen, Eastwood's mythic resonance has dampened. The undistinguished *Kelly's Heroes* (1970), with its misfit GIs teaming up to hijack German gold in the midst of the Allies' European push, says more about the political use to which Eastwood's image could be put than his own spurious war rhapsody, *Heartbreak Ridge*, made in 1986. Eastwood has said he was disappointed that the "subtle antiwar message" of *Kelly's Heroes* got lost; indeed it is a Vietnam movie set in WWII, just as *M*A*S*H* is a Vietnam movie set in the Korean war.

Heartbreak Ridge, on the other hand, is unabashedly gung ho. Eastwood ripped off the name of a famous army battle to honor his Marine gunner sergeant, who is a less driven, and less compelling, retread of John Wayne's Sergeant Stryker in *Sands of Iwo Jima*. Eastwood's grizzled performance is one of his most enjoyable character turns, but even he can't muster the right stuff to make the "pre-dawn vertical insertion" into Grenada look like one of America's proudest moments, despite all the talk about evening up our score in the world. *Heartbreak Ridge* is a pathetic example of that Eighties phenomenon, the

Poor Little Superpower. The American Empire is not going gracefully into decline, apparently, but is ending with both a bang and a whimper.

Eastwood's directing career has revealed a sensibility fully aware of the contradictions in his blockbuster persona, but he can always be counted on to come back to the trough again for a turn at Dirty Harry, his most popular character. In later years Eastwood has explored—always in his own productions—good-ol'-boy romps, romantic comedies, tearjerkers, and character parts far from those that made him a star. In *Bronco Billy* (1980) he wrote his own gentle farewell to the Western, playing the buckskinned owner of a second-rate Wild West show. Billy is really an eastern refugee, and a man with enough brotherly love to let an oafish lawman humiliate him in order to help a friend.

Offscreen Eastwood has been shy about his politics, describing himself as a "a political nothing" and a moderate. A friend of Ronald Reagan—who made political hay out of Dirty Harry's famous *Sudden Impact* threat, "Go ahead. Make my day" (an invitation to congressional Democrats)—Eastwood is probably a conservative, though he does not flaunt it. He has opposed offshore drilling, lamented government freeloaders, and denounced electronic surveillance in the name of national security. He held public office, a term in 1986 as mayor of Carmel, California. In 1989 he told *The Ladies' Home Journal(!)* that he was tired of being confused with Harry. "Harry is a bitter man, a roughneck, who in effect has no choice but to rebel against the rules he considers unfair. I think the role is the one that I play best onscreen—but not in real life."

Nevertheless, Harry may well be Eastwood's most lasting legacy, overshadowing the dark compassionate poetry of *Bird* (1988), his portrait of jazz giant Charlie Parker, and such fascinating meditations on the policeman's susceptibility as *Tightrope*. When Eastwood strays further

than *Tightrope* from his assertive image, his films often fail commercially—*Pink Cadillac,* the quirky 1989 romantic comedy with Bernadette Peters, was such a flop that the trade papers began to talk about the end of Eastwood's career. *The Rookie* (1990), named for his costar Charlie Sheen, hardly reassured; as a cop movie, it's unmistakable hack work, and his heart didn't seem to be in it.

In 1991 Eastwood bravely attempted to both direct and star in *White Hunter, Black Heart,* Peter Viertel's *roman-à-clef* about John Huston. Eastwood the auteur proved far too fond of the old elephant hunter to follow through on Viertel's scathing indictment of Hollywood ego. The result was a whitewash.

None of these failures could have prepared Hollywood or Eastwood's fans, then, for the success of *Unforgiven* in the summer of 1992. It took box offices and critics by storm, and indeed serves as a kind of summa of Eastwood's Western career. In the story of outlaw-turned-farmer Will Munny, who takes up his rusty guns for a bounty hunt, Eastwood found the perfect vehicle for commenting on the web of lies that is Western legend. Not the least of these is that it's always clear who the good guys are. Eastwood spent three decades redefining them, and in *Unforgiven,* droll and dry and deadpan as it is, he has what should be the last word on the subject.

Eastwood has not found another secure box office niche like that reserved for No Name and Harry Callahan. They have the box office virtue of simple emotions, and, with Harry especially, of impeccable timing. Harry is not the anarchist that No Name is, but a man shackled to society by his badge and betrayed by it, much as some on the right claimed the U.S. military was unfairly shackled by politicians in Vietnam. Harry is more realistic than No Name and so more frustrated, like the audience who watches and cheers his liberating explosion of will upon a sluggish social order they know only too well.

In the Seventies Harry arose alongside the antigovernment, antiliberal themes of the neoconservatives. The presidential Reagan at times even seemed to be imitating Eastwood's steady, laconic whisper, a note of calm that disguised the bloody menace both No Name and Harry offered to any opponent. Both were shaped by the bitter recriminations and popular feelings of betrayal let loose in the atmosphere of the Vietnam War, to which Eastwood belongs as surely as John Wayne belongs to World War II. Eastwood ascended to a far different kingdom than Wayne's, one gone awry, where men were asked to die and kill in an unpopular war and then punished for it. Harsh times require harsh measures, and Eastwood effected a retreat into the last-ditch bastion of individualism, the lone killer with no allegiance but to himself. Spectacularly supreme in a kingdom no bigger than himself, No Name and Harry reminded Americans in general and men in particular of a lost supremacy, and perhaps inspired them to retake it.

—Pat Dowell

RECOMMENDED BIBLIOGRAPHY

Johnstone, Iain. *The Man With No Name: The Clint Eastwood Biography.* NY: William Morrow and Co., 1989.

Plaza, Guensanta. *Clint Eastwood/Malpaso.* Carmel Valley, CA: Ex Libris Publishers, 1991.

Ryder, Jeffrey. *Clint Eastwood.* NY: Dell Publishing Co., 1987.

Smith, Paul. *Clint Eastwood: A Cultural Production.* Minneapolis, MN: University of Minnesota Press, 1993.

Thompson, Douglas. *Clint Eastwood: Riding High.* Chicago, IL: Contemporary Books, 1992.

Zmijewsky, Boris and Lee Pfeiffer. *The Films of Clint Eastwood.* NY: Carol Publishing Group, 1982.

Fairbanks, Douglas
(Elton Ulman)
(May 23, 1883 – December 12, 1939)

Douglas Fairbanks has been called America's first movie hero. Because of his boyish charm and enthusiasm, Fairbanks became the nation's most popular matinee idol by 1920 and went on to become the cinema's first great swashbuckler in roles from Zorro to Robin Hood.

His early success depended upon his ability to perceive the social and political ideals and aspirations of the common man, then to embody them, quite literally, in his stage and screen personas.

Fairbanks was born in Denver, Colorado, May 23, 1883, to H. Charles Ulman and Ella Fairbanks Ulman; his mother divorced his father when Fairbanks was still a boy and by 1900 had moved her family to New York, where "Doug" made his Broadway debut in 1902. In 1907 Fairbanks married Beth Sully, the daughter of an industrialist, and tried to settle down to a "respectable" desk job at the Buchan Soap Corporation, but the theater was in his blood. By 1910 he had returned to the Broadway stage to become a star. In 1914, the same year he appeared in *He Comes Up Smiling*, considered his best Broadway role, he signed his first movie contract with the Triangle Film Corporation, a contract offering him a stable income of $2,000 per week. His first movie, *The Lamb*, directed by W. Christy Cabanne, was released in September 1915, and by December 1916 he had established himself as one of Triangle's most successful stars, able to demand a weekly salary of $15,000. Thereafter, he broke with Triangle to form the Douglas Fairbanks Pictures Corporation, with his wife Beth as vice-president and his brother Jack as general manager. Artcraft contracted to serve as

distributor for his production company for up to eight pictures annually, expected to earn $200,000 each. His business sense was demonstrably good, and within two years, in 1919, Fairbanks was to join forces with Mary Pickford (later to become his second wife), Charles Chaplin (his longtime friend), and D. W. Griffith to form the United Artists Association. At the peak of his popularity, Fairbanks himself produced the first United Artists release, *His Majesty, The American*, in 1919.

Fairbanks is probably best remembered today for the United Artists costume films—*The Mark of Zorro* (1920), *The Three Musketeers* (1921), *Robin Hood* (1922), *The Thief of Bagdad* (1924), *Don Q., Son of Zorro* (1925, with Fairbanks playing a double role as both father and son), *The Black Pirate* (1926), *The Gaucho* (1927), and *The Iron Mask* (1929). But Fairbanks was already tremendously popular and successful before moving into this phase of his career, and his political importance is perhaps best identified with the earlier pictures, which have all but dropped into obscurity. The early screen persona of Douglas Fairbanks was firmly linked to popular mythology, presenting an ideal of good-natured, patriotic optimism and an unbounded enthusiasm that would see him through any adversity. His culture heroes were Teddy Roosevelt, Horatio Alger, and Billy Sunday, and the Fairbanks persona came to embody what

these figures represented. Alistair Cooke called Fairbanks a "popular philosopher" whose "philosophy" was published in two books Fairbanks (presumably) wrote— *Laugh and Live* (1917) and *Making Life Worthwhile* (1918)—but also demonstrated by the examples set in his movies.

The Fairbanks persona is usually associated with the moneyed industrial class that Fairbanks himself married into, usually a naive idealist, restless, itching for action, but somehow interested in abstract humanitarianism and somehow believing that good will and good humor could correct social problems such as labor unrest and unemployment. Sunny Wiggins, the Fairbanks character in *The Habit of Happiness* (1916), for example, is a firm believer in "the Brotherhood of Man" who organizes a "happiness society" on the Bowery to lift the spirits of unemployed down-and-outers, the movie offering a comic variant on the theme of social improvement and a lunatic rendering of the so-called "Social Gospel." Fairbanks combined the gymnastic evangelism of Billy Sunday with the adventuresomeness and frontier curiosity of Theodore Roosevelt. Roosevelt believed that material wealth should be applied to ideal ends, and Sunny Wiggins in *The Habit of Happiness* puts that belief into practice. In *The Mollycoddle* (1919) the Fairbanks character is even made up to look like Teddy Roosevelt, who, by the way, coined the word "mollycoddle." Moreover, Roosevelt, like Fairbanks, was obsessed with the notion of physical fitness: both men were disciples of the "gospel of strenuosity," and both seemed to believe in the regenerative power of the Western frontier. The image of the apparently effete young man from the East strengthened and transformed by the Western environment is present in *The Lamb,* the first Fairbanks film, and recurs regularly in *Wild and Woolly* (1917), *The Mollycoddle, Till the Clouds Roll By,* and *Knickerbocker Buckaroo* (all in 1919), among others. The vitality of the Western hero later carried over into the United Artists features, particularly *His Majesty, The American, The Mark of Zorro,* and its sequel.

Fairbanks therefore became the paradigm for upper-middle-class striving and "values," for democracy and capitalism, for example, and against tyranny and revolution, but especially distrustful of immigrants, particularly blacks and Asiatics, as Lary May points out in his book *Screening Out the Past* (Oxford, 1980). The insidious fears of the controlling middle class suggested by Fairbanks's movies, however, are generally subsumed by the hero's positive values, his energetic good nature, and his naive charm. In brief, it is easy to dismiss the films of Douglas Fairbanks as merely escapist movies and inconsequential diversions, but their naive ideals, under scrutiny, reveal a great deal about common American attitudes during the first three decades of the current century.
—James M. Welsh

RECOMMENDED BIBLIOGRAPHY

Carey, Gary. *Doug and Mary: A Biography of Douglas Fairbanks and Mary Pickford.* NY: Dutton, 1977.

Hancock, Ralph and Letitia Fairbanks. *Douglas Fairbanks: The Fourth Musketeer.* NY: Henry Holt and Co., 1953.

Herndon, Booton. *Mary Pickford and Douglas Fairbanks.* NY: W. W. Norton and Co., 1977.

Schickel, Richard. *The Fairbanks Album.* Boston, MA: New York Graphic Society, 1975.

Tibbetts, John C. and James M. Welsh. *His Majesty the American: The Cinema of Douglas Fairbanks, Sr.* South Brunswick, NJ: A. S. Barnes, 1977.

Farmer, Frances

(September 19, 1913 – August 1, 1970)

The life and career of Frances Farmer are worthy of scrutiny not so much for what she was to Hollywood, but for what Hollywood was to her. At the outset of her career, Farmer was compared to Garbo.

She displayed the promise of becoming a fine actress and, perhaps, a shining star in the Paramount Pictures constellation. Yet, for all her gifts, she was moody and unstable. Her instincts for self-destruction were fueled by a domineering mother, and an industry which ignored her needs and required that she be no more than a well-behaved pinup. Farmer may have been intensely individualistic, and fiercely rebellious, but she lacked the temperament for survival. Liquor became a crutch and, as the result of a bizarre chain of events stemming from her arrest on a minor traffic violation, she spent five years in the violent ward of a state mental institution.

The key to understanding Farmer is her relationship with her mother, Lillian. During World War I, this woman crossed a Rhode Island Red, a White Leghorn, and an Andalusian Blue to create a red, white, and blue chicken. She dubbed the bird "Chicken Americana," and even lobbied to have it replace the eagle as the nation's national emblem.

Frances, meanwhile, was busy scandalizing her hometown of Seattle. While a high school junior, her creative writing teacher (a controversial woman named Belle McKenzie) entered an essay by Frances titled "God Dies" in the National Scholastic student writing competition. She won the $100 first prize, and created a furor because of her "denial of God." Frances, just sixteen years old, was denounced from pulpits across the country.

In March 1935, Farmer won a free trip to the U.S.S.R. in an essay contest sponsored by *The Voice of Action*, Seattle's Communist newspaper. Frances wrote a disclaimer, published in *The Seattle Times*, in which she declared that she was travelling to Russia solely because of her interest in drama. This was overshadowed by such newspaper headlines as "Co-ed Still Determined to Act for Reds," "Seattle Girl Aids Reds," and "Mother Warns Against Red Teachers." Lillian Farmer was quoted in *The Seattle Post-Intelligencer*, "If I must sacrifice my daughter to Communism I hope other mothers save their daughters before they are turned into radicals in our schools....I'm afraid Frances may never return if she goes there, and even if she does she will be so swayed by Soviet propaganda that she will become a firm Communist."

Frances did indeed return—to Hollywood, and a Paramount contract. Throughout her career she acted in only fifteen features, mostly programmers. Her top credits: *Rhythm on the Range* (1936), in which she is a runaway heiress romanced by Bing Crosby; *The Toast of New York* (1937), in which she plays the whore Josie Mansfield opposite Edward Arnold's Jim Fisk and Cary Grant's Nick Boyd; and *Come and Get It* (1936), based on Edna Ferber's epic about a Wisconsin lumber dynasty, in which she stars in two roles, cabaret singer Lotta Morgan and her daughter, Lotta Bostrum.

But Farmer's interests clearly were not in appearing in such entertainments. She originated the role of Lorna Moon in the

Group Theatre's 1937 premiere production of Clifford Odets's *Golden Boy.* At the end of the play's run, as punishment for her Group Theatre transgression and her antipathy toward life in Tinseltown, she was cast in *Ride a Crooked Mile* (1938), a one-dimensional melodrama in which she appeared as a chanteuse.

Soon after, Farmer had an affair with Odets, which is described in her posthumously published autobiography, *Will There Really be a Morning?*: "His promise of marriage ended with a wire to my hotel which read, 'My wife [Luise Rainer] returns from Europe today, and I feel it best for us never to see each other again'...Odets maneuvered me as he would a character in one of his plays. He toyed with my attitudes and reactions. He was a psychological button-pusher, able to crush me with a word or sweep me into ecstasy with a gesture...Whereas I had once lived secure within myself, after Odets I became a bundle of raw hesitant nerves, confused and almost without purpose: and it was during my affair with him that I became dependent on liquor."

Her relationship with Odets pushed her over an edge that she had, in reality, long been teetering on. While Farmer might have flourished as a stage actress, she was offered—and accepted—a Paramount contract. What ambitious young girl wouldn't? But from her earliest days at the studio, she had difficulty playing the Hollywood game. She despised posing for cheesecake and putting on a happy face for the studio publicists. She wore no make-up, drove a beat-up car, worked to support the Loyalists fighting in Spain and to improve the lot of California's migrant workers. She constantly quarrelled with her costars and directors: for example, she wrangled with William Wyler, who had replaced Howard Hawks as the director of *Come and Get It*, calling him a "slave driver." She rebelled against the roles she was assigned. She fought with the powers at RKO over their decision to soften the character of Josie

Mansfield in *The Toast of New York*.

Marlon Brando might play the off-screen nonconformist, and Bette Davis could rail against Warner Bros. casting her in superficial roles. But Farmer was no Brando or Davis, either in her psychological makeup or star power. She was, after all, only a promising newcomer. The struggle between Farmer as the sexy, mindless, publicist's creation and Farmer as a young, insecure woman clinging to her individuality is reflected in two magazine articles. One, in the February 1937 *Photoplay*, was titled "Miss Sex Appeal of 1937," while the other, in the May 8, 1937 *Colliers*, was called "I Dress As I Like."

Farmer came to see motion pictures as a false art. She believed that as a contract player without power to choose her projects she was being forced to grind out product, to appear in film after film that would rake in profits from her beauty. To her way of thinking, the studios were unconcerned with her worth as a person or growth as an actress. Hers was a classic case of wanting to be an "actress," while having to fight a system that saw her potential as that of a "movie star." After her relationship with Odets, Farmer immersed herself in her work and accepted the restrictions placed on her, yet she could not shake her reputation as a "Communist" and "rebel.'

She was lonely, she drank too much, and she popped too many amphetamines. On October 19, 1942, while driving to a party at the home of Deanna Durbin, Farmer was arrested on a minor traffic violation. Without benefit of breath test or attorney, she was charged with drunken driving and tagged with a suspended 180-day jail sentence. Three months later, after a fracas with a studio hairdresser, she was pulled from her hotel bed, arrested, and charged with failure to report to her parole officer. She was sentenced to 180 days in jail. After being denied the use of a phone, the actress was taken from the courtroom kicking and cursing. Frances Farmer was placed in a straightjacket, and given mas-

sive treatments of insulin shock. Eventually, her mother instigated her commitment to the Western State Hospital at Steilacoom, Washington. From 1945 through 1950, she remained incarcerated—mostly in a ward which housed the incurably insane. In late 1948, she may even have been the victim of a secret transorbital lobotomy.

Was Frances Farmer insane? In *Shadowland*, his investigative journal on the life of Frances Farmer, William Arnold presents evidence that the judge in charge of her commitment proceedings, John A. Frater, was powerful and right-wing; the psychiatrist assigned to the case, Dr. Donald A. Nicholson, was politically connected; and her court-appointed lawyer made no attempt to defend her. "Whether or not there was actually an overt conspiracy between Seattle politicians and specific psychiatrists to incarcerate Frances Farmer in 1944, I do not know," Arnold writes. "Given the political climate and the people involved, it seems very possible."

After her release from Steilacoom, Farmer's personality was forever changed. This once vibrant woman had become submissive and all but lifeless. After working as a secretary and sorting dirty laundry in a hotel, she attempted a comeback and appeared on TV and in a juvenile delinquency programmer titled *The Party Crashers* (1958). The hype was that the actress was "amazingly recovered" from her illness. In reality, she was barely able to memorize lines and was constantly drinking. Farmer could hardly recall major events in her life. She ended up in Indianapolis, hosting an afternoon movie program at a local TV station and attending supermarket openings. By 1966, she was drinking to such excess that she was incapable of functioning on her job, and was fired. In her last years, she was almost totally dependent upon a friend, a young widow named Jean Ratcliffe, who wrote the bulk of her autobiography.

Frances Farmer died on August 1, 1970, in Indianapolis's Community Hospital, of cancer of the esophagus. She was fifty-six.

Over a decade later, her story was recounted in a trio of films. The first two are *Frances* (1982), with Jessica Lange, and the made-for-TV feature *Will There Really be a Morning?* (1983), starring Susan Blakely. Both are well-acted dramas that more or less trace the details of Farmer's life (the latter reportedly far more factually), but offer no profound insight either into the actress or the American left of the Thirties. More daring is the independently produced *Committed* (1983), directed by Sheila McLaughlin and Lynne Tillman with McLaughlin appearing as Farmer. Here, the actress is depicted as a martyr and a model by which can be measured America's disposition to political activism and women who attempt to be assertive.—Rob Edelman

RECOMMENDED BIBLIOGRAPHY

Arnold, William. *Shadowland*. NY: McGraw-Hill Publishing Co., 1978.
Farmer, Frances. *Will There Really Be a Morning?* NY: Putnam, 1972.

The Film and Photo League

The Workers' Film and Photo League was formed on December 11, 1930, for the purpose of using cinema as a stimulus to transform the despair of the Great Depression into energy for radical social change. Three interlocking objectives made up the organization's agenda for action.

The most important of these was to produce motion pictures and still photographs centered on the struggles of American workers and to distribute those images to a mass audience. Backing up this creative work would be campaigns to promote radical films that had been made abroad and various efforts to woo American viewers away from the politics of Hollywood.

A score of filmmakers who would remain the backbone of American radical film production for decades were either founders or early members of the organization whose name usually was shortened to The Film and Photo League. Most of the FPL alumni have chosen in subsequent years to remain somewhat vague about the exact relationship between their work and the Communist Party. Some have claimed to have been politically committed to nothing more than making films for and about the working class. Whatever the degree of sectarian identification (member, fellow-traveller, sympathizer), no one could long remain in the FPL without realizing that the Communist Party was the dominant force in all of its affairs. The FPL, in fact, belonged to the Comintern-linked Workers' International Relief and absorbed a number of film-related groups previously organized by the Communist Party. The first formal meeting of the FPL was capped with a screening of the Soviet film, *In Old Siberia*.

Of the two dozen or so branches of the league which existed at one time or another with a combined membership of between seventy-five and a hundred, only the Detroit, Chicago, Los Angeles, and New York units actually produced any films. New York was the most imporant by far, doing most of the editing of FPL-released films and sending teams out to film events in parts of the country where there were no active league members. In some instances, filmmakers doubled as still photographers, and after films ceased to be produced in the mid-Thirties, the organization became The Photo League and continued to function as such until 1951 when it was destroyed in the postwar red scare.

Newsreels were the film form usually favored by the league because of their relatively low cost and their immediacy. Using handheld cameras and placing themselves in the midst of demonstrations, FPL filmmakers developed a dynamic visual style, a kind of proletarian *cinéma-vérité*. These unpaid film workers often undertook arduous trips to areas of social ferment where they worked under the threat of police and vigilante terror. Filming, editing, and screening demands often required working around the clock and taking up residence in FPL offices. Although scenes were sometimes staged for the camera and some scenes were repeated in more than one film, the FPL newsreels accurately captured the tenor of the mass movements of the time.

The esthetic principles guiding the FPL were primarily derived from Soviet film theory, especially the views of Dziga Vertov. The first American translations of Vertov's writings on film were published in

Film Front, the FPL bulletin, and in *Experimental Cinema,* a journal to which many FPL members contributed. Sergei Eisenstein's *Potemkin* and Esther Shub's *Cannons or Tractors?* were other major influences. The possibilities inherent in montage techniques were constantly debated. The filmmakers believed that rapid cutting and juxtaposing of scenes showing sharply contrasting social realities amounted to a cinematic language equivalent to the dialectics of Marxist discourse.

The League hoped to become self-supporting through the sale of its newsreels to commercial outlets, but except for an agreement reached with New York City's Acme Theater for 1932–'33, few sales ever materialized. Most FPL films had to be exhibited in noncommercial circuits organized by the Communist Party. These included innovative outdoor screenings using automobile engines as energy sources as well as meetings organized by labor, farm, and student groups. The screenings usually were part of a sustained educational program, but occasionally they took place in the midst of strikes and other agitational activities. On at least two occasions, FPL films were successfully used in courtrooms to prove that police, not demonstrators, had provoked a violent incident. As noncommercial rentals never produced sufficient income to meet FPL production needs, the cost of raw footage and processing had to be borne by the Workers International Relief. Other financial assistance came from the rental of foreign films, sales of still photographs (mainly to radical newspapers), donations by wealthy individuals, and benefits.

Educational campaigns mounted by the FPL were as vigorous as its filmmaking efforts. Through lectures, formal classes, publications, and direct action, the league attacked Hollywood for its class and racial stereotypes and for the conservative political messages implicit or explicit in most of its products. The league charged that a Hollywood conspiracy prevented the wide-spread distribution of radical films, and FPL members endeavored to bring such films to the attention of mass audiences and influential tastemakers. But the FPL was not opposed to censorship when its own ideological aims were being served. It called for the outright banning of all films from fascist countries and led boycotts against American films such as *Black Fury,* a Warner Bros. film about coal miners, and *No Greater Glory,* a Columbia film thought to glorify the military. A favored screening strategy to show what could be done outside the Hollywood studio system was to couple an FPL film dealing with the hardships of working-class Americans with films depicting social advances in the U.S.S.R.

Perhaps the most innovative and ambitious of the FPL's educational initiatives was the establishment of a film school. Named after radical film critic Harry Alan Potamkin (see separate essay), recently deceased from a stroke at age thirty-three, the school opened in 1933 with an enrollment of fifty. The faculty included Nathan Adler, Joseph Freeman, Leo Seltzer, David Platt, Ralph Steiner, Barton Yeager, Leo Hurwitz, and Lewis Jacobs. A year later a class in sound by Edgar Zane was added, and it was proposed that future courses of study involve the New Dance League and the New Theatre League. The Harry Alan Potamkin Film School was all the more remarkable as it came at a time when few universities or museums treated fim as a serious art form and fewer still sponsored film departments.

During the period the FPL was formed, the political line of the Communist Party stressed the need to portray the struggles of the working class in the bluntest terms possible. This outlook was ideally suited to the kind of films most FPL members wanted to make. As Roosevelt's New Deal took hold at home and fascism became a greater menace abroad, the Communist Party undertook a new policy of trying to form coalitions of all progressive forces which, among other things, meant far less

emphasis on points of difference.

With the change in party line, *The Daily Worker* and other Communist publications began to complain that the FPL films were too infrequent, too humorless, and too oriented to crude documentary. Some factions within the FPL responded to such criticism by deciding to break away to form new organizations. The most important of these was Nykino Films, created by a group of league members who prided themselves on their theoretical sophistication and who had long wanted to make feature films. More defections occurred with the formation of The New Film Alliance by leading Communist intellectuals active in different artistic fields. The Alliance soon took over the distribution of foreign films and other educational work previously done by the FPL. The harshest blow came from the dissolution of the German-based Workers International Relief, which had been doomed by Hitler's accession to power in 1933. Although a few films released in 1936 and 1937 can be considered Film and Photo League projects, by late 1935 most FPL filmmaking had ceased.

Despite the briefness of its existence and its haphazard financing, the Film and Photo League produced a substantial body of work. A sample of FPL titles—*National Hunger March, Harlem Sketches, The Ford Massacre, Chicago May Day, Sheriffed, Workers on the Waterfront, Hillsboro Relief Scandal*—give a sense of the range and mood of the work. Approximately a dozen of the FPL films still exist in part or in whole. Compared with the commercial newsreels of the same years, the FPL films seem somewhat amateurish. Yet the films also have a zeal and directness lacking in concurrent commercial films and in radical films made later in the decade. The FPL filmmakers effectively evoked a time when the future of capitalism was in question and no one could predict to what political banner an unhappy and volatile America would rally. The solution to the crisis favored by the FPL would be rejected, but its films remain as an invaluable documentation of some of the most bitter moments of an angry era in American life.

—Dan Georgakas

RECOMMENDED BIBLIOGRAPHY

Alexander, William. *Film on the Left: American Documentary Film from 1931 to 1942.* Princeton, NJ: Princeton University Press, 1981.

Campbell, Russell. *Cinema Strikes Back: Radical Filmmaking in the United States, 1930–1942.* Ann Arbor, MI: UMI Research Press, 1982.

The Big Sleep

Film Noir

Film noir, the crime melodrama of the Forties and early Fifties, achieved its fullest expression in the disillusioning postwar years, sounding a death knell to the myth of the American Dream of upward mobility and unlimited bounty awaiting us all. Inaugurated in 1941 with John Huston's adaptation of Dashiell Hammett's *The Maltese Falcon*, it was Hollywood's most profound response to the Depression and its aftermath.

Film noir fascinated audiences and, if the form was short-lived, it was only because it so acutely addressed the mood of that particular historical moment that its intense, highly stylized note of despair would come to seem inappropriate amid the widespread optimism of the Fifties.

The most talented creators of *film noir* included leftists like Abraham Polonsky, John Garfield, Edward Dmytryk, Jules Dassin, Dalton Trumbo, Ring Lardner, Jr., Joseph Losey, and Albert Maltz. These low-budget B-pictures, forays into the nightmare world of the decaying American city, expressed disaffection from a social order unable to cope with the economic and cultural deprivations of the Great Depression. Returning veterans, despite their service and their faith, found hard times had only deepened after the respite offered by the Second World War, and it is this insight which animates the *film noir*.

Often, as in films like *The Big Sleep* (1946), *The Postman Always Rings Twice* (1946), and *Mildred Pierce* (1945), the *film noir* is content to project an ambiance of

corruption, a universe freighted with treachery and betrayal, advancing no generalizing social commentary. Other *films noirs* are anticapitalist by design, like Abraham Polonsky's *Force of Evil* (1948), based on a novel called *Tucker's People* which attracted Polonsky because "ostensibly a melodrama…it's really an autopsy on capitalism." In both *Body and Soul* (1947), which he wrote, and *Force of Evil*, which he both wrote and directed, Polonsky's central metaphor for capitalist corruption is the underworld's hegemony over American business. The lawyer played by John Garfield in *Force of Evil* is entrusted to enact the central impulse of capitalism—to monopolize, no matter that the business in question is the numbers racket. Joe (Garfield) must squeeze out the little guy—in this case his own brother, Leo. Big business engulfs small business because under capitalism the little guy doesn't stand a chance. Polonsky expresses his moral repugnance for this system by having brother destroy brother.

In Polonsky's films the only way out of poverty is to submit to the rules of the jungle, as Garfield does both as the prizefighter Charlie in *Body and Soul* and as the upwardly mobile lawyer in *Force of Evil*. Business means selling oneself, whether in the corrupt fight game or as a shill dressed up in fancy clothes for the mob. To be "businesslike" for Charlie is to bet his purse against himself. "I just want to be a success," he begins, "it's better to win than to lose." By the end, because he is a good man, he must retire from the arena of free enterprise, defying its corrupt engineers with the bravado that originally made him so pugnacious a combatant: "What can you do? Kill me? Everybody dies."

In *Force of Evil* Leo calls Joe a crook, a cheat, and a gangster. Joe's retort is to offer to make his small entrepreneur brother rich by inviting him to join the combine. When a bookkeeper threatens to quit the rackets, Joe threatens him with death. Joe's dilemma is that of everyone struggling to survive under capitalism, "strong enough to fight for a piece of the corruption," but not strong enough to resist it. In a world where "something was wrong," where Leo's body is dumped "like an old dirty rag nobody wants," the ruthlessness of capitalism is beyond anyone's calculation.

But even in those countless *films noirs* whose scriptwriters and directors had no thought of making statements about the ruin wrought by capitalism gone out of control, the *noir* artist invariably revealed a system in severe trauma, an America transformed into a decadent landscape controlled by Mafia hoods with an underworld so pervasive that no hero, no investigator, however hard-boiled, could restore order. War had become a permanent condition, the theater of combat brought home in film after film which at last reflected realities denied by the screwball comedies, musicals, and paeans to patriotism of the Thirties and early Forties.

In *Key Largo* (1948), a typical *film noir*, Humphrey Bogart says that before the war he had "believed some words." Now he expresses disillusionment upon discovering that society has not lived up to its bargain with its fighting men, that the Depression has been replaced by something worse. Once, Bogart adds, he had hoped for a world in which there was no place for a gangster like Johnny Rocco (Edward G. Robinson). Now he discovers he must fight "everybody's battles."

So labyrinthine and deep-rooted is the corruption of the community in most *films noirs* that it is beyond the power of any individual to redress it. Bogart and Bacall are lucky to wind up in Peru at the end of *Dark Passage* (1947). The elevator man in *Double Indemnity* (1944), because he has a bad heart, cannot buy medical insurance from the same insurance company for which he has toiled his entire life. In *Force of Evil,* independently produced by John Garfield, shots of Wall Street stand for big business on the verge of swallowing up the little guy, even when he too is a racketeer

willing to play by its rules. The plot of the *film noir* is so often immune to unravelling because it parallels the irremediable evil by which society has been strangled. Asked to settle a dispute between director Howard Hawks and star Bogart as to whether one of the characters in *The Big Sleep* was murdered or committed suicide, author Raymond Chandler is reported to have replied, "Dammit, I didn't know either."

The term *film noir* was coined after World War II by French critics who saw a similarity between these films and the *série noire*, French translations of American pulp gangster stories published during the Twenties and Thirties in such detective magazines as *Black Mask*. Although *noir* stylistics occasionally crept into other genres, *film noir* became a full-blown genre in its own right, complete with visual and dramatic icons carried over from film to film, so that what John Wayne became for the Western, John Garfield, Humphrey Bogart, and frequent B-film actors like Dana Andrews and Alan Ladd were for the *film noir*. Unlike genres such as the Western or the gangster film, which evolved stylistically and which are not dependent upon a single cinematic approach, *films noirs* share a similar tone, lighting, camera angles, editing, and point of view. Yet like the Western (and the gangster film, from which it originated), the *film noir* offers a continuing set of expectations regarding the hero and a particular setting which reappears in film after film.

The *noir* setting is most often that scene of capitalism's deepest failure, the American city at night, with rain-washed pavements and a gloom predicting the lurking dangers of violence and defeat. The city stood for capitalism in its most degenerate form, as in *The Asphalt Jungle* (1950) where social Darwinism exacts its unexpected price. The hostile urban setting both defeats and outlasts the characters, which is why it is so fitting that it often figures in the films" titles:*Cry of the*

City (1948), *The House on 92nd Street* (1945), *The Street with No Name* (1948), *They Live by Night* (1948), *Naked City* (1948), *Night and the City* (1950), and *Where the Sidewalk Ends* (1950).

From alleys filled with brimming garbage cans and back streets, the *mise-en-scène* might move to the docks and waterfronts, or interiors characterized by narrow corridors—physical expressions of the claustrophobic unconscious. Spiral staircases evoke psychological disarray. Invariably, the *film noir* is set at night when the impulses of the unconscious are most likely to surface and anything can happen.

German Expressionism, brought to the *film noir* by Fritz Lang, among others, defined its visual character. The typical *film noir* image was underlit and relied on the chiaroscuro of contrasting light and dark elements for dramatic effect. Half a shot might be in light, the other half in darkness, or light might bisect a shot. Light was often manipulated to form geometric patterns, so a character might be seen behind prison-like bars of light or through venetian blinds (the metal bars of an elevator door move across Mary Astor's face as she is carried off to prison in the final scene of *The Maltese Falcon*). Shadows and silhouettes foretold of impending danger, and the sense of menace was often emphasized by unusual camera angles or lenses. Many images were seen as reflections—in mirrors, windows, or puddles of water on city streets—the reflected images on these surfaces suggesting demons within clamoring to be set free.

The characteristic plot of the *film noir* is less a causally constructed grid than a labyrinth, a maze from which there is no exit. The hero generally must uncover a secret, expose a lie or a conspiracy, and no one is safe from suspicion. It is always urgent to move swiftly because the plot revolves around matters of life and death.

Whereas narrative coherence might have suggested that the social order made

sense, the scrambled storylines and ambiguous character motivations of the *film noir* insist that it does not. Convoluted time sequences punctuated by flashbacks, as in *The Killers* (1946) and *Mildred Pierce* (1945), underline the hopelessness of all *noir* artists, left-wing or otherwise, in redressing the inequities permeating the social order. All we can do is look back and discover *how* things went wrong. To know *why* would suggest they could have been otherwise or that we can still do something about them. This investigative structure, aided by voice-over narration, is sometimes complicated by an abundance of points of view. The search for truth so often fails not only because there are as many "truths" as there are observers, but also because someone, usually a woman, is lying. Once the story has been told, nothing changes, and no one is better off. Walter Neff (Fred MacMurray), the dupe of *Double Indemnity*, does the summing up in his confession: "I didn't get the woman and I didn't get the money."

With its premise that America has failed to offer the individual a humane life, the *film noir* borrows a truth from early gangster films like *Little Caesar* (1930). The bad guy may simply be the little man who under a condition of economic deprivation saw no avenue but crime as the means to becoming "somebody." Disenchantment with a rigidly closed social structure—being on the outside without the promise of a decent life—is what leads to crime.

At the beginning of *The Postman Always Rings Twice*, John Garfield is looking for a job; he never liked any job he ever had; maybe he'll like the next one. That he does not start out as a murderer suggests that any man may wake up one day to find himself on the wrong side of the law, like Henry Fonda in *The Long Night* (1947), playing an ex-GI who returns home to become a killer.

From *Little Caesar* on, cops and hoods were doubles, mirror images of each other; Flaherty the policeman is so vocifer-

ous in his pursuit of Rico that he wishes he were not restrained by the law. "When I think of all those awful people you come in contact with, downright criminals, I get scared," the lawyer's wife tells him in *The Asphalt Jungle*. "There's nothing so different about them," he answers. In *Dark Passage* Bacall becomes interested in Bogart even before she meets him because his case so closely resembles that of her father, unjustly accused of killing her stepmother; father and lover become *doppelgängers*. We are all victims of a ruthless social order where, with no mediating moral authority in evidence, anyone can fall victim to a frame-up. "I hope I'm not a coward," Bogart says in the same film. "We're all cowards," the doctor tells him.

In such a universe paranoia replaces friendship. It is dangerous to imagine anyone a friend, although strangers may help, like the cabbie in *Dark Passage*. When comfort does come, it is not from those in power, those upper classes reeking with duplicity and betrayal. "P. Marlowe and I," Raymond Chandler wrote, "do not despise the upper classes because they take baths and have money; we despise them because they are phoney."

In a world which promises only to cheat us, someone in *The Treasure of the Sierra Madre* (1948) notes, conscience "will pester you to death." Paranoia becomes reasonable; in *Ministry of Fear* (1944) Ray Milland suspects his girlfriend of being a Nazi spy and in *Suspicion* (1941) Joan Fontaine is certain Cary Grant is trying to kill her. Dobbs out on the desert in *Treasure of the Sierra Madre* decides to bury a victim out of fear that the buzzards will give him away.

Where crime is ubiquitous, and, as *Kiss of Death* (1947) reveals, despite its tacked-on ending, the law is powerless, melodrama becomes understatement. The wise man operates on the periphery, that Hammett-Chandler antihero, hard-boiled, cognizant of his vulnerability, assuming the mantle of loneliness as the human condition, eschewing cheap sentimentality,

fortified by irony. "Success to crime!," Spade (Bogart) toasts the two cops who suspect him of killing his partner early in *The Maltese Falcon*. "In the heat of action men tend to forget where their best interests lie and let their emotions carry them away," Sydney Greenstreet's Caspar Gutman warns in the same film, speaking reliably for Hammett and Huston.

With nary an outlet for normal, generous impulses, dignity is hard to come by for the *noir* hero. "You're a stupid little man in a dirty little world," Chandler's Marlowe is told in *Murder, My Sweet* (1944). The *noir* hero is most often short (like Ladd and Bogart), fat, or homely. Garfield in *Body and Soul* is introduced to us as a prizefighter having gone to seed. "You're not very tall, are you?," Bacall's younger sister accosts Bogart in *The Big Sleep*. "I try to be," is his retort.

Hunted and weak, vulnerable and frightened, and without the slightest vision of social transformation, let alone personal liberation, the *noir* hero is always in danger of losing everything he cares for. "It's a free country," the promoter in *Body and Soul* declares, "Everything's for sale." Indeed, Mildred Pierce buys her playboy husband: "Sold—one Beragon!," she exults. "Everybody makes book on something," says Robert Ryan, the ill-fated prizefighter of *The Set-Up*.

Perception, a realistic view of the world, must be its own reward. The alternative is mental disarray since in the *film noir* psychological disintegration is always just around the corner. Indeed, what could be darker, as *The Snake Pit* (1948) and *The Lost Weekend* reveal, than the complete loss of control? Occasionally the *film noir* turned to Freudian explanation, as in *Detective Story* (1951), but always with the sense that once things start to go wrong, they will run their course and nothing can stop them.

Psychopathic villains surface frequently in the *film noir*, engineering new levels of brutality. Abraham Polonsky aspired to create a "language of the unconscious" in his *films noirs*; the genre came equipped with at least one character acting out the id run rampant, a surrogate for the boundless corruption of a dispirited social environment. The quintessential psychopathy of the *film noir* was, of course, Richard Widmark's Tommy Udo in *Kiss of Death*, amid gales of psychotic laughter pushing an old lady in a wheelchair down a flight of those omnipresent *film noir* stairs. But there were other lunatics, too—Edward G. Robinson's Rocco in *Key Largo* and Cagney's Oedipal madman in the *noir*-like gangster film *White Heat* going berserk over the death of his "Ma." The psychopath doing his worst reiterated the powerlessness of the innocent, the irredeemable vulnerability of those unallied with the corrupt powerful. Sometimes the *film noir* psychopath would be a weak but benign individual driven mad by a society offering him neither dignity nor peace, a bewildered Everyman cracking under the strain of the corruption of others. In *The Blue Dahlia*, for example, Alan Ladd plays a husband who almost shoots his unfaithful wife.

The *noir* hero is well aware that power and money are incompatible with integrity, that for every success someone must pay. What remains is survival and, in a world loaded with eccentrics and worse (*Maltese Falcon* being the paradigm), *appearing* tough must suffice. Bogart emerges from his meeting with Greenstreet amused to discover his hand still shaking; in *The Set-Up* Ryan is beaten to a pulp by the mob and will never fight again. The *noir* protagonist just misses being destroyed and, like Dick Powell's Marlowe in *Murder, My Sweet*, is too worldly not to know it. Style and arbitrary home-grown moral codes become the last defense against chaos: you may have an affair with the wife of a partner you despise, but you cannot allow his murder to go unavenged, Spade decides.

In the jungle of the *film noir* relations between men and women are tenuous at best. Women are treacherous betrayers

who turn on men and the men turn back on them. No one is really to blame since the social order is responsible for the nightmare in which people find themselves. *Film noir* heroines from Bacall and Crawford to Hayworth and Davis were among the strongest, most independent and self-sufficient women to grace the American screen, despite the distinctly misogynous cast of so many *films noirs.*

It seemed that capitalism couldn't accommodate both men and women in the work force. In the late Forties and early Fifties, not only films but also magazines and newspapers began a concerted campaign to drive all those Rosie the Riveters back into the home and out of the workplaces where they had achieved seniority and positions of responsibility. The returning veterans found a new breed of women at home. They were proud and self-sufficient, equipped with new expectations, and, both in real life and on screen, they produced a heightened sense of anxiety. With its sensitivity for expressing unconscious, unarticulated cultural tensions, the *film noir* offered a spate of works ranging from *Mildred Pierce* and *The Postman Always Rings Twice* to *The Strange Love of Martha Ivers* and *Double Indemnity* in which women are portrayed as both mysterious and frightening.

Their "criminality" seems to express itself, however, as much in unabashed sexual desire as in the greed, aggression, and ruthlessness for which the plot ostensibly punishes them. The punishment of threateningly independent women in *film noir* addressed itself to the terror of men supplanted in the job market by women whose seemingly new capacities produced sexual self-doubt in their partners. These were women with obvious sexual needs, women who could taunt men, as Bacall does in *To Have and Have Not* (1944), and they were so menacing that many *films noirs* seem positively angry at the gender itself.

To avoid the threat of the voracious "spider woman," women in *films noirs* were automatically perceived as betrayers,

deceivers, and liars, unashamed even to admit it. "I am, I've always been a liar," Brigid tells Spade, trying to disarm him by confessing. "Don't brag about it," he answers, the bravado scarcely concealing his helplessness. It was only natural that men should avoid such women. Their evil, their moral unreliability, justifies the films' sexism and misogyny, and society's determination to bar them from factories and other work places. "I hate all women," Wally complains to Ida in *Mildred Pierce,* "Thank God you're not one."

Visual icons characterized these women: the long, tossed hair of Bacall; Veronica Lake's long legs encased in silk stockings atop spike heels; Barbara Stanwyck and her gold ankle bracelet in *Double Indemnity,* Mildred Pierce enticing Monte Beragon from atop a ladder; Cora in *The Postman Always Rings Twice,* Velma in *Murder, My Sweet.*

These sensual women were often also criminals with mysterious pasts, their punishments satisfying the Breen Office and MPAA rulings, although they were chastised as much for their sexual aggressiveness as for actual crimes. Often, like Lana Turner's Cora, they prefer to have some man do the killing for them. In *Postman,* Garfield would have been satisfied just with her; it is Cora for whom love without money is not enough, who won't start out "like a couple of tramps." The Garfield character doesn't want to murder Cora's husband Nick ("He never did anything to me"), but she eggs him on.

In such a context love becomes indistinguishable from erotic obsession, and sexual gratification is possible, as in *Woman in the Window* (1944), *Double Indemnity,* and *The Lady from Shanghai,* only outside of marriage—further justification for the punishment of such intrinsically evil heroines as Ava Gardner in *The Killers* who allows her lover to take the rap for her and then twice betrays him.

Relationships between men and women are also uneasy because the women, motivated by corrupt values, are likely to hide

their true colors behind false appearances of innocence. You're "not the kind of person you pretend to be," Spade tells Brigid. Men of the world, Bogie and Greenstreet, unlike Astor, are straightforward and understand each other, knowing "everybody has something to conceal." So Bogart can laugh when Greenstreet says, "If you lose a son, it's possible to get another. But there is only one falcon," *film noir* cynicism at its best. The only woman who can be trusted is the nonsexual one. "You're a good man, sister," Bogart tells his trustworthy secretary, Effie, the only woman in the film with whom he does not go to bed.

At the end these spider women get their just deserts. Spade himself sends Brigid over, knowing he could never trust her again. Uncovering Brigid's duplicity was solving the puzzle of the falcon; understanding Mildred's unnatural erotic obsession with her daughter Veda illuminated the reasons for that woman's tragedy.

But what remains for us of these dark erotic women is the image of their strength and determination, their unrepressed sensuality and their restlessness. Even their emotional hysteria, the sense that we will never know how bad they are, is fascinating. A sympathetic Bacall in *Dark Passage* admits, "I was born lonely." We remember not the Mildred in a light-drenched final scene returning to her boring middle-class husband Bert, but the Mildred who told us how she stood on street corners counting cars until she found just the right location for her first restaurant.

Love does triumph at the close of *The Big Sleep, To Have and Have Not, Key Largo,* and *Dark Passage,* perhaps because Bogart and Bacall as a couple had become icons in their own right. "What's wrong with you?," he asks at the end of *The Big Sleep.* "Nothing you can't fix," she replies. But there is no kiss, no clinch. All they do is face each other.

The *film noir* rarely ended happily. No matter how the camera tilted and dollied,

reaching for high angles or low, the truth could neither be known nor set anyone free. There would be no redemption, no recompense, for the innocent paying for somebody else's crime. The real crime in the *film noir* was asking too many questions, demanding to be left alone, hoping to partake of the promised right to the American Dream.

These films appealed to their audiences primarily as crime melodramas; the stylistic conventions of the genre precluded it from becoming overtly political. The *film noir* was successful because it made no statements, its style alone enunciating the tone of social disarray. With stoicism and bravado, shunning explanation (these were never "message films"), they showed that things are likely to end badly. "Short farewells are best," quips Sydney Greenstreet, departing *Falcon* with a flourish. In the world of the *film noir,* the lingering hope that merit will be rewarded or goodness triumph are best left to the fools and the phonies.

Film noir drew to a temporary halt in the Fifties, its last great expression Orson Welles's *Touch of Evil* (1958). Many *noir* artists were blacklisted. In any case, the forced good cheer and easy panaceas of Fifties' films precluded the truths of the Thirties and Forties which the *film noir* actually addressed. An inspirational boxing biography like *Somebody Up There Likes Me* (1956) would replace the tawdry environments and brutal honesty of films like *Body and Soul* and *The Set-Up.*

Film noir was a genre rooted in a historical moment of political disillusionment. The Forties films had been, in part, a response to the failure of the radical politics of social transformation in the Thirties. The *film noir* genre was renewed in the Seventies and early Eighties, another period marking the collapse of a decade of political hope. In *Chinatown* (1974), giant, untameable forces overwhelm society. Noah Cross (John Huston) is the pioneer monopoly capitalist who seizes the entire water supply for the city of Los

Angeles for his own gain. In both style and attitude, *Chinatown* is a classic *film noir*. Given the right time and the right place, Cross pronounces, anyone can be tempted to do anything. He is so rich that he can commit any crime with impunity, including incest. No one can stop him, for as his daughter-victim screams, "He owns the police." *The Long Goodbye* (1973) and *Farewell My Lovely* (1975) were less distinguished examples. Stylistic elements of *film noir* surfaced even in a Western like *McCabe and Mrs. Miller* (1972) with its bleak, color-bleached effects and its tale of a ruthless corporation extending its tentacles over all. The 1982 spoof *Dead Men Don't Wear Plaid* revealed a continuing fascination with the genre, while *Blade Runner* (1982), with its cynical, down-and-out hero speaking in voice-over, marries *film noir* with science fiction so felicitously that the film is a near masterpiece demonstrating, like *Bonnie and Clyde*, the imaginative resiliency of the genre.

—Joan Mellen

RECOMMENDED BIBLIOGRAPHY

Crowther, Bruce. *Film Noir: Reflections in a Dark Mirror.* NY: Continuum Publishing Co., 1989.

Hirsch, Foster. *The Dark Side of the Screen: Film Noir.* San Diego, CA: A. S. Barnes, 1981.

Kaplan, E. Ann., ed. *Women in Film Noir.* Urbana, IL: University of Illinois Press, 1980.

Krutnik Frank. *In a Lonely Street: Film Noir, Genre and Masculinity.* NY: Routledge, Chapman and Hall, 1991.

Ottoson, Robert. *A Reference Guide to the American Film Noir: 1940–1958.* Metuchen, NJ: Scarecrow Press, 1981.

Silver, Alain and Elizabeth Ward. *Film Noir: An Encyclopedic Reference to the American Style.* Woodstock, NY: Overlook Press, 1992.

Telotte, J. P. *Voices in the Dark: The Narrative Patterns of Film Noir.* Urbana, IL: University of Illinois Press, 1989.

Flaherty, Robert Joseph

(February 16, 1884 – July 23, 1951)

Although he spent much of his life in faraway places, Robert Flaherty was a quintessentially American filmmaker. Often regarded as the 'father of the documentary,' Flaherty's quasianthropological docudramas celebrate a cult of innocence which has more in common with the sensibilities of Whitman, Melville, and Twain than with John Grierson and the didactic British Documentary Movement, a group with which he was sometimes identified.

From *Nanook of the North* (1922) to *Louisiana Story* (1948), Flaherty's films are nature fables *sui generis*, artlessly simple stories which pit representative human heroes in survival battles against large and impersonal forces of wind, water, and ice.

In a career that spanned some thirty years, Flaherty completed only seven films, most of them short and marginally commercial. Yet he was enormously influential and established a reputation as an

important stylistic innovator. This reputation is all the more remarkable since Flaherty remained essentially a silent filmmaker well into the sound era and never fully mastered some of the fundamental elements of cinematic grammar and editing.

Born in 1884 in Iron Mountain, Michigan, he was strongly influenced by a time he spent as a boy with his father on the Canadian frontier. During a series of mineralogical explorations in the Hudson Bay region (1910–'21), he began to photograph Inuit people (Eskimos), first with a still camera and later with a Bell and Howell on which he had received three weeks of instruction, his only formal training as a cameraman. In 1922 he produced *Nanook of the North*, a technically simple but ground-breaking work which inaugurated a new cinematic genre—the nonfiction film or "documentary," as John Grierson was later to call it.

Prior to *Nanook*, other films of actuality had appeared—primitive newsreels of World War I, travelogs, Martin Johnson's *Jungle Adventures* (1921)—but Flaherty was the first to make a nonfiction film which had coherent esthetic shape and purpose, the first to portray the daily life of a nontechnological culture. *Nanook* is not an entirely accurate record of that culture, however. Most of the scenes were specifically staged for the camera. The primitiveness of the twentieth-century Inuit was artfully enhanced. The fur costumes which Nanook and his family wear *are* costumes, purchased by Flaherty for them. Despite his insistence that his camera eye was innocent of preconceptions, Flaherty clearly set out to create certain existential encounters between Man and Nature. The stark contrasts inherent in the Arctic landscape were ideally suited both to Flaherty's Victorian moral values ("struggle builds character") and to the values of his orthochromatic film stock. These contrasts lend a mythic quality to Flaherty's simple long shots—small black figures moving slowly across an expanse

as empty and unforgiving as the *mare* of the moon.

In *Nanook*, as in *Moana* (1926), *Man of Aran* (1934), and *Louisiana Story* (1948), Flaherty indirectly conveys more about his own industrial society than he does about the alien society he ostensibly investigates. His films invariably contain a silent dialectic between past and present which mourns for the world as it is by recreating the world as it once was—or ought to have been. The physical and emotional closeness of the Inuit community is a deliberate reverse image of modern alienation. The sheer intensity of Nanook's life, the easy laughter that comes from living close to the edge, express for Flaherty the existential poverty of consumer capitalism. Here are a people who have everything by virtue of having nothing at all.

Flaherty had little gift as a cinematic storyteller—odd since in private life he was renowned as a raconteur. In absence of true plot, his scenarios rely instead on a unit of mood and symbol and a set of simple suspense constructions, the visual equivalent of shaggy dog stories. The first of these anecdotes appears in *Nanook*. In a long sequence shot basically from one static camera setup, Nanook struggles with a fishing line which descends through a hole in the ice. His prolonged exertions, presumably intended by Flaherty to be heroic (the ur version of Hemingway's *Old Man and the Sea*), gradually take on a cosmic-comic quality analogous to Buster Keaton's struggles against the wind in *Steamboat Bill, Jr* (1928). The punchline of this protracted existential joke is a limp seal (obviously long dead).

This elemental moment—a man struggling with invisible forces, a man struggling for mastery of himself—is the sense of emotion for Flaherty, a moment he tries to repeat in each of his subsequent films but never quite recaptures with the same purity of line and context as he did in *Nanook*. His second major film, *Moana* (1926), shot on location in Samoa, is more

technically innovative (with its long, slow camera movements, high angle shots, and pioneering use of the chromatically richer panchromatic filmstock), but its almost stereoscopic images are emotionally flat and lack the symbolic coherence which made plot irrelevant in *Nanook*.

The environment of Samoa was essentially benign and giving, and Flaherty had difficulty finding a locus for the elemental struggle between Man and Nature which was his preconceived theme. To create dramatic conflict, he bribed his native collaborators into resurrecting for his camera an ancient rite of passage in which a complex design is etched into the flesh by means of a mallet and chisel. The mythic importance of the design was less important to Flaherty than the pain. Tatooing was a "character-building" ordeal which introduced necessary hardship into an otherwise too sensual lifestyle.

In *Man of Aran* Flaherty again introduced a deliberate anachronism—the hunting of the Basking Shark. The Aran Islanders actually had more problems with their British landlords than they did with sharks, but Flaherty, interested in the dialectics of wave and shore rather than the dialectics of class, needed a symbolic Moby Dick, a hostile force against which men could be made to test themselves. Excising modern technology from his frame, he insisted that his native collaborators relearn the use of the harpoon.

Elephant Boy (1937) and *Louisiana Story* reveal more clearly than *Aran* the sentimental underside of Flaherty's fables. The essential image in both films—a little boy's mastery of a big beast—is the paradigm of all of Flaherty's work, including *Nanook. Elephant Boy* and *Louisiana Story* mythologize Flaherty's own Family Romance with his father on the Canadian frontier at the turn of the century, detailing prelapsarian male worlds in which the civilizing-constraining influence of women is noticeably absent. Although Flaherty is often praised for having communicated "the clear, true vision of a child," both films project a peculiarly tricky, adult view of a child's view of the world, filtered through the lens of the Protestant work ethic.

At the end of *Louisiana Story* (sponsored by Rockefeller's Standard Oil) the adult oil drillers, who at first seem to disrupt the primordial environmental rhythms of Bayou life, are ultimately partnered by the mystical boy-hero. The resultant father and son reunion not only cancels Oedipal guilt but also seamlessly joins the ancient world of passive, pantheistic ritual to the modern world of aggressive technological transformation. Flaherty's final film thus brings his life and art into an aesthetically pleasing closed circle—but only by using imagery which generates a dangerous political simplicity.—Nancy Steffen-Fluhr

RECOMMENDED BIBLIOGRAPHY

Barsam, Richard Meran. *The Vision of Robert Flaherty: The Artist as Myth and Filmmaker.* Bloomington, IN: Indiana University Press, 1988.

Flaherty, Frances Hubbard. *The Odyssey of a Film-maker: Robert Flaherty's Story.* Putney, VT: Threshold Books, 1984.

Murphy, William. *Robert Flaherty: A Guide to Research and Resources.* Boston, MA: G. K. Hall, 1978.

Rotha, Paul. *Robert J. Flaherty, A Biography.* Philadelphia, PA: University of Pennsylvania Press, 1983.

Ford, John
(Sean Aloysius O'Fearna)

(February 1, 1895 – August 31, 1973)

illiam Blake suggested that in poetry, as in the Kingdom of Heaven, all are equal. But in American filmmaking, that is, in the Kingdom of Hollywood, some are more equal than others. If D. W. Griffith is undeniably the most important American director of the silent era, John Ford seems just as undeniably the most important American director of the sound era.

Granted, that may be partly by default, for who are Ford's possible rivals? Capra fizzled; Welles fell victim to Hollywood, or his own weaknesses, or both; Hitchcock, even with his pointed social satire and his virtuosity as a technician, is at his most complex in a narrow world of individual psychology and obsession; while Hawks, for all his ability, is less centrally situated in the political and cultural mainstream. Hawks could go where Ford feared to tread: into the modern world, into an urban and urbane society. But no filmmaker was more important in representing American history, American myths, and American values than John Ford—and not just because he made John Wayne a major star and Monument Valley the archetypal Western landscape.

Like a storybook figure in one of his own films, the young man born Sean O'Fearna in Maine went west and became John Ford. He made well over a hundred films during a career that breaks roughly into three sections. The silents, mainly Westerns, are almost all lost. Among those that do survive, two of the most significant are tributes to empire building and Manifest Destiny. *The Iron Horse* (1924) tells the story of the transcontinental railroad that represented "the inevitable path to the West"; *Three Bad Men* (1926) celebrated the homesteaders, with the trio of

the title among the first of Ford's self-sacrificing heroes, who surrender their own lives for the good of the community.

From roughly the coming of sound to World War II, Ford gained recognition as the best "all-rounder" in Hollywood. This second period features a series of literary adaptations, beginning with *Arrowsmith* (1931), then moving to the self-consciously artistic, "masterpiece" style of *The Informer* (1935), before reaching a climax with *The Grapes of Wrath* (1940) and *How Green Was My Valley* (1941). The last three won Ford Academy Awards for Best Director. But there are other important works from this period, including *Stagecoach* (1939) and *Young Mr. Lincoln* (1939), which occasioned Eisenstein's observation that Ford's craftsmanship and harmonious view of the world seemed to grow out of "a womb of popular and national spirit."

For Ford, as for other directors such as Stevens and Capra, World War II marked not just an interlude but a turning point. During the war Ford worked for the Office of Strategic Services (O.S.S.), supervising the gathering of reconnaissance footage while making training films and propaganda documentaries such as *The Battle of Midway* (1942) and *December 7* (1943), as he was to do later with *This is Korea!* (1951).

In the postwar period, as America and

Hollywood changed dramatically, Ford entered a new stage, when he again became known primarily as a director of Westerns. When not working in Monument Valley, Ford turned increasingly to distant locales—Ireland, Africa, the South Seas, China. His apparent distance from contemporary America and his apparent marginality in Hollywood did not prevent him from making intensely personal films that in their own fashion represent an extraordinary response to American society around the mid-century.

Like many other figures from the early days of Hollywood—like most people, perhaps—Ford became increasingly more conservative, and this has colored the perception of his politics. Near the end of his life his devotion to the military led him to aid in the making of a Vietnam propaganda film, *Vietnam! Vietnam!* (1972), and one of the most disturbing moments in the history of the relationship between Hollywood and Washington was Ford's obeisance to Richard Nixon during a 1973 tribute to Ford sponsored by the American Film Institute. But that was just after the Vietnam POWs were released, and Ford was a loyal Navy man made a full admiral that night by Nixon, who was, after all, his commander-in-chief.

Politically and personally, Ford was a guarded, complicated man. He apparently only began voting Republican with Goldwater (there are conflicting reports). As one might expect of a liberal, Democratic, Irish Catholic, he adored Kennedy, but he despised Johnson. Though some members of his stock company, notably Wayne and Ward Bond, played reactionary roles during the McCarthy period, in a famous meeting of the Directors Guild—which he had helped organize—Ford defended Joe Manckiewicz against a right-wing attack led by Cecil B. De Mille. He regarded the witch hunts as mere publicity-seeking, and responded when he heard of blacklisted actors by saying, "Send the commie bastard to me, I'll use him."

Ford's Catholicism may account for some of his conservatism, as in the redemptive pardon at the end of *The Informer* (though it represents a compromise version he resisted), the religious vision near the end of *How Green Was My Valley*, and his decision to film Graham Greene's *The Power and the Glory* as *The Fugitive* (1947). But his Catholicism also gave him an outsider's point of view, as did his Irishness and his awareness that show business was not universally regarded as a respectable profession. *Stagecoach* begins with a comment on "a foul disease called social prejudice" and ends with sarcasm about "the blessings of civilization." It is the bank president who is the scoundrel, blustering about "America for Americans" and "What's good for the banks is good for the country" as he absconds with the assets of his bank. The hero and heroine are a prison escapee and a whore, aided and abetted by a drunk doctor.

To look for any sort of Marxist analysis of class conflict in Ford would be misguided. Yet in *How Green Was My Valley* Ford pointedly distinguishes between the mineowner and his blackguard son on one side and the noble foreman and his stalwart, prounion sons on the other. In later films, Ford makes it clear that his sympathies are primarily with the enlisted men in the cavalry and with the officers only insofar as they are enlightened, unlike the rigid, disdainful West Point colonel in *Fort Apache* (1948). Throughout his career, Ford showed an unmistakable disrespect for authority—excepting, of course, his own, and that of the paternal figures in his movies with whom he identified.

Ford's version of *The Grapes of Wrath*, as has many times been pointed out, is less radical than the book. Still, Ford has the benign manager of the only decent camp for migrants played as a miniature FDR, complete with cigarette holder and pince-nez. Ford was no radical by the Hollywood standards of the Thirties; the Communist Party was far out of his range. When Tom Joad asks another character in the movie

about the "Reds," the reply is, "I ain't talking about that one way or another." But Ford described himself as "a Socialistic Democrat—always left" in 1937, on at least one occasion gave a speech attacking Wall Street, and supported both the Spanish Republic (unusual for a Catholic) and the New Deal. Such a position was not exactly the norm among those with incomes in six figures.

Ford's most famous statement about his politics—"I love America. I am apolitical"—may sound paradoxical. Certainly no American filmmaker, not even Capra, made so many films dealing with politics and political figures. Lincoln in particular appears again and again, in small parts as in *The Prisoner of Shark Island* (1936), and in large ones as in *Young Mr. Lincoln*. He is Ford's political polestar, as is shown in *Cheyenne Autumn* (1964), Ford's apology to the Indians, when Edward G. Robinson as Carl Schurz looks at a picture of Lincoln as a symbol of guidance when confronted with a difficult situation.

Ford often uses fictional political characters as well, such as the title character in *Judge Priest* (1934), Senator Ransom Stoddard in *The Man Who Shot Liberty Valance* (1962), and Frank Skeffington, the mayor of Boston, in the film version of Edwin O'Connor's *The Last Hurrah* (1958). There are also figures with a quasipolitical significance, such as MacArthur in *They Were Expendable* (1945). In many of Ford's Westerns the officers are, as authority figures, much like politicians, though with a more exalted sense of duty; the politicians themselves are frequently shown as self-important bumblers, or worse, like the self-serving officer in *The Horse Soldiers* (1959), a kind of Civil War Western, who thinks of military success only insofar as it can help his postwar political career. In that light, Ford's statement makes sense: he upholds patriotism while criticizing politics and politicians.

Ford's politics appear mainly outside government, with the important exception of the military; they are embodied in his view of history and society, which turns in the course of his career from idealism (if not optimism) to stoicism (if not pessimism). Ford frequently indulged in sentimentality and low comedy in equal amounts, but the heart of his work was tragic, and the tragedy was based upon the lack of conviction that the things he revered most—family and duty and justice—would triumph, or even survive. As Jeffrey Richards has concluded, "Ford's work can be seen as a single extended soliloquy by the director over the grave of the American Dream."

The apparent conservatism in Ford's postwar films, such as the so-called Cavalry Trilogy—*Fort Apache* (1948), *She Wore a Yellow Ribbon* (1949), *Rio Grande* (1950)—is qualified by the most important aspect of his late style: the calling into question of necessity is insisted upon. Or, as expressed in a famous line repeated in *Fort Apache* and *The Man Who Shot Liberty Valance*, "When the legend becomes fact, print the legend." Ford knew that the historical myths he promoted were just that, and his honesty compelled him to expose them. Yet he insisted that "It's good for the country to have heroes to look up to." Thus *Fort Apache* presents a Custer-like martinet played by Henry Fonda who stupidly leads his men into a massacre, then, given the chance to escape, returns, suicidally yet nobly. His memory is upheld because debunking would be socially destructive. Ford's double vision, though not always sustained, sets him apart from the naive (Capra) and the simple gung-ho guys (it was Allan Dwan, not Ford, who directed Wayne in *The Sands of Iwo Jima*), as well as from later revisionists on the left (Penn, Altman) and the right (Peckinpah).

Ford has often been regarded as sexist, racist, and jingoistic, yet those epithets do him no justice: he was also an admirer of female strength, minorities, and other nationalities. *They Were Expendable* is among the least jingoistic of WWII movies, with no anti-Japanese sentiment to speak of. All the same, Ford's treatment of minori-

ties and women and foreigners suffers from paternalism and condescension, and a disturbing romanticism. Thus, when Ford attempted to present the Indian side of the story of the West in *Cheyenne Autumn*, he only exposed his preconceptions in a different fashion. He tried unsuccessfully to convince the producers to use Indians rather than whites to play the main Indian roles, but in any case he wanted to use Navajos to play the Cheyenne, as he had used them to play Apaches. An early description of the film noted that "The Cheyenne are not to be presented as heavies, nor are they to be ignorant misguided savages...If there is to be a heavy, it must be the distant United States Government, a government blind to the plight of the Indians." But there is something askew in having the Army "portrayed as a group of dedicated professionals trying to keep the peace despite Washington's mismanagement" and the Indians as "magnificent in their stoical dignity." The melodramatic division into good guys (Indians and cavalry) and bad guys (politicians and speculators), though qualified by a few exceptions such as the embattled Schurz, is too sharp: it does not match the complex ambivalence of Ford's overall sense of history.

A similar problem arises in *Sergeant Rutledge* (1960), Ford's tribute to the black soldier, where the entire narrative is compromised by an underlying inability to confront the problem of racism head-on. Resorting to a story of an innocent black falsely accused of rape, as in *To Kill a Mockingbird*, is too simple a formulation. The film is therefore limited as most Hollywood social-problem films are limited, tripped up by its own good intentions and attempts at candor, as when a dying black cavalryman says, "We're fools to fight the white man's war," only to have his comrade respond with the inadequate rejoinder, "We're fighting to make us *proud*."

What redeems Ford, given his personal and esthetic and political trespasses, is his talent, of course, and his willingness to dramatize his conflicting ideas and tensions.

Above all, there is his magnanimity, his greatness of spirit. His politics are, finally, to be found in the human sympathy that he bestows upon characters and situations. Perhaps to regard Ford in this way is sentimental; but to withhold admiration for Ford at his best—for instance, in the early films with Fonda, or the late films with Wayne—is to place political dogma over human concern in a narrow, self-defeating way. That Ford, essentially a man of the Thirties and of the studio system, does not pass ideological muster by the standards of the Sixties and after is neither surprising nor damning.

Ford's postwar desire to get out on location, and in effect away from the modern world, led him to embrace that curious twilight genre, the Western, where, as Robert Warshow observed, "it is always about 1870—not the real 1870, either, or the real West." Ford's vision of America finds its epitome in that metaphysical landscape that he made all his own, Monument Valley. It could be Texas, it could be Tombstone: it signified "The West." Ford's displacement in time and space paid off, because it gave him a set of conventions within which he could create his historical romances, at bottom social allegories, narratives embodying a consideration of abstractions such as Justice and Violence and Freedom and Masculinity and Femininity. At the same time, the historical distancing allowed a kind of searching topicality that would not be possible in a modern-day version. The psychotic racist virulence of Richard Widmark in *No Way Out* is nothing compared to that of John Wayne as Ethan Edwards, the Ahab of the West, in *The Searchers* (1956)—partly because of our awareness that it is John Wayne, that American icon, playing a role that as Godard noted is both irresistible and horrifying.

Ford's values might seem perfectly representative of his generation, the generation of white, middle-class Americans, children of immigrants, who started out adventurous and liberal and Democrat and became successful and conservative and

Republican. At first glance, Ford's male, military-dominated universe seems an exact reflection of a businessman's power elite view of America. Yet Ford was in the peculiar business of filmmaking, and so instead of simply selling some product and making money and playing golf and the like, without ever being forced to assess America's past and present, Ford was making films that mirrored his own feelings, for better and for worse. Or rather, for bitter and for worse. Ford's self-portrait is not just in Ward Bond's caricature of the director as "John Dodge" (!) in *Wings of Eagles* (1957); it's also in the portrait of Spig Wead. And a bleak portrait it is, too, not just in the stunted marital relationship, but in the ambivalent results of a lifelong devotion to an institution: Wead's dedication to the military is comparable to Ford's dedication not just to the military, but to the film industry as well.

A similar subtext seems visible in *The Last Hurrah*, where, in mourning the passing of Mayor Frank Skeffington, autocratic yet ultimately benign, Ford mourns himself—as in the retirement of the Wayne character, Nelson Brittles, in *She Wore a Yellow Ribbon*, as in the death of Tom Doniphon (Wayne again), the West, and the Westerns in *Liberty Valance*. In these films the populist vitality of the folk tunes and the tragic piety of "The Battle Hymn of the Republic" have long since departed. The Ford mourning Skeffington's defeat stands in marked contrast to the Ford who captured the lyrical, buoyant spirit of *Young Mr. Lincoln*. The Lincoln of Fonda and Ford is an individual who, as the *Cahiers du cinéma* editors noted in a famous critique, moves untainted beyond the political process to a transcendent, if tragic, status. He is the embodiment of American ideals—the spirit of law and righteousness, filial devotion and generosity, humility and wit. In Ford's last films this triumphant spirit is lost: there are no more flagraisings and churchraisings, no more of the dances that indicate communal harmony. The founding faith of the communities in *Drums Along the Mohawk* (1939), *My Darling Clementine*

(1946), and *Wagon Master* (1950) weakens and disappears; the old get older, retire and die, leaving behind young men and women who are not their equal.

If Ford's later Westerns are repeatedly elegiac, his non-Westerns represent a search for a time and place where his model of community can still be found—in the Never Never (Ire)land of *The Quiet Man* (1952), a quaint haven from the deadly violence the Wayne character experiences as a boxer in the United States, or the Polynesian paradise of *Donovan's Reef* (1963), where even prim and proper Bostonians come round. Perhaps most striking of all, Ford remakes *Judge Priest* (1934) as *The Sun Shines Bright* (1953), one more journey into the post-Civil War South where the benign paternalism of the judge, the perfect image of the leader as nonpolitician, unites the community—redneck and black, Jew and gentile, Northerner and Southerner. It is a dream, and a sentimental one at that; it was old-fashioned when Ford did the first version and it was doubly old-fashioned and fading fast when he did the second, but it remains central to his vision of small-town life as the heart of American society, where the good triumphs and lives happily ever after. And it is, in its own way, a noble dream of tolerance, benevolence, and decency.

If Ford is in many ways the representative man, that does not mean that he is always the most exciting: in Ford's films, after a point, the world is established and the proceedings are conventionalized, like the jokes ("JONES!" "Name's *Smith*, sir."). There is room for elaboration and fine execution, but not for innovation. His late style can be an instrument of economy and clarity; it can also be stilted and uneven. The idea of Ford making a Hawks comedy, or *Citizen Kane*, or *On the Waterfront* is all but unimaginable, although Ford did things that resembled elements of those films, was a close friend of Hawks, and was greatly admired by both Welles and Kazan. (Ford was supposed to direct *Pinky*.) Ford makes many supposedly serious directors

seem like puppies, and not just because he was adept at creating the macho image of John Wayne toughness: to see Michael Cimino trying to place figures in the landscape of *Heaven's Gate* or Lawrence Kasdan mucking up (and trying to send up) the Western in *Silverado* is to miss Ford's eye, his dramatic sense, his assurance. Yet the energy and ferocity of a film like Peckinpah's *The Wild Bunch* seem modern in a way that Ford's filmmaking no longer does. Though Ford may have helped perfect the classic Hollywood style, formally his work does not open up possiblities for filmmakers, as films like *Kane* and *8 1/2* do. But *The Searchers* (1956) has rightly been called "the cult film of the new Hollywood" because of its influence upon filmmakers such as Scorsese, Lucas, and Schrader. As filmmaking, the movie has its great moments but just as frequently wobbles. As a study of cultural tensions, however, of the relationship between savagery and civilization, the film remains unrivaled. With its wrenching plot of sexual frustration and isolation, massacre, revenge, and rescue, *The Searchers* represents as complex and personal a bit of auteurism as Hitchcock's study of sexual obsession in *Vertigo*.

There is something terribly sad about the transformation of Ford from the determination in the face of adversity in the Thirties to the fatalism of the Fifties and Sixties, where the desire to affirm is checked by an agonizing sense of loss, a crumbling faith in social institutions and individual goodness. Beneath the apparently simple surfaces of his later work lies a profound disillusionment and questioning. Films like *The Wings of Eagles* and *The Long Grey Line* (1955) are in their own way as desolate as anything by another of Ford's admirers, Ingmar Bergman. Ford's last film, *Seven Women* (1956), is a throwback to the Thirties that depicts a small community beset by its own internal weaknesses and the barbarians at the gate, with the heroine, the last of Ford's self-sacrificing heroes, a hard-bitten doctor whose cynical worldliness cannot hide her heart of gold.

Even in the Thirties, when Ford was most confident in his heroes and in the essential goodness and indestructibility of "the people," his films did not proclaim that life was all sweetness and light. Ford's dark side comes out as melancholy in *Young Mr. Lincoln* and borders on nihilism—tempered by fatalism—in *Liberty Valance*, where the inevitability of historical change is accepted but not identified wholly with progress. If Ford is apolitical, that is because in the end, for all his concern with community, he is also profoundly asocial, even antisocial. Ford reveals what seems a typically American split, at once devotional and distrustful with respect to government and social life. *The Searchers*, he said, is "the study of a loner." For all his fullness of feeling, Ford's view of humanity is ultimately that presented in the epigraph to *The Long Voyage Home* (1940), where men who live on the sea "never change," but "live apart in a lonely world." All possible shelters, all possible bonds—the military, home, and family—count for little in the face of such a devastating view of the world. That is why in the end for Ford politics must appear not merely as an objectionable, petty business but an inconsequential one as well, having nothing to do with the essentials of human experience.
—Robert Silberman

RECOMMENDED BIBLIOGRAPHY

Anderson, Lindsay. *About John Ford*. NY: McGraw-Hill Publishing Co., 1981.

Bogdanovich, Peter. *John Ford*. Berkeley, CA: University of California Press, 1978.

Lourdeaux, Lee. *Italian & Irish Filmmakers in America: Ford, Capra, Coppola and Scorsese*. Philadelphia, PA: Temple University Press, 1990.

Maland, Charles J. *American Visions: The Films of Chaplin, Ford, Capra and Welles, 1936–1941*. Salem, NH: Ayer Company Publishers, Inc., 1977.

Place, J. A. *The Non-Western Films of John Ford*. Secaucus, NJ: Citadel Press, 1979.

——— *The Western Films of John Ford*. Secaucus, NJ: Citadel Press, 1979.

Foreman, Carl

(July 23, 1914 – June 26, 1984)

At the close of the Forties, Carl Foreman was emerging at the forefront of the Hollywood liberal left, scripting such socially oriented features as *So This Is New York* (1948), *Champion* (1949), *Home of the Brave* (1949), *Young Man With a Horn* (1950), *The Men* (1950), and *Cyrano de Bergerac* (1950).

In all but *Champion*, Foreman deals compassionately or (in *So This Is New York*) satirically with the problems and feelings of outsiders, those who are alienated from the mainstream because of their looks (*Cyrano de Bergerac*, a poetic soul with an oversized nose); the color of their skin (the psychologically tortured African-American GI in *Home of the Brave*); their sensitivity as a creative artist (the troubled trumpet virtuoso in *Young Man With a Horn*); their physical affliction (the rebellious but helpless paraplegic veteran in *The Men*); or their social and cultural standing (small-towners in the big city in *So This Is New York*). *Champion*, too, is the story of a man set apart, but for a less sympathetic reason. He's a talented boxer, with the world at the end of his jab, but he's isolated because of blind ambition and capitalistic greed.

In 1951, as his career was beginning to peak, Foreman was blacklisted after refusing to confirm or deny Communist Party membership before the House Un-American Activities Committee. Some of his contemporaries were to quickly produce cinematic apologies for naming names in front of government committees, including Elia Kazan and Budd Schulberg, in *On the Waterfront* (1954). But Foreman remained steadfastly committed to the belief that, if the law and those who uphold it are morally corrupt, that law and those upholders must be viewed with contempt. Furthermore, those who lack the courage to stand by their values are no less worthy of scorn. All of this is poignantly expressed

in the film that Foreman scripted immediately before his blacklisting and subsequent self-imposed exile in England: *High Noon* (1952). This Western classic is no escapist shoot-em-up for the Saturday matinee crowd. Its hero is as alone as any previous Foreman character, and his situation mirrors some universal moral dilemmas: what is the meaning of loyalty, responsibility and courage, and when does violence become justified?

Gary Cooper's Sheriff Will Kane—a simple, strong name for a simple, strong character—is a man of conscience. On the day of his wedding to a pretty Quaker (Grace Kelly), he learns that Frank Miller, a gun-toting thug he'd sent to jail five years before, has been pardoned. Miller is scheduled to arrive on the noon train, when he'll be joined by three cronies. This quartet, in its personification of evil, is analogous to the self-serving, undemocratic disposition of HUAC.

"They're making me run," Kane-Foreman explains. "I've never run from anybody before." Kane does not kowtow to the "respectable majority," his law-abiding friends who, to a person, urge him to "get out of this town this very minute," to "go while there's still time [because] it's better for you, and it's better for us." The mere presence of Miller and his cronies will open their city up to the lawlessness that Kane had struggled to crush. But the townsfolk still refuse to back the sheriff, a support that is not only ethical but logical. Kane-Foreman, however, will defend themselves

against the forces of evil: the scriptwriter vs. HUAC, and his character vs. the gunslingers.

Kane triumphs, but not without the help of his wife, who abandons her pacifism to defend her man. The point is that, in trying times, good people cannot, even for the best of reasons, rationalize inaction, but must take action against the forces of evil. Furthermore, in the film's final moments, as the townspeople crowd around the victorious Kane, he removes his badge—the symbol of the law that he'd been defending as the town's peace officer—and throws it to the ground in disgust. Foreman's point is ever so vivid and clear, and this is a very radical action to be found in any Hollywood film released in 1952. *High Noon* is, on its own merits, one of the great Western dramas; knowledge of who authored its script and the context in which it was written adds poignancy to its story.

Unlike dozens of blacklisted actors, whose presences in front of the camera earned them their livings, Foreman was able to continue his career—albeit from across the ocean, and with his name not to be found in any screen credits. For instance, he authored the British-made *The Sleeping Tiger* (1954) as "Derek Frey"; blacklisted director Joseph Losey is credited here as "Victor Hanbury." Sadly, for his professional survival, Foreman was indeed forced to "get out of town."

It remains one of the ironies of the blacklist that scripts penned under pseudonyms by "unemployable" writers garnered Academy Awards. "Robert Rich" (blacklistee Dalton Trumbo) and "Nathan E. Douglas" (blacklistee Nedrick Young) earned Oscars for, respectively, the ironically titled *The Brave One* (1956) and *The Defiant Ones* (1958). Foreman, too, along with fellow outcast Michael Wilson, was posthumously awarded an Oscar for writing the blockbuster war drama, *The Bridge on the River Kwai* (1957). They had worked anonymously on the project; officially, the screen credit went to Pierre Boulle, author of the novel upon which the film was based,

even though Boulle spoke no English.

In fact, in his postblacklist career as both writer and producer, the deeds and dilemmas of men in war became a popular Foreman subject. This is alluded to or depicted in *The Key* (1958), *The Guns of Navarone* (1961), *The Victors* (1963), *The Virgin Soldiers* (1969), and *Force 10 from Navarone* (1978). Most fail to take a moral stance about war; rather, they explore the dynamics of battle, of how some specific strategy is employed to defeat the enemy; they highlight the lack of experience of raw recruits; or they detail the soldiers' various sexual and romantic escapades. *The Victors*, which Foreman also directed, is the nominal exception here. An antiwar message is suggested: an army deserter is executed as Frank Sinatra sings "Have Yourself a Merry Little Christmas" on the sound track; in a blatant Cold War analogy, an American and Russian soldier kill each other in a silly dispute over right of way. But the combat scenes remain rousing and exciting: *The Victors* is a confusing (as well as dramatically heavy-handed) film.

In *Young Winston* (1972), the early life of Churchill is entertainingly presented, but Foreman's script offers a conventional, popularized look at its title character. Foreman's point of view is that Churchill needed to gain the love and approval of his parents via his attempts at personal accomplishment: a stock, superficial, pop-psychological approach to Churchill's motives. Foreman doesn't raise any real issues about his subject. There's neither feeling for the man's complexity or genius, nor is there any deep insight from a political perspective. *Young Winston* is biographical cotton candy: it's fun while it lasts, but there's no nourishment.

In the end, Carl Foreman aged into an inoffensive, strictly commercial writer-producer. It's as if his blacklisting took the sock out of his spirit, transforming him into the maker of safe, standard entertainments. One can only wonder what his output might have been had his Hollywood career not been short-circuited.—Rob Edelman

Frankenheimer, John
(February 19, 1920 –)

John Frankenheimer's career has risen and fallen with the fortunes of American liberalism. In the Sixties he pioneered the liberal Gothic with *The Manchurian Candidate* (1962) and *Seven Days in May* (1964), both about dire right-wing threats to the republic turned back by benevolent white male democrats (and, one suspects, Democrats).

The American Civil Liberties Union commissioned him to do a television film about the organization's goals and achievements (a project abandoned as too costly). He also directed Robert Kennedy's television appearances during his 1968 presidential campaign in between movie projects.

In the Seventies his career began a precipitous slide from prominence and power, a descent barely slowed by a few box office and critical successes, and this fair-haired boy of the Kennedy era has created hardly a ripple in Reagan and Bush's brave new world. Frankenheimer has continued to pursue political themes in thrillers, with wildly uneven results. *The French Connection II* (1975) is a muscular antidrug cop movie, but *Prophecy* (1979) is a floundering ecological chiller eager to swim in the wake of *Jaws* and capitalize on the supernaturalism of *The Exorcist*. Frankenheimer made a ludicrous overblown antiterrorist thriller preoccupied with neo-Nazi conspiracies, *The Holcroft Covenant,* in 1985. He scaled down with a workmanlike, small business-man's *film noir,* Elmore Leonard's *52 Pickup,* in 1987 and a gritty *policier* featuring Don Johnson in pursuit of organized white supremacists (*Dead-Bang,* 1989).

With *The Fourth War* (1990), a post-Soviet parable about superannuated soldiers, and *Year of the Gun* (1992), a steely antiterrorist fable set in 1978, Frankenheimer retrieved some of the film-making energy if not box office success that eluded him in the preceding two decades. Frankenheimer's social commitment may have lost its edge and its appeal, but he has kept a deft touch with paranoia, American style.

His sardonic masterpiece is *The Manchurian Candidate.* It exposes the right-wing threat of a red-baiter in the White House who really harbors the ultimate left-wing bogeyman, communism. In George Axelrod's script, faithfully adapted from Richard Condon's novel, that's just part of the joke. Cold War liberals always said McCarthy did more for totalitarianism in America than Stalin could hope for—here's the proof.

The eponymous candidate is a dim, McCarthyist Dan Quayle on the bottom half of his party's ticket, whose stepson Raymond Shaw (Laurence Harvey) is a Korean vet who has just won the Congressional Medal of Honor. Raymond's act of valor is nonexistent, planted in the heads of GIs who have been brainwashed by an uneasy consortium of Russian and Chinese specialists. Poor unwitting Raymond has been subliminally programmed to murder the conservative presidential nominee (an act to be blamed logically on communists) and thereby catapult the "Manchurian" candidate, his stepfather, into the White House. There, Raymond's mother (Angela Lansbury), a Washington hostess and a communist

agent of forbidding ambition, will rule through her idiot consort.

Mom is also Raymond's control, using the Queen of Diamonds from a pack of cards to lock his will to hers. She orders him out to kill a liberal columnist, his own bride, and the girl's father, a progressive senator. Only Raymond's army buddy, Major Marco (Frank Sinatra), whose brainwashing didn't take, stands in Lansbury's way, as he begins to unravel the mystery of his bad dreams.

In faithful Cold War liberal fashion, *The Manchurian Candidate* plays both sides of the street, defeating demonic communism, with its urbane and ruthless Chinese inquisitor (Khigh Dhiegh), while trouncing those right-wingers, too, who, despite all their finger-pointing at the State Department, are the real communist dupes.

Angela Lansbury's devouring ice-queen mother is a vivid example of female-hating Momism in a decade full of such grasping creatures. Lansbury's performance is lustrous and commanding, but Sinatra and Harvey are at the top of their form as well, along with screenwriter Axelrod and Frankenheimer himself. The director has said he felt secure enough to return to some of the things he had learned in his days staging live television drama, but the film shows particularly well his interest in new image technology. The ubiquitous television screens and the media chaos of a government press conference lend a newsreel ambiance to the plot's surreal twists. He mixes prankish humor with macabre situations, and realistic quasidocumentary camera work in black and white (especially the finale in Madison Square Garden) with expressionistic settings.

Consequently, from its bizarre opening setpiece behind the communist lines—in which the captured soldiers imagine they're listening to a garden club lecture while the brainwashers are murderously demonstrating their success (both realities are intercut)—*The Manchurian Candidate* evokes an inimitable feeling of dislocation.

It has the air of a giggling psycho's nightmare. In the end it mocks both left and right and even the electoral process itself, which emerges as a travesty of democracy ruled by backstage manipulation. Small wonder it didn't catch on at the time.

Rereleased in 1988 after many years' unavailability, *The Manchurian Candidate* seemed keenly prophetic, not only for its acute awareness of television, and its assassination theme, but in its Byzantine subversive conspiracies. Some of the dialog would not have sounded out of place in the Iran-Contra hearings, and of course the automaton veep candidate, an opportunistic right-winger with a formidable woman behind him, rang all too true in 1988. The movie's mordant wit seems a particular leap for Hollywood and is without peer—when the liberal senator, a bleeding heart to the end, is shot at his refrigerator, the milk (of human kindness?) literally pours forth from his breast, or at least the carton in front of it. The tone grows increasingly somber and grim, however, as Raymond's tragedy unfolds, ending finally with Frank Sinatra's curtain speech explaining that the medal falsely bestowed on Raymond truly belongs to him after all. Raymond had, in a last effort to cut the umbilical cord, killed his mother to save his country and his own soul.

Frankenheimer played it straight in his next film, *Seven Days in May,* which was equally suspenseful but far less knowing, with a humorless but taut script by Rod Serling. This time the nightmare was a military coup against the liberal government of the LBJish-sounding Jordan Lyman (given a patrician boost by Fredric March's polished delivery). The would-be dictator was a right-wing general with a political following, James Matoon Scott, played with stoic fanaticism by Burt Lancaster as equal parts Edwin Walker and Douglas MacArthur.

An officer on Scott's staff (Kirk Douglas) discovers the plot and tries to convince the civilians in the White House. They are incredulous, but bit by bit the evi-

dence piles up, and a small coterie of loyal men—a trusted aide, an alcoholic senator, the Brahmin secretary of state, and the head of the Secret Service—joins forces to defeat the plot without ever letting its existence reach the public (lest civilization as we know it collapse in a heap). It's a near thing, with the president's oldest friend losing his life in the process, but the loyalists succeed. The president demands the resignations of the Joint Chiefs of Staff in a televised press conference, and gets them.

The idea of a charismatic military man with a contempt for civilian government seems a more plausible threat in the shadow of Oliver North. What would North think of *Seven Days in May?* While he sought to make policy as the surrogate of a popular president, James Matoon Scott seeks to supplant an unpopular one. The object of North's scorn was Congress, while Scott ridicules his commander-in-chief, the country's chief executive, as a "weak sister" for signing a treaty with the Soviets. Scott and North share the basic sentiment, as voiced by North's secretary (and telegenic witness) Fawn Hall, that sometimes you have to go "above the law." Scott sought to unseat authority, North to protect it from a messy democracy. If Scott were working today, he'd have no need for such a blatant ploy as a coup; he'd have his own slush fund as well as his secret base and he'd simply circumvent his commander in chief. *Seven Days in May*, peopled with statesmen, has an air of brave naiveté; it's really *Dr. Strangelove* without the laughs or the final mushroom cloud.

It's also much more of a cautionary tale than *The Manchurian Candidate*, whose leveling wit it does not share. Men of integrity make the system work in *Seven Days*, and it rewards them. Ordinary men and women are grateful for it, but they'd better keep watching the skies—er, Pentagon. *Seven Days in May* even has its bug-eyed monsters, in the implacable monitors with their cameras sweeping the halls of the military sanctuary, in the slightly futuristic picture phones, in televi-

sion's eye-devouring stage-managed rallies. The president's use of television saves the state, and Scott intends it to be his most powerful weapon to mold a public largely unseen. "We the people"—of the constitutional graphic that appears under the titles—show up in person only in the pseudodocumentary opening scene that features placard-carrying protesters, two diverging lines clashing in a fist fight. So much for free speech. The Constitution's battleground here is not the streets or even the open court, but the back rooms of the White House and the Pentagon. *Seven Days in May* sometimes comes close to sharing the fascist fear of democracy that it condemns.

These were Frankenheimer's best films, but not his only interesting ones. Earnest liberal problem films, enlivened by an unusual dramatic flair and a talent for the apprehensive detail, were his forte from the beginning of his film career with *The Young Stranger* (1957) and *The Young Savages* (1961). The first was about a misunderstood teenager from an affluent family and the second about a gang murder in the slums and its political implications for a prosecutor who had climbed out of the old neighborhood (Burt Lancaster).

Confronted by the killing of a blind boy, Tom Bell (née Bellini) resists going for a quick conviction, after much teeth-gnashing (quite a spectacle in Lancaster's case) and a prod from his socially conscious uptown wife (Dina Merrill). The conviction would help Bell's boss swim in the political mainstream, but Bell discovers complications in the case and convinces one of the accused boys (the son of his old neighborhood flame) to forsake gang loyalties and point out the triggerman. Upward mobility is what really saves the day, and the system of justice survives the threat of corruption because it produces men of integrity, the kind who would save the ship of state come May.

Frankenheimer crusaded on other relevant social issues besides juvenile delinquency. In *Birdman of Alcatraz* (1962) he

took on prison reform with Burt Lancaster as Robert Stroud, the lifer whose conspicuous rehabilitation threw an antiquated penal system into high relief. *The Fixer* (1968) adapted from Bernard Malamud's novel, examined anti-Semitism in Czarist Russia, where a handyman accused of child murder (Alan Bates) endures an ordeal of prison and beatings, all the while insisting on his day in court. The film earnestly exemplifies Frankenheimer's avowed dedication to the nobility of the individual and the ideals of justice through law.

The Train (1965) set in World War II France, pitched resistance leader Burt Lancaster into a tortuous dilemma; ordered to protect a German train carrying off priceless paintings from Paris, he thinks the price of saving it far too high in human life. He pays the price, but grudgingly. There is no discernible sense at the end that the crates of Picasso, Pizarro, Renoir, etc., scattered on the tracks, were worth it. *The Train* is a spectacular exercise in black and white, pulsing with palpable physical excitement in its full-scale train wrecks and in Lancaster's athletic performance. Paul Scofield plays the effete snob who commands the German train, obligingly smug and Teutonic even at the end when Lancaster guns him down in cold blood, after a heartbeat's hesitation.

A notable exercise in pure paranoia was *Seconds* (1966), the fable of a mysterious corporation that provides aging men a second chance with a new identity and plastic surgery. John Randolph emerges from the operating room as Rock Hudson, but discovers his younger, footloose self to be totally circumscribed by the company. It surreptitiously supplies friends, lovers, and home, but demands total conformity and obedience. The price of rebellion is obliteration, as Hudson finds out. Shot in black and white by the great James Wong Howe, *Seconds* perfects the imagery of anxiety with claustrophobic angles and fisheye lenses, most notably used for the harrowing final gurney ride down a hospital corridor. Knowing the fate to come and powerless to do anything about it, Hudson suffers what must surely be the complete nightmare for the filmmaker as champion of liberal individualism.

The Seventies and Eighties were an almost unbroken streak of bad luck for Frankenheimer, a road littered with busted projects, might-have-been deals, and distribution misfires. Like so many liberals left out in the cold by the Reagan era, the director has lately been drifting center-right while still clinging to a few bedrock constituencies. *Dead-Bang* (1989) combined a disappointingly routine revenge-cop motif (frazzled workaholic Don Johnson on the trail of his partner's killer) with a bald acknowledgment that white racism has spawned a dangerous terrorist movement in the western states. Johnson and a black law officer from the sticks stage a united front assault on the gang, which features those familiar sniveling psychos who embody racism as Hollywood has always imagined it. (The loudest message is I-ain't-one-of-'em.)

Such topical dramas migrated from the big screen to the small one while Hollywood was busily redefining cinema as the trillion-dollar B-movie. Indeed, it's not hard to imagine live-TV pioneer Frankenheimer returning to his origins in television, making a true-crime movie-of-the-week with social undertones.

He seems determined to work for theatrical release, however, no matter how spotty it may be. Both his latest films received minimal exposure in America. *The Fourth War* (1990) is a sly, trim allegory made almost instantly irrelevant by the fall of the Berlin Wall barely three months before its release. Publicity for the film gamely insisted it was set in 1988. Frankenheimer pitted Roy Scheider and Jurgen Prochnow against each other as U.S. and Soviet commanders on an Eastern European border. The Cold War becomes a pissing contest between two obsolescent soldiers—veterans, respectively, of Vietnam and Afghanistan. The

title refers to Albert Einstein's answer to a question about what the Third World War would be like. He replied that he didn't know, but the fourth one would be fought with stones, which is pretty much where the two soldiers end up.

Scheider is the perfect Frankenheimer hero, far too tightly wrapped, and like Don Johnson in *Dead-Bang*, he rails against bureaucracy very much in the style of the antigovernment mood so popular on and off the screen. In *The Fourth War*, that new army bureaucrat is no villain, but there's a sense his interests are not those of our sort-of hero, and, surprisingly, he's a black man, an Affirmative Action baby played by Tim Reid, who was Don Johnson's ally in *Dead-Bang*.

The romance of left-wing activism is the target in *Year of the Gun*, which recreates the 1978 kidnapping of Italian politician Aldo Moro by the Red Brigades, right down to staging it in the same Roman neighborhood. A convoluted plot aims for but misses the pinnacle of paranoia firmly held by *The Manchurian Candidate*. Andrew McCarthy is a quiet American, a journalist by day in Rome and a novelist by night, imagining the Brigades would kidnap a bigwig like, say, Moro. He has populated his novel with friends and acquaintances, all of whom become potential dead meat once the Brigades unearth the manuscript (they have contacts everywhere.) They think of it as nonfiction notes penned by a youthful CIA agent.

Frankenheimer depicts the Brigades with unremitting grimness as ruthless fanatics governed by a shadowy council of intellectuals and politicos—far less quirky and less *visible* as individuals than the terrorists who tried to frag the Super Bowl crowd in *Black Sunday* (1977). That was the last memorable movie of Frankenheimer's heyday (and even then, one that occasioned much press as his "comeback").

Frankenheimer ran Pontecorvo's *The Battle of Algiers*, a film that aims to convey a unique understanding of the terrorist act, over and over again for the crew of *Black Sunday*, which starred Bruce Dern as a bitter, unstable Vietnam vet in league with Palestinians. As in *Year of the Gun*, the leading terrorist is a seductive woman (blank Marthe Keller in *Black Sunday*, a more expressive and more tragic Valeria Golino in *Year of the Gun*). Keller and Dern hijack the Goodyear blimp for a suicide mission to explode an ingenious homemade fragmentation bomb over the Miami football fans. World-weary Israeli agent Robert Shaw saves the day.

Year of the Gun is a grubbier, less dramatically forgiving portrait of terrorists having their way with Americans and other dupes. The Red Brigades' fellow travelers in Italian academia and the press are pitiable stooges in this overcast and uninviting Rome, and our American hero, casually sympathetic to them, is hopelessly naive and almost pays with his life. There's a gallows humor in the terrorists' dogged refusal to believe McCarthy is less than what he seems (America's dilemma in the Nineties, you might say), but *Year of the Gun* is no beguiling parable on the order of *The Manchurian Candidate*.

It is, however, a vigorous, tough little movie that suggests the director still commands a rare cinematic boldness and a fondness for conspiracy theories. In the age of *JFK*, which took some sustenance from his Sixties jeremiads on the state of our state, surely there is a place for John Frankenheimer.—Pat Dowell

RECOMMENDED BIBLIOGRAPHY

Pratley, Gerald. *The Cinema of John Frankenheimer.* NY: A. S. Barnes, 1969.

Higham, Charles and Joel Greenberg, eds. *The Celluloid Muse: Hollywood Directors Speak.* London: Angus and Robertson, 1969.

Native Land

Frontier Films

O ne of the projects of the Communist Party movement in the Thirties was to create film production collectives that would challenge the cinematic hegemony of Hollywood. In the opening years of the decade, the Workers Film and Photo League was formed to serve this end primarily through the creation of radical newsreels.

The filmmaking component of the league began to dissolve at mid-decade due to shifting political and esthetic disputes. Some of the New York-based League members reorganized as Nykino in 1935 and then in 1937, with the support of prominent Communist Party intellectuals, expanded their group to become incorporated as Frontier Films. Seeing themselves as full-time cultural workers who would live by their craft, the Frontier Films activists planned to make films of greater complexity than any contemplated by the Film and Photo League, including fiction and documentary films of feature length.

During the first two years of its existence, Frontier Films produced four political documentaries: *Heart of Spain* (1937), *China Strikes Back* (1937), *Return to Life* (1938), and *People of the Cumberland*

(1938). Also conceived and largely filmed at this time, but not released until 1942, was *Native Land*, a feature-length film with both fiction and nonfiction elements. Rounding out the credits for Frontier were two nonpolitical films—*The History and Romance of Transportation* (1939), made for the Chrysler Exhibit at the World's Fair, and *White Flood* (1940), a film dealing with glaciers that was made on commission—and *United Action Means Victory* (1940), made in association with the UAW-CIO film department. A number of other projects were begun but abandoned, and members of the collective sometimes worked on films of other production companies. The core group of Frontier Films consisted of Leo Hurwitz, Paul Strand, Ben Maddow, Sidney Meyers, and Lionel Berman. Among those who worked on at

least one film were Ralph Steiner, Henri Cartier-Bresson, Willard Van Dyke, Jay Leyda, Earl Robinson, Herbert Kline, Erskine Caldwell, and Elia Kazan. No women played a major role in any of the productions.

Much as Frontier Films aspired to do work with lasting historical resonance, its films were so shaped by the utilitarian politics of the day that they have become dated and questionable on the very political grounds that should have been their strength. This is clearly evident in *Heart of Spain* and *Return to Life*, two films about the Spanish Civil War conceived as vehicles to raise funds for medical relief for the Republican forces. Given the films' purpose, any airing of differences within the Republican camp would have been inappropriate, but the films barely deal with the issues of the civil war at all, much less the ideals of the socialists, communists, and anarchists who dominated the Republican leadership. Generalissimo Franco is not even mentioned in *Heart of Spain* and gets only passing reference in *Return to Life*. The political aspect which is projected is that Spain has become a dress rehearsal for the coming struggle between the world democracies (the U.S.S.R. included) and Europe's fascists. Even this theme is muted in order to give as little offense as possible to any viewer inclined to the democratic perspective. Having abandoned the specific Spanish and class nature of the conflict, the films become dependent on the kind of blood, guts, suffering, and debris footage that can be used by either side in almost any war. Rather than winning new adherents to the Republican cause, the films mainly functioned to rally the committed and to shame those politically sympathetic to the Republic but not active in its behalf.

A similar tone characterizes *China Strikes Back,* which featured Chinese footage shot by Harry Dunham. Although the Dunham reels were the first motion pictures ever available in the U.S. showing the Red Army in Yenan, *China Strikes Back* elects to skim over the Chinese civil war to again concentrate on the national struggle against an outside invader, this time Japan. Instead of being depicted as a revolutionary people carrying out profound social change, the peasants of the Red Army are portrayed as little more than patriotic Boy Scouts in arms. This Frontier Films tendency to shy away from internecine conflict was reinforced in the Chinese case by the formal cease fire reached by the Communist Party and the Kuomintang shortly before the film was made, a truce which predictably proved to be honored mainly in the breach.

China Strikes Back offers no background to the struggle that would convulse China as soon as the Japanese were defeated and which would culminate in the establishment of a communist regime noted for its revolutionary ardor. As an effort to redress the negative media image of Chinese communists, the film was somewhat successful, but only at the cost of avoiding discussion of any of the published programs and objectives of that movement. In this respect, the film compares most unfavorably with Edgar Snow's *Red Star Over China*, an American book written at approximately the same time, just as sympathetic to the revolutionaries, but accurately projecting the struggles that would consume the Chinese people in the forthcoming decade.

People of the Cumberland is a domestic equivalent to the approach evidenced in the films on Spain and China. Using the radical (but not communist) Highlander Folk School in Tennessee as a reference point, the film depicts union organizing in Appalachia, a revival of folk art, and mountain poverty. After a reenactment of the slaying of a union organizer and footage in which class differences are starkly etched, the film gradually slips into a long segment in which the politics of the New Deal and conventional trade unions seem to provide more than enough ideology to right all of America's wrongs. The Fourth of July labor picnic sequence that ends the film is so suf-

fused with patriotic imagery that it might just as easily have been made for the American Legion. The filmmakers obviously desire to reclaim Americanism from the right, yet their film offers no radical alternatives or even a radical spur to mainstream liberalism. Devoid of revolutionary passion, *People of the Cumberland* also lacks the genuine zeal for populist reform that marked the contemporaneous work of Pare Lorentz in films such as *The Plow That Broke the Plains* (1936) and *The River* (1937).

The distance between internal Frontier Films debates about the esthetic theories of Brecht, Stanislavsky, Vertov, and Eisenstein and the documentaries actually made is vast. A problem never adequately discussed was that the filmmakers addressed projects in the same spirit as reporters for *The Daily Worker* might. They were to lead as much of the public as possible over immediate political terrain, taking as few ideological risks as necessary. The heavy use of voice-over narration, not unlike the despised narrations of *The March of Time* newsreels, shaped the audience's response more than the films' images, songs, editing, poetry, and reenactments did. There was no sense that filmmakers could take on a topic in the spirit that the Seventies would call "investigative reporting," letting the factual and political chips fall where they might. Nor was there any of the ideological daring, outrageous satire, or prophetic imagery found in the high-spirited IWW songs and graphics that had been highly successful as mass art in the 1910s and 1920s and which subsequently became part of American folklore.

The Frontier Films core group often stated that their films were intended to respond to negative images of workers and revolutionaries found in most Hollywood films. They were particularly outraged by films such as *Shanghai Madness* (1933), *Black Fury* (1935), *Oil for the Lamps of China* (1935), and *Last Train from Madrid* (1937). Nonetheless, the sanitized union organizers, Spanish revolutionaries, and

Red Army soldiers projected by Frontier Films were not very convincing and no more "real" than Hollywood's stereotypes. The audiences for the documentaries proved to be mainly partisans attending antifascist events or, as in the case of *China Strikes Back*, audiences attracted by unique footage of distant wars. Although the Spanish films were effective fund-raisers and all the documentaries got some exhibition as selected shorts at commercial theatres, the collective's balance sheets for 1937–'42 indicate that none of the films ever made back their costs.

However faithfully Frontier Films expressed the Communist Party line, there was no direct political pressure on what films to make or how to make them. The filmmakers involved, whether Party members or fellow travellers, simply were part of the prevailing state of consciousness within the communist orbit. They never thought it their role to lead, goad, or challenge the party hierarchs. Accordingly their documentaries have historical value mainly as examples of an art narrowly defined by the perceived political imperatives of a time period measureable in years.

Native Land, the major work of Frontier Films, stands up much better than the shorter productions. Among feature films made by radicals prior to the Sixties, it is often ranked second in quality only to *Salt of the Earth* (1954). Codirected by Leo Hurwitz and Paul Strand, photographed by Strand, and edited by Hurwitz, *Native Land* had a script by Ben Maddow, music by Marc Blitzstein, spoken and sung narration by Paul Robeson, and performances by left-wing New York actors such as Howard Da Silva. The focus of the film is the American workplace. Its immediate inspiration was Leo Huberman's *The Labor Spy Racket* (1937) and the revelations of the La Follette Civil Rights Committee hearings of 1936–'37, which investigated the union-busting techniques of big business.

An often proclaimed objective of the makers of *Native Land* was to redefine cinematic dialectics. In addition to the pre-

dictable alternation of light and dark light-ing, urban and rural vistas, and advancing and retreating political tides, the film would alternate fact and fiction, narration and drama, abstraction and realism. The hustle of cityscapes found counterpoint in idyllic pastorals which in turn were contrasted with industrial and technological iconogra-phy. Farmers and workers struggling to better their economic and social standing would be opposed by hoodlums and the Ku Klux Klan. The integrity of working people would be contrasted to the corruption of politicians and employers. The rich texture of the film is a cinematic equivalent of the techniques employed by John Dos Passos in his *U.S.A.* trilogy in which poetic but fac-tual biographies, newspaper headlines, snatches of popular songs, intervals of stream of consciousness, and independent vignettes were interwoven in a narrative following the fates of many individuals rather than a single person or family, a col-lectivist rather than an individualist overview.

Little people trying to live the decent life command the sympathies of *Native Land*. The unifying motif of its various episodes is that of modest workers as vic-tims of unemployment, racism, or employ-er violence, with a number of sequences ending with the martyrdom of a particular worker and a temporary setback for labor. One can almost hear a subliminal AFL-style plea for a fair day's wage for a fair day's work. The appeal to pity and the gen-erally defensive tone of *Native Land* were not reflective of the dominant political mood of the era. At the very time *Native Land* was being made, the CIO, openly uti-lizing communist cadres, was leading mil-lions of industrial workers in often bloody but hugely successful strikes. The ambiance permeating *Native Land* is trace-able to the antifascist framework reflected in all Frontier Films' productions. The film-makers thought it necessary to identify potential fascists at home who might col-laborate with fascists abroad. To defeat such native American fascists, emphasis on the unity of class interests was imperative

and conflict between the classes had to be minimized. The worker as potential revolu-tionary socialist, or even as militant striker, did not serve the end of class unification.

Compromised and conservative as its vision was, *Native Land* still managed to make contact with important American aspirations, movingly addressing themes of racial equality, the dignity of labor, and the democratic ideal. Although its episodic dichotomies were not satisfactorily resolved, the blend was artistically intrigu-ing and inventive. Compounding the con-ceptual difficulties of *Native Land* was the fact that it took far too long to complete. By the time it was ready for release, the United States had already become actively involved in WWII. The Communist Party was now vociferously condemning any strikes in basic industry or any agitation that might be disruptive to workplace har-mony during the national emergency. Even the relatively tame perspectives of *Native Land* were judged to be the wrong mes-sage for at least the duration of the war. Frontier Films formally dissolved before *Native Land* was even released, and the film, destined to earn a measure of latter-day fame with film students and scholars, proved to be a financial and political failure.

The personnel of Frontier Films would continue their careers in film, but the cycle of work that had begun with The Film and Photo League was closed. When the next wave of radical filmmaking took shape in the Sixties, filmmakers would have far dif-ferent esthetic and political priorities than their predecessors. The work of the film-making radicals of the Thirties would be respectfully remembered but not emulat-ed.—Dan Georgakas

RECOMMENDED BIBLIOGRAPHY

Alexander, William. *Film on the Left: American Documentary Film from 1931 to 1942.* Princeton, NJ: Princeton University Press, 1981. Campbell, Russell. *Cinema Strikes Back: Radical Filmmaking in the United States 1930–1942.* Ann Arbor, MI: UMI Research Press, 1982.

Fuller, Sam

(August 12, 1911 –)

Samuel Fuller is the Mickey Spillane of the auteurist set, a tough-talking, cigar-chomping original who writes and directs formula stories—Westerns, war dramas, spy thrillers—to enforce his right-wing convictions.

Military valor, the pervasive threat of communism and of crime syndicates, the necessity for vigilante justice, rabid pro-Americanism—these are recurrent Fuller tropes injected into his dime-novel scenarios. Fuller's sincerity, his urgency and commitment, infuse his work with a raw vitalizing energy: his brute partisanship turns pulp into an authentic popular art.

Typically Fuller's action plots are set in a momentous context, with recent or contemporary history in tense deep focus. The foreground drama, articulated in crude B-movie fashion, is often linked to themes of present political emergency and national destiny. The stakes are often catastrophically high as missions impossible and obsessive personal quests uncover cancerous communist plots or tentacled crime syndicates. Drawing on his own journalistic background, Fuller presents his stories with tabloid boldness: his customary prologues, in which a clipped voice-over narration established historical significance and accuracy, are like newspaper headlines that mix paranoia with preparedness. At his best, pushing his moral with a seemingly no-frills straightforward simplicity, Fuller creates an illusion of reportorial directness and immediacy.

Fuller's most active period coincided with the height of Cold War anxieties. Weaving variations on the communist threat, the Fuller canon is rife with motifs of infiltration and deception, yet Fuller typically presents spies, double agents, and stool pigeons as engaged in a gutsy resis-

tance against reds. His implicit message is that ends justify means: it's all right to be a double agent if the cause is just; preserving America's democracy warrants subversive activity, complicated strategies of role-playing, and counterintelligence.

In *Pickup on South Street* (1952), for instance, a petty thief (Richard Widmark) accidentally steals missile plans that American communists are delivering to Soviet scientists. Forced by authorities to infiltrate the communist gang—to use his professional skills for national defense—he becomes a reluctant hero whose enflamed Americanism earns him a happy romantic finish. Also enlisted in the urgent fight against communist rot is an underworld informer, a waterfront pack rat (Thelma Ritter) who sells names to the cops. Ritter plays the part with disarming dignity, thereby underlining Fuller's implicit statement that underworld ethics can be redeemed by patriotism. While he transforms criminals into dutiful citizens, Fuller photographs the American communists in looming shadows and tilted angles that make them look like monsters in a horror movie.

In *Hell and High Water* (1953), another tough, capable, reluctant Fuller loner (Richard Widmark again) is drafted into the underground war against communism. Captain Jones commands a submarine to a remote Japanese island on which Russians have built an atomic arsenal. Skillful spies, Jones and his crew ("a consortium of private individuals of several countries, united against a common

enemy") discover a Russian plot to drop an A-bomb on Korea and "blame it on us." "They're going to drop the biggest egg in history and we're going to take the rap for it," Jones says as he bombs the Russian plane, an act of civil disobedience that marks a decisive victory for Us against Them.

For Fuller communism and crime are thematically as well as iconographically indistinguishable and his crime stories therefore have the same setup as his anti-communist thrillers, with strategies of spying, disguise, and infiltration offered in heroic contexts. In both *House of Bamboo* (1955) and *Underworld USA* (1960), a double agent masquerading as a hood gains entrance into a criminal network. Working for government authorities, the shrewd intruders insinuate themselves into privileged positions with the syndicate kingpins as they conduct systematic campaigns of termite-like subversion—planting fake evidence against gang members—that topple omnivorous underworld empires. "I can't figure a guy who'd betray a friend, who'd worm his way in and then squeal," the dyspeptic head mobster (Robert Ryan) in *House of Bamboo* announces, while Fuller's subtext clearly applauds the politics of infiltration.

By the early Sixties Fuller began to subject his double agent scheme to ironic reversals. In the notorious *Shock Corridor* (1963), for instance, a journalist intent on solving a murder committed in an insane asylum fakes madness in order to be admitted as a patient. His masquerade helps him to track down the murderer and he wins a Pulitzer, but this time role-playing turns real when the spy becomes a catatonic, submerged in irreversible dementia.

In his thrillers Fuller's pro-Americanism is often couched within narrative twists and tangents while in his war films, when the enemies are Nazis rather than communists, his right-wing sympathies are proudly undisguised. The prologue announces *Merrill's Marauders*

(1961) as the reenactment of "an inspiring page from history": the heroic trek of American troops through two hundred miles of treacherous Asian jungle in order to prevent Japanese soldiers from joining forces with the Germans. Dramatizing episodes drawn from Fuller's own World War II combat unit, *The Big Red One* (1980) culminates in the liberation of a concentration camp. Both films skillfully manipulate us into accepting military zealots as sympathetic father figures who indoctrinate young soldiers into manhood. Merrill (Jeff Chandler) and the unnamed sergeant (Lee Marvin) in *The Big Red One* are possessed Fuller heroes, men with missions who have no time for private lives. "If you're at the end of your rope, all you have to do is make one foot go out in front of another," Merrill says to his exhausted troops. As he drives himself to a fatal heart attack, Merrill explains to his protégé, "When I pinned those bars on you I made a leader out of you, which means that sometimes you have to hurt your men." Relishing the thrill of war, the sergeant in *The Big Red One* escapes from a hospital bed in order to rejoin his boys. Yet this gritty, single-minded, emotionally inarticulate warrior shyly accepts from a Sicilian girl a helmet garlanded with flowers and safeguards a young camp survivor who dies on the sergeant's back.

In *Verboten!* (1958), American soliders in postwar Germany are naive do-gooders swindled by German hoods pretending to work for the denazification program while forming a secret society dedicated to perpetuating Hitler's goals. "I'm up to my neck in double crosses," the American hero proclaims, overwhelmed by duplicity. But American pluck and idealism triumph: "We'll build a democracy here with Nazi bricks," a patriot promises.

Although Fuller's combat films document war's devastating toll on both the victors and the defeated, his kinetic battle scenes and steadfast soldiers clearly celebrate brute force. The climactic action in *The Big Red One* occurs when a notably

gun-shy soldier maniacally slaughters a German camp commander: unleashing violence is as cathartic for the former pacifist as it is meant to be for us. Like his double agents termiting communism, Fuller's violent, rugged, idealistic American soldiers are world-saviors.

Virulent patriotism is more sinuously incorporated into Fuller's off-beat post-Civil War Western, *Run of the Arrow* (1956). A disaffected Confederate soldier (Rod Steiger) leaves the Union ("I'll hang before I recognize that flag") to join up with another dispossessed group, the Indians. While Fuller is careful to portray a variety of Indians according to the fake-liberal principle that there are good and bad of every kind, ultimately the white man is displaced among his adopted red brethren. His squaw tells him: "You were born an American and what you are born you will die." A statesmanlike Yankee soldier (Brian Keith) counsels him that "man's love of country must supersede love of home and family."

Like his hard-hitting headline theses, Fuller's visual vocabulary is basically journalistic. An occasional thriller like *Pickup on South Street* or *Shock Corridor* has Gothic insignia of exaggerated chiaroscuro, vertiginous and disorienting angles, jittery zooms, and diagonals nervously cutting across the screen, but Fuller's usual composition is (perhaps surprisingly) sober: typically his camera is a neutral observer of a realistically rendered space. Like his often stationary camera, his attraction to long takes and deep focus indicates a reportorial stance. A Fuller leitmotif of handmade signs, posters, and placards underscores his primary journalistic intentions.

Like his visual style, acting in Fuller's movies is uneven. An overwrought Constance Towers in *Shock Corridor*, pacing back and forth in a doctor's office, is guaranteed to draw titters from any revival-house audience, and Rod Steiger with a wavering Irish brogue as a Southern renegade in *Run of the Arrow* is a prime example of Method intensity run amok. But Fuller is always secure with tough guys and gals: in *Pickup on South Street* he coaxed from the usually simpering Jean Peters a bracingly tart moll; as the driven, narrow-eyed, wildly misogynistic hunter in *Underworld USA*, Cliff Robertson has never been better; Fuller provided the ideal *mise-en-scène* for Richard Widmark's lean and throaty tough guy style; and Lee Marvin's grizzled sergeant in *The Big Red One*, who never says much but whose eyes and gestures are often eloquent, achieves real stature.

Fuller's dialog is also best when it is in the tough, laconic range. When he reaches for moralizing set speeches, or when he strains for tag lines meant to summarize his theme, he can be preachy and maudlin: *Run of the Arrow* ends with the announcement that "Lee's surrender was not the death of the South but the birth of the United States"; *Hell and High Water* concludes with the homily that "Each man has a reason for living and a price for dying."

With his skewed vision and idiosyncratic style Fuller is the kind of director who inspires cultist adulation. But to discuss Fuller's work in Olympian terms, and to elevate him to the status of a major artist, is to deny him his true place as a provocative B-movie maverick, a lively pop primitive who spins right-wing tall tales.
—Foster Hirsch

RECOMMENDED BIBLIOGRAPHY

Garnham, Nicholas. *Samuel Fuller*. NY: Viking Press, 1971.

Hardy, Phil. *Samuel Fuller*. NY: Praeger Publishers, 1970.

Garfield, John
(Julius Garfinkle)
(March 4, 1913 – May 21, 1952)

The cold, hard eyes get you first. They prepare you for the cocky gait, the chip-on-the-shoulder air that tells you this is one tough character. Yet, somehow, he strikes a responsive chord. You have to like the guy and, despite his flaws, you have to root for him to triumph over his adversaries.

He's called the anti-hero, and he's an established fixture in the Hollywood movies starring Marlon Brando, James Dean and Montgomery Clift and, more recently, Jack Nicholson, Al Pacino, and Robert de Niro. Yet the first celluloid anti-hero, working during the late Thirties and Forties—an age that seemed to prefer Errol Flynn combatting cutthroat pirates, James Stewart unearthing shady politicians, or John Wayne battling sadistic Nazis—set the tone for all the rest.

John Garfield, the original, stood in jarring contrast to the moral, honest, comic-book caricatures of American manhood that Hollywood felt the public wanted. Garfield vaulted to stardom with his screen debut in Warner Bros.' *Four Daughters* (1938). He created an entirely new screen personality, one he sustained throughout his career: the swaggering, cynical loner-loser, alone and estranged from society's mainstream, who would often break the law or cause others extreme sorrow. Or, if he was not an outright rule-breaker, he was a kid from the lower economic strata who found success in the boxing ring or concert auditorium only to end up confounded by his fame, unable to fit snugly into the upper-class world of which he was now a part.

Despite their moral or psychological makeups, Garfield's anti-hero characters— Mickey Borden in *Four Daughters*, Charlie Davis in *Body and Soul* (1947), Harry

Morgan in *The Breaking Point* (1950)— were as attractive as they were antisocial. Their alienation was the result of their working-class, urban-ethnic origins, if not luckless childhoods spent scraping for themselves on mean streets. Beneath their crude exteriors were sensitive, sympathetic men seeking their identities, their places in the world. Their histories enabled them to view society with the perceptions that were beyond most John Wayne or Errol Flynn characters.

Pre-Garfield, there were two ways of doing things on screen: the right and the wrong. The hero was right, and "lived happily ever after" with the heroine; the villain was wrong, and either perished or ended up doing hard time at Sing Sing. Yet Garfield, during this era of illusory simplicity, exemplified the actuality that "good" and "evil" are characteristics in all of us.

Sadly, the Garfield screen prototype and the real-life actor were frighteningly alike in that both were unable to make peace with themselves. The fictional Mickey Borden in 1938 and the real John Garfield in 1952 were each victims, unable to fit into a society whose rules they could not accept, if even grasp.

Garfield knew all too well the characters he created. He himself was a New York City street boy, whose early years were spent in a Dead End Kids existence. Morose, defiant, and the toughest kid on the block, he became the leader of a street

Body and Soul

gang, was involved in petty lawbreaking, and was expelled from several schools. He might have ended up a two-bit hood, like a number of his screen characters, if not for his being steered toward the theater by Dr. Angelo Patri, an educator and child psychologist who took a personal interest in him. After an apprenticeship in the Group Theater, he played Mickey Borden in *Four Daughters*, in its own modest way a milestone in film history.

Four Daughters chronicles the romances of a quartet of attractive, musically inclined sisters, the youngest of whom falls for Borden, an out-of-work music arranger. Screenwriters Julius J. Epstein and Leonore Coffee described Borden as follows: "His dress is careless, almost shabby. But...his carelessness adds to his attractiveness. His manner is indolent, his expression wry, almost surly. His

humor is ironic. [He] doesn't think well of himself and the world. Poverty has done the trick." Garfield-Borden blurts such lines as "I wouldn't win first prize if I was the only entrant in the contest" and "Talking about my tough luck is the only fun I get." In one memorable sequence he sits at a piano, a cigarette dangling from his lips, and tells his girl (Priscilla Lane) that "they" are to blame for his troubles.

Garfield replayed Mickey Borden throughout his career in such aptly titled melodramas as *They Made Me a Criminal* (1949), *Dust Be My Destiny* (1939), and *Nobody Lives Forever* (1946). Occasionally, he was cast as an outright heavy. His dazed criminal in *Castle on the Hudson* (1940) brags that "Nothing ever got me down. Once I'm in the joint I'll own the place. I'll show ya how tough I am." His small-time racketeer in *Out of the Fog*

(1941) says, "You wanna gyp, do it slick like me" and "Don't talk foolish, I got rocks inside me." When Thomas Mitchell tells him, "You won't live to be an old man," he retorts, "Anyway, I won't starve to death."

He played drifters, outcasts, and victims, moralists and immoralists. He was the latter when he heated up the screen with Lana Turner as the alienated drifter in James M. Cain's *The Postman Always Rings Twice* (1946). He was an alienated working-class war hero in *Pride of the Marines* (1945), starring as Sergeant Al Schmid, a GI blinded by a grenade blast after having killed two hundred Japanese at Guadalcanal. In *Humoresque* (1946), he's an alienated working-class youth who's a brilliant violinist; his success on stage, and romantic involvement with his wealthy patroness, bring him no lasting happiness. The same holds true for his character in *Force of Evil* (1948): an alienated, up-from-the-slums lawyer who finds himself irrevocably immersed in the numbers rackets. In *The Breaking Point*, a version of Hemingway's *To Have and Have Not,* he played what is perhaps his most mainstream blue-collar character: the gutsy (and, of course, alienated) captain of a heavily mortgaged fishing boat who, to feed his wife and daughters, becomes involved with smuggling illegal Chinese aliens.

The actor is perhaps best remembered for *Body and Soul,* in which he played Mickey Borden with boxing gloves instead of a piano. Garfield is Charlie Davis, a poor boy with a whale of a knock-out punch who rises in the fight game, albeit at the expense of alienating his family, friends, and the girl he loves. Ultimately, he becomes a victim of the society he desires to conquer. But in the end he reforms, defies the mob by refusing to throw a fight, and walks off into the night with his girl.

Garfield's cinematic swan song was *He Ran All the Way* (1951), a run-of-the-mill melodrama. The film ends with the actor, in his usual criminal-on-the-lam role, shot down, defeated, dead, his face in the gutter. This image is a depressingly apt finale to his screen career, and an omen to his real-life catastrophe.

In 1951, Garfield testified before the House Un-American Activities Committee as a cooperative witness. He described himself as a liberal member of the Democratic Party, and inferred that communist front organizatons had used his name without permission. Although he avowed his allegiance to his government, he refused to name names—Garfield was, after all, a street kid, with a street kid's sense of loyalty—and became confused when asked to recall meetings and dates. When questioned as to who asked him to sign a brief supporting the Hollywood Ten, he replied that he had been approached by someone at the Beverly Hills Tennis Club, but could not remember if it was a man or a woman. He then was asked if he would have signed the document not knowing who was requesting him to do so. "Not if it was any stranger," was his response. HUAC was not satisfied. An FBI investigation of Garfield was ordered and his Hollywood career came to an abrupt, shattering halt.

Garfield was called before HUAC as much for his anti-hero screen personality and the tone of the films in which he appeared as for his politics. His working-class characters were not satisfied with their lot, but railed against the inequities of society. The Mickey Borden character, uttering such lines as "I guess when you're used to standing on the outside looking in, you can see things that other people can't," is the classic unbridled socialist. In a Garfield film, a poor American living in an urban jungle with little chance at upward mobility would not be beneath complaining that "All men are created equal. Who am I equal to? Nobody!" At the same time, Garfield's Paul Boray (in *Humoresque)* or Charlie Davis found no happiness after moving up in class. Instead, they were cast adrift in a world of snobs, hypocrites, and downright crimi-

nals. At the outset of McCarthyism, any criticism of mom's apple pie, or any aspersions cast at the values of America's upper class, were construed by HUAC as being tantamount to un-Americanism.

Many of the films in which Garfield appeared were concerned with the social problems of the day. In *Pride of the Marines*, the blinded Al Schmid is reminded by his friend Lee Diamond, a Jew played by Dane Clark, that his affliction does not give him a monopoly on persecution. A shamrock and a Star of David are visible on a machine gun at Guadalcanal, implying that the Goldbergs and Murphys are as much a part of America as members of the D.A.R. "We need a country were nobody gets booted around for any reason," Diamond tells Schmid.

Canada Lee's delineation of a washed-up boxer in *Body and Soul* is one of the early portraits of a black man as a human being with emotions and feelings, a man exploited. The camaraderie between Garfield's Harry Morgan and Juano Hernandez's black mate Wesley Park in *The Breaking Point* is one of the most moving aspects of the film.

Although a major star, Garfield insisted on taking a secondary role in the Academy Award-winning *Gentleman's Agreement* (1947) because of that film's anti-Semitic theme. Because of his upbringing and his nature, he remained concerned with the plight of his fellow citizen even after he had permanently escaped the ghetto. He was one of the lucky ones, having risen to Hollywood stardom. Yet he remained sensitive to racism and the problems of the working class.

Garfield was no great political theoretician. He was more emotional than philosophical in his liberal attitudes. During the Thirties, he supposedly wanted to join the Communist Party, but more as a status symbol than out of any deep political motivation. He was little more than a vocal, naive liberal who would sign a petition or endorse an organization without asking questions. Group Theater cofounder Harold Clurman said of Garfield, "There was in him...a confused rebelliousness in the name of love."

Like many of the characters he created on film, Garfield had become a victim of a force larger than himself, a force over which he had no control and could not understand. Even though not officially blacklisted, film and theater prospects fell through as a result of his HUAC ordeal. Inactivity was depressing him, and his days were frighteningly numbered. He had had several mild heart attacks, and had been warned to watch his health, yet he kept up his drinking and chain-smoking lifestyle. In May 1952, he died of heart failure. At the time, he had allegedly been preparing an article for *Look* magazine which would claim that he had been duped by the communists. Its title: "I Was a Sucker for a Left Hook."

A tribute to Garfield, written by his friend Clifford Odets, appeared in the May 25, 1952 *New York Times*. The playwright wrote, in part, "Many believe, and among them such critics as Brooks Atkinson and Richard Watts, Jr., in their last reviews, that John Garfield at 39 was just beginning to reveal himself as an actor in terms of wider range, new sensitivity and maturity. They were correct, for the sheen of Hollywood fooled him only a little; and one may surmise that in his work he felt himself a beginner, while in his life he had come to know himself as a man seeking his identity."—Rob Edelman

RECOMMENDED BIBLIOGRAPHY

Beaver, James. *John Garfield: His Life and Films*. NY: A. S. Barnes, 1978.

Morris, George. *John Garfield*. NY: Jove Publications, 1977.

Sklar, Robert. *City Boys: Cagney, Bogart, Garfield*. Princeton, NJ: Princeton University Press, 1992.

The Children's Hour

Gays and Lesbians in the Cinema

I n the spring of 1991, the production of Carolco's *Basic Instinct* moved to San Francisco for some necessary location shooting. Directed by Paul Verhoeven, *Basic Instinct* is a nasty drama about a homicidal lesbian and her beautiful, deranged bisexual girlfriend; Michael Douglas plays the investigative heterosexual hero.

Even before the crew's arrival, San Francisco's lesbian and gay activist groups were prepared. Earlier complaints about Joe Eszterhas's script—mean and misguided even beyond the standard exaggerations of Hollywood fiction—had gone unreplied. On the first night, filming was interrupted by a furious crowd of protestors who came armed with ear-splitting whistles. Riot police made a number of arrests. Despite a court restraining order, local news coverage encouraged attendance and continued disruption of the shooting. Photocopies of the script were circulated on Castro Street.

The protests against *Basic Instinct* were neither new—New York had seen the same thing in 1980 when William Friedkin's *Cruising* hit the gay bars—nor especially successful in effecting changes to the finished film, but they summarize the feeling of American lesbians and gays in the early Nineties. "Hollywood only understands money," declared one speaker at the *Basic Instinct* demonstration. "If they're going to make films that endanger my life, they better budget for my anger."

It's true. If Hollywood merely offered career advice, gay men and women would be better off on unemployment.

Mainstream movies have presented gays with a repetitive and sinisterly limited range of job opportunities—as spinster school teachers and sly spies; as hairdressers, fashion photographers, gossip columnists, and worried politicians with sweaty brows and secrets to hide; as gossipy best friends, sneaky butlers, poorshow prostitutes, twisted prison wardens, serial killers, and assorted borderline psychotics.

But this persistent belittling belies Hollywood's real agenda. In films as different as *Adam's Rib* (1949) and *American Gigolo* (1980), *A Florida Enchantment* (1914) and *The Hunger* (1980)—from Laurel and Hardy to lesbian vampires—since cinema began, Hollywood has been fascinated with finding ways of representing gayness. It is a part of popular cultural mythology that homosexuals are meant to be obsessed with Hollywood—all those queens crying for Judy, dykes swooning for Garbo. What is much less remarked upon is precisely the reverse: Hollywood's obsession with homosexuality.

Confronted by this torrent of lesbian and gay images, subtexts, and sensibilities, the question is not whether Hollywood's homosexuals have matched up to real life, but rather, how has sexuality been represented on the screen? What are the defining characteristics and how do they relate to common ideas about gay men and women?

There are essentially two ideas behind the label "gay cinema': first, that Hollywood's images of homosexuals are worth investigating and, second, that gay filmmakers themselves have been working independently—and in opposition—to these images. Thus there are two strands to a gay film history, which only really intertwine in the last few years, when independent films like *Longtime Companion* (1990), *Desert Hearts* (1986), and *Parting Glances* (1985) proved that gay and lesbian culture has what Hollywood cutely calls "crossover" potential. Despite the critical and commercial success of these films, les-

bian and gay cinema isn't something that happened only since gay liberation—although politicization has provided the impetus to sift through history and tease out what was previously concealed.

A 1916 Swedish film, *The Wings*, seems to be one of the first overt gay screen romances; based on Herman Bang's novel, *Mikael*, it races through the melodrama of sculptor Claude Zoret and the elusive youth of the title. Anticipating the dominant theme of mainstream cinema over the next fifty years, their romance ends unhappily, with adopted son Mikael provoking his patron and lover to a feverish death. In *The Wings* at least Zoret dies of a broken heart, a genuinely romantic demise; more often, gay characters have died out of guilt or punishment.

Meanwhile, in Weimar Germany, a second version of homosexual tragedy was being played. Magnus Hirschfeld's Institute for Sexual Science in Berlin initiated the first campaign for decriminalizing homosexuality; *Different from the Others* (1919), starring Conrad Veidt, explicitly pleaded for tolerance. A tale of blackmail and suicide, prefaced by a direct-to-camera monolog by Hirschfeld, *Different from the Others* set the standard for liberal tolerance and for a durable new genre of gay sympathy films.

While Hirschfeld was pleading for tolerance, Hollywood was playing for laughs. Hirschfeld's theories were based on the radical idea of a "third sex," whereas contemporary popular conceptions identified homosexuality as an inversion of ordinary gender: women in men's bodies, men in women's. Hence Hollywood's most enduring stereotype: the sissy. In his benchmark history, *The Celluloid Closet*, Vito Russo, the prodigious researcher and author, picked out characters like the dressmaker in *Irene* (1926), played by George K. Arthur, and Grady Sutton in *Movie Crazy* (1932) as early examples of the sissy type. In *Movie Crazy* Sutton shrieks and leaps on a table at the thought of a mouse; it's this sort of incongruous and effeminate behav-

ior that marks out the early characterizations.

In later films the shading of the sissy becomes more complex; the dialog often juggles with their sexual ambiguity. Comedians Eric Blore, Edward Everett Horton, and Franklin Pangborn most often occupied these roles. In *The Gay Divorcee* (1934), Horton plays Astaire's priggish friend Pinky, who enjoys some quick banter with Blore (tagged as having an "unnatural passion for rocks"); besides the innuendoes, the homosexuality of the sissies lies in their easy association and their comic conspiratorial conversation compared to the edgy air between would-be lovers Astaire and Rogers.

Naturally, most gay people would now dispute the causal connection between gender and sexuality, but there's also something to celebrate in the sissy image. There is a flipside to the sissy's intimations of conspiratorial behavior, overemotionalism, and frivolous humor: companionship, sensitivity, and back-bite wit. David Wayne as Katharine Hepburn's best friend Kip in *Adam's Rib* (1949) is a shining example of these fairly noble qualities.

If the sissy was premised on the idea of a man behaving like a woman, it didn't work out so well the other way round. In *Turnabout* (1940), a convenient genie enables overworked husband John Hubbard and jejeune wife Carole Landis to swap bodies. Whilst Hubbard arrives at work with a clutchbag and enjoys a bit of gossip with stockings salesman Franklin Pangborn, Landis takes to full-throated thigh-slapping, donning men's pants, and mountaineering on the roof of their Manhattan apartment. But the woman-in-man's-clothing gag lacked the longevity or easy humor of the male sissy; as an image it rarely attained sexual tenor. According to archivist Andrea Weiss (in *Vampires and Violets: Lesbians in the Cinema*), lesbian interest in early Hollywood figured less on broad comedy and more on drama's major stars like Garbo, Hepburn, and Dietrich—who all had their moments

of cross-dressing in films like *Queen Christina* (1933), *Morocco* (1930), and *Sylvia Scarlett* (1935)—and who in their combination of sexual objectification and stage-center action became pinups for women as much as men.

The sissy is something that can be signalled immediately, in the flick of a wrist or a rapid sashay. The other predominant image in mainstream movies is a little more elusive. If the sissy belongs to the domain of farce and comedy, the tragic figure haunts the genres of crime, melodrama, and horror. As a stereotype, the tragic homosexual is to be found wherever Hollywood is required to signal shady bars on the wrong side of town, bohemian decadence, or the ill-effects of same-sex proximity. As with the sissy, so much is signalled by certain visual conventions. With Glorida Holden in *Dracula's Daughter* (1936), Judith Anderson in *Rebecca* (1940), and, later, Sal Mineo in *Rebel Without a Cause* (1955), and Robert Walker in *Strangers on a Train* (1951), the tragic homosexual's torture is concentrated in the eyes—sunken, searching out love or, in the thrillers, young prey. His or her most common profession is in roles of minor authority (schoolteacher, warden, housekeeper), or some equally small part in the criminal world (blackmailer, getaway car driver), or merely as devoted mother's boy or best friend. Often the male characters were pictured in a bohemian context—this is what writer and critic Richard Dyer has identified as the image of "the sad young man."

The Sad Young Man wasn't merely an invention of Hollywood; like the sissy, which can be traced back to nineteenth-century images of the fop and dandy, it already existed in literary and art history. The Sad Young Man is part Dorian Gray, Part Narcissus. In *Now You See It*, his exhaustive study of the American lesbian and gay underground, Dyer finds the image in the films of Kenneth Anger and Gregory Markopoulos. Anger's *Fireworks* (1947), one of the first, widely-screened

gay underground movies, is the imaginative and seemingly masochistic sex fantasy of its slim, solitary dreamer. Fifteen years later, Markopoulos's New York-set *Twice a Man* exploits the image seemingly without irony: Paul, the melancholic, suicidal hero, literally weeps his way through the Oedipal drama.

Dyer relates the rise of the male gay underground to the popularization of Freudianism (which, however fumblingly, emphasized the idea of unconscious and therefore unwilled attraction), to the war (which brought large numbers of gay men and women together in single-sex environments), and to the boom in paperback publishing (where exposés of homosexual lives were frequently accompanied by the first illustrations of the gay milieu). These same latter factors also led to the widescale distribution and manufacture of gay pornography. From beginnings with the Athletic Model Guild—a studio devoted to male photography based in Los Angeles—an empire was quickly assembled. AMG auteur Richard Fontaine started making short, silent posing-pouch snapshot films in the mid-Fifties and moved on to sound titles like *In the Days of Greek Gods* (1958) and *Muscles from Outer Space* (1962), which featured narratives as well as nudity. Fontaine's films are among the first gay-campaigning documents in American cinema—he often managed to include references to the lowly status of the homosexual. His first feature-length erotic film, *In Love Again* (1969), is more like propaganda than porn.

Dyer has characterized the gay images—and there are many—of the Sixties underground as "listless and inconsequential." Warhol's films very much capture the essence of this limp mode; his stars are passive hustlers—Joe Dallesandro in *Blow Job* (1969) or drugged, drunken queens (Taylor Mead in any title). In the late Sixties, it is only the work of less-well-promoted directors like George Kuchar, Curt McDowell, and John Waters which allow the appearance of energetic, lusty gay protagonists.

Lesbian underground filmmakers took a different route. As it is with the history of all independent cinema, there is less work by women at this time, for obvious economic reasons. Apart from an exceptional moment of semi-seduction in Maya Deren's *At Land* (1945), it was left to Seventies filmmakers like Constance Beeson and Barbara Hammer to break new ground. Hammer's films—among them, *Superdyke* (1975), *Labryis Rising* (1977), and *Women I Love* (1976)—express a metaphoric, collective lesbian iconography: instead of the individualistic narratives of the male underground, they try to present new images for all lesbians. Hammer's work since then has persistently continued this devotion to new vocabulary, and in the Eighties she starts to look back at the success of the lesbian avant-garde, by reprocessing and juxtaposing footage from both decades. Hammer's most recent film recuts a classic of the gay male underground: Melville Weber and James Sibley Watson's *Lot in Sodom* (1930).

For mainstream cinema, as for popular culture in general, the late Fifties and Sixties were times for the tragedy of the homosexual experience. As the censorship systems in Britain and the U.S. were found to be more malleable, the image of the Sad Young Man (and Woman) figured in narratives. Movies were suddenly keener to diagnose the condition of their characters; studio executives, however, read the boom in pop psychology and hand-me-down Freud a little differently from the intellectuals of the underground.

Films like *Tea and Sympathy* (1956), *The Children's Hour* (1962), *Suddenly Last Summer* (1959), *Boys in the Band* (1970), and, from Britain, *Victim* (1960) and *The Killing of Sister George* (1968), set about creating a narrative context for the stereotype. These films focused on the loneliness of their homosexual figures, but their vision was blurred by a double movement of sympathy and voyeurism. *Victim* osten-

sibly credits the anomie of gay men to their illegality and sets out to prove that their susceptibility to blackmail and imprisonment ensures a miserable life. Designed therefore as a campaigning, liberal film, *Victim* also ends on an image of unbearable isolation.

Similarly, in the final frames of *The Children's Hour*, after Shirley MacLaine hangs herself, wrongly labelled lover Audrey Hepburn walks proudly and tearily down a desolate tree-lined avenue; after ejecting and humiliating his dinner party guests, *The Boys in the Band*'s host Kenneth Nelson wipes a tear and takes another tranquilizer. One of the most dour denouements belongs to a British film, *Walk a Crooked Path* (1969), in which a married gay teacher is abandoned by the schoolboy he adores, after having engineered the murder of his wife; he sits alone in his now-still home and the image changes from color to black and white as the film flashes through long shots of each deserted room. Yet these intensely melancholy fantasies were of course rooted in real-life homophobia, legislation, and social stigma. Just as musicals capture moments of ecstasy and community, *Victim* and *The Children's Hour* exaggerate isolation and injustice to a degree that is recordable, palpable, and undeniable.

Another key moment in films of the Sixties and Seventies is the gay bar scene. *The Detective* (1968) pitches Frank Sinatra in pursuit of a homosexual killer and comes up with a crawl tour of New York's gay dives. There's a self-consciousness not just in the representation of "casual" gay social life but also in the camera pans and overhead shots, a sense in which the film is proud to present something so explicitly, and yet still be bewildered by what it sees. *The Detective* wasn't the first film to peek inside a gay bar (Vito Russo pinpoints this to *Call Her Savage*, a 1932 Clara Bow drama), but it typified the realist trend of the next decade.

On the one hand, each gay-themed film made a special claim to authenticity. *Sister George*'s publicity made much of the fact that its bar scenes had been partly filmed at London's famous Gateways Club; ten years later, William Friedkin took to Manhattan leather bars in search of real-life clubbers for *Cruising*. Second, the mid-Sixties films often used the device of an investigative figure delving into the gay scene in order to resolve a mystery, a commentator to a criminal kind of *Lifestyles of the Rich and Famous*. Later, *Investigation of a Murder* (1973), *Partners* (1982), and *Cruising* made their heroes literal detectives.

The bar scene is also constructed to confirm culture's queer conspiracy theory, that goes something like: "Homosexuals have a secret code and a secret meeting place, just below the surface of ordinary social life." Yet for gay viewers the bar scene may function as a vision of utopia, a restorative after all the hours of miserable, cinematic isolation. The self-consciously casual scenes of Seventies social life potentially offered the pleasure of recognition for lesbian and gay audiences. Not for the first time, Hollywood's homosexual images can be experienced differently, and in complex ways, by a gay audience.

By 1980, though, the curiosity of gay viewers had been both sorely tested and exploited. Twentieth Century-Fox released *Making Love* (1982) with much self-generated excitement. Penned by openly gay writer Barry Sandler, and promoted as the first honest look at gay relationships, *Making Love* is best remembered for a sex scene of astonishing discretion. More interesting than the movie itself—a TV-movie tale of broken marriage and bisexuality, with Kate Jackson as the hurt wife on the trail of her husband's nighttime liaisons—was the narrative of the film's marketing. Aside from the standard campaign, which presented *Making Love* as an old-fashioned women's picture and bleached away the gay theme, Fox also ran a separate campaign for the gay community. This involved preview screenings for gay journalists and other community

"opinion-makers," as well as a new poster picturing Harry Hamlin undressed and embraced by Jackson's movie husband, with Kate herself banished to the background. *Making Love* was a failure with both constituencies, gay and nongay. Against that film's much-derided middle-class coziness, the plurality of lesbian and gay lifestyles was apparent in the increasing vigor of the American gay movement. In the Seventies, independent documentarists had tried to get at this diversity. *A Position of Faith* (1973), *Gay USA* (1977), and Peter Adair's hands-across-America panorama, *The Word is Out* (1977), all attempted not just to explain the premise of gay liberation, but showed it, too. When interviewees in *The Word is Out* claimed, "We're just like you," audiences could see that it was true. Later nonfiction features achieved this mission more succinctly: *The Times of Harvey Milk* (1984) is a persuasive political tearjerker, while *Before Stonewall* (1984), made the same year, is an elegant family album of archival footage; both films, like the documentaries of the Nineties—*Tongues Untied* (1990) and *Voices from the Front* (1991)—still rely on the truth of personal testimony to move, or forge identification with, their audiences.

In the Eighties and Nineties, gay-themed fiction commands a high profile. In *Parting Glances* (1986), *Desert Hearts* (1987), and *Lianna* (1986), the blur between Hollywood and independent has produced narratives which address both gay and nongay audiences. Many of these are directly the result of filmmakers' experience in the Seventies with international work made and screened exclusively for gay men and women. For American audiences, annual gay film festivals (in San Francisco, New York, Los Angeles, and other cities) have discovered European directors like Eloy de l'Iglesia (*The Deputy*, 1979), Monika Treut (*Seduction: The Cruel Woman*, 1986), and Alexandra von Grote (*November Moon*, 1984) or have otherwise reclaimed the lesbian and gay "sensibility"

of avant-gardists like Ulrike Ottinger, Isaac Julien, and Rosa von Praunheim. Crucially, dedicated researchers like Richard Dyer, Vito Russo, and Andrea Weiss have brought new perspectives to the work of earlier filmmakers.

Eroticism features strongly in today's mainstream gay movies. AIDS has moved gay-themed films once again away from realism, has clarified that films are indeed fictions. Whether it's boredom with heterosexuality or another burst of voyeurism, Hollywood seems captivated by what gay people do in bed, hence *Lianna, Longtime Companion* (1990), *Maurice* (1987), and *Torch Song Trilogy* (1988), all made independently but picked up by major distribution companies. Of course, it would be unfair to claim that eroticism is the sole project of any of these films, but it is true to say that the bed scene has replaced the bar scene.

As Hollywood claws back and reconstitutes the novelty of lesbian and gay culture, and as independent gay filmmakers confess to the pleasure of mainstream genres like romance, gay themes and influences cluster in increasingly bizarre groupings: the adoration of the male body/buddy (Schwarzenegger, Cruise; *My Own Private Idaho*, 1991); the mass marketing of camp (*Too Much Sun,* 1990; *Pee Wee's Big Adventure*, 1987; *Soapdish*, 1991); ceaseless homosexual subtexts about Oedipal indecision in teen movies like *Fright Night* (1986) and *Point Break* (1991); the reappearance of the destructive *film noir* lesbian (*Slamdance*, 1986; *Bellman and True,* 1987; *Basic Instinct,* 1992); the dominance of educational-TV movies (*An Early Frost*, 1986; *Consenting Adult*, 1985; *André's Mother*, 1990); AIDS and associational imagery in horror (*The Fly*, 1986; *Lifeforce*, 1985); homosexual serial killers and their newly graphic crimes (*The Krays*, 1990; *Silence of the Lambs*, 1991). Oppositional work is also thriving, either as agitprop or avant-garde. Video allows for fairly instant responses to issues: there are now hundreds of tapes

around AIDS, and within a few months of Britain's new antigay legislation in 1988, eighteen campaigning tapes had been logged. At the same time, a new kind of underground cinema is indentifiable; filmmakers like Su Friedrich (*Sink or Swim*), Gregg Araki (*The Living End*), Tom Kalin (*Swoon*), and Todd Haynes (*Poison*) are unarguably at the vanguard of a playful new esthetic.

The tentative and fractious nature of these recent groupings is proof that heterogeneity is still the norm. For as long as homosexuality occupies the same difficult ideological position that it does—ceaselessly yoked with anxieties about disease, reproduction, and contamination; bound in with legislative and civil rights discourse; shaped by sociological surveys and

celebrity scandal—filmmakers will undoubtedly continue to produce consistently provocative and complex images.

—Mark Finch

RECOMMENDED BIBLIOGRAPHY

Bad Object-Choice Collective. *How Do I Look?: Queer Film and Video*. Seattle, WA: Bay Press, 1991.

Dyer, Richard. *Gays and Film*. NY: New York Zoetrope, 1984.

——— *Now You See It: Studies on Lesbian and Gay Film*. NY: Routledge, Chapman & Hall, 1990.

Russo, Vito. *The Celluloid Closet: Homosexuality in the Movies*. NY: Harper and Row, 1987.

Tyler, Parker. *Screening the Sexes: Homosexuality in the Movies*. NY: Holt, Rinehart and Winston, 1972.

Genre

A movie genre is at base a story formula, a system of narrative and dramatic conventions. Genres like the gangster film, the Western, the sci-fi film, and the musical involve established character types acting out familiar patterns of conflict and resolution within a familiar setting.

All of America's popular-culture industries, including cinema, are heavily genre oriented. From TV sitcoms to rock 'n' roll songs, from romance novels to video games, the products of our commercial /industrial/popular arts are standardized commodities geared for success in the marketplace. While every product must be sufficiently "new" and innovative to compete in that marketplace, their production is typified less by innovation than by a reliance on established convention.

Genre forms are as old as the arts

themselves. The term genre is derived from the root "genus" and indicates the species or category to which an artwork belongs. Genre categories have been applied to literature, drama, painting, and other art forms for centuries, dating back at least as far as Aristotle's *Poetics*. In those preindustrial forms, genre categories generally were imposed by scholars to facilitate critical analysis or historical organization. With the rise of the industrial arts, however, genre categories are now invoked by both the producers

and consumers of popular culture, and have become indispensable in the merchandising and promotion of movies, TV, popular music, and so on.

Because contemporary genres are exploited by commercial industries as presold, marketable commodities, many critics and historians dismiss them out of hand. Without question, popular genres do seem to manifest qualities of contemporary mass culture that fly in the face of traditional esthetic values: they are designed not to please the cultured elite but the massive, anonymous public; they are not created by individual artists but are produced by a corporate collective; their production relies less on innovation and personal expression than "standard practice"; they shy away from complex or critical views of society, tending instead to reproduce familiar conflicts whose resolutions reinforce the status quo.

Despite the prevalence of genre production in the American cinema, film criticism has been dominated by traditional elitist esthetics. The auteur policy, in particular, celebrates the director-author as stylist and visionary working in a medium that militates against individual authority over the production process. This critical approach is not without its merits, though, whatever its debt to nineteenth-century romanticism. As John Ford, Hollywood's consummate auteur, once described the medium's potential for individual artistic expression: "For a director there are commercial rules that it is necessary to obey. In our profession, an artistic failure is nothing; a commercial failure is a sentence. The secret is to make films that please the public and also allow the director to reveal his personality."

Significantly, virtually every American auteur during Hollywood's classic era was essentially a genre director. Like the forms they worked with, these directors became commodified; indeed, the most successful Hollywood directors became genres unto themselves. A Griffith melodrama, a Chaplin comedy, a Ford Western, a Minnelli musical, a Hitchcock thriller—these represented forms that had "pleased the public" and consigned (or condemned, depending on one's viewpoint) the director to work more or less exclusively in that form. Like the movie stars of the studio era, directors were deemed "bankable" so long as they operated within the range of earlier successes. Ironically, directors had more "freedom" and creative authority when they stayed within that range.

At first glance, the cinema's industrial and commercial imperatives would seem to be responsible for its heavy genre orientation. But economic determinism cannot begin to explain how or why certain movies were pleasing to the public. French film critic and theorist André Bazin, a grudging admirer of Hollywood and its products, was among the first to address this problem. Warning his protégés at *Cahiers du cinéma* against developing an auteurist "cult of personality" during the Fifties, Bazin described the Hollywood cinema in terms that are worth quoting at some length:

If you will forgive another commonplace, the cinema is an art which is both popular and industrial. These conditions, which are necessary to its existence, in no way constitute a collection of hindrances—no more than in architecture…And this is especially true of the American cinema, which the theoreticians of the [auteur policy] admire so much. What makes Hollywood so much better than anything else in the world is not only the quality of certain directors, but also the vitality and, in a certain sense, the excellence of a tradition. Hollywood's superiority is only incidentally technical; it lies much more in what one might call the American cinematic genius, something which should be analyzed, then defined, by a sociological approach to its production. The American cinema has been able, in an extraordinarily competent way, to show American society just as it wanted to see itself; but not at all passively, as a simple act of satisfaction and escape, but dynamically, i.e. by participating with the

means at its disposal in the building of this society.

Bazin went on to suggest that Hollywood projected this idealized cultural self-image primarily through its "tradition of genres," which he considered "a base of operations for creative freedom." This may seem paradoxical, but Bazin felt that Hollywood's dynamic, interactive rapport with its audience provided the industry with "fertility when it comes into contact with new elements." Keep in mind that the American public developed its appetite for genre films when the major studios controlled the production, distribution, and exhibition of their movies. (By the early Forties, the majors distributed their own films and owned roughly seventy-five percent of the first-run theaters in the nation's twenty-five largest cities.)

Robert Warshow was another postwar critic who recognized the interactive, self-regulating nature of the studio system and who regarded the public as possessing some measure of taste and a desire to participate in the building of its society. But Warshow perceived Westerns and gangster films and melodramas in considerably more complex social and cultural terms than did Bazin. Warshow's views are presented most clearly and powerfully in an essay he wrote for *The Partisan Review* in 1948, "The Gangster as Tragic Hero." The piece still stands as the best single analysis of the genre and also as a pioneering work in the as yet uncharted territory of popular-culture theory.

Like Bazin, Warshow recognized the overtly prosocial function of movies: "Every production of mass culture is a public act and must conform with accepted notions of the public good." In Hollywood's classic gangster films, however, Warshow found certain elements running counter to the genre's superficial celebration of law and order and the socio-economic status quo. "Even within the area of mass culture," wrote Warshow, "there always exists a current of opposition, seeking to express by whatever means are

available to it that sense of desperation and inevitable failure which optimism itself helps to create."

Basic to the gangster genre was a conflict between the "public good" and the gangster hero's own sense of ambition, individual initiative, and accomplishment. The movie gangster, according to Warshow, "is what we want to be and are afraid we might become." Thus the genre allows us to participate vicariously in the gangster's illicit rise to power and wealth, and then to celebrate the community's return to moral and social stability at film's end with the hero's inevitable "death in the gutter."

The inevitability of the gangster's fall couldn't do away with his essential heroic nature, though. He represented the hungry, savvy immigrant who pulled himself up by his bootstraps—a brutal, ruthless perversion of Horatio Alger, writ large across American movie screens. Clearly the gangster was more than merely a depiction of America's urban criminal; he had become a cult figure, a mythic hero. As Edward G. Robinson's character, Johnny Rocco, put it in *Key Largo*: "There's thousands of guys with guns, but there's only one Rocco."

The gangster-hero's subversive qualities were obvious not only to Warshow, but also to the Legion of Decency, to Hollywood's Production Code Administration, and to various other social groups intent on stifling the genre and blunting its obvious appeal to movie audiences. But had these public watchdogs looked a bit closer at other movie genres they might have found equally unsettling themes at work. Consider even the classic Western, whose hero invariably protects some defenseless community but is unwilling (or unable) to "settle down" there, opting instead to "ride off into the sunset" in the form's standardized denouement. The Westerner, like Hollywood's hard-boiled detective and other idealized male heroes, may uphold the Public Good but he cannot compromise his rugged individualism or

assimilate the community's values.

Consider too the portrayals of male-female bonding in genres like the musical and screwball comedy, genres designed to reproduce the couple (and thereby to celebrate romantic love, marriage, and the family, at least by implication). These films generally end with the couple's embrace, a charged moment designed to efface the romantic antagonism that had previously fueled the narrative conflicts. That embrace and all it implies, however, cannot do away with the essential incompatibility of Hollywood's—and these genre's—idealized female values (domestication, stasis, community). Nor can the prosocial finale resolve the genres' essential opposition between the community's repressive constraints and the individual's celebration of life through music or "screwball" behavior.

These observations center on the fundamental elements of drama: conflict and resolution. The nature of drama is to generate and resolve conflict, and as America's principal means of public discourse earlier in this century, movies—particularly genre movies—served in a very real sense as social problem-solving operations. The "happy endings" and idealized heroes in genre movies do indicate that, on the surface at least, these movies work to resolve social conflicts. But the sustained success of any genre, whatever it is that keeps audiences coming back time and again to its ritualized dramatics, seems to rely more on the social conflicts that the genre repeatedly animates than it does on the genre's false promise of resolution. In other words, genres address ongoing social problems that simply cannot be solved.

We might pause here to consider how far away we've moved from our initial view of Hollywood as a sort of formula factory and of genres merely as marketable commodities. Hollywood's longstanding reliance on genre production has been, without question, a means of hedging its bets, of standardizing what had already proven successful in the marketplace. But that success was itself a measure of public response. Hollywood, we might say, produces only movies; the public produces genres.

Any established genre, then, represents a genuine cultural dialectic, a synthesis of contradictory forms of *economy*. For the industry, genre production represents a form of material economy: genre filmmaking manifests the industry's need to standardize and thus economize the production process. For the public, however, genres represent something altogether different. From the audience's perspective (on the "other side" of the screen, oblivious to the production process) a genre is a form of *narrative economy*, the condensation and displacement of lived experience and real social issues into distinct dramatic patterns.

This "economy principle" is fundamental to all genre production in the commercial arts, where the efficiency of production and the quality of expression continually counterbalance one another. If we are ever to understand how this process works in movie genres, we must consider the social functions that genre films perform and thus the process whereby they condense and transform social reality into narrative formula.

British critic Robin Wood addresses just this question in his essay, "Ideology, Genre, Auteur." According to Wood, "What we need to ask, if genre theory is ever to be productive, is less What? than Why? We are so used to the genres that the peculiarity of the phenomenon itself is too little noted." Extending concepts developed in Robert Warshow's "seminal essays on the gangster hero and the Westerner," Wood answers this "Why genre?" question by considering a genre's social function in terms of its formal structure and rhetorical strategy. Wood perceives America, like all active and dynamic cultures, as being rife with internal conflicts and contradictions: between competitive capitalism and egalitarian democracy, for example, or between

individual initiative and the common good.

Bazin had argued that Hollywood, in its efforts "to show American society just as it wanted to see itself," developed a popular cinema that "shrinks away from depicting even the contradictions of that society." Wood's position is antithetical to Bazin's. For Wood, "the development of genres is rooted in the sort of ideological tensions" that characterize American society at large. "*All* the genres can be profitably examined in terms of ideological oppositions," Wood suggests, with the genres themselves serving as "different strategies for dealing with ideological tensions."

Thus the essence of the Western genre is its opposition between civilization and savagery, and between man and woman as agents of the wilderness and the hearth, respectively. The gangster repeatedly examines conflicts between avaricious self-interest and the public welfare. The musical treats the tension between social repression and the potentially liberating qualities of individual musical expression, and also between the unbridled music man and his domesticating counterpart.

While movie genres maintain this dynamic relationship with real-world conflicts and issues, though, they are by no means "realistic." Any genre's treatment of social reality occurs within a stylized, highly coded and iconographic milieu. "It is only in the ultimate sense that the type appeals to the audience's experience of reality," Warshow pointed out. "Much more immediately, it appeals to the previous experience of the type itself; it creates its own field of reference." Or, in the words of a newspaper editor in John Ford's *The Man Who Shot Liberty Valance*, "when the legend becomes fact, print the legend."

All American movie genres, as popular formulations of our shared values and concerns, are indeed legends which have become facts. Transforming lived experience into drama and thus creating sites of ideological struggle and negotiation is in fact the essence of our popular-culture

industries. TV's Bill Moyers once described that mass medium as "the campfire around which our nation-tribe sits to weave and reweave its traditions and tales." This evocative description would have applied to the cinema as well, before it was displaced by television as America's primary form of mass communication and public discourse—with the exception that moviegoing was less a metaphoric gathering around the campfire (as with TV's electronic hearth) than a form of community worship in a virtual temple of mass culture.

These references to legend, to the reweaving of traditions and tales, and to the American nation-tribe, all have a distinctly mythological ring to them. In fact, recent developments in structural anthropology have had significant impact on popular-culture studies. One of the more influential scholars in this field has been Claude Lévi-Strauss, who provides this description of mythmaking:

A myth exhibits a "slated" structure which seeps to the surface...through the repetition process. However, the slates are not absolutely identical to each other. And since the purpose of myth is to provide a logical model capable of overcoming a contradiction (an impossible achievement if, as it happens, the contradiction is real), a theoretically infinite number of slates will be generated, each one slightly different from the others.

From this perspective, myth is identified not by its content (stories about the gods, about creation, etc.) but rather by its characteristic form and function. Consider how appropriate this definition is to movie genres. Through the repetition process, genre films formulate a conflict-to-resolution structure that works endlessly to resolve some ongoing social conflict, to "overcome" some cultural contradiction. And because the social issues addressed by Hollywood genres are indeed "real," a virtually infinite number of variations (i.e., genre films) will be produced, none of which will fully resolve the conflicts at

hand.

Roland Barthes, a French critic and theorist who applied Lévi-Strauss's ideas to his own contemporary society, contends that the mythmaking impulse in primitive societies survives in the form of ideology. "The very principle of myth," argues Barthes, is that "it transforms history into nature." Today, this process serves to naturalize those familiar belief systems like Christianity, democracy, capitalism, monogamy, and so on. The power of myth is evidenced by the fact that these ideologies do indeed seem natural, they seem to be commonsensical or self-explanatory (even though they may be peculiar to only certain "nation-tribes').

It's also interesting to note that Barthes describes myth in terms of narrative economy. In "Myth Today," Barthes writes, "In passing from history to nature, myth acts economically: it abolishes the complexity of human acts, it gives them the simplicity of essences, it does away with all dialectics, with any going back beyond what is immediately visible, it organizes a world which is without contradiction because it is without depth." This description would apply only to genres in their simplest form and, from a critical viewpoint, in their least interesting form—a B-Western from Monogram studios, say, or a Boston Blackie crime thriller. Only in those simplified bare-bones versions does the genre's "logical model" seem capable of overcoming the cultural contradictions it repeatedly confronts.

But when we consider Hollywood's more ambitious (and generally its more critically and/or commercially successful) genre films—movies like Ford's *The Searchers*, Minnelli's *The Band Wagon*, Hitchcock's *Vertigo*, or Sirk's *Written on the Wind*—we find works that do indeed manifest the complexity of human acts, that grapple directly with contradictory values, that display formal and thematic depth. These and other genre films, in fact, manifest the qualities often associated with high narrative artistry, qualities like irony, ambiguity, narrative complexity, formal self-consciousness, and so on.

Recourse to auteurism begins to explain this; many Hollywood artists (producers and screenwriters as well as directors) certainly were sophisticated enough to recognize and exploit the inherent complexities of the genres with which they worked. But we also should note that this level of sophistication tends to surface at a later stage of either the genre's or the artist's development. As one becomes more familiar with a genre's system of conventions, it seems, the more one tends to appreciate seeing those conventions embellished, subverted, or otherwise manipulated.

Leo Braudy once suggested that "change in genre occurs when the audience says, "That's too infantile a form of what we believe. Show us something more complicated."' This recalls the audience-industry dynamics we discussed earlier, and also the genre's relationship to the public's shared values and beliefs. And it implies that as audiences (like filmmakers) grow increasingly conscious of generic conventions, they seek out more sophisticated treatments of what is "at issue" in the genre.

These related problems of generic literacy and generic evolution have been addressed by Christian Metz in *Language and Cinema*. When he examined the development of the Western, Metz found that the genre evolved from a "classic" stage into a "parody" and then into a stage of "contestation," where the basic formal and thematic codes of the genre are being questioned or "contested" by filmmakers and viewers alike. From this point, observes Metz, "contestation gives way to "de-construction': the entire film is an explication of the [Western] code and its relation to history. One has passed from parody to critique, but the work is still a Western."

Consider, for example, four Ford Westerns produced in subsequent decades: *Stagecoach* (1939), *My Darling*

Clementine (1946), *The Searchers* (1956), and *The Man Who Shot Liberty Valance* (1962). From the classical evocation of the genre in *Stagecoach*, we do indeed find traces of parody in *Clementine*, particularly in Henry Fonda's portrayal of Wyatt Earp and Victor Mature's portrayal of Doc Holliday. In *The Searchers* John Wayne, arguably the genre's essential icon (along with Monument Valley), portrays a hero whose hatred of Indians and sense of vengeance verges on the psychotic—clearly the traditional heroic qualities associated with the Westerner are being "contested." With *Liberty Valance,* the legend of a notorious outlaw's death is quite literally "deconstructed" through flashbacks and self-conscious discussions of myth and history ("When the legend becomes a fact...").

We might consider later musicals (*The Band Wagon, It's Always Fair Weather*), detective films (*The Big Heat, Touch of Evil*), melodramas (*Imitation of Life, Cobweb*) and other films appearing late in a genre's cycle along these same lines. In each case, the film honors its generic conventions even as it turns our attention toward the nature and workings of those conventions. Significantly, each of these films was produced during the Fifties, when industrial decline in Hollywood was offset by artistic experimentation and excess, giving rise to what might be termed the American cinema's "baroque" period.

During this period a new generation of self-conscious genre auteurs emerged—in melodrama with the likes of Nick Ray and Douglas Sirk, in the Western with Anthony Mann and Budd Boetticher, in the musical with Stanley Donen and Gene Kelly, in screwball comedy with Frank Tashlin and Billy Wilder, in urban crime thrillers with Sam Fuller and Don Siegel. The Fifties also saw established directors like Ford, Minnelli, and Hitchcock drift into their late "mannerist" periods.

It's little surprise that the work of these filmmakers has been so appealing to recent critics, especially those interested in genre, ideology, and narrative deconstruction. For anyone willing to look beneath the surface of films like Hitchcock's *Rear Window* and Minnelli's *The Band Wagon,* these films were "about" their own genres as formal and social entities; they addressed the ways that movies work in and on our culture. These and countless other Fifties movies, particularly genre films, actually initiated critical inquiry; far from being escapist "diversions," these self-reflexive films brought the artist and critic and viewer into an odd rapport.

Most viewers didn't care to look beyond the surface, of course, which not only contributed to Hollywood's decline but also points up one of the more troubling aspects of genre criticism and cultural studies generally. Clearly, critics tend to be drawn to works that are themselves "critical" of the traditions in which they operate. But to what extent do critics and analysts impose these same values and "readings" on genre films when there is little evidence that contemporary audiences "read" the films that way? Listen to Molly Haskell, in *From Reverence to Rape,* discussing narrative resolution in Hollywood's classical melodramas: "The forced enthusiasm and neat evasions of so many happy endings have only increased the suspicion that darkness and despair follow marriage, a suspicion the "woman's film" confirmed by carefully pretending otherwise."

Haskell may understand the narrative logic and ideological machinations of the woman's picture well enough to sense this kind of indirect subversion. But whether similar "suspicions" were felt by the mass of viewers who consumed these weepies unself-consciously, along with their popcorn and Kleenex, is another question altogether. Douglas Sirk's melodramas (*All that Heaven Allows, Written on the Wind, Imitation of Life,* et al.) may strike recent Marxist and feminist critics as masterpieces of irony and Brechtian distantiation. But these same films were enormously

successful with Fifties matinee audiences, and their formal and thematic subtleties went utterly unnoticed by Fifties film critics.

In the Sixties, with yet another crop of filmmakers and a new generation of younger, more cine-literate viewers, the formal and thematic countercurrents sensed by critics like Haskell in classical Hollywood movies surfaced with a vengeance. Although the demise of the old studio system had liberated filmmakers from relying so heavily on genre production, still there was a fascination with genre films, an attraction motivated less by commercial than by formal and ideological concerns.

In other words, genre filmmaking for the likes of Arthur Penn, Robert Altman, Francis Coppola, Martin Scorsese, George Romero, and others, was less a matter of ensuring audience appeal and thus financial success, than it was a means of "getting at" whatever it was that made the genre tick. In the words of George Romero, whose *Night of the Living Dead* and *Dawn of the Dead* helped to regenerate the horror film:

Nowadays, we don't want to be removed from our heritages, but we do view them differently. Whereas we used to be able to do camp and call it homage or a goof on this or a spoof on that, you can't even use these words anymore. We need a new word for whatever we are doing now. It's a little more rebellious. It's like taking the old genres, the old horses, and baring all the nerves.

Hip young viewers translated Romero's nerve-baring, low-budget horror films into commercial success, but mainstream audiences balked when traditional genres were taken on in more ambitious and costly genre productions. The ironic narratives and stylized *mise-en-scène* in mainstream Westerns like *Ulzana's Raid* and *The Missouri Breaks* or in musicals like *All That Jazz* and *Pennies from Heaven* reduced their marketability virtually to nil. Or consider the repeated incursions into the hard-boiled detective tradition with Altman's *The Long Goodbye*, Coppola's *The Conversation*, and Penn's *Night Moves*. Widely praised by critics and genrephiles, these films were simply too self-conscious, too formally and thematically complex to succeed with the general public—a public that by now was satisfying itself with blockbuster movies and TV sitcoms.

The period from the mid-Sixties into the early Seventies was a heady one in American filmmaking, a period of unprecedented experimentation and innovation. Genre experimentation rarely was complemented by widespread popularity, but when it was—in films like Penn's *Bonnie and Clyde*, Peckinpah's *The Wild Bunch*, Altman's *M*A*S*H*, and Copppola's *The Godfather*—genre traditions were shaken to their very foundations and forever transformed. But these were exceptions, and in retrospect the period was but an inspired interval between the old Hollywood and the new, between the studio system and the emerging blockbuster syndrome. Like their counterparts in the French New Wave (Truffaut, Godard, Rohmer, et al.), America's premiere Sixties filmmakers were part critic and part artist, with a penchant for self-reflexivity that was perceived by most viewers as confused self-indulgence.

As the Seventies wore on, it became increasingly obvious that the mass of occasional moviegoers could be drawn away from the tube and out of their living rooms only by genre films fashioned in the classical tradition, particularly by viscerally charged spectacles that exploited Hollywood's inflated budgets and high-tech effects—sci-fi films like *Star Wars* and *Close Encounters*, occult-horror thrillers like *The Exorcist* and *Carrie*, disaster epics like *The Poseidon Adventure* and *Jaws*. The New Hollywood's neoclassical bent is also evident in the enormous success of a few male stars like Sylvester Stallone, Burt Reynolds, and Clint Eastwood, whose idealized images not only are throwbacks to the old Hollywood, but which also have

had virtual genres built around them.

Adolescent viewers are the closest thing to a "regular audience" in today's cinema, and their desirability as a target market is indicated by the spate of genres designed for teenage consumption: stalk-and-slash films like *Halloween* and *Dressed to Kill*, sexual initiation-rite films like *Porky's* and *Risky Business*, musicals tied to pop trends like the disco-inspired *Saturday Night Fever* and MTV-inspired *Flashdance*.

Because network television now attracts the public on a regular basis and a massive scale, its production process is considerably more conservative and genre-bound than the cinema's. The relative freedom and flexibility this allows filmmakers is further enhanced by changes in distribution and viewing patterns brought about by cable, VCRs, and other emerging video technologies. But these developments scarcely seem to diminish the attraction of filmmakers and audiences alike to genre films. So long as Bazin's "commonplace" assertion that "the cinema is an art which is both popular and industrial" still applies, so will the genre-based economy principle. Filmmakers will con-tinue to cultivate forms that strike a balance between efficiency and expression, that economize production and at the same time provide the public with dramatic arenas where shared cultural concerns can be repeatedly addressed and reexamined.—Thomas Schatz

RECOMMENDED BIBLIOGRAPHY

Gehring, Wes D., ed. *Handbook of American Film Genres*. NY: Greenwood Press, 1988.

Grant, Barry K. *Film Genre: Theory and Criticism*. Metuchen, NJ: Scarecrow Press, 1977.

———*Film Genre Reader*. Austin, TX: University of Texas Press, 1986.

Neale, Stephen. *Genre*. Bloomington, IN: Indiana University Press, 1980.

Reed, Joseph W. *American Scenarios: The Uses of Film Genre*. Hanover, NH: University Press of New England, 1989.

Schatz, Thomas. *Hollywood Genres: Formulas, Filmmaking, and the Studio System*. Philadelphia, PA: Temple University Press, 1981.

———*Old Hollywood/New Hollywood: Ritual, Art, and Industry*. Ann Arbor, MI: UMI Research Press, 1983.

Gilliam, Terry Vance

(Nov. 22, 1940 –)

A cross between Rube Goldberg and Hieronymus Bosch, animator-director Terry Gilliam has emerged from the Monty Python comedy group as a powerful auteur in his own right, whose distinctive visual style supports a fiercely antiauthoritarian point of view.

His 1985 film *Brazil*, a prescient work of political satire, is an unremittingly dark, Swiftian view of the twentieth-century world in which the worst of U.S. consumer capitalism and the worst of Soviet bureaucracy are collapsed into a dystopian state which is stylistically indistinguishable from Thirties Nazi fascism.

Unlike the Python group in general, whose form is formlessness and whose comedic hallmark is the nonpunchline, Gilliam is a master of structural engineering whose didactics flow directly from his architectonic imagery. He thinks in terms of visual strings, not discrete ideas ("I have a philosophy built out of puns"). Gilliam's feature films, like his animated bridges between Python sketches, are designs in time, rather like two-dimensional kinetic sculptures—and also political statements. Life is seen as a series of interconnected accidents and losses, often expressed in the literal lopping off of hands or feet or heads—the famous legless, armless knight sequence in *Monty Python and the Holy Grail* (1974) is a paradigm. His plots are a series of "modest proposals" in which capitalist consumption of proletarian labor is metaphorized as literal cannibalism. People take bites out of each other in an illusionary quest for security (power, money, status) only to be eaten up by life itself.

Gilliam's surreal fantasies— *Jabberwocky* (1975), *Time Bandits* (1981), *Brazil* (1985), *The Adventures of Baron Munchausen* (1989), and *The Fisher King* (1991)—are a carefully designed "flipside of now." His targets are essentially the same as the Pythons'—autocrats, plutocrats, and hypocrites of all colors and creeds and the whole array of Establishment institutions (including TV) which serve to bullshit ordinary people into cooperating in their own oppression. Gilliam is ruthlessly unsentimental about the way of the world ("Living in the real world is a terrible thing…There's always a great big boot ready to squash you flat") but he is not really cynical or misanthropic, as is often charged. Indeed, the key to his black humor is a kind of inverted empathy for characters who seem to have no normal empathy for themselves. The ordinary people in his films suffer atrociously and unfairly and yet remain passive, cheerfully oblivious to the horror of their own oppressed condition (e.g., the beggar in *Jabberwocky* who cuts off his foot and displays it for alms, congratulating himself on having found a clever new way to make a living). Our laughter is thus political laughter; it signals that we, at least, recognize a horror when we see it.

In Gilliam's films, class conflict and Oedipal conflict are often condensed in the same imagery. Father-son battles are central to many of his plots, especially the narcissistic fantasy image of little David felling the big Goliath. In *Jabberwocky*, loosely suggested by the Lewis Carroll poem, a father on his deathbed suddenly disowns his compliant, smiling son, and dies happily with a curse on his lips. It is a fortunate fall of sorts for the son who, after a series of ludicrously improbable mistakes and transformations, ends up as a male Cinderella—slaying the monstrous Jabberwocky, marrying the princess, and inheriting half the kingdom. Unfortunately, he really loves the gross peasant Griselda (love is blind), so the conventional happy ending is for him a tragedy.

Time Bandits is a cross-dressed version of Carroll's *Alice in Wonderland,* full of insecurity, sudden transformations, and adult brutishness. While his bossy parents stare passively at a TV game show *(Your Money or Your Life),* Kevin reads alone, escaping through his imagination. Suddenly a knight bursts through the wall; his room elongates into a corridor; he runs and falls down a trapdoor into a new reality. Unfortunately, this new reality offers no escape from arbitrary authority or suburban avarice. His companions are a sleazy, lawless version of Disney's hardworking seven dwarfs, and the universe they inhabit is full of holes—the "botched job" of a cynical and indifferent creator.

Kevin's father-nemesis is a low-tech devil with high-tech ambitions who is eventually melted down into a "lump of evil" which is itself transformed into a toaster oven in the charred ruins of Kevin's suburban home. "Don't touch it!," Kevin warns his parents, ever the con-

sumer capitalists. But they can't resist a shiny new gadget and thus are blown to smithereens, taking their tacky world with them.

Brazil is a sequel to *Time Bandits.* Gilliam's protagonist, the passive/compliant clerk Sam Lowry, is what happens to imaginative boy heroes when they grow older but don't grow up. He is dominated and manipulated by a series of authoritarian father figures, collectively embodied in the brutally bureaucratic Ministry of Information (MOI) for which he works. He channels his Oedipal anger and sexual energies into fantasies in which, as a winged warrior, he rescues his Ideal Woman (who resembles his mother) from a gigantic, metal-clad Samurai.

In *Brazil,* Gilliam carries his analysis of his Oedipal fantasies a step further than he did in either *Jabberwocky* or *Time Bandits.* The epic battle between Sam and the giant Samurai (itself a wry symbol of the technological Japaning of the world) is revealed as a psychomachical conflict: under the alien metal mask is Sam's own pitiably human face. Sam's real battle is neither with his father nor his mother but with himself and his own fears of political commitment and sexual intimacy—his fears of connecting with others. He is not separate from evil but complicit in it. (MOI is a pun meaning "me.')

In *Brazil,* Gilliam uses a series of intensely interconnected visual puns and mirror images to create a cloacal vision of the modern world as an old-fashioned sewer. The whole force of industrial technology is turned to creating masks and screens to cover the incompetence and rot at the core of consumer capitalism. Gilliam's opening sequence embodies in miniature the structure of the film as a whole. There is a close shot of a tiny TV screen, one of many such screens behind a shop window (like most of the technology in *Brazil,* the TVs are retrotech in design, old-fangled new gadgets which suggest that the more things change, the more they stay the same). The TV pro-

gram segues into an ad for heating ducts in designer colors. In front of the window a figure passes in silhouette, pushing a laden shopping cart. Suddenly there is a terrible explosion which obliterates everything in the frame.

The explosion which shatters the window shatters several kinds of illusory security—the false comfort of things, the false emotion of big/little screen fantasy. In the film, all versions of security are devastated repeatedly—their fragments reconnected, each time in a new and more powerful form—only to be shattered again. The surface of *Brazil,* its relentless, transforming movement, seems chaotic, but the deep structure is terrifyingly coherent: a labyrinth of ducts which connect the private sorrows of individual bodies to the general woe of the body politic.

This hidden connectedness structures *The Adventures of Baron Munchausen* as well, although at first glance the film seems almost without any structure at all. Like Rudolph Raspe's original eighteenth-century text, Gilliam's *Munchausen* is a sustained attack on the adequacy of Reason as a guide to life. The very absurdity of the Baron's tales—replete with bizarre contingencies, coincidences, chance escapes, and miraculous transformations—defines a world which is itself absurd, contingent, and ruled by chance rather than by a benign clock-maker god. That is, the Baron's "lies" embody existential truths.

This theme is developed most obviously in the central conflict between the Baron, as dreamer-artist-romantic, and his archenemy, the rationalist diplomat "Horatio Jackson," an eighteenth-century Dr. Strangelove whose devotion to "logic" makes him a proponent of perpetual war, chaos, and death. At the climax, the Puritan-black figure of Jackson is fused with the fantastic Black Bird of Death, which has been stalking the Baron and his companions throughout the film.

The essential simplicity and sentimentality of this opposition—i.e., war is bad;

imagination is good—is qualified and complicated, however, by other head/heart dualities within the film. The Baron's partner, a child dramaturge named Sally, is another of Gilliam's Alice-in-Wonderland figures, as stubborn in her common sense as the Baron is in his romanticism. Their relationship is a duel within a duel. It is also implicitly incestuous—a role-reversed reprise of the Oedipal subtext of *Brazil.*

The antiplatonic dualism central to the plot is reiterated in a sequence of visual decapitation metaphors—beginning with a long opening camera movement which discloses a giant equestrian statue, sans horse head, sans human head. The psychomachical nature of these metaphors surfaces most clearly in the King of the Moon sequence, featuring an unbilled and unbridled performance by Robin Williams. The giant king (like his consort) is a composite and conflicted being whose head and body attach and detach by means of a threaded screw mechanism. The king's head (detached) is devoted to Big Thinks and Controlling the Universe through pure mind power. Conversely, his body is devoted to eating and stupping, not necessarily in that order. Every time the head thinks it is finally free, it is recaptured by the aggressive body which screws the head back on and then screws the queen.

This battle between Head and Body is the internal conflict which makes external political conflict—war, class oppression, racism, sexism—both "logical" and inevitable. Thus, as in *Brazil,* Gilliam hard-wires connections between the delusional systems of individuals and the delusional system which is society.

Gilliam's political critique is socialist in its general values and its targeting of villains. Moreover, in *Baron Munchausen,* more than in any of his previous films, his plot demonstrates the transforming power of collective action, especially when alliances bridge traditional polarities of class, race, and gender. The Baron alone is an impotent old dreamer; but the Baron's group is magnificently resource-ful. Significantly, that group includes young and old, male and female, white and nonwhite—Little People as well as big people, social defectives, and pariahs who possess special gifts.

And yet, the victory which this group seems to achieve over the avatar of White Male Reason is highly qualified—perhaps illusory. As in *Brazil,* Gilliam gives us two alternate endings, one after the other: 1) the Baron dies, assassinated by the figure of "Jackson'/Death, shooting down onto an heroic procession like Oswald atop the Texas Book Depository; 2) the Baron is revived, Tinkerbell-style, by the sheer power of Sally's love and belief. She simply wills his "lies" to be true—and they are.

This is not precisely what Marx had in mind when he envisioned the ultimate triumph of the proletariat. For all his loathing of late-stage capitalism, Gilliam can never buy into Marx's utopian vision—in part because he equates utopias with authoritarian repression of imagination and, in part, because he equates social entropy with existential entropy. Thus, although heterogeneous alliances are valorized in Gilliam's work, his own final solution to social madness resides in the possibility of a separate peace.

The Fisher King (1991) is a somewhat bowdlerized, more popularly accessible version of Gilliam's perennial theme: the connection between private madness and social disorder. For Gilliam, as for T.S. Eliot, *The Fisher King* is a symbol of the "Waste Land" of the modern world—wounded, impotent, thirsty for a grail drink of spirituality and hope. The two protagonists in the film, Jack and Parry, double each other as Fisher King and Grail Knight. Their lives and destinies are connected by a series of random acts of violence. As in *Brazil* and *Baron Munchausen,* mere contingency is everything.

Jack, a talk-show host, is hyper-verbal, left-brained, "realistic," and cynical; Parry,

a yuppie, is right-brained, "imaginative"—a romantic dreamer. Both thrive on denial—denial of the city, denial of each other. At the beginning, when neither knows the other or knows how the "other half lives," solipsism makes both vulnerable to unexpected wounds. A cynical, thoughtless word from Jack shatters Parry's secure life and sends him spiraling down into an underground world of madness and "homelessness'—into a nightmare called New York City. In *The Fisher King,* as in *Brazil,* Gilliam insists (with Mephistopheles) that "This is hell, nor are we out of it."

Jack's own downward spiral intersects Parry's in a cloacal room under the city—a favorite locus of helplessness for Gilliam. They are both "down the toilet." As they come together and learn to meld their abilities—imagination and trust, assertiveness and self-protection—they rise up again toward their separate goals. Parry wants intimacy; Jack wants ascendancy. They bond with two equally isolated, wounded women—the sweet but klutzy Lydia and the sexy but emotionally masochistic Anne. Together, the four form a self-rescue squad of sorts—a cadre, a collectivity for survival.

Predictably, however, given the carefully polarized nature of the men's yearnings—emotional intimacy vs. worldly success; inner peace vs. a piece of the action—their partnership fractures anew. The past reappears in the present and reshapes the future (here Gilliam's patented winged Dream-Beasts, otherwise suppressed in this film, make a poignant appearance). Parry descends again into madness and the wounded Waste Land world from which he came. Jack, vampirelike, ascends. He denies any connection with Parry, Anne, Lydia, or the painful underground world of the homeless—except to turn that pain into a sleazy commercial product: a TV comedy about the homeless as "wacky and wise."

If Terry Gilliam himself were not beset with Jack's own yearnings and fears—a fear of failing and falling back into the toilet—*The Fisher King* might well have ended right there, as Gilliam's first cut of *Brazil* ends with Sam in the torturer's chair. Instead, it pivots 180 degrees and marches back into a delayed happy ending, against the grain of its own material: The Grail is recovered; and, magically, the world's wounds are healed; the Waste Land becomes Never Never Land: Parry is restored to Lydia; Jack proposes to Anne; and Parry and Jack celebrate a kind of private greenpeace in the nude on the Great Lawn of Central Park.

This ostensible Happy Ending is very sad stuff indeed when compared to the politically rich metaphors with which the film began. It is possible that Gilliam actually believes in his ending; there is a distinct psychotherapeutic line in all his films in which "wholeness, integration, and openness" are primary goals. Guys naked on the grass presumably expresses such goals. And yet, the loss of any social context in that scene marks it, finally, as another tacked-on, corporate Hollywood fantasy. Sam Lowry does not escape with Jill to a cabin in the wilds of nature. There are no wilds. There is no nature. There is only the boob tube. And the State.

Thus, for the cognoscenti, Gilliam's Happy Ending to *The Fisher King,* and the consequent popularity of that film because of its "uplifting" ending, can only be a source of despair. It is equivalent to Sam's confession under torture and signals that in real time, not reel time, the dystopian world of *Brazil* is in fact the "flip side of now."—Nancy Steffen-Fluhr

RECOMMENDED BIBLIOGRAPHY

Mathews, Jack. *The Battle of Brazil.* NY: Crown Publishers, 1987.

Yule, Andrew. *Losing the Light: Terry Gilliam and the Munchausen Saga.* NY: Applause Books, 1991.

Griffith, David Wark

(January 22, 1876 – July 23, 1948)

The description of D. W. Griffith as 'the man who invented Hollywood' no doubt smacks of publicist's hyperbole, but is essentially true nonetheless. Griffith may not have been the first to make movies in California, any more than he was the first to use a close-up.

But it was Griffith whose unprecedented success with *The Birth of a Nation* (1915) demonstrated that huge sums of money could be made in films, thereby decisively turning the movies from a minor amusement into a major industry. And it was Griffith, more than any other individual, who established the artistic potential of the medium.

The rub comes because Griffith demonstrated that potential most undeniably in *The Birth of a Nation*, a film that remains controversial for its interpretation of American history and especially race relations. Not until Leni Riefenstahl and *The Triumph of the Will* would another director demonstrate so clearly both the political potential and the political dangers offered by the cinema. Before that, however, Griffith had served as the master whose films Soviet directors such as Eisenstein and Pudovkin screened over and over again, until the prints all but wore out, studying the secrets of montage, the dynamics of clashes between massed forces, the emotional value of an all-out chase and last-minute, climactic rescue.

Griffith began as an actor and would-be writer. His experiences as a trouper taught him to be a genuinely popular crowd-pleaser as he turned out short films in next to no time. Griffith had a frightening lack of intellect; his imagination veered to the sentimental and melodramatic. But his ambition—and his artistic energy—was immense. As James Agee observed, no other director can ever do what Griffith did, move forward and bring the medium with him, enlarging its possibilities at each step. Only Chaplin's development offers a reasonable parallel to Griffith's early success. Chaplin's achievement, however, was in a sense purely personal, since Chaplin the director served Chaplin the performer, and did so brilliantly—but without providing a basic model for the entire industry as Griffith did.

Griffith could be hackneyed, but his work is full-hearted in a way that is rare. He did not hold back any more than his great performers did. Whatever the unfortunate social stereotyping, the stilted situations, and the Victorian sensibility underlying his narratives, many of the performances remain moving and convincing today. There have been many epics, but where De Mille seems crude and condescending, willfully philistine, *Intolerance* (1916) preserves a kind of purity and innocence, its ambition a sign of imaginative daring, not just egotism, its awkwardness a result of genuine experimentation. Griffith's sensibility was limited, but not that limited: it could encompass both the poetic lyricism of *Broken Blossoms* (1919), a perfect miniature, and the forceful realism of the contemporary story in *Intolerance*, an imperfect epic.

Griffith's politics are no simple matter precisely because his political ideas are so simple. He was, as Richard Schickel has noted, "essentially apolitical...[though] something of a populist...until the New Deal...turned him into a mild reactionary."

Schickel argues that Griffith's spirit was "classically that of the artist—self-absorbed, and only dimly aware of the larger political issues of the day, perhaps excessively so." He adds, "He had no politics, except on those occasions when some manifestation of the *zeitgeist* reached out and touched him directly"—as when the furor over *The Birth of a Nation* led him to write a pamphlet on free speech and then incorporate an attack on meddling reformers into *Intolerance*.

Griffith had a healthy sympathy for the poor and an unhealthy racist (or, perhaps more accurately, paternalistic) attitude toward blacks, but it is unlikely that in either case he envisioned himself as making a political statement—as opposed to merely reflecting popular attitudes. Griffith was anti-German during World War I, and shortly thereafter echoed the Red Scare in a famous title in *Orphans of the Storm* (1922). Yet he also betrayed a strong streak of pacifism that probably reflected not a political position but the influence of a sentimental, moralizing Christianity that was intertwined with his overheated melodramatic imagination. The ostensible lesson of *Broken Blossoms* is one of compassion, and the need for international and interracial understanding, though that message tends to get lost in the sadomasochistic goings-on (in a Griffith film the text is almost inevitably at odds with the subtexts). One of his late films, *Isn't Life Wonderful?* (1924), is a realistic and sympathetic portrayal of the suffering of Germany in the postwar period.

As John Belton has noted, Griffith therefore offers an important case of a director who is not so much ideological as emotional: his ideas are all bound up with the narratives that embody his sense of the world, as in the revealing treatment of sexuality, haunted by images of helpless virgins beset by brutes. The tension between the puritan and the libertine in Griffith's psyche is disturbing; by today's standards, Griffith's films are perhaps even more questionable for their attitudes toward women, a combination of pathos and pathology, than their ideas about race, which seem comprehensible, though not acceptable, as an expression of the dominant attitudes of Griffith's time and place. Griffith was born, after all, in Kentucky, the son of a former Confederate officer; *The Birth of a Nation* was in part an unfortunate effort to "set the record straight."

Griffith made more than four hundred short films and a few longer ones before making *The Birth of a Nation,* he made less than thirty after *Intolerance,* his next film. His career was really over by the mid-Twenties, long before his legendary last days as Hollywood's forgotten man. Griffith was a child of the nineteenth century, of Dickens (who he credited with the kind of parallel plots that led to crosscutting) and the potboilers of the nineteenth-century stage. He was rooted in Victorian melodrama and sentimental religiosity. But he also reflected the reformist tendencies of the Progressive era. His sympathies for the poor in the famous short *A Corner in Wheat* (1909), adopted from *The Pit* by Frank Norris, may have been balanced, as William Everson has observed, by a seemingly uncritical presentation of the rich: in his Biograph period Griffith was in desperate need of scripts and used all kinds of stories, without necessarily enforcing a consistent point of view. Even in *Intolerance* there is admiration for the king of Bablyon as an enlightened despot, along with the contempt for the upper-class women reformers—a particular peeve of Griffith—and an unsympathetic portrayal of an industrialist modeled on Rockefeller. In the great scenes of the workers versus the militia and the Pinkertons, the sympathy is completely with the workers.

Griffith's politics are founded upon a conservative devotion to love, home, and the family—to community, in short. Yet as might be expected from such a romantic, Griffith's films uphold charismatic, even revolutionary, authority in Lincoln, in Danton, in Washington, in the Little

Colonel. Given Griffith's tendency to present a sharp opposition between good and evil, it is not surprising that he assumed personalities and principles offered no complexities, or at least no contradictions. Thus what has gone unremarked in *The Birth of a Nation* is its endorsement of vigilante action: the Klan is portrayed as a legitimate political force bringing about national unity, and the film ultimately sides with the Klan's control of the electoral process as a counter to the equally authoritarian but for Griffith illegal and illegitimate behavior of the carpetbaggers and Union troops during Reconstruction. It is because Griffith thought he was creating an epic of national unity that he could include the notorious title card describing the group of whites in the cabin shooting at the black troops outside: "The former enemies of North and South are united again in common defense of their Aryan birthright."

As a director of historical epics Griffith's tastes may have proved controversial but were at bottom conventional: patriotic pageantry and (questionable) storybook history. In any case, his values come out most clearly not in his ideas but in his style, in his discovery—or development—of the feature film as a melodramatic exercise combining a love story and a war story, with strong doses of moralizing and a complicated balance between realism and intimate drama on the one hand and theatricality and spectacle on the other, between individual biography and collective history. The characteristic shape of his narratives was determined not just by the crosscutting and rally (chase) at the end, but by an expressive use of close-up and long shot that balanced the individual and the group, a strong sense of environment and *mise-en-scène*, and a sure sense of dramatic gesture.

Griffith's legacy is enormous. He influenced not only the Russians and Abel Gance but also such important figures as Ford and Von Stroheim. Von Stroheim took Griffith's realism (and his use of

Norris) and carried it to an extreme in *Greed,* he also more overtly and deliberately exploited Griffith's fascination with illicit sexuality. Ford, in films such as *Rio Grande,* adopted Griffith's use of historical pageantry and melodrama as well as the ride to the rescue. Similarly, *Young Mr. Lincoln* can be taken as a recasting of Griffith's *Abraham Lincoln* (1930) and *Drums Along the Mohawk* of *America* (1924); but in fact Ford's entire career can be regarded as a revisionary effort under the influence of Griffith, with clear parallels. For example, the "fate worse than death" that confronts the women in *Stagecoach* recalls the similar situations in *The Battle of Elderbush Gulch* (1914) and *The Birth of a Nation.* Two important moments in *The Searchers* seem indebted to Griffith, with Ethan Edwards's homecoming harking back to the return of the Little Colonel in *Birth of a Nation,* just as the two hysterical girls encountered at a fort, who were formerly held by the Indians, seem a clear homage to the Gishes, or to Mae Marsh and Miriam Cooper frantically clutching each other in the basement of the Cameron house during the Northern raid in *The Birth of a Nation.* Ford was generally far more self-conscious, and far more ambivalent, in his interpretation of American history, but he worked within a framework inherited from Griffith.

Griffith's influence on Ford and others is politically significant because, by establishing the dominant narrative patterns, Griffith established the conventions for portraying history, women, and other important subjects. He also in effect defined the limits of political expression—including the supposedly nonpolitical nature of most Hollywood films and the contradictory aspects of those films that attempt to demonstrate social concern. The film epic remains essentially a Griffith creation, though Griffith was indebted to literary models such as Dickens and Scott. It is entirely fitting that *Gone With the Wind*, novel and movie, should be so great-

ly indebted to Griffith, for *The Birth of a Nation* and *Gone With the Wind* span the Golden Age of Hollywood, marking its rise and fall.

Eisenstein noted the paradoxical combination in Griffith of "Small-Town America...the traditional, the patriarchal, the provincial," and "Super-Dynamic America...speeding automobiles, streamlined trains, racing ticker tape." Griffith used a modern medium, brilliantly. Yet he was never really a modern artist. Certainly Griffith was no cinematic theoretician or political ideologue, beyond his belief that cinema was a universal, democratic language and should be devoted to inculcating cultural values. He may have brought film grammar close to perfection, but he was not an innovator in the modern sense: his sensibility was conservative, not avant-garde, and he lacked the kind of irony or the taste for extremes that characterize so much modern art. Yet it was in Griffith, a traditionalist driven to originality, that Hollywood found its first great master.
—Robert Silberman

RECOMMENDED BIBLIOGRAPHY

Barry, Iris and Eileen Bowser. *D. W. Griffith, American Film Master.* NY: Garland Publishing Co., 1985.

Drew, William M. *D. W. Griffith's* Intolerance: *Its Genesis and Its Vision.* Jefferson, NC: McFarland & Co., 1986.

Graham, Cooper C. *D. W. Griffith and the Biograph Company.* Metuchen, NJ: Scarecrow Press, 1985.

Gunning, Tom. *D. W. Griffith and the Origins of American Narrative Film: The Early Years.* Urbana, IL: University of Illinois Press, 1991.

Henderson, Robert M. *D. W. Griffith: His Life and Work.* NY: Garland Publishing Co., 1985.

Jesionowski, Joyce E. *Thinking in Pictures: Dramatic Structure in D. W. Griffith's Biograph Films.* Berkeley, CA: University of California Press, 1987.

Lang, Robert. *American Film Melodrama: Griffith, Vidor, Minnelli.* Princeton, NJ: Princeton University Press, 1989.

Leondopoulos, Jordan. *Still the Moving World:* Intolerance, *Modernism and* Heart of Darkness. NY: Peter Lang Publishing, Inc., 1991.

Schickel, Richard. *D. W. Griffith: An American Life.* NY: Simon and Schuster, 1984.

Williams, Martin. *Griffith: First Artist of the Movies.* NY: Oxford University Press, 1980.

The Hollywood Blacklist

The Hollywood motion picture blacklist of the Forties and Fifties went through two phases. It began as a limited tactic, devised by movie industry executives as a means to halt congressional hearings into "Communist Infiltration" of the industry (by demonstrating that Hollywood was capable of cleaning its own house); it ended as a political lever wielded by the American right as part of its campaign to silence left-wing opposition to the Cold War by forcing progressives to recant and retreat from their efforts on behalf of the New Deal, labor unions, antiracism, and antifascism. Neither phase, however, could have had any impact nor done any damage had it not been for the belief of movie executives that the blacklist was the essential, indeed only, means to protect

the industry from government regulation or mass audience boycott. First, last, and always, the blacklist was the product of studio heads: they were the ones who instituted it and oversaw it. And, during the fifteen years of its existence (1947–1962), not one of the eight major studios knowingly broke ranks and hired a blacklisted employee.

The architect of the first blacklist, that of the Hollywood Ten in November 1947, was Eric Johnston, president of the Association of Motion Picture Producers. He had urged a blacklist as early as June, following a highly publicized set of hearings held by a subcommittee of the House Committee on Un-American Activities in May, at the Biltmore Hotel in Los Angeles. The Hollywood-based studio heads, notably Louis B. Mayer, Samuel Goldwyn, and Dore Schary, objected, refusing at that time to bow to the dictates of a congressional committee. But, following the full-scale, formal hearings in Washington (October 1947), and notwithstanding the criticism heaped on the Committee by newspapers such as *The New York Times* and *The Washington Post*—criticism that led chairman J. Parnell Thomas to halt the hearings before all the witnesses had been called—the studio executives began to rethink their position.

For all the unfairness of the circus atmosphere that HUAC had calculatedly created, the hearings had succeeded in revealing that at least ten Hollywood employees (seven writers, two directors, and one producer) were probably members of the Communist Party, had long records of radical activity, and were certainly going to be cited for contempt of Congress. Thus even before Eric Johnston reconvened the producers' associations for a two-day meeting at the Waldorf-Astoria Hotel in New York (November 24–25), the New York-based financial chiefs of two studios, RKO and Twentieth Century-Fox, fearing loss of attendance and financing, ordered the firing of three members of the Hollywood Ten—Edward Dmytryk, Adrian

Scott, and Ring Lardner, Jr.—for violations of the morals clause of their contracts.

At the meeting itself, there was little opposition to the sacrifice of the Ten, but the Hollywood contingent, led by Mayer and Schary, were determined to hold the line at those bodies. They planned a counteroffensive aimed at preventing HUAC from future hearings to expose the dozens of other names gathered by committee investigators since 1945. A committee was appointed to draft a resolution that came to be known as the Waldorf Statement. It read, in part: "We will forthwith discharge or suspend without compensation those [of the Ten] in our employ and we will not re-employ any of the ten until such time as he is acquitted or has purged himself of contempt and declares under oath that he is not a communist...We will not knowingly employ a communist or member of any party or group which advocates the overthrow of the Government of the United States by force or by illegal or unconstitutional methods." The producers, by taking this position, succumbed completely to the political hysteria of the era. As a result of their decision, five capable, experienced screen artists were fired, and five others found their services unwanted, solely as a consequence of their political beliefs.

Although there had been blacklists in the movie industry before (notably of talent guild organizers during the Thirties), none had been so baldly announced and none had such wide-ranging potential: hundreds of studio employees had been politically active during the previous decade. To calm the fears of those people, and to enlist them in a united Hollywood campaign to ward off further incursions by HUAC, the Waldorf attendees appointed a committee to meet with the presidents of the Actors, Directors, and Writers Guilds. In effect, the producers pledged a blacklist limited to the Hollywood Ten if the guilds publicly supported the Waldorf Statement. The guilds had already indicated that they would not support the Ten, but they refused to give any validity to any industry

blacklist. They not only had to protect their unexposed members, they also had to protect themselves against being put, sometime in the future, in the position of judges of the political behavior of their members.

Even though no guild demanded the rehiring of the Ten, and they became, for all practical purposes, nonpersons in Hollywood, the producers had only bought time; they had not, by their callousness, purchased security. The currents of fear that motivated a blacklist percolated through and palpably affected the entire industry. The fears of further investigations caused script readers to view material with the eyes of a member of HUAC or a Daughter of the American Revolution. *Variety* reported that anticommunist films, once avoided as box office poison, had "become the hottest to hit the screen this year," while "studios are continuing to drop plans for 'message' pictures like hot coals." There were also unpublicized additions to the blacklist: three of the "unfriendly" witnesses who had not testified—Waldo Salt, Gordon Kahn, and Howard Koch—were either fired or ceased to receive contract offers.

In the face of this atmosphere of creeping intimidation, only two groups fought the blacklist head-on. The Hollywood Ten, individually and collectively, took the producers to court on eight occasions, charging breach of contract and conspiracy to blacklist. They did not receive a favorable verdict in any, although three were settled out of court for money desperately needed for legal and living costs. The Ten and their supporters also tried to sound a warning in Hollywood and throughout the country, by numerous speeches and a movie, that they were only the first in what would be a long line of blacklistees if a concerted resistance to HUAC did not form. Independently of the Ten, only the Screen Writers Guild offered resistance to the blacklist, hiring the Washington law firm of Arnold, Fortas, and Porter to file a suit against the producers. (The suit,

which was not intended to aid the Ten, never reached court; the Guild dropped it—and whitewashed the blacklist—in exchange for the producers' agreement to close a loophole in its contract with the guild that operated to the guild's detriment.)

As severe as it was, the fate of the Hollywood Ten proved to be only a small foretaste of the political, professional, and human destruction that hit the movie industry in 1951, a few months after the prison doors slammed behind the Ten. The stature of HUAC had skyrocketed since 1947, propelled by a series of national and international events that blotted out the warnings and fate of the Ten: the trial and conviction of Alger Hiss; the fall of China to the communists; the Russians' detonation of an atomic device; the arrest of atomic spy Klaus Fuchs; the outbreak of the Korean War; the arrest of the Rosenbergs; and the Supreme Court's approval of the Smith Act. Rumors of HUAC's renewed interest in Hollywood surfaced during 1950 and prominent liberals, such as Edward G. Robinson, voluntarily appeared before the Committee, while former communists, such as actor Sterling Hayden and writer Leo Townsend, telephoned the FBI to confess.

This new HUAC offensive against communism in Hollywood was considerably broader in scope than that of 1947, but more carefully focused and better designed. The Waldorf Statement had shown the committee that it would be more expeditious to put individuals, not an entire industry, on trial. Studio executives had proved that they would willingly jettison tainted employees as long as the committee did not bring into question the quality of the product. Instead, therefore, of aiming its guns at subversion of the movie industry, HUAC targeted subversives in the industry. Implicitly agreeing with the producers' position that Hollywood films had not been affected by communist studio employees, the hearings, which began in 1951 and dragged on until 1956, had as

their goal the eradication of liberal and radical thinking and behavior in Hollywood.

This time, Hollywood's collapse was complete. The guilds refrained from even token support of those witnesses who refused to cooperate, while the ranks of the left-wing opponents of HUAC were lessened by about one-fifth, as fifty-eight former members of the Communist Party or its fellow travellers chose to cooperate. In other words, they decided to acknowledge their communist pasts, deplore their lack of judgment, and, as proof of their contrition, provide the committee with the names of those who had also been party members. This "name game" not only provided the blacklist with credibility—by removing HUAC from the role of accusant—but it ripped apart the fabric of support and camaraderie that had held together the progressive alliance in Hollywood since 1935. The question "Who were the other persons you knew in the Communist Party?" marked the decisive moment of every "friendly" witness's testimony. An informer could not himself or herself be assured of getting off the blacklist without the prompt recital of a dozen or more names. This ritual served no legislative or investigative purpose; it was, rather, a purification ritual that also served to distance the "friendly" from the "unfriendly" and further isolate the latter.

The producers' blacklist, composed as it was only of persons who had been named before HUAC and who had refused to name others, however, was too "exclusive" to satisfy the large army of reaction that gathered in the committee's shadow to stamp out the lingering effects of the radical era of New Deal reforms, extensive union organizing, and antifascism. The committee delivered the knock-out punch—the blow that shattered the alliance of radicals and liberals—and it had conducted the mopping-up operation of radicals (few communists or fellow travellers escaped its net), but it did not have the time or resources to expose or intimi-

date the liberal members of the progressive alliance. That task was left to a group of subcontractors—the "smear-and-clear" profession. The American Legion, American Business Consultants, the Wage Earners Committee, and Aware, Inc. developed and policed a graylist by means of an insidious two-step of censure and redemption for anyone who had signed a petition, joined a group, or supported a cause that was left of center. The graylists never enjoyed the publicity or effectiveness of the blacklist, but they affected the lives of many more people. The myrmidons of this skulking army culled national and state legislative investigating committee reports, appendices, and hearing transcripts, back issues of left-wing publications, letterheads of defunct Popular Front organizations, and so on, to compile a list of people who, while they could not be accused of "communism," could be made to appear "pink" or "dangerous." The graylists also housed the names of those mistakenly identified or recklessly accused, dozens of whom suffered without knowing they were infected.

Yet, despite the tenacity and single-mindedness of those engaged in the blacklist and graylist industries, their abiding purpose was not to destroy—it was to save—souls. Every agency, from HUAC to ABC, offered a means of exculpation for those who had sinned. One could remove one's name from the blacklist by appearing before HUAC and naming names. Graylisted people had to write clearance letters explaining why they joined or participated in the subversive groups or activities, who else did they know in the group or activity, and when they resigned or left. The completed letter would then be sent by the accused's lawyer or studio to one of the accepted clearance agencies: Roy Brewer, the fanatically anti-communist head of the Hollywood branches of the International Alliance of Theatrical Stage Employees; George Sokolsky, the equally fanatical Hearst columnist; Vincent Hartnett, who began with ABC and then

helped found Aware, Inc.; James F. O'Neil, Director of American Legion Publications; and, if one were Jewish, the Anti-Defamation League of the B'nai Brith. Letters had to be appropriately "sincere" and complete to be approved; oftentimes, two or three rewrites were necessary. (Some people who chose not to follow any of the clearance procedures, and hence remained on the blacklist or graylist, believe that clearances could be purchased; but no evidence exists that any other gate save confession existed for people who wanted to return to work.)

In proportion to the number of people working in the movie industry at the time of the first hearings in 1947 (approximately 30,000), a very small percentage (perhaps 500) had their careers affected by time spent on the blacklist or graylist. But the names of those so affected were so highly publicized, usually in banner headlines across the front pages of *The Los Angeles Times* or *Examiner*, or the rumors of their truncated careers so widely and quickly spread, that the effect of the blacklist cannot be measured solely in terms of its impact on the lives of those listed. The blacklist had a chilling effect on Hollywood and it was a scourge on America.

The blacklisted lived for over a decade under a dark cloud of professional and personal opprobrium. They were outcast from the community in which they had lived, worked, and tried to serve politically for many years. Not only were large numbers of them forced to emigrate in order to find work, but they were continually harassed and shadowed by FBI agents and Passport Department officials. A small percentage found work on the scriptwriting "black market" (crafting scripts for independent producers), acting or directing on Broadway, or working abroad. The writers, who could work behind fronts or pseudonyms, might have had a slightly better chance of finding remunerative work in the movie or television industry, but the wages were far below their accustomed level, their control was nil, and they had to work anonymously. A tiny percentage found satisfying and remunerative work either in Europe or in the New York television industry. The vast majority had to find other careers, most unrelated to the skills and craft they had spent years practicing. The effects of these disruptions shattered the spirit and marriages of dozens of those afflicted. Nevertheless, many look back on the era as a time of testing, one that they would have preferred to have avoided, but one which they feel proud to have survived.

The blacklist did succeed in its main goal—it destroyed the political influence of the Hollywood left. Even though the blacklisted launched a many-sided effort to be heard, their resources were too limited, their numbers too small, and they were too scattered to generate more than a faint whisper. In the political field, though most of the studio population had gone into hibernation, one small group of blacklisted people created *Hollywood Review*, a journal containing radical critiques of movie and television trends, while another initiated and sustained for two years *California Quarterly*, a journal devoted to literature. Ring Lardner, Jr. and Abraham Polonsky wrote novels revealing the absurdity and shame of the era, John Wexley shredded the government's case against the Rosenbergs, and John Howard Lawson committed his Marxist film theories to paper. (It should be noted that a blacklist also existed in the publishing industry; if not for the efforts of Angus Cameron and Carl Marzani, themselves blacklisted, few of the literary efforts of the blacklisted would have been published.)

The two great achievements of the blacklisted during their time of exile were the film *Salt of the Earth* and the television show *You Are There*. The former was the first film produced by Hollywood people to deal honestly and realistically with labor, women, and minorities, and was as vigorously blacklisted by the movie industry and the United States government as its

makers had been; the latter depicted dramatic historical moments, usually involving a courageous individual saying "no" to a more powerful antagonist (Socrates, Joan of Arc, John Peter Zenger, for example) and was written by three blacklisted writers.

The blacklist began to fade in the late Fifties and early Sixties, following the beginning of détente with the Soviet Union. The election of John F. Kennedy to the presidency signalled a liberalized political atmosphere in which the pariahs of another era could find a measure of acceptance. Nevertheless, although most of the blacklisted tried, only about ten percent were able to resume respectable careers in the movie or television industries (in stark contrast to the informers, most of whom flourished during the Fifties). They returned to a profoundly altered industry. Never daring in the first place, the studios of the Fifties had retreated from any project hinting at controversy or social significance. Hollywood films did not, however, lack political content; most reflected the conservative, chauvinistic doctrines that had triumphed with HUAC and McCarthy. The studios took giant steps backward in the depiction of women, war, crime, and government practices; the poor, workers, blacks, and other minorities (except for Indians—depicted as savage targets for heroic white soldiers to massacre) disappeared from the screen.

Nor did the America of the blacklist era shine with the inner glow of the newly purified. Political movements on behalf of progressive or humane causes shriveled as people withdrew into protective, fearful shells; friendships shattered as people either took sides in the controversies generated by the Cold War or feared guilt by association; and the Bill of Rights suffered a savage beating as people in all parts of the country, in all types of vocations, lost their jobs as a result of their political opinions and the government's wanton disregard of the most elementary principles of due process.

The literature on the blacklist reflects, for the most part, the political atmosphere in which it was written. The first and still lengthiest book, John Cogley's two-volume *Report on Blacklisting* (1956), suffers from a strong anti-communist bias and Cogley's inability to name his sources, but it remains among the best documentations. (Cogley himself defied HUAC, burning all his notes rather than allowing the committee to review them.) Most of the books that have followed have tended to recycle the anecdotes or quotations unearthed by Cogley, paste together excerpts from the congressional hearings, or repeat the conclusions reached by Murray Kempton in his elegant but nasty profile of communists in America, *Part of Our Time* (1955). Kempton decided, on the basis of a very meager sample, that most people joined the Communist Party because of neurotic needs, except for the Hollywood contingent who joined to compensate for their minuscule talents. Books written in the Sixties and Seventies have tried to be both more sympathetic to the blacklisted and more thorough in their research, but Robert Vaughn's *Only Victims* (1972) is simply a pastiche of interview quotations and hearing excerpts, while Stefan Kanfer's *A Journal of the Plague Years* (1973) is condescending and supercilious. A thoroughly researched and carefully written study of the blacklist—how it came into existence and how it functioned—has been written, but not published: Howard Suber's doctoral dissertation, *The Anti-Communist Blacklist in the Hollywood Motion Picture Industry* (UCLA, 1968).

The memoirs that have appeared are of mixed quality. Herbert Biberman's *Salt of the Earth* (1965) relates, in graphic and haunting detail, the vigilante atmosphere that surrounded the making and attempted distribution of that film. Alvah Bessie *(Inquisition in Eden,* 1956), Ring Lardner, Jr. *(The Lardners,* 1976), and Lester Cole *(Hollywood Red,* 1981) provide very personal accounts of life on the blacklist. Bruce Cook's biography of Dalton Trumbo

(1977) too faithfully follows his subject's contention that he almost single-handedly broke the blacklist, but does contain extended comments by Trumbo about the scriptwriting black market. Trumbo's own *The Time of the Toad,* his acid commentary on the blacklist, was reprinted in 1972. Finally, Lillian Hellman, in *Scoundrel Time* (1976), has, to a large degree, tried to mythologize her role in the struggle against the blacklist, while failing to mention that dozens of others did at least as much as she, while dozens did more.

The most comprehensive and thoroughly researched treatments of the background to the blacklist are to be found in Ceplair and Englund's *The Inquisition in Hollywood* (1980) and Nancy Lyn Schwartz's *The Hollywood Writers' War* (1981). Victor Navasky has provided a detailed examination of those who escaped the blacklist by informing in *Naming Names* (1980).—Larry Ceplair

The Hollywood Studio System

E ven the casual moviegoer is aware that filmmaking is systematic, that the consistency of movie products signals a certain consistency in the actual production of these movies.

The feature-length fiction film with its familiar stars and genres, its conventional narrative techniques, its "realistic" style and predictable plot structure, even the steady unwinding of its closing credits— all of these manifest a formalized filmmaking process, all are directly related to the distinctive division of labor and mode of production in commercial cinema.

The division (and detailed subdivision) of labor and mode of production in American filmmaking have not changed significantly since Hollywood's halcyon era of a half-century ago, although both the top-level management and the financing of feature films have changed a great deal. It has become an historical commonplace to note the gradual "death of Hollywood" during the Fifties, even though movie and TV production based in Los Angeles has continued unabated since then. What actually "died" in postwar Hollywood was the *stu-dio system* that had dominated the industry since the Teens and Twenties. Under that system a cartel of interrelated companies controlled every phase of the production and merchandising of the motion-picture industry.

The most powerful of those companies were the five "major" studios: MGM, Warner Bros., Twentieth Century-Fox, Paramount, and RKO. Much of their power derived from their "fully integrated" status; these studios not only produced films but also controlled their distribution and exhibition. During Hollywood's classic era—from the early Thirties into the Fifties—each of the five majors produced anywhere from thirty to fifty films annually in their own studios and then leased them to theater chains which they owned or controlled. There were also nonintegrated majors like Columbia and Universal, which had their own production facilities and personnel but did not own theater chains. Also active during the studio era were minor studios like Monogram and Republic, which churned out B-movies for the lower half of the then standard double bill.

Even during the studio era there were several important independent producers. Sam Goldwyn, David O. Selznick, and Walt Disney developed independent companies with contract personnel and limited production facilities. Their companies concentrated on producing only a few prestigious, expensive films each year that were released through one of the major studios. United Artists, founded in 1919 by D. W. Griffith, Charlie Chaplin, Mary Pickford, and Douglas Fairbanks, flourished throughout the studio era but produced far fewer films than the major studios. UA actually was not a "studio" per se, but served as a financing and distribution company for its owners and other independent producers—including Selznick, Goldwyn, Howard Hughes, Walter Wanger, Alexander Korda, and others.

Standardized filmmaking practices can be traced to earlier, prestudio years, of course. With the commercialization of cinema in the early 1900s came the demand for an economical and thus a standardized work process. In fact, commercial filmmaking followed a general pattern of industrial development in early twentieth-century America, particularly those strategies of mass production, mass marketing, and mass consumption. In the first decade or so of commercial filmmaking, from about 1896 to 1908, both the financial and creative aspects of filmmaking were fairly haphazard and experimental. At this stage, individual artists tended to dominate production. These were generally cameramen who worked for some established company—Vitagraph, Edison, Biograph, et al.—but who were free to conceive, shoot, and edit their own work, and who were as likely to film current events or "actualities" (including popular theater and vaudeville performances) as they were to invent fictional stories for the new medium.

As the tremendous commercial viability of the cinema became more evident, however, experimentation necessarily gave way to standardization. Those most interested in standardizing the production process and also the business of marketing and exhibiting motion pictures were the companies holding patents on photographic and projection equipment. Nine of these companies merged in 1908 to form the Motion Picture Patents Company (MPPC, also known as the Trust), a virtual monopoly controlled principally by Thomas Edison and by another early corporate power, Biograph. Because public fascination for motion pictures sustained and steadily widened patterns of consumption in these early years, the MPPC was concerned less with refining its product and competing for box office revenues than with forcing production and exhibition outfits to pay license fees for their use of film equipment. Meanwhile, independent producers and entrepreneurs like William Fox, Adolph Zukor, and Carl Laemmle started their own companies with varying degrees of cooperation with the Trust. (Legend has it, in fact, that the "colonization" of Hollywood by filmmakers between 1908 and 1913 was due not only to the favorable climate for location filming but also to the geographical distance from the Eastern-based MPPC and the proximity to the Mexican border for those renegade independents who refused to pay license fees to the Trust.)

During the mid-Teens, the Trust's domination of the industry was weakened by several factors. One was the successful lawsuit that Fox brought against the Trust for restraint of trade in New York. But even more important was the Trust's own insensitivity to market demand, particularly in two key areas: they refused to identify and exploit feature players ('stars') because they feared inflated salary demands, and they resisted a growing penchant among independents to produce movies longer than the standard one-reel (about eighteen minutes) due to envisioned problems with both distribution and exhibition. The independents were willing to risk these changes, and indeed the emergence of the "star system" and "feature length" fiction film as standard

industry practice by the mid-to late-teens indicates their responsiveness to public tastes and market demands.

Due to the increasing demand for films, the more competitive posture of the independents, and the overall impulse to standardize and streamline the production process between 1908 and 1915, the cameraman-dominated system gradually declined after 1908. By the mid-teens the cameraman had been relegated to the role of technical expert and the conceptual aspects of filmmaking were usurped by a writer and a director—both roles adapted from the theater. By 1912–13, the demand for product became so great that many companies created multiple production units, each one supervised by a director. At this stage we see the beginnings of the cinema's distinctive division of labor: management separated from actual production, the production in a hierarchy under the director, and a general division within production between conception (writer and director) and execution (cameraman, performers, technicians).

The growing dominance of the feature-length fiction film led to even further adjustments in the mode of production, however. Filmmakers came to realize that fiction films could be produced more easily than could documentary or other film forms, particularly if the production operations were centralized and if each product was carefully preplanned. Thus the earlier strategy of multiple director-controlled units steadily gave way to a strategy of studio-based production under the perview of an executive. Many of the basic principles of the factory and the assembly line were adapted to filmmaking during the period, only now the producer (as studio executive) controlled the conception and procedure rather than the director. In fact, this period saw the emergence of distinct stages of planning, shooting, and editing in the filmmaking process, with separate departments for everything from costuming and set design to musical scoring (even in the silent era) and advertising.

This period also saw the necessary standardization of the detailed "continuity script" or "shooting script" as an industry norm, which served as a blueprint for every stage of production. And it was during the mid-teens that trade unions and guilds for production personnel first emerged, which solidified the division of labor and ensured those "production values" associated with the feature-length fiction film.

Thus the centralization of production operations standardized the assembly-line process of *preproduction* (securing of story rights, scripting, cast and crew assignments, set design, and art direction, et al.), *production* (shooting the picture), and *postproduction* (editing, musical composition and scoring, marketing, et al.). Significantly, the systematic qualities of actual production were complemented by a more systematic approach to merchandising. Until the late Teens, the production of movies was for the most part separated from the business of releasing and showing those movies—comparable, in a sense, to the separation of manufacture, wholesale, and retail in other industries. By the late Teens and early Twenties, the more powerful companies in each of these areas began to see the obvious advantages of operating in all three general areas at once. Major exhibition outfits like First National began moving into production (they later would merge with Warner Bros.), distribution companies like Paramount-Publix joined with production companies (in this case Famous Players-Lasky) and began seeking capital to buy theaters, and so on.

Competition at this level mounted throughout the Twenties, and two watershed events late in that decade separated the victors from the vanquished—with the victors emerging as what we now remember as the "majors" and the "major minors." Those two watershed events were the coming of sound and the collapse of the stock market, both of which put intense financial pressure on existing pro-

duction and exhibition companies—hitting them with the need to convert to sound technology while facing the prospect of declining attendance. The companies which could not survive the Depression and conversion to sound either were swallowed up by healthier corporations—Warner Bros. bought out First National in 1929, for example, and the Fox Film Company merged with Twentieth Century Pictures in 1935 to avoid dissolution—or else they simply went out of business. By the early Thirties, the principal players in Hollywood's classic studio era had been cast, with the integrated majors taking center stage.

By this time, the system of authority—both creative and financial—in the film industry had become fairly complex. In general, the eight major studios had a distinct three-tier administrative structure. The "New York office" with its chief executive(s) made decisions regarding the direction of capital; actual studio operations in Los Angeles were handled by another executive (usually an employee but occasionally a principal owner); and actual filmmaking was supervised by one or more executives in charge of production. Thus MGM had Marcus Loew and Nicholas Schenck in New York, Louis B. Mayer running the studio in Los Angeles (with its twenty-three sound stages on its 117-acre facility), and Irving Thalberg supervising production. Warner Bros. had Harry Warner in New York, his brother Jack running studio operations in California, with Darryl Zanuck supervising production—until Zanuck left to run Twentieth Century-Fox for Joseph Schenck and was replaced by Hal B. Wallis at Warners.

Some studios like Paramount and RKO had remarkable turnover in their studio-based personnel and thus had little consistency in actual production practice (and thus in the style and quality of their product). RKO, for example, had nine different studio bosses in a twenty year span from the late Twenties until Howard Hughes bought the failing company in 1948. In fact, whatever success studios like RKO and Paramount had during the classic era was the result of producer-directors who concentrated on only one production at a time—men like C. B. De Mille, Josef von Sternberg, Preston Sturges, and Billy Wilder at Paramount, and Meriam Cooper, Orson Welles, Ed Dmytryk, and Val Lewton at RKO. Another significant variation during this period was at Columbia, where studio mogul Harry Cohn ran roughshod over studio operations but gave remarkable freedom to producer-directors like Frank Capra and Howard Hawks, whose success carried the studio from "poverty row" to "major minor" status during the Thirties.

The studio executive is in many ways the key to any company's success, given the complexities of the hierarchy of authority on the one hand, and the assembly-line production process on the other. Each studio had only one or two individuals who were privy to both the financial and the creative machinery involved in feature filmmaking—i.e., who understood the concerns of the New York office as well as the actual creative process of making movies. These men also understood the need to standardize and economize the production process, as well as the need to differentiate the products themselves within a competitive market. This is an important distinction because, unlike other industries oriented toward factory-based mass production, filmmaking required not only efficiency but also a certain quality and differentiation of its products. Because movies competed for the public's attention (and thus its entertainment dollars), their mass production was not equivalent to the creation of automobiles or sewing machines, where each unit is identical to all the others coming off the assembly line.

Certainly there were types of films, especially B-pictures and programmers, whose marketability was virtually guaranteed; these films exhibit what might be termed "regulated difference." Similarly, there were occasional periods—during

An American in Paris

necessary demise of the centralized studio with its production facilities, its "stables" of stars and other contract personnel, and the established outlets for its products. They also were responding to changes in tax laws (the introduction of the capital gains tax, for example) and in the financing of films.

The most severe challenges to the established studio system, however, came after the war and actually took roughly a decade to realize their full impact on the industry. Principal among these were 1) the Supreme Court's 1948 antitrust ruling, resulting in the studios' divestiture of their theater chains, 2) changes in American life-styles, particularly the flight from the inner cities to the suburbs and the concurrent "baby boom," both of which curtailed attendance, and 3) the steady rise of commercial television, which by the late Fifties had replaced the cinema as America's mainstream mass entertainment form.

As a result of these and other factors, American filmmaking became an increasingly "independent" enterprise, with each movie representing a separate business venture that is packaged by a producer or talent agency. After the Fifties, the major studios no longer conceived and created movies for their own theaters. Instead, they generally provide financing for prepackaged ventures in exchange for eventual distribution rights, thus providing the vital intermediate step in what was once an integrated process of production, distribution, and exhibition. And the actual studios themselves, those production facilities in and around Los Angeles, remained active but were controlled by the independent film and television companies that leased the facilities for independent production.

World War II, for example—when sustained heavy attendance patterns tended to minimize concern to product differentiation. But the impulse for differentiation did dominate Hollywood's more costly and ambitious productions, which led many of the studios in the late Thirties to a system of multiple production units, each one supervised by a single producer. This unit generally was a specialist in certain types of pictures, and this role was to ensure the stylistic and generic qualities of that type—best exemplified by Val Lewton's horror film unit at RKO *(Cat People, I Walked with a Zombie,* et al.) and Arthur Freed's musical unit at MGM *(An American in Paris, Singin' in the Rain,* et al.).

In a distinct countermove during the Forties, many successful producers, directors, screenwriters, and even stars began moving into independent production. Following the lead of individuals like Selznick and Goldwyn, producers like Hal Wallis and Meriam Cooper, directors like John Ford, Frank Capra, and John Huston, and writers like Ben Hecht and Robert Riskin formed their own independent production companies. Undoubtedly, these men recognized the various threats to Hollywood's integrated system and the

This shift away from centralized, studio-based movie production within an integrated industry represents an important

development in the history of American cinema. But we should note that while the integrated production-distribution-exhibition system passed away, the actual making of movies continued in the same systematic mode developed during Hollywood's studio era. Whatever the vagaries of Supreme Court decrees, import quotas, tax laws, competing media industries, changing life-styles, and so on, our basic notion of "a movie" did not change significantly with the demise of the studio system. Social and economic factors may have altered strategies for merchandising motion pictures, but the narrative conventions, basic techniques, and production values of feature filmmaking have remained fairly consistent, tied as they are not only to established audience expectations but also to a standardized mode of production and division of labor.

Equally significant has been the major studios' continued domination of the industry and financing and distribution companies. The only company among the eight majors to actually go under during the studio system's demise was RKO, due both to Howard Hughes's mismanagement and to the onslaught of television. In 1957 an independent TV production company, Desilu (which had rented an RKO sound stage in 1951 to shoot a series pilot for *I Love Lucy)*, bought the entire studio outright. But the other majors, along with Disney, continued to dominate the market, and their hegemony continues today. From 1975 to 1985, those companies (which number only seven after the MGM/UA merger in 1981), accounted for eighty-five to ninety percent of all film rentals among mainstream movie releases. A key factor in this continued domination has been the studios' willingness to allow production and marketing costs to inflate substantially: by the early Eighties, the average feature cost roughly $10 million to produce and another $5 million to $7 million to market. This has provided an effective barrier to entry, in that genuinely "independent" filmmakers cannot compete with established production companies at those costs without securing financing and distribution from one of the major studios.

Thus the dismantling of the integrated studio system had much the opposite of the envisioned effect. Instead of encouraging entry into the film industry by independents, the ever-growing blockbuster syndrome and high-tech esthetic in feature filmmaking have created a different but equally effective barrier to entry. Another irony is the general nostalgia that has developed among film critics and historians for the studio system of old and even for the "moguls" who ran them. The quality and efficiency of that system was reflected in its products, which in turn reflected the sensibilities of the men who ran them. Successful contemporary directors have tried to recover that level of quality and efficiency by establishing their own studios—Robert Altman with Lion's Gate, for example, or Francis Ford Coppola with American Zoetrope. Only George Lucas's studio, Lucasfilm Limited, has been successful; he admits he's more producer than director or writer, and his is the only company that has not suffered from artistic self-indulgence or mismanagement. Considering the failure of companies like Lion's Gate and Zoetrope, and considering too the gross inefficiency of current production practices with their inflated budgets and slim chances of box office success, perhaps a general revaluation of the Hollywood studio system is warranted. We might do well to recognize what French film critic André Bazin, writing about the Hollywood industry, begrudgingly referred to as "the genius of the system."—Thomas Schatz

RECOMMENDED BIBLIOGRAPHY

Dunne, John Gregory. *The Studio*. NY: Limelight Editions, 1985.

Gomery, Douglas. *The Hollywood Studio System*. NY: St. Martin's Press, 1986.

Schatz, Thomas. *The Genius of the System: Hollywood Filmmaking in the Studio Era*. NY: Pantheon Books, 1988.

The Exorcist

The Horror Film

The horror film, certainly the most controversial of film genres, has always been with us. Its origin, indeed, is the origin of all moving pictures, going right back to the Lumiere brothers' 1895 exhibition of *A Train Entering a Station*, a short documentary sequence to which early audiences reacted with a frenzy, ducking away from the seemingly onrushing train on the screen and fleeing the auditorium in fear.

Of course, the Lumieres' little film was not a horror film as we've come to know it, but it provoked fear and psychological unease in its audiences (who had not yet learned how to "look" at movies), and that is precisely how the horror film has always functioned historically.

The scope of the horror film genre is huge, ranging from documentary films like Franju's *Le Sang des Bêtes* (1949) to respectable literary adaptations like Welles's *The Trial* (1963); from avant-garde works like Buñuel's *Un Chien*

Andalou (1928) and Anger's *Scorpio Rising* (1964); to cartoons and Westerns like Jodorowsky's *El Topo* (1971). Horror elements have consistently been utilized in mainstream films and in art films like Lumet's *The Pawnbroker* (1965), Eisenstein's *Battleship Potemkin* (1925), Russell's *The Devils* (1971), and in much of Bergman's work.

Perhaps because of its scope, the horror film has never been adequately defined. The most common confusions arise with the fantasy and, more particular-

ly, science fiction genres, with an overlap often occurring not only on criteria of content or theme but also of style and the explicitness of violence or morbidity. The overlap with science fiction, especially in the Seventies with films like *Alien* (1979), is most problematical, although science fiction must utilize, extrapolate from, or subsume scientific principles (i.e., *fact*), while the horror film deals with aspects, both positive but mostly aberrational, of psychology. A rigid definition of the genre is not required, although many verbose ones have been attempted. Essentially, and simply, horror is what scares us.

And statistically, if it scares us, it's good box office. The horror film is the most continually popular and prolific cinematic genre. In Hollywood, always famished for box office dollars that connote trends, nothing breeds success like imitation, especially in horror fare.

The earliest origins of horror films per se lay in Georges Melies's trick films, although the first identifiable flourishing of the form evolved in Germany where the speculative tradition of art and literature combined with legendary-magical elements in German culture led to expressionist masterpieces like Weine's *The Cabinet of Dr. Caligari* (1919), Rye's *The Student of Prague* (1913), Wegener's *The Golem* (1920), Rippert's *Homunculus* (1916), and Murnau's *Nosferatu* (1922). American silent films picked up the, at this point, largely visual tradition, most notably in a series of master makeup-artist Lon Chaney vehicles like *The Hunchback of Notre Dame* (1923), *The Phantom of the Opera* (1925), and *London After Midnight* (1927). Universal, which produced these films, later benefited in the early sound era from the importation of German film artists like Weine, Leni, and the great cameraman Karl Freund; the result was a string of accomplished horror films like *Frankenstein* (1931), *Dracula* (1931), *Murders in the Rue Morgue* (1932), *Freaks* (1932), *Island of Lost Souls* (1933), and *King Kong* (1933). With the appearance of

the Hays Office in 1934, to that time the most rigid of Hollywood's self-censoring bodies, the horror film's content suffered. Through the Forties the genre yielded little except personality-oriented vehicles for Boris Karloff, Bela Lugosi, and George Zucco. The exception was a series of subtle little horror thrillers by Val Lewton and Jacques Tourneur, led by *Cat People* (1942), *The Leopard Man* (1943), and *I Walked with a Zombie* (1943).

The Fifties, with the rise in popularity of the idiosyncratic drive-in theatre, gave birth to Roger Corman/AIP horror cheapies. With their prime audience in mind, producers began to make their youthful protagonists both rebellious and heroic. Hitchcock's *Psycho* was released in 1960, and it signalled a trend: the rude horror film. Britain's Hammer Films picked up the new freedoms allowed by a changing society and loosening morality in a series of highly successful, stylish, color horror films that increasingly accentuated sexuality, nudity, and gore, a trend that came to dominate the Seventies' output, which has, in turn, led to the present day, where quite literally almost anything goes in film form and content.

The horror film reached new heights of popularity beginning in 1973 with the release of *The Exorcist*, the first of the big-budget horror films, and continuing through the Eighties, although it appears to be subsiding, for reasons I will suggest later. Horror audiences have consistently been young (sometimes belying the MPAA R-rating most horror films carry) and enthusiastic, often seeing a favorite film several times. Numerically, more horror films are released than any other single genre of film, apart from what has become known, beginning in the Seventies, as the youth comedy. Part of the reason for this is the fact that consistently the horror film is cheaper and quicker to produce than any other kind of film. (Its rival, the youth comedy, may be even cheaper to produce, but it does not require even the modicum of filmmaking skill nec-

essary to the horror film.) Upon its release in 1978, John Carpenter's *Halloween* was the most successful independently financed (as is most horror product) film of all time, produced for about $300,000 and netting, within only a few years of its release, nearly $20 million (and this does not count non-theatrical markets like cable and network TV, home video, etc.). The horror film's impact is seen in other cultural phenomena (largely shared by youthful consumers) like comic books, video games, and rock music; the most successful rock video thus far was the John Landis-directed *Thriller*, which plays almost like a précis of the entire genre.

All this popularity has bred controversy. Nothing alarms intellectuals like mass success, for they then feel compelled to explain it. They have responded with a bewildering array of theories, positing the horror film as, among other things, alternative reality, plunges into dream/nightmare worlds, the exploration of the forbidden with relative psychological safety, or exploitation of the overt titillation of voyeurism (which rests at the base of all film viewing). By far, it is the psychoanalytical theories, applied to film from the work of French thinkers like Lacan, that seem most logical and convincing. Noel Carroll sees psychoanalysis as "the *lingua franca* of the horror film...[which] often seem[s] to be little more than bowdlerized pop psychoanalysis, so enmeshed is Freudian psychology with the genre" (*Film Quarterly*, Vol. 34, No. 3). In this context, for instance, vampire films are about rebellious sons, while *doppelgänger* (like Polanski's *The Tenant*, 1976) and werewolf tales are about the triumph of the alter ego. Films like *The Exorcist* that deal with possession exhibit the terrors of the loss of self (control) and also the pleasures of our watching unleashed emotions like rage and revenge that are usually repressed. The horror film is a violent film, and sociologists, psychologists, educators, and the clergy have battled back and forth, from the Twenties to the present day, with

fierce arguments that such visual expressions are inherently dangerous or inherently healthy. The question will never be resolved.

Horror director George Romero predicts (probably only half seriously, but who knows?) a time when there will be horror peepshows, much like the present porn variety, where one will be able to drop in off the street, throw a couple of quarters into a viewer, and get a fix of hardcore violence. The only thing that is certain is that audiences love to see things in the movies they would never want to see in real life, and thus, be scared, perhaps even repelled, and the horror film serves that purpose and that purpose only.

The horror film readily divides itself into subgenres, each with established, traditional, basic story formulas and stock characters. Probably the oldest of these is the vampire film, which owes its origins to Bram Stoker's 1896 novel *Dracula*, which created the genre's chief protagonists who for the most part have been faithfully adhered to by filmmakers to present times: Dracula, the vampire, the undead being cursed for centuries to drink the blood of his victims to sustain his existence (which in the more thoughtful films is always seen to be a tortuous, wretched life but to which the vampire must cling); and Van Helsing, the learned vampire killer, who is the only man with the knowledge and courage to fight and defeat the fiend. Both are equally obsessed figures. As is true in Stoker's wholly apolitical novel, the vampire represents a figure of corrupt aristocracy, usually preying on nearby villages, whose citizens are powerless and clearly in thrall (yes, somewhere there probably is a Marxist theory of the vampire film), until the vampire, with or without his newly converted "family," decides to move on. However, the Van Helsing figure is also aristocratic—there are very few films in which the vampire killer is a populist hero, perhaps the most notable exception being *Captain Kronos, Vampire Hunter* (1972). This father/son

duality can represent, of course, the working out of the Oedipus myth, in which the "father" eventually triumphs. (For that matter, there are few films in which the vampire's mother is even portrayed, notably *Brides of Dracula,* 1960). Films that take the vampire from his native land, usually an eponymous "Old Europe" antiquity like Germany *(Nosferatu),* although mostly England (the many Hammer Draculas), plop him down in an equally aristocratic society in America which eventually produces his demise.

The vampire is totally consumed with satisfying the demands of his very existence, which is pictured as depraved, corrupt, immoral, and a lot of work; in the better films, it is no less than tragic, although his plight does not make him into a heroic figure. (William Marshall, in the blaxploitation entry *Blacula,* 1972, comes closest; he is one of the few screen vampires to, in effect, commit suicide by willingly walking into sunlight, although race consciousness is not one of his motives for doing so.) Consumed with his effort to survive (the numerous bits of vampire lore pretty much stack the deck against his continued existence), he has no time to foster dreams or pursue, say, political or material power, as does, for example, Fu Manchu or Dr. Mabuse, although a surprising exception is the last Hammer Dracula film, starring the venerable Dracula/Van Helsing acting team of Christopher Lee and Peter Cushing, released here briefly in 1973 as *Count Dracula and His Vampire Brides,* in which Dracula actually does express such designs and sets up a multinational corporate structure to achieve that end.

Perhaps more than in any other horror subgenre, filmmakers have added new wrinkles to the classic vampire formula: thus we've had teenage, women, gay, lesbian, and Jewish vampires. In Bob Kelljan's interesting low-budget *Count Yorga* films (1970, 1971) with Robert Quarry, the age-old vampire plunks himself down into and amusingly confronts busy, modern Los Angeles culture. In *The*

Deathmaster (1972), displaying its end-of-Sixties cultural milieu, the vampire (again Robert Quarry) becomes guru to a hippie commune. In one of the best nonclassical vampire films, George Romero's *Martin* (1978), the titular character, an adolescent in small-town, heartland America, drinks the blood of his victims—more neatly as he uses drugs to subdue his victims and syringes to extract the blood—but the complex point of the film lies in whether Martin, submerged in teenage culture, including monster movies and vampire lore, *is* a real vampire or a (mere) psychotic obsessed with the idea that he is a vampire. In any event, his behavior and eventual demise adhere to the formula.

There was an historical Count Dracula, although he was not a vampire, but it is the creature of myth and folklore that is the immediate cinematic model, and these two preliterary narrative sources have provided the horror film with a rich store of beasties. A person becomes a werewolf through the bite of an already afflicted creature, and he or she, at the right conjunction of the moon and stars, turns into a ravenous wolf. The werewolf is a true tragic figure, because he is an innocent and thus becomes a threat especially to those who love him and against whom (unlike the vampire) there is little protection. Love is the all-powerful emotion here—it can stave off the disease for awhile. In *Curse of the Werewolf* (1961), a young man, conceived when his mother was raped by a "Dog Man," does not become a werewolf until the strong maternal love is broken in adolescence. In most of the werewolf films, the monster is killed by his or her loved one and reverts in death to natural form.

Greek, Roman, and Egyptian mythologies have provided scores of creatures, from minotaurs to gorgons to cyclops to mummies, all unleashed usually to wreak havoc in unsuspecting modern times. Their appearance in ancient settings, firmly surrounded by the myth, are usually in sword-and-sandal beefcake epics, which also revived these beasts' classical slayers,

heroes like Hercules and Sinbad. The most striking examples here are the Ray Harryhausen/Charles Schneer adventure fantasies, popular in the Fifties and Sixties, featuring stop-motion animation of models, like *The Seventh Voyage of Sinbad* (1958), *Mysterious Island* (1961), and *Jason and the Argonauts* (1963). They, along with *Conan the Barbarian* (1982), are the immediate progenitors of the much-touted sword-and-sorcery pictures which rely on heavy doses of horror-film-style violence and gore, but which flopped miserably in their initial box office season in 1982.

Giant prehistoric creatures and mythical dragons, usually revived by atomic bomb tests, were a Fifties staple and perfectly illustrated collective national fears and unfocused dark imaginings of atomic (and worse, as we were soon to discover) weaponry and the dangers of communism creeping like mist across the ocean (or worse: starting up here). All of these are technically science fiction films or fantasies, although a few were horror inspired. Oddly enough, the monsters, which ranged from ants, spiders, caterpillars, grasshoppers, and praying mantises to the more traditional dinosaurs to animals like shrews, and, in the most unlikely case, rabbits (*Night of the Lepus*, 1972), were usually defeated, after squashing man's feeble military forces and hardware, by the forces of science (the guys who caused the problem in the first place) via a bigger bomb or death ray or toxic substance. And this at a time when science promised everyone a rosily healthy future ("Better Living Through Chemistry").

Fairy tales, many of which, especially the Grimm variety, are excellent examples of horror litrature, have also served as inspiration for horror films, either in a fairly straightforward version (*Who Slew Auntie Roo?*, 1971, is pretty much *Hansel and Gretel* with a few twists, including Shelley Winters as the witch) or more removed from the source: what else is the murderous, supranatural villain of *Halloween* but the Boogieman, unstop-

pable, unkillable, inhuman, a pure film distillation of nightmare.

Scientists are one of the great props of the horror (but mostly science fiction) film; working on their little projects, they all seem to go mad in secret, sometimes for the right reasons: Boris Karloff in *Corridors of Blood* (1958) attempting to discover anesthetics; or sometimes out of plain silliness, like primitive evolutionist John Carradine attempting to create a woman out of an ape in *Captive Wild Woman* (1943) and vice versa (!) in its sequel *Jungle Captive* (1945); or Dana Andrews reviving Nazis in *The Frozen Dead* (1967). In fact, Nazis deserve a little category all their own, as a kind of quick catch-concept of pure evil; they are constantly being revived, most effectively in *Shock Waves* (1977), and Hitler's brain has been "saved" a few times. In all these films, the scientist's obsession is perverted into a dangerous megalomania, and he is killed (or suffers, learns his lesson and frees himself, as in *Frankenstein*, although he was back for more in the sequels) by his creation, if not physically, then by his blind striving to create it. The scientist in horror films is never political—he can seldom see beyond his laboratory and alienates those few humans around him, usually a suffering daughter or wife who slowly becomes involved (for love interest) with best friends or sharper-discerning colleagues of the scientist. The horror film scientist is simply a tyrant and ultimate victim of accumulating knowledge.

Another major category of the horror film deals with devils and other all-powerful evil forces. These are haunted house tales, from Whale's eccentric *The Old Dark House* (1932) to the popular Amityville films (1979–), and stories of possession which flourished in the wake of *The Exorcist*. Again, there is no political impact or posturing; the stories are simply yarns functioning in the unbelievable made real (most of them involved perhaps unconsciously a thorough trashing of the Catholic religion). The main theme is the

doppelgänger effect, whether from within (Jekyll-Hyde stories) or without (demon possession) or in combination, such as the subgenre of movies based on Curt Siodmak's 1943 novel, *Donovan's Brain*, in which a person keeps someone's brain alive after death, only to come under its power (in the best version, 1953, Donovan was a Howard Hughes-ish tycoon, who continues his quest for power in his scientist underling, who eventually goes mad). Whatever the form, the victims, especially in demon possession, are innocent, often children, and provide strong identifying figures, which increases the emotional power of these films for audiences.

A final type of horror film features the slasher on the loose, films in which a psychotic killer runs amok—his killing spree largely replaces any story or plot line, and the film becomes a succession of killings until the fiend is himself killed. In the wake of *Halloween* and *Friday the 13th* (1980), both of which have had multiple sequels, slasher films have literally overrun the genre. The origin of the form goes back at least to Lang's *M* (1931) and Hitchcock's *Psycho* (1960), both of which complexly elicited some sympathy for the compulsive killer, and also *Fiend Who Walked the West* (1958) and various Jack the Ripper tales. The form has degenerated; current offerings offer violence only. No longer is there a parallel story of the efforts made by heroes to track down or capture the killer (and in many cases he isn't caught at all), and the films are permeated with generous doses of sex and nudity. Psychologically, these films are antediluvian and cynical; victims, almost always attractive adolescents, seem to be punished for their sexuality and lack of inhibition—for their very youthfulness, perhaps.

The horror film exists almost solely as a rollercoaster ride. Whatever the hard work and occasional thought that go into their making, their aim is not to provoke thought in the audience. The addition of thought can, indeed, be a liability, for the entire narrative and stylistic energy of the horror film must constantly work to the purpose of postponing audience disbelief, to which process a little thought could be detrimental; you have time to think about it, and the movie, like a house of cards, falls apart. The horror film is a triumph of style over content, and it shuns political content almost like a plague. Political meanings, for the most part, must be read, often abstrusely, into them on the part of overzealous viewers. Thus, for instance, *King Kong* (1933) has been seen as a peculiarly American allegory of slavery and racism.

There are some exceptions to this rule, which mostly lie in the broad (Godardian) notion of politics as social and sexual criticism, as an exploration of the society that produced the film. Several of the silent German Expressionist classics like *The Cabinet of Dr. Caligari* and *Der Golem* are directly pinned to the society from which they sprang, a period of social unrest and postwar collapse. In the Thirties, Victor Halperin's cheapie *White Zombie* (1932) seems to make more of the fact that the zombies are used as slave labor in a sugar mill, and by a white boss, than that they are being created in the first place. Tod Browning's one-of-a-kind *Freaks* (1932) is a classic, a forceful statement of the plight of the outsiders and the dispossessed. In an almost social activist manner, Mark Robson's *Bedlam* (1946) explores the horrors of nineteenth-century asylums and treatment of the mentally ill. Fifties genre films exploited the just-birthed nuclear nightmare and Cold War applications. *Invasion, U.S.A.* (1952) posited a Third World War, and the trick ending—it was only a dream—sends its neighborhood bar denizens who have experienced a group illusion scurrying in patriotic fervor to prepare for the Russians. The Japanese-made *Godzilla* (1957) is a conscious exploration of a cultural identity surviving one holocaust (World War II and the atomic bomb) and facing another. The crux of the film is not the destruction of the beast but a sci-

entist's agonizing moral decision to offer the military use of an ultra-powerful weapon he has just discovered to kill the monster. Godzilla actually became, in his increasingly kiddie-oriented sequels, a good guy, doing battle with evil monsters to save the world for man. In 1972, he both invented and warned us about ecological horror by facing off against a "Smog Monster" created from man's pollution.

In the Sixties came Bergman's *Shame* (1968), in a sense studying the plight of the artist uninvolved in politics who must still survive its ruinous implications. Michael Reeve's *The Conqueror Worm* (1968) turns to the seventeenth century and becomes a study of the horrors of unleashed political power in a fearful, civil-war-strewn population; the witchfinder (Vincent Price) is a sadist more powerful than the military, religion, the legal system, or, of course, the ever-suffering people. John Frankenheimer's *The Manchurian Candidate* (1962) involves a group of Korean war veterans, brainwashed in captivity, who can be triggered to commit political assassinations. Bob Clark's little-seen *Deathdream* (1972) concerns a Vietnam War vet, reportedly killed in action, who returns home, a murderous ghoul; this is one of the few instances of Vietnam rearing its ugly head in horror films (not surprisingly, the picture was produced in Canada).

By the time of the modern horror film, even these few socially oriented examples disappear in the gush of gore. Out of the schlock have emerged two craftsmen: David Cronenberg and George Romero. The former, in *They Came from Within* (1976), *Rabid* (1977), *The Brood* (1979), *Scanners* (1980), *The Dead Zone* (1983) and *The Fly* (1985), among others, has consistently explored the behavior of individuals caught in restricted, hence claustrophobic, social emergency situations. George Romero has similarly, although even more overtly, dealt with the same subject. *The Crazies* (1973) accidentally lets loose a biological weapon upon an unsuspecting American population, similar to his zombie pictures (Romero is also into plagues). *Dawn of the Dead* (1979) is loaded with social criticism which is so extreme that it becomes comical and "pop': the zombies wander around a huge shopping mall in a sort of collective remembrance of what it once meant to them. More incisive is that, in both pictures (including the classic *Night of the Living Dead*, 1968), the armed-to-the-teeth "clean" civilians roaming the countryside gleefully and sometimes erroneously pick off the zombies like empty beer cans perched on a wall.

A third director, John Carpenter, is even more of a consummate craftsman who also loads his films with portions of often witty film-buff lore. His horror films include *Halloween* (1978), *Someone is Watching Me* (made-for-TV, 1978), *The Fog* (1980), and *Escape from New York* (1981). What is interesting to note is that all three men are fervent *independent* filmmakers successfully rejecting the lure of Hollywood which is eager to latch onto their success (Carpenter, who learned his craft by writing Hollywood features, has embraced the industry, and his later films, including a 1982 remake of *The Thing* and the 1987 *Prince of Darkness*, are by far the weakest of his career).

The Eighties horror film was, in fact, dumb, even driving the decades-dependable formulas into outdated nonsense (or doing away with them entirely); they seem to be used today only in horror comedies and derisive parodies as ostensible clichés to be laughed at. The multitude of descendants from *Halloween* and *Friday the 13th* —which actually owed their origins to *The Texas Chainsaw Massacre* (1974) and *Last House on the Left* (1972)—a gore rip-off of Bergman's *The Virgin Spring*—are not even horror films per se (the late Boris Karloff, who could not stand the term, liked to call them "terror films"). The modern horror film has become instead simply a test of stamina: can one sit through this film without throwing up? *Mark of the*

Devil (1972) even used the notion as a promotional ploy; everyone who entered the theatre to see it received a vomit bag. The technology of makeup and special effects, so exhilarating and wonderfully enhancing in the science fiction film, has improved so greatly that filmmakers can put on screen almost anything imaginable (and they've come up with some things not readily imaginable). That amazing technology, tied to the loosening of moral and societal structures, has become a deadly force. Gone are the days when Rex Reed could rail in *The Reader's Digest* about finding *Night of the Living Dead* showing at a Saturday kiddie matinee. Special effects have now replaced human values. Every form of violence to the human body can now be (more or less) convincingly shown, in unflinching close-up. Consequently, there is nothing left for the imagination of the viewer, and, as a result, audiences sit there stunned, then are aroused for more. The horror film has become a suspense-bereft game of audiences daring the filmmakers to do more.

In the Forties, Val Lewton and director Jacques Tourneur collaborated on a string of subtle, eerily effective horror films in which the unseen was more terrifying than the seen. Today these films are seen (if they're seen at all) as quaint and boring. They worked then because they involved the emotions and imagination of the viewers, so that film, filmmaker, and viewer became one. Today there is no such thing; audiences are turned off, except for knee-jerk arousal of bloodlust, and that is why the horror film is dying, if not, like the Western, dead already. Today the horror film genre is in danger of being trivialized out of existence.

There is, however, one area in which the horror film has interestingly and consistently exhibited political import, and that is in sexual politics. In the largely macho world of horror, women have been portrayed as screamers and losers, the ultimate and handiest victims of whatever terrors the film provided. Up through the Forties and Fifties, the heroes were males, and they were attended to by women as secretaries, girl friends, nurses, wives, bewildered daughters, and coffee-makers (*Them*, 1954, was one of the few Fifties horror/sci-fi films to feature a woman as a resourceful, strong-willed scientist and one of the active monster-battlers.) Only in a more arcane sense, (unintended) feminist principles and rage may be discerned in pulp exploitation quickies like *The Wasp Woman* (1959) and *Attack of the 50-Ft. Woman* (1958).

This subservient nature was aggravated when the Sixties discovered nudity; almost all of it was female, adding insult to injury. This can be no surprise—the horror film is traditionally largely male, so we've had tit-fodder absurdities like lesbian vampires—*Countess Dracula* (1972) and *Vampire Lovers* (1971)—lady Frankensteins and werewolves, and, of course, the traditional if now eroticized witch. One of these films, *Dr. Jekyll and Sister Hyde* (1972), is an interesting and in a sense oddball, lower-planed forerunner (unintended) to *Tootsie*: the staid, lily-white Dr. Jekyll becomes, in his Hyde form, a carnal woman of the streets, and he discovers that he likes the freedom of sensuality—a perfect capsulization of Victorian hypocrisy.

Then something interesting happened: in the Sixties came the horror harridan films in which aging actresses (aged even more by makeup), many former glamorous Hollywood movie stars like Bette Davis and Joan Crawford, Tallulah Bankhead, and Olivia de Havilland, replaced the monsters—in, respectively, *Whatever Happened to Baby Jane?* (1962), *Die! Die! My Darling* (1965), and *Hush Hush Sweet Charlotte* (1965)—without disturbing the plot. In Roman Polanski's *Rosemary's Baby* (1968), a traditionally victimized woman at least accedes to her fate: she decides to nurture the demon baby. The next step was Brian De Palma's *Carrie* (1976), in which a victimized female adolescent takes active revenge on her

oppressors with telekinetic powers (the film also featured the surprise "shock" ending, which also set a trend for almost every horror film to follow). Thus was born the macho female—the tormented woman who turns the tables on her (usually) male victimizers. She has appeared most prominently in *Eyes of a Stranger* (1981), *Happy Birthday to Me* (1981), *The Funhouse* (1981), *Friday the 13th, Part II* (1981), and *Halloween II* (1981). In *Mother's Day* (1980), the trio of brutalized women withdraw, recuperate, form themselves into a fighting guerrilla force, return, and wipe out their oppressors. The next step in this journey may well be slasher movies in which women are the deranged killers. And they will probably have to be subdued by the poor victimized male—who knows where this could lead?

This new wrinkle in the slasher picture, of women taking on the traditional male role of revenge-seeker or deranged violence dispenser, marks a reversal in the stature of women in film (horror and otherwise), at least in the area of sexual politics. But if the modern horror film has lost its moral stance (and sense) and conscience in a welter of special effects and streaming gore, can this be considered progress? If so, the cost is all too evident.—David Bartholomew

RECOMMENDED BIBLIOGRAPHY

Clover, Carol J. *Men, Women & Chain Saws: Gender in the Modern Horror Film*. Princeton, NJ: Princeton University Press, 1992.

Douglas, Drake. *Horrors!* Woodstock, NY: Overlook Press, 1989.

Everson, William K. *Classics of the Horror Film*. Secaucus, NJ: Citadel Press, 1974.

Justice, Keith L. *Science Fiction, Fantasy and Horror Reference: An Annotated Bibliography of Works About Literature and Film*. Jefferson, NC: McFarland and Co., Inc., Publishers, 1989.

Kendrick, Walter. *The Thrill of Fear: Two Hundred Fifty Years of Scary Entertainment*. NY: Grove Weidenfeld, 1991.

McCarty, John. *The Modern Horror Film: Fifty Contemporary Classics from* The Curse of Frankenstein *to* The Lair of the White Worm. Secaucus, NJ: Carol Publishing Group, 1990.

Tudor, Andrew. *Monsters and Mad Scientists: A Cultural History of the Horror Movie*. Blackwell Publishers, 1989.

Wiater, Stanley. *Dark Visions: Conversations with the Masters of the Horror Film*. NY: Avon Books, 1992.

Leopard Man

Gentleman's Agreement

Jews in American Cinema

D espite their small numbers in the United States, Jews have enjoyed an advantage unequalled by any other ethnic group in America—a virtual control over their own self-image on the screen. This was made possible by the great influx of Jewish talent into all areas of film production.

Indeed, Ben Hecht once commented that Hollywood experienced "a Semitic renaissance sans rabbis and Talmud."

In the movie industry, Jews have been a dominant force as producers, writers, directors, and composers. Their participation dates back to the earliest period, but perhaps the most unique aspect of Jewish participation, that which sets them apart

from any other ethnic group, has been their virtual monopoly on film producing. During the heyday of Hollywood, every major studio, save Twentieth Century-Fox, was headed by a man of Jewish origin. Jews moved into motion picture production and exhibition for the same reason they had gravitated to such other fields as small merchandising and the garment

trades. Participation took little skill and little capital and, as a new industry, was open to immigrants; all newcomers were on an equal footing. As the Jews gained a foothold in the industry, they hired friends and relatives, and so their numbers, and influence, grew.

Following such early pioneers as Sigmund "Pop" Lubin and Max Aaronson, better known as Bronco Billy, a second generation of Jewish film producers emerged to build Hollywood moviemaking into a major industry. In this list are the names Carl Laemmle, William Fox, Adolph Zukor, Samuel Goldwyn, Jesse Lasky, Harry Cohn, Louis B. Mayer, the Warner Brothers, Irving Thalberg, and B.P. Schulberg, and financiers like the Schenck brothers and Marcus Loew.

These men had an overwhelming desire to prove themselves good Americans. As Phillip French observed in *The Movie Moguls*, "their commitment to the melting pot had many consequences for their work." One was a wish "to impose a certain uniformity upon their employees and their product, to advance from a notion that fundamentally everyone is much the same to a demonstration that everyone really is the same." Two was the "re-naming of actors and actresses capable of being identified with immigrant groups." And three was a bias towards resolving scenarios with intermarriage, a circumstance which reflected events in their own biographies. In short, it fell to the foreign-born Jewish immigrants to establish the patterns for American film culture.

Following in their footsteps came a third generation of producers, men such as David Selznick, Dore Schary, Pandro Berman, Arthur Freed, William Goetz, Sam Jaffe, Anatole Litvak, Joseph Mankiewicz, Joseph Pasternak, Sam Spiegel, Michael Todd, Hal Wallis, and William Wanger. Since the collapse of the "Old Hollywood" at the end of the Fifties, executives have come and gone. None have had the bearing of the old moguls.

None have become household names. In the main, however, these men are still of Jewish origin. American born, educated, and assimilated, they are a breed and constitute the fourth generation of Jews active in the industry.

Jewish participation in the film industry has not been limited solely to production. Major artistic contributions have been made in the area of screenwriting by Julius and Phil Epstein, Carl Foreman, William Goldman, Ben Hecht, Garson Kanin, Herman Mankiewicz, and Budd Schulberg; in directing by George Cukor, Stanley Kubrick, Ernst Lubitsch, Otto Preminger, Billy Wilder, William Wyler, Fred Zinnemann, and, more recently, by Sydney Pollack and Steven Spielberg; and in composing by Burt Bacharach, Elmer Bernstein, Bernard Herrmann, Marvin Hamlisch, Alfred Newman, Miklos Rozsa and Max Steiner.

In the first two decades of the twentieth century, Jews were portrayed quite frequently in American movies, especially as immigrant characters. Such portrayals diminished during the Thirties and Forties as the drive toward assimilation among Jews in America was reflected on the screen. Recently, however, there has been a resurgence of ethnic identity in American life. This has resulted in an increase in the depiction of Jewish characters on the screen. But always in such portrayals two questions nag Jewish participants in filmmaking: How will the Jews appear to the outside world? How will an individual film affect the Jewish community? In short, is it good for the Jews?

Despite the waves of anti-Semitism in America during this century, it has never been a state policy as in Europe nor has it taken on the proportions known elsewhere in the world. Similarly, although anti-Semitic literature has appeared in every decade, anti-Semitism has not been a dominant or even prevalent aspect of the mass media (newspapers, radio, film, television) or the fine arts (painting, literature, drama). Therefore, it is not surprising to

discover that although negative portrayals of Jews exist in film, little overt anti-Semitism occurs. The large number of Jews who held the reins of Hollywood's power prevented this. Lack of overt anti-Semitism also reflected the thinking of an industry in which appeal to the largest numbers and offense to none was the order of the day. Because Jews made up a high percentage of the urban film audience, their interest could not be slighted.

A case could be made, however, against some of the early silent shorts produced by film companies in which the heads of production were not Jewish. Included in this group are many of the early comedies in which Jews appear as the butt of the joke, the scapegoat. Typical of such works is *Levitsky's Insurance Policy, Or When Thief Meets Thief* (1908), produced by the Vitagraph Company, in which even a thief is able to best the Jewish merchant and to teach him a lesson, and *Cohen's Fire Sale* (1907), produced by Edison, wherein Cohen finds a quick solution to his financial problems by setting fire to his millinery shop.

The scheming Jewish merchant appears in many comedies up until the Twenties and possesses elements of anti-Semitic caricature. Gross features and vulgar gestures usually accompany the portrayal, a carry-over from the burlesque Jews of vaudeville, which, along with Victorian melodrama, served as the basis for early scenarios and interpretations before film writers developed their own conventions.

In addition to the burlesque Jew, early films also provide a sympathetic image, especially in melodrama. D.W. Griffith's *Old Isaacs, The Pawnbroker* (1907) offers one of the first images of the benevolent Jewish moneylender. Here the pawnbroker saves an ailing Gentile woman and her child. The story has all of the elements of pathos and sentimentality which long adhere to stories about Jewish life.

Through the Teens, the Jew appears in a wide variety of melodramas, comedies, and literary adaptations. Of this group, the melodrama is the most prevalent. Two themes emerge as dominant—the depiction of immigrant life in America and the depiction of Czarist oppression in Europe. In comedy, the films tend to reproduce the vaudeville routines with little emphasis on narrative development. In the area of literary adaptation, works include *Oliver Twist, The Merchant of Venice, Ivanhoe,* and *Daniel Deroda.* The films, generally faithful to the original texts, brought to the screen anti-Semitic characters like Fagin and Shylock. Each of these genres introduced a whole stable of character types which laid the basis for the depiction of Jews in film for years to come. The character types which appeared in the period before 1920 include: the scheming merchant; the benevolent pawnbroker; the stern patriarch, who clings to the old ways; the prodigal son, who strains to break away; the rose of the ghetto, who slaves in the sweat shops to support her family or lover; the innocent Jewess, betrayed by a Gentile lover; and the Yiddisher cowboy, a *schlemiel* in the Old West, who eventually proves his manhood.

The Twenties was the golden age for anti-Jewish images. Within the decade, Jews were portrayed in over ninety-five films, mostly in major roles. Like the two preceding decades, the films fall into two large groups—melodramas and comedies. The overwhelming number of films devoted to domestic life constitute a separate subgenre, a blossoming of the ghetto film from the decade before.

In a sense, the Twenties began and ended with a ghetto film—in each instance a blockbuster. Both *Humoresque* (1920), based on Fannie Hurst's story, and *The Jazz Singer* (1927) typify the period. Both bring to the fore the struggle of immigrant children to take full advantage of the benefits of American democracy. Both depict success stories; in *Humoresque*, the hero becomes a famous violinist, and in *The Jazz Singer*, Jackie emerges as a Broadway entertainer. And in both works success

entails the abandonment of traditional Jewish ways. Such is the price of "making it" in America.

Also of significance is Jackie's choice of a Gentile bride. Although statistics show the rate of intermarriage among Jews in real life was very small, an overwhelming number of films in this period depict Jewish intermarriage. This tendency promoted by Jewish producers remains, even today, a strong factor in film and reflects an assimilationist ideal shared by creators and viewers alike.

During the Twenties the comedy developed into a full-blown vehicle with several stars who became familiar for their depiction of the Jew. Included were the rotund George Sidney, shaggy Max Davidson, large-beaked Sammy Cohen, as well as Alexander Carr, George Jessel, and Benny Rubin.

During the Thirties, a drastic decline in the number of Jewish characters on the screen occurred. This phenomenon has three explanations. First, there was a tendency among Hollywood producers to appeal to the greatest numbers in the belief that by portraying the "average American" (a WASP) all people could identify with the image.

A second factor which influenced screen portrayals was the sharp reduction in immigration beginning in 1924. This meant that the constant influx of new immigrants virtually ceased, and the Jews as a group, along with others, were moving continually towards acculturation and then to assimilation. By the mid-Thirties many had completed this process. And for those who had not, the assimilated Jew was an ideal.

Last, the rise of Adolf Hitler and the changes occurring in Nazi Germany created fear and tension, even in America. Although men like Ben Hecht organized to fight the monstrous anti-Semitic state, others felt it was not a good time to place Jewish characters and Jewishness in the foreground of films.

In most of the films of the Thirties in which Jewish characters appear, they have a low profile, being Jewish in name only. A few important films ran counter to this trend. These include *The House of Rothschild* (1934) and *The Great Dictator* (1940). The former starred George Arliss as the Jewish prime minister, Benjamin Disraeli. *The House of Rothschild* focuses on the rise and business acumen of the four Rothschild brothers. The film highlights family solidarity, communal concerns in the wake of European anti-Semitism, and the necessity of wealth to secure physical safety for Jewish survival. As such, the film provides one of the few logical and sympathetic explanations of the Jew's concern for money.

The Great Dictator, produced, directed, written, and played by Charles Chaplin, was one of the first films to directly confront the growing threat of Nazi Germany. A few works had dealt with political problems, but without clearly relating them to the Jews. These films include *Confessions of a Nazi Spy* (1939) and *The Mortal Storm* (1940). With slight disguise, *The Great Dictator* shows the growing power of Adenoid Hynkel (Hitler) as he imposes a policy of discrimination, then physical violence, against the Jews of Tomania (Germany). Chaplin plays the dual role of Hynkel and the Jewish barber. Developing his character of the tramp in a new direction, he sympathetically portrays the plight of the little man (this time Jewish), incorporating some elements of the traditional Jewish *schlemiel*, a clumsy and gullible character, whose good nature allows him to live in the world joyously. The Jewish barber eventually emerges as a political activist and, in the end, his speech to Tomania and those in the world beyond is a lesson on courage and humanity.

For the first half of the Forties, the Jew makes few appearances on the screen. Exceptions include the presence of Jewish characters, usually privates, as members of a united fighting force. The Jew's contribution was generally to provide humor and raise morale. With the close of World War

II and full knowledge of the Holocaust, however, Hollywood producers turned their attention to the origins of prejudice, most specifically anti-Semitism. Although several projects were planned, only two reached completion—RKO's *Crossfire* (1947), produced by Dore Schary, and Twentieth Century-Fox's *Gentleman's Agreement*, produced by Darryl F. Zanuck. Both were critical and commercial successes and achieved an intended goal of raising certain questions in the mass media. Yet despite the impact of such works, both films sidestepped the deeper issues. When all is said and done, *Crossfire*, which deals with the murder of a Jew by a disturbed ex-soldier, implies that most anti-Semites are psychotic killers, and *Gentleman's Agreement*, which focuses on the efforts of a Gentile reporter to expose anti-Semitism in America by posing as a Jew and reporting his experiences firsthand, proves that differences between Jews and Gentiles involve merely a matter of labels.

If Schary and Zanuck hoped to create a new era of social protest on the Hollywood screen, their hopes were short-lived. Following several works such as *Pinky* (1949), a film about black-white relations, Hollywood turned its back on films which pleaded for human tolerance. In the wake of the House Un-American Activities Committee investigation, Hollywood producers turned to other subjects.

The HUAC hearings had a heavy impact on many talented Jews in Hollywood, and it is no secret that John Rankin, who officiated at the first investigations, was an anti-Semite. Of the original "Hollywood Ten," six were Jewish (Dmytryk, Lardner, Scott, and Trumbo were not). Later blacklisting affected a large number of Jewish actors and screenwriters, including Judy Holliday, Zero Mostel, Carl Foreman, Lillian Hellman, Joseph Losey, Abraham Polonsky, Ben Maddow, and Ben Barzman.

In the Fifties Jews once again emerged as recognizable characters in Hollywood films, although for most of the decade they appear only as important minor characters who affect the central action in some significant way. In some measure this reappearance reflects the achievement of the Motion Picture Project, a Jewish liaison group who worked to improve the image of Jews on the American screen. Toward the end of the decade, Jews resumed center stage in a few films, especially dramas which portray the Jew as a successful, integrated member of society with middle-class standing. Jews also made a major comeback as Hebrews in a deluge of Bible films. The Holocaust, however, was carefully avoided until the end of the decade.

In the latter part of the era, films dealing with specifically Jewish problems were released. In these works, many based on popular novels by Jewish authors, the emphasis was upon Jewish life or anti-Semitism. Such films as *I Accuse* (1958), *Me and the Colonel* (1958), and *The Diary of Anne Frank* (1959) deal with prejudice against Jews, while *Marjorie Morningstar* (1958), *The Last Angry Man* (1959), and *The Middle of the Night* (1959) deal with being Jewish in America. Whether Jews were played by Jewish actors did not seem of great importance. Danny Kaye and Paul Muni take the leads in *Me and the Colonel* and *The Last Angry Man*, but non-Jews like Jose Ferrer, Natalie Wood, and Gene Kelly were cast as Jews in *I Accuse* and *Marjorie Morningstar*.

The most significant aspect of the Fifties was the appearance of films set in Israel and the creation of new character types—the Israeli warrior and his female counterpart. The first film in this genre was *The Sword in the Desert* (1949). This was followed by *The Juggler* (1953), starring Kirk Douglas, a story of the Holocaust refugees who fled to Israel after World War II. But most important was Otto Preminger's epic production *Exodus* (1960), which established henceforth the image of the proud Israeli with a gun in hand. This image lent dignity to the Jewish character who had for so long been depict-

ed as a victim. In a subtle way, pride in Israel and the new Jewish image also altered the defensive posture of many American Jews and allowed for a new openness on the screen.

At the same time *Exodus* more than any other work about Israel helped romanticize the struggle and to solidify the image of a warrior state. The message was clear—only with force comes freedom. The film version also consciously played down the anti-British sentiments which had been a major factor in the novel.

With the opening of the Sixties, the stage was set for a full return of the Jewish character. The films are numerous and cover many genres—drama, comedy, biography, war films. Beginning in 1968, several films highlight Jewish issues, Jewish humor, and Jewish performers, as even minor characters take on a pronounced ethnicity. Reflecting the new sense of ethnic identity (if not strict religious observance) felt by many groups throughout America, these films form a prelude to the Seventies.

It is also in the Sixties that Hollywood addressed itself to the full impact of the Holocaust. Only after a distance of fifteen years did producers and audiences feel ready to confront the emotional and intellectual significance of such an event. *Judgment at Nuremberg* (1961) raises the question at the beginning of the decade, and although the film lacks any Jewish presence, except for the bodies in the documentary footage, the film does confront the issue. The major contribution, however, was *The Pawnbroker* (1965) which focused on the scars of the survivors. Both films were produced independently.

For the first time since the Twenties, Jewish domestic comedy reappeared. In several works such as *Come Blow Your Horn* (1963), *Enter Laughing* (1967), *I Love You, Alice B. Toklas* (1968), *Goodbye, Columbus* (1969) growing up Jewish became a central theme. Other comedies of the era include *A Majority of One* (1961), *Bye Bye Braverman* (1968), and

The Producers (1967). Most works poked fun at the Jewish family, the overbearing mother, the weak father, the confused son, and the Jewish drive for success and money. What had been sentimental in the Twenties now emerged as gross and reprehensible.

The mystique of Israel continued as a fascination in films like *Judith* (1965) and *Cast a Giant Shadow* (1966), a fictionalized biography of Colonel Mickey Marcus. In all of these works, the pro-Israeli sentiments are given which are presented without questioning.

Critic Robert Alter has commented on the tendency in the literature of the Sixties to sentimentalize the Jew. This same trend appeared in the cinema as well. *The Apartment* is one case in point. But the engaging portrayal of Fagin in the British musical production *Oliver!* (1969) confirms the issue. One has only to recall the offensive caricature in David Lean's 1951 dramatic version, *Oliver Twist*, to appreciate the shift.

The year 1968 serves as a watershed. A quick glance at the film dates mentioned above indicates the number of significant movies which appeared that year. Also, it is important to note the appearance of Barbra Streisand in *Funny Girl*, George Segal in *No Way to Treat a Lady*, and Woody Allen in *Take the Money and Run*. The success of these performers as specifically Jewish stars paved the way for others like Richard Benjamin, Elliott Gould, Dustin Hoffman, and Richard Dreyfuss, all of whom define their screen characters by the infusion of their own off-screen personalities.

During the Seventies Jews appeared as major characters in several dozen films and as minor characters in an endless list, where their Jewishness served as a quick indicator of other traits (intellectualism, drive for success, a mother complex and its accompanying affliction—sexual problems). In other cases, the Jewishness seems gratuitous, implying anyone can be a Jew.

There were several reasons for the increase in Jewish portrayals. One was the growing concern with ethnic roots experienced by all minority groups during the Seventies. Jewishness became eminently marketable. Two was a desire on the part of Hollywood producers to expose what had been suppressed in earlier films—sexuality, profane language, and ethnic identification. Three, the new producers and writers, mostly Jewish, no longer felt insecure about their place in American society. Totally assimilated, there was no question of belonging nor any need to hide their religion. Jewish organizations responded to some of these new works with defensive skepticism. Films which prompted severe criticism include: *Goodbye, Columbus* (1969), *The Heartbreak Kid* (1972), *Portnoy's Complaint* (1972), *The Long Goodbye* (1973), the Canadian production, *The Apprenticeship of Duddy Kravitz* (1974), and *Lepke* (1975). Sensitivities revolved around the depiction of Jewish criminality and negative portrayals of contemporary Jews. Images of Jewish women were especially demeaning. Some critics believed that these fictions constituted a new form of anti-Semitism based on Jewish self-hatred. The producers argued it was a healthy sign when Jews could laugh at themselves in public. The success of Woody Allen's films based on insider jokes seemed to prove their point.

In these works both Jews and non-Jews can identify with the image of "the little man'—physically weak and inept, sexually awkward and socially insecure, who must rely on his good intentions, affability, and intelligence to survive in a precarious world. As such, the *schlemiel* represents the position of modern man in contemporary society. Among Allen's more significant works were: *Play It Again, Sam* (1972), *Annie Hall* (1977), and *Manhattan* (1979). *Annie Hall* is especially strong in probing differences between Jews and non-Jews.

Several of the productions of the decade focused on an earlier world or the situation of Jews in other countries. Of interest are *The Angel Levine* (1970), about an elderly Jewish couple in New York; *Romance of a Horse Thief* (1971), set in Czarist Russia; the enormously popular *Fiddler on the Roof* (1971), which depicts the Jewish *shtetl*; *Cabaret* (1972), the portrayal of life in the waning days of the Weimar Republic; and *Hester Street* (1976), about emigrating to America.

In addition to these dramas, works continued to focus on Israel. *The Jerusalem File* (1972), *Rosebud* (1974), and *Black Sunday* (1977) all highlighted the current Middle East problem, while the Entebbe films cashed in on the spectacular daring of the news event. The Holocaust emerged in several works, most prominently *The Man in the Glass Booth* (1975), a fictionalized account of the Eichmann trial, *The Marathon Man* (1976), and *The Boys from Brazil* (1979).

With the appearance of *The Godfather, Part II* (1974), *The Big Fix* (1978), *The Frisco Kid* (1979), and *An American Werewolf in London* (1981), it was clear that in contemporary America Jews could not assume the classic roles of all Hollywood genres—gangsters, hard-boiled detectives, cowboys and movie monsters.

This trend continued into the Eighties, where the representation of Jews and Judaism was marked by a forthrightness not seen on the screen since the Twenties. Both as minor players and as protagonists, Jewish characters filled the screen in a wide range of characterizations. These characters were both more and less ethnic, thus mimicking the diversity of the American Jewish community itself. Especially important was the appearance in mainstream cinema of a recognizable Jewish milieu comparable to the American-Jewish literature of the Fifties and Sixties.

The period was dominated by the work of four serio-comic filmmakers-writers—Woody Allen, Neil Simon, Paul Mazursky and Barry Levinson—each of whom has presented his version of the Jewish immigrant experience. Other topics to emerge

Enemies, A Love Story

during this period included the Holocaust, Jewish Orthodoxy, Jewish crime, and the female Jewish experience. Often these themes overlap. As always, there were a large number of films with Jewish minor characters.

Woody Allen, Neil Simon, and Paul Mazursky have been creating Jewish characters since the Sixties. Yet for each of these men the Eighties presented a new departure—for Allen, a focus on Jewish family life (*Radio Days*, 1987 and *Crimes and Misdemeanors*, 1990); for Simon, an autobiographical sojourn (*Brighton Beach Memoirs*, 1986 and *Biloxi Blues*, 1988); and for Mazursky, the presentation of more Jewish-identified characters (*Down and Out in Beverly Hills*, 1986, and *Enemies, A Love Story*, 1989). In these works, the dominant world is Jewish with its pluses and minuses. Although religion is only a minor aspect of this world, it did surface in a way not seen in the previous decades. More importantly, both Allen's *Crimes and Misdemeanors* and Mazursky's *Enemies* raised ethical and philosophical questions

seldom explored in commercial films about Jewish life.

Barry Levinson's first film, *Diner* (1981) deals with a group of Jewish youths coming of age in the Baltimore of the Sixties. His later work, *Avalon* (1990), chronicles the life of one Jewish family over several decades showing the shifts in life-style and values as each generation succeeds the next.

Another view of the immigrant experience was offered by two animated films: Ralph Bakshi's *American Pop* (1981), which covers the long road from Russia to L.A., and Don Bluth's *An American Tail* (1986), where the suffering of its mouse hero, Fievel Mousekewitz, doesn't end with his arrival on American shores.

While the Holocaust and anti-Semitism are touched upon in many of these works, it is only central in *Sophie's Choice* (1982) and *Enemies, A Love Story* (1989). The first work, based on a novel by the non-Jewish writer William Styron, offers a stark visualization of the bleakness of the concentration camps, but is more concerned with its

Polish heroine Sophie than with the plight of the Jews. The second work, *Enemies*, based on a story by Isaac B. Singer, focuses on four characters, each of whom has been marked by the Holocaust. *Enemies* also provides one of the few depictions of observant Jews to appear on the American screen. Other films offering insights into the world of traditional Judaism were *The Chosen* (1981), which focused on the Hasidim of New York City and *Yentl* (1983), which is set among the Orthodox community of a Polish yeshiva. Two points of interest: first, almost all of the Eighties films mentioned so far depicted a world exclusively Jewish; second, almost all were set in previous decades.

No discussion of Jews and film or Jewish comedy is complete without mention of Mel Brooks. Although few of his works offer recognizable Jewish characters or Jewish plots, nevertheless Brooks's films evolve out of a Jewish comic tradition of social critique. Beginning with Brooks's *Blazing Saddles* (1974), Brooks has used satire not only to parody Hollywood genres, but also to expose hypocrisy and oppression. Included in this category are *History of the World, Part I* (1981), *To Be or Not To Be* (1983), and *Life Stinks* (1991). Other works such as *Young Frankenstein* (1974), *High Anxiety* (1977), and *Spaceballs* (1987) are laced with Jewish references and in-jokes.

A continuing trend from earlier films is the exploration of Jewish crime. Foremost in this category was Sergio Leone's *Once Upon a Time in America* (1984), a saga of Jewish gangsters born and bred on the Lower East Side. Further uptown in Harlem, Francis F. Coppola's *The Cotton Club* (1985) depicts the activities of Dutch Schultz (born Arthur Flegenheimer). Most apparent is the independent feature *The Plot Against Harry* (1969, released 1989), which wryly depicts the exploits of a small-time Brooklyn racketeer. Jewish gangsters also turn up in *Miller's Crossing* (1990) and *Mobsters* (1991).

But the major contribution of the Eighties was the representation of Jewish women. In comparison with the previous decade where Jewish females were stereotyped and demeaned, the Eighties offered characters of depth and sensitivity, admirable models of Jewish womanhood. Respon-sibility for such changes emanated from the input of women writers, directors, and producers.

The decade began with *Private Benjamin* (1980), starring and produced by Goldie Hawn, which tells the story of an attractive Jewish Princess who gains wisdom and autonomy by film's end. In contrast *Tell Me a Riddle* (1980), based on a novella by Tillie Olson, focuses on an aging Jewish couple, particularly Eva, and the shifts that occur when she discovers she is dying of cancer. Of interest is the relationship between Eva and her granddaughter.

Relationships across generations form the basis of several other films, including *Sweet Lorraine* (1987), an independent feature set in the waning days of the Catskill resorts and *Crossing Delancey* (1987), a modern-day romance directed by Joan Micklin Silver, set partly on the Lower East Side. Female friendship is central to *Beaches* (1988), starring Bette Midler, although here it crosses religious as well as class lines.

Jewish heroines star in such works as *Dirty Dancing* (1987), another film set in the Catskills, and *Driving Miss Daisy* (1989), starring Jessica Tandy as an indomitable Southern Jewish matron. And, of course, there is Barbra Streisand's *Yentl*, a story of a young woman who disguises herself as a man in order to enter the yeshiva. What distinguishes all of these works from their predecessors is the moral fiber of the women and their drive and determination. It is also interesting that many of these works feature older women whose life and vitality easily match their younger sisters.

A major shift during the Eighties was the presentation of the Arab-Israeli conflict. Whereas previously Hollywood films

had strongly supported the Israeli position, both *Hanna K.* (1983) and *The Little Drummer Girl* (1984) are sympathetic to the Palestianians. Both works also feature women in the central role.

Finally, there is the whole array of minor characters. First there are the Jewish professionals: the psychiatrist in *Ordinary People* (1980) and the Jewish attorneys in *Presumed Innocent* (1990) and *Reversal of Fortune* (1990). Next there are a variety of types such as the film producer in *Ragtime* (1981), the journalist in *The Big Chill* (1983), the wealthy deb in *St. Elmo's Fire* (1985), the fat kid in *Goonies* (1985), the aging couple in *Cocoon* (1985), the club owners in Spike Lee's *Mo' Better Blues* (1990)—a film which provoked outcries of anti-Semitism from some members of the Jewish community—the Major in *Bonfire of the Vanities* (1990), and the mobster's wife in *GoodFellas* (1990).

There are also the perennially popular Jewish mothers. Such roles were taken by Lainie Kazan in *My Favorite Year* (1982), Anne Bancroft in *Torch Song Trilogy* (1988), and Bette Midler in *Down and Out in Beverly Hills* (1986). While main characters have become more overtly Jewish identified, though ethnically less specific, minor characters continue to generate stereotypical attitudes and mannerisms. Typical of this tendency is one of the first films of the Nineties, *White Palace* (1990), in which the Jewish attorney played by James Spader would be hard to distinguish from a WASP in any crowd, while his friends and family seem to come directly from a Borscht Belt.

Two films are hard to categorize. *Talk Radio* (1988), based on the self-destructive life of Kansas City DJ Alan Berg, unleashes the diehard anti-Semitism of middle America and, as such, is a difficult film to watch. Likewise, *Torch Song Trilogy* chronicles the difficulties of being Jewish and gay in New York City and likewise challenges audiences.

All told, the Eighties presented a much fuller view of American Jewish life. Whether it's the Catskill Mountains of an earlier era, the world of crime or typical family life in the Bronx, these worlds seem more authentic, more genuinely Jewish, and less concerned with how the rest of America will view them.

In summary, Jews, both on screen and off, span the entire history of Hollywood cinema. As producers, screenwriters, directors, composers, and actors they have been a dominant force in the industry and continuously provide for its creative sustenance. Perhaps it is fitting that the top awards at the 1991 Cannes Film Festival went to the Coen brothers' *Barton Fink,* a film which memoralizes the Jews who peopled the great Hollywood studios.

On the screen Jewish characters and their narratives reflect the history of Jews in America as they moved from an immigrant people to an assimilated, though still distinct, minority—full participants in the general culture. While stereotypes appear in an overwhelming number of works, recent films have allowed for a wider range of roles, more in keeping with the true diversity of contemporary Jewish life. In short, despite distortions, the representation of Jews in Hollywood cinema is a telling story of the American-Jewish experience.—Patricia Erens

RECOMMENDED BIBLIOGRAPHY

Doneson, Judith E. *The Holocaust in American Film*. Philadelphia, PA: Jewish Publication Society, 1987.

Erens, Patricia. *The Jew in American Cinema*. Bloomington, IN: Indiana University Press, 1984.

Friedman, Lester. *The Jewish Image in American Film*. Secaucus, NJ: Citadel Press, 1991.

———— *Unspeakable Images: Ethnicity and the American Cinema*. Urbana, IL: University of Illinois Press, 1991.

Gabler, Neal. *An Empire of Their Own: How the Jews Invented Hollywood*. NY: Anchor Books, 1988.

Insdorf, Annette. *Indelible Shadows: Film and the Holocaust*. NY: Cambridge University Press, 1990.

Rumble Fish

Juvenile Delinquents

For many Americans during the Depression, outlaws such as Pretty Boy Floyd and Bonnie and Clyde were heroes. The frustrated and the dispossessed vicariously identified with the criminal's triumphant defiance of the law and rigid social stratification. Responding to the prevailing audience mood, Hollywood deified the gangster as an heroic individualist, a modern-day Horatio Alger who could rise to the top only by moving outside the law.

The gangster films were successful at the box office, but their antisocial implications proved highly offensive to those who had remained unscathed by the economic collapse. The Hays Office effectively censored the gangster cycle, and the juvenile delinquent replaced him as Hollywood's favorite outlaw hero.

Rather than glorify delinquency and thus incur the wrath of the Hays Office, the studios portrayed the juvenile delin-quent as the impressionable victim of Depression society's mistakes. Delinquency was the product of a bad environment, specifically the slum and/or the reform school. In later years, when the Depression was but a dim memory, Hollywood would suggest other causes for delinquency: psychological disorders, unhappy home environment, the numbing conformity of modern suburban life. Through it all, filmmakers would remember the

lessons of the censorship of the gangster film. No matter how violent and alienated he became, the delinquent could always be reformed by an understanding adult, or, if necessary, physically vanquished by the law. The delinquent was rarely—as the gangster was—a threat to society.

The two key juvenile delinquent films of the Thirties are *Mayor of Hell* (1933) and *Dead End* (1937). The former film concentrates on the reform school, while the latter examines the slum life which often leads children to delinquency. Following the lead of such early Thirties prison films as *The Big House, I Am a Fugitive from a Chain Gang,* and *Twenty Thousand Years in Sing Sing, Mayor of Hell* catalogs the brutalities of life in the reformatory—the beatings, solitary confinement, improper medical treatment, and inedible food. Typically, the blame is pinpointed to a single corrupt warden (Dudley Digges) and the problem is resolved through a tough-guy hero, Patsy Gargan (Jimmy Cagney), a gangster whose abilities to raise votes for the party machine are rewarded with an appointment as deputy commissioner. Cagney's duties take him to the reform school where he witnesses the brutal beating of a rebellious inmate. Suddenly and fully dedicated to the cause of reform, Cagney has himself appointed warden, sends the corrupt warden on holiday, and sets about to prove the Hollywood maxim that there's no such thing as a bad boy. He quickly ends the drill-camp regimentation, and allows the boys to govern themselves. Even the most alienated of the young toughs, the rebellious volatile Jimmy (Frankie Darro), is won over by the charismatic Gargan, proving that reform schools don't necessarily have to be "crime schools.'

Probably the most despairing of the Thirties juvenile delinquency films is Samuel Goldwyn's production of *Dead End.* In contrast to squeaky-clean films like MGM's *The Devil Is a Sissy* (1936) and *Boy's Town* (1938), *Dead End*'s delinquents are not cute little mischief-makers molli-

fied by a reformer but defiant, antisocial hoodlums. Like the gangsters before them, they are at war with society, fully aware that the straight and narrow path leads only to the well-meaning poverty of the film's protagonists, Dave (Joel McCrea) and Drina (Sylvia Sidney). The case for criminality is eloquently stated by the Dead Enders' idol, gangster Babyface Martin (Humphrey Bogart), who incessantly ridicules his old friend Dave: "Six years o' workin' at college and all you get out of it is handouts. That's a good one. I'm glad I ain't like you saps. Starvin' and freezin'. For what? Peanuts. I got mine. I took it. The fat o' the land I'm livin' off of."

Though *Dead End* proved popular with Depression audiences, few producers besides Samuel Goldwyn would tolerate the film's radical leanings. Various spinoff films saw the Dead End Kids transformed from hardened toughs into easily reformed social victims. The best of the *Dead End* sequels, Warner Bros.' *Angels With Dirty Faces* (1938), does not hesitate to depict the squalid living conditions which produce young criminals, but manages to restore the childrens' faith in society at the last moment. The film opens with a craning camera exploring the crowded streets and dilapidated tenements of the slums. Initially the Dead Enders are tempestuous roughnecks who blow the bounty of their petty crimes in pool halls, cynically commenting, "My mother has to work a week to earn this much." As in *Dead End,* the juvenile delinquents are presented with two contrasting role models, the ineffectual priest Father Connelly (Pat O'Brien) and the local-boy-made-good, big-time gangster Rocky Sullivan (Jimmy Cagney). Naturally the boys turn to the gangster for leadership. On the verge of *Dead End*'s conclusion that antisocial violence is the most viable reaction to the slum environment, the film shifts emphasis. Father Connelly decides that the problem is not poverty, but the bad example that Rocky and other gangsters set for the boys. Connelly temporari-

ly abandons his attempts to get the kids into the choir stall for an all-out effort to get Rocky into jail. Finally Rocky is captured, but even as he faces the electric chair, he remains a hero to the boys, who boast, "He'll die spittin' in their eye." The priest asks Rocky to die "yellow," to pretend that he's afraid as he walks the "last mile." Rocky refuses, but as he gets to the chair, he begins to scream and whimper for mercy, effectively destroying the boys' respect for him. The film ends with the presumably reformed Dead Enders following the priest to church to say a prayer for Rocky, a boy who went wrong.

Later films featuring the Dead End Kids softened their image until the young hoodlums of the Goldwyn film had become little more than rambunctious clowns. *Crime School*, a 1938 remake of *Mayor of Hell*, considerably mellowed its portrayal of the reform school hardships and of the delinquents. Where the earlier films merely hoped for a more promising future for the delinquents, *Crime School* shows that future realized. At the end of the film, a judge paroles the Dead Enders and finds trades for them. The final shot shows the boys comically perusing a book entitled *How to Break Into Society*. Soon, the Dead End Kids were renamed the Little Tough Guys, starring in a series of low-budget films that turned juvenile delinquency into slapstick comedy. Eventually they became the Bowery Boys and any pretext of social commentary was abandoned.

During the war years, juvenile delinquency, along with most other social problems, was not considered suitably patriotic fare. Films like those starring the Bowery Boys kept audiences amused during these years—presumably most of the so-called juvenile delinquents were now soldiers or soldiers-in-training, leaving no time for street brawls and other mischief. Finally in 1949, Hollywood once again turned to the problem of juvenile delinquency, with *City Across the River* and *Knock on Any Door*. The former film subscribes to earlier premises that juvenile delinquency is caused by poverty and is distinguished mainly by its documentary look. *Knock on Any Door* is the more interesting of the two films, hinting for the first time that poverty is not the sole cause of delinquency. Nick Romano (John Derek) is a brooding misfit who finds reconciliation with society impossible. Unlike previous delinquents, Nick is a murderer who lies to his lawyer about his innocence—he will never be reformed by well-meaning do-gooders.

By the time of *Knock on Any Door*, the Depression was long over and America was once again prosperous. Although slums continued to exist and helped produce juvenile delinquents, environmentalism fell out of favor as an explanation for delinquency. Even an old-fashioned social problem film like *The Blackboard Jungle* (1955) offered significant variations on the Thirties formula. Set in the heart of an inner-city slum, *Jungle* is basically an updated version of the "crime school" films, exposing the gradual degeneration of the inner-city school system and the "prison guard" mentality of the mostly cynical, indifferent teachers. The film gives no real insight into what causes these problems, but offers a familiar cure in the figure of a Patsy Gargan-like teacher, Mr. Dadier (Glenn Ford)—"Daddy-O" to his charges —who is able to reach many of his alienated students through patience, understanding, and love. But unlike previous redeemer figures, Dadier is not able to reach everyone. He is continually thwarted in his efforts by a vicious, homicidal punk (Vic Morrow) who terrorizes both the students and staff. There appears to be no rational explanation for the punk's behavior and finally the only way for Dadier to defeat him is through violence.

In a film like *The Wild One* (1954), the emphasis is again on rebellion and violence rather than the causes of delinquency. When a motorcyle gang called the Black Rebels rolls into the all-American small town of Wrightsville and terrorizes the inhabitants, they do so not because they come from slums or went to reform

school but simply because Wrightsville is there. The leader of the Rebels, played by Marlon Brando, is completely contemptuous of the law and of the townsfolk's way of life. When the local cop's daughter (Mary Murphy) tries to defend her town and life as a waitress, Brando snaps his fingers and utters a disdainful "Zowie." There is a brief allusion to a traumatic childhood—as he is beaten up by some local vigilantes, Brando taunts his assailants, "My old man hit harder than that"—but Brando's anger is aimed at anything that crosses his path. There is no tangible goal in his rebellion—he is not fighting for a better place to live or a job. He is simply exercising his belief that "the whole idea is to go out and have a ball."

If *The Wild One* and *Blackboard Jungle* are reluctant to suggest a motive for the rebellions they describe, *Rebel Without a Cause* makes it clear that the explanation is psychological rather than sociological. Jim Stark (James Dean) comes from a comfortable, suburban home, but like *Knock on Any Door*'s Nick Romano, he just can't seem to fit into society. Jim's rebellion is different from the rebellion of the kids in *Blackboard Jungle*, different from that of Marlon Brando's motorcycle gang in *The Wild One*. He actually resists the urge to rebel—he wants to fit in, tries to communicate with his parents, and he shies away from violence. When he is challenged by a peer to a "chicken run" (in which opponents speed their cars toward a cliff, the winner getting closest to the edge before jumping out), he goes to his father for guidance, only to be told that he will "probably laugh about this twenty years from now." His revolt results in two deaths, including that of his newfound friend, the innocent Plato (Sal Mineo), an unnecessary tragedy that serves to further alienate Jim. But Jim also reveals just how much he really wants to "belong" in society, to be "normal'—in one sequence, he pretends an old, abandoned mansion is the middle-class suburban home of himself and his girlfriend, Judy (Natalie Wood).

Ultimately, a compromise is reached. By the film's final scene, the boy's father seems to have learned to be a little stronger for his son, and Jim Stark, inspired by his father's concern and his new friendship with Judy, is reconciled, at least temporarily, to his parents and society.

All three of these films emphasize Fifties youth in rebellion for rebellion's sake. Dean and Brando as rebel heroes personify a psychological ennui on the part of young people, whose delinquency seems less a consequence of poverty or poor living conditions than the ever-growing rift between themselves and their parents. When Dean cries out to his weak father, "You're not listening to me," he is sounding a cry that would echo throughout Fifties cinema, the plea for love and support from the misunderstood teenager, tormented that he "can't do anything right."

The success of *Rebel Without a Cause* and *The Wild One* inspired a host of second-rate imitations. Not surprisingly, audience interest in youth rebellion films began to wane, and Hollywood turned to less serious youth films. Just as the Dead End Kids were refined into harmless pranksters by Hollywood in the Forties, so the rebellious youth of the mid-Fifties soon became fun-loving young people romping on the beach or dancing to that "crazy beat." Hollywood began producing pure entertainment films for youth audiences such as *Beach Party* (1963), *Ski Party* (1965), and *Ride the Wild Surf* (1964), starring such teen idols as Frankie Avalon, Annette Funicello, Tab Hunter, and Fabian. The rock craze led to films like *Rock Around the Clock* (1956), *Rock, Rock, Rock* (1956), a string of Elvis Presley films, and *Bye Bye Birdie* (1963), which reduced rock-and-roll rebellion to a parent's lament, "Kids! I don't know what's the matter with kids today!"

In contrast to the rebel-hero films of the early Fifties, Holywood seemed now to be putting the youngsters' image com-

pletely right again. In these films the kids may be more independent than their parents would like, but just as the inherent goodness of Jim Stark triumphs in *Rebel Without a Cause*, the kids of these fun films are not really bad—they're just noisy.

With the exception of *West Side Story* (1961), a musical update of *Romeo and Juliet* that was set against a backdrop of New York's Puerto Rican slums and teen gang warfare, juvenile delinquency again disappeared from the screen. It was not until the late Sixties that teenagers again began questioning society and their parents' values. With the rise of the Vietnam protest movement and the psychedelic era, youth audiences began to "turn on and drop out." Hollywood tried to keep pace by producing a series of films about college revolutionaries (*The Strawberry Statement, R.P.M., Zabriskie Point, Getting Straight, The Revolutionary*), teenage druggies (*The People Next Door, Psych Out*, Milos Forman's *Taking Off*), and even briefly revived the motorcycle gang film with *Hell's Angels on Wheels, Violent Angels,* and *The Wild Angels*.

Unlike the Dead End Kids or Jim Stark, the youth of these rebellion films have no desire to be reconciled to society. In Arthur Penn's *Alice's Restaurant* (1969), the children, unable to fit into a society that condones racism and would send them off to die in Vietnam, try to form their own alternative society, based on communal living, youthful idealism, and freedom from the sexual restrictions of their parents. Unlike more simplistic films of that period, *Alice's Restaurant* recognizes that such an ideal is impossible, that the children are prey to the same human failings as their parents and that inevitably these weaknesses will be reflected in the society they form. But the failure of the commune in no way justifies the hypocrisy of American society. The film's central incident, based on Arlo Guthrie's famous song, recounts the singer's ironic encounter with his draft board, where he is deemed unfit to fight and kill in Vietnam because he was once convicted of being a litterbug.

The futuristic *A Clockwork Orange* (1971) presents the juvenile delinquent as the last rebel against conformity. Made in England by an American expatriate, Stanley Kubrick, the film offers the audience an unpalatable choice between the violent, antisocial behavior of juvenile delinquents and a rigidly conformist society that would erase all traces of individuality. As played by Malcolm McDowell, the film's hero is probably the nastiest juvenile delinquent in screen history, until he is arrested and brainwashed into a "clockwork orange"—a model citizen-robot who never questions the state.

The juvenile delinquent faded from Hollywood screens until the late Seventies, when another teen gang film, *The Warriors* (1979), became a major box office success. Walter Hill's film created a large controversy when three murders occurred in movie theatres where it was being shown. The film was immediately accused of excessive violence, despite the fact that it was far less graphic and disturbing than Kubrick's *A Clockwork Orange*. 1979 was to be Hollywood's year of the juvenile delinquent. Besides *The Warriors*, the studios produced *The Wanderers*, an adaptation of Richard Price's novel about the South Bronx gangs of the Fifties, *Walking Proud*, a West Side Story without the music, set in the barrios of Los Angeles, and *Boulevard Nights*, which focused on two Chicano brothers, one struggling to escape the barrio and the other caught up in the life of the street gang. But the controversy over *The Warriors* and the potential of more violence in the movie houses limited the distribution of these films, among the few films since the Thirties to hark back to the environmentalist premise that the slums produce criminals.

The most interesting film of the 1979 delinquent films, Jonathan Kaplan's *Over the Edge*, was not released until a few years later. Set in a middle-class neighborhood, its rebellious teenagers are the products of

the spiritual and emotional deprivation of America's suburban wasteland. Compared to the ugly sameness of suburbia, the slum's teeming street life seems a palatable alternative. Bored by TV, school, and faced with the prospect of following in their parents' footsteps, the kids turn to drugs and petty crime for excitement and escape. When a local teenager (Matt Dillon) is killed by the police, the parents decide that their youngsters are getting out of hand and call a meeting at the local high school to discuss how to deal with the problem of delinquency. In a frightening dramatization of the potential of teenage violence, the kids lock their parents in the high school and start to destroy all the cars in the parking lot. Eventually the frightened parents escape, but by the end of the film, the kids have wreaked a fatal revenge on the local sheriff whom they blame for the death of their friend. The film is continually sympathetic to the kids, whose violence is a justified expression of individualism in a conformist society.

Compared to the despairing vision of *Over the Edge*, Francis Ford Coppola's *The Outsiders* (1983) seems almost safe and old-fashioned by comparison. Based on S. E. Hinton's popular teen novel, the film recycles many of the old Hollywood clichés about delinquency. In Coppola's overblown saga of Sixties teenagers growing up in the Southwest, juvenile delinquency is once again the product of a bad environment. The teenagers are divided into the "socs" (the rich kids) and the "greasers" (the poor kids, from minority groups, from broken homes), continually at war with each other. The greasers, trapped by their social and economic position, are basically good kids who turn to crime out of frustration. In the film's most important sequence, young greaser Johnny commits murder out of self-defense when he is set upon in a park by a group of drunken, nasty "socs." Besieged by guilt, he later redeems himself when he rushes into a burning church to save the lives of some trapped youngsters. Almost half a century after *Boys Town* and *Mayor of Hell*, Hollywood still believes that there's no such thing as a bad boy.

This belief is not shared by the makers of *Class of '84* and *Bad Boys*. *Class of '84* (1983) is a tawdry, violent rehash of *The Blackboard Jungle* in which the kids listen to punk music instead of good old rock and roll and have become correspondingly more violent. As in *Blackboard Jungle*, an idealistic newcomer (Perry King) is shocked by the cynicism of his fellow teachers, who dismiss the kids as "animals." Like Glenn Ford before him, King reaches out to the students and soon wins their trust, except for a small band of psychotic criminals who terrorize the students and staff. When they kidnap his wife, King finally recognizes that there are some kids who can't be reached. The film switches from liberal fantasy (*Blackboard Jungle*) to right-wing vengeance fantasy (*Death Wish, Joe*) as King seeks revenge against his wife's abductors. He brutally murders the juvenile delinquents in a sequence that answers the students' revenge in *Over the Edge*. As King saws the arm off one hoodlum, then torches another, and finally pushes the gang leader off a roof, he is gaining a brutal revenge for all the parents and all the teachers who tried and failed to reach their troubled charges.

Bad Boys (1983) depicts the modern crime school with graphic realism. When Mic O'Brian (Sean Penn) accidentally kills the brother of a local drug dealer, Paco, he is sent to the local correctional institute, where inmates literally spit on newcomers, where sexual assault is common, and murder not uncommon. Mic's plans to do "clean time" are interrupted when the drug dealer is sent to the reformatory. In a final sequence that recalls the terror of *Over the Edge*, the vengeful Paco outsmarts the cell-block guard, and disconnects the wires that sound the emergency alarms. With the death fight between Paco and Mic in progress, the rest of the

inmates haul benches and chairs against the gates, locking the guards out. The delinquents have effectively taken over the cell block. Finally, Hollywood steps in to provide a "happy ending." Mic gains the upper hand in the fight, but reason conquers rebellion, and he chooses not to commit the murder that would send him to the state pen. Still, the crime school has inflicted so much damage on so many kids, that this boy's inherent goodness seems relatively insignificant.

Such realistic portrayals of delinquent life did not prove popular with audiences in 1983. Of that cycle, only *The Outsiders* achieved any box office success. Coppola's second adaptation of an S. E. Hinton novel, the moody and unpretentious *Rumble Fish* (1983) proved to be a major box office disaster. Coppola was clearly trying to make Matt Dillon, who also appeared in *The Outsiders* and *Over the Edge*, into a James Dean for the Eighties, but audiences just weren't interested in Dillon's brooding, troubled persona. Instead they flocked to see films like *Porky's* (1981), in which the main teenage problem was losing one's virginity.

The failure of *Rumble Fish* did not kill off one of Hollywood's most enduring genres. Since then, Hollywood has produced a new batch of delinquency films. Three of these, *Stand and Deliver* (1988), *Lean on Me* (1989), and *The Principal* (1987), were highly derivative depictions of life in tough inner-city schools. In *Stand and Deliver*, dedicated teacher Edward James Olmos successfully fights bureaucratic indifference, the lure of the streets, and the cynicism of his students to upgrade the status of his ghetto school. *Lean on Me* recounts the struggle of bat-wielding, tough-guy principal Joe Clark (Morgan Freeman) to rid his school of drugs and crime. Clark too faces opposition from bureaucrats as well as from parents who dislike his bullying and occasionally illegal tactics (he locks school fire exits to keep criminals out), but ultimately turns his school into a safe and learning environment. In *The*

Principal, Jim Belushi finds that dedication and hard work aren't enough to turn his students into model citizens. Like Glenn Ford in *The Blackboard Jungle*, he finally wins their sympathy when he beats up a vicious drug dealer in a climactic confrontation. In the best tradition of the delinquency film, these films reassured audiences that even the poorest and the toughest kids can be reached, that juvenile delinquency is still a problem that can be overcome.

In Michael Lehmann's hilarious spoof of teen angst films, *Heathers* (1989), the juvenile delinquent is once again not really bad. Misguided by the attentions of a teen psychopath appropriately named J. D. (Christian Slater), girlfriend Veronica (Winona Ryder) commits several murders at her exclusive high school before finally coming to her senses and turning her murderous intentions toward J. D. His elimination, the film suggests, will return the community, and no doubt society, to its rightful, peaceful social order.

Most other recent films suggest that the problem will not disappear so readily. *River's Edge* (1986), directed by Tim Hunter, who cowrote *Over the Edge*, focuses on the problems of middle-class suburban children. Perpetually stoned, completely alienated from their parents and society, its protagonists barely blink an eye when one of their friends murders a girl from their clique and leaves her body on the riverbank. Although the murderer freely confesses his crime, even inviting his friends to see the nude body of the girl, nobody reports the crime to the police for a few days. A couple of the kids show some signs of humanity by the end of the picture, but *River's Edge* offers no reassurance that these members of the Blank Generation will ever turn into good citizens.

Pump Up the Volume (1990), again set in the suburban wastelands of America, focuses on a bright but alienated student named Mark Hunter (Christian Slater) who anonymously operates a pirate radio

show out of his "Paradise Hills," Arizona, bedroom. By day, Mark is shy and withdrawn, but at night he becomes a dynamic radio personality, the Southwest's Lenny Bruce, a completely uninhibited and funny spokesman for the area's angry, despairing, and needy teenage population. He labels his community "whitebread land," a place where "everything is sold out," openly addresses sexual issues from masturbation (which he simulates on air) to homosexuality, and encourages acts of civil disobedience. When one of his listeners, considered a model student, defiantly sets a microwave-triggered explosion in her domineering father's kitchen and another listener phones in what amounts to a suicide note, Mark becomes a target for the authorities. As local educators (including Mark's sell-out father), the police, and the FCC all try to track down the mystery disc jockey and get him off the air, the film degenerates into a typical teen rebellion film with a pat ending. Still, *Pump Up the Volume* never completely loses its angry tone. In contrast to *River's Edge*, here the Blank Generation are the dense, conformist adults. The question is not whether these kids will fulfill society's mandates and become "productive" adults, but rather whether they should want to.

John Singleton's *Boyz N the Hood* (1991) and Dennis Hopper's *Colors* (1988) are both set in the inner-city slums of L.A., where angst and conformity are the least of the problems. Singleton's feature is something of a throwback to the environmentalism of the Thirties. Although this neighborhood is predominantly African-American and in the earlier movies everyone was lily white, these modern teenagers still face lives of little hope. The central problem is how to escape the awful cycle of poverty and violence. Jobs remain scarce and higher education is a pipe dream for all but the lucky few. Like their screen predecessors, Singleton's "boyz" are angry and alienated. Living in a society that has turned its back on them, that is fascinated by problems in the "hood,"

these kids turn their back on society. And who can blame them? As Joel McCrea's character, Dave, commented in *Dead End* when the kids were labelled "enemies of society'—what have they got to be so friendly about?

Like *River's Edge* and *Pump Up the Volume*, *Boyz N the Hood* offers no easy solutions to complex social problems. As in the Thirties films, there is a father figure, Furious Styles (Larry Fishburne), who offers all sorts of possible solutions to the problems, but he is a role model rather than a savior. Throughout the film, Furious lectures his son and the neighborhood kids on everything from African-American self-sufficiency to safe sex to the need for getting an education. The problem is that he can't force them to follow his advice. Try as he may, Furious is unable to keep most of the kids from getting enmeshed in the horrible violence that plagues South Central L.A.

Singleton is a sunny optimist compared to Dennis Hopper. A documentary-style exposé of gang violence in east Los Angeles, *Colors* sets its audience up for a traditional Hollywood happy ending. At first, Hopper trots out all the familiar Hollywood explanations for juvenile violence—the slum environment, the lure of drugs and the criminal lifestyle, etc. He also offers a traditional redeemer figure in the person of Robert Duvall's wise, conciliatory cop who tries to talk members of an Hispanic gang out of their dead-end street life. It even appears that Duvall is making some progress when the leader of the gang warns Duvall of an impending attempt on the life of his partner (Sean Penn). Instead of coming to their senses and proving that they're really good boys, after all, the Hispanic gang provokes a brutal and senseless shootout with a rival black gang that results in their own and Duvall's deaths.

By reversing our expectations, expectations bolstered by more than fifty years of delinquency films, movies like *Colors* force us to acknowledge just how serious the

gang problem has become. The individual redeemer is no longer effectual. The tide of violence will not be stopped until some basic social changes have been made. These films do not in any way glorify delinquency, but the Hays Office, if it still existed, would most decidedly have objected. For the first time in the history of the genre, the delinquent has been portrayed as a genuine threat to society.

—Peter Roffman and Beverly Simpson

Kazan, Elia
(Elia Kazanjoglou)
(September 7, 1909 –)

Probably no American director has ever been more sought, honored, or esteemed than was Elia Kazan between 1947 and 1959. The plays he directed on Broadway and the movies he directed in Hollywood garnered him three Tonys, two Oscars (plus two other nominations), a vast range of offers, and increased control over the projects he chose.

An incredibly active, restless individual, during those years he also founded the Actors Studio, which, under Lee Strasberg, trained dozens of artists for stage, screen, and television. Increasingly, though, he became disenchanted with both stage and screen and turned almost exclusively to writing novels.

Kazan's adult, professional life has been a search for self-control and control of the material on which he works. As he succeeded in both realms, the artistic quality of his work declined. Once hailed for the quality of "social realism" that seemed to stem naturally from his personal and professional background, he came to be criticized for the ersatz nature of the "psychological realism" and self-involvement that preoccupied him after he made *Wild River* (1960).

Kazan enjoyed great commercial success on Broadway for nearly two decades, but he did not change the nature of theater or of theater directing. His success was built on a keen sensitivity for scripts that tapped contemporary concerns, close analysis of a play's structural components, a deep knowledge of what made actors tick, and a powerful drive to succeed. He directed the work of the most successful playwrights of his era—Thornton Wilder, Tennessee Williams, Arthur Miller, William Inge. His stage success opened the doors of the Hollywood studios to him as well, but here the results were spottier. In any case, by the mid-Fifties, his best work in both venues was behind him.

Kazan is Greek. He was born in Turkey, in 1909, and came to the United States in 1913. He graduated from Williams College in 1930 and attended the Yale School of Drama until 1932. For the next ten years, he was intimately involved with the Group Theatre, mainly as an actor. He sought, however, a variety of other channels for his political and esthetic impulses. He cowrote a play (*Dimitroff*), joined the Communist Party in 1934 (for eighteen months), codirected two plays for the communist-supported Workers

Laboratory Theatre, appeared in two movies produced by the left-oriented Nykino Films, and codirected a documentary, *People of the Cumberland*, for Frontier Films.

By 1941, with the Group Theatre dead, and Kazan's acting career stifled by typecasting as a mob figure, he decided to focus his sights on stage directing. His third play (of three in 1942) made his reputation. *The Skin of Our Teeth* played for over a year and won Kazan The New York Drama Critics Award. Following three more successes, Kazan, who had always been more interested in film than stage, signed a five-picture contract with Twentieth Century-Fox.

The first five movies he directed were not remarkable achievements. Two of them, *Gentleman's Agreement* (1947) and *Pinky* (1949), were solid box office successes that tepidly and conventionally dealt with two social "problems'—anti-Semitism and racism. Both, however, were studio projects, almost entirely dependent on Darryl Zanuck's decisions. Broadway remained Kazan's enchanted realm. *A Streetcar Named Desire* (1947) and *Death of a Salesman* (1949) were critical and commercial smashes.

Panic in the Streets (1950) altered the direction of Kazan's movie career, providing him with the opportunity to work closely with the scriptwriter (Richard Murphy), tailor his directing to the location, and more freely employ the camera as a means of enhancing dramatic tension. It also contained the seeds of Kazan's altered political sensibilities. *Panic* reveals, in the story of a frantic search for a plague carrier, the ideas of a cynical, disillusioned left-winger. The people are no longer seen as admirable and capable of self-consciousness; instead they are depicted as ignorant and manipulable. They can be saved from their enemies and themselves only through the efforts of a dedicated, devoted crusader, single-handedly battling the emotional and social forces stacked against him.

But the movie that represented Kazan's most profound effort to cut himself off from his political past and tie himself to present political reality was *Viva Zapata!* (1952). Although John Steinbeck wrote the script, Kazan worked closely with him. They tried, Kazan later said, "to express our feelings of being Left and progressive, but at the same time anti-Stalinist." The finished product was an esthetic and commercial failure. From the casting of Marlon Brando as Emiliano Zapata to the fade-out—where a white horse walking up a mountain path is meant to serve as the symbol of people's hopes for a savior—Kazan revealed a complete lack of understanding of the dramatic possibilities of Mexican history and people's revolution.

It is entirely possible that Kazan made *Zapata* with one eye on the merits of the story and the other on the House Committee on Un-American Activities. During preproduction, the committee had reopened its crusade against communism in Hollywood, and Kazan was vulnerable. His associations with left-wing groups and causes in the Thirties and his support of the Hollywood Ten in the Forties made him an obvious candidate for a subpoena. In early 1952, he appeared twice before the committee, testifying both times in executive session. Only the second transcript, that of April 10th, was made public.

Two oddities attended the second appearance: he testified in the presence of only one member of the committee, and he took out a large ad in *The New York Times* to explain why he named seventeen people as communists and defended all of his plays and movies, one by one, as examples of the human, American, democratic spirit. In fact, his most recent movie, *Viva Zapata!*, he told the Committee, was "an anti-communist picture." He said, in the advertisement, "I believe that communist activities confront the people of this country with an unprecedented and exceptionally tough problem...I believe that the American people can solve this problem wisely only if they have the facts about

Communism. All the facts. Now, I believe that any American who is in possession of such facts has the obligation to make them known, either to the public or to the appropriate Government agency."

As with most aspects of Kazan's life, his testimony and advertisement were compounded of conflicting motives: his passionate dislike of communists ("I really hate them a lot," he told an interviewer twenty years later), his cynical liberalism, and his desire to save his professional career. He succeeded in the latter endeavor, but at the expense of violent attacks against his integrity by many who had once been close to him, including Arthur Miller. Kazan remained deeply troubled by this event, and much of his later work bears the psychological imprint of the anguish of the good but misunderstood individual. Unfortunately for his reputation as a movie director, however, Kazan's passion to explain the informant and the misjudged was dramatically spent in *On the Waterfront* (1954) and *East of Eden* (1954), respectively. *On the Waterfront* is a very powerful depiction of the nature of betrayal. Kazan and scriptwriter Budd Schulberg, informers who claimed to be motivated by the Communist Party's betrayal of their trust and faith in the cause it represented, tried to dramatize the difference between telling the truth and "ratting" or "stooling." It is the story of Terry Malloy's discovery, with the help of Father Barry and Edie, that informing against betrayers is a matter of "conscience" and "truth." It is a manichean movie—Christ and love are mobilized against crime, corruption, and passivity—focusing on the loneliness of the struggle of the righteous. Father Barry and Edie are unable to gather support and Terry, when he finally sees the light, has to fight Johnny Friendly and his goons alone. Kazan and Schulberg also use the movie to distance themselves further from their communist past, by portraying the workers as mindless sheep, unable to see their true benefactors and protectors, unwilling to come to the aid of those of

their comrades who stand up for workers' rights. Although Terry wins his fist fight, there is nothing hopeful in the movie's finale: the workers who follow the battered Terry back to their jobs have not learned anything and will not resist the next union boss who manipulates and exploits them.

By 1954, Kazan had begun to look inside himself and to his past as sources for material, to involve himself more in scriptwriting (twice using his own novel as the source), and to act as his own producer. Ironically, however, Kazan, whose reputation rested on his ability to draw brilliant characterizations from actors and actresses, proved unable to draw complex or interesting characters in his novels and screenplays. In addition, having chosen to cut his ties to the "social realism" that had infused his work in the Thirties and Forties, he failed to reestablish an artistically valid link to the social problems of the Fifties, Sixties, and Seventies, to infuse his material with compelling psychological insights, or to develop interesting cinematic techniques of depiction.

Of the seven studio films he directed after 1954, only *Baby Doll* (1956) achieves a steady coherence. The others fluctuate between hysteria (*Splendor in the Grass*, 1961), bland melodrama (*America, America*, 1963), noisy posturing (*The Arrangement*, 1969), and etiolation (*The Last Tycoon*, 1976). Only *Splendor* did well at the box office. Regularly accused of making the same movie over and over again, he takes it as a compliment, proudly stating: "I am not catholic in my tastes, I'm not a man of broad aesthetics."

The written word has become Kazan's main form of expression since the Seventies. He has written six novels since 1962. In fact, if Kazan is to have a firm reputation in the future, it will have to depend on the written word: the quality of the notebooks he kept while staging his plays and his autobiography. The plays are not permanently recorded and only two of his movies stand the test of time—*Streetcar* (1951), because of the quality of

Tennessee Williams's words and the performances of Marlon Brando and Vivien Leigh, and *On the Waterfront*, because Budd Schulberg's script and Kazan's direction dynamically documented a decade's anatomy of betrayal and its ethics of informing, subjects with which they were personally familiar.

In his autobiography, *A Life* (New York: Knopf, 1988), Kazan provides a detailed firsthand account of life in the left-wing theater movement in New York during the Thirties, and detailed, critical assessments of the many famous people with whom he worked on Broadway and in Hollywood and his own stage and film assignments.

It is a very long (825 pages), candid account in which Kazan describes a life lived behind a series of masks. The man behind the disguises is not very attractive. He has not remained faithful to a single conviction or ethical principle; instead, he has allowed himself to be buffeted by the winds of opportunity, ambition, emotion, and vindictiveness. Incredibly sensitive to slights from others, he is equally insensitive to his own betrayals and disloyalties.

His long-awaited explanation and evaluation of his decision to provide the House Committee on Un-American Activities with the names of the members of the Group Theatre who had been in his communist branch simply reveals what his critics had long suspected: he informed to save his movie career. Though he proclaims he came to believe it was his "proper duty" to help HUAC "break open the secrecy" of the Commmunist Party, it is evident from his own words that in his mind it came down to doing what was required to preserve himself as a filmmaker. Why, he asked himself, give up a career to defend a cause in which he no longer believed and a party which he hated?—Larry Ceplair

RECOMMENDED BIBLIOGRAPHY

Ciment, Michel, ed. *Kazan on Kazan*. NY: Viking Press, 1974.

Jones, David Richard. *Great Directors at Work: Stanislavsky, Brecht, Kazan, Brook*. Berkeley, CA: University of California Press, 1986.

Kazan, Elia. *Elia Kazan: A Life*. NY: Alfred A. Knopf, Inc. 1988.

Michaels, Lloyd. *Elia Kazan: A Guide to References and Resources*. Boston, MA: G. K. Hall, 1985.

Pauly, Thomas H. *An American Odyssey: Elia Kazan and American Culture*. Philadelphia, PA: Temple University Press, 1983.

Kramer, Stanley

(September 23, 1913 –)

As producer and/or director of some of Hollywood's most overblown epics on so-called big social issues, Stanley Kramer has done much to prove the validity of the reactionary Hollywood cliché, "If you've got a message, send it Western Union."

From *Home of the Brave* (1949) to *The Runner Stumbles* (1979), Kramer has consistenly turned out liberal preachments for reform that dilute their messages with turgid melodrama, managing neither to inform nor entertain. Kramer's greatest achievement has been commercial rather than political or artistic. Despite a string of

box office failures in recent years, Kramer has been one of the few Hollywood filmmakers to consistently make financially successful social problem films.

Working independently in the late Forties, Kramer pioneered a new, more economical approach to moviemaking with the aim of surviving amidst big studio domination. Since he was making one film a year on a small margin, he could neither compete with the big studios on their own ground nor afford any major financial losses. According to Kramer, to operate effectively, "the independent producer has to add something to the industry's output ...In our case, instead of relying on star names, we pinned our faith in stories that had something to say." But as Penelope Houston writes, "His most fitting territory is that range of material sufficiently unusual to attract public notice, without being so daring or so novel as to frighten them away," an estimation that recalls one critic's view of Darryl Zanuck, who had a "gift for spotting stories that bothered people's consciences a little, but not enough to cite them to action." The result was a series of pseudo-controversial problem pictures which Kramer, like Zanuck, devised with a keen eye for public receptivity. *The Champion* (1948) cashed in on the popularity of *Body and Soul*'s boxing exposé; *Home of the Brave* was the first of the 1949 films denouncing racism against blacks; and *The Men* (1950) rekindled interest in veteran rehabilitation on the eve of the Korean War. Later films that Kramer made as an independent producer at Columbia— *My Six Convicts* (1952), *The Wild One* (1954), and *The Caine Mutiny* (1954)—followed the same formula of topical melodrama.

Unlike Zanuck, who paid close attention to the dramatic values of his films, Kramer tended to sacrifice drama for the most obvious message-mongering, taking a particular problem, giving it a self-important glow, and then reducing it to a simple-minded plea for human tolerance. In *Guess Who's Coming to Dinner?* (1967), he uses the metaphor of two families' personal reactions to an interracial marriage not only to denounce racism, but also to suggest that if all parties were to sit down over a cup of coffee to talk, a solution to the problem might be forthcoming. His epics on issues such as nuclear war (*On the Beach*, 1959), the Scopes monkey trial (*Inherit the Wind*, 1960), Nazi war criminals (*Judgment at Nuremberg*, 1961), and student rebellion (*R.P.M.*, 1970) all stake out the middle ground, attacking the Establishment for its complacency while chastising radicals for being impatient and going too far.

Although Kramer has dealt with almost every major issue of the last forty years (at one point in the late Eighties, he even announced his intentions to produce an epic about Lech Walesa and the Polish Solidarity movement), one big issue that he has avoided is that of McCarthyism and the blacklist. The only Kramer film to remotely refer to this issue, *The Caine Mutiny* (1954), is an apologia for the witch hunt, chastising an insidious, plotting left-winger for fomenting a shipboard revolt against an obviously incompetent Captain. When forced to deal with the issue off-screen, Kramer sided with McCarthyites. It is ironic, yet somehow fitting, that for all his professed liberal convictions, Kramer failed to support his key business partner and screenwriter of his early hits, Carl Foreman, when the latter was called before HUAC. Instead, Kramer bought out Foreman's stock in their company and ended his association with him, helping to exile him to the ranks of the blacklisted.

For Kramer to have supported Foreman would have meant taking a firm political position that would have cost him his own career. It is unrealistic and perhaps unfair to expect a success-oriented filmmaker whose oeuvre so consistently seeks out the safe, commercially viable middle ground to take such a radical, economically unfeasible stand.

—Peter Roffman and Beverly Simpson

Kubrick, Stanley

(July 26, 1928 –)

Stanley Kubrick is known as a visionary American director, an artist capable of transforming generic stories into visions of man's failure first of reason, then of nerve. Kubrick's vision of America, however, is affected by the distanced objectivity he enjoys in "self-imposed exile" in England.

The result of his thorough research and his clinical production process are films that continually elaborate particular interests in cerebral ways yet lack passion or vigor as individual works. *Full Metal Jacket* (1987) distilled his obsession with the military as a microcosm of a world power, analyzing the way rigid, reactionary behavior causes deterioration, the effects of which he richly portrays in "civilian" works such as *Lolita* (1962), *Barry Lyndon* (1975), and *The Shining* (1980).

Kubrick's work proposes that sociopolitical collapse rises out of a foolish attempt to transcend limitations that seem all too apparent to us yet remain irresistible challenges to his characters. Kubrick's heroes bumble in where angels fear to tread, because they are men (there are no women of action in Kubrick's films) and subject to the temptations of war and women. He resists providing a political analysis of moral myopia or of bravado eclipsing intelligence and common sense. Kubrick prefers to rouse a classical pity and fear, the result of his deliberately distancing approach to man's tragic insignificance.

Kubrick's career, as of this writing, offers convenient bookends in *Fear and Desire* (1953) or his better-known *Paths of Glory* (1955) and *Full Metal Jacket,* along with *Dr. Strangelove: Or How I Learned to Stop Worrying and Love the Bomb* (1964) functioning as trenchant comic inversions of Kubrick's military dramas. Man is responsible for his own destruction and too stupid to stop; his only moral option is to isolate himself against the demands of society, which Kubrick's heroes attempt.

A telling scene occurs in *Full Metal Jacket* when a young soldier fumbles with a map he cannot read and blurts out, "I think we should change direction." A political position stated ten years after the controversial events depicted, the statement rises out of the mud in the middle of uncharted terrain in an undeclared war and only confirms how impossible change is—and always was. Likewise, *Paths of Glory* trains its steely gaze on French soldiers defended in a court martial by an incompetent attorney who calls for "compasion, the noblest impulse in man," and loses his appeal. The men will go before French bullets for having changed direction in the face of German fire.

By choosing a distant conflict, World War I, over military debacles closer to *The Paths of Glory,* Kubrick avoided contemporary politics and simply but cynically observed military organization. The "diptych" structure of *Full Metal Jacket*'s training and warfare sections is foreshadowed in the harshly delineated atmospheres of *Paths of Glory,* first in the fields and trenches and then in the cold elegance of the chateau where the generals design the strategies of death beneath the imperious arrogance of eighteenth-century portraits. Thirty years later, Kubrick would still be obsessed by the conceptual immorality of a place like Parris Island where soldiers are turned into "full metal jackets" (the

title refers to the encasement around a bullethead which doesn't shatter upon impact, a progressive and more humane form of killing) and who must later face the horror of death in a God- and officer-forsaken battlefield.

In a similar fashion, the gladiators in *Spartacus* (1960) were subjected to the dehumanizing process of being turned into war machines and their impulse to resist is crushed as easily as the compassion invoked in defense of the French soldiers. Kubrick wanted to turn the tale of the Roman slave uprising into a debate over the necessary violence of war, rising out of the brutality required to overthrow an entrenched empire, and the human sacrifice necessary to prove a point. An interesting debate rose between Kubrick and blacklisted screenplay author Dalton Trumbo over whether the failure of the slaves lay in their inability to cope with a new freedom. It is consistent with Kubrick's worldview that Spartacus can be seen, despite Kirk Douglas's show of force, as yet another tragically ambitious man who fails in a military context.

Kubrick's career has been devoted to the motivations, needs, and justifications of killing, from his boxing film *Killer's Kiss* (1955) and his heist movie *The Killing* (1956) to even his dark romance *Lolita* with the pitiful Humbert Humbert locked up as a murderer. Even in the elegance of *Barry Lyndon*, Kubrick is at his best in delineating the vendetta waged across class barriers between Lyndon (Ryan O'Neal) and his implacably vicious stepson, Lord Bullington. Yet his films avoid debate in favor of pronouncements, whether in the opening sequence of *2001: A Space Odyssey* (1968), in which we see the first weapon, a mark of progress, hurled exultantly into the air by man's earliest simian ancestors or in the grandiose finale of *Dr. Strangelove* as an idiot officer rides a state-of-the-art bomb into the apocalypse.

Kubrick's grimace of humor infects his subjects with a sensibility even darker than most black comedy. A grim irony underlies the slogan "Born to Kill" scrawled across the helmet adorned with a peace symbol or the graffiti "In Vietnam the wind doesn't blow, it sucks" in *Full Metal Jacket*. Kubrick's most famous scenes prompt jittery laughter. Is Humbert Humbert funny when he abases himself at the feet of Lolita to paint her teenage toenails? Why does HAL's voice make us want to take a sledgehammer to him? What is so devastating about General Jack D. Ripper's concern about his "precious bodily fluids"? Or about Matthew Modine's reporting to a general, "I always wanted to meet people from ancient cultures and kill them"?

There is very little in Kubrick's background to explain his negative if brilliant anti-establishment esthetic, and his isolation prohibits any inquiry into his past or mind. Born in 1928 in the Bronx, Kubrick started his professional career as a photographer working for *Look* magazine, while picking up courses at City College's night school. At Columbia University, he sat in on classes taught by Lionel Trilling and Mark Van Doren without enrolling. An obsessive and continuing interest in chess and jazz seems to have imparted the mental rigor and the refined sense of rhythm that are his trademark. In revolt against American expansionism and fascinated by military history, he moved to London in 1968, the year of the Tet offensive that is so succinctly dissected in *Full Metal Jacket*. Perhaps a line in the film points to his own mild schizophrenia: "How is the war going to get won if you wear a peace symbol?," an officer asks Private Joker, who by way of apology responds, "Sir, I think I was trying to say something about the duality of man."

From England, with "distance giving better perspective," as he has said, Kubrick essays the duality of America—its frightening propensity, on the one hand, to program the individual into a cog and, on the other, Americans' romantic obsession with themselves as heroic loners. He con-

sistently strips these maverick characters of any sentimental appeal by showing how ignorant individual men are of the big picture. In *2001*, the history of mankind is not under human control but guided, rather, by a higher and unknown order known only to HAL, the acme of electronic perfection with a deceptively human voice. Despite the vast canvas of America and the arguable freedom of Americans, Kubrick sees only slaves in a wasteland.

By working in epic dimensions, Kubrick has distinguished himself as an artist of monstrous—in both the moral and physical sense—proportions. The rocketship as giant womb in *2001*, the megalomaniacal dimensions of the War Room in *Dr. Strangelove*, the apocalyptic burning buildings of Hue in *Full Metal Jacket*, and the enormity of pride and prejudice in *Barry Lyndon* (not to mention his decade-long project about Napoleon) amply reflect his insistence on the big idea, the cosmic dilemma.

Kubrick has made one intriguing foray into America's internal political situation that has been misunderstood or ignored in its implications. The American family has seldom been so tragically dysfunctional as in the haunted halls of the cavernous Hotel Overlook in *The Shining*. Nor has American heritage been used with such quiet precision as the ur-cause for horror thriller effects.

Against the backdrop of a seasonally abandoned tourist resort, Jack Nicholson plays a psychotic who believes he is a writer and takes his family to the Overlook for the winter, where his son's psychic powers prove stronger than the father's impinging insanity in confidential chats with a ghostly barkeep. As he leaves the family in charge of the place, the manager recalls casually that the hotel is built on an Indian burial ground. "I believe they actually had to repel a few Indian attacks as they were building it," he says in dialog added by Kubrick to Stephen King's story, which he adapted.

Kubrick turns generic horror into a compelling but subtle legend of American racism, particularly the massacre of Native Americans. With the natives cleared away, Kubrick's camera trains on the foodstuffs stockpiled like an arsenal. At regular intervals, close-ups of cans of Calumet (an Indian word for peace pipe) baking powder with the recognizable Mohawk profile emphasize the trivialization of America's past. The Indian artifacts and decor throughout the hotel provide a cunning commentary on the utilization of Indian art and style.

No living Indian is seen; yet the rushing blood that wells up silently from the hotel's elevator shaft must spring from the very burial ground alleged to have cursed the Overlook and its keepers. Kubrick takes this premise beyond occult horror and into the realm of mythological archetypes like human sacrifice in a labyrinth to assuage primeval gods, which in turn has the resonance of crime and punishment proper to European tradition as well. In the finale, as Jack is absorbed into an old photo of a 1921 July 4th celebration at the hotel, history as an evolving concept is supplanted by the idea of senseless repetition—like Jack's fat manuscript with the same sentence repeated on every line or the slaughter of several families by various fathers over the years. The political underpinnings reinforce the psychological import of *The Shining* and enrich it.

Kubrick is no ideological innocent, even if the politics of *The Shining* are more subtle than the political satire of *Dr. Strangelove* or the nihilism of *A Clockwork Orange*. The latter is a kinetic, brutal tour de force that makes the audience deal with a drugged and psychotic killer in a world so dissipated and hypocritical that Alex is almost a breath of fresh air. Alex explores destruction as a form of self-expression, forcing us either to adopt his point of view, from which the entire story has been told, or to react in disgust. Violence, unified as content and style, strikes an impervious, outrageous pose aimed to offend.

Perhaps in reaction to the moral and

esthetic turbulence of *A Clockwork Orange*, Kubrick's next film was *Barry Lyondon*. Its stately pace contrasted with the title hero's ambitions, vital and vulgar in the context of hidebound British social rituals. Again, a story of human impotence against historic cycles concluded with an ironic subtlety all but overlooked in interpretations of the film. In one scene, a date on a check reads 1879; and as sure as that check draws down on a depleted account, so shall the French Revolution of that year "bounce.'

Clearly, Kubrick is adept at manipulating us into feeling exactly the critical tenor of the worlds he creates. He harangues his audience not to be mere recorders in either film or life. Implicit in Kubrick's acerbic cinema is a criticism leveled at his audience for being as dead as England, as destructive as Alexa, as jaded as Private Joker, as foolish as Humbert Humbert, as imperfect as HAL, and as insane as Dr. Stangelove. As provocative as he is astute, he still abjures any overt political purpose to his filmmaking or any political subtexts.

Perhaps his masterpiece and greatest contribution to popular culture is *Dr. Strangelove*, an oddly prophetic work about nuclear double-talk that captures the ideology of American patriotism at its most fascistic. As a U.S. Air Force SAC bomber heads for "Armageddon," one Major Kong feels safe promising his crew promotions. Getting those bombers to turn around, opines another officer, is "reduced to a very low order of probability." He figures on "no more than ten to twenty million killed. Tops. Depending on the breaks."

Meanwhile, a gadfly president remonstrates with George C. Scott in a fisticuffs with a Russian Ambassador: "Gentlemen, you can't fight here. This is the War Room."

This is quintessential Kubrick, full of characters wallowing in ignorance and about to self-destruct. Here may lie the clue to Kubrick's attempt to distance himself from *Spartacus*, a film which "had everything but a good story," he has said. To satisfy Kubrick a story clearly requires a strong dose of pessimism. Combined with Kubrick's glorious sense of excess, his pessimism imbues his work with the sensibility of what can only be called pratfall existentialism. How he will whittle this into a story of Napoleon will fascinate— and undoubtedly infuriate—anyone who believes, as Kubrick claims to, that cinema has given twentieth-century artists an advantage over history unprecedented and, for the most part, unappreciated.

—Karen Jaehne

RECOMMENDED BIBLIOGRAPHY

Ciment, Michel. *Kubrick*. Translated by Gilbert Adair. NY: Holt, Rinehart and Winston, 1983.

Coyle, Wallace. *Stanley Kubrick: A Guide to References and Resources*. Boston, MA: G. K. Hall, 1980.

Kagan, Norman. *The Cinema of Stanley Kubrick*. NY: Continuum Publishing Co., 1989.

Kolker, Robert Phillip. *A Cinema of Loneliness*. NY: Oxford University Press, 1988.

Nelson, Thomas Allen. *Kubrick: Inside a Film Artist's Maze*. Bloomington, IN: Indiana University Press, 1982.

Lardner, Jr., Ring

(August 19, 1915 –)

Ring Lardner, Jr.'s historical importance as a member of the Hollywood Ten casts intriguing shadows onto his career, inviting us to read his work for its possible political codes. To what extent do his screenplays both before and after he was blacklisted in 1947 reflect Lardner's impassioned partisanship, the political ideals for which he sacrificed his professional security?

However buried or disguised, is there evidence in his work of the subversion of which the House Un-American Activities Committee accused him? Is his pro-Russian sympathy, his belief that the Soviet system provided the model of a new society, insinuated into his scripts?

Lardner's recurrent subject matter—war, feminism, sporting competition—certainly contains liberal promise, yet in their final version his scripts uphold the system of capitalist privilege that financed them. Bearing the stamp of corporate compromise, there is little to distinguish his work from that of a writer without political portfolio. Commercial sweetening thus dilutes Lardner's Oscar-winning screenplay, cowritten with Michael Kanin, for *Woman of the Year* (1942). For most of the film we are expected to admire an extraordinary person, a political writer who speaks many languages, is on easy, intimate terms with world figures, snaps orders to a male secretary, and, as cleverly played by Katharine Hepburn, is withal charming and dizzy, a woman whose periodic pratfalls appealingly tarnish her perfection. Superwoman meets a sports writer (Spencer Tracy) whose sly disapproval also helps to scale her fabulousness down to human size. Tracy and Hepburn expertly enact this elitist couple's edgy, brittle courtship and marriage, but the script raises issues about superior, liberated womanhood that it doesn't begin to know how to resolve.

After Tracy walks out on his dazzling, competitive wife on the eve of her crowning as Woman of the Year, the film collapses. Cornered, unable to make an honest getaway, the filmmakers place their resplendent New Woman in a kitchen, where she is less threatening though infinitely less competent than on the world stage. Belatedly assuming her wifely functions, she tries and utterly fails to make a proper breakfast for her estranged mate. The cultural indignity of pushing the character into her "proper" domain is oddly consistent with the way the film has paraded her before us as a kind of performing seal, a freak with star power. Nonetheless, the crisp, literate dialog befits characters who make spectacular livings wielding words.

A sampling of Lardner's other scripts reveals a similar leashed power in which thematic impulse is cut to bureaucratic demand. Cowritten with Albert Maltz (also to be blacklisted), *Cloak and Dagger* (1946) is a disappointingly routine though politically "immaculate" war thriller in which an American scientist (Gary Cooper) becomes a secret agent determined to prevent German and Italian fascists from developing the atomic bomb. Scripted by writers who were to be called subversive, the film indeed supports the subversive activity of the anti-Nazi resistance movement. Filled with didactic set

speeches, *Cloak and Dagger* is a militantly pro-Allies propaganda poster and only a humorless group like the House Un-American Activities Committee would try to read communist overtones into the heroine's declaration that "in this work we are all comrades." Based on a best-selling romantic novel, and blandly written and acted to conform to the "good taste" standards of costume pictures, *Forever Amber* (cowritten with Philip Dunne in 1947) is in fact politically more daring than *Cloak and Dagger.* Implied in the history of its tenacious heroine, a country woman who uses her beauty to seize social and economic advancement in Restoration London, is a critique of morally distorting materialist values. Glancingly the film suggests that her capitalist drive made Amber a whore.

The Cincinnati Kid (1965), Lardner's first postblacklist credit, cowritten with Terry Southern, is about a card shark who loses both the big game and his girl. When he sees the game is rigged, the Kid won't play, and it's tempting to read the film's honest loser as an emblem of blacklisted writers refusing to participate in a crooked contest. The bruised, wised-up Kid may be a little too pleased with his integrity, but the film is aflame with an American competitive spirit, a morally crippling lust to win.

*M*A*S*H* (1970), Lardner's second Academy Award-winning screenplay, is also freighted with an idealized personal symbolism: the movie's hipster trio of army doctors are feisty mavericks who challenge repressive army regulation, confound straitlaced bureaucrats, and confront war's cruel absurdity with their own improvised absurdist humor. Lardner's anti-establishment anger—his assault on the kind of corporate mentality that underlay the blacklist—is expressed in abrasive, liberating farce, a quality that was not apparent in his other work. As in *Woman of the Year,* however, *M*A*S*H* has a clear-cut elitist strain; social class, education, and wit protect its smart aleck heroes from experiencing war the way common soldiers did.

Lardner's two famous screenplays, for *Woman of the Year* and *M*A*S*H,* remain curiously isolated instances in a middling, anonymous career; in markedly different styles which reflect their almost thirty-year separation, the two films remain flawed works that demonstrate a promise which remained largely unfulfilled. For whatever reasons, personal, political, and professional, working as a studio hired hand Lardner was unable to carve out a substantial body of work that expresses a coherent, sustained vision or a distinctive personal style.—Foster Hirsch

RECOMMENDED BIBLIOGRAPHY

Froug, William. *The Screenwriter Looks at the Screenwriter.* NY: Macmillan Publishing Co., 1972.

Hamilton, Ian. *Writers in Hollywood, 1915–1951.* NY: Harper and Row Publishers, 1990.

Lardner, Ring, Jr. *The Lardners: My Family Remembered.* NY: Harper and Row Publishers, 1976.

Lawson, John Howard

(September 25, 1894 – August 11, 1977)

In the history of Hollywood's left-wing politics there is perhaps no more indelible visual image than the film clip of John Howard Lawson's final moments of testimony as the first 'unfriendly' witness at the House Committee on Un-American Activities hearings in October 1947.

"Are you a member of the Communist Party or have you ever been a member of the Communist Party?," Chairman J. Parnell Thomas shouted, and Lawson, in a voice nearly as rancorous, replied, "It is unfortunate and tragic that I have to teach this committee the basic principles of American..." Thomas hammered his gavel to cut off the witness, and called for officers to take him away from the stand. Lawson was cited for contempt of Congress, and served a term in prison as one of the Hollywood Ten.

Lawson was a member of the Communist Party, though proclaiming that fact, on or off the witness stand, in the growing climate of ideological repression emerging with the Cold War, was regarded as a tactical impossibility. Indeed, he was sometimes regarded as the "Commissar" of Hollywood Communists, their nominal head, because of his close links to Communist Party leaders who formulated cultural policies. Vilified by the right, perhaps overly sentimentalized (at least retrospectively) by the left, Lawson remains an enigmatic figure, whose historical role—as screenwriter, organizer, and ideologue—has yet to be fully assessed.

Lawson was in his forties before he formally joined the Communist Party in 1936, and by then he had been prominent as a writer and activist in the political communities of Broadway and Hollywood for more than a decade. Born in 1894, he was raised in a bourgeois assimilationist Jewish family (which had changed its name from Levy), attended Williams College, and, with many other writers of his generation, served as a volunteer in the ambulance corps during World War I. During the Twenties he gained notice as author of "expressionist," satirical plays (*Processional* ran for over one hundred performances on Broadway in 1925) and also was among the literary figures arrested in 1927 for picketing the State House in Boston to protest the death sentence for Sacco and Vanzetti. He began working in Hollywood in 1928 and by 1930 had six screen credits at MGM, including as cowriter of dialog for Cecil B. DeMille's first talkie, *Dynamite* (1929).

Shortly after President Franklin D. Roosevelt's inauguration in 1933, when Hollywood moguls declared a fifty percent pay cut for creative personnel, Lawson was among a group of left-wing writers who proposed a Screen Writers Guild to defend writers' economic interests. It's indicative of his reputation then as a moderate that when the Guild was soon formed, the wider membership body voted unanimously for him to serve the first one-year term (1933–'34) as president. Meanwhile, he had recently been spending more time in New York writing plays for the Group Theatre. Their production of *Success Story* was optioned by RKO and brought Lawson back to Hollywood as coscriptwriter on the adaptation, *Success at Any Price* (1934).

It was at this point that Lawson was challenged as an intellectual and artist even more severely than he was to be by

HUAC. The communist literary critic Mike Gold attacked him in *New Masses* as "A Bourgeois Hamlet in Our Time." Lawson replied that he was working out his inner conflicts and making his choice in the class war. This was perhaps the impetus that led him to adopt a position of ideological certainty, not only as a party member but also as one of its cultural functionaries, capable of such authoritarian acts as ordering the closing (as contrary to Party aims) of the magazine *New Theatre and Film*. In 1936 he also published *Theory and Technique of Playwriting*, an influential treatise favoring the esthetics of socialist realism.

However rigid an ideologue Lawson thereafter became, studies such as Ceplair and Englund's *The Inquisition in Hollywood* have made clear that the Communist Party did not invariably impose the strictest discipline on its Hollywood cohort. Rather, it sought to gain advantage from their financial contributions, their leadership in broad-based coalitions (as in organizations opposed to fascism), and the possibility of their influencing motion picture content.

This latter issue, considering its importance, has barely been given serious attention (even HUAC, probably in a deal with the studios, was willing to drop the question of movie content in exchange for industry support of the blacklist). The prevailing opinion is that communist writers were ideologically ineffective, either limited to attempts to place clever lines of "progressive" dialog, or recognizing the futility of challenging producers' hegemony. A more fruitful approach is to regard every production situation as a site of struggle, and to investigate specific films to ascertain the ways communist creative personnel may have played a role in the shaping of such basic elements as narrative and characterization. A different assessment may emerge, especially because in their most active decade in Hollywood, from the mid-Thirties to the mid-Forties, the communists' stance was often compatible with that of liberals.

Lawson's greatest success as a screenwriter in fact came in this period, with eight films in as many years, including the antifascist *Blockade* (1938) and the prounion (and pro-Soviet) *Action in the North Atlantic* (1943). Whatever the weaknesses of Lawson and his communist associates in Hollywood, they were neither hacks nor the inconsequential journeymen that various liberals asserted at the time, in an effort to downplay HUAC's devastation of the movie industry.

In the blacklist years, though he did some screenwriting anonymously, Lawson turned primarily to writing books: *The Hidden Heritage*, a social history, 1950; *Film in the Battle of Ideas*, essays on contemporary movies, 1953; and *Film: The Creative Process*, history and theory of cinema, 1964. An expanded *Theory and Technique of Playwriting and Screenwriting* also appeared in 1949. He died in 1977, shortly before his eighty-third birthday.
—Robert Sklar

RECOMMENDED BIBLIOGRAPHY

Carr, Gary. *The Left Side of Paradise: The Screenwriting of John Howard Lawson*. Ann Arbor, MI: UMI Research Press, 1984.

Hamilton, Ian. *Writers in Hollywood, 1915–1951*. NY: Harper and Row Publishers, 1991.

Lee, Shelton Jackson "Spike"

(March 20, 1957 –)

Megastar status and big-budget respectability have done nothing to blunt the edge of Spike Lee, the most successful African-American filmmaker in history and as instantly recognizable a motion picture director as America has.

In *Do the Right Thing*, Lee wears a Los Angeles Dodger jersey, the Jackie Robinson of another American pastime, but a more apt model might be Duke Ellington. Like Ellington, Lee is a conductor leading an orchestra through his score, not a soloist in performance, the more familiar showcase for black talent. On the motion picture playing field, too, command and control precede composition. Lee's diaries—for ancillary marketing purposes, all his screenplays-cum-memoirs have been published in tandem with the release of his films—reveal a singular obsession with the purely administrative and entrepreneurial aspects of moviemaking, an urgent need to keep a succession of projects in the pipeline and to avoid the wounds, self-inflicted and otherwise, that have crippled the mature development of black artists in the maw of American culture. The scale of his achievement, and its representational significance, is truly unprecedented. To white America, for black America, Lee demonstrated the intellectual force, organizational ability, and mercantile savvy to be a powerful overseer of another peculiar institution— the art and business that is Hollywood moviemaking.

Renowned from countless television interviews, scene-stealing appearances in his own films, and prominent display in stylewise commercials for Nike Air Jordans and Levi's 501 Jeans, Lee is both high-profile celebrity and media-certified Black Spokesman. In the latter role, the director is given to the intemperate remark and the self-righteous pronouncement—taking shots at black superstars who fail to meet his stand-up standards and evincing a dogmatic intolerance (no black man, he once told a Boston audience without irony, can be a Celtics fan). Predictably, he has been welcomed by the very establishments he disses—teaching a film course at Harvard, serving on the board of trustees at his alma mater, Morehouse College. An avowed subversive who thrives in the marketplace, he embodies the contradictions of a politically charged artist willing to shill $150 sneakers to inner-city street kids for corporate America.

The mixed signals in Lee's public persona infuse his motion picture work, where the tensions between popular art and militant politics, good-natured humor and self-righteous didacticism, can make for a tight squeeze. At once lovingly ethnographic and brutally censorious, his vision focuses in on the internal cohesions and internecine enmities of New York's black communities (plural) in a post-civil rights, pre-dawn era. Like his kindred souls in hardcore rap, he is of a generation less likely to keep his eyes on the prize than to watch out warily for trouble. Cinematically, Lee's operatic, eclectic style bespeaks the alert scoping and cautious scanning of the NYC pedestrian—and summer afternoons spent soaking up air conditioning while watching Sergio Leone Westerns, Hong Kong chop socky, and blaxploitation

flicks. Crane shots lower majestically in a gesture of omniscient inspection only to adopt the street-level perspectives of the stoop sitter and pavement pacer. A sepia veneer to his set design and cinematography alternates with the high yellows and deep blues of a logo which serves as his production credit and chain-store name, "A Spike Lee Joint." His trademark shots are off-kilter close-ups of looming faces and the low-angle once-overs of full-bodied street life. In *Do the Right Thing*, the perspective transforms Radio Raheem into a mythic giant, a warrior brandishing a talisman ghetto blaster.

Lee's militant, Afrocentric esthetics cut both ways. With whites literally out of the picture, blacks bear a greater burden of blame for their choices, failures, and lives. In one of his journals, Lee writes that "Black people cannot be held responsible for racism. We are not in that position. We are, and have been, victims." Yet his work consistently refuses to grant any dispensation for victim status. As early as his student film project for NYU, *Joe's Bed-Stuy Barbershop: We Cut Heads* (1983), the admonition is to look inside, to the souls of black folk, not outside to the support of white folk. Hence the double edge to the numbers racketeer in the film, a black mobster who preaches the gospel of economic self-sufficiency and personal uplift. In seizing control of the local rackets from the Mafia, he has done the right thing— and though a parasite on the community, he is at least *of* the community. Not incidentally, *Joe's Bed-Stuy* introduced the Lee wit along with the wisdom. "He just needs direction," says a concerned social worker about one of her charges. Pointing east, her companion cries, "Riker's Island is that way!"

Lee's first feature film, made on the storied shoestring budget (a hiliarious trailer had the director hawking athletic socks on the streets of New York to secure financing), was the semifeminist *She's Gotta Have It* (1986). A double-barreled defiance of stereotypes (racial and sexual), it featured a free-spirited siren named Lola Darling getting not only her share of the antecedent but the better of three would-be black knights. Fluid, frank, and really funny, it was also well-timed: had its promiscuous heat been lit closer to the epidemic of inner-city AIDS, it would have missed its moment.

From sex and color Lee moved to class and color in his second film, *School Daze* (1988), a reworking of the director's undergraduate years at Morehouse College. Again, the focus was intraracial, the issue the meaning of black brother (and sister)hood. It builds to a harrowing climax, an act of willful self-degradation wherein a hotshot sorority sister and a desperate male pledge engage in sex at the demand of a fraternity kingpin. Prostitution is the logical culmination and appropriate metaphor for what the pair has been doing throughout the film: sacrificing personal integrity for social ambition, black identity for white assimilation.

Though hardly a black version of *Animal House*, *School Daze* was more memorable for its hijinks than high-mindedness. Lee's impassioned call to student protest paled against his vivid, affectionate portrait of undergraduate life at an all-black college—the dance craze "da butt," the brief vogue for Washington, D.C.'s indigenous go-go music, the ritual chants and choral dancesteps of the fraternity system, and, strikingly, the casual exposé of the social shadings to pigmentation among the talented tenth, what James Baldwin called "the color wheel." Reversing the melanin hierarchy of Oscar Micheaux, the pioneer black filmmaker who is Lee's acknowledged forebear, Lee set the "high yeller" Wannabees against the deep-dark "Jigaboos," hypocrisy against authenticity, in a hair-curling musical sequence called "Straight and Nappy." Like the sepia-tone visual sheen of his films, life, even in a segregated world, is hardly monochromatic.

It was *Do the Right Thing*, released in the summer of 1989, that propelled Lee from minor figure to major auteur, from

inner-city venues to suburban malls. Set in New York's Bed-Stuy on a sweltering summer day, the film tracks a vivid cross section of black and white types—the wide-eyed, all-talk, no-walk Buggin' Out; the boom-box-toting Radio Raheem; the shiftless pizza delivery man Mookie; his mellow sister Jade; and the Italian pizzeria owner Sal and his two sons, the racist Pino and the befuddled Vito. In temper and set design, the community is more than a few steps removed from metropolitan verisimilitude, but Lee is less interested in concrete reality than in conjuring a theatrical stage to play out the dynamics of race, ethnicity, and power under meteorological extremes. His cinematic chops were as adventuresome and ambitious as his social concerns. Dreamy pull-backs, long takes, and angular close-ups (Lee calls them "Chinese angles" after the awed, skewed gaze of the kung fu films) defined the directorial perspective; the color scheme was steamy yellow and dull red, a celluloid slow burn conjuring the equatorial oppression of summer in the city; the sound track measured out rising degrees of anger and resistance via the dissonant rap of Public Enemy. Social meltdown was always just a match away. After the warm glow of a cozy shot-reverse-shot sequence between Sal and Jade, the camera swings laterally to catch in turn the cold, hate-filled eyes of Pino and Mookie, the white son of the one and black brother of the other united in the look of racism. When the community ignites, the violence is not justified, condemned, or even cathartic, just inevitable. In the celebrated, much-debated coda, Lee reached the limits of his own commentary, placing side by side a pair of epigrams from Martin Luther King, Jr. and Malcolm X, offering two responses, two divergent attitudes, no one guide for doing the right thing.

Lee registered a cooler tone in *Mo' Better Blues* (1990), a pleasantly meandering jazz fusion of music and melodrama. The inability of horn player Bleek Gilliam to commit to either of a pair of luscious girlfriends is the slim scaffolding for an exploration of nightclub subculture and woodwind temperaments. Lee's most personal film, it shows the discipline, dedication, and personal cost exacted by an unforgiving taskmaster, namely, art. If not in the pocketbook, in the music at least is a payoff, a creative compensation, a source of peace and common ground. Little wonder the band on screen seemed an expression of the community Lee nurtures on both sides of the camera. Already the *éminence grise* to an astonishing crop of young, gifted, and bankable black filmmakers (John Singleton, Bill Duke, the Hudlin Brothers), he has also fashioned a solid stock company of high-salary stars and utility players—Bill Nunn, Giancarlo Esposito, Joie Lee, John Turturro, Denzel Washington, and Wesley Snipes.

Jungle Fever (1991) seemed less deeply felt, more high concept than gut instinct. Ironically, just as the humanism of Danny Aiello's performance as Sal undercut Lee's condemnation of Italian-American racism in *Do the Right Thing*, the actors in *Jungle Fever* subverted what was supposed to be an exposé of dueling racist stereotypes. Lee intended an unblinking look at the delusionary erotic projections of Annabella Sciorra's lower-class Italian onto Wesley Snipes's uptown buppie, and vice versa— only to be undone by the visible evidence that the attractive, affectionate pair actually made a good match. Seemingly frustrated, Lee quickly veered from the forbidden fruit of miscegenation to the plague of crack cocaine. In Wesley Snipes's hijara through a netherworld crack house, in Samuel L. Jackson's harrowing incarnation as a cadaverous crackhead, an urban horror story pushes aside the indulgent melodramatics of interracial romance. Not coincidentally, the family torn asunder by crack is headed by Ruby Dee and Ossie Davis. Representatives of the last generation of pre-civil rights black actors, the real-life couple is a visible link to a screen history that rendered blacks invisible, or worse. In paying tribute to their old-fash-

ioned gravitas, the total lack of urban street style, Lee is acknowledging his roots by calling up a past that contemporary black artists are increasingly seeing, segregation and all, as preferable to the ultraviolent, drug-ridden present.

Lee's best stock character may be himself. The hormonal urgency of his performance as Mars Blackman in *She's Gotta Have It* ("Please baby, please baby, please baby, baby, baby, please!") gave way to wrenching desperation in his portrayal of Half Pint, the fraternity pledge only too willing to endure whatever ritual humiliation the BMOC overseers can concoct. By way of ironic projection the workaholic multihyphenate tends to cast himself as shiftless incompetents—the ne'er-do-well pizza deliveryman in *Do the Right Thing*, the outclassed manager with the gambling jones in *Mo' Better Blues*. His access to street slang and gestures is inside-dopester verifiable. Signature shtick—the forward arm thrust Lee gives to pantomime the infidelity of Bleek's girlfriend in *Mo' Better Blues* or his atomic reaction to a revelation of cross-race sexual congress in *Jungle Fever*—is sure to be greeted with howls of recognition from the floor seats. Lately, playing second banana to heartthrob leads Denzel Washington and Wesley Snipes, the actor has moved further away from the emotional center of the director's films. Like Woody Allen, though, Lee's attempts to submerge himself into an ensemble are never quite successful; he's always more bottled up, tightly wound, pissed off. Lee has a sharpness, a bitterness, one that probably owes as much to height as color. In his films, he is more likely to be slurred for stature than race.

Lee's alarm bell polemical line ("WAKE UP!") and penchant for extended speechifying never quite manage to smother his generosity of spirit or his insights into private motives. The content of the films is often at odds with his public proclamations and private diary entries. His characters voice a full range of perspectives, daring to speak what white liberals cannot—

expressing envy at the success of Korean shopkeepers, irritation at the sight of another teenage welfare mother. On camera, each voice gets a fair hearing, each character a fair shake. In *School Daze* the antiapartheid activist Dan Dunlap may be politically correct to the max, but he's also a major pain in da butt; the sharecropper's son Grady is understandably reluctant to blow his chance at college education to fulfill Dap's agenda; and even the odious frat brother Big Brother Al-might-ty scores a direct hit when he sneers at Dap's naive Garveyism: "Back to mother Africa, that's bullshit. We're all Black Americans. You don't know a goddamn thing about Africa. I'm from *Chi-town*."

In sync with the New York state of mind, whether in Bensonhurst or Harlem, Lee has as good an eye (and ear) for Italians as blacks. The lone exception was the pair of Jewish nightclub owners exploiting the Bleek Gilliam Quintet in *Mo' Better Blues*. Unique among Lee's people, they are cardboard shylocks, the only screen characters warranting the label offensive stereotypes. Unlike Italians, or even Koreans, Jews are an American ethnic group whose skin he cannot get under.

The lapse in ethnic sensitivity was duly noted and roundly reviled: it garnered Lee the most negative commentary of his career. By way of explanation, not apology, the director filmed a precredits statement to be shown at the top of *Mo' Better Blues*, an incitement later jettisoned from the release print. Responding instead in a *New York Times* op-ed piece, Lee complained, or bragged, "My films are watched more carefully than those of any other filmmaker." A dash of megalomania, but probably true, for if he is not held to a double standard, he's certainly held to a color-coded one. The enduring American dilemma for this native son is captured in the resonant name of his film production company, Forty Acres and a Mule, a phrase that yokes an old promise of freedom and prosperity to the stubborn persistence of bondage and racism.—Thomas Doherty

RECOMMENDED BIBLIOGRAPHY

Lee, Spike with Lisa Jones. *Do The Right Thing: The New Spike Lee Joint.* NY: Simon and Schuster, 1989.

—— with Lisa Jones. *Mo' Better Blues.* NY: Simon and Schuster, 1990.

—— with Ralph Wiley. *By Any Means Necessary: The Trials and Tribulations of the Making of* Malcolm X. NY: Hyperion, 1992.

—— with Lisa Jones. *Uplift the Race:*

The Construction of School Daze. NY: Simon and Schuster, 1988.

—— *Spike Lee's* She's Gotta Have It: *Inside Guerrilla Filmmaking.* NY: Simon and Schuster, 1987.

McMillan, Terry. *Five for Five: The Films of Spike Lee.* NY: Stewart, Tabori and Chang, Inc., 1991.

Patterson, Alex. *Spike Lee.* NY: Avon Books, 1992.

..

LeRoy, Mervyn

(October 15, 1900 – September 13, 1987)

"Ihave never felt that motion pictures were the place to try to champion any cause—political, religious, economic, anything. Motion pictures are to entertain, not to change someone's mind. If you have a fine story that deals with a social issue, that's fine. But the story comes first, not the philosophy."

Despite this eloquent disclaimer, Mervyn LeRoy was the star director at Warner Bros., Hollywood's "socially conscious" studio in the mid-Thirties, the man responsible for such liberal works as *Five Star Final* (1931), *I Am a Fugitive from a Chain Gang* (1932), *Gold Diggers of 1933* (1933), and *They Won't Forget* (1937). He also directed a number of "escapist" films during this period (he followed *I Am a Fugitive* with *Heart of New York*, starring comics Smith & Dale, and *They Won't Forget* with a piece of fluff called *The King and the Chorus Girl*), but LeRoy's professed dedication to entertainment for its own sake invites skepticism.

Although he remembers *I Am a Fugitive* chiefly as a condemnation of prison camp brutality, it is far more than that. A mini-history of America from 1918 to the Depression, and, along with *They Won't Forget,* one of the most radical and subversive political films ever to come out

of Hollywood, it is the searing tale of America's "forgotten men" who returned from World War I as heroes only to find themselves scorned as unemployable bums a decade later. One such veteran, James Allen (Paul Muni), returns from the destruction of WWI with a restlessness and ambition, a desire to "build, construct and create" rather than kill. Not satisfied to return to his old job as a clerk, he becomes a hopeful hobo in search of a construction job in the "land of opportunity." But his search is futile, and broke and hungry, he finally recognizes he has no choice but to sell his Medal of Honor. In a powerful and symbolic scene, the local pawnbroker silently refuses, pulling out a box to reveal a heap of similar medals. Allen is eventually implicated in a robbery he didn't commit, and sentenced to the living hell of a chain gang. Later he escapes and actually becomes a successful builder during the Roaring Twenties, until he

makes a deal with the authorities in an effort to clear his name for good. He voluntarily returns to the chain gang to serve a ninety-day sentence, but the government breaks its promise and state officials refuse to release him. "Their crimes are worse than mine!," cries Allen. "They're the ones who should be in chains, not me!" The film bristles with anger at the plight of Allen, a helpless victim of a society that cares so little for its heroic citizens. The film's ending is shattering, as Allen escapes from the chain gang a second time, only to find America mired in the Depression. Unable to find work, he becomes a petty thief, hiding by day and travelling by night. Even a visit to his girlfriend offers no hope. He slinks away from her into the darkness of the night in the final scene. When she calls out to him, "But Jim, how do you live?," out of the darkness he replies simply, "I steal."

Unlike other Depression films that pinpointed a crooked individual as the cause of Depression ills, LeRoy's film blames American society at large. In a radical departure from the happy ending most Hollywood films demanded, *I Am a Fugitive*'s pessimistic fade into darkness is Hollywood's angriest statement on the Depression. To paraphrase critic Russell Campbell, *I Am a Fugitive* is the story of a man who, wanting only to do his patriotic duty, is continually frustrated, thwarted in his attempts to succeed, and is even unjustly punished. With no alternatives left, he is forced into survival through a life of crime.

It is a startling and subversive conclusion for an American film, with a degree of radicalism that LeRoy would approach only once more in his career. *They Won't Forget* is, along with Fritz Lang's *Fury*, the best of Hollywood's many antilynching films, an antifascist parable that is also an eloquent statement on the fragile nature of American democracy. Working from a script by Robert Rossen and Aben Kandel, LeRoy carefully details the manipulation of a volatile mob of bigots at the hands of

community leaders who will trade justice for personal gain. When a Southern teenager is raped and murdered, the cynical and greedy District Attorney Griffin (Claude Rains) accuses a Northern schoolteacher of committing the gruesome crime, despite the fact that there is little evidence against him. But Griffin hopes the Northerner's origins will fan North-South factionalism enough to generate publicity and make the DA a celebrity. Aided by his own flamboyant courtroom tactics, the case becomes a sensationalized news story, and the townspeople's suppressed anger and bigotry erupts, turning them into a murderous lynch mob.

The parallels between the mob's mentality and fascism are chillingly obvious. Both the lyncher and the fascist follower are prone to manipulative leadership, their irrationality controlled by self-serving powers. The film is clear on who achieves success: Griffin, supported by the town's gentry and the sensationalist press, obtains all of his goals, while the one honest official in the film, the liberal governor who commutes the teacher's sentence, sees his career potentially destroyed when the angry mob ignores his decision and lynches the prisoner. The film's finale is almost as shocking as *Fugitive*'s fade into darkness. When the schoolteacher's widow confronts Griffin, he is unrepentant, more concerned with capitalizing on his newfound fame. After she leaves, Griffin's campaign manager ponders whether or not the teacher was really guilty. Griffin calmly replies, "I wonder."

As with *Fugitive*, much of the film's impact comes from LeRoy's refusal to compromise his story with a happy ending. Whereas most films adhered to the Hollywood formula by which Evil is punished and Good is rewarded, *They Won't Forget* suggests the opposite. The implications about the political system are obvious, but the director's intelligent handling of his story material should not be confused with his personal political beliefs. In his autobiography, LeRoy actually laments

that *They Won't Forget* gave him a reputation as a political liberal, claiming that he made the film only because it had a good story. Any message the film had was purely a byproduct of that story. Likewise, he sees many similiarities between *Fugitive* and his *Blossoms in the Dust*, a conservative soap opera about a home for unwed mothers. LeRoy groups these two dissimilar films together as his contribution toward "making this a better country," but he would prefer to be remembered as a director of entertainment films. He even trots out that old line, "If you want to send a message, go to Western Union." Indeed, his post-Warner Bros. career at MGM seems to prove his dedication to that cliché. After his switch to the family entertainment studio in 1938, LeRoy produced the ultimate Hollywood fantasy film, *The Wizard of Oz*. He then turned to lush soap operas, directing *Random Harvest* and *Waterloo Bridge,* as well as the more "socially conscious" *Blossoms in the Dust.*

LeRoy's insistence that he was a maker of entertainment pictures raises questions about his creative input on Warner Bros. projects like *Fugitive* and *They Won't Forget.* Were these LeRoy's films or were they the products of the studio itself, or of politically radical screenwriters? After all, Robert Rossen, coauthor of *They Won't Forget*, later directed the leftist *Body and Soul,* and in the Fifties was called to testify before the House Committee on Un-American Activities. Yet it was LeRoy himself who initiated the *Fugitive* project, and, with producer Hal Wallis, worked closely with scriptwriters on the screenplay. As a successful director, there is no doubt that he had considerable creative control over his pictures. While producer Wallis tried to change the pessimistic fade-out at the end of *Fugitive*, LeRoy insisted on it, and was backed up by production chief Darryl Zanuck. Like LeRoy, Zanuck was no political radical. Both men saw the story as all-important, believing the unhappy ending would have the most dramatic effect on the audience. LeRoy also insisted on the

cynical climax to *They Won't Forget,* undoubtedly for the same reason.

Looking back on his career, LeRoy seems almost completely ignorant of the political implications of his own films, and claims never to have been a political person. In his autobiography, *Mervyn LeRoy: Take One,* he comments on the HUAC hearings of the Fifties, declaring: "There was never any personal worry, because I am not a political person. I am, however, strongly pro-American and I had come to recognize that some communist propaganda was creeping into movies. I felt it was a good thing to root that out, but I deplored the excesses that went with the rooting out process." He staunchly denied that either *Fugitive* or *They Won't Forget* were message films with a left-wing political viewpoint. While they raise no political banners, and certainly do not champion any alternatives to the American political system, they are nevertheless as subversive as any film ever made by a blacklisted director.

The contradictions in LeRoy's career are enormous. In the late Fifties, he returned to Warner Bros. where he made *The FBI Story* (1959), a picture with a decidedly right-wing bias. Now the director of the Thirties' *I Am a Fugitive* and *Little Caesar*, films that suggested criminals were only a reflection of a criminal society, was responsible for the ultimate paean to the lawmakers he had earlier scorned. And yet, listening to the director's own words, the consistency in his works at both studios, throughout his career, becomes clear. Whether liberal or conservative, radical or apolitical, he remained true to his story material, making the best film possible from that material.

If films like *The Wizard of Oz, Waterloo Bridge, Johnny Eager,* and *Mr. Roberts* have a different political viewpoint than *I Am a Fugitive* or *They Won't Forget,* they are still fine films. Perhaps we should remember LeRoy's films as the director intended—as good entertainment.

—Peter Roffman and Beverly Simpson

RECOMMENDED BIBLIOGRAPHY
Denton, Clive and Kingsley Canham. *The Hollywood Professionals: King Vidor, John Cromwell, Mervyn LeRoy.* NJ: A. S. Barnes, 1976
Kozarski, Richard, editor.*Hollywood Directors: 1941-1976.* NY: Oxford University Press, 1977.

LeRoy, Mervyn and Alyce Canfield. *It Takes More Than Talent.* NY: Alfred A. Knopf, 1953.
LeRoy, Mervyn and Dick Kleiner. *Mervyn LeRoy: Take One.* NY: Hawthorn Books, 1974.
Meyer, William R. *Warner Brothers Directors.* NY: Arlington House, 1978.

•••

Losey, Joseph Walton

(January 14, 1909 – June 22, 1984)

As a director, Joseph Losey matured and acquired a distinctive style during his years as an expatriate American in England and France, but his stylistic concerns and political preoccupations originated in the United States during the Thirties and Forties.

Born in 1909 in La Crosse, Wisconsin, into a privileged and educated family, he became very aware of the prejudices and puritanical stratification of the immigrant society in which his mother lived a life of frustration as a society matron. After studying medicine at Harvard, he quickly turned to the theater. Through his small acting parts, critical reviews, and production of public-service spectacles—such as an antiwar political cabaret on 54th Street in New York, the subsequent prowar Lunch Hour Follies for factory workers, the Russian War Relief show that later became the United War Relief, the Homage to Roosevelt at the Hollywood Bowl, and a State Department film called *Youth Gets a Break* (1939) with Jay Leyda and Willard Van Dyke—he gained a reputation as a leftist.

In 1946, Dore Schary, a noted Hollywood liberal, invited Losey to go to work for MGM, where he did nothing until following Schary to RKO two years later to direct *The Boy With Green Hair* (1948). It is often claimed that Losey's work has never really changed since this allegorical piece about a war orphan who becomes a pariah when his hair changes color. Losey's films feature stories structured around the ideology of class conflict with a psychological inversion of conventional norms. In his best-received films, *The Servant* (1963) and *The Go-Between* (1971), he drew attention to the expressions of class prejudices and roles by reversing them. As the manservant in *The Servant*, Dirk Bogarde assumes control over his master and exercises that power best when shaming him for being ungentlemanly, due to some all-too-human weaknesses. A young schoolboy, the title character in *The Go-Between*, is the fulcrum in the power struggle between Julie Christie and her aristocratic mother Margaret Leighton, who tries to get the go-between to betray Christie's illicit love affair with Alan Bates, a local farmer far below the station of her or her fiancé. While *The Boy With Green Hair* was meant as a science fiction allegory about prejudice, racism, and peace, and was, furthermore, endowed with the bold visual effects of studio sets and genre conventions, these two English films are more modestly presented and stylistically display more

fidelity to the social criticism at work in their artistry.

Meaning and political import were great motivating forces behind Losey's work, going back to his theater training which included developing "The Living Newspaper"; a study tour in Scandinavia and in the Soviet Union, where he studied Piscator's theory and Meyerhold's practice (1935); and a notable production of Brecht's *Galileo Galilei* (1947) that involved close collaboration with the playwright himself. The distilled theatrical gesture recurs in his films to signify the kernel of the affair, such as Eva's constantly distorted reflection in mirrors to point back to the self-reflective decadence of Venice in *Eva* (1962, a film which in its entirety, rather than the mutilated version distributed at the time of its release, is a jigsaw puzzle of symbols), or so succinctly in *La Truite* (*The Trout*, 1982) when Isabelle Huppert tosses her fish-farmer employer's beloved stuffed trout out the window and into the river. Most chilling is *Mr. Klein*'s (1976) use of a city map of Paris and dispassionate voice announcing the distances from one point to the next and the minutes necessary to round up the Jews, a visual correlative that illustrates the murderously inhumane efficiency to which the Nazis aspired. The wealth of such translations and overwrought details in Losey's films leave the viewer almost exhausted and too confused to see "the forest for the trees." Losey's pleasures in paradox can be quickly grasped, but they rarely achieve more than a critique of sophistication disguised as awareness in the lives of his characters. He is, in fact, so critical of his protagonists that he could be described as a misanthrope.

Losey's bitterness and disappointment in humankind can be traced back to his persecution by McCarthy as a communist in spirit and a New Dealer in his profession. When his colleagues opposed the signing of a loyalty oath at the Directors Guild, Losey led the way and helped organize; among his papers is a letter from sev-

enteen filmmakers including Ring Lardner, Jr., Lewis Milestone, Dalton Trumbo, and Brecht thanking him for his "unselfish and effective work" in "the common defense of our Constitution and our industry. You have launched a counterattack from which our whole people will profit." His extraordinary action, besides organizing a now-famous meeting at which John Ford defied the reactionary Cecil B. DeMille, was to galvanize the Guild against the oath. In 1951, four Hollywood films later, Losey was in Italy involved in a coproduction, *Stranger on the Prowl*, when he was summoned to appear before HUAC, which he failed to do because the production was in a constant crisis. He had already sat out a year waiting for his potential summons before embarking on a new picture, and he was in no mood to kowtow to a witch hunt. When he at last returned to New York, he had been effectively blacklisted, so he left almost immediately for Europe, rather than give secret testimony as his lawyer had encouraged him. Joseph Losey's name did not appear on the U.S.-Italian film when it was released in 1952.

In England, Losey's work was profoundly affected by a collaboration with Harold Pinter, which gave a psychologically perverse twist to an already distorted political perspective. Losey's exacting intelligence had found its equal in Pinter's scripts, and the resulting films illuminate darker areas of human motivation, if not political action. Losey's British films earned him an international reputation for his sharp perceptions of the class structure of that culture. His choice of locales and visually rich designs offer intellectually challenging cinema that often teeters on the edge of mannerism and pretentiousness. The Royal Artillery War Memorial introduces *King and Country* (1964) most effectively; Elisabeth Frink's sculptures in *The Damned* (1961) seem too overtly significant; *Modesty Blaise* (1966) uses op art quite in the ironic spirit in which it was created; the labyrinthine and byzantine

spirited house in *Secret Ceremony* (1968) is also stylistically haunting; and although Baden-Baden may be too romantic with no hint of deadpan humor in *The Romantic Englishwoman* (1975), Losey's view of transistorized, sushi-chic Japan in *La Truite* shows how adept he was at measuring the significance of a society and its weight on an international scale. Although Losey's point of view is usually serious and highly intellectual, his films are perhaps interpreted too seriously, for he enjoys a flair for small talk about big problems. His conversations tinkle like ice in a cocktail glass.

Losey's overtly political subjects such as *The Assassination of Trotsky* (1972) and *Les Routes du Sud* (*The Roads to the South*, 1978) tend to become psychological investigations lacking a firm foundation on the historical events that inspire them. *Trotsky* lacks ideological conflicts or tension and becomes a study in isolation. *Roads to the South* was a kind of sequel to *La Guerre est Finie* (1966), written for Alain Resnais by the same scriptwriter, Jorge Semprun, and featuring the same actor, Yves Montand. Semprun remarked on Losey's alleged political motivations, "He is a man who maintains his faith regardless of what happens, who has no desire to say anything critical about the Communist Party," which reduced the film's political critique considerably in Semprun's eyes. Losey's steadfast support of the Spanish Republic from his leftist days in Hollywood shines through an interesting pristine morality within the film, which unfortunately overpowers the opportunity to observe contemporary Spain. Compared to these films, *Mr. Klein* successfully manages to politicize the theme of the *doppelgänger*, as a professed Aryan Mr. Klein searches Paris for his Jewish namesake and, in the process, develops himself into that tormented and persecuted character. It is an intriguing fusion of the sadomasochism that runs as a constant theme through Losey's other films, where the point of view is usually confined to the masochistic character.

When Losey died in 1984, he had made thirty films and left one unfinished. A master of *mise-en-scène*, his work had often stumped critics and, even more often, audiences, but he continued to work in his analytical style on pathological stories quite fascinating in themselves but whose points were obscured in the telling. Controversy had riddled his life, and he had become inured to criticism from those less eloquent than he. As is apparent in Michel Ciment's 412-page interview book, *Conversations with Losey*, he was his own best critic, both politically and cinematically.

—Karen Jaehne

RECOMMENDED BIBLIOGRAPHY

Ciment, Michel. *Conversations with Losey*. NY: Methuen, Inc., 1985.

Hirsch, Foster. *Joseph Losey*. Boston, MA: Twayne Publishers, 1980.

Leahy, James. *The Cinema of Joseph Losey*. NY: A. S. Barnes & Co., 1967.

Milne, Tom. *Losey on Losey*. NY: Doubleday & Co., 1968.

Lumet, Sidney

(June 25, 1924 –)

Sidney Lumet's directorial career could be viewed as a successful prototype of the New York school of issue-oriented, anti-Hollywood auteurism. His work has reflected his political concerns more than his esthetic concerns, yet he is quick to deny such things as 'auteurism' and the elevation of the filmmaker as a high priest of culture.

His own reputation for speed, efficiency, and technical prowess is the result of having made over thirty films since 1958, in which he has directed some of the most talented and difficult actors in the film industry. Stories abound of Lumet's quick, good-natured dispatch of problematic productions, which often feature an ungainly mixture of politics, theatricality, social problems, and a complex montage that mingles past and present. Moreover, a wide spectrum of acting styles can occur in a Lumet film, lending the impression of different kinds of behavior typifying the class distinctions of his characters.

Actors' respect for Lumet seems to be in a direct correlation to his respect for them, which possibly derives from his own training as a child actor. He is the son of a noted veteran of the Yiddish stage, and acquired his first and only acting credit at the age of fifteen in *One Third of a Nation* (1939).

After a noteworthy career in television drama (in series such as *Omnibus, You Are There*, and *Alcoa Theater*), he made his film debut with *Twelve Angry Men* (1957), which drew on two major strengths he had developed in the years of telefilms: the ability to maintain dramatic tension with an ensemble of actors representing diverse social views, as well as a commitment to dramatizing an individual's sudden realization that he must face a potentially corrupt and unjust system alone. Throughout Lumet's career, these two traits have created the impression of a talent divided against itself. Lumet's actors render riveting performances as long as the characters are allowed to overpower the film (as Armand Assante does in *Q & A*, 1990); but when the message prevails, Lumet's direction (for example, of Nick Nolte in *Q & A*) is too heavy-handed to be effective. Nevertheless, he is careful to try to balance the weight of certain superstars (Ed Asner in *Daniel*, 1983) against the often moralistic import of his stories.

His more important films break down into two general categories: theatrical adaptations and political thought-pieces. Lumet's filmic translations of stage plays include *Stage Struck* (1958), *The Fugitive Kind* (1960) with Marlon Brando and Anna Magnani, *A View from the Bridge* and the critically acclaimed *Long Day's Journey Into Night* (1962) with Katharine Hepburn, and, much later in his career, the unlikely *Equus* (1977), *The Wiz* (1978), and *Deathtrap* (1982). Lumet is not afraid of imposing a starkly theatrical style on cinema, nor of importing the flair and shock value of clever stage plays. Still, his most successful adaptation, Chekhov's *The Sea Gull* (1968), is quiet, forceful, and faithful to the original's melancholy view of the passing of a whimsical, morally bankrupt era.

Lumet tried to explore the same nostalgia for the slipping away of ideals in both

The Group (1966) and *Bye Bye Braverman* (1968). The former settles for being simply a reunion confrontation, but *Braverman* is a witty if devastating analysis of four Jewish intellectuals on their way to a friend's funeral in a Volkswagen, anticipating the concept of Lawrence Kasdan's *The Big Chill* (1983), but penetrating far deeper the failure of this group's cherished and specifically Jewish ideals, while avoiding the parody frequently used for such comedy.

Indeed, Lumet is at his best portraying the desires and contradictions of Jewish life in New York. His two most ambitious films, *Daniel* (1983) and *The Pawnbroker* (1965), each deal with persecution. Presenting the past as open wounds that will not heal, Lumet creates a montage of memories that account for the psychological imbalance of his central characters, both of whom have been the victims of irrational political torment. The pawnbroker can no more escape the trauma of concentration camps than Daniel can escape a childhood in which his parents were electrocuted for treason. As each film shows the process of sorting out the truth from official versions, it merely leads to the realization that historical amnesia is the unofficial policy of life and survival in America.

Lumet directly confronts this syndrome in *Running on Empty* (1988), the story of two aging radicals (Judd Hirsch and Christine Lahti) responsible for a Sixties bombing at a napalm laboratory, which accidentally killed a janitor. They live "underground," necessarily forcing their children to give up the continuity of a normal childhood, and Lumet focuses on the links of the chain, as victims inevitably victimize others. It is arguably the best film about the heritage of Sixties college radicalism, but it does not attempt to recreate that era but rather reveals the continuing cost of crimes resulting from political commitment with an Old Testament twist as the "sins" of the fathers are visited upon the children.

In an even more literal fashion, *Family Business* (1989) featured three generations of criminals: the grandfather (Sean Connery) loves the life of crime; the son (Dustin Hoffman) reluctantly resumes it when his son (Matthew Broderick) abandons his scientific studies for a caper with Grandpa. This "family affair" features some riveting father-son conflicts in a story so riddled with credibility problems that one can only conclude that Lumet's attention was on the family, not the plot.

The patent necessity of digesting the past in order to prevent its repetition is one of those characteristics that can't help but create didactic cinema. *Daniel* is hampered by its source, E. L. Doctorow's *The Book of Daniel*, a novelization of the Rosenberg family masked as fiction. *The Pawnbroker* suffers from the excessive use of flashbacks to illustrate the isolation of the hero from a world utterly cut off from the man's suffering. *Running on Empty* failed to delineate the former faith or commitment of its protagonists and seems to echo facile judgments of Eighties yuppies against Sixties hippies. Nevertheless, perhaps it is not Lumet's personal politics that prompt him to drag into the light of the projector the tragic dimensions of political life in America, but rather his astute observations about the ways in which family bonds are inevitably weakened by individual aspirations.

Lumet's readiness to address the conflicting emotions of filial piety can even be seen in the truffle of a comedy, *Garbo Talks* (1984), in which a nice Jewish boy tries to track down Greta Garbo for his dying mother, whose obsession with the actress is the only frill in a life devoted to stamping out social injustice in Manhattan. Lumet's fondness of Jewish ethnicity is a strength that permits him to highlight its nuances with precision and verve.

The general public responds most favorably to the social indignation that drives Lumet's thrillers—*The Anderson Tapes* (1971), *Dog Day Afternoon* (1975), *Network* (1976), and *Power* (1986). In each of these, he packs a furious indictment

against media-mad America and sketches out a Watergate style of the technological invasion of privacy. The apparatus is in place to record any and all communication in *The Anderson Tapes*, and the concept is driven to glamorous extremes in *Power*, a film full of slick surfaces and shallow characters. In *Dog Day Afternoon*, a determined criminal is intent on cathode celebrity, while *Network*'s anchorpersons have been boxed into the lunacy of media power to the point of becoming caricatures of their own inspiration, as far removed from the realities that shape the news as they are from the responsibility of reporting it. Clearly, Lumet's thrillers provide a framework for criticizing the media.

Lumet's propensity for ripped-from-the-headlines realism gave *Dog Day Afternoon* its alarming edge and subsequently electrified two "cops-as-robbers" films. *Serpico* (1973) features the policeman as hero, an iconoclastic crusader, to whom Lumet lends the complexity of having an obsession that may cost him his life and freedom, however just his cause. It was, incidentally, Serpico's battle against police corruption that led to the formation of the Knapp Commission, called The Chase Commission in Lumet's later cop corruption movie, *Prince of the City* (1981). That film was based on Robert Daley's taut account of the case of Robert Leuci, a narcotics detective in the Special Investigating Unit with dubious motives for cooperating with an investigation. The 167-minute movie sprawls across the city, exposing the quicksand beneath the con-

crete jungle that sucks logic and reason down into argumentative, vicious cycles. This extraordinary tapestry of New York law enforcement-*manqué* is considered by many to be vast but shallow, yet it has been defended by critic Andrew Sarris as "the high point of cinematic realism in the New York school of filmmaking."

With *Q & A*, Lumet attempted a reprise of a cop so jaded that he willfully ignores police procedure in order to pursue his own savage vision of justice based on racism and homophobia. The dialog indulges in endless racist slurs and epithets to illustrate the point that ethnic diversity is never melted down in the New York pot and only provides the basis for a society fractured by fear of "the other."

Many critics consider the pretension of Lumet's themes in conflict with his avowed workaholic approach to production. If his films do not achieve their political ambitions, at least they are imbued with a rare social commentary. At the very least, Sidney Lumet remains the most politically adventurous director of big-budget Hollywood fare.—Karen Jaehne

RECOMMENDED BIBLIOGRAPHY

Bowles, Stephen E. *Sidney Lumet: A Guide to References and Resources*. Boston, MA: G. K. Hall and Co., 1979.

Cunningham, Frank R. *Sidney Lumet: Film and Literary Vision*. Lexington, KY: University of Kentucky Press, 1992.

Rose, Reginald. *Twelve Angry Men: A Screen Adaptation, Directed by Sidney Lumet*. Irvington, NY: Irvington Publishers, 1989.

Maltz, Albert

(October 28, 1908 – April 26, 1985)

s the gates of five federal prisons opened, in the summer of 1950, to admit seven Hollywood screenwriters, two directors, and one producer, a blanket of censorship began to envelop free expression in America.

When the gates reopened, in the spring of 1951, a motion picture blacklist was in full effect, a new, wider set of congressional inquisitions were opening, and sponsors, producers, and publishers were setting limits on what topics could be written about and what people could write them. By 1953, libraries were purging their shelves of books written by "communists" or favoring "communist" ideas.

Albert Maltz, the only one among the Hollywood Ten who had established a successful literary career outside the studio system, was thrice punished. For steadfastly maintaining his First Amendment right to remain silent about his political beliefs, Maltz was fined and jailed, blacklisted from the movie industry, and shut off from access to mainstream book and magazine publishing in America. Between 1935 and 1941, when he was pursuing the short story genre, Maltz's work appeared in *Harper's*, *Scribner's*, and *The New Yorker* magazines and was selected for prestigious anthologies; after 1950, no mainstream magazine printed his work until the *Saturday Evening Post* accepted two in 1968. (*Afternoon in the Jungle*, a collection of his stories, was printed by Liveright in 1971.) When Maltz switched to novels, in the late Thirties, Little, Brown published all three he submitted to it (*The Underground Stream* in 1940, *The Cross and the Arrow* in 1944, and *The Journey of Simon McKeever* in 1949); seventeen publishers rejected his next novel, *A Long Day in a Short Life*, while sixteen foreign publishers and the American communist publisher,

International, printed it (1956). A British film, Calder and Boyers, published *A Tale of One January* in 1966.

By 1950, Maltz had established himself in America and abroad as a talented author of dramatic tales of individuals facing difficult, human choices. A meticulous researcher, all his stories and novels succeeded in rooting his characters in believable social and historical milieus. His political concerns directed him to his subjects, but his artistic sensibility dictated his treatment of them. Maltz's literary skills did not suddenly disappear in 1951, and the truncation of his fiction writing career stands as a depressing testament to the effectiveness of the censorship that he and nine other men had warned the country about during their three-year fight to stay out of prison. All were punished professionally for their politics—Maltz more than the rest.

Maltz did not come from a political or literary background. He was born October 28, 1908, in Brooklyn. His parents were immigrants from Eastern Europe. But by the time he graduated from Columbia University, in 1930, Maltz had developed a powerful hatred for war and racial and ethnic intolerance, and a determination to become a writer. During his second year at the Yale School of Drama, he and George Sklar wrote a play about political corruption (*Merry Go Round*), which was produced in New York in the spring of 1932. Their second play, an antiwar drama (*Peace on Earth*), became, in 1933, the first production of the Theatre Union,

America's only professional theater devoted to producing plays of social importance for working-class audiences, and the first example of a grassroots people's front organization. The members of the Executive Board came together voluntarily from all points of the left political spectrum, and stayed together, producing eight plays, until a lack of money forced them to disband in 1937. Maltz wrote one other play for the Theatre Union, *Black Pit*, concerning labor unions in the coal-mining industry.

During those years, Maltz worked for the Dramatists Guild, joined the Communist Party, served on the Executive Board of the League of American Writers, and helped found and edit *Equality*, a magazine dedicated to countering the anti-Semitism of Father Charles Coughlin.

Because he could not support his family on the money he earned from plays, short stories, and teaching, Maltz decided, in the spring of 1941, to come to Hollywood. He needed financial means to support the novel-writing career on which he had just embarked. "I came to the film industry," he recently said, "with a personal plan, which I adhered to for the six and a half years from my arrival until the blacklist, and that plan was to do everything I could to minimize the amount of film work I did in order to have as much time as possible for fiction...For me, until the blacklist came, Hollywood was a blessing. It was the way in which I could finance my serious writing while meeting my other obligations."

He found scriptwriting challenging, but not as challenging as novel writing. Therefore, he avoided long-term contracts, and, when finances permitted, proved very selective in the projects he accepted. His philosophy education and play-writing experience endowed him with a keen sense of dramatic structure, and he took to screenwriting with relative ease. During the Forties, none of his scripts were rewritten by other screenwriters.

His first two screenplays (*This Gun for Hire*, 1941, and *Destination Tokyo*, 1943) were formula melodramas—the former an espionage thriller, the latter a submarine adventure—for which Maltz produced tightly crafted scripts, interspersing dramatic incidents and lean dialog. There is nothing in either to indicate that Maltz was a member of the Communist Party, but he was fortunate to secure two jobs whose subjects paralleled his political activity. In 1942, he wrote the commentary for a documentary film on Russian resistance to the German invasion, *Moscow Strikes Back*. In 1945, he wrote the script for a short subject, *The House I Live In*, which advocated tolerance for all peoples. The studio assignment that most closely touched Maltz's political life was *Pride of the Marines* (1945). He told the story of Al Schmid, a Marine blinded during the battle of Guadalcanal, and, at the same time, effectively dramatized the ideals and emotions that sent a generation of Americans to war in 1942 and the fears and hopes that accompanied their return to civilian life.

Maltz was much in demand by the studios. He worked fast and produced filmable scripts on or ahead of schedule. His work received the accolades of his profession: *Moscow Strikes Back* received an Oscar in 1942; *The House I Live In* a special statuette in 1945; Maltz was nominated for a best screenplay award for *Pride of the Marines*; and the films made from his scripts did very well at the box office. Nevertheless, after 1945, Maltz was in a financial position to be selective about movie projects; he would only interrupt his novel writing if the price were high enough (*Cloak and Dagger*, 1946—a spy potboiler) or the project interesting (*The Naked City*, 1947—a police procedural in quasidocumentary form).

An unsolicited, unremunerated piece of writing, however, snared Maltz in the most painful episode of his professional life. On February 12, 1946, *New Masses*, the communist literary magazine, printed "What Shall We Ask of Writers?" that Maltz had written in response to the magazine's invitation for a wide-ranging discussion of literary viewpoints. No writer of worth disagreed

with Maltz's comment that the Communist Party thesis of art as a weapon in the class struggle was a "vulgarization of the theory of art" and a "straitjacket for the writer"; it certainly had not produced any worthy literature. But the article appeared at the cusp of a critical period in international affairs. The Cold War had begun and the two sides were arming. communist leaders decided that discipline had become too lax and ideological militancy too passive for the impending struggle against the postwar policies of the United States government. Maltz was attacked in writing by party critics and in person by party hierarchs. The vast majority of Hollywood writers deserted Maltz, and he, feeling isolated, fearful of weakening the party and being expelled from it, recanted. His "apology" appeared in the April 9 edition of *New Masses*. It was, he later said, "the most unsettling experience of my life, infinitely worse than going to prison." He had become the unwilling symbol of CP dictatorship and membership subservience. Yet he continued to write as he always had.

During the blacklist era, two scripts of his were made into movies, but neither bore his name. His finest screen work was *Broken Arrow* (1950), a film he wrote to raise money for the defense of the Ten. It was the most sensitive film portrayal of Native American culture to come from the pen of a Hollywood writer. Maltz depicted the clash of cultures objectively and treated both whites and Apaches as peoples capable of civility, dignity, and savagery. Michael Blankfort, as an act of friendship, put his name on the script, and, when it was bought by the studio, made the revisions. The movie was well received and Blankfort was nominated for an Academy Award. (He died in an accident, in 1982, shortly after he told several associates that he was about to write a letter acknowledging Maltz's authorship.) Twentieth Century-Fox released *The Robe* (1953), which Maltz had written in 1944. Philip Dunne, who revised it for production, was not told that Maltz was the author.

Maltz did no screen or political work for several years after his release from prison. He moved to Mexico to free himself to write novels. He left the Communist Party in 1956, after reading Khrushchev's speech exposing some of the crimes of Stalin, and he resumed some scriptwriting in 1957. As a favor, he rewrote a script for a Mexican film (*Flor de Mayo*) and, to earn money, agreed to write a film based on a historical novel, that was to be released by United Artists. But bad luck dogged his efforts. The American film was not made, but Maltz, in the meantime, had to turn down an offer to write *Spartacus* (which Dalton Trumbo wrote, under his own name, for Universal in 1960). Then, Maltz's adaptation of *Exodus*, a more accurate presentation of the events depicted in the novel, was rejected by Otto Preminger, who used Trumbo's more direct treatment. Finally, as other blacklisted writers were openly returning to work, Frank Sinatra's announcement that Maltz would write *The Execution of Private Slovik* drew such a blast of opprobrium from right-wing groups, that Sinatra abandoned the project.

It was not until January 1964 that Maltz signed a film contract under his own name. Three scripts of his have since been made into films, but he was not happy with any of them: *Two Mules for Sister Sara* (1970); *Beguiled* (1971), from which he had his name removed; and *Scalawag* (1973), from which he wished he had his name removed.

Albert Maltz died, on April 26, 1985, shortly after completing his last book, *Bel Canto*, a novel about a woman in the French Resistance.—Larry Ceplair

RECOMMENDED BIBLIOGRAPHY

Maltz, Albert. *Afternoon in the Jungle*. NY: Liveright Publishing Corp., 1971.
————— *Tale of One January*. NY: Riverrun Press, 1989.
Salzman, Jack. *Albert Maltz*. Boston, MA: Twayne Publishers, 1978.
Zheutlin, Barbara and David Talbot. *Creative Differences: Profiles of Hollywood Dissidents*. Boston, MA: South End Press, 1978.

Woman of the Year

Marriage in the Movies

M arriage has always been the premise of personal happiness in American films, especially for women who, no matter how beautiful or accomplished, wither when they don't marry.

Even in the films of the Seventies and Eighties made long after Hollywood had supposedly been enlightened to the injustices to which women in our society—and in our films—are heir, the achievements of a woman crumble if she remains alone. So Lily (Jane Fonda) is lost without Hammett in *Julia* (1977) and, likewise, Emma (Anne Bancroft), the aging ballerina, founders in *The Turning Point* (1977).

Power, protection, consolation, validation—these are provided to women in American (and many foreign) films most reliably in marriage. It was only a Mae West who could say (in *My Little Chickadee*, 1939), "Every man wants to protect me. I can't figure out what from." At the end of that film, when she must

choose which of her suitors to marry, West decides to keep both at bay; she promises her verdict "maybe tomorrow, maybe never."

But Mae West was unique, her persona resembling more a man's than a woman's. The heroes of American films, from genre to genre, begin in positions of power, know how to protect themselves, seek consolation more often than not from other men, and, like Mae West, resist marriage as long as they can.

The Production Code of 1933–'34 which governed the treatment of morality and sexuality in our films until the Sixties viewed marriage as indispensable to the integrity of good people, the stars with whom we vicariously identified. The Hays

office was devoted to preserving the social and cultural institutions of capitalism in our films, and along with them the notion that in marriage woman functioned as the property of a man. No wonder that, in part, it was the sexually uninhibited Mae West, never anyone else's possession, who spurred him on to achieve his stranglehold over Hollywood. This was the Mae West who, in the pre-Code *She Done Him Wrong* (1933), when asked, "Ever meet a man who could make you happy?," could reply, "Sure, lots of times." From the early Thirties on, women's sexuality expressed outside of marriage would be treated as vulgar, humiliating, and immoral—and this includes supposedly post-Code films like *Klute* and *Chinatown*, both made in 1972.

The Production Code insidiously divorced sexuality from marriage. If marriage was sacrosanct, the twin beds required of married couples in Hollywood films suggested that if sex existed between people, it was not here. (This absurdity did not, of course, go unnoticed; in *Adam's Rib* [1949] there are indeed two beds in the bedroom of married lawyers Hepburn and Tracy, but, in the morning *mise-en-scène*, it is apparent that one has not been slept in!)

But *Adam's Rib* was an exception. In most American films marriage meant family and children, not sexual excitement between men and women. The family as a social institution was safeguarded. Marriage became a reward for sexuality withheld, as if our films recognized that were sex readily available, marriage itself would disappear. Despite the resurgence of the career woman in American films of the late Thirties and Forties, coinciding with women occupying the workplaces while the men went off to war, in most of these movies career either palls or disappears entirely once marriage completes a woman's life. When the men returned in the Fifties and wanted their jobs back, marriage became not the culmination of a woman's life, but her very *raison d'être*.

Nevertheless, it has also been true that even before the Code, marriage had been

an imperative for upright men and women in at least the "woman's film." Marriage as woman's fate began with the first fiction films, with D. W. Griffith and with such films as Cecil B. DeMille's *Male and Female* (1919). Meanwhile, side by side with the soaps, entire genres (the Western, the gangster film, and science fiction) grew up devoted to men's escape from the constraints of domesticity; in *Close Encounters of the Third Kind* (1975), the wife cannot compete with the shining aliens; in *Butch Cassidy and the Sundance Kid* (1969) and *The Sting* (1973), the men opt for an anarchic precapitalist arena of self-expression, renouncing marriage with its implications of woman as both property and jailor.

Marriage does not even fare well in a late "woman's film" like *The Way We Were* (1973). As Molly Haskell puts it in *From Reverence to Rape*, "The flight from women and the fight against them in their role as entrappers and civilizers is one of the major underlying themes of American cinema."

Indeed, the interesting men, the flamboyant men, even in nongenre films like *Gone With the Wind* (1939) and *Citizen Kane* (1941), manage to leave their wives behind. When a man must define himself in a marriage, as in *Straw Dogs* (1972), it is because marriage is finally about property. For Dustin Hoffman protecting his wife and his home from the rampant low-lives amounts to the same thing. "This is my house. I fixed up this house," George (Albert Finney) echoes in *Shoot the Moon* a decade later. Wife and property remain interchangeable.

Hollywood's reaction to the women's movement of the late Sixties and Seventies was to eliminate women from films almost entirely, and so we were given "buddy films" depicting quasimarriages between two men. The list includes *Midnight Cowboy* (1969), *Butch Cassidy and the Sundance Kid* (1969), *The Sting* (1973), *Pat Garrett and Billy the Kid* (1973), *M*A*S*H* (1970), *Deliverance* (1972),

Papillon (1973), *Thunderbolt and Lightfoot* (1974), and many more.

But this was nothing terribly new for American films. The true marriage in *Red River* (1948) was between John Wayne and Montgomery Clift; their reunion at the end, when they admit that they really do "love each other," proves that when things go wrong, no relationship with a woman, no marriage, can make them right.

For the women in American films, the opposite has been true: without marriage they cannot survive. Marriage has been the symbol of woman's subservience. In the Thirties this was as true for Katharine Hepburn in *Christopher Strong* (1933), a film directed by a woman (Dorothy Arzner), as it was for Claudette Colbert in Frank Capra's screwball comedy, *It Happened One Night* (1934). The wedding at the end of the Capra film is aborted, with the aid of the rich capitalist father, because the woman must marry the "right" man (Clark Gable), but marry she must.

In *Christopher Strong,* when aviatrix Hepburn conceives a child out of wedlock, rather than break up the marriage of Strong and his all-suffering wife (Billie Burke), she kills both herself and her unborn baby. Although Arzner chose career women as her heroines, as in *Dance, Girl, Dance* (1940), their lives were incomplete without marriage. Conveniently Ralph Bellamy, on whose shoulder ballerina Maureen O'Hara leans at the end of *Dance, Girl, Dance,* is both director of the ballet company she wishes to join, and a likely candidate for marriage.

Marriage was an imperative for women in the unlikeliest of films, from *Casablanca* (1942) to *Mildred Pierce* (1945). Mildred without a husband is a ship without a rudder; if temporarily she succeeds in business, she also manages to ruin the lives both of her two daughters and herself.

But it was the Fifties which really put the career woman in her place, and demanded that no arena of self-expression, however fruitful, compete with marriage

as a woman's destiny. It would appear that in periods of economic prosperity for America, like the Fifties and the Eighties, marriage is newly depicted as the *sine qua non* of personal happiness. In *How to Marry a Millionaire* (1953), marriage is called "the biggest thing you can do in life," and Marilyn Monroe vows to marry "any Rockefeller—or Mr. Cadillac." In this fantasy of upward mobility through marriage, the fate worse than death is being an old maid, that parched neuter portrayed by Hepburn in *Summertime* (1955), Rosalind Russell in *Picnic* (1956), and later Joanne Woodward in *Rachel, Rachel* (1968), and Maggie Smith in *The Prime of Miss Jean Brodie* (1969). *Father of the Bride* (1950) and *Father's Little Dividend* (1951) depicted marriage and family as the only natural course of human life, along with owning property; so father Tracy bought his own home when he was made partner. Fiancé Rod Taylor says "everyone should marry young," while mother Joan Bennett contributes this: "A church wedding is what every girl dreams of."

The full drama of marriage encompassing even the career woman's very existence is enacted best in *All About Eve* (1950). Bette Davis plays Margo Channing, brilliant star of the stage, and in love with director Bill Sampson (Gary Merrill), eight years her junior. Because the premise behind the depiction of women in American films has been that wife must function as reliable childbearer, young women have often been matched with older men—Audrey Hepburn with Gary Cooper in *Love in the Afternoon* (1957) being the most flagrant example. Rarely has the older woman been permitted happiness, let alone marriage, with a younger man.

In *All About Eve* Davis, never more beautiful or more worldly, must therefore worry not only about not being married, a disgrace no matter her professional achievements, but also that her younger partner may easily stray. The solution is to put marriage first, career somewhere in

the caboose. "Nothing's good unless you can look up at dinner or turn around in bed and he's there," says Margo. "Or you're something with a French provincial office—but you're not a woman."

When Bill proposes, Margo is ecstatic: "I'm going to look up at six o'clock and there he'll be." Exchanging her career to be "a married lady," she announces, "it means I finally have a life to live." The character of Karen played by Celeste Holm, who feels "that helplessness you feel when you have no talent to offer, except for loving your husband," and who almost loses playwright Lloyd Richards to the scheming Eve (Anne Baxter), suggests that marriage alone is not enough. This final ambivalence about marriage adds tension and nuance to an already remarkable film.

It might also be noted that the marriage partners proposed for the women in these Fifties films were hardly the models of virility reserved for Westerns and other male soaps: Monroe was paired with David Wayne in *How to Marry a Millionaire* (1953), Tom Ewell in *The Seven Year Itch* (1955), and Don Murray in *Bus Stop* (1956). Real men did not marry, reformed playboy Rock Hudson in *Pillow Talk* (1958) notwithstanding. Indeed, those professional virgins maneuvering to trap men—Debbie Reynolds in *The Tender Trap* (1955) and Doris Day in *Pillow Talk* (1959), *Lover, Come Back* (1961), and *That Touch of Mink* (1962)—were hardly advertisements for marriage.

In fact, there had always been unappealing portraits of marriage in American films from Rosalind Russell in *Craig's Wife* (1936) and Barbara Stanwyck in *Double Indemnity* (1944) to Bette Davis as the restless, amoral housewife in *Beyond the Forest* (1949) and Elizabeth Taylor's shrew in *Who's Afraid of Virginia Woolf?* (1967). In spite of themselves, Hollywood filmmakers have occasionally depicted marriage—even the nuclear family, although more often marriage without children—as a hothouse of stifling repression, suspi-

cion, and thwarted impulses, a prison for women from which there was no escape. Yet Hollywood could propose no solution that was not even more debilitating than the marriage itself. With the increasing relaxation of the Hays Code as the Sixties wore on, and the influence of the rebellion against a puritanical approach to sexuality that characterized the decade, more films exploring the limitations of marriage began to appear.

The challenges to political authority in the Sixties led to a corresponding skepticism about marriage as a viable institution. Coupled with a backlash against the women's movement, this produced a spate of films in which marriage is portrayed as dull and enervating, as George Segal in *Loving* (1970) and John Cassavettes in *Husbands* (1970) found.

The movement for equal rights for women awakened a misogyny in an industry run largely by men. Remaining interested in one woman in a marriage seemed as difficult for Art Garfunkel in *Carnal Knowledge* (1972) as it did for James Bond. In a film sympathetic to women like Robert Altman's *McCabe and Mrs. Miller* (1972), marriage is viewed as legalized prostitution. So Mrs. Miller (Julie Christie) tells the mail-order bride played by Shelley Duvall—sex with her husband was not her duty, she did it to pay for her room and board. "I was your hooker," says Erica (Jill Clayburgh) to her husband Martin (Michael Murphy) in *An Unmarried Woman* (1978), "a fancy East Side hooker by way of Vassar hooker." As Ingmar Bergman expressed it in *Scenes from a Marriage* (1973), "Two people who have matured together in a marriage" need change, even if it is only change for its own sake.

From *Bob & Carol & Ted & Alice* (1969) to *Diary of a Mad Housewife* (1970) to *Kramer vs. Kramer* (1979), films of the Sixties and Seventies revealed that when faith in the social order—communist or capitalist—has declined, an institution like marriage, with its roots in male authority,

cannot remain intact. "Do you think we're living in utter confusion?," Marianne asks Johan in *Scenes from a Marriage,* referring to "the whole lot of us." Indeed, the "fear, uncertainty, folly" of which Marianne speaks make the permanent marriage assumed in films of the Forties and Fifties a quixotic ideal of childhood.

"Maybe it's just not meant to be enjoyable with women you love," says Sandy in *Carnal Knowledge,* while Jonathan (Jack Nicholson) avoids marriage because "I'm taken—by me!" When her daughter asks her to name three happily married couples, Erica in *An Unmarried Woman* cannot do it. Atypically, Erica at the end refuses to succumb to another marriage, although her suitor Saul is a paradigm, and her best friend advises her, "Do you know how rare a man like Saul is?...Start packin', honey." "Saul and Erica will be different from Martin and Erica," pleads Saul. But will it?

The "liberation" of the Sixties and Seventies is belied by the narcissism of the characters in films where marriage is an issue; it is a self-absorption that makes both marriage and parenthood very precarious undertakings. Indeed, marriage in American films has often been viewed as if children were not a likely product of the union of men and women. The marriage between equals of Tracy and Hepburn in *Adam's Rib* and *Pat and Mike* (1952) seems possible only without the complication of children; having children is presented as a working-class phenomenon: Doris Attinger (Hepburn's client in *Adam's Rib*) has a brood; Hepburn has a childlike nickname, as does Tracy (Pinky, with a "y" for him and an "ie" for her).

By the Sixties, Seventies, and Eighties, children become symbolic of the impossibility of a harmonious marriage, like the two nasty little girls, clones of their father (Richard Benjamin) in *Diary of a Mad Housewife* (1970). When Woody Allen in *Manhattan* (1979) lists the things that make life worth living, he includes the crabs at Sam Wo's (a restaurant on Mott Street in New York's Chinatown), but does not mention his son.

More realistic were *Kramer vs. Kramer, Terms of Endearment* (1980), and *Shoot the Moon* (1982), where marriage is seen in the context of family and what happens to children when marriages go wrong. Decrying romanticism, each of these films—as well as others like *Ordinary People* (1980)—views marriage as a responsibility to children that nothing ought to supersede. Meryl Streep's selfish Joanna trying to "find herself" in *Kramer* is ludicrous and deserves to lose Billy. If Ted (Dustin Hoffman) should keep his son, it is because after Joanna's defection, he and his son have "built a life together." As for Joanna and Ted, it appears that they can be civilized to each other only outside of marriage.

The trauma inflicted on older children is dramatized most painfully in *Shoot the Moon* where the oldest daughter Sherry screams, "I hate Daddy," and "I'll never get married." Her anger extends equally to her mother: "You fucked Daddy last week and you fuck Frank this week. Who're you gonna fuck next week?" As *Making Love* (1982) painfully reveals, heterosexuality itself has been called into question. The married couple may watch clips of *An Affair to Remember* (1956), but when the psychiatrist husband finds a male lover, it heralds the breakdown of the very concept of marriage as an option.

In the films of the mid-Eighties, however, marriage seems revised as a personal imperative. Films like *The Big Chill* (1983) discover that the characters with the best careers have not found personal happiness; it is only the marriage between Harold (Kevin Kline) and Sarah (Glenn Close) that provides an atmosphere of love. They are the enviable ones, their marriage so secure that Sarah even offers Harold as a stud to an old friend who wishes to get pregnant before her biological clock stops ticking.

In *Falling in Love* (1984) Frank (Robert De Niro) and Molly (Meryl Streep) cannot

come together outside of marriage (that would be cheating); "Would it become once, twice a week?," Molly asks Frank. In the best tradition of Hollywood, and as if the Sixties and Seventies with their more realistic views of marriage had not happened, Molly holds out for permanence.

As if Will Hays had been raised from the dead, Eighties films warned women: Should they treat marriage lightly, they will wind up like Jacqueline Bisset in *Rich and Famous* (1981). They will be reduced to picking up homosexual hustlers in the street, or pinning their hopes on younger, narcissistic men who will soon dump them. Strong men available for marriage are as scarce as they were in the days of John Wayne; neither Redford in *Out of Africa* (1985) or Nicholson in *Terms of Endearment* is husband material; we are left with the Richard Benjamins, the weak Ted Danson soon killed off in *Just Between Friends* (1986), or Kevin Kline, domesticated, passive, and uncertain in *Violets Are Blue* (1986).

The Eighties concluded that marriage may be diminished, but without it we resort to anarchy, like Albert Finney slamming into his wife's new tennis court at the close of *Shoot the Moon*. Living together won't do for Professor Gretchen in *Sweet Liberty* (1986); under the endtitles we view a very pregnant and self-satisfied wife on the arm of her prey Alan Alda. It is 1958 all over again—Doris Day enlisting Rock Hudson to push their baby carriage at the end of *Pillow Talk*.

Equally for the "*auteur des auteurs Ameriques*," as Norman Mailer has described Woody Allen, the treatment of marriage has also changed with the times. The freedom demanded at the end of *Annie Hall* (1977), or the marriage with

neurotic women of a certain age rejected in *Manhattan*, where Isaac can joke, "People should mate for life like pigeons and Catholics," becomes the glorification of the couple, of marriage sustained in *Hannah and Her Sisters* (1986).

The marriage between equals remains as elusive in the American film as it did in the Thirties, Forties, and Fifties. In such a film the woman must work at a fulfilling profession, and in a society not given to gestures encouraging economic equality between rich and poor—or between the sexes—such an image has been more than rare. Lauren Bacall as saloon singer to Bogart's adventurer in *To Have and Have Not* (1944) comes close. Hepburn and Tracy, of course, reveal the possibility in *Adam's Rib*.

Here for the woman, as for the man, marriage is viewed as just one aspect of life. It may be the most important, but it does not rule out the other half of the equation proposed by Freud. Equality is perhaps contingent on having money— Hepburn and Tracy cook together on the maid's night off! Untrammeled self-expression in this film rules out the presence of children, but that the free woman makes the best wife there is little doubt. With the genuine equality between man and woman that suffuses this film, marriage indeed becomes sheer bliss.—Joan Mellen

RECOMMENDED BIBLIOGRAPHY

Gehring, Wes D. *Screwball Comedy: A Genre of Madcap Romance*. Westport, CT: Greenwood Press, 1986.

Kendall, Elizabeth. *The Runaway Bride: Hollywood Romantic Comedy of the 1930s*. NY: Doubleday, 1990.

Sikov, Ed. *Screwball: Hollywood's Madcap Romantic Comedies*. NY: Crown Publishers, 1989.

A Night in Casablanca

The Marx Brothers

Marx, Leonard "Chico" (March 22, 1891 – October 11, 1961)
Marx, Adolph "Harpo" (November 23, 1893 – September 28, 1964)
Marx, Julius "Groucho" (October 2, 1895 – August 19, 1977)
Marx, Herbert "Zeppo" (February 25, 1901 – November 29, 1979)

L
ike Chaplin, the Marx Brothers aren't for real: in costume
and makeup, in the way they move and the sounds they
make, they are fantasy creations who could exist only on a
stage.

On the street—in the real world—they would be arrested for disturbing the peace. Unlike Chaplin, who of course directed his own work and who evolved a subtle film style in order to protect his performances, the Marxes never fully adjusted their act to movies; they remained knockabout vaudevillians, zany sketch artists performing a series of blackout routines. By all the odds, they really ought to have flopped in pictures.

Given the kind of antic cutup comedy that was their stock-in-trade, it is probably true that the theater was their ideal medium. In vaudeville and then on Broadway in the Twenties, the Marxes talked back to the audience as well as to the script, spinning delirious variations on their patented gags. Filmmaking robbed them of crucial props, an audience to play with, and the freedom to ad lib. Performing for a wooden-faced director and crew and having to repeat routines for take after take sapped their spontaneity, and on screen their work often has a frozen quality: it looks stagy. The Marxes complained about their directors, claiming they never found one who understood their humor or the way they needed to work to keep their performance fresh, but in fact their directors

were remarkably self-effacing. To a fault, the films were designed as Marx Brothers showcases. Typically the camera maintains a fixed, neutral distance from the comics, giving them the kind of empty forestage that was traditionally accorded dancers and singers in musical production numbers. The camera mimicks the viewpoint of an audience member in a theatre, and the long takes and medium to long shots that are the filmic equivalent of unbroken theatrical time and space reinforce the illusion that we're watching a show. Avoiding rhetoric—editing and composition are severely minimalist—the films have a stilted quality that's at variance with the mayhem the Marxes concoct. When they are cutting up the camera remains glued in place, paralyzed in a misguided attempt to preserve the integrity of their burlesque routine.

Their first films, *The Cocoanuts* (1929) and *Animal Crackers* (1930), were virtually literal transcriptions of their stage successes. But even later original films were constructed in a theatrical-revue format, their stories stitched together as a series of more or less discrete comic and musical numbers. In the mid-Thirties Irving Thalberg attempted to camouflage the Marxes' vaudevillian shtick with MGM gloss by ordering more fully developed romantic subplots and more frequent and elaborate production numbers. Of all their films, only *A Day at the Races* (1937) achieves, intermittently, a genuine movie-like rhythm, in the climactic race and in a musical skit with Harpo wandering into what looks like a set from *Porgy and Bess*. Its black singers, dancers, and musicians may be racist stereotypes but the extended number beautifully reconstructs the closed, limbo-like stage space in which most of Marxian vaudeville is suspended. And only in *A Day at the Races*, despite the trademark diversions, is there a story that sustains interest: will Maureen O'Sullivan be able to raise enough money to save her failing sanitarium?

But of course it isn't filmic fluency or narrative suspense that we want from the Marxes. Their movies continue to be popular not because they are well-made but because they still arouse laughs. It is indeed the triumph of Marx Brothers comedy that it breaks through the staring, inhibiting camera and the antediluvian narrative format. The films are archaic yet they are not museum pieces, records of a lost theatrical art; at their best they are unobtrusive frameworks for a comic trio whose personae are still vital, quick, and unnerving.

Dedicated to subverting pomposity and propriety, the Marxes are political humorists with timeless targets. The boys certainly wouldn't have defined themselves in this way—they always claimed they were interested in getting laughs rather than in making statements, and indeed to talk solemnly of Marxian "politics" is to be set up as the butt of one of their con jobs. Politicians without a platform, they are anarchists bent on toppling middle-class pieties. As the American talking pictures' first surrealists they are cagey lords of misrule who oppose logic, common sense, a longing for order; they're Minnie's bad boys who delight in demolishing whatever unlikely place they happen to be in—the opera, a college campus, a cruise ship, a society party. Thumbing their noses at repression, confounding authority, ruffling their archetypal foil, stately matron Margaret Dumont, they provide vicarious release for their audiences, as they enact a cathartic charade of irresponsibility and chicanery.

The characters they created were trickster-clowns who act on feelings of aggression and sexual desire in ways that the folks on the other side of the footlights wouldn't dare to. Their getups declare their distance from the grown-up real world: Groucho with his thick painted eyebrows and mustache and his diagonal walk; Chico with his derby, tight-fitting antiquated suit and fabricated accent; Harpo with his curly fright wig, beeping horn, floppy clothes, and his silence.

Working as a team, pooling their motley oddnesses, fortifies their assaults.

Groucho is the ringmaster, the boss (as Chico calls him, always with a sly undertone) whose stream of staccato quips, puns, one-liners, and nonsequiturs delivered in caustic New York-ese punctures the possibility of rational discourse. Always a fake, a play-actor, Groucho is cast absurdly against type as an African explorer, a college president, the leader of a country, a veterinarian. His bogus roles mock professionalism and make saps out of everyone who plays by the rules. It's often been noted that Groucho can be cruel, especially in his treatment of the eternally forgiving Margaret Dumont; he spews disdain, aimed almost as often at his brothers as at the pompous fools he dupes. Less remarked on is Groucho's edge of boredom. He was the Marx who most wanted a theatrical career and who held onto fame longer and more greedily than his brothers, yet sometimes he doesn't seem to enjoy performing. For all his verbal alacrity, a heaviness trails him: sometimes his voice dries up, his energy runs down, and he always has the deadest eyes in movies.

Chico is the front man, the sly fox operator who often outsmarts the boss. Like Groucho he is a cunning sense-slayer, cleverly mauling language. In the ur-Marx plot Groucho and Chico are conspirators hatching schemes to outwit con men and gangsters on the one hand and society swells on the other. They're both cool customers, enemies of sentiment and good will who have a ripe potential for cynicism that the movies never fully exploit. It's a testament to the Marxes' show-business shrewdness that they balanced Groucho's sneer and Chico's leer with Harpo's sweetness. With his bright eyes, his wide smile, and his prancing gait Harpo projects a simple pleasure in being where and who he is. He brings a Chaplinesque pathos to the enchanting interludes with kids that are sneaked into several of the films. And when he plays the harp, his fingers traveling lightly over the strings, his clown's face takes on a radiant dignity. When he chases blondes, beeping his horn in joyous anticipation, he's a naughty child-satyr.

Once they found the individual ingredients for their characters, their masks remained firmly in place. Like all the other great screen comics, the Marxes eventually became prisoners of their created selves, trapped into playing the same part in the same narrative framework. Not surprisingly, their true heyday was brief, less than a decade. Yet collectively they continue to embody a welcome spirit of comic anarchy. Their films may be static but their characters offer a bracing antidote to dull logic and numbing conformity: Marxian absurdity survives.

—Foster Hirsch

RECOMMENDED BIBLIOGRAPHY

Adamson, Joe. *Groucho, Harpo, Chico, and Sometimes Zeppo*. NY: Simon and Schuster, 1973.

Arce, Hector. *Groucho*. NY: G. P. Putnam's Sons, 1979.

Bergen, Ronald. *The Marx Brothers*. NY: Smithmark Publishers, Inc., 1992.

Chandler, Charlotte. *Hello, I Must Be Going: Groucho and His Friends*. Garden City, NY: Doubleday, 1978.

Gehring, Wes D. *The Marx Brothers: A Bio-Bibliography*. NY: Greenwood Press, 1987.

Jordan, Thomas H. *The Anatomy of Cinematic Humor: With an Analytic Essay on the Marx Brothers*. NY: Revisionist Press, 1975.

Marx, Groucho. *Groucho and Me*. NY: Simon and Schuster, 1959, 1989.

——— *The Grouchophile: An Illustrated Life*. Indianapolis, IN: Bobbs-Merrill, 1976.

——— *Memoirs of a Mangy Lover*. NY: Simon and Schuster, 1963, 1989.

Marx, Harpo and Rowland Barber. *Harpo Speaks!* NY: Limelight Editions, 1985.

Marx, Arthur. *Son of Groucho*. NY: David McKay Co., 1972.

Marx, Maxine. *Growing Up With Chico*. NY: Limelight Editions, 1986.

One Flew Over the Cuckoo's Nest

Mental Illness in the Movies

Mental illness is a subject that has fascinated filmmakers and audiences ever since movies began. Certain popular genres, like the horror movie, have always leaned heavily on madness, while others have borrowed liberally from the stereotypes of the mad scientist, the psychotic killer, and so on.

A surprising number of films now considered classics, like *The Cabinet of Dr. Caligari* (1921), *M* (1931), and *Psycho* (1960) have made use of the theme of insanity for stylistic effect. In the wake of World War II, an entire body of films aspiring to a serious treatment of the subject has appeared.

The fascination with mental illness is partly an outgrowth of nineteenth-century romanticism, which sought to strip away layers of social convention and lay bare the human soul. The twentieth century, with all its convulsions and catastrophes, has proved to be a fertile period both for men-

tal illness and works of art about it. Film as a medium seems particularly well suited to this subject. A ticket to the movies opens up a world of fantasy and imagination, a world in which the subconscious reigns supreme. Concurrent with the development of film, the twentieth century has also seen the rise of psychoanalysis, concerned with the vital role of the subconscious.

The ideas of Freud caught on in Europe before they did in the rest of the world and European filmmakers were the first to seize upon them. G. W. Pabst's *Secrets of a Soul* (1926) and Walter

Wanger's *Private Worlds* (1935) were early examples of films adopting Freudian theories. The event that propelled the mental illness movie into an urgent new genre, however, was the Second World War. This global cataclysm brought not only an infusion of European refugees—and ideas—into America, but also a heightened interest in the psychological effects of war, as the soldierly victims of "battle fatigue" streamed home.

A film that addressed itself specifically to psychologically scarred veterans was John Huston's *Let There Be Light* (1945). Shot in an Army hospital, Huston's documentary made the point that as many as twenty percent of American casualties had suffered acute trauma in battle. This was a hot piece of information, powerfully conveyed, that the Army did not want to share with the U.S. public, so it suppressed the film. Even so, the fact that the Army had commissioned the film—apparently to show that these men had recovered and were employable—was evidence of a new attitude toward mental illness, a recognition that it was not an affliction unique to a few congenital idiots.

One of the first popular vehicles for Freudian analysis was Alfred Hitchcock's *Spellbound*, in which, as in *Psycho* later on, mental disarray was to a large extent what Hitchcock called the "McGuffin," a framework or ploy by which suspense could be established. But the manner in which Peck's malady was presented helped to set the tone for this budding genre.

The film that solidified the tone and terms of the Hollywood version of mental illness was *The Snake Pit* (1948), directed by Anatole Litvak. *The Snake Pit* portrayed a young woman (Olivia de Havilland) undergoing a nervous collapse. On the verge of marriage to a man she seemingly loves she suffers fits of crying and hysteria. She is taken to a mental hospital where treatment by a team of doctors begins. In the course of this treatment the sources of her sickness are gradually revealed. Flashbacks of key childhood incidents,

especially the death of her father, are replayed until a pattern emerges and an analysis can be made. A confused guilt over her father's death has both attracted her to Gordon, a dead ringer for her father, and agitated her with the fear that she will be responsible for a repeat disaster. When all this is explained to her she is able to confront her guilt and get well.

The Snake Pit was a well-crafted film with fine camera work (Leo Tover) and a great performance by de Havilland. Its entertainment value was very high, but its importance surpassed entertainment. It set forth a particular view of mental illness that was echoed by dozens of films throughout the Fifties and Sixties and still echoes distantly in case-history films like *I Never Promised You a Rose Garden* (1977). According to this view, mental illness is caused by a traumatic episode, usually occurring in childhood, which the individual tries unsuccessfully to suppress. The trauma is inevitably triggered again, a nervous breakdown ensues, and then a cure is provided by psychiatrists piecing together the puzzle and forcing the individual to confront his or her own fears. The cure is thus a kind of exorcist ritual—an exorcising of irrational demons—which paves the way for the patient's reentry into society.

For more than a decade filmmakers embarking on this subject would strive to fit and even embellish the mold created by *The Snake Pit*. The paragon of virtuosity in this line was undoubtedly *The Three Faces of Eve* (1957) in which Eve (Joanne Woodward) splits into three personalities whose origins must be tracked down by a patient, benign psychologist-sleuth. Needless to say, the wonder-worker is equal to the task—he locates the trauma in childhood, at a funeral where she is forced to kiss a grandparent's corpse—and by film's end Eve is fully integrated. Later versions of Eve and her expert, exacting savior figured in such acclaimed and commercially successful films as *The Mark* (1961), *David and Lisa* (1962), and *The Slender Thread* (1965). Despite their obeisance to

a phony formula these movies did achieve a fairly high level of characterization and emotional resonance.

Interestingly enough, in 1957, the same year that saw the release of the paradigmatic *Three Faces of Eve*, another film appeared that marked a slight but significant departure from the mold. This was *Fear Strikes Out*, the story of Red Sox outfielder Jimmy Piersall. For the most part, *Fear Strikes Out* was true to the now-familiar formula. Piersall (Tony Perkins) breaks down and undergoes counseling which brings him self-knowledge and, ultimately, the confidence to resume his baseball career. But director Robert Mulligan's focus on Piersall's pushy father, trying to fulfill his own thwarted athletic ambition through his son, opened up a dimension of social criticism, because the injurious values of the father reflected the social value structure of America.

The modest social criticism in *Fear Strikes Out* became more explicit in Elia Kazan's *Splendor in the Grass* (1961). Here the breakdown of Deenie (Natalie Wood) is blamed not so much on her parents as on a generalized attitude toward sex which held that only "bad girls" made love before marriage. This Victorian outlook is shared by the parents of her boyfriend and is even linked to an old order of laissez-faire capitalism in that both sets of parents are heavy investors in a stock market doomed to crash. The film upholds the popular stereotype of the caring psychiatrist, however, in the person of genial father-figure Dr. Judd (John McGovern) who shepherds Deenie back to sanity at the Kansas State Hospital.

A note of ambiguity towards the psychiatric profession began to creep into American films in the Sixties. Two examples of this trend were *Lilith* (1964) and *Charley* (1968). In *Lilith* Warren Beatty plays a therapist who is unable to help an inmate (Jean Seberg) at a Maryland sanitarium and ends up becoming an inmate himself. In *Charley* a mentally retarded man (Cliff Robertson) becomes the object

of a surgical experiment that transforms him into a genius, temporarily, until he regresses. Mainstream filmmakers were making the somewhat belated discovery that all was not miracles in the mental-health profession.

History was taking an apocalyptic turn in the Sixties. Young Americans looked at the society they were inheriting and were not happy with what they saw—an imperialist war in Vietnam, an arid commercial culture, hypocritical values, racism. These realities and many more provoked a widespread revolt that took shape in a New Left and a search for alternative lifestyles. Authority was everywhere under challenge, a challenge which extended to the field of mental health.

Traditional psychiatry, with its Establishment orientation, was in retreat. Progressive psychiatrists like R. D. Laing were criticizing social norms and exploring links between creativity and madness. The Hollywood film that addressed itself most pointedly to changing views of mental illness was Milos Forman's *One Flew Over the Cuckoo's Nest* (1975), based on the novel by Ken Kesey. In *Cuckoo's Nest* a dynamic drifter, McMurphy (Jack Nicholson), chooses a stint at a mental hospital over a prison work detail and turns the place upside-down with his insistence that there is nothing wrong with the people there that a good time won't cure.

McMurphy tries to show them some fun, going so far as to break out of the hospital grounds and take the members of his ward to the Oregon coast. His active resistance to the hospital program, and to its most visible authority figure, "Big Nurse" Ratched (Louise Fletcher), puts into play a series of events that reveals the institution in its true colors. A stammering inmate, Billy (Brad Dourif), who had shown signs of recovery under McMurphy's plan of freedom, is punished by Big Nurse and reverts to his stammering. McMurphy himself is lobotomized, prompting the huge, silent, brooding "Chief," an Indian, to break a window and escape. This end-

ing offers the hope that McMurphy's sacrifice on behalf of life and freedom has not been completely in vain.

The tone and message of *One Flew Over the Cuckoo's Nest* demonstrated just how far films about mental illness had come in the twenty-five years since *The Snake Pit*. The source of the inmates' problems was no longer some obscure trauma to be dredged up in flashbacks of childhood. Instead it was a condition all around them: the system itself, personified by the sexless, rigid, punitive Big Nurse. The alleged cure afforded by Big Nurse and the hospital was a fraud; worse, it ensured that inmates would remain in a state of emotional slavery, depending on mind-numbing drugs and deadening routines. *Cuckoo's Nest* focused on the mental-health system but it also functioned as an allegory about the larger society, an America whose rulers had responded to the hopeful movements of the Sixties with a machinery of repression ranging from billy clubs and bullets to *agents-provocateurs* and grand juries, all accompanied by a steady drumbeat of media distortions. *Cuckoo's Nest* spoke to both the protest movement that had energized youth and minorities and the sense of despair that set in with its forced disappearance.

After *Cuckoo's Nest* it became difficult for filmmakers to return to the old stereotypes about the mentally ill and their "helpers," although certain films tried. *I Never Promised You a Rose Garden* was pretty much in the traditional mold—featuring as psychiatrist the warm, attractive Bibi Andersson of *Persona* fame—but even here there were some telling concessions to truth: a sadistic guard, an aging inmate population without hope, and so forth. A more representative vehicle on the road smoothed by *Cuckoo's Nest* was *Frances* (1982), which pictured the mental-health system in a luridly negative light and stressed the idea that Frances Farmer was being punished for her nonconformity.

No discussion of mental illness in the movies would be complete without a men-

tion of Roman Polanski, whose psychological thrillers—*Repulsion* (1964), *Rosemary's Baby* (1968), and *The Tenant* (1975)—exploit mental illness in the manner of Hitchcock and horror movies. These films are important precisely because they reflect the level at which mental illness is perceived by opportunists and power mongers. All three films are about lonely, naive, or passive individuals—all vulnerable—who are *driven* to madness by clandestine forces they are powerless to defend against. Their predicament is epitomized by Rosemary, who pours out her tale of malevolent witchcraft to an affable Dr. Hill who then proceeds to call on the very people who have conspired to use her. Polanski's films are allegories of mind control (e.g., the Devil to which Rosemary gives birth is really madness, in the old pejorative sense, leading to social chaos).

An offbeat Canadian film, *Ticket to Heaven* (1981), made a further exploration of the same frightening territory. It charted the regression of a young schoolteacher (Nick Mancuso) into a state of infantile, mindless dependency within a California cult. The cult portrayed so credibly in *Ticket to Heaven* was based on the Unification Church, or the "Moonies." Since this cryptofascist organization is known to have ties to the CIA and the Republican Party, the film provokes questions about the political uses of sensory deprivation, "coercive persuasion," and so on. Lesser films like *The Fury* (1978) and *Patty Hearst* (1988) appear to raise—but really deflect—such questions by obscuring them in the murk of special effects or celebrity worship.

The psychological sadism shown in *Cuckoo's Nest* and *Ticket to Heaven* nearly makes one nostalgic for the benign healer-psychiatrists of *Spellbound* and *The Snake Pit*. Yet the efforts of those fallen idols, who keep trying to reorient patients to society, are being undermined and mocked by the very society they serve. The persistence of unemployment, racism, and war, the illusory narcotic of commer-

cial TV, the rise of an obscenely overpaid celebrity caste, and other social injustices too numerous to mention, can only have the effect of creating disturbed people faster than the mental-health professionals can sedate them. The times are rife with the evidence and potential of madness, in every sense of the word—creative and destructive, liberating and confining—and

some of the best films on this important subject are probably still ahead.

—Burns Raushenbush

RECOMMENDED BIBLIOGRAPHY

Fleming, Michael. *Images of Madness: The Portrayal of Insanity in the Feature Film*. Rutherford, NJ: Fairleigh Dickinson University Press, 1985.

..

Milius, John

(April 11, 1944 –)

J ohn Milius was one of a number of filmmakers who emerged in the Seventies to establish a new profile for directors—film buffs who learned their craft in film school and through study of traditional Hollywood filmmaking. Milius found his inspiration in the films of John Ford, Howard Hawks, and Raoul Walsh.

Even in that group of "movie brats," and despite his close association with Francis Coppola and George Lucas, Milius cast himself as a cultural outsider. He flaunted political and cultural eccentricities in a mixture unshared by his friends or, for that matter, anyone in history. At various times he has claimed to be a surfer, gun-freak, a Mongologist student of Genghis Khan, and a Zen fascist. He decorated his "A-Team" office in the casual disarray of a military command post, and his contracts have stipulated delivery of shotguns from Purdey's of London. Although his enthusiasms include health food and ecology, he professes contempt for the Sixties. When Milius hears the word "counterculture," he reaches for his revolver.

While this media persona makes suspiciously good copy for journalists, it also fits the preoccupations of many of his movies. From the beginning, Milius's films have glorified an ethic of violence, in

which courageous but lonely gestures pit the outsider hero against society, his personal code against conventional morality. The restraints of civilization are seen as hypocrisy by his heroes, who are above such lies. They are endowed by their screenplays with a mythic status which seemingly justifies killing and brutality.

At USC, Milius made an animated short which won an International Student Film Festival Award and the offer of a job as animator upon graduation, which he declined. Screenwriting was to be his path to directing. His plan was, he later said, to become a successful screenwriter and then use the high price of his screenplays to bargain for the right to direct.

Like others of his film generation, his entry into the industry was through Roger Corman's patronage at American International Pictures. There he began as a story assistant after Corman bought *Devil's Eight* (1968), a biker "Dirty Dozen," which Milius coauthored. He was

soon asked to work on the screenplay of *Little Fauss and Big Halsy, Evel Knievel,* and was given important help by Francis Ford Coppola, who paid him $25,000 to write a screenplay for *Apocalypse Now.*

Although *Apocalypse Now* (1979) will be his most enduring credit, it was extensively reworked by Coppola, who didn't share his screenwriter's love of war. Milius claims credit for the idea of setting Conrad's *Heart of Darkness* in the Vietnam War and making the narrator a U.S. agent sent to kill Colonel Kurtz, a Green Beret officer gone mad waging war in Cambodia. Milius and then Coppola kept Conrad's conception of the narrator's journey upriver as a journey into self-awareness and change, and the character of Kurtz as an expression of the horror of "civilization" which, shorn of lies and hypocrisy, is revealed as insanity and barbarism. Years later, the film is still unsurpassed in its surreal images of the "horror" and "madness" of the Indochina war.

After Coppola bought *Apocalypse Now* in 1969, Milius's career took off. He was soon able to sell his screenplay for *Jeremiah Johnson.* The story was inspired by a historical figure, John "Liver-Eating" Johnson. The Milius hero rejected "civilization" to become a mountain man, learning to live alone in the wilderness and respect the Indians, later desecrating their burial ground and becoming a "savage" pursuing them in a blood feud. The rewrite by Edward Anhalt spared Robert Redford the eating of the livers of his Indian victims; the original John Johnson only pretended to eat the livers, but Milius apparently thought he should have done it. The slaughter of Indians remains, however, with the film conveying the impression that it was somehow justified as a part of the process through which Johnson, a true American, became a living legend to both Indians and whites.

Milius early achieved notoriety for his rewrite of *Dirty Harry* (1972) and for its sequel, *Magnum Force* (1973), which he wrote with Michael Cimino. Milius here diluted his vigilante politics by repeatedly opposing Harry to grotesquely vicious characters. Even so, Harry seems violent in a way the traditional Western heroes rarely were, violent not for the sake of justice but for the sake of blood. Although *Magnum Force* ambiguously pits Harry against true fascist vigilantes, a death squad within the police department, it ends as Harry chooses to bomb their leader rather than face him in court. But Milius's later screenplays over which he had directorial control give less diluted expression to his avowed love of violence for its own sake.

In *The Life and Times of Judge Roy Bean* (1972), Milius pursued his fascination with American myth and vigilantism. He was in fact inspired less by the historical figure of Bean, a con man who made himself a judge, than by the "hanging judge" and murderer of an earlier film, William Wyler's *The Westerner* (1940). Milius received $300,000 for the screenplay, but lost his bid to direct the film. He says he deplored the casting of Paul Newman as Bean and fought when director John Huston watered down the viciousness of the screenplay. Milius's hero was the man who set himself up to be law, yet differed little from the criminals upon whom he passed judgment, ready to commit any crime for the sake of "progress," a man from an earlier time who survived his historical use and then passed into legend. When Bean's violence is followed by the more contemptibly evil shysters who come after, representing modern times, he returns from the dead to a biblical vengeance, calling himself "Justice" as he purges his town with fire and blood. Surviving here in some startling imagery, Milius's ideas seem more promising than the cuteness, sentimentality, and humor which overpowered them as they were sacrificed to Huston's love of the offbeat for its own sake.

When at the age of twenty-nine Milius directed his first feature, *Dillinger* (1973), for American International, his control

over production allowed a more consistent expression of his ideas. The film was marked by tough-guy posturing, brutality, and pretensions to myth which were to reach sublime heights in his preposterous masterpiece, *Conan the Barbarian* (1982). No excuses are made for Dillinger, despite the film's glorification of him as a folk hero; his hunter, G-Man Purvis, is less like a pious Eliot Ness than he is like Dillinger himself, defined by violence and the desire to become a legend.

Milius was able to direct all his subsequent screenplays. In *The Wind and the Lion* (1975), he again mystifies history to promote his Movietone Americanism. This time the American vigilante hero is Teddy Roosevelt, who is compared with the grizzly bear both he and Milius think should replace the eagle as the American symbol. Milius's Dirty Teddy sends Marines into Morocco in blithe disregard of international law, using the kidnapping of an American woman as a pretext for intervention. (Incidentally, the man upon whom this woman was based, Ion Perdicaris, had renounced his American citizenship years before, but this did not worry Roosevelt any more than it did Milius.)

Roosevelt is presented as sharing the spirit of the romantic kidnapper, the Berber chief Raisuli (Sean Connery), but also as reluctant representative of a new time which will sweep away the old nobility and code of honor. The film shows also a nostalgia for the violence and lawlessness of a hero who scorns civilized ways and law; the director's point of view is seen through the eyes of the kidnapped son of Mrs. Perdicaris, who thoroughly enjoys the adventure and admires the tribal chieftain. Curiously, Milius here romanticizes a hero who fights against western imperialism; this is, however, no problem for him, since Raisuli's archaic and honorable tribal warfare is an assertion not of world revolution, but of noble barbarism against effete civilization.

Big Wednesday (1978) was especially close to Milius's heart—indeed, it is not clear why else he would have made the film. It is a loosely structured glorification of surfers, male friendship, and youth, a nostalgic story of coming of age on the beach and the tragic passing of the great days of surfing. In this pretentious saga of man alone against the elements, perhaps what was most pretentious was Milius's attempt to make a truly personal, partly autobiographical film. The surfer is a bizarre choice of a hero for our times, and Milius's grotesque priorities become clear when one hero's tour of duty in Vietnam is presented as only an interruption of surfing and friendship. The story is unredeemed by some startling photography of waves and surfing, as the nearly incoherent drama struggles to reach a depth best appreciated by marine life.

Conan the Barbarian (1982) may prove to be Milius's best film. This pulp and comic-book material proved the perfect vehicle for Milius's philosophy, with the simple energy and gross visual excitement of a comic book, matched by the perfect if obvious casting of Arnold Schwarzenegger, who looks like a comic-book figure come to life. In a strange blend of Nazi mythmaking and anarchism, the Germanic hero battles the evil black priest, opposing his own mysticism based upon flesh and steel to the sinister cult of Thulsa Doom (James Earl Jones). Conan is the loner in heroic assault against the totalitarian society, the state as cult. The humorous camp tone is misleading; the film rivals *Red Dawn* as Milius's most serious statement, his romanticizing of mythical barbarism over degenerate and lying civilization, the liberating power of violence, war as the most profound and ennobling experience, and nostalgia for a primitive Aryanism, an imagined time when white was good and black evil.

Red Dawn (1982) received less recognition as an action movie than as a vehicle for silly political ideas. Here Milius projects a paranoid fantasy of a Cuban-Nicaraguan invasion of Colorado which is nearly defeated by a few high school foot-

ball players and cheerleaders. Where did these Rocky Mountain Guevarists learn to wage war so effectively, defeating experienced guerrilla fighters? No doubt from watching the same war movies from which Milius derived much of his material. For all Milius's anti-communism, it is interesting that the communists are not blamed for starting the war. "What started it? I dunno. Two toughest kids on the block, I guess. Sooner or later they're gonna fight." The fascist view of human nature implicit in this explanation is more grim even than the fascist view of communism.

When the guerrillas visit a friendly farmhouse, they remain true to right-wing priorities: they take guns, horses, girls, but no contraceptives. Indeed, the film shows a chastity astonishing among teenage coming-of-age films. The chastity also seen in *The Wind and the Lion* and *Jeremiah Johnson,* the idealization of Lilly Langtree by Roy Bean, the camaraderie of Conan and tomboyish Valeria, the degenerate sexual displays preceding and inviting the massacres in *Magnum Force*—all indicate arrested development. The preadolescent sexuality suggests the preadolescent source of Milius's social and political fantasies as well—the movies and, in particular, the Western, with its simplifying myths, lonely heroes, corrupt elites, chaste sex, anarchic towns, and individual violence without worries about grownup due process. Milius draws out of the seemingly innocent Hollywood tradition an implicit promotion of violence as a good in itself, with the opponents hardly different from each other because of their practice of it. This may be a deeper expression of his outlook than his more familiar personal and rightist points of reference. Milius is from the "movie generation" of baby boomer directors who looked to the movies of their childhood for philosophy, as well as technique.

Milius returned to the romance of war in two later and lesser efforts, *Farewell to the King* (1989), which he wrote as well as directed, and *Flight of the Intruder* (1991).

In *Farewell to the King,* Learoyd is a nicer Kurtz, a World War II army deserter who becomes King of a Borneo tribe, rejecting "civilization" for a nobler barbarism. Although their values are supposedly superior, the natives require a Westerner to unite and lead them. This is a boy's version of Conrad, with idealized primitives in the background, along with nostalgia for war and admiration for warrior-heroes.

Flight of the Intruder flirts with the premise that the Vietnam War was waged by warriors and lost by politicians. In *Apocalypse Now* Kurtz rails at the "lies," and the most promising part of *Intruder* is Milius's reprise of this theme in the story of naval pilots who die because politicians refuse to let them bomb Hanoi. But the promise of genuine drama is overwhelmed by war-movie clichés and lapses from seriousness that expose the political pretensions as shallow posturing.

Milius's sources are Hollywood tradition, and so it is not surprising that, despite his eccentricities, he professes to be a very American filmmaker. He celebrates what he believes to be the essential American: a self-reliant, gun-loving individualist, a warrior who finds violence natural and invigorating, who is sexually innocent, and distrustful of authority and the social order. If this is a crank's idea of America, still it draws on inescapably American history. Critics who call him a fascist are oversimplifying. His outlook is a confusion of fascism and anarchism, based on an idea of justice which would heroize Bernard Goetz but fear the police state. His surfer heroes try to subvert the draft in *Big Wednesday* and rail against "the lifeguard state"; Dirty Harry is at odds with the establishment as well as the criminals; the heroes of *Red Dawn* are a small group of outsiders betrayed by the appeasers and sellouts in Washington and local government; Conan is a thief who respects no rulers and destroys the state power of his alter ego, the evil Thulsa Doom.

In *Apocalypse Now,* Kurtz rails against the "lies," and Milius was at his best and

most influential when he flaunted a fascism without pieties. This is a convenient philosophy in an industry in which it is violence, decent or indecent, right or wrong, which makes the bucks. Milius is one of the few who tried to make a philosophical virtue of this economic imperative. If he ends up with a philosophy that is too preposterous for serious consideration, it will always have a place in the Hollywood, which was, after all, its source.

—Paul Elitzik

RECOMMENDED BIBLIOGRAPHY

Gallagher, John Andrew. *Film Directors on Directing*. NY: Greenwood Press, 1989.

Pye, Michael and Lynda Miles. *The Movie Brats*. NY: Holt, Rinehart and Winston, 1979.

Swing Time

The Hollywood Musical

An old Hollywood story has it that James Cagney, who began his show business career as a hoofer and then went on to become one of Hollywood's foremost gangsters, once said to Fred Astaire, "You know, you old so and so, you've got a little of the hoodlum in you."

This seems an odd comment to make to someone whom dancers and moviegoers alike revere as the epitome of "class"—combining poise, charm, elegance, and sophistication—and whose image in Hollywood iconography is one perennially clad in top hat and tails. Yet Cagney was far from wrong, especially if one thinks of

scenes from Astaire movies like the one in *Top Hat* (1935) in which he mowed down a chorus line using his cane as an imaginary gun; or the "Girl Hunt" dance sequence in *The Bandwagon* (1953) in which he plays a Mickey Spillane character; or his role as a conman in *Yolanda and the Thief* (1945).

Cagney's remark reflects not only on an ambiguity of the Astaire persona, but also on the fact that ambiguity and irony are part and parcel of the Hollywood musical as a whole. Although the musical was generally acknowledged to be Hollywood's most escapist form of entertainment, it was also the one that most self-consciously examined the role of entertainment in people's lives. Similarly, while it generally evoked fantasies of romance and exotic places, it also called attention to the very nature of those fantasies by interrupting them with even more fantastic songs and dances. Appearing at other times, even amidst the most opulent glitz and glamor of these numbers, were brief episodes of gritty social comment or glimpses of psychic and social breakdown. While the Hollywood musical has a reputation for perpetuating the most conventional beliefs about individualism, success, and patriotism, it was also a genre which oftentimes seethed with an energy which could only be described as communal, even utopian. Escapist, lighthearted, and fantastic as they were, musicals still went a long way toward meeting the standards of even the toughest critics, including James Agee who argued that, "There is no reason, after all, why a movie musical should not be as good as any other movie."

Nevertheless, making good movies hardly seemed to matter at all to the moguls who presided over the birth of the genre. Most would have gone along with Harry Warner's remark, made after his studio's introduction of sound in *The Jazz Singer* (1927): "The music, that's the big plus in this." Indeed, the words had barely passed his lips when the Hollywood studios began rushing off to try to outdo one another with "All Talking, All Dancing, All Singing" musical films.

This early period of the musical (1927–'31) is generally considered to be the "Stone Age" of the genre. In fact, producers behaved almost like Visigoths sacking the Broadway stage for talent and the rights to any hit musical—everything from Sigmund Romberg operettas like *New Moon* (1931) to the quintessential Twenties college musical, *Good News* (1931)—and then threw them onto the screen without even the slightest regard for the special problems they presented for the medium.

Despite the chaotic qualities of this era, it is also worth noting that at the same time Al Jolson first opened his mouth to sing on celluloid, Jerome Kern and Oscar Hammerstein II launched *Show Boat* (1927), the first Broadway musical to fully integrate the songs and dances with the story. As a result, the Hollywood musical emerged in an era which was incomparably rich in singers, dancers, songwriters, and choreographers, and during which the musical stage had reached a level of sophistication hitherto unknown in America or elsewhere. By presenting American moviegoers with the talents of Fanny Brice, Al Jolson, Eddie Cantor, Helen Morgan, and Marilyn Miller (to name only a few), the Hollywood musical went a long way toward becoming a form of American popular opera.

Nor was this period totally devoid of experimentation and innovation. In some of the early musicals of Ernst Lubitsch, for instance—*Love Parade* (1929), *The Smiling Lieutenant* (1931), *One Hour With You* (1932)—and Rouben Mamoulian—*Applause* (1929) and *Love Me Tonight* (1932)—the camera escaped its bondage to the sound technician, and sound and image were integrated in a way that was to become unique to the musical. In a musical like Lubitsch's *Monte Carlo* (1929), for example, the music to "Beyond the Blue Horizon" seems to come from the wheels of a train, and in Mamoulian's *Love Me*

Tonight, the song "Isn't It Romantic?" seems like a bouncing ball as it jumps from one character to another.

Similarly, the themes of these early musicals benefited from an openness and willingness to experiment that later musicals avoided in favor of much safer formulas. Thus, in those early years King Vidor made the all-black musical *Hallelujah* (1929) and in *Applause* (1929) Rouben Mamoulian, eschewing any idea of escapism, told an unflinching story of a burlesque queen who commits suicide.

Just as significant, however, was the unique relationship that the movie musical established with its audience. In the traditional Hollywood screenplay, the audience watched the unfolding drama or comedy as if what was taking place on the screen was actually happening. In contrast, the film musical incorporated the audience into its fantasy world. From early moments like Maurice Chevalier's wink at the camera in *One Hour With You* (1932) to the frequent shots of audiences in these early films, the Hollywood musical acknowledged the fact that it was entertainment pure and simple.

Nowhere was the interest in the audience as evident as in the first of the major musical formulas—the backstage plot. The original intent of the formula was to allow the film musical to move from dialog scenes to musical numbers without sacrificing a sense of realism. By introducing the numbers as part of rehearsals, or even the show itself, the backstage musical minimized the awkwardness of the transition to singing and dancing. Nevertheless, this wasn't the only achievement of the backstage plot. It also capitalized on audiences' curiosity about what went on behind the curtain, and also about the lives of performers on that most magical of all streets, "ol' Broadway."

Indeed, going behind the scenes was a major selling point of that granddaddy of all backstage musicals, *Broadway Melody* (1929). As one of the film's ads promised, "The microphone and its twin camera poke themselves into the backstage corners, into dressing rooms, into rich parties and hotel rooms." *Broadway Melody* followed the rise of a sister act made up of Queenie Mahoney (Anita Page) and Harriet "Hank" Mahoney (Bessie Love) from vaudeville to Broadway, in the process singing—along with song and dance man Eddie Kerns (Charles King)—"You Were Meant for Me," "The Boy Friend," and other original songs by Arthur Freed and Herb Nacio Brown.

Ironically, in view of the fact that one of the staple themes of later musicals was to be the consummation of the romantic couple, in *Broadway Melody* the sister act breaks up over Queenie's involvement with Eddie (even though he was Harriet's boyfriend). There was no irony, however, about Bessie Love winning the Academy Award for best performance by an actress and *Broadway Melody* winning 1929's Best Picture of the Year award. The success of *Broadway Melody* signalled the fact that the musical genre had come of age.

Despite these honors, however, the Hollywood musical soon went into a period of serious decline. For one thing, there was a glut of them. For another, their lightheartedness—especially the echoes they evoked of Jazz Age frivolity and flapper gaiety—hardly seemed in keeping with the turmoil and despair of the early days of the Great Depression. Indeed, the years 1931 to 1933 were the nadir of the Hollywood musical.

The musical was revived when Warner Bros. wedded the backstage musical plot to the money-starved, job-hungry times of the Thirties in films like *42nd Street* (1933), *Gold Diggers of 1933* (1933), and *Footlight Parade* (1933). Filled with main chance guys and hard-boiled or slightly tarnished dames, the musical again connected with its audience. Consequently, such scenes as the opening of *Gold Diggers of 1933*, in which Ginger Rogers and the other choristers, costumed as giant coins, click their heels to a version of "We're in the Money," conveys a brilliant feel for

some of the despair and irony of the decade.

It was also ironic that the sense of realism in these films coexisted with choreography that was almost surreal in form and content. In films like *Gold Diggers of 1933*, *Footlight Parade*, *42nd Street*, and others, Broadway refugee Busby Berkeley revolutionized traditional conceptions of choreography. Marshaling lines of chorus girls playing violins (*Gold Diggers of 1933*), harps (*Fashions of 1934*), and pianos (*Gold Diggers of 1935*), cavorting by a waterfall (*Footlight Parade*), or on a honeymoon train (*42nd Street*), he convincingly demonstrated that choreography didn't involve just the feet. In the films that Berkeley choreographed and later directed, it is the camera that dances—underwater, through transparent floors, and overhead—as we lose a sense of the individual dancer (in many ways they seemed to be little more than props to Berkeley) and instead see them as part of a larger kaleidoscopic pattern.

It was this sense of collectivity, of putting aside one's selfish motives for the "good of the show," that also marked the storylines of the Warner's musicals. Thus, in contrast to individualistic moments as when Julian Marsh (Warner Baxter) pushes Peggy Sawyer (Ruby Keeler) onto the stage in *42nd Street* for her big break at stardom with the comment, "You're going out a youngster, but you've got to come back a star," a few scenes earlier "Anytime" Annie (Ginger Rogers) refuses to stand in for the injured star and instead suggests Peggy. Similarly, Chester Kent (James Cagney) in *Footlight Parade* sets aside his professional and personal problems to dance the lead in the film's final "Shanghai Lil" number when the regular actor is unable to go on. In the process, he not only finds the inscrutable "Lil" (Ruby Keeler), he also gets to lead the assembled choristers in producing the image of the ultimate in Thirties cooperative symbols—the New Deal Blue Eagle.

Amidst these moments of Berkely-esque bravura, however, one surprisingly found poignant moments of social comment and evidence of psychological despair. In Ruby Keeler's "42nd Street" number, for instance, Berkeley filled the screen with an urban pastiche of shoeshine boys, knife fights, and nannies. Likewise, *Gold Diggers of 1933* includes an unforgettable homage to the Bonus Marchers, "Remember My Forgotten Man." Nor could one forget the shock of seeing a chorus girl plunge to her death in the "Lullaby of Old Broadway" number in *Gold Diggers of 1935*.

Nevertheless, despite these moments of realism or social comment, the major thrust of the movie musical of the Thirties remained relentless uplift—something that even President Franklin D. Roosevelt was aware of when he said, "When the spirit of the people is lower than anytime during the Depression, it is a splendid thing that for just fifteen cents an American can go to the movies and look at the smiling face of a baby and forget his troubles." Although FDR didn't mention that baby by name, he was referring to Shirley Temple. From 1934 to 1939, Shirley led the way in keeping America's "Sunny Side Up" as they marveled at her precocious singing and dancing and her ability to wrap around her little finger even the frostiest curmudgeon or sternest authority figure.

From the moment she appeared in the "Baby Take a Bow" number in *Stand Up and Cheer* (1934) to her dances with Bill "Bojangles" Robinson—*The Little Colonel* (1935), *The Littlest Rebel* (1935), *Rebecca of Sunnybrook Farm* (1938), *Just Around the Corner* (1938)—she not only won America's heart but also took a sizable chunk out of their pocketbooks (especially with the innumerable Shirley tie-ins, such as dolls, books, etc.). Accompanied by her mother's offscreen admonitions to "Sparkle, Shirley, Sparkle!," in her oft-repeated roles as an orphan, or as a lonely and sometimes neglected child, she was the American Dream revitalized, proudly

proclaiming, "I'm awfully self-reliant, you know" (*Rebecca of Sunnybrook Farm*). Yet there was another side of the Temple image. Although some suggested she was a midget or even a midget female impersonator, Graham Greene, writing in the British periodical, *The Spectator*, best articulated the matter in his review (which got him a libel suit) of her performance in *Captain January* (1936): "Shirley Temple acts and dances with immense vigor and assurance, but her precocity seems to rest on a coquetry as mature as Miss Colbert's and an oddly precocious body as voluptuous in grey flannel trousers as Miss Dietrich's."

Although hardly intended to inspire pedophilia, there was something slightly seductive—perhaps even a bit incestuous—about the Temple image. In many of her films she seemed almost a little wife to her leading men; in one film she even climbs upon her daddy's knee and says, "Marry me and let me be your wife." Of course, nothing untoward ever happens or was supposed to (this was, after all, Hollywood during the Production Code). Nevertheless, scenes like these suggest that neither the Temple image, nor the genre in which she was so often featured, were as simple and as straightforward as they might seem.

Fortunately, the Hollywood musical hardly needed Shirley Temple to consummate romances with her leading men, since it had older romantic couples who could accomplish just that. First and foremost of these couples was Fred Astaire and Ginger Rogers. In fact, in the nine films they made together for RKO in the Thirties—*Flying Down to Rio* (1933), *The Gay Divorcee* (1934), *Top Hat* (1935), *Roberta* (1935), *Follow the Fleet* (1936), *Swingtime* (1936), *Shall We Dance?* (1937), *Carefree* (1938), *The Story of Vernon and Irene Castle* (1939)—they became the apotheosis of Hollywood's romantic couple.

On the surface, the Astaire and Rogers films were simple enough. The plots, which usually took place in upper class or exotic locales (Rio, London, Venice, Paris, New York) generally dealt with Fred falling in love with Ginger (in *Shall We Dance?* he falls in love with her before he even meets her!) and pursues her despite her initial resistance until she finally falls in love with him. These plots almost always hinged on mistaken identities and other confusions keeping the lovers apart until the final scenes, which were usually celebrated by huge production numbers like "The Carioca" (*Flying Down to Rio*), "The Continental" (*The Gay Divorcee*), and "The Piccolino" (*Top Hat*). Fleshing out this rather slight structure were the camp buffooneries and sly sexual innuendoes of Edward Everett Horton, Eric Blore, and Erik Rhodes, and the finest music of the finest songwriters in America (Irving Berlin, George Gershwin, Cole Porter, Vincent Youmans).

Despite storylines that would have done credit to Sardou, the Astaire and Rogers musicals were hardly the lightweight vehicles they seemed to be. First of all, rather than using the dance as mere embellishment, or the justification for some spectacle (à la Berkeley), Astaire and Rogers made the dance integral to the plot as dialog. Indeed, whenever Astaire and Rogers did dance, their movements spoke volumes about feelings which their characters were either ignorant of or too reticent to reveal. In addition, the dancing gave their otherwise chaste courtships (they don't even kiss until their eighth film, *Carefree*, and then only in a dream sequence) a sensuality rivalled by few other screen lovers of the era.

Of course, a great deal of the success of their dances was the result of Astaire's perfectionism and innovation. Sometimes demanding countless takes, he forced his directors to concentrate solely on the dancers (foregoing then-standard cutaways and reaction shots). Furthermore, Astaire and Rogers's ability to combine jazz dance with tap and even classical ballet moves exploited all the resources of the

dance.

Just as important was the fact that Astaire and Rogers added a significant—perhaps potentially even subversive—image to the catalog of American pop culture heroes and heroines. Indeed, in contrast to the alienated protagonists of the Western, the gangster film, or even the screwball comedies of the Thirties, who fit D. H. Lawrence's description of the American soul as "hard, isolate, and stoic," Astaire and Rogers created the symbol of the romantic couple, a gentle, cooperative, and joyous twosome.

Moreover, their dances conveyed a sense of ease, spontaneity, and freedom from the constraints of life (Fred might break into a dance anywhere, from a ship's boiler room to a posh hotel suite) which few people ever experienced in their lives—something that Graham Greene was again first to call attention to when he wrote that Astaire's dancing "broke the laws of nature."

All of this was accomplished, interestingly enough, without even the slightest taint of the hedonistic stigma that had dogged the reputation of the dance in America since the early nineteenth century. In fact, Fred and Ginger legitimized the dance as a courtship ritual of the middle class as no other couple had since the days of Vernon and Irene Castle (which undoubtedly contributed to their being chosen to star in a screen biography of the two). In so doing, they made the romantic couple into a staple of the Hollywood musical, and other Hollywood studios soon followed suit with their own romantic duos.

Perhaps the most famous of these—even rivaling Fred and Ginger in popularity—were Nelson Eddy and Jeanette MacDonald. In eight films between 1935 and 1942—*Naughty Marietta* (1935), *Rosemarie* (1936), *Maytime* (1937), *The Girl of the Golden West* (1938), *Sweethearts* (1938), *New Moon* (1940), *Bittersweet* (1940), and *I Married an Angel* (1942)—the virile-looking but wooden baritone alternately fought with and wooed the seemingly aloof but actually passionate "iron butterfly.'

In contrast to Fred and Ginger, who despite their posh surroundings were still confirmed egalitarians (most often they were both cast as entertainers or show-biz types) and even twitted their own chaste courtships in songs ("A Fine Romance /with no kisses" in *Swingtime*), Nelson and Jeanette's outpourings of songs like "Sweethearts," "The Indian Love Call," and "Ah, Sweet Mystery of Life" raised the musical romantic couple to new sentimental heights. In comparison to Fred and Ginger's egalitarianism, their Thirties films usually established some sort of social gap between them. Thus, in *Naughty Marietta*, MacDonald played the Princess Marie and Eddy the backwoodsman, Captain Jim Warrington; in *Rosemarie* she was the Canadian diva, Marie de Flor, and he the mountie, Sergeant Bruce.

Although Eddy and MacDonald always marched off together at the conclusion of these films, and consequently expunged whatever traces of social or other barriers that existed between them, their films together never entirely rid themselves of the taint of "class" (albeit of a totally different variety from the social and economic kind), primarily because their operatic bearings and voices gave the Hollywood musical an injection of high culture. They had particularly wide appeal since the robust singing style of the manly Eddy ("Tramp, Tramp, Tramp") combined with the saucy beauty and soprano trilling of MacDonald ("The Italian Street Song") made them more attractive as a singing duo than anything La Scala, Covent Garden, or the Met had to offer.

Interestingly enough, high culture itself was frequently the subject of musical film pairing. Whether it was the desire of Jackie Robin (née Jackie Rabinowitz aka Al Jolson) to sing pop music rather than follow in his cantor father's footsteps in *The Jazz Singer,* or the *entrechats* of ballet star Petrov (Fred Astaire) versus the tap routines of Broadway star Linda Keane

(Ginger Rogers) in *Shall We Dance?*, the clash of opera, classical music, and the ballet with pop, jazz, ballroom, and tap dancing was a staple of the Hollywood musical.

This contrast also marked a rather obscure MGM short subject called *Every Sunday* (1936). Although the featurette caused little stir at the time, it did introduce Deanna Durbin and Judy Garland as two young performers (singing classical and pop tunes respectively) who join forces to save a local band concert series from extinction. Besides the fact that it was the first film appearance of two future stars of the Hollywood musical, it also indicated the importance afforded both forms of music in the musicals of the Thirties and early Forties. This parity was soon to disappear as classical music, opera, and operetta gave way in the musical (undoubtedly due to their lack of flexibility) before the ascendancy of pop music, jazz, and, ultimately, rock music.

During the Thirties and throughout the early Forties, the musical continued to feature stars from the classical music and opera world such as Grace Moore (*One Night of Love*, 1935), Lawrence Tibbett (*Metropolitan*, 1935), Lauritz Melchoir (*Thrill of Romance*, 1945), and Jose Iturbi (*Anchors Aweigh*, 1945). Moreover, if anyone's films testified to the continued significance of classical music and opera in the musical, they were those of Deanna Durbin.

Despite the fact that her popularity and even her reputation as a star have dimmed since the late Thirties and early Forties (her films are rarely shown in revivals these days), in the prewar and early war years her musicals were tremendous box office hits. Certainly, part of that acclaim was due to her pleasing coloratura, which was heard to excellent advantage in such light classical works as Verdi's "Libiamo" (*La Traviata*) and Mozart's "Alleluia." Also (and this might to some degree explain her popularity in the Soviet Union and in the communist-bloc nations even during the height of the Cold War) she most often

played an adorable "Little Miss Fix-It" who can just as easily mend the marriage of her silly upper-class father (*Three Smart Girls*, 1937) as she can help reduce the unemployment rate by organizing one hundred out-of-work musicians into an orchestra (*One Hundred Men and a Girl*, 1937).

Although Judy Garland didn't attain the immediate stardom of her *Every Sunday* costar, her success and fame would ultimately match and eclipse that of her early singing partner. Moreover, no matter how much of her later fame resulted from the tragic circumstances of her life, Garland's career at MGM was initially built on her girl-next-door good looks and charm, a trembling soprano, and roles that increasingly stressed her sensitivity and vulnerability. Furthermore, Judy was particularly fortunate in that her film career was simultaneous with the heyday of the MGM musical and its finest production organization, the Freed Unit.

Arthur Freed began his career at MGM writing lyrics for musicals like the Academy Award-winning *Broadway Melody* ("You Were Meant For Me") and its sequel *Broadway Melody of 1936* ("You Are My Lucky Star"). Upon being later given a chance to produce, starting with *The Wizard of Oz* (1939), he gathered around him undoubtedly the most creative personnel Holywood and Broadway had to offer. Under his aegis, performers and artists like Fred Astaire, Gene Kelly, Frank Sinatra, Kathryn Grayson, and Judy Garland, directors Vincente Minnelli, Busby Berkeley, Stanley Donen, and George Sidney, choreographer Robert Alton, and musical directors Kay Thompson and Roger Edens combined to create an unparalleled number of musical hits between 1939 and 1960.

The artistic and financial success of the Freed Unit were such that they not only aroused almost universal critical admiration, they also raised interesting questions in another sphere—that of film theory, particularly what became known as the "auteur theory." Indeed, a critical theory

that placed the director at the heart of the creative process of filmmaking seemed inappropriate when applied to the musical. Who would dare to place the creative contribution of a Lloyd Bacon above that of a Busby Berkeley in *42nd Street*, or even suggest that the creative impetus that dominated the films of Fred Astaire and Ginger Rogers emanated from directors like Thorton Freedland and Mark Sandrich? Thus, the Hollywood musical always seemed to place its creative emphasis elsewhere than on the director, and, in the case of the Freed Unit, it pointed in the direction of the producer, and, ultimately, the studio. In turn, it also seemed to place itself in the same category as Richard Wagner's music dramas which he called *Gesamtwerkskunst*—works of art which were amalgamations of all the other arts.

Not surprisingly, the signature of the studio is writ rather large on the first Arthur Freed-Judy Garland collaboration, *The Wizard of Oz*. It was the studio's attempt to repeat the success of Walt Disney's animated musical fairy tale, *Snow White and the Seven Dwarfs* (1937), which prompted MGM to produce L. Frank Baum's classic children's tale in the first place. The studio not only had ten writers working on the script, but four directors also participated in the production at various stages. By the same token, Judy Garland was not the studio's first choice for the lead. Shirley Temple was originally slated for the role, but, because she was unavailable, Garland was chosen to star in it. Although the film propelled her into the front rank of MGM players, Garland had to compete with such accomplished scene stealers as the ex-vaudevillians Ray Bolger, Jack Haley, and Bert Lahr. In addition, the shaping force of the studio can be discerned in the way the songs, dance, dialog, and production values all combined to form what would soon be referred to as an integrated musical, a musical wherein all of its elements advanced the plot.

Undoubtedly also contributing to the film's great success was the producer's decision to mine for all it was worth the "Home is Best" theme in the Baum story rather than deal with any of its political aspects (Baum's original story contained many satirical references to the Populist movement of his day). This theme was also enhanced by the good mother/bad mother combinations of the Wicked Witch/Glinda and the Auntie Em/Miss Gulch images that would have such unconscious resonance for generations of children who became the film's most devoted followers. Similarly, the use of black and white and color to designate Kansas and the Land of Oz respectively made explicit what until then had been implicit in the musical—its mingling of the real and the fantastic.

Beyond its esthetic and psychological implications, however, *The Wizard of Oz* has also woven itself and its messages into the cultural fabric of America and the world, becoming an international cultural icon. During World War II, it practically became the theme song of the Allies. For instance, British RAF pilots flying against the Luftwaffe and Montgomery's Eighth Army chasing after Rommel in the desert both sang "We're Off to See the Wizard," and on VE Day crowds in Trafalgar and Times Square sang, "Ding, Dong, the Witch is Dead." Similarly, "Over the Rainbow" became a song of hope for a better and more peaceful postwar world everywhere, from Los Angeles to Leningrad.

Advertisers, political cartoonists, and journalists around the world have made *The Wizard of Oz*'s Cowardly Lion, the Tin Man, the Scarecrow, and the Wizard of Oz into familiar images and metaphors. Since its first annual showing on television in 1956, *The Wizard of Oz* has become not only a rite of passage for the nation's young but also a great source of emotional satisfaction and moral certainty for children of all ages. In fact, the story of a little girl who is blown by a tornado into the Land of Oz, and then is helped to return home by a cowardly lion, a rusting tin

man, an ineffectual scarecrow, and a con man Wizard, has outgrown its original role as a charming musical fairy tale and become a universally beloved moral fable—a status unique for any Hollywood film.

Although *The Wizard of Oz* would catapult Judy Garland into the limelight, and ultimately even make her America's sweetheart, she initially remained somewhat in the shadow of her irrepressible, indefatigible costar, Mickey Rooney. Despite the fact that they made eight films together (including four in the Andy Hardy series), they were probably best known as a team for the series of "Hey Kids, Let's Put on a Show!" musicals—*Babes in Arms* (1939), *Strike Up the Band* (1940), *Babes on Broadway* (1942), and *Girl Crazy* (1943).

Today, of course, these musicals are regarded as quaint anachronisms, a charming throwback to the dinosaur era of musicals when it was necessary to have some kind of hook on which to stage bravura production numbers like the gigantic minstrel show in *Babes on Broadway* or the wild and woolly rodeo romp in *Girl Crazy*.

Despite the clichéd quality of the "Hey Kids, Let's Put on a Show!" hook, and their storylines involving the need to rescue some aged vaudevillians from the poor house, or to raise money to send some underprivileged kids to the country, these films retained some of the old "communitarian" spirit that marked the early Thirties Warner Bros. musicals. In addition, their hyperkinetic quality (usually associated with Rooney) made manifest an energy that the musical had always possessed but rarely acknowledged so openly. Indeed, in many ways this restless energy, which in these films was safely channeled into "Show Biz," may have been the first outright Hollywood recognition of the existence of that separate and vigorous entity that in the Fifties and Sixties would become known as "youth culture."

During World War II, the Hollywood studios were second to none as morale boosters or in their enthusiasm for the war effort. Consequently, along with musical performers who rushed off to join the colors (at least in films) like Fred Astaire—*You'll Never Get Rich* (1941) and *The Sky's the Limit* (1943)—and Gene Kelly—*As Thousands Cheer* (1943) and *Anchors Aweigh* (1945)—the musical also pushed the war effort in flag-waving films like *Star Spangled Rhythm* (1942) and *This Is the Army* (1941). And if flag-waving was called for, what could fill the bill better than a screen biography of the flag-waving champion of all time, George M. Cohan. In producing a screen biography of the great entertainer, Warner Bros. not only made a contribution to the war effort, they also created a landmark in a musical subgenre that Hollywood practically invented—the musical biography.

Starting with MGM's *The Great Ziegfeld* (1936), Hollywood specialized in presenting highly fictionalized and romanticized accounts of the lives of the great and sometimes near great of show business. *Yankee Doodle Dandy* (1942), the Cohan screen biography, was no exception to this formula, since it conveniently left out one of his marriages and attributed his early show business retirement to some kind of malaise rather than his implacable hatred and opposition to Actors Equity. Nevertheless, songs like "I'm a Yankee Doodle Dandy," "You're a Grand Old Flag," "Over There," and "Mary" tapped a vein of nostalgia and patriotism that proved to be extremely timely. This, plus a stellar performance by James Cagney as the ex-vaudevillian, dancer, composer, and producer all combined to make this musical biography the best of its kind and a model for others. Unfortunately, too many of the imitations—*Rhapsody in Blue* (1945, George Gershwin), *Night and Day* (1946, Cole Porter), *Till the Clouds Roll By* (1946, Jerome Kern)—seemed to fall into a "And then I wrote" rut.

Another somewhat diminishing note in the same manner came from the increasing use of the turn of the century and the

"Gay Nineties" as the setting for many musicals. To Hollywood, the era's presumed peace and stability (forgotten, of course, were the Populists and Coxey's Army, not to mention the often violent labor struggles of the decade) provided a vivid contrast to the turmoil of the Great Depression and World War II. In addition, the era's reputation as a "Golden Age" for show business made it a godsend for the musical. Nowhere was this reverence for this bygone age carried to greater extremes than at Twentieth Century-Fox, which turned out a series of musicals—*In Old Chicago* (1938), *Alexander's Ragtime Band* (1938), *Rose of Washington Square* (1939), *Lillian Russell* (1940), *Tin Pan Alley* (1940), *Hello Frisco, Hello* (1943)—set in this period, and starring the shapely blonde Alice Faye, which were nothing more than an excuse to string together a group of familiar melodies.

This sense of the Nineties as a time of tranquility also inspired other Forties musicals, with the era achieving Edenic status in MGM's *Meet Me in St. Louis* (1942). Indeed, the Smith family seemed to have walked out of a Currier and Ives print, a picture made all the more lively by the inclusion of such memorable songs as "The Boy Next Door," "The Trolley Song," and "Have Yourself a Merry Little Christmas," and by the fact that it was the first screen collaboration of Judy Garland and her husband, director Vincente Minnelli.

Meet Me in St. Louis stands apart from other turn-of-the-century idylls, most particularly in the manner in which Minnelli was able to infuse it with a sense of the psychic and social terrors that lurked beneath such seemingly placid surfaces. Thus, moments like Tottsie's (Margaret O'Brien) terrifying Halloween night with its shadows and dark colors, and the Christmas Eve of family anguish caused by the threat of Father Smith's (Leon Ames) possible job relocation, indicated just how fragile that world was. Despite revealing this delicate balance, the film

still ends well as Father Smith decides to turn down the job, and the family joins in celebrating the Louisiana Purchase Centenary with all its promise of a future of American greatness and prosperity.

Interestingly enough, *Meet Me in St. Louis* was not alone among musicals in straying from the path of official wartime American optimism. In films like *For Me and My Gal* (1942) and *Thousands Cheer* (1943), Gene Kelly was permitted, at least initially, to evince an almost *Casablanca*-like reticence about getting involved in the war effort, and even a daring bit of cynicism about it. Nevertheless, these were only fleeting moments before his inevitable commitment, and, by the time Kelly made *Anchors Aweigh* (1945), he was playing the least skeptical of recruits.

Nothing, however, could undermine the psychological propensities, or for that matter the athletic grace and joyous bonhomie, that Kelly brought to the dance musical. In fact, in the same manner that the Forties and Fifties films of Fred Astaire, his dance rival in the Freed unit, seemed to take on a semiautobiographical tinge—e.g., *Easter Parade* (1948), chronicling his search for a new partner after Ginger left, and *The Barkleys of Broadway* (1949), his film reunion with Ginger which fictionalized their early backstage problems—Kelly's musicals after *Anchors Aweigh* took on more and more psychological and sociological resonances.

Part of that had to do with Kelly's penchant for using the dance as a form of self-analysis. Beginning with the dance with his alter ego in *Cover Girl* (1944), his dreamlike cavorting with an animated mouse in *Anchors Aweigh*, and his fantasy images of himself as Douglas Fairbanks, John Barrymore, and Errol Flynn in *The Pirate* (1948), Kelly turned his dances into free association. This, when combined with the sophisticated satiric wit of writers Betty Comden and Adolph Green, and the energetic choreography of his codirector and choreographer Stanley Donen, resulted in a tryptych of musicals—*On the Town*

(1949), *Singin' in the Rain* (1952), and *It's Always Fair Weather* (1955)—which not only achieved an unparalleled integration of dance, song, and character into musical storytelling, they also offered a unique look at America's cultural transition from Forties optimism to Fifties anxiety.

On the surface, however, these three musicals would appear to be rather unremarkable. Many, for instance, might have argued that *On the Town* was merely an overblown version of Jerome Robbins's ballet *Fancy Free* (Louis B. Mayer argued that it was slightly communistic because it had a black woman dancing with one of the sailors). Similarly, *Singin' in the Rain* seemed like nothing more than a chance to pay homage to Arthur Freed by arranging a musical around his collected works. And *It's Always Fair Weather* probably appeared to be just a crass commercial attempt to recapture some of the magic of *On the Town*. Nonetheless, all three musicals had a charm, vitality, and spirit that transcended all of these objections.

In *On the Town*, for example, Kelly overrode studio opposition and filmed on location in New York. As a result, from its opening crane shot of a weary longshoreman singing "I Feel Like I'm Not Out of Bed Yet" to its three sailors (Gene Kelly, Frank Sinatra, and Jules Munshin) on shore leave, dancing and singing their way from the Battery to the Bronx, the film practically became a paean to postwar urban America. New York becomes such a bouyant metropolitan utopia, in fact, that for the three gobs and the three gals (Vera Ellen, Betty Garrett, and Ann Miller) they meet on leave, it turns into a place where they can all find love and the fulfillment of their dreams. This is accomplished with such whirlwind movement that it seems none of them ever stand still, thus raising the energy that had always inhabited the Hollywood musical to new heights.

Singin' in the Rain not only maintains this energy level in moments like Gene Kelly's dance through puddles and up the side of lampposts, it also elevated it into a symbol of exuberant, self-confident optimism. In addition, by taking a satiric look at the movie industry's changeover from the silents to the talkies, *Singin' in the Rain* added a critical edge to the musical's oft-repeated looks at the world of show business. Despite this, however, nothing in the film could detract from the feeling it gave of being absolutely at home with itself and its rosy view of the world. Indeed, so synonymous did "Singin' in the Rain" become with a kind of carefree lightheartedness, that years later, in Stanley Kubrick's *A Clockwork Orange* (1972), it was used to provide ironic counterpoint to a world of violence and despair.

Nevertheless, even before *A Clockwork Orange*, Hollywood seemed to be aware (if only dimly at first) that its halcyon days were just about over. Consequently, in *It's Always Fair Weather* the optimism and cheerfulness that had marked *On the Town* and *Singin' in the Rain* have a strained quality about them. In fact, the story of three soldiers (Gene Kelly, Dan Dailey, and Michael Kidd) who go through the war together and then vow to reunite ten years later, only to find out when they do that they can't stand one another, is hardly upbeat. Such is the sense of gloom that envelops the film that even Gene Kelly's yeoman attempt to recreate the optimism of "Singin' in the Rain" with a dance on roller skates ("I Like Myself") couldn't dispel it. The film's sourly satiric swipes at advertising and television didn't help any, either.

To some degree, these potshots at Madison Avenue and television were a hint that Hollywood recognized the handwriting on the wall. That sense of foreboding was hardly off the mark, since by 1955 over sixty percent of American homes had television (by 1960 it would be ninety percent). It increasingly seemed that the great days of the Hollywood studios, and especially the musical, might be a thing of the past.

Nevertheless, the Hollywood studios did not halt production of musicals

throughout the Fifties and Sixties; some have even argued that musicals kept Hollywood alive during those decades. In fact, from 1950 onward not only did Hollywood musicals win more Academy Awards for Best Picture—*An American in Paris* (1951), *Gigi* (1958), *West Side Story* (1961), *My Fair Lady* (1964), *The Sound of Music* (1965), *Oliver!* (1968)—than in the two previous decades since *Broadway Melody*, but a few like *The Bandwagon* (1953), *Seven Brides for Seven Brothers* (1954), *Funny Face* (1957), and *Mary Poppins* (1964) also rank with the best of Hollywood in any era. Yet the daring and innovation that had come to characterize the musical, even permitting experiments like Gene Kelly's all-dance musical, or encouraging the Third World oriented choreography of Jack Cole—*There's No Business Like Show Business* (1954) and *Kismet* (1955)—seemed no longer to have a place at the studios. Progressively shorn of their armies of contract players, directors, writers, and technicians, the studios more and more played it safe by importing musicals from the Broadway stage, with presold audiences presumably guaranteed by long runs and hot albums.

Even here, however, the expertise acquired over the years didn't entirely desert Hollywood, as it turned out some credible screen versions of these stage hits. Standing out and holding up rather well in the transition from stage to screen were the adaptations of Rogers and Hammerstein Broadway hits like *Oklahoma!* (1955), *The King and I* (1956), and *South Pacific* (1958). For a time, in fact, it seemed that Hollywood's attempt to recapture its audience with experiments in wide screen and three dimensions (e.g., VistaVision, CinemaScope, et al.) and the piling on of stars like Marlon Brando, Frank Sinatra, and Jean Simmons into recycled stage hits like *Guys and Dolls* (1955), might do the trick. Furthermore, moments like the aerial photography of Manhattan that gradually narrows to a shot of a ghetto street in the opening of

the film version of *West Side Story* (1961), as well as Jerome Robbins's ballet treatment of the gang rumbles between the Sharks and the Jets, created a sense of both the beauty and menace of the city, and indicated that Hollywood hadn't quite lost its touch.

Unfortunately, nothing seemed able to stem the tide, and the production of musicals took a startling nosedive. Many Holywood insiders even began to predict the genre's eventual demise. Their predictions, however, proved to be rather premature, especially when *The Sound of Music* (1965) proved such a smash hit (eventually reaching number one on *Variety*'s all-time box office hit list, where it still occupies an elevated ranking). *The Sound of Music*'s success, built on its brilliant use of aerial cinematography, hummable Rodgers and Hammerstein songs like "Climb Ev'ry Mountain," "My Favorite Things," and "Do-Re-Mi," a charming performance by Julie Andrews, an upright, adorable family of heroes, and hissable Nazi villains, proved an unbeatable combination. When Twentieth Century-Fox tried to repeat its success with a string of musicals—*Dr. Dolittle* (1968), *Star* (1968), and *Hello, Dolly!* (1969)—it came close to bankruptcy.

Clearly what was mising in the attempts to imitate the success of *The Sound of Music* was the fact that, despite (or possibly because of) the film's simplicity and mawkish sentimentality, it appealed to children of all ages. That was something becoming harder and harder for the musical to do as time went by, since by 1965 most youngsters had deserted forever the kind of hummable music that had made superstars of Frank Sinatra and Bing Crosby for a new form of pop music—rock "n' roll. Unhappily for the musical, Hollywood either didn't understand this new music—most of its executives were too old to really be in touch with it—or placed it in the unrewarding confines of the B-movie or exploitation film.

One of the best examples of this almost

complete lack of comprehension can be seen in Hollywood's handling of the Fifties king of rock 'n' roll, Elvis Presley. Instead of developing the image of Presley intrinsic to his song lyrics, his stage presence, or his three earliest films—*Loving You* (1957), *Jailhouse Rock* (1957), and *King Creole* (1958)—as someone tall, dark, and dangerous, Hollywood allowed his image to be turned into a nearly clean-cut one after his return from the army in 1960 (*GI Blues*, 1960), thereby losing some of the outlaw tendencies inherent in both the Presley image and his music.

Given this treatment of Presley, it shouldn't come as a shock that Hollywood missed other chances at using rock music to revitalize the musical. One of the most glaring examples of this was Hollywood's almost complete lack of interest in following up on the brilliant ensemble of the Beatles in their semidocumentary, *A Hard Day's Night* (1964). The documentary, in fact, became the form in which rock music was shown to its greatest advantage. Films like *The T.A.M.I. Show* (1964), *Monterey Pop* (1969), *Woodstock* (1970), *Gimme Shelter* (1970), and *The Last Waltz* (1978) were able to concentrate on the performers and their music work, while at the same time giving some sense of the lifestyle of the young that went with the music.

Almost simultaneous with the domination of pop music by the young, a number of young directors began to acquire more and more creative influence in Hollywood. Many of them had attended film schools, or grown up on the output of the old Hollywood studios, and saw directing a musical as a challenge. Some, like Francis Coppola, whose first production at his Zoetrope Studio was the technologically sophisticated but largely inept musical, *One From the Heart* (1982), may have even seen it as a symbol of a resurrected studio system.

Whatever the reason these directors approached the musical, however, the results were decidedly mixed. On one hand, there was the loving but almost laughable attempt to recreate the magic of the Astaire-Rogers musicals in Peter Bogdanovich's flatfooted *At Long Last Love* (1975). On the other, Martin Scorsese's equally nostalgic *New York, New York* (1977) was able to capture some of the spirit of the era when musical styles changed from the big band to beebop, while at the same time using the bittersweet love story of jazz saxophonist Jimmy Doyle (Robert De Niro) and band singer Francine Evans (Liza Minnelli) to take an ironic look at some of the conventions of the old Hollywood musical. That examination was rendered both poignant and illuminating by the presence of Minnelli, some of whose songs were staged so as to remind the audience of her mother, Judy Garland, and by its steadfast refusal to evoke the most basic of all Hollywood musical clichés, the happy ending.

Scorsese was hardly alone, however, in making musicals in the Seventies which commented on or inverted some of the standard Hollywood musical formulas. Bob Fosse, a dancer-choreographer during the heyday of the MGM musical, directed two musicals in the Seventies that included some particularly interesting departures from, and ironic observations on, the musicals of old. The first of these, the Academy Award-winning *Cabaret* (1972), contained Brechtian cabaret songs like "Money, Money" and "Mein Herr" sung by Sally Bowles (Liza Minnelli) and the Master of Ceremonies (Joel Grey) which, although ostensibly taking sardonic swipes at life in Weimar Germany, also hit the mark for contemporary society. In contrast to the relentless heterosexuality of the old Hollywood musical, Fosse allowed the bisexual relationships of Brian Roberts (Michael York), Maximilian Von Heune (Helmut Griem), and Minnelli to play an important role in the film. Similarly, he staged the Nazi hymn, "Tomorrow Belongs to Me," in a way that suggested that the communitarian-utopian strain so often credited to the musical might also

have fascistic potential.

Later in the decade, in *All That Jazz* (1979), Fosse took this self-reflexiveness one step further when he made a film based on Federico Fellini's *8 1/2*. Filling it with details from his own life in the guise of choreographer-director Joe Gideon (Roy Scheider), Fosse topped it off with some interesting ideas about the "death of the auteur," as he depicted Joe dying after open heart surgery (all too vividly shown on screen) and then proceeding to direct his own dream sequence death scene.

Despite the funereal and nostalgic moments, the musical was neither moribund nor near death. In fact, along with the lamentations and the revival attempts came such celebrations of the musical and its place in our collective consciousness as Daniel Melnick's *That's Entertainment* (1974), a collection of scenes from MGM's greatest musical hits, and *That's Entertainment, Part 2* (1976). Furthermore, a new generation of musical talent seemed to be emerging in Hollywood, including Barbra Streisand—*Funny Girl* (1968), *Hello, Dolly!* (1968), *On a Clear Day You Can See Forever* (1970), *Funny Lady* (1969), *A Star is Born* (1976), and *Yentl* (1983)—and John Travolta—*Saturday Night Fever* (1976), *Grease* (1978), *Staying Alive* (1983). With the megabuck success of rock and disco musicals like *Saturday Night Fever, Grease*, and *Fame* (1980), Hollywood finally seemed capable of integrating every kind of modern pop music, from heavy-metal rock to state of the art punk, into the musical.

This occurred not a moment too soon, since technology, which had inspired the creation of the Hollywood musical and then contributed to its serious decline, seemed ready in the Eighties to come to its rescue. Cable television, which had grown steadily if unspectacularly throughout the Sixties and Seventies, in the Eighties spawned MTV (Music Television), a twenty-four hour-a-day all-music channel, which seemed to be the savior of the Hollywood musical. With an audience of more than 19,000,000 exposed daily to excerpts of their songs and dances, previously unheralded musicals like *Flashdance* (1983) and *Footloose* (1984) became overnight sensations. The Hollywood musical, it appeared, might be headed for better days.

The Eighties saw a steady stream of musicals such as *Can't Stop the Music* (1980), *Xanadu* (1980), *Grease II* (1982), *Annie* (1982), and *A Chorus Line* (1985), plus plans for Hollywood versions of such Broadway blockbusters as *Evita*. The question, however, was never really one of quantity but of quality, of whether or not the Hollywood musical would be able to sustain its tradition of innovation, and if, in sustaining that tradition, it could continue to maintain the rich tension between diversion and discourse that had made it both the most glorious example of American escapist entertainment and the most consistent and illuminating observer of that phenomenon. These kinds of questions about the future of the musical recall the words of Richard Wagner on the opening night of one of his music dramas at Bayreuth: "Now that you have seen what we can do, now want it. And if you do, we will achieve an art." It still remains to be seen if the Hollywood musical, which has so often been equated with an American form of popular opera, can do just that.

—Albert Auster

RECOMMENDED BIBLIOGRAPHY

Altman, Rick. *The American Film Musical.* Bloomington, IN: Indiana University Press, 1987.

——— *Genre: The Musical.* Boston, MA: BFI, 1981.

Feuer, Jane. *The Hollywood Musical.* Bloomington, IN: Indiana University Press, 1982.

Green, Stanley. *The Encyclopedia of the Musical Film.* NY: Oxford University Press, 1981.

Kobal, John. *Gotta Sing, Gotta Dance: A History of Movie Musicals.* NY: Exeter Books, 1983.

Sennett, Ted. *The Hollywood Musicals.* NY: H. N. Abrams, 1981.

Broken Arrow

Native Americans in Hollywood Films

F ilms about Native Americans—usually categorized as a subgenre of the Western—are among the most prolific and diverse of all American films. Not counting foreign or ethnographic titles, thousands of silent and sound features include Native Americans as major protagonists.

The great majority of these films are set in either the colonial era or the period 1855–'90, but some of the most creative take place in the twentieth century. Major themes such as the noble savage, the assimilationist process, intercultural dynamics, and the demonic foe find expression in various chronological and geographic subdivisions and often coexist within the same film.

The relationship of the "Eastern" to national identity is explicit in films that take place in a historical period roughly bound by the French and Indian War and the American Revolution. Demonic Iroquois, first allied with the French and then with the British, face off against frontier settlers seeking to "civilize" the American wilderness. One of the most emotional evocations of the savage foe theme is found in *Drums Along the Mohawk* (1939), in which Iroquois terrorize farmers during the American Revolution. This anti-Iroquois sentiment had developed into animosity against Native Americans in general in *Northwest*

Passage (1940) when Iroquois do their best to wipe out a band of colonial irregulars led by Colonel Rogers (Spencer Tracy). At a climactic moment, Rogers, to the accompaniment of martial music, states that the only Northwest Passage for true Americans is overland and that it will be forged by "men who break trails and fight Indians."

A more balanced view of Native Americans is found in the numerous films based on James Fenimore Cooper's *Leatherstocking Tales*. Cooper's characters and plots were used often in the silent era and recycled thereafter as movie serials, feature films, made-for-television movies, and a television series. Seven films are based on *The Last of the Mohicans* alone (three silent features in 1911, 1914, and 1920; a sound serial in 1932; and four sound features in 1936, 1947, 1977 and 1992). The Cooper-based Eastern featured a white frontiersman, who might be named Deerslayer, Pathfinder, Hawkeye, or Nat Bumpo. Clad in buckskin, this rugged individual is contemptuous of British aristocrats and American townsfolk. His most trusted companion is the Indian Chingachgook, whose Mohican tribe is a traditional foe of the Iroquois.

Deerslayer and Chingachgook live on the cusps of their respective societies, and they value many aspects of their friend's native culture. Some critics have seen homosexual overtones in their relationship, but what truly distinguishes them is that both are mavericks. Deerslayer will not become a farmer in a log cabin and Chingachgook will not return to an Indian lodge in the forest. These comrades will always be ready for some new adventure; they will always be prepared to explore a new place or idea beyond the established frontier. Deerslayer dominates the relationship, but Chingachgook has independent goals. As a unit they embody the best of two worlds and may be interpreted as a cinematic hope for a genuinely multicultural United States.

Another important literary influence on early filmmaking was the image of Longfellow's Hiawatha, a Native American of noble bearing who expresses a complete range of human emotions. D. W. Griffith had an early box office success with *The Mended Lute* (1909), an Indian love story having no European characters. Griffith often dealt with Indian subjects. His first hit, *The Redman and the Child* (1908), features an Indian with exotic religious views who rescues a white child from white kidnappers; and his *The Massacre* (1912) is unflattering to General Custer. Such "friendly" Native American films were common throughout the silent era. Among the best films of this type from other directors are *The Invaders* (1912) and *The Heart of an Indian* (1912). Skillfully directed by Francis Ford, who also plays the lead role, *The Invaders* evaluates an Indian uprising as the consequence of white violations of a peace treaty. *The Heart of an Indian*, directed by Thomas Ince, includes a sensitive interaction between a white woman and a Native American woman on the meaning of motherhood.

Perhaps the most comprehensive rendering of the doomed noble savage is *The Vanishing American* (1925), based on a Zane Grey novel written with a film version in mind. The film's prologue shows how warrior tribes from the North destroyed a peaceful, pueblo-centered culture before the coming of the white man, and the film advances the idea that existing Native American culture likewise must inevitably be overwhelmed by modern technological civilization. Set in 1915–'20, *The Vanishing American* centers on a Navajo male, Nophaie (Richard Dix), who falls in love with the reservation's white schoolteacher (Lois Wilson). The couple struggles against corrupt reservation officials influenced by Booker (Noah Berry), an assistant Indian Agent. Nophaie had been a hero on the battlefields of World War I and he is an avid learner, but, like his people, he is doomed. The novel had him perish in a flu epidemic that devas-

tates his entire tribe, but the film contrives to have him chopped down by a blast from Booker's war-surplus machine gun.

As film production moved to California, the Native American film increasingly had a Western locale. Such Native American Westerns were so profoundly influenced by popular culture that it may be rightly claimed that Hollywood did not create the Hollywood Indian. Dime novels put out by Erastus Beadle and set in the West had sold a million copies annually as early as the 1860s. From this pulp tradition came characters that would populate many a film: Buffalo Bill Cody, Annie Oakley, Calamity Jane, Wyatt Earp, Billy the Kid, and Kit Carson, to name just a few. These Western heroes constantly fought Indians and passed on Indian lore largely invented by deskbound authors living east of the Mississippi.

The western tribes that dominated pulp fiction, the Sioux and the Apache, became the tribes that dominated the Native American Western. Their notoriety stemmed from wars against the whites. The Sioux had prevailed in one war (Red Cloud's War, 1866–'68), and one epic battle (The Little Big Horn, 1876), while some Apache raiders had fought whites in the late 1860s, making newspaper headlines throughout the nation. In the case of the Sioux, when Buffalo Bill created his famous Wild West Show, he hired famous warriors, Sitting Bull included, to play themselves in "historical reenactments." The war cry whooping attack on stagecoaches while wearing ceremonial feather bonnets, along with other elements of Cody's shows, were directly transferred to the screen. Some of the first silents, in fact, were simply filmed Wild West Shows. The process fed upon itself when early screen stars like Tim McCoy formed Wild West shows from the cast of their films and toured between pictures. Geronimo, the most infamous Apache raider, had also become an entertainer by 1900, appearing in presidential inaugural parades and signing autographs at fairs.

The Battle of the Little Big Horn, or Custer's Last Stand, had become an industry of its own. Custer's widow labored for years to create the myth of the heroic Indian fighter. Huge canvases depicting the battle toured state fairs for decades. The romantic version of the battle made into a lithograph by Cassily Adams was used by many film directors as the basis for their screen portraits. Adams showed Custer with pistol and saber in hand as the last man standing. He wears a short jacket, has long hair, and sports a red neckerchief. This outfit, which is hardly army regulation, is an artistic invention. No sabers were used in the engagement and, as the individual whose death would bring the most glory to a Native American warrior, Custer was not likely to be the last man alive, especially if he was foolish enough to stand. In 1896 a St. Louis brewery distributed 150,000 free copies of Adams's "Custer's Last Stand" to be hung as decorations in taverns, hotels, and restaurants.

Custer became the subject of twenty feature films between 1909 and 1971 and two serials (1932, 1936), and Custerlike figures would be the subject of numerous other films, most notably John Ford's *Fort Apache* (1948). The treatment of Custer offers an example of how Native American films often reflect a changing national self-image. The view of Custer as gallant hero reached its apogee in *They Died With Their Boots On* (1941) starring Errol Flynn as a flamboyant but totally sympathetic hero. *The Glory Guys* (1965), reflecting some of the cynicism created by the Korean "police action," portrays Custer as a cunning politician, extremely unscrupulous but quite rational. *Little Big Man* (1970), which is told from a Sioux perspective, has transformed Custer into a sadistic lunatic. Another film of that era, *Soldier Blue* (1970), also depicts peaceful Indians slaughtered by a berserk army general. The true reference for both films is not Indian massacres but events taking place in Vietnam.

Authenticity in Native American films became a major critical issue in the late Sixties. While fully recognizing that Hollywood is an entertainment business rather than an educational institution, critics argued that the distortions regarding Native Americans were far more significant than the liberties taken in the typical Hollywood historical romance or uplifting biography. Native American films were a direct account of the very formation of the nation and a reflection of its basic values. Seen in that context, the conflict with Native America as recreated by Hollywood was an enormous self-deception and a fundamental rewriting of history.

Critics pointed out that the vast majority of Native American tribes rarely appeared in films and that major leaders such as Tecumseh and Pontiac were bypassed for sagas about minor chiefs such as Geronimo. Studios responded by stating that they had always employed Indian actors, used genuine Indian artifacts, and hired Indian consultants. Despite these sometimes sincere efforts by filmmakers, the critics were right. The distortions in Native American films were wholesale. Iron Eyes Cody, who appeared in hundreds of Westerns, was raised in an Indian family that rented artifacts to filmmakers. In *My Life as a Hollywood Indian*, Cody wrote that although objects used in films were often genuine, they were mixed into an inauthentic cultural stew. Indian items were combined as if it were correct to clad a Swede in a Scottish tam, Italian neckwear, German *lederhosen*, and Dutch wooden shoes. A supposed war outfit usually included elements originally meant for marriage, naming, or fraternal rituals. Even the skin tone of Native Americans was fabricated. A reddish-brown paint called *bole armenia* was sprayed not only on whites who played Native Americans but also on Native Americans playing themselves.

Attempts to redress such distortions often led to new inaccuracies reflective of the bias of the times. This was strikingly

so in the "friendly" films of the Vietnam era. *A Man Called Horse* (1970) and its sequels make the sun dance a test of bravery rather than humility and they glorify British military tactics. *Little Big Man* (1970) projects the Native American as a nineteenth-century counterculture hippy. Indian eloquence is reduced to a greeting card poesy, while the smoking of peace pipes, a central aspect of Indian diplomacy, is compared to passing a marijuana joint around a circle of merrymakers. Other Indian customs are presented in a jovial manner that often reverses their intent.

Major distortions are often central elements of the entire genre. The suicidal frontal assault is the supreme example. In film after film, Native Americans hopelessly fling themselves against stockades, stagecoaches, circled wagons, and fortified positions of all kinds. A technical high point for such scenes is found in John Ford's *Stagecoach* (1939). Viewers had no way of knowing that the Apache who mount the attack did not fight from horseback, never made frontal assaults, or that more warriors are slain in the film's attack than Geronimo ever commanded. War chiefs almost always personally led attacks and could not retain their leadership if many of their men were wounded, much less killed.

What accounts for the war fantasies and many other Hollywood inventions is that Native Americans are not the true subject of most films in which they appear. Their usual esthetic function is to serve as an anonymous, irrational, but omnipresent force that perils the expansion of the United States and tests the individual bravery of the white heroes with whom the viewer is to identify. Their function is best reflected in the long line of silent warriors who often stare down upon a prospective target from atop high bluffs. These silent and unrepenting foes are a kind of national nightmare, a reminder to the pioneers that they are not alone, that the continent is not virgin, and that each westward step might have to be paid in blood.

Films set in the twentieth century often take up the spiritual and cultural challenge represented by Native Americans even after their military defeat. A red shadow seems to haunt the American psyche, whispering that the Native American way had not been entirely wrong. This unsettling aspect of the Native American image is so powerful that Native Americans have often become symbols of generalized social injustice. In *Massacre* (1935), Native Americans are an exploited working class desperately in need of FDR's New Deal; in *Key Largo* (1948) the Seminole left out of doors in the hurricane are literal huddled masses victimized by fascistic gangsters; in *Billy Jack* (1971) and its sequels, the Native American stands tall for the Bill of Rights; and in *One Flew Over the Cuckoo's Nest* (1975) Chief Bromden is a kind of national superego recoiling from a bureaucracy that uses lobotomy to enforce its will.

A postwar attempt to refine the Native American image began with *Devil's Doorway* (1949) which revived many themes of *The Vanishing American*. Broken Lance (Robert Taylor) has won a Congressional Medal of Honor in the Civil War but, returning home to Wyoming, he finds his land about to be taken by white homesteaders. Even though Lance's family is highly respected by the white townspeople, as Indians they cannot hold legal title to land. Lance, aided by a young woman attorney (Paula Raymond) and opposed by a corrupt land agent (Louis Calhern), struggles to keep his land. Ultimately, Lance dies defending his property under circumstances that leave the audience yearning for greater racial understanding.

A year later, *Broken Arrow* (1950) had the noble Chief Cochise (Jeff Chandler) allowing his white friend Tom Jeffords (James Stewart) to wed an Apache maiden (Debra Paget). The film's numerous non-military ceremonies, if not authentic, are meant to be highly complimentary. At the end of the film, white vigilantes kill Jeffords's bride in an unprovoked assault.

In a role reversal, the Indian must dissuade the white man from irrational retaliation. As would be the case in many films, Cochise is taller, lighter-skinned, and better groomed than Indian adversaries who oppose friendship with the whites.

The noble savage is also central to John Ford's influential *Cheyenne Autumn* (1964) in which two bands of Cheynne leave a desert reservation to seek peaceful reunification with relatives in their native plains region. This work is often regarded as an apology by Ford for previously negative films about Native Americans. As might be anticipated, the aid to the Cheyenne given by missionaries and government officials, while in keeping with America's faith in religion and government, is at odds with the reality that missionaries and government officials were the Indians' most determined foes. The military men who fought Native Americans usually understood them best and treated them fairly. This is a subtheme in yet another Ford Western, *She Wore a Yellow Ribbon* (1949). John Wayne plays a major about to be retired who rides into an Indian war camp under a truce flag to head off hostilities. He speaks with a war chief his own age, a man with whom he has done battle in the past, and the two veterans lament the folly of their situation and the martial spirits of their young men.

Among the boldest efforts to deal with Native Americans on their own terms is *The Savage Innocents* (1960), whose plot revolves around the killing of a white man by an Eskimo (Anthony Quinn) because the white has violated Indian laws. The value system of the Eskimo is shown to have reason in its climactic and cultural setting, and Western judgement is revealed to be sometimes hasty and shallow. *Ulzana's Raid* (1972) goes even further by showing that torture and other specifics of Indian war that seem fiendish may be part of a coherent and honorable culture.

The ultimate fate of the honorable savage who does not perish is assimilation, and some of the most ambitious of the

Native American films address the theme poignantly. *The Apache* (1950) shows a warrior making a painful transition to farming; *Jim Thorpe—All-American* (1951) depicts a world-class athlete who is driven to alcoholism by racism and personal tragedy; *The Outsider* (1961) offers a tragic account of Ira Hayes, the Native American who helped raise the flag at Iowa Jima, only to find stateside discrimination unabated; and *Tell Them Willie Boy is Here* (1969) presents a scenario in which death is preferable to second-class citizenship. In *Drums Along the Mohawk*, there is a semi-Christianized Indian within the colonial fortress, and in *Battle Cry* (1955) Navajo soldiers save their outfit by using their native language during radio transmissions in order to foil eavesdropping Japanese who understand English. A number of other war films include an Indian in the all-American ethnic platoon, and police films such as *The FBI Story* (1959) place Indians on the law-and-order team.

Even the most sympathetic assimilationist films often manage to gerrymander the facts to ease white guilt. In *Jim Thorpe—All-American*, the crucial event which plunges Thorpe into alcoholism is the death of his son, an event which did not occur in real life. The film transforms his full-blood Indian wife into a half-blood of higher education who can play the usual white teacher role. The film conveniently omits the years Thorpe spent performing nonspeaking parts as an Indian extra in Hollywood's lowest-budget films. Thorpe asked for a small role speaking in the film about his own life, perhaps as his father or coach. The request was denied and he disavowed the film.

Falling somewhere on the noble savage-assimilation axis is the Western version of the Native American buddy film. The Lone Ranger and Tonto relationship is the best known. The duo first appeared on screen in a 1938 serial and then rode on to four feature films, comic book treatments, radio programs, and a television series. The relationship is more problematic than Deerslayer-Chingachgook. The Native American is clearly secondary in importance. The Lone Ranger speaks, Tonto grunts. The Lone Ranger rides "a great white horse" and shoots silver bullets, while Tonto manages with a pinto and lead ammunition. Tonto's name is the Spanish word for foolish. Nevertheless, even in this literal horse opera intended for children, Tonto is more than a faithful companion. He is truly the masked man's only friend. It is Tonto who has saved the Lone Ranger's life and is privy to his secrets. The teammates are chivalrous paladins who uphold the virtues of law and order by guaranteeing human rights to all. Their crusade lacks sophistication but it is an important popular-art phenomenon in which the darker companion is a moral being far superior to the majority of humankind.

Sexual interest is absent or muted in the buddy films, but hundreds of other films deal directly with love and marriage on the Native American frontier. Some representative titles from different decades are: *Ionna, The White Squaw* (1909), *Bronco Billy and the Indian Maiden* (1912), *One-Eighth Apache* (1922), *Behold My Wife* (1935), *Duel in the Sun* (1946), *White Feather* (1955), *The Way West* (1967), and *Run, Simon, Run* (1970). The morality of such films is predictable. Lust is bad and marriage is good. The less culturally Native American the couple, the better their chance for happiness.

White males have the most options in the Native American romance. Usually they are the love object in a variation of the Pocahontas myth. Although the Indian maiden is invariably a beauty and of high social rank, she not only falls in love with the white stranger, but is also willing to leave her people and go off to the hostile white settlements. A male hero may live with his bride among her people if, unlike the Native Americanized fur trapper who is usually French or Irish, the time away from civilization is brief. As in *Broken Arrow*, the Indian partner often becomes a

martyr to racial understanding. Taking up the theme of white man in love with Indian maiden after *Broken Arrow*'s success was *Ghost Town* (1955), *Gunman's Walk* (1958), and *The Unforgiven* (1960). Such films had been popular from the beginning of the industry through to the late teens, but they had been almost nonexistent in the Twenties and Thirties.

In contrast to white males, white women nearly always come into the Native American orbit against their will, either by being abducted or being found as abandoned children. Plots which featured white female captives were very common until the early Twenties, all but disappeared in the Thirties and Forties, and then were part of the revival of Native American films in the Fifties. The white female among Native Americans usually yearns for escape to her native culture, and however long a woman has been with Native Americans, she will culturally revert as soon as she is separated from them. The abducted white child grown to womanhood in John Ford's *The Searchers* (1956) is a good example. In those rare cases when the attraction between the white woman and the Native American is mutual, rather than the white woman seeking to become more Native Americanized, the Native American wants to be more Europeanized. Scenarios in which a white woman actively seeks the love of an Indian man are seen in only a handful of films, while the Indian man in love with a white woman, responsive or not, or lusting after a white woman, is common.

Irrespective of which mate is Native American, films rarely expend much footage on integrated couples living in harmonious circumstances. The focus is more likely to be on the mating process, the furor a union ignites, and the problems faced by mixed blood children. In early films, children of mixed parentage tended to represent the worst of both cultures, but after World War II the tendency was to show the mixed blood as embodying the best of the two cultures. The term *half-breed*, with its negative connotations, was avoided except to show racial bigotry on the part of a character. Outstanding examples of the honorable mixed blood are Jeff Hunter in *The Searchers,* Elvis Presley in *Flaming Star* (1960), and Steve McQueen in *Nevada Smith* (1960).

Predictable as the Native American romance films may be, they are remarkable by their sheer number and candor. This is in contrast to the sexual treatment of blacks, Hispanics, Asians, and Arabs in American cinema. Despite all the negative images projected through the years, the general American public has retained a unique awe and respect for the Native American. If this were not so, Hollywood would not dare cast so many of its most attractive and popular stars as Native Americans or lovers of Native Americans. In addition to performers already named, Hollywood favorites cast in such roles have included Anne Bancroft, Clara Bow, Charles Bronson, Cyd Charisse, Gary Cooper, Douglas Fairbanks, Sr., Paulette Goddard, Burt Lancaster, Audie Murphy, Mary Pickford, Tyrone Power, Robert Young, Katharine Ross, and Loretta Young.

Native American films have run in cycles, being extremely popular in the industry's infancy and then enjoying periodic revivals. As the Sixties ended, there was a wave of "friendly" films, a number of which have already been discussed. More traditional themes soon got an imaginative reworking. *Jeremiah Johnson* (1972) depicts a white mountainman who begins as the sworn enemy of the Crow but comes to identify with them. *Three Warriors* (1977) features an elder who teaches his grandson Native American values as a guide for living as a man of dignity in the white man's cities, while in *When Legends Die* (1972) a young Ute who has had a successful but unhappy and corrupt career in the white world elects to return to the reservation. One of the most unusual films of the decade was *House Made of Dawn* (1972) based on Kiowa writer N.

Scott Momaday's Pulitzer Prize-winning novel. Momaday coscripted the film, the first feature to treat Native American alienation and despair from a Native American perspective.

Perhaps the most prophetic film of the revival, however, was *Buffalo Bill and the Indians, or Sitting Bull's History Lesson* (1972), a satire which savaged the genre's every conviction and indicated there was nothing new to say. The ambiguous either/or title was appropriate in that many Americans were no longer certain how they felt about the Indian Wars. Vietnam, Watergate, the civil rights movement, and other political events had cast doubt on the values of the dominant culture and what was truly valid in the national iconology.

Many of the supposedly innovative aspects of the Seventies films, such as having Native Americans play Native Americans on screen, were just old practices resurrected. A new concern of political activists was that Indian actors such as Dan George, who played the wise elder in *Little Big Man*, and Iron Eyes Cody, newly famed for his work on behalf of the environment, were being projected in a condescending manner not unlike the sentiment that had produced the noble savage and old cigar store Indian stereotypes. The desire of actors like Jay Silverheels, famed as the Tonto of television, to have Native Americans play as broad a range of roles as any other ethnic group, seemed as elusive as ever.

The most extreme attempt to Native Americanize the Native American film occurred with *Windwalker* (1980). Excepting British actor Trevor Howard in the lead role, the cast was entirely Native American. Aside from a voice-over in English, all spoken language was either Cheyenne or Crow, giving *Windwalker* a foreign film flavoring. The plot involved tribal rivalries in a time preceding the arrival of the Europeans. *Windwalker* did poorly at the box office, discouraging further productions along similar lines.

The Eighties eventually proved to be the first decade without a major Native American film. Unlike the war and gangster genre, which were able to find new life by revitalizing established formulas, both extremes of the Native American cycle, the demonic hostile and the noble savage, appeared to have become unacceptable to public opinion. Rigid authenticity had not proven to be box office magic either and the symbolic use of Native Americans for indirect discourse was unnecessary as filmmakers directly addressed conflicts in Latin America, Asia, and Africa; and white cop/black cop buddy films had far more appeal than another reworking of the Deerslayer/Chingachgook dynamic. In an era marked by patriotic flagwaving, there seemed to be little interest in challenging the nation's most revered myths. As the decade ended, the longest-lived Hollywood genre seemed to be in a state of suspended animation with no visible signs of revival on the immediate artistic or political horizon.

Any hope for the genre seemed dependent on rethinking and perhaps reinventing the genre's basics. Then, without much warning, came Kevin Costner's *Dances With Wolves* (1990), one of the biggest blockbusters in Hollywood history. More amazingly, for all its claims to originality and daring, the film's director-star offered no more than a rather unimaginative mix of established classic and revisionist conventions: good Indians vs. bad Indians; the white man gone native; the beautiful Indian bride; Indians portraying Indians; Indian language in subtitles; colorful ceremonial interludes; and a gratuitous Civil War opening. The one innovation was a reversal of genre givens so that the cavalry in the West is so villainous that the audience cheers as an Indian war party successfully rides to the rescue of the hero. Ecological sensitivity, particularly as regards the fate of animals, was another trendy aspect of the film, but was presented in the maudlin traditions of *Lassie* and

My Friend Flicka.

The major psychological factor in the American response to *Dances With Wolves* seemed to be a subliminal reaction to the arrogance of the Reagan years, for the film presented everything European as shallow and disreputable. *Black Robe* (1991), an Australian feature, and a 1991 made-for-television movie starring Kris Kristofferson as the sensitive white man reprised many of the themes Costner had featured. A year later, *Thunderheart* offered a story vaguely related to the 1973 violence at Wounded Knee associated with the American Indian Movement. The film sought to make a strong statement about the rights of Native Americans but was severely compromised by having mystical elements as a major plot factor and an FBI agent, rather than a rebel, as its major

character. The lukewarm reception of these films indicated that *Dances With Wolves* might prove to be a genre nova rather than the harbinger of yet another cycle of Native American films.
—Dan Georgakas

RECOMMENDED BIBLIOGRAPHY

American Film Institute. *The Native American Image on Film.* Washington, D.C.: The American Film Institute, 1980.

Bataille, Gretchen and Charles Silet. *The Pretend Indian: Images of Native Americans in the Movies.* Ames, IA: Iowa State University Press, 1980.

Friar, Ralph and Natasha Friar. *The Only Good Indian: The Hollywood Gospel.* NY: Drama Book Specialists, 1972.

McClure, Arthur F. and Ken D. Jones. *Heroes, Heavies and Sagebrush.* NY: A. S. Barnes, 1972.

· ·

Peckinpah, Sam

(February 21, 1925 – December 28, 1984)

“**W**hat I am is a nihilistic anarchist living on residuals,” says a survivor of *The Osterman Weekend* (1983), Sam Peckinpah's last movie. The director seldom articulated his own point of view so clearly offscreen—preferring such coy formulations as, “I'm a good whore. I go where I'm kicked”—but his films certainly exemplify Bernie Osterman's mocking self-assessment.

From his beginnings, directing television series episodes and writing screenplays, Peckinpah belonged to a long line of unruly American mavericks, such as Sam Fuller, who championed individual revolt against the powers that be: the law, moneyed interests, government, tradition, politicians, family, outlaws, or just the local louts. This vague, undifferentiated

libertarian refrain persisted through all his films, from the profoundly influential (*The Wild Bunch*) to the infamous (*Straw Dogs*) to the relatively unnoticed (*Convoy*). He did not go where he was kicked without kicking back, as many goaded producers, dismissed crew members, and tormented actors were quick to point out.

As for nihilism, few directors killed off

so many of their protagonists. And despair visibly swelled in Peckinpah's films as his career ebbed, leaving him with a reputation as a bloodthirsty virtuoso in the editing room, whenever producers would let him get near one.

Peckinpah's screen surrogates are haunted by self-doubt, despite the swaggering macho facade their creator promoted. It took baroque form in his violently imagined world of men betrayed by friends, lovers, family, and patriarchy itself, which Peckinpah pursued to its apocalyptic dead end in his best films. Despite the fact that he is remembered as a director of Westerns, he was attuned metaphorically to the Vietnam era, where for him what was at stake was American manhood and by extension American hegemony, both driven into a frenzy of destruction by forces they had once contained through firm but benign, one might even say paternal, ministration.

Peckinpah's career can be seen as one long howl of pain about the breakdown of patriarchy and the betrayal of its birthright, a lament expressed on behalf of his brothers by the black-sheep son of the family. The boys prove to be real sore losers, but to whom? The easy answer is to women and people of color, of course, but Peckinpah is surprisingly ambivalent about their ascendancy, despite his justified reputation for misogyny. Their fitness for power is something he is willing to consider, and his failing heroes often throw their last measure of strength to the blacks (*Convoy*), Mexican peasants (*The Wild Bunch*), Asian insurgents (*The Killer Elite*), and various females (*The Ballad of Cable Hogue, The Getaway, Bring Me the Head of Alfredo Garcia*) who have taken up the fight against vested interests.

Which is not to say Peckinpah is a progressive or a liberal—the real meat of any Peckinpah movie is not passing the torch, but answering the sphinx's riddle, how did the boys lose their promised inheritance? He never finds the answer, although the question took him into his own heart of

darkness, a place where patriarchal values of manhood reach their reductio ad absurdum in *Straw Dogs*, and a literal dead end, a grave or a killing ground, in *The Wild Bunch* and *Bring Me the Head of Alfredo Garcia*. Peckinpah's films give life to an apalling vision that he could not repudiate

Peckinpah properly began his quest with America's formative myth, the Western, to which he wrote what appears to be the final and most significant chapter, altering it irrevocably. No Western made after *The Wild Bunch* (1969), with its convulsively edited shootouts, could fail to take into account that story of a fading outlaw gang on one last caper in Mexico; in fact, Peckinpah attacked the Western with such finality that it seemed to implode and disappear from the screen. Even he himself could not pursue it with such conviction again, as the artistic and commercial failure of *Pat Garrett and Billy the Kid* in 1973 attests. (Despite its developing a cult upon rerelease of a director's cut, it seems to me a far less candid and a far more confused attempt to negotiate that same idelogical cul-de-sac.)

Peckinpah reversed the terms of the elegaic Western, replacing nostalgia for the frontier with a sense of its betrayal by the very society to which it had given birth. Betrayal, Peckinpah's favorite motif in any setting, is epidemic in *The Wild Bunch*. One of the Bunch's former leaders, Deke Thornton, betrays his best friend, Pike Bishop (William Holden), by heading up the railroad company posse in exchange for release from prison—where he landed after Pike abandoned him in a tight spot. The Bunch hand over their Mexican comrade Angel to the tender mercies of the Generalissimo Mapache; Angel had shot his childhood sweetheart after finding her in Mapache's arms. In a larger sense, the past has been betrayed by the present—a reversal of the traditional thrust of the Western, which has generally served America as a vindication of what is, through the legend of how it came to be.

The Western has always been willing to see the past give way to "progress," albeit with regret for lost warriors. That mournful theme is John Ford's contribution, seen most clearly in *The Searchers*, with Ethan Edwards framed outside the cabin door, the man whose ferocity not only made civilization possible but also rendered him unfit to partake of it. In Peckinpah's Westerns, however, there is no progress, only a poor substitute for heroic days long gone. As one survivor of the Bunch tells Deke Thornton at the movie's end, offering him a life with peasant revolutionaries, "It ain't like it used to be, but it'll do." Scant comfort after the bullet-riddled holocaust of Mapache's village.

Peckinpah's revisionist West, with its sense of betrayal and usurpation, contains the mythic underpinnings of the New Right and its populist face, the sagebrush rebellion against big government and big cities. The American town caught in the crossfire of *The Wild Bunch*'s opening scene is not worth saving, it would appear, though once men like the heroes of *Ride the High Country* (1962), Peckinpah's earlier, lyrical tribute to his grandfather, died to give such communities life. Now it's just a pawn between the railroad and its outlaw quarry. The Bunch does find a town worth saving—in Mexico, which is for Peckinpah, who died a Mexican citizen with a Mexican passport, the land where things are possible.

The Bunch, in their haste to find new markets abroad, seek business south of the border with a cutthroat dictator, Mapache, advised by the German army. These entrepreneurs dressed as soldiers (their disguise in the abortive bank robbery that opens the film) have come—as critics of American imperialism often argued—not to pursue ideals but to close deals—to run guns. But the mercenaries are drawn inexorably to the revolutionary movement of the peasants in Angel's village, a romantic fiction that no doubt helps to account, in addition to Peckinpah's bloody candor about entry and exit wounds, for the conservative backlash against *The Wild Bunch*.

In fact, *The Wild Bunch*'s foreign-policy salvos are ambiguous. (Similarly, Peckinpah in real life was thought to be by some a Democrat, while others were convinced he voted Republican. In either case he hated the CIA, and made two antispook movies to prove it.) Like many Cold War parables of a previous decade, the film can be read two ways. Angel's village, where the Bunch are greeted like heroes, is also American foreign policy's fondest interventionist dream, the natives eager for military advisers and weapons. The Americans have to be convinced to intercede, and do so finally at great cost to themselves, in a *beau geste*. *The Wild Bunch* thus comes out *for* military adventurism, as long as it's on the right side. But then, of course, when has America ever thought it was on the wrong side?

Peckinpah's Vietnam Western is couched in the sexual political terms of professionalism and male bonding, for he was above all a man consumed with the manifest destiny of masculinity. Women play at best a symbolic role for him, serving as refuge or mantrap, and appearing more often than not as prostitutes by title or deed.

The best and the worst of them appear in the same movie, *The Getaway* (1975), the sunniest of Peckinpah's movies. Allie McGraw is the wife whose devotion to her imprisoned husband Steve McQueen is boundless. She sleeps with an influential mobster to spring McQueen, and spends the rest of the movie atoning, proving herself by killing for him. But lest we forget what creatures women are, Sally Struthers plays the sluttish, whiny wife of an unfortunate veterinarian forced to treat a wounded thug. She cuddles up to sleazy Rudy with unseemly haste, until her husband hangs himself in shame.

Peckinpah's women are instrumental to a man's self-definition, but they rarely exist outside it. This is hideously clear in *Straw Dogs* (1971), Peckinpah's first contempo-

rary drama, his "fascist work of art" in Pauline Kael's famous phrase.

Straw Dogs taps a favorite American formula, the call to arms, in which a man who refuses to kill (*Destry, Shane, Sergeant York*) must be brought to his senses. The least likely Peckinpah hero, mousy urbanite Dustin Hoffman, plays David, a furtive American astrophysicist who has settled on the Cornish moors with a bored, hot-blooded British wife, Amy (Susan George). Peckinpah's first, defining shot of Amy is a closeup of her bra-less breasts jiggling under her sweater as she walks through town.

Taunted by Amy's former lover and a loutish working-class clan who would shame the no-account Clantons of John Ford's *My Darling Clementine*, David eventually endures a horrifying siege of his home while trying to protect the village idiot, who is accused of rape and murder. "I will not suffer violence against this house," David proclaims, and becomes a man by going *mano-a-mano* with his enemies. Killing, which takes him from the abstract world of his equations back to the concrete, makes him a man who can finally tell his wife what to do. Oh, and he need no longer be afraid of the American turmoil he had fled.

Peckinpah's macho bravado found its masturbatory climax in *Straw Dogs*—he's caught with his pants down, you might say, confessing a nasty fear and hatred of women, which reportedly leaked on to the set. The more he hated Amy, the more he tormented the actress playing this ball-busting, dumb-blonde wife, who warms to rape by her former boyfriend and then gets her comeuppance when a less gentle cohort finishes the job. That the villains are slobbering, working-class brutes barely reined in by an ineffectual gentry contrasts oddly with Peckinpah's blue collar sympathies in later films like *Convoy* (1978), the ballad of a truckers' protest, and *Junior Bonner* (1972), about a rodeo rider's return to a hometown taken over by suburban businessmen. *Straw Dogs*

destroyed Peckinpah's following among liberals who admired *The Wild Bunch*.

However, Peckinpah fascinates politically not for any progressive agenda, but because he exposes so much of the patriarchal mind. He is a tragic figure in some respects, a brilliant filmmaker, capable of lyrical flights of imagery, and a serious questioner of values, who heard only the ideological bad news in the ferment of the Sixties. An allegorical *film noir* set in present-day Mexico, *Bring Me the Head of Alfredo Garcia* (1974), Peckinpah's last adventurous film and one of the few that came to the screen in the form he intended, demonstrates the extent of his disillusionment with patriarchy and his subjugation to it.

Warren Oates plays Benny, an expatriate loser in Mexico who stumbles on a chance for riches. The south-of-the-border godfather called only El Jefe has offered a reward for the head of the man ("He was like a son to me") who got his daughter with child. The bloody quest for the golden fleece takes Benny and the devoted prostitute who loves him, Elita (Isela Vega), into a world of horror: murder, grave-robbing, greed, and rape. Elita is murdered and Benny is buried alive. But he escapes to deliver his grisly filial tribute, where, at the impromptu urging of El Jefe's proud daughter, he shoots the crime lord whose "honor" has required so many deaths.

There's no escape for Benny, though, who goes down in a hail of bullets after blowing away the patriarch whose favor so many sons vied for (and died for). The screen freezes on a gun firing point blank at the screen, an image echoing the first Western, *The Great Train Robbery* (1903). Perhaps Peckinpah's heroes have something in common with Ethan Edwards of *The Searchers*, after all; they are men who cannot go forward into the future, just as the film points back to the past. But then it's a tomorrow Peckinpah had little hope for.

His own future after *Alfredo Garcia*

held increasingly cynical films brightened only by trademark violent setpieces, constructed with an inimitable blend of slow motion, multiple camera setups, and quicksilver editing. The blood flowed, the casual and shocking misogyny remained, and along the way, Peckinpah also took amusing potshots at corporate duplicity (*The Killer Elite*, 1975), corrupt politicians (*Convoy*), military stupidity (*Cross of Iron*, 1977) security (*The Osterman Weekend*)— but with none of the feverish conviction of those films he made before the fall of Saigon.—Pat Dowell

RECOMMENDED BIBLIOGRAPHY

Fine, Marshall. *Bloody Sam*. NY: Donald I. Fine, 1991.

Kitses, Jim. *Horizons West: Anthony Mann, Budd Boetticher, Sam Peckinpah*. London: Thames and Hudson, 1969.

McKinney, Doug. *Sam Peckinpah*. Boston, MA: Twayne Publishers, 1979.

Seydor, Paul. Peckinpah: *The Western Films*. Urbana, IL: University of Illinois Press, 1980.

Simmons, Garner. *Peckinpah: A Portrait in Montage*. Austin, TX: University of Texas Press, 1982.

Penn, Arthur

(September 27, 1922 –)

Arthur Penn's career has many affinities with the work produced by his older Hollywood colleague, Elia Kazan. Like Kazan, Penn came to film from a successful career in the Broadway theater, and he has also displayed a marked preference for a highly stylized 'realism' and the technique of Method actors such as Marlon Brando.

Nonetheless, the disparity between these two directors becomes apparent when one examines their attitudes toward politics and history. Despite his HUAC transgressions, Kazan consistently embraced an optimistic New Deal creed. Penn's films, on the other hand (with the possible exception of *The Miracle Worker*), resist striking a tone which could be interpreted as naive or affirmative. They are scarred by the uncertainties of a more ambiguous era.

Penn's frequently bleak perspective— which many critics have been tempted to label pessimistic—is apparent in his earliest films. His first Hollywood effort, *The Left-Handed Gun* (1957), is a subtle attack on the conventions of the Western genre. Paul Newman's Billy the Kid is a far cry from the virile figure of heroic rebellion we have been primed to expect from Hollywood films. Instead of portraying the macho gunfighter of Western lore, Newman's William Bonney is a whining, mother-fixated adolescent who appears to be "growing up absurd." This rather modish investigation of an alienated youth—a thematic preoccupation quite characteristic of Fifties cinema—continued through Penn's third feature, *Mickey One* (1964). This film contrasts sharply with the remarkably unsentimental inspirational film, *The Miracle Worker* (1962), which preceded it, in that Penn is deliberately attempting to unburden himself of the accoutrements of the "well-made" film. The plight of Warren Beatty's Mickey, a talent-

less nightclub comic, is conveyed by Penn in an ersatz New Wave style that utilizes elliptical editing and an allegorical narrative. Although this foray into Pop "existentialism" is one of Penn's more problematic films, his courageous willingness to challenge the strictures of mainstream film practice within a commercial context paved the way for more substantial achievements.

In contrast to *Mickey One*'s largely apolitical celebration of alienation American style, *The Chase* (1965), despite a predictably florid script by Lillian Hellman, remains one of the rare American films to explore the relationship between class and racial hierarchies. An archetypal small Southern town, with all the racial and social animosities viewers have been conditioned to expect from a spate of Tennessee Williams adpatations, provides the backdrop for an often hyper-melodramatic narrative. Yet Penn manages to transcend many of the clichés of this subgenre by unobtrusively linking the film's turbulent events with contemporaneous political turmoil. For example, the rather sinister figure of Val Rogers, a millionaire who manipulates the fate of all of the film's protagonists, features E. G. Marshall successfully evoking the duplicitous countenance of Lyndon Johnson. Robert Redford's Bubber Reeves, on the other hand, is a charming renegade who wholeheartedly rejects all of the values represented by local patriarchs such as Rogers. Marlon Brando's surprisingly restrained portrayal of an incongruously liberal Texan sheriff incarnates all of the contradictions of an ineffectual liberalism that was beginning to be undermined by more radical voices by the mid-Sixties. Jane Fonda's Anna Reeves, who oscillates between affection for husband Bubber and the roguish son of Val Rogers, seems to herald an incipient feminism by virtue of her independence and unsentimental clearheadedness. Above all, the gratuitous harassment of a black man named Lester who unwittingly violates the taboo of consorting with white women by delivering a message to Anna, presents an analogue to the struggles that were being waged by a burgeoning civil rights movement.

Bonnie and Clyde (1967) was not only a landmark film for Arthur Penn, it also became a cultural milestone for an emerging counterculture. According to Todd Gitlin, these glamorized Depression bank robbers became "free-standing angels of revolt...Sixties people set back in the Thirties." *Bonnie and Clyde* provided ironic counterpoint to Rap Brown's observation that violence was "as American as cherry pie" since the film managed to depict both the amoral violence of hardened criminals and echo the institutionalized violence epitomized by the Vietnam conflagration. The loving but ultimately treacherous relationship between Bonnie and Clyde and their extended family mirrored the familial tensions which provided the fodder for transgenerational conflict during the late Sixties. On another level, the film triggered a continuing debate concerning the representation of violence in film. Some lambasted the film's bloodier sequences (especially the spectacular slow motion shoot-out which serves as the film's lurid climax) as vile celebrations of gore, while others viewed these interludes as legitimate reflections of an innately violent culture. Dede Allen's virtuosic disjunctive editing imbued the film with the aura of an American *Breathless* (the film was supposedly initially offered to both Jean-Luc Godard and Francois Truffaut), and, whatever the film's limitations, it certainly made possible the work of subsequent iconoclastic directors such as Robert Altman. While Gitlin's retrospective coupling of *Bonnie and Clyde* with the spirit of Frantz Fanon and the NLF may seem hyperbolic, the film certainly had its finger on the pulse of an often inchoate rage which had the potential to be channeled either into concrete political action or nihilistic violence.

Alice's Restaurant (1969) lacked the buoyant comic tone of *Bonnie and Clyde*, and its elegiac tenor seemed at the time to constitute a despondent meditation on the failed communal aspirations of the late

Sixties. While Arlo Guthrie's witty antiwar ballad provided the initial impetus for the film's leisurely narrative, Penn was eventually more interested in the contradictory impulses of hippie communitarianism than in the dynamics of draft resistance. Unlike many other dissident voices of his era, there is a sense of continuity between Arlo and his father's generation. The ailing Woody Guthrie (impersonated in the film by an actor) and folksinging compatriot Pete Seeger appear as representatives of a vestigial Old Left culture: the Popular Front and the New Left are united by guitars and banjos. Like Brook Farm in the nineteenth century, Arlo's communal experiment in Massachusetts falls prey to discord and disillusionment. Marital tension threatens the promise of "free love," hard drugs besmirch the ideal of psychedelic nirvana, and the deconsecrated church that Arlo and his friends envision as a haven for secular communion lies abandoned by the film's conclusion. The apolitical naifs of *Bonnie and Clyde* proved much more exuberant.

Little Big Man (1970), Penn's adaptation of Thomas Berger's picaresque novel and perhaps his last film of genuine interest, coincided with the rediscovery of the U.S. government's supervision of the extermination of its Native American population. This newfound historical awareness was fostered by revisionist studies such as Dee Brown's *Bury My Heart at Wounded Knee*, and Penn's film combines an acute sense of historical guilt with a comic expansiveness that is greatly aided by Dustin Hoffman's bravura performance. In contrast to the many Westerns that featured pale Hollywood actors as "Indians," Penn decided to cast an actual Native American, Chief Dan George, in the pivotal role of Old Lodge Skins. Yet Penn and scriptwriter Calder Willingham's decision to have Old Lodge Skins incessantly spout folksy aphorisms spawns a discomforting mawkishness, and is itself part of an ethnocentric tradition. Despite this sort of cinematic solecism, Penn's recreation of the Battle of the Little Big Horn offers a disturbing portrait of American imperial hubris, an "arrogance of power" embodied by the film's incorrigibly vain Custer who foreshadows similarly deluded figures who were destined to continue the General's unfortunate legacy in Southeast Asia.

Penn's later films are either marred by maundering introspection or by genre-mongering sensationalism. The long-awaited *The Missouri Breaks* (1976) was bogged down by the narcissistic star turns of Marlon Brando and Jack Nicholson. *Night Moves* (1975) seemed to parody *To Have and Have Not*, Hemingway's lively tale of Key West smuggling, but the film's despairing tribute to the glory days of *film noir* was both confused and dispiriting. *Four Friends* (1981) offered a stereotyped version of the Sixties cultural landscape that Penn had helped to shape, and appeared to suggest that this time of cultural ferment merely leaves a legacy of irrationality and ideological dishonesty. *Target* (1985) and *Dead of Winter* (1987), colorless examples of the "spy film" and the "thriller," were barely recognizable as Penn's handiwork. *Penn and Teller Get Killed* (1989) was a clumsy attempt to superimpose narrative coherence upon the antics of a magic team with a peculiarly macabre sense of humor. Ultimately, the film was stymied by the elder Penn's desperate attempt to remain hip. After his taboo-shattering early work, Arthur Penn seemed exhausted, and sought refuge in the money and ease that the standard genres can provide. It is hopefully not to late for this once vital director to swallow his bitterness and reassert his talent.
—Richard Porton

RECOMMENDED BIBLIOGRAPHY

Kolker, Robert Phillip. *A Cinema of Loneliness.* NY: Oxford University Press, 1988.

Wood, Robin. *Arthur Penn.* NY: Praeger Publishers, 1970.

Zuker, Joel Stewart. *Arthur Penn: A Guide to References and Resources.* Boston, MA: G. K. Hall, 1980.

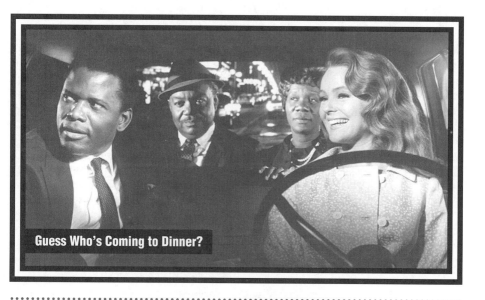

Guess Who's Coming to Dinner?

Poitier, Sidney

(February 20, 1924 –)

If Sidney Poitier had not existed, he would had to have been invented. In the aftermath of the Holocaust and the Second World War, and at the dawn of the Atomic Age, white moviegoers were no longer content with the escapist singing, dancing, and melodramatics that dominated the prewar cinema.

A market emerged for more serious films which examined inadequacies in American society, notably in the area of race relations and religious discrimination.

In 1947, two films, *Crossfire* and *Gentleman's Agreement*, focused on anti-Semitism. And, in 1949, four features—*Pinky*, *Lost Boundaries*, *Home of the Brave*, and *Intruder in the Dust*—spotlighted African-American characters who were as honest, tormented, or complex as white roles were allowed to be. Their appearance in Hollywood movies remains significant, even though they were presented in films meant for consumption by white audiences, and even though they were depicted as blacks in a white world, all too willing to relinquish their ethnicity for accep-

tance by whites, on white terms.

Still, Jackie Robinson had just broken the color barrier in major league baseball; it was five years before the Brown vs. Board of Education desegregation case; and America was ready for an African-American actor to achieve full-fledged celluloid stardom. And that actor was Sidney Poitier, who debuted on screen in *No Way Out* (1950). For the next two decades, he would be the sole African-American to become a major American movie star.

In *No Way Out*, Poitier is cast as Luther Brooks, a young intern humiliated by a white racist thug (Richard Widmark); he must prove that he did not let the hoodlum's crony die while under his care. The fact that a black man could star in a major

Hollywood motion picture as a doctor was in itself a revelation. "We've been a long time getting here," Brooks's wife symbolically tells him. "We're tired but we're here, honey. We can be happy. We've got a right to be." At the finale, Brooks's nemesis has been shot and the doctor could easily, and justifiably, let him die. But Brooks chooses to save his life. "Don't you think I'd like to put the rest of these bullets through his head," he says. "I can't...because I've got to live, too...I can't kill a man just because he hates me."

From this debut, it was apparent that Poitier's presence would irrevocably alter the types of roles available to a black actor. As *Variety* perceptively noted in its *No Way Out* review, "Sidney Poitier is a young, talented Negro actor whose quiet dignity and persuasive style mark him for an important future." Indeed, Luther Brooks is the model upon which Poitier's screen persona was based: he's refined, intelligent, and friendly, and he remains calm even when harassed. Any complaining would come from reason, not rage.

In *Edge of the City* (1957), he plays a dock worker who befriends (and, typically, lays down his life for) an army deserter played by John Cassavetes. In *Lilies of the Field* (1963), he stars as an amiable handyman who builds a chapel for a band of German-speaking nuns in the Arizona desert. In *To Sir, With Love* (1967), he's a teacher who tames a class of unruly British teens. In *In the Heat of the Night* (1967), he's a Philadelphia police detective who educates backwoods America (in the person of a redneck sheriff played by Rod Steiger) that blacks are capable of solving crimes, not just committing them.

Poitier's most symbolic films are *The Defiant Ones* (1958) and *Guess Who's Coming to Dinner* (1967). In the former, he and Tony Curtis portray convicts who escape, symbolically chained together, from an overturned prison truck. Although they dislike each other at first, they develop a mutual respect, even love; as in *Edge of the City*, Poitier sacrifices his life for his

white friend. In *Guess Who's Coming to Dinner*, a beautiful young white woman (Katharine Houghton) finds the man of her dreams in a brilliant black doctor (Poitier). Of course, in order to be worthy of Houghton, Poitier has to be no less than a candidate for the Nobel Prize. In most of his films, however, Poitier (unlike his white counterparts) rarely had a wife, a girlfriend, a family life, or a sex life. It wasn't until 1968, and the release of *For Love of Ivy*, that Hollywood dared portray a contemporary black love story. Here, Poitier is paired with Abbey Lincoln, whose character is, incredibly, a maid.

Poitier's integrationist characterizations dominated the Hollywood films of the Fifties and Sixties. They may have been far-removed from the mammies played by Hattie McDaniel or the dimwits personified by Stepin Fetchit and Willie Best (who at one time was billed as "Sleep 'n' Eat": after all, a "good Negro" supposedly would be pleased with his lot if he had nothing more in life than food and a bed). But they nonetheless fostered an altogether new stereotype: the Good Negro, ever so willing to relinquish his ethnicity in order to be accepted by whites, on white terms; whose saintly compassion and humanity would ease white audiences' fears about racial equality because he would even be willing to sacrifice his life for his newfound white brother. Off the set, Poitier was accepted by white America. He was the first (and, to date, only) African-American to win an Academy Award for a star performance (in *Lilies of the Field*), and he was the first African-American to be named one of the top ten money-making attractions by a *Motion Picture Herald* poll of U.S. distributors. In 1968, he even headed this list. But to African-Americans, still trying to meet white middle-class standards, the neat, de-ghettoized Poitier was an acceptable if unreal role model.

Back in the Fifties and Sixties, there could be room for only one Sidney Poitier. Such a fine, sensitive actor as James Edwards, the star of *Home of the Brave*,

was denied a major screen career because he was, personalitywise, too much a carbon copy of Poitier. Edwards's career is an intriguing footnote to film history. A fine actor with exceptional looks and leading-man potential, the stardom he earned in *Home of the Brave* was short-lived because of Poitier's casting in most every prestigious role requiring an African-American actor. Throughout the Fifties, Edwards was relegated to nondescript parts, mostly in war films. His final screen appearance came in a minor role in *Patton* (1970), cast, tellingly, as George C. Scott's valet.

Even by the early Sixties, Poitier's "integrationist" screen persona was becoming outdated. The idealism of 1949 was no longer viable in 1963, as African-Americans were as determined as ever to win their civil rights. The response from a certain portion of white America: the bombing of a Birmingham, Alabama, church in 1963, leaving four young girls dead; the murder of civil rights leader Medgar Evers, also in 1963; the murder of three civil rights workers in Mississippi, in 1964. Race riots erupted in Detroit, Newark, and Watts. Although integration remained the major theme in screenplays which focused on racism in America, a new type of racial film hinted at the premise that African-Americans and whites were irreparably different. In this regard, Poitier serves as a necessary link between the mammie-coon-buck celluloid stereotypes and the multidimensional, sometimes controversial depictions of African-Americans in films from the independently produced *Nothing But a Man* (1964) and *Sweet Sweetback's Baadasssss Song* (1971) to *Do the Right Thing* (1989), *Glory* (1989), *To Sleep With Anger* (1990), and *Boyz N the Hood* (1991).

Lately, Poitier has become a successful director of such unmemorable features as the 1972 Western *Buck and the Preacher*, the 1980 box office hit *Stir Crazy*, the 1982 comedy *Hanky Panky*, and the 1990 come-dy *Ghost Dad*. *Shoot to Kill* (1988) and *Little Nikita* (1988), his first screen appearances in a decade, are barely footnotes to his career. More appropriate to his celluloid roots is his acclaimed performance in the 1991 television movie *Separate But Equal* as NAACP lawyer (and later Supreme Court Justice) Thurgood Marshall: the man who argued Brown vs. Board of Education, and who mirrors the kind of Fifties–Sixties liberalism that allowed for Poitier's acceptance as a Hollywood star.

Today, it is easy to criticize Poitier for being a white man's black man. But historically he was, like Jackie Robinson, the right man at the right time, the necessary and essential connection between Hattie McDaniel and Cicely Tyson, Mantan Moreland and Melvin Van Peebles, Snowflake and Spike Lee. And Poitier does reflect the sensibilities of the younger generation of African-American filmmakers, the Spike Lees, Charles Lanes, Charles Burnetts, John Singletons, Julie Dashes, and Mattie Riches, when he observes, in his autobiography, *This Life*, "We're going to have to make most of our own films. I think we should no longer expect the white filmmaker to be the champion of our dreams....So, black filmmakers, potential creators and producers of 'software,' be ready, stay alert. Don't let "the man" beat you on your own home ground. If you do, the chances are you'll find yourselves locked out, again."—Rob Edelman

RECOMMENDED BIBLIOGRAPHY

Hoffman, William. *Sidney*. NY: Lyle Stuart, 1971.

Keyser, Lester J. and Andre H. Ruszkowski. *The Cinema of Sidney Poitier*. South Brunswick, NJ: A. S. Barnes, 1980.

Marill, Alvin H. *The Films of Sidney Poitier*. NY: Carol Publishing Group, 1978.

The Parallax View

Political Assassination Thrillers

Hitler appears squarely in the crosshairs of a high-powered rifle's telescopic sight. A man in a hunting outfit on a cliff some distance from the Führer's forest retreat slowly squeezes the trigger. There is a click followed by the man's smile. He then opens the rifle chamber, loads it, and takes aim again, only to be discovered by a Nazi guard who happens upon the would-be assassin in the nick of time.

Thus opens Fritz Lang's *Man Hunt* (1941). Walter Pidgeon portrays Briton Thorndike, an Englishman who claims upon arrest to be after Hitler not for the kill but for the sport of proving he could be "hunted down." Hitler was, of course, very much alive in 1941, and so Lang's film served as both melodramatic entertainment and Allied propaganda coupled with wish fulfillment. As scripted by Dudley Nichols, Lang's film dared to project Hitler's death (although Pidgeon is captured in the beginning, he outwits Nazi officer George Sanders and by film's end returns to hunt down that "strutting little Caesar"), but Nichols settles for a long romantic subplot between Pidgeon and

Joan Bennett instead of suggesting that Thorndike's act was part of an organized plot or conspiracy.

In form and content, however, *Man Hunt* prefigured a number of films which today constitute a subgenre within the larger category of thrillers: the political assassination thriller. Political assassination has long been a reality, but the immediate danger and potential chaos of the assassin's act has become painfully familiar around the world since WWII. The murders of John and Robert Kennedy and Martin Luther King, Jr. are only the most obvious examples for the United States and so for Hollywood. Political assassination thrillers that directly or indirectly

evoke such events since 1945 offer a fascinating look at the complex "two-way mirror" that operates between the world of narrative film and sociopolitical reality.

Political assassination as a theme has figured in the plots of countless films, such as Hitchcock's *Saboteur* (1942) and both versions of his *The Man Who Knew Too Much* (1934, 1956), as well as more recent films such as Scorsese's *Taxi Driver* (1976), in which Robert De Niro stalks a senatorial candidate only to vent his murderous anger later on a couple of pimps. Among the many films that have constructed their main plot around a political assassination while using many of the thriller genre's conventions are *The Manchurian Candidate, A Bomb for a Dictator, The Liquidator, Strategy of Terror, The Assassination Bureau, The Day of the Jackal, To Commit a Murder, Hennessy, The Revolutionary, Z, Nada, The Parallax View, Executive Action, Black Sunday*, and, more recently, *JFK*.

These films share most of the following elements: the calculated murder of an important political figure; the generation of suspense through a combination of psychological melodrama and semidocumentary techniques; an approximation of real historical events; and the suggestion of a conspiracy at work that may or may not be uncovered by film's end. Although historical or period political assassination movies have been made, the political assassination thriller is most often set in the present or the recent past.

In thriller form, these films simultaneously distance us from the reality of the events and yet increase our uneasiness because of their real-life implications. Echoing events we recognize from everyday life, these films act as thrillers in the Hollywood tradition by generating suspense and melodrama, simplifying issues and characters, and by often using music to create strong moods. We are made uncomfortable because of the verisimilitude of the subject matter, but the genre formulas employed remind us we are

watching a fiction movie and not a documentary. Still, the overall effect is a disturbing one: it is difficult to regard such films as mere "entertainment" as we leave the theater and pick up the daily newspaper.

John Frankenheimer's *The Manchurian Candidate* is the modern prototype. Made in 1962, a year before John F. Kennedy's death in Dallas, the film concerns a Korean War hero, Raymond Shaw (Laurence Harvey), who has been brainwashed by the Communist Chinese while a prisoner of war and programmed to become a political killer under the control of American agents. As the film progresses, we learn that his controller is his ambitious mother (Angela Lansbury) who secretly works for the Russians and who hopes to install her senator-husband in the White House. Suspense mounts as Major Marco (Frank Sinatra), Shaw's commanding officer in Korea, uncovers the plot and rushes to head off the assassination of a presidential nominee during the convention. The conflict is resolved as Shaw shoots his parents as they sit on the speakers' platform. He then puts a bullet through his own head. The trained killer thus becomes a martyred savior who, in his last words, explains to Major Marco that, "You couldn't have stopped them... The army couldn't have. So I had to."

Frankenheimer meant the film as an attack on McCarthyism and an America brainwashed by "television commercials, by advertising, by politicians, and by a censored press with its biased reporting." That John Kennedy died at the hands of an assassin less than a year later not only boosted the reputation of the film, but also brought home Frankenheimer's point that the seemingly impossible could become a reality in contemporary America.

The thriller formula is followed as we watch Major Marco race against time to stop Shaw's deadly mission. But what makes the film so memorable is Frankenheimer's handling of the brainwashing episodes. The plot depends upon Major

Marco "remembering" what happened in prison camp when he, along with Shaw, was brainwashed. We are made to experience Marco's brainwashing in a rather surrealistic form of psychodrama as actual scenes (American prisoners on a stage with Chinese and Korean Communist officials in the audience) are juxtaposed and confused with brainwashing induced scenes (small-town American women in frilly dresses attending a local garden club meeting). Frankenheimer creates a three-way tension as these two realities are played against the events unfolding in the narrative's present tense in the United States.

By dealing with Chinese-Korean brainwashing, McCarthyite witch hunts on Capitol Hill, and the possibility of a conspiratorial assassination of a future president of the United States, Frankenheimer went further than previous Hollywood filmmakers in dealing with these controversial issues. In doing so, he created a film that both entertains in the best thriller tradition and simultaneously makes the audience uncomfortable about its sociopolitical implications: what would happen if the trained killer *did* succeed?

The Manchurian Candidate was a chilling film because of its prophetic realism, but Frankenheimer's later work in the genre, *Black Sunday* (1977), failed as entertainment and as a plausible mirror of political terrorism. We are led through a web of suspense as a neurotic Vietnam vet pilot (Bruce Dern) uncovers the desperate attempt of a Palestinian terrorist group to blow up the Super Bowl game while President Carter is attending. Unfortunately for Frankenheimer, we never take the would-be assassination seriously and thus the plot twists figure only as gimmicks in a drawn-out adventure fantasy.

During the Sixties political murder was commercially exploited by numerous films. Producer David L. Wolper rushed out a feature-length documentary on John F. Kennedy's death, *Four Days in November* (1964), which recapped the events of the assassination without probing beneath the suspicious surface of unexplained questions. In terms of narrative films, the British offered several examples of the assassination thriller. Rod Taylor portrayed a world-weary private executioner in *The Liquidator* (1966) who is caught up in a plot to eliminate the Duke of Edinburgh, a plot he manages to foil in the nick of time, thus single-handedly saving the British Empire from a Kennedy-like conspiracy and tragedy. *The Assassination Bureau* (1969), another British entry, represents an attempt to create an international blockbuster with a cast including Oliver Reed, Diana Rigg, Telly Savalas, Curt Jurgens, and Philippe Noiret. The story is a turn-of-the-century version of Frankenheimer's *Black Sunday* in which Oliver Reed manages to fall in love and become a hero as he averts an international plot to drop a bomb from a zeppelin on the kings and queens of Europe who have gathered in a castle to discuss peace.

The beauty of the near-miss thriller, of course, is that it allows filmmakers to weave intricate plots and romantic subplots around historical figures and events, thus adding an element of authenticity to an otherwise fanciful film. Assassination films of this sort became increasingly realistic in the Seventies.

Fred Zinnemann's *The Day of the Jackal* (1973) placed Charles de Gaulle in the crosshairs of a suspenseful movie based on an actual attempt on de Gaulle's life by the "Jackal," an international killer still on the loose. An image of a watermelon being blown into pink pulp as the Jackal tests his rifle becomes an especially chilling memory when Zinnemann reaches the climax of the film and de Gaulle's head replaces the watermelon as the target.

Hennessy (1975) take advantage of the seemingly endless turmoil in Northern Ireland while simultaneously working a variation on the political assassination thriller. Instead of treating a devious conspiracy, this film presents Rod Steiger as a frustrated nonpolitical Northern Irishman

who needs to vent his anger over the street murder of his wife and child during a confrontation between Catholics and Protestants. His solution? To blow up Parliament while the Queen is addressing both Houses on Guy Fawkes day (the British version of the 4th of July). Needless to say, he is caught at the last minute, but the very real frustration of the common man in dealing with the Irish question finds its cinematic expression in Don Sharp's film.

The film that most caught the public's imagination in the genre at the end of the Sixties was Costa-Gavras's *Z*. A fictionalized account of the assassination of a liberal member of the Greek Parliament, Grigoris Lambrakis, in Salonika in 1963, the very year Kennedy died, the film strongly echoed the Kennedy assassination for American audiences and also seemed realistic to audiences in many countries which had witnessed similar plotted deaths of liberal and leftist leaders. Gavras and scriptwriter Jorge Semprun, known for his political scripts such as Alain Resnais's *la Guerre est finie*, downplayed the Greekness of the story in order to create a more universal appeal (the film was shot in Algeria with a French cast since Greece was under the control of a military junta which had seized power in 1967).

The result was a film that seemed like a cross between a documentary (the term "docudrama" had not yet come into common use) and a highly manipulative Hollywood drama of the Forties. Like *The Manchurian Candidate*, *Z* depicts a conspiracy theory of assassination. As the film progresses, we learn that high officials in a right-wing government in an unnamed Mediterranean country have ordered the death of Deputy Z, portrayed by Yves Montand ("Z" represents the Greek word *zei* which means "he lives"). *Z* ends before the young prosecutor (Jean-Louis Trintignant) is able to bring the guilty officials to justice, but the conspiracy revealed is all the more frightening because it rep-

resents a threat from *within* the government as opposed to an external power (the Chinese Communists) in Frankenheimer's work. The realism of such a conspiracy is made even more obvious by the ending which, instead of posing as an unrealized threat about the future as in *The Manchurian Candidate*, lists a number of items banned at the time by the military junta in Greece. This documentary-like fiction thus keeps our attention squarely on the political and social realities outside the theater (although some critics pointed out Gavras's loaded allusion to the military junta, since Lambrakis was actually murdered by the right-wing Karamanlis regime which preceded the junta).

Yet for all of its topical realism, *Z* is rooted in the Hollywood thriller and newspaper melodrama genres. A young photojournalist and public prosecutor track down clue after clue in a fashion similar to hundreds of thrillers and newspaper investigation films. Typecasting further assures that the story is reduced to a simplistic political melodrama: the photographer and prosecutor are young, intelligent, and handsome, while the conspirators are seen as fat, stupid, and crafty, and one of the two murderers is shown as gay.

Other stock suspense elements include the strongly dramatic music by Greek leftist composer Mikis Theodorakis that adds a nervous energy and intense emotion to the narrative, and the restless camerawork of Raoul Coutard, the cinematographer for many French New Wave directors. Much more so than in *The Manchurian Candidate*, we have the impression we are watching a thriller shot in documentary style. Furthermore, tension and suspense are heightened by the large number of close-ups Gavras employs and by the brevity of most scenes. The pace is one of a frantic chase, which, because the camera seldom remains still, means the audience has no time to distance itself from the action. The viewer, like the prosecutor, becomes swept up in a dangerous political puzzle that allows no time for reflection.

As a thriller, the emphasis is on suspense, the forward thrust of the plot, and an intensification of audience identification with the main protagonists (both the slain politician and the magistrate).

Nevertheless, today *Z* appears as more than a propagandistic vehicle for a leftist cause. It is, rather, what Stanley Kauffmann called "not a story of politics but of a quest for justice." Costa-Gavras's skillful manipulation reinforces our sympathy for those who have suffered unfairly and allows us to identify with a few "heroes" who will not sell out their values in order to cover-up the assassination.

Costa-Gavras's *State of Siege* (1973) proved a studied contrast to *Z* in its depiction of politically motivated murder. The film is closely modeled on the execution of an American AID official by the Tupamaro guerillas in Uruguay in 1970. Thus, while *Z* is a polemical thriller about a right-wing murder plot within a government, *State of Seige* concerns assassination by the revolutionary left. Yves Montand is once again the target, but as Philip Michael Santore, the AID official, his screen presence lends sympathy to a role that could easily have become a one-dimensional, anti-American portrayal.

Part of the value of this political thriller scripted by Franco Solinas, best known for his screenplay for *The Battle of Algiers*, is that it dares to show that assassination can be carried out as an act of impotence rather than as a political action. Gavras shows how the Tupamaros order Santore's death after the American government allows the deadline to expire without meeting their demands. In effect, they *must* kill him in order to save face. The film, banned from the Kennedy Center screenings sponsored by the American Film Institute in 1973 because of its alleged anti-American slant, nevertheless played to packed theaters everywhere. While reviews were generally positive, some questioned Gavras's method of basing his film on real-life events without choosing either to further distance the story from the actual murder

or, on the other hand, to more closely document what really happened. The film, which is set in an unidentified South American country, is suspended between fact and fiction.

The popularity of Gavras's films signaled the possibility of politically engaged works by other left-leaning directors. The success of such documented fiction films is that predominantly middle-class audiences around the world who would usually be classified as conservative or apolitical, saw, discussed, and were affected by such works. The genre thus became a way for politically concerned directors to convey political messages to a general public through a mass entertainment medium.

Many of these directors have been European. Gillo Pontecorvo, in fact, predated Costa-Gavras with *The Battle of Algiers* (1966), the riveting re-creation of the national liberation struggle waged by the Algerians against the French. Pontecorvo was more daring and thus less successful at the box office than Costa-Gavras in his depiction of political murder. In the most shocking sequence, we watch three typical Algerian women shed their traditional clothing, don Western dress, and then proceed to plant bombs in two cafes and an airline office. As we await the explosions, Pontecorvo purposely gives us a number of close-ups of the innocent men, women, and children so that we *feel* the high cost in individual terms that a revolutionary movement exacts. Pontecorvo builds suspense with thriller techniques (especially through close-ups and strong music), but, unlike more commercial assassination thrillers such as *The Liquidator, The Battle of Algiers* contains no star actors chasing after the likes of a Hitler, a Queen of England, or even a Duke of Edinburgh. Instead, he shows how a revolutionary movement is ultimately the direct action of common people acting against other common people who, although innocent victims, are nevertheless linked to and with the oppressors.

The early Seventies produced other

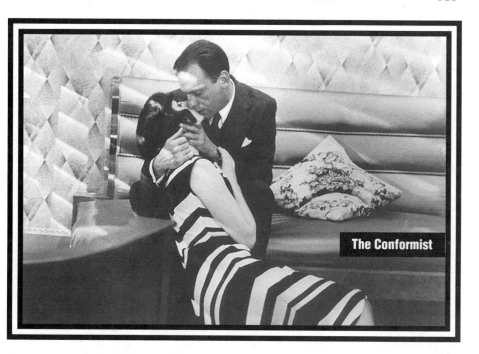

The Conformist

European assassination films. Elio Petri painted a frightening satire of contemporary bureaucracy in *Investigation of a Citizen Above Suspicion* (1970). A police chief in Rome flagrantly puts himself above the law by committing murders for which he is never punished despite his obvious guilt. Bernardo Bertolucci, who has described himself as a Freudian Marxist, studies both the Oedipal and fascist implications of political murder in *The Conformist* (1970), while Jorge Semprun went on after *Z* to script *l'Attentat* (1972, directed by Yves Boisset), a gripping fictionalized account of the 1965 kidnap and murder of Moroccan left-wing opposition leader Mehdi Ben Barka. In Greece Theodoros Angelopoulos used a political murder as the pretext for exploring modern Greek history as viewed from the left. In *Days of '36,* Greece under the dictatorship of Metaxas is the subject while in *The Hunters* (1977), it is Greece in the present as haunted by the "executed" body of the Greek Civil War (1945–'49) that concerns Angelopoulos.

American assassination films influenced by both European and American

examples of the genre have tended to be less politically engaged and less historically explicit. The screen adaptation of Hans Koningsberger's novel, *The Revolutionary* (filmed in 1970 from Koningsberger's own script), is a case in point. Jon Voight portrays a radical student in an unspecified country and time who moves increasingly toward the fanatical far left. He finally joins a plot to assassinate a judge who has sentenced student strikers. In the closing scene, he is left holding a bomb that, although we do not learn of the outcome, will presumably kill both himself and the judge. Koningsberger is more concerned with the education of a radical than the actual results of the attempted killing. Because the film does not echo any specific assassination, however, it loses the immediacy of a film such as *Z* or *The Battle of Algiers.*

Alan J. Pakula's *The Parallax View* (1974) emerged as the most significant American entry in the assassination genre of the Seventies. Genre codes and everyday reality fuse in Pakula's story about a Robert Kennedy-like murder to suggest, according to Joseph Kanon, writing in *The*

Atlantic (August 1974), "that the society from which it takes its material has itself become an epic B picture, a crackpot life fueled with cheap violence." The film borrows both from *The Manchurian Candidate*—including brainwashing, a conspiracy that is never exposed, and thriller suspense that culminates in a convention hall—and from *Z*—an assassination occurring early in the film followed by an investigation, the use of music to intensify emotion, and many of the fast-paced cinematic techniques of Costa-Gavras.

Warren Beatty plays the lone investigative reporter, Joe Frady, who attempts to track down a suspicious trail of murders related to a young senator's murder in Seattle's Space Needle, an assassination meant to strongly suggest Robert Kennedy's violent end. Using classic suspense formulas, Pakula follows Frady's discovery of the Parallax Corporation, a clandestine national corporation dedicated to recruiting assassins for "assignments." Frady, a hip hero who treads a thin line between a counterculture life-style and his journalistic profession, tries to expose the Corporation by posing as a new recruit. As clever as he is, however, the Corporation is one step ahead of him. In the closing scene, Frady discovers that another senator is about to be murdered during a speech in a huge auditorium. Before Frady can escape to warn others, he becomes a witness to the senator's assassination during the rehearsal.

Pakula constructs the film as a thriller-melodrama, but the ending of the film turns our expectations upside down. We are accustomed to having the investigator expose the criminals in the end after overcoming a number of obstacles. Pakula, however, shocks us by having the Corporation rub out Frady before he can get out of the auditorium. The final shot is the same as the first but in reverse (a framing technique he also employed in *Presumed Innocent*): a court (looking much like the Supreme Court) solemnly proclaims that, after six months of investigations and eleven weeks of hearings, they conclude that Joseph Frady acted as a lone assassin.

Frady's death leaves the audience frustrated, confused, troubled. This ending is more troubling than that of Frankenheimer's or Costa-Gavras's films, since the cover-up of a double assassination in Pakula's film suggests the grim possibility that the Corporation is still at work throughout the United States. With Frady dead, not only is justice left undone, but our basic American belief in the power of individualism is also seriously shaken. We need not subscribe to conspiracy theories, as one critic has noted, to still feel disturbed by "the mental climate that produces them."

Executive Action (1973) was the most explicit fictionalized account of the John F. Kennedy assassination up to that time. Based on a story idea by Mark (*Rush to Judgment*) Lane with a script by Dalton Trumbo, this low-budget and crudely constructed film directly links Pakula's concept of a corporate conspiracy to the Kennedy murder. Burt Lancaster is the assassination expert hired by right-wing business executive Robert Ryan to eliminate President John F. Kennedy because of his dangerous liberal leanings. Kennedy is a threat not only because he is a friend of the poor and of blacks, he is also against the war in Vietnam and nuclear armament. Trumbo's script is not a docudrama because a good third of the film is made up of actual newsreel footage of Kennedy as presented on TV throughout the unfolding of the plot. Beginning with the date, "June 5th, 1963," the film builds suspense by juxtaposing the Kennedy footage with the "executive action" conspiracy using ex-CIA and FBI agents as assassins while simultaneously setting up Lee Harvey Oswald as the fall guy using an Oswald look-alike.

The film closes with photographs of eighteen eyewitnesses to the Kennedy assassination, all of whom we are told died within three years of Kennedy's death,

although an actuary calculated that the odds against all of these witnesses dying in so short a time were one hundred thousand trillion to one. The final announcement, tying fiction to supposed fact, is that the Burt Lancaster figure, Farrington, died of a "heart attack" (he had earlier made it clear to Ryan that he wished to retire after the Kennedy assignment).

Trumbo and director David Miller's intention is clear: the Warren Commission's report has been proven to be more an awkward cover-up than a thorough investigation, and the uneasy result is that we may never learn the truth behind Kennedy's death. *Executive Action* is a chilling exercise in "what if?" and certainly leaves the audience asking questions it would not ask after viewing *The Day of the Jackal*. Nevertheless, the film is seriously flawed. While melodrama allows the filmmaker much flexibility in exploring realistic events in fictionalized surroundings, Trumbo's script, in making use of a real event represented with newsreel footage, has a responsibility to a closer historical accuracy. It is too easy to use the Kennedy footage to dredge up our painful memories and deepest fears and then cry "corporate conspiracy" without more thoroughly and honestly making a connection between the actual events as we know them and the suspected plotting behind them.

Oliver Stone's 1991 film, *JFK*, follows surprisingly close in Trumbo and Miller's effort to reopen the Kennedy file. But Stone does so in a more powerful manner by following the actual conspiracy investigation conducted by New Orleans District Attorney Jim Garrison rather than adopting the fictional protagonist mode used by Trumbo and Miller. The result is that *JFK* appears bound to hold its place in American cinema as what historian Marcus Raskin, writing in *The American Historical Review* (April 1992), has called "a work of art" which "succeeds because it confronts powerful emotions and political truths that are as age-old as Homer and Sophocles."

It is fitting to close this overview with a film that is not only one of the most recent examples of the political assassination genre but also the most significant, a film that a *Cineaste* magazine editorial called "arguably the most important political film ever made in the United States." Oliver Stone had the vision and the means to mount a major Hollywood production aimed at using the power of American cinema as a forum to confront an important page in American history as it has been officially reported and as it remains to be resolved. Historian Robert A. Rosenstone sums up the effect well: "The film hits us with a double whammy: one of America's most popular directors not only explores our most recent history's most touchy subject but does so in a bravura motion picture that (maybe it's a triple whammy) also takes a highly critical stance toward major branches of the American government" (*American Historical Review*, April 1992).

Kevin Costner plays Jim Garrison who tirelessly promoted the idea of a conspiracy in Kennedy's death. With an ad campaign that labeled the narrative "the story that won't go away," Stone dared to do what earlier films closer to the historical events did not attempt: to directly re-create the events around the assassination as seen from the viewpoint of one of the "real" players. Though shot with much more sophistication and complexity than *Executive Action*, using an at times mindnumbing, MTV-style editing technique to keep us constantly off guard, *JFK* does adopt the same approach of mixing documentary footage and dramatic re-creations as used in *Executive Action*.

Certainly the huge box office receipts proved that Stone's daring blend of politically aware history and carefully constructed fiction can "work" in an industry usually given over to the politically empty entertainment of the Seventies and Eighties as reflected in everything from comic book narratives such as *Superman* and *Batman* to sugarcoated fairy tales such as *Pretty*

Woman and *Home Alone.*

But *JFK* became much more than a "must-see" film; it also became, even during its production, the object of a national controversy that engaged Americans from all walks of life in a dialog unprecedented in terms of Hollywood cinema. Senators and other government officials attacked the film long before its release as did major journals and newspapers such *The New York Times, Time,* and *The Washington Post.* The production and release of *JFK* touched on basic issues of freedom of expression and of press slander and censorship. A film about the American political system ironically became a test case about many of the very issues raised in the film. Clearly what disturbed many is the fact that Stone exposes much of the cover-up that took place surrounding the Kennedy assassination. Although many important documents in the case remain classified to this day, *JFK* suggests a political conspiracy and distortion of justice on a disturbingly large scale.

For all of the film's accomplishments, however, *JFK,* like *Z* before it on a much less immediate scale, does pose some troubling issues about political narrative cinema for filmmakers and critics alike. Along with many other historians, Hayden White has made it clear that history always involves subjective interpretation and usually a narrative one at that. As he writes in *Tropics of Discourse: Essays in Cultural Criticism:* "The older distinction between fiction and history in which fiction is conceived as the representation of the imaginable and history as the representation of the actual, must give place to the recognition that we can only know the *actual* by contrasting it with or likening it to the *imaginable.*"

There could be, on one hand, no more solid defense of political narrative filmmaking: bringing history into narrative cinema obviously makes historians who feel they are above narrative elements (but are not) uncomfortable. That stated, however, there is a need, as White suggests, to provide some *distancing effect* from any historical narrative—a "metahistory" is his term—so that the viewer-reader is aware of the particular orientation of the individual author-filmmaker.

Warren Beatty's use in *Reds* of interviews with actual individuals who knew John Reed, for instance, is a metahistorical element that allows audiences enough distance to consider the film that follows as simply "one telling" of events. *JFK* provides no such metahistorical distance since Stone is determined to put over his particular perspective using the controlling power of MTV-paced editing (which is particularly effective for audiences under thirty raised on music videos and fast-paced TV commercials) which allows a viewer no opportunity to think or judge for himself-herself. Furthermore, the furious pace of the film glosses over narrative problems, the most central being Garrison's insufficient motivation as a protagonist in pursuing the investigation. Why does he care so much? The pace of the film keeps most from asking the question, but, for those who care about motivation, we are left, like Garrison's baffled wife, puzzled and dissatisfied. Garrison is too much a stick figure convenient for Stone's political agenda. Ultimately this hurts Stone's cause, not on the issue of "misrepresentation of history," as some have charged, but rather on the side of "poorly constructed narrative," a craft we expect a leading filmmaker to have mastered.

Such criticism, however, does not diminish the influence of Stone's film. We do not need a crystal ball to realize that it is very likely that his success will lead others to attempt further efforts at blending history and fiction, the actual and the imaginable as White says, in Hollywood narratives. Can *RFK* and *MLK* be far behind? Certainly the appearance of Spike Lee's *Malcolm X* (1992) proves the point: a new era in Hollywood political filmmaking has begun.—Andrew Horton

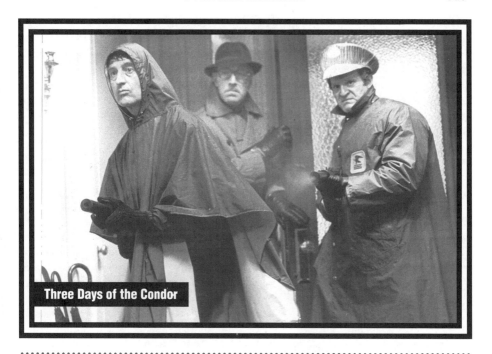

Three Days of the Condor

Political Thrillers

As a genre label, "thrillers" does not describe the subject, narrative style, or mode of the movie, like "Western" or "musical" or "comedy." Instead, it considers affect, describing films in terms of the audience's psychological reaction, but there are, as is often the case with genre terms, confusions, ambiguities, and compounds.

In England, "thrillers" refers to what in America would be described as detective stories, for example works by Hammett and Chandler, or mysteries, as in works by Agatha Christie. In France, such a film would be a *policier*.

As an American term, "thriller" refers to a film of suspense, fear, and excitement. Thus "thriller" leads in one direction to the horror film, as in the old TV show *Thriller*, a Gothic version of *The Twilight Zone*. In the other direction thrillers move toward the detective story and the murder mystery. But there is a middle ground where politics can appear, making the thriller

into a tale of political intrigue, often a spy story. Without suggesting that sharp boundary lines and neat categories exist, it is possible to discern three main kinds of political thrillers.

First, there is the Hitchcock-style political thriller. Though some of the mechanisms are the same, notably suspense, a film such as *The 39 Steps* (1935) or *The Lady Vanishes* (1938) differs from a film such as *Psycho* (1960) or *Shadow of a Doubt* (1943) because of the political framework. Hitchcock never seems interested in politics per se, only in the situations that arise from political intrigue—the

world of spies, secrets, disguises, and deceit, the threat of potential violence and death. Into that world, the hapless hero can tumble like Alice going down the rabbit hole, only instead of a white rabbit and a march hare and, yes, a threatening queen, there are courteous gents who turn out to be evil men missing bits of finger.

A "political thriller" may represent a thriller with a political setting, a thriller with a political purpose, or both. In Hitchcock's case, politics and the deadly struggle for power serve primarily to indicate the general untrustworthiness of the world and its Hobbesian undercurrents. Though his villains are usually Nazis in the early films and Communists later on, real political values are rarely at stake, and even the pro forma patriotism is negligible, except perhaps in *Foreign Correspondent* (1940). As in Lucas and Spielberg films, what matters is not the exact nationality of the villain or the political situation as a whole, but the fact that there are villains, that they are sinister, nasty, and dangerous, and that they are chasing the hero. Hitchcock-style thrillers are usually, in effect, what Graham Greene called his collaborations with Carol Reed (*The Third Man, Ministry of Fear, This Gun for Hire*)—"entertainments." The political background suggests a global significance, licenses the use of violence, and often makes for a neat melodramatic contrast between innocence and villainy. In the Hitchcockian model, however, the emphasis is definitely on "thriller" at the expense of "political." With Hitchcock and his followers, such politics as do exist combine a skepticism toward authority, especially the police, with a genial sense of deference to God and country that has no more bearing upon the real world than Hollywood confections such as Zenda and Shangri-la.

A second category of political thriller is the overtly ideological and polemical film, identified most closely with Costa-Gavras. Thus *Z* (1967), based on the assassination of a liberal Greek deputy, is a kind of snazzy *policier*, but with a moralistic political argument to go with its energetic editing and vibrant musical score. Hitchcock, for his part, often liked the villains more than the heroes: the Nazi played by Claude Rains in *Spellbound* (1945), for example, certainly displays a love for the Ingrid Bergman character that is less questionable than that of the U.S. agent played by Cary Grant. In Costa-Gavras films such as *Z*, however, the villains are unmistakably villainous. When Costa-Gavras seeks to be "balanced," as in *State of Siege* (1973), it's time to look out, because any attempt to generate sympathy for the devil can appear only rhetorical—even if Yves Montand, as the AID official kidnapped by the left-wing Tupamaro guerrillas, creates an interesting counterbalance. In *Missing* (1982), there is no question about who is bad and who is good, as is made clear by the familiar use of Jack Lemmon as the "swing man" who starts doubting the evil of the Chilean dictatorship and of the cooperation or at least tacit acceptance by the American government but winds up sharply critical, his consciousness raised. Costa-Gavras, precisely because he is trying to make films that are political but not dull, and that will appeal to a broad audience, always runs the risk of conceding too much to popular taste.

The third major kind of political thriller suggests what might be called—with apologies to Richard Hofstadter—the paranoid style in American political films. Where John Buchan and Joseph Conrad inspired Hitchcock, Richard Condon's books provided the basis for two major works in the paranoid genre, *The Manchurian Candidate* (1962), directed by John Frankenheimer, and *Winter Kills* (1979), directed by William Reichert (of course, Condon also supplied the story for *Prizzi's Honor*, 1985). In these films, as in Seventies films such as Alan Pakula's *The Parallax View* (1974) and Sydney Pollack's *Three Days of the Condor* (1975), the threat comes from within—from corporations, from the CIA, from the police. Anything is possible. Hitchcock, after all, always let his

Everyman (or Woman) off the hook in his political thrillers (*The Birds* or *Psycho* would be another matter entirely). But in the post-Kennedy assassination world, Kafka becomes the guiding spirit: there's no telling the good guys from the bad guys anymore. Condon grinds no ideological axes: the films made from his novels display not an earnest attack on protofascism in the United States, but a frightening, occasionally exuberant black humor, as in *The Manchurian Candidate*, where the McCarthy figure turns out to be the puppet of Moscow, or in *Winter Kills* when it seems that the John Kennedy figure has been assassinated by his own father. Such works present politics as a playground, as a wasteland, as an insane asylum.

If the thriller, as its name implies, represents a cinema of excitement and fear, then a "political thriller" may represent a thriller with a political setting, a thriller with a political purpose, or both. What is so peculiar about the thriller as a form is that it is constantly in danger of becoming mere thrills, a manipulative exercise in plotting (in both senses of the term), whether that means Fritz Lang playing with an evil genius in *Spies* (1928) or a liberal American director playing with mad generals in *Seven Days in May* (1964). The more thrills, the less serious the politics seem, until what is left is the cartoon Cold War exercises of the James Bond films, one cheap thrill after another, or films such as *Marathon Man* (1976) and *The Boys from Brazil* (1978) that show you just can't keep a bad Nazi down. When the paranoid fantasies become extreme, as in *Twilight's Last Gleaming* (1977), left meets right ideologically: in that film, an ICBM site is "kidnapped" to force the public revelation of the truth about the war in Vietnam, namely that (surprise!) it wasn't fought for noble ideals. In the end, the plot is foiled, and the liberal, compassionate president has been murdered by a conspiracy of generals and conservative cabinet members.

Within the dominant Hollywood narrative tradition, the thriller structure can also become merely a framework from which to hang a romance, usually on the run: the questions to be resolved then include not merely the physical survival of the couple, but the outcome of their relationship. Except in the "paranoid" versions, their final triumph over the villainy and love for each other is assured, as part of the formula. But that very notion of heroic individualism defined in terms of survival tends to remove their action from the arena of politics as group action deliberately undertaken as a response to a specific social situation.

The thriller as a form, and Hitchcock as its master, therefore suggests a structural obsession, with technique all. But obviously introducing politics suggests that form is a mere means to an end, the serious investigation of issues and "geopolitical" situations. In the case of a Hitchcock, where politics is merely a prop, that problem is easily resolved—in favor of thrills. But in the case of a director such as Costa-Gavras, the outcome is more ambiguous, and the charge is easily made that the thriller component ultimately diminishes, or coarsens, any political lesson. *All the President's Men* (1976) is ostensibly a kind of journalistic political thriller about how the forces of light conquer the forces of darkness. Yet it is a perfect instance of how thrillers intersect stylistically with *film noir*; the *noir* revival of the Seventies and the penchant for thrillers go hand in hand as a disenchanted, expressionistic view of the world, a view of the world as a global Chinatown. The style of thrillers then becomes an indication of their politics, but those "politics" are antipolitical, metaphysical in their skepticism toward the possibility of moral behavior and concerted action. Thus De Palma's *Blow Out* (1981), a seemingly political version of Antonioni's *Blowup* (1966), denies politics by denying that there is any possibility for genuine political action. Ironically, then, the stronger the "thrills" in thrillers and the more powerful the sense of danger

that is generated, the less likely it becomes that any final solution will be convincing as an image of political reality.
—Robert Silberman

RECOMMENDED BIBLIOGRAPHY

Davis, Brian. *The Thriller.* NY: Dutton, 1973.

Hammond, Lawrence. *Thriller Movies.* London: Octopus Books, 1974.

McArthur, Colin. *Underworld, U.S.A.* London: Secker & Waraburg, 1972

Michalczyk, John J. *Costa-Gavras: The Political Fiction Film.* Philadelphia, PA: The Art Alliance Press, 1984.

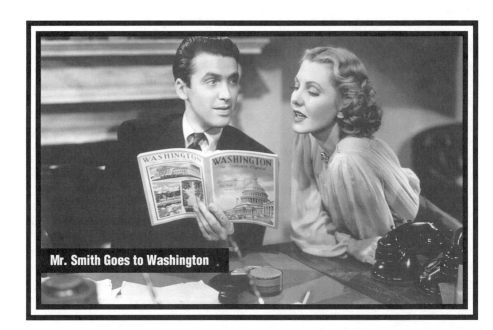

Mr. Smith Goes to Washington

Politicians in the American Cinema

M ovies were very much in evidence at the 1988 Republican National Convention in Atlanta. CBS anchorman Dan Rather several times wondered if nominee George Bush would be able to *Stand and Deliver* in the days ahead. The source of Bush's much-quoted "read my lips" quip in his acceptance speech was, of course, Clint Eastwood's *Dirty Harry.*

The then-vice president paralleled J. Danforth Quayle, his vice presidential choice, to the minor league baseball player in *Bull Durham.*

While accepting the nomination, the

Indiana-bred Quayle attempted to link himself to the high school basketball champions depicted in *Hoosiers.* Finally, the genesis of President Ronald Reagan's plea to Bush to "win one for the Gipper"

was his performance as Notre Dame football star George Gipp almost a half-century before in *Knute Rockne, All-American*. This clearly calculated attempt to win votes by merging the Republicans of Washington and the pop culture of Hollywood is most ironic. After all, the manner in which the movies have depicted the American politician is best summed up by the following repartee from the gangster comedy *You and Me* (1938). "Only the biggest sap in the world thinks crime pays in dividends," observes Sylvia Sidney, cast as a now-upright ex-con who's offering some of her fellow former jailbirds a lesson in economics. "But, sister," protests one of her reluctant students, "you ain't tryin' to tell us that the big shots don't make any more than [$113.33 per man per robbery]?" Retorts Sidney, "The big shots ain't little crooks like you. They're politicians."

There is, however, another paradox about politicians in movies. Before Vietnam and Watergate, it was unthinkable to present real-life elected officials—particularly president—as anything less than saints. There were exceptions, but they had to be fictionalized: most famously, the Huey Long-ish despot so memorably portrayed by Broderick Crawford in *All the King's Men* (1949). Most instead were treated with reverence, even awe: Abraham Lincoln in *Abraham Lincoln* (1930), *Of Human Hearts* (1938), *Young Mr. Lincoln* (1939), and *Abe Lincoln in Illinois* (1940); Woodrow Wilson in *Wilson* (1944); Franklin Roosevelt in *Yankee Doodle Dandy* (1942) and *Sunrise at Campobello* (1960); and John F. Kennedy in *PT 109* (1963). All are wise, heroic men of vision who are worthy of leading a nation.

But in recent years, those elected to the Oval Office have not been so revered. Lyndon Johnson is depicted as a buffoon in *The Right Stuff* (1983); Richard Nixon's cover-ups are chronicled in *All the President's Men* (1976) and *Secret Honor* (1984); George and Barbara Bush are

comic caricatures in *Naked Gun 2 1/2: The Smell of Fear* (1991). These films were released after the presidency had been demystified by the media, after it could be reported that a chief executive was only human and fallible, that he could curse, lie, cheat on his wife, even share a mistress with a Mafia chieftain.

While for so long Hollywood was loath to trash real politicians, its fictitious ones have been consistently portrayed as corrupt, self-important, power-mad czars. They're concerned not with public service but with muttering shallow rhetoric while scheming behind closed doors to throw elections, abuse the public trust, and obtain the fast buck. The electoral process is perverted as those seeking office mount slanderous attacks on their opponents, con voters into believing they are honest, or stuff ballot boxes with the votes of dead men.

Most of these characters are party loyalists, machine men backed by powerful lobbies and stealthy capitalists. They often are the heavies; on occasion, it is not beneath them to consort with gangsters. In appearance, they are rarely younger than fifty, and always look well-fed. Edward Arnold, overweight and jowly, is the embodiment of the crooked politician. His nemesis would be a young, idealistic upstart, unaware of the ins and outs of political power and too naive to be corrupt: an honest Mr. Smith who, in respresenting the common people, would successfully take on the boss of his hometown or go to Washington to singlehandedly foil big bad government.

Political dirty tricks are featured in several dozen silent films. Perhaps the most noteworthy is *The Racket* (1928), a drama depicting politicians in cahoots with bootleggers, which received a Best Picture Academy Award nomination. Older, scheming stalwarts are outmaneuvered by Jack Armstrong hopefuls: in *Our Leading Citizen* (1922), an upright young lawyer back from the war defeats the dastardly machine-backed politician and goes off,

his new bride in tow, to conquer Washington.

From the early sound era to the advent of World War II, the unsavory side of politics was a popular subject in American films. But, here, mere elected officials were insufficient targets: the American power elite often found itself chastised in movie scenarios. Perhaps this was a reflection of the Great Depression, and the film industry's understanding of the American public's need to shake its finger at those in power whose irresponsibility caused the nation's crisis.

In film after film—the screwball comedy *My Man Godfrey* (1936) is a textbook example—the Park Avenue crowd is portrayed as frivolous, content to play games of charades while the less fortunate around them struggle, if not starve. *Holiday* (filmed in 1930 and 1938) is the story of Johnny Case, a free-spirited Everyman who's been working since age ten. It's twenty years later, and he wants to find out why he's been working. He wishes to knock off from his career for awhile, and see how he fits into the world. Johnny meets *"the* girl," only he doesn't know that she's fabulously wealthy and doesn't realize that she's a symbol of the status quo. To her and her father, a Great American Capitalist, Johnny's lack of "reverence for riches" is downright subversive.

Among scenarios featuring characters more overtly involved in politics, Ben Hecht and Charles MacArthur's *The Front Page* (filmed in 1931 and remade nine years later as *His Girl Friday*) features a mayor and sheriff who are as comically tainted as the cash they readily take under the table. *The President Vanishes* (1934) chronicles the plight of a peace-loving chief executive at odds with a militant Congress manipulated by big business, financiers, and lobbyists. In the satire *The Dark Horse* (1932), the title character, a dolt who happens to be running for governor, is guided in his campaign by a man who has just been freed from jail. *Washington Merry-Go-Round* (1932) is the saga of an upright young congressman who goes off to the Capitol and encounters corruption and graft. *Politics* (1931) chronicles the efforts of an outspoken widow running for mayor against an incumbent entangled with gangsters. *The Washington Masquerade* (1932) is the story of cutthroat lobbyists who pressure senators. In *Bullets or Ballots* (1936), gangsters openly conspire with elected officials. In *Louisiana Purchase* (1941), local politicians try to frame a senator who is bent on investigating them. *First Lady* (1937) details political catfighting among the wives of Washington. And the political ambitions of Charles Foster Kane in *Citizen Kane* (1941) are thwarted when his private love life is exposed and magnified by his rival, a blackmailing political boss.

In an intriguing, unique fantasy titled *Gabriel Over the White House* (1933), Judson Hammond (Walter Huston), a party hack and "old-fashioned politician," is elected president. After his inauguration, he tells one of his cronies, "When I think of all the promises I made to the people to get elected." Jokes his pal, "By the time they realize you're not gonna keep them, your term will be over." Hammond declares that the issues of the day, starting with unemployment and the rising crime rate, are "local problems"; while the leader of America's unemployed army gives an impassioned radio address, Hammond frolics on the floor on all fours playing with his young nephew. He admits that his "party has a plan. I'm just a member of the party."

After an automobile accident, however, and the intervention of the Archangel Gabriel, Hammond is transformed into a tough but compassionate, reform-oriented leader. He declares himself benevolent dictator; implements a series of acts designed to end unemployment; rids the country of Capone-like thugs; presses for disarmament between nations; and becomes "one of the greatest men who ever lived."

On one level, *Gabriel Over the White House* is an exercise in wish-fulfillment. But the point is clear that it would take

nothing short of divine intervention to create a politician who truly cared about the welfare of the people, and who knew how to properly lead the nation. By far, the majority of celluloid pols were like *The Great McGinty* (1940), an allegory about a bartender who, via flashback, reveals how he rose from poverty to the governor's mansion in no time at all by using chicanery, a variety of illegal tactics, and his fists. In the film, a city boss pays bums two dollars each to vote for his man, the "governor" meets his downfall only when he tries to go straight, and a political henchman observes, "If it wasn't for graft, you'd get a very low type of people in politics."

The classic political film of the era is Frank Capra's *Mr. Smith Goes to Washington* (1939), the tale of a wide-eyed, idealistic Boy Ranger leader with the All-American name of Jefferson Smith (James Stewart). He's appointed to the Senate after a party hack dies in office, and heads off for Washington. Eventually, he discovers he was chosen for the job solely to help line the pockets of Jim Taylor (Edward Arnold, perfectly cast), an egomaniacal profiteer who owns the souls of the state's governor (Guy Kibbee), and its senior senator, Joseph Harrison Payne (Claude Rains); the latter, a presidential aspirant, is a once-good apple who's now rotten to the core.

"Why don't you go home?," Smith's cynical, savvy secretary (Jean Arthur) tells him. "This is no place for you. You're half way decent. You don't belong here." Once our hero's ideals are shattered by the truth, he declares, "What are you gonna believe in?...I don't know, a lot of fancy words around this town. Some of them are carved in stone...I guess the Taylors and Paynes put "em up there so suckers like me can read "em." But Smith perseveres, and then soundly defeats his foes during a filibuster.

In the film, Capra comments on who controls America's "freedom of the press." The various Washington correspondents are depicted as having a "boys in the back room" mentality. They may be in the know, but are more interested in fireworks; they're content to pen rumor and gossip, rather than facts. Additionally, Taylor is a media mogul who, during the filibuster, "has practically every paper in the state lined up, and [is] feeding them doctored-up junk." The scenario depicts what might happen if the Jim Taylors of the nation are allowed to thrive: a loss of free speech and freedom of assembly, which can only result in fascism. As Jeff Smith declares, "There's no compromise with truth."

Greed in high places is a subject dear to Capra. His heroes in *Mr. Deeds Goes to Town* (1936), *You Can't Take It With You* (1938), *Meet John Doe* (1941), and *It's a Wonderful Life* (1946) are innocent, kindhearted, or sweetly eccentric populists manipulated by crooked lawyers, greedy newspaper owners, and avaricious bankers. He less than favorably portrays America's power elite; indeed, *Mr. Smith Goes to Washington* takes on a strikingly radical tone when, during the filibuster, Jeff Smith reads the section of the Declaration of Independence which states, "Whenever any form of government becomes destructive...it is the right of the people to alter or abolish it."

But, according to Capra, American democracy will survive because the people, the masses of men, women, and children, remain the backbone of the nation. They will rise (either collectively or in the person of such folk-hero types as Longfellow Deeds or Jefferson Smith) to thrash any profiteering politician or greedy businessman attempting to take their government from them. "You see, boys forget what their country means by just reading 'the land of the free' in history books," Smith observes. "When they get to be men, they forget even more. Liberty is too precious a thing to be buried in books...Men should hold it up in front of them for every single day of their lives and say, "I'm free, to think and to speak. My ancestors couldn't. I can. And my children will.'"

Once America entered World War II, Hollywood's major concern, aside from escapist entertainment, was to churn out propaganda pieces which preached gung-ho patriotism. The public morale had to be boosted, and there was no time for cinematic indictments of the American political system. Even so, an ever-so-playful jab could still be poked at American politics. Note the final line of *New York Times* critic Bosley Crowther's review of *The More the Merrier* (1943), a comedy about wartime housing conditions in the nation's capital: "[This film] even makes Washington look attractive, and that is beyond belief."

Immediately after the war, and with the advent of the Cold War and rise to power of Joseph McCarthy, the writer of such an innocent line might easily be held suspect for its "subversive" implication. Still, a number of films did explore the political process, or depict political corruption. *The Racket*, of all films, was remade in 1951. *The Phenix City Story* (1955) is an exposé of a real-life sin town reeking with political corruption. The Academy Award-winning *All the King's Men*, from the Robert Penn Warren novel, is the tale of an honest, down-home politician who is transformed into a corrupt, egocentric demagogue as he rises to the governorship of his state. He has presidential aspirations, but an assassin's bullet ends his career. *A Lion in the Streets* (1953) offers a similar scenario: a back-country lawyer and champion of the poor permits his political ambitions to turn him into a tyrant. Along with *All the King's Men*, the film is loosely based on the career of Huey Long.

In *Alias Nick Beal* (1949), the devil, in the person of suave Ray Milland, persuades an honest district attorney to become as corrupt as the political forces he's anxious to expose. *The Senator Was Indiscreet* (1947) is a spoof featuring a long-winded senator whose hot political diary causes him much embarrassment. *State of the Union* (1948), directed by Frank Capra, is a satire about a presidential aspirant who confronts political bossism.

Films with such content, however, were the exception rather than the rule. During the McCarthyist Fifties, movie scenarios which were critical of politicians were risky ventures: portray elected officials as crooks, and you just might find yourself labelled a communist. Typical is a column, written by Irving Hoffman, which appeared in *The Hollywood Reporter*: "If you think Frank Capra isn't using his movie version of the hit Broadway satire, *State of the Union*...to peddle some peculiar 'advanced' political thinking, you had better take a second look," Hoffman wrote. "The indictment against this country, its customs, manners, morals, economic and political systems...would not seem out of place in *Izvestia*."

When a politician would be depicted as less than a pillar of Americanism, it would be written into the script that he was little more than a misfit among patriots. In *Born Yesterday* (1950), a crude, pushy, self-made millionaire, Harry Brock (played by Broderick Crawford, direct from *All the King's Men*), arrives in Washington and attempts to use his money and strong-arm tactics to achieve his aims.

The rhetoric in *Born Yesterday* may be essentially correct. "All this undercover pressure, this bribery, corruption, government between friends," declares the scenario's journalist-hero (William Holden). "Sure it goes on all the time, and it's tough to crack. Just ask me, I've tried for years. You need more than knowing about it. You got to have facts, figures—and, most important, the names." But, in the end, only one name is mentioned: a congressman, whose soul has been purchased by the millionaire. "That's some fun congressman you bought me," Brock complains to his legal advisor. "Yeah, well, I'd like to trade him in...for instance, on a senator." The lawyer responds, "You don't go around this town buying up senators and congressmen as if they wore price tags. These guys are honest, sincerely trying to do a job. Once in a while you find a rotten

apple like Hedges, and you can have him. But [that's] just once in a while, in a great while."

A film which tellingly reflects the era is *On the Waterfront* (1954). The film's heavy is Johnny Friendly (Lee J. Cobb), a waterfront union racketeer. But what are Friendly's ties? To whom is he beholden? Where are the true sources of his power? "Stoolie" Terry Malloy (Marlon Brando) testifies about Friendly's murderous activities before a crime commission that's attempting to "tell the waterfront story the way the people have a right to hear it"; this signals the end of Friendly's reign on the docks. As Malloy speaks, a man with his back to the camera—a faceless figure, holding a cigar and being served by a butler—watches the hearing on television. He tells the servant, "If Mr. Friendly calls, I'm out...If he calls ever, I'm out." And that's the last we see or hear of this faceless, nameless man.

If Malloy were to truly have "named names," the script would have allowed him to come forth with Friendly's big business-political connections. That they exist is acknowledged in this sequence. But this is 1954, and politicians and lawbreakers were of two different species. Taken literally, *On the Waterfront* tells us that government (in the form of the crime commission and its hard-working, well-meaning investigators) is good and fair, and unions (in the form of the longshoremen's local, operated by Friendly and his bunch of goons) are invariably corrupt. That the film's director, Elia Kazan, and scriptwriter, Budd Schulberg, each were "friendly witnesses" before HUAC, and *On the Waterfront* serves as a justification for their "naming names," went for years unnoticed by most critics and filmgoers.

The mood of the era is best summed up in a pair of very different films. One is the story of a colorful but notoriously corrupt real-life politician. *Beau James* (1957) could have been a potent, insightful film tracing the career of controversial New York City Mayor Jimmy Walker. Instead,

it's a thanks-for-the-memories reminiscence starring Bob Hope. The other, *The Last Hurrah* (1958), is the account of a tough, sentimental Irish-American boss during his final political campaign. Although the character (who is loosely based on Boston's Mayor Curley) embodies the wheeling-and-dealing mentality, he also symbolizes pride and loyalty to those who deserve it, and good government.

While its scenario does not deal directly with politicians of the elected variety, *The Apartment* (1960), a film that examines another type of politics, serves as a signpost for the decline of the McCarthyist influence in American movies. *The Apartment*, set amid the ivory towers of corporate America, is a cynical black comedy, among whose key characters are a go-getter who will debase himself to rise up the corporate ladder, and a powerbroker who manipulates a pretty but troubled, vulnerable office girl, and disposes of people like yesterday's newspaper while remaining untouched by emotion. Among the film's truths: too often, how far one will succeed in business is based not on merit but on how willing one is to engage in office politics. Unlike *Born Yesterday*, the abusers of power and trust are in the clear majority. Any bets on which film comes closer to reflecting the way it is when business in the real world is conducted as usual?

By the early Sixties Senator McCarthy was dead, the pressure from HUAC had subsided, and films depicting the seamy side of American politics were again being churned out with almost as much regularity as thirty years before. *A Fever in the Blood* (1961) features a troika of villains: a conniving district attorney who prosecutes an innocent man for murder to further his political ambitions; an unscrupulous senator who tries to bribe a judge; and a judge who uses a smear campaign to cop a gubernatorial nomination. In *Ada* (1961), a flunky becomes governor through the machinations of a political boss. *Advise and Consent* (1962) is a behind-the-scenes

glimpse at Washington politicians, many of whom are blackmailers, connivers, and liars. A major character in *Sweet Bird of Youth* (1962) is a tyrannical political boss, the epitome of the stereotypical Southern roughneck.

In *The Best Man* (1964), a front-running candidate for his party's presidential nomination attempts a vicious smear campaign against his rival on the eve of a national convention. *Gaily, Gaily* (1969), based on the memoirs of Ben Hecht, is the tale of a young fellow initiated into the corrupt political realities of Chicago in 1910. Hecht and MacArthur's *The Front Page* was remade in 1974. In *Bullitt* (1968), an ambitious politician toys with a police lieutenant in order to coerce a hoodlum to testify before a senate subcommittee on crime and thus advance his career. The gangster films of the era, from *Al Capone* (1959) to *The Godfather* (1972) and *The Godfather, Part II* (1974), feature criminals with elected officials in their pockets.

With the tragedy of Vietnam, many Americans (in particular, those of the post–World War II generation) became more cynical than ever about the fairness of the American political process and the integrity of the men who occupy political office. There were no Franklin Roosevelts (or Judson Hammonds) to save the Republic. All the progressive young men were disenfranchised from the system, were joining SDS or experimenting with drugs. A film symbolic of the time is *Wild in the Streets* (1968), which depicts a political system gone haywire. After the voting age is lowered to fourteen, a drug-dealing rock star becomes president and incarcerates everyone over thirty in concentration camps.

In the aftermath of the Sixties, films dealing with American politics have become more grim and pessimistic. Two of the best films of the mid-Seventies chronicle the campaigns of frighteningly real politicians aspiring to attain the presidency while basing their campaigns not on an open discussion of issues but an all-out, image-building effort utilizing the media as

the prime indoctrinary tool. In *Taxi Driver* (1976), the candidate has a handsome, youthful appearance, and advertises himself as a progressive. His slogan is "We Are the People," yet his Manhattan campaign headquarters and the computerized rhetoric of his speeches are far removed from the realities of the streets. In *Nashville* (1975), the sum total of a candidate's campaign is an army of loudspeaker-equipped vans announcing that he's running for the highest office in the land and mouthing off populist rhetoric, the jargon of which is the concoction of a Madison Avenue copywriter.

Then there is *The Candidate* (1972), in which a young, liberal lawyer runs for the Senate while attempting to maintain his integrity. Yet he unknowingly is manipulated by power brokers and the media. He is elected, but it is impossible for him not to have become tainted in the process.

The difference between *Taxi Driver, Nashville, The Candidate,* and the films of an earlier era is that the system as portrayed has become so corrupt, so dependent on big money, so controlled by media hacks and flacks that it is impossible for any real-life Jefferson Smith to return it to the people. After the revelations of Watergate, no politician is sacred: not even the chief executive. *All the President's Men* is the actual if slightly altered story of how two young investigative reporters alter history by exposing a trail of slush funds, illegal campaign contributions, wiretapping, cover-ups, and an all-around abuse of power which leads all the way to the corridors of the White House. As we enter the final years of the twentieth century, the fiction portrayed in *Taxi Driver, Nashville,* and *The Candidate* has become the fact: the accepted manner in which political campaigns are carried out and covered. Only the commentary inherent in each film has been forgotten. Today, the candidate with the slickest commercials, and speechwriters who are able to hammer out the catchiest phrases that will capture the attention of television news directors for

their sound-bite coverage, will have a better shot at winning the votes of an electorate that is at once fickle and apathetic. So it is no surprise that candidate George Bush and television anchor Dan Rather would choose to allude to so many movies, so many fictional concoctions, during the 1988 Republican convention.

As politicians have been shown to be extensions of their big-money backers and media controllers, it is appropriate that the key film about an American leader during the late Eighties should focus not on a senator or president but on a businessman. Of course, that businessman could only be depicted as anything but magnanimous. The prototype of the morally bankrupt powerbroker Eighties-style is Gordon Gekko (Michael Douglas), the villain of *Wall Street* (1987). Gekko is the heaviest of the heavy hitters, whose face adorns the cover of *Fortune* magazine. To Gekko, $800,000 is just another day's profit. But he is utterly ruthless and passionless. Professional involvement with Gekko means twisting the rules, using insider information to trade stocks and artificially manipulate the market.

"The most valuable commodity there is is information," Gekko declares. "If you're not inside, you're outside," is his motto. His bottom line: "You do it 'right,' or you get eliminated." Gekko is the kind of man who will look with disdain upon the factory worker, the farmer, the fisherman, or the waitress. Without these blue-collar types, these "outsiders," the Gordon Gekkos of the world would have no sushi to fill their stomachs, no vegetables for their chefs to chop up in Cuisinarts, and no expensive suits to cover their backs. In the end, how many cars, boats, or houses can this man own? Will he ever begin to give back what he has taken? How much is enough for Gekko? The answer, of course, is that there never will be enough for a man like Gordon Gekko.

At the same time, the generic celluloid politician-as-villain remains alive and thriving. That old warhorse *The Front Page* was remade yet again—actually, updated—as *Switching Channels* (1988). The scenario chides demographics-obsessed politicians (as well as egocentric television personalities more concerned with primping their hair than reporting the news, and yuppies who expect to be served mesquite-grilled fish and baby vegetables in a beer-and-burger sports bar).

It now is a given that politician characters in most any Hollywood drama or thriller will be portrayed as greedy, hypocritical, on the take, and up to their necks in slime. One example among many: in *Betrayed* (1988), a presidential hopeful who receives major media coverage spouts such rhetoric as "We have to return America to the real Americans." Who are these "real Americans"? At one point, Mr. Candidate appears at a white supremacist compound, and lashes out against "Jews, niggers, and faggots." Later on, it's revealed that this representative of the "little guy" has been pilfering campaign funds.

Then there is *Blaze* (1989), a fact-based entertainment chronicling real-life Louisiana Governor Earl (brother of Huey) Long's relationship with stripper Blaze Starr during the Fifties. As conceived by director-writer Ron Shelton and played by Paul Newman, good old Earl is a buffoon, a lovable crackpot: the politician as comedian, as entertainer, as fodder for the tabloids rather than responsible elected official.

It should be no surprise, then, that an actor, with a reassuring public presence honed by years of playing roles in movies from *Bedtime for Bonzo* and *Brother Rat and a Baby* to *This is the Army* and *Hellcats of the Navy*, would in 1980 be elected the real-life president of the United States. If Ronald Reagan never did have a profound grasp of the issues, he was an expert at playing to the television camera and exuding a grandfatherly reassurance. By this standard, an actor with a warm, heroic presence could be elected to office based on that presence, and the words he reads

off a teleprompter. His leadership ability and his views on the day's issues are irrelevant; his ultimate role in government is as king and figurehead, rather than president and commander-in-chief. Those who remain quietly on the sidelines, and whose names never are found in voting booths, become the true policymakers.

After serving his two terms, Ronald Reagan not so much retired from office as rode off into the sunset. The man, as America's fortieth chief executive, got to play the biggest role of his career, and he most assuredly gave an Oscar-worthy performance.—Rob Edelman

RECOMMENDED BIBLIOGRAPHY

White, David Manning and Richard Averson. *The Celluloid Weapon: Social Comment in the American Film*. Boston, MA: Beacon Press, 1972.

Pollack, Sydney

(July 1, 1934 –)

Sydney Pollack is said to be the best "actor's director" in Hollywood. This trait has enhanced his commercial success and allowed him to tackle controversial political themes within mainstream studio pictures due to the box office value of the stars he can attract for his films.

Pollack's early film and television work marked him as a man with something to say about, for example, spiritual and economic depression in *They Shoot Horses, Don't They?* (1970) or the political gap between careerism and commitment during the McCarthy era in *The Way We Were* (1973), yet by the time he collected an Oscar for *Out of Africa* (1986), he had succumbed to an epic flatulence that would turn *Havana* (1990) into a movie about the less than lamentable loss of gambling in Cuba. Pollack's big-budget turkeys are most annoying because the overt social commentary in his earlier work promised much, much more.

"Visionary director" is a label Pollack prefers to avoid, and when faced with this dubious distinction, Pollack speaks of the ideas that preoccupy him. He expresses surprise that critics perceive basic patterns in his films and attributes this more to the intensive script work he exacts from his writers. *Tootsie* (1982) is said to have suffered some twenty-five revisions before there was sufficient goofball comedy to remedy its strong message about sexism.

In contrast to Pollack's excruciating expectations of screenplays is his tendency to start shooting even before the script is completed, apparently because extensive experience in television left him uninhibited about the production process. This, in combination with Pollack's own training as an actor and thorough sensitivity to his actors' needs, permits a certain insight into the sure-handedness with which he crafts swaggering social messages in basically risk-averse studio films.

In the Sixties, Pollack began cultivating major Hollywood figures, beginning as a dialog coach for Burt Lancaster, who helped him into Universal Studios. As an actor on the set of *War Hunt* in 1960, Pollack met Robert Redford, launching an association that would bind them through various hits and flops. Pollack often evaluates those years as a learning process that

taught him to work hard and fast and let him experiment on budgets sufficiently low to get "all the razzle-dazzle out of my system." The glitz of *Havana* would cast doubt on that claim.

After Pollack's first feature, *The Slender Thread* (1965), Natalie Wood chose him to direct her in *This Property is Condemned* (1966). Burt Lancaster brought him in to direct *The Scalphunters* (1967) and *Castle Keep* (1968), in which he launched the theme of America as a youthfully arrogant and wildly unpredictable civilization. In *Jeremiah Johnson* (1971), he would mold a more mature vision of a domineering culture violating the native's way of life and death. Even if Jeremiah (Redford) adopts Indian dress and takes an Indian wife, he cannot be assimilated. Against his better judgement, he is commanded by military officers to enter an Indian burial ground, which annihilates all his previous efforts to contribute toward a pacific expansion into the West. Even his own fragile peace with the Indians he has known and respected is shattered.

The Scalphunters employs dry comedy in illustrating the conflict between the encroaching white man and the Kiowa tribe in an unusual way. A runaway slave (Ossie Davis) with a classical education meets up with a villainous scalphunter (Telly Savalas) and the man's mate (Shelley Winters). After the Kiowas kill the scalphunter, she joins the Indians with the comment, "What the hell, they're only men." By its fusion of genre conventions with contemporary nihilism, Pollack's vision of an American West settled by outcasts and dissidents seems more closely related to the Spaghetti Westerns of Sergio Leone than to the classical Hollywood Western.

The cowboy continues to figure as an outsider in *The Electric Horseman* (1978), in which Redford portrays a modern version of the disaffected Jeremiah Johnson. Instead of the military, a nefarious corporation called Ampco has claimed that icon of the West—cowboy turned rodeo hero— for a Las Vegas show. Enter Jane Fonda as a journalist intent on getting the story behind the marketing of this cowpoke. Her demands awaken a dormant desire for some kind of freedom: forbidding any coverage of this defiant gesture, he takes her without her camera to a Utah canyon where he releases his horse to run with the wild herds.

Pollack further explored the Fourth Estate in *Absence of Malice* (1981). Paul Newman figures as a maligned victim of investigative journalism. Despite a noble intention to explore the distinctions between press harassment and journalistic responsibility, the film is doomed by Sally Field playing the journalist as a whining woman with more ambition than common sense.

Pollack's portrayal of women indulges in a stereotypical faith in female as vessel of life and civilization—with a healthy dose of American initiative and resilience. Certainly, one of the most challenging female roles of counterculture cinema in the Sixties was Gloria in *They Shoot Horses, Don't They?* The weighty metaphor of America's Depression years as a dance marathon falls squarely on the shoulders of Jane Fonda as the desperate but determined contestant against inhuman odds. Pollack's predilection for neat dichotomies is visible in the other female in the story, Ruby (Bonnie Bedelia), whose pregnancy offers promise in contrast to Fonda's death wish.

Another stark dichotomy gave muscle to the love story of *The Way We Were*. Barbra Streisand's energetic fervor for political change makes her an outcast in the glamorous world of her Hollywood husband, Robert Redford. As the opportunistic WASP embarrassed by his wife's Jewishness, Redford can no longer sustain the pose he adopted as a student, when he was liberal enough to marry Streisand in an anti-Semitic Midwestern Indiana town. In this, Pollack is better at unveiling the jellyfish ways of Southern California society than the petty hypocrisies of small-

town America.

Pollack's talent for urban drama is impressive; the only intriguing element of *Havana* is the thesis that the Cuban city in the 1959 revolution gave birth to modern Miami. Havana is seen as a U.S. fiefdom; one American says, "We invented Havana and we can goddam move it somewhere else." Twenty-five years earlier, the question of ownership of and identity with a place had provided the spine of the story of *This Property is Condemned*, harking back to the displacement brought by the Depression. A young woman clutches a few childhood souvenirs and says of her home, "This property is condemned, but there ain't nothin' wrong with it." Cubans are not so simple.

Property "condemned" by historical forces more powerful than the people who want to preserve it is also the subject of *Castle Keep*, in which Yankee "liberators" tromp all over European culture. Japanese traditions provide the foil for a similar theme in *The Yakuza* (1974), where the Americanization of postwar Japan takes its toll on revered family values. And *Bobby Deerfield* (1977) again raised the spectre of the American abroad, not in the midst of intriguing cultural collision, but as a hero who is little more than the product of capitalist expertise alienated from his own background and bereft of any emotional vitality.

It is within this context of Americans wreaking havoc beyond their own shores that Pollack's signature on *Out of Africa* and *Havana* should have rendered forceful films. *Out of Africa* is the story of the Danish writer Karen Blixen (Meryl Streep), a landowner surrounded by black Africans at the turn of the century. The potential for a political view of the attitudes that shaped the conflicts of modern Africa is eclipsed by romantic claptrap between Streep and Robert Redford as a vagabond aviator arriving in Africa in the spirit of Teddy Roosevelt.

An equally promising story of the overthrow of a corrupt government in *Havana*

follows the same blueprint: a maverick gambler (Redford) becomes fleetingly involved with the wife of a revolutionary (Lena Olin) but cannot rescue her from her own commitment to a political cause. A thinly disguised attempt to recast *Casablanca* against this backdrop makes the *Playboy* magazine esthetics of the production even more objectionable than *The National Geographic* esthetics of toiling, simplistic natives in *Out of Africa*. The melodrama of both epics is as tiresome as their suntanned, complacent casting. Certainly, the opening line of *Out of Africa*—"I hahd a fahrm in Ahfreekah..."—became a derisive cue for the ridicule of Meryl Streep, what with her fondness for foreign accents.

At the height of his career, Pollack seems to have developed a tin ear. *Havana*'s biggest clunker is "Isn't politics just a kind of hope?" The rhetoric is as empty as the idea that the revolution is first felt when the waiters stop serving drinks in the casino. Pollack's rip-roaring action thrillers flaunt better conceived politics: he could successfully incorporate his favorite metaphors into a taut paranoid tale like *Three Days of the Condor* (1975), with its post-Watergate anxiety about an intelligence unit run amok.

Tootsie (1982) remains Pollack's most entertaining film and possibly a valuable contribution to our awareness of sexism in the workplace. We see Dustin Hoffman turn the tables on the entertainment industry by transforming himself from a consistently rejected actor to a soap opera star by simply dressing the part: clothes make the man...into a woman. His disguise takes the story through the many faces of sexual discrimination into a farce which concludes with the sentiment that "Tootsie" was a better friend to a woman as a woman than he ever could be as a man. Small enigmas such as this offer the illusion of wisdom and political commentary in the Hollywood product at which Pollack is so adept.

Pollack's conscience shines through in

the subjects he chooses; his social aware-
ness has been amply demonstrated; he
has shown interest in the role America and
Americans play offshore. Yet he has grown
accustomed to depicting that world as vir-
tually apolitical. Or is it perhaps too politi-
cally complex to tackle in a movie? His tal-
ent has instead been devoted to burying
controversial issues beneath the confec-

tioner's sugar of Hollywood.
—Karen Jaehne

RECOMMENDED BIBLIOGRAPHY

Dworkin, Susan. *Making* Tootsie: *A Film Study
with Dustin Hoffman and Sydney Pollack.* NY:
New Market Press, 1983.
Taylor, William Robert. *Sydney Pollack.* Boston,
MA: Twayne Publishers, 1981.

Polonsky, Abraham Lincoln
(December 5, 1910 –)

Though he knew from his eleventh year that he wanted to
write, Abraham Polonsky did not pursue a writing career.
In fact, until he arrived at Paramount Studios, in mid-
1945, writing was but one of many activities in which he
had been involved—English teacher, attorney, labor organizer, and
clandestine radio operative for the Office of Strategic Services.

During this period (1928–'45), he wrote
for student publications, various radio pro-
grams, and a CIO newspaper; he also
wrote short stories and two novels, the
second of which, *The Enemy Sea*, was pub-
lished in 1943.

Polonsky had been an avid moviegoer,
but he did not choose moviemaking, "it
chose me. American artists have generally
been the waste products of more
respectable professions, movie people
refugees from the more respectable arts. I
have been both." He found at Paramount
an artistic medium that "overwhelmed me
with a language I had been trying to speak
all my life." Several years later, at
Enterprise Productions, he discovered
that directing was also language—"a more
complex writing experience."

All writers appreciate language, but
Polonsky uses it more effectively than the
vast majority of Hollywood screenwriters.
His scripts are virtual seminars in the

esthetics of film construction. Visual
images, characterizations, dialog, and nar-
rative are consciously manipulated, made
to function at various tempos, and placed
in unfamiliar relationships to achieve the
author's purpose. Human regeneration is
the essence of Polonsky's work; genre is
the framework in which he places it; con-
tent is the material with which he works.

Polonsky's imaginative world is freight-
ed with ambiguity, possibility, and the
ambiguity of possibility. It is a world in
which "uneven contraries...interact with
each other." The main characters in
Polonsky's fiction are always caught
between the suppressing force of social
conventions and the need to express their
humanity. Victory in this struggle comes
through commitment of individuals to ful-
filling what is best within them, their
human identity. Any individual can liber-
ate himself or herself; it is a matter of
choice. Hopes can be defeated, but people

should not be. Polonsky offers no general solutions to human or social problems, he simply and consistently depicts the truth that is most clear to him: "Any single person can stop anytime."

The Marxist in Polonsky hopes for, and the Socialist activist in him has worked toward, a set of conditions in which enough such individuals will make enough such halts. He was born into a milieu where Socialist attitudes and social commitment were an integral part of life. "I did not have to discover Marxism; it was an active political and intellectual force surrounding me." He joined the Communist Party in the early Thirties, shortly after he graduated from City College of New York, because it was the only organized, effective force on the American left. He was not a party line dogmatist nor an unthinking admirer of party leaders; he was critical, sometimes openly, but he did not formally leave the party. It was, for him, a community of committed individuals no matter how many errors it made. He watched it dissolve around him in 1956 and 1957 when its leaders failed to take seriously the kernel of truth in Khruschchev's partial indictment of Stalin, in 1956. Polonsky understood that the crisis in Marxism revealed by that speech had not been caused by the Stalinist cult of personality but by the Communist Party's "repudiation of the cult of the human."

Polonsky did not subscribe to the "socialist realist" dogma of party cultural commissars, nor was he troubled by the prospect of a party member writing commercial films in Hollywood. If one wanted to write movies, there was no other place to be. The real question was whether a screenwriter should be a Communist.

Polonsky is a political person, and though all his work is political (he believes that life is political), he does not compose political tracts. If the content of a story or a story idea interests him, he will naturally accentuate the material to fit his world view, but it is simplistic to regard his movies as manifestoes against capitalist corruption, bourgeois decadence, or racial bigotry.

His first two years in Hollywood were more personally notable for his political activity, his association with *Hollywood Quarterly*, and his scripts for a radio show, *Reunion, U.S.A.*, than for his movie work. He wrote three scripts for Paramount; two were not produced and the third, *Golden Earrings* (1947), was thoroughly rewritten. Discouraged, Polonsky learned from a friend about Enterprise Productions, a newly-formed independent company. He spun them a folk tale about a New York City boy who rises from poverty to become a world champion boxer. Enterprise "borrowed" Polonsky to write *Body and Soul* (1947).

It is a fairy tale of the Depression. While Charley Davis's body rises to the top, his soul descends into the sewer of greed. But it is not a dark tale of evil; the symbols of good are equally prevalent and Charley has many opportunities to choose. The script is notable for Polonsky's attention to milieu and his skillful use of street language. Language is a weapon that exposes and reveals. Although basically a story of street honor lost and regained, *Body and Soul* went well beyond other boxing movies in its exploration of the tension between skill and reward, the manipulation of people's destinies, and the contradictions within choices made and ignored. It starred John Garfield, was directed by Robert Rossen, and was a commercial success.

Enterprise then assigned Polonsky to adapt a book about the numbers racket and to direct it. *Force of Evil* (1948) is a study in fear and anxiety. It explores the ways in which people connect, disconnect, and reconnect. Polonsky broadens his use of language, using dialog, narrative, and the babblings of the unconscious in juxtapositions with visual symbols to create an atmosphere laden with tension. It is not a film about evil, not a *film noir* nor a ganster movie, but a movie about the power of love and human attachment.

Once again, John Garfield was the star, but this time the movie was not a success. Enterprise was falling apart, and MGM, the distributor, did not understand or take much interest in the film.

Body and Soul, Force of Evil, and Polonsky's next two novels (*The World Above*, 1951, and *A Season of Fear*, 1956) demonstrated that he was a revolutionary romantic. The passions, conflicts, and struggles to overcome do not cease when the movie or book ends, but are projected into the future, and the "hero" must continue to make choices and hold fast to commitments.

By 1949, Polonsky himself realized that he was about to be thrust onto the stage of history. He was in France, writing a novel, and he noted in a diary he kept there: "In all the sun struck stillness, the city is not unbeautiful, and at peace, and yet one forces the imagination to realize that people I know are being hounded to jail, fined, imprisoned and pursued for their political opinions...The lessons of Germany must not be forgotten, and they are being forgotten."

Polonsky wrote one more film, *I Can Get It For You Wholesale* (1951), before being named by three informers. He was subpoenaed by the House Committee on Un-American Activities, appeared on April 25th, 1951, and refused to answer questions about individuals or his politics.

The blacklist experience could have been a Polonsky script: a double-edged sword of suffering ("It is bad for people not to be allowed to do what they do well") and possibility ("I could adapt and I did things I might not otherwise have done"). He wrote scripts for two television series (*Danger* and *You Are There*), wrote and directed for a Canadian series (*Seaway*), wrote a shooting script for Tyrone Guthrie's movie version of *Oedipus Rex*, and rewrote movie scripts on the black market. *Odds Against Tomorrow* (1959) is the only one he will acknowledge.

Finally, in 1968, Polonsky was given the opportunity to work under his own name.

He rewrote the script for *Madigan* and was assigned to write and direct *Tell Them Willie Boy is Here*. Polonsky approached this 1910 incident involving a native Californian in a manner that played with the "romantic investment" Americans have in their glorified historical memories, notably those encapsulated in the Western movie genre. Polonsky stripped the esthetic structure to its basic elements, matching it to the bareness of the landscape. Characters, dialog, and scenery are reduced to the elemental, no explanations are offered, and the extended chase becomes the contrapuntal mechanism defining the characters' attitudes and complexities. Willie Boy's triumph is not a symbol of native goodness over white evil, but his human willingness to see the alternatives, to choose that which is best for him—death—and secure it on his own terms.

The movie became a pawn in American politics, and critics missed the point of it. Radicals complained that it was not sufficiently critical of white society; moderates attacked Polonsky for being too negative about America.

Since then, Polonsky has directed one movie (*Romance of a Horse Thief*, 1971), and has had two scripts made into movies (*Avalanche Express*, 1979, and *Monsignor*, 1982). He wrote a fourth novel, *Zenia's Way* (1980), directed a play he wrote, and taught filmmaking at various American and Israeli universities.

In 1988, it appeared as though Polonsky had found the ideal screenwriting assignment: writing a script about his blacklist days in Europe for Bertrand Tavernier. At some point, when Irwin Winkler came on board as producer, it was decided to rewrite the script and set it in blacklist Hollywood, circa early Fifties. It still remained Polonsky's story about himself. But when Tavernier dropped out of the project, Winkler decided to make his directorial debut and chose to rewrite the script. The central communist character became an apolitical liberal, the Cold War

context was stripped away, and most of the texture and dynamism of Polonsky's concept disappeared. *Guilty by Suspicion* (1991) was the result. Not a terrible movie, by any means, but not one to which Polonsky wanted his name attached. Though most of the characters and situations were Polonsky's, the superficiality and political naiveté were all Winkler's. The Cold War may be over, but communism and communists remain uncomfortable subjects for Hollywood moviemakers.

As of publication of this book, Polonsky is writing another novel.—Larry Ceplair

RECOMMENDED BIBLIOGRAPHY

Corliss, Richard. *Talking Pictures: Screenwriters in the American Cinema.* NY: Penguin Books, 1975.

Henderson, Ron, ed. *The Image Maker.* Richmond, VA: John Knox Press, 1971.

Sarris, Andrew, ed. *Hollywood Voices.* NY: Bobbs-Merrill, 1971.

Sherman, Eric and Martin Rubin. *The Director's Event: Interviews with Five American Film-Makers.* NY: Atheneum, 1970.

Zheutlin, Barbara and David Talbot, eds. *Creative Differences: Profiles of Hollywood Dissidents.* Boston, MA: South End Press, 1978.

Potamkin, Harry Alan

(April 10, 1900 – July 19, 1933)

U ntil the publication in 1977 of *The Compound Cinema*, a collection of his criticism, Harry Alan Potamkin was an obscure figure, dimly remembered as one of the first intellectuals to take movies seriously.

Indeed, with virtually no critical models and scorned for the most part by the academic and literary establishments, Potamkin worked a lonely terrain as he hammered out his comprehensive plans for film's artistic and political enlightenment. From 1927 to 1933, in the back pages of such journals as *Close-Up, Hound and Horn,* and *The New Masses,* Potamkin conducted a vigorous campaign against the Hollywood dream factories as he tried to inspire new American filmmakers to follow the example set by the Russians.

Self-appointed moral guardian and militant Marxist ideologue, Potamkin submitted films to a hard-core, party-line assessment. He condemned the imprint of Western capitalism and imperialism on the standard Hollywood product while citing with messianic enthusiasm the Soviet cin-

ema of the Twenties for its creative as well as cultural revelation. Like that of most American Marxists in the early Thirties, Potamkin's commitment to Russia was emboldened by the Depression, which seemed to validate the inherent faultiness of the American system, and by ignorance of the Stalinist tyranny that make a mockery of the true communist ideal. In the light of what we now know about its barbaric violations, Potamkin's zeal for contemporary Soviet society seems eerily misguided, special pleading for a perverted cause.

Nonetheless, his sometimes strident denunciations of the Hollywood ethic, with its insistence on redemption, its assignment of blame to corrupt individuals rather than corrupt institutions, its insinuating perpetuation of middle-class plati-

tudes and the class system, and its escapist formulas, are brisk and unnerving. Potamkin undervalues Hollywood's skill in concocting light entertainment, but his enflamed convictions fortify us with new insights and critical ammunition. Disdaining the cultist star worship that fuels the Hollywood machine, Potamkin maintains that the individual—the actor, the director, the writer—is only as effective as the social idea to which his or her talent is harnessed. Therefore, despite its formal brilliance, Griffith's work, for instance, does not pass Potamkin's acid test: *The Birth of a Nation* is defeated by its primitive social analysis, the scabrous, racist source, Thomas Dixon's *The Klansman*, that provides its animating spirit.

Like most ideologues Potamkin seemed to lack humor. He writes in a ponderous, at times antiquated, style, with little of the vibrant idiosyncracy that has been the signature of most major film critics; and yet his love of the *art* of film protects him finally from being simply doctrinaire or narrowly prescriptive. Dismissive of artless propaganda on the one hand and of self-infatuated artistic experiment on the other, Potamkin proclaimed that ideologically "correct" content must be served by an equally inspired technique.

Overseeing a crucial period in film history, the awkward transition between silent and talking pictures, Potamkin advocated what he called the "compound cinema." He embraced film's newfound ability to record sound, arguing for creative counterpoint between sound and image while chastising the American film's predilection for mere "literalism" and "duplication." Potamkin's progressive esthetics—his impatience with those who held onto silence with nostalgic adulation, his demand that film continue to evolve and to renew itself, to expand its language—were politically motivated. Rhythm, montage, the artful deconstruction and reassemblage of time-space fragments, were skills which had to be mastered in order to make film an effective weapon in depicting class conflict; nevertheless, Potamkin repeatedly cited Dreyer's timeless and essentially apolitical *Passion of Joan of Arc* as the finest articulation of film's basic grammar.

If Potamkin's political gods now seem dated or misinformed, his basic critical premises remain valid. What Potamkin boldly spoke up for was the idea that criticism, like films, should provide entertaining social and political illumination. To Potamkin criticism was an active, pragmatic process dedicated to correcting, adjusting, and elevating the sensibilities, the artistic and political attitudes, of filmmakers as well as their audiences. In his terms a critic not only passes judgement on finished works, connecting individual films to their larger social context (Potamkin is especially astute on ways in which national temperament permeates film), he also prosleytizes, recruits, trains, hectors, infiltrates, and agitates. Potamkin sees the critic as one who not only provides a theoretical framework for revolutionary art but also as one who is himself prepared to enter the battle: "Action without theory is aimless; theory without action is sterile," he writes.—Foster Hirsch

RECOMMENDED BIBLIOGRAPHY

Jacobs, Lewis, ed. *The Compound Cinema: The Film Writings of Harry Alan Potamkin*. NY: Teachers College Press, 1977.

20,000 Years in Sing Sing

Prison Films

Hollywood's first prison films were simplistic moral commentaries, exposing audiences to the cruel injustices of the American penal system. Films like *The Fight for Right* (1913) decried the exploitation of prison laborers by a miserly factory owner, while Raoul Walsh's *The Honor System* (1917) protested the brutalities suffered by inmates at the hands of sadistic wardens and prison guards, and D. W. Griffith's *Intolerance* (1916) spoke out against the barbarism of capital punishment.

While later films added new twists to the sermon, the basic ingredients of the genre have remained remarkably consistent over several decades. To the present, Hollywood prison films continue to be populated by inmates who are innocent victims, viciously punitive jailers, and reformers who seek the humanization of our prisons.

In the Thirties, the "golden years" of the prison film, audiences were treated to

what appeared to be the beginning of a truly socially significant genre, with films that worked on two levels—both as liberal exposés of prison conditions, and as subtle metaphors for the quality of Depression life. Yet only a handful of filmmakers since that time have attempted to develop the genre by offering more than a simple admonishment to the penal system. With few exceptions, the viewpoint of the prison film has remained as simplistically socially critical as were its initial post-Victorian versions, concentrating on such specific evils as inedible food and solitary confinement, and neglecting to make the larger connection between the failures of the prison system and those of America itself.

During the Depression years, the prison film was one of Hollywood's most popular genres. It was easy for audiences, feeling the pinch of a depressed economy, to identify with the sense of frustration and entrapment experienced by prison inmates. Audiences flocked to see films like *The Big House* (1930), *20,000 Years in Sing Sing* (1933), and *I Am a Fugitive from a Chain Gang* (1932), which emphasized the regimentation, confinement, and dehumanization of prison life. The opening scene of *The Big House* perfectly captured the prisoner's loss of individuality as he is introduced to the regimentation of prison life. Fingerprinted, measured, numbered, and outfitted in a drab, anonymous uniform, the protagonist is gradually robbed of his identity. Dwarfed by the enormity of the institution, he is soon lost in the marching multitude of convicts. The mechanical subjugation is even more oppressive in *I Am a Fugitive:* while the jail cells of *The Big House* provide limited freedom within a small group, there is no relief on the chain gang where the men are chained to their beds and to each other in a large bunkhouse. There is no mobility, no privacy. The human being is reduced to a machine with neither will nor dignity, forced to perform the daily functions—work, eat, sleep—mechanically and endlessly. Just as the legions of

Depression unemployed and hungry were victimized by circumstances beyond their control, so the protagonists of Thirties films were almost always innocent victims, unjustly convicted of crimes they did not commit. In *I Am a Fugitive*, James Allen (Paul Muni) is forced at gunpoint to participate in a robbery and is caught by the police with his hand in the till. In *Ladies of the Big House* (1932), newlyweds (Sylvia Sidney and Gene Raymond) are framed for murder and arrested on their wedding night, while in *20,000 Years in Sing Sing*, a gangster (Spencer Tracy) is executed for a murder he didn't commit. *Numbered Men* (1930), *The Criminal Code* (1931), *The Last Mile* (1932), and *The Big House* likewise feature leading characters who are innocent victims.

With the advent of FDR and a growing confidence in the system's ability to rebound, the prison film lost much of its impact as a metaphor for filmgoers' own unhappy lives. The genre retained its popularity, but with the focus now on the rehabilitative potential of the prison system. Numerous late Thirties films concentrated on reform schools—*Crime School* (1938), *Boys Town* (1938), *They Made Me a Criminal* (1939)—showing how a progressive, enlightened warden could transform delinquents into law-abiding citizens. Other films, like *San Quentin* (1937), *Each Dawn I Die* (1939), and *Castle on the Hudson* (1940), entertainingly recycled the clichés of the genre—but they were not particularly socially relevant. *Castle on the Hudson*, a remake of *20,000 Years in Sing Sing*, followed the original script closely, but with one exception: in the earlier film the hero's death is clearly blamed on a vengeful, hostile society, while the remake's hero (John Garfield) is merely a victim of bad luck.

Only Fritz Lang's *You Only Live Once* (1937) retained the metaphoric social impact of the early Thirties prison films. To Lang, Thirties America is a prison from which there is no escape. The film is dominated visually by images of entrapment.

The doomed hero, Eddie Taylor (Henry Fonda), shuttles back and forth between prison and society but he is never free. We see him enclosed by window frames, in doorways, and finally through the telescopic sights of a policeman's rifle. One of the film's most memorable images is that of a jail cell whose bars create shadows that fan out to encompass the entire screen. Society's literal prison reaches out to embrace its surroundings, and, no matter where Eddie flees, he will never escape those prison bars.

You Only Live Once was a despairing film, very much a product of the Depression. Such solemn images of entrapment and persecution were hardly appropriate fare during the war years, however, and the prison film all but disappeared until the release of Jules Dassin's *Brute Force* (1947), a somber depiction of the fatal struggle between a malicious warden and a group of prisoners trying to escape. When the genre made a comeback in the Fifties, the films followed the pattern of such prewar programmers as *Castle on the Hudson*—familiar pleas for prison reform combined with action-packed adventure. Of the many Fifties' prison films, including *Caged* (1950), *My Six Convicts* (1952), *Black Tuesday* (1954), *Duffy of San Quentin* (1954), and *Unchained* (1955), Don Siegel's *Riot in Cell Block 11* (1954) was one of the few that managed to rise above worn platitudes.

During the Sixties, Hollywood produced only a handful of prison films. The most important of these films, John Frankenheimer's *The Birdman of Alcatraz* (1962) and Stuart Rosenberg's *Cool Hand Luke* (1967), mercifully moved away from the traditional complaints about prison life. Both films instead emphasized the struggle against a repressive, conformist society. In the true story of *The Birdman of Alcatraz*, Burt Lancaster plays Robert Stroud, a prisoner held in solitary confinement for forty-three years. Stroud confounds the authorities, who seek to destroy his rebellious individuality, by

becoming a world famous expert on birds. The title character of *Cool Hand Luke* (Paul Newman) is a social outcast whose open defiance of established mores invites persecution both inside and outside prison walls. Luke's response is a staunch, stubborn adherence to his own, slightly askew sense of independence which, according to this film, is a crime punishable by death. The film's most memorable line, "What we have here is a failure to communicate," aptly summarizes the conflict between the individual and society. As a result, *Cool Hand Luke* registers an impact on audiences as powerful as that of many of the best Thirties prison films.

Probably the most successful prison film of recent decades is Robert Aldrich's *The Longest Yard* (1974). Like *Cool Hand Luke*, *The Longest Yard* deemphasizes many of the concerns of other prison films, completely turning away from the traditional denunciation of squalid living conditions. Although Aldrich's prison officials are as ill-tempered as ever, the prisoners are hardly innocent victims. Rather they are the dregs of society—rapists, psychopaths, crooks, and irresponsible losers. Aldrich's theme, as in his earlier *The Dirty Dozen* (1967), is that no matter how evil, cynical, or wretched, prisoners are human beings who, given the choice and the opportunity, can band together in a common cause and gain a sense of individuality and self-worth. In *The Dirty Dozen*, the cause was the completion of a dangerous mission against the Nazis in order to escape execution. In *The Longest Yard*, the prisoners, led by a down-on-his-luck ex-pro quarterback (Burt Reynolds in perhaps his best screen performance), join forces to challenge a football-crazed warden and his staff in a football game. The warden, played with evil relish by Eddie Albert, tries to blackmail Reynolds to throw the game, and orders his "troops" to use excessive violence during the game to ensure victory for the guards. But he underestimates the significance of winning to the downtrodden prisoners, and ulti-

mately the powerful representatives of authority lose the game. The analogy between the football game and the Vietnam War, in which a powerful nation, led by a president who loves to use football expressions in political speeches, is unable to defeat a group of dispossessed people who have nothing to lose in battle, is obvious if never directly stated. Despite the potentially heavy-handed theme, Aldrich maintains a light, comic touch. The football game itself is an often hilarious if violent spoof of America's game, with Albert coming off as a cross between Richard Nixon and the country's most beloved tyrant-coach, Vince Lombardi. The prison team's cheerleaders, a surly-looking group of cons dressed in drag, may not be as pretty as the Dallas Cowboys Cheerleaders, but are certainly a lot funnier.

Other than *Cool Hand Luke* and *The Longest Yard*, most prison films of the postwar era merely introduce new sensational details to the tired formula. *Riot* (1968) added the topical element of racial tension to the prison riot story while *Fortune in Men's Eyes* (1971) gained some notoriety for its treatment of the previously taboo subject of homosexuality among inmates. Other films like *Jackson County Jail* (1976) and the women-behind-bars movies starring Sybil Danning are luridly sensational tales which provide audiences with explicit sex and violence to spice up bland stories about "the shame of our jails.'

In the Eighties and early Nineties, prison films have become rarer and rarer. They have varied in quality from the well-meaning, well-acted *Brubaker* (1980), in which a liberal warden cleans up one of the most brutal prisons in film history, and the interesting *Weeds* (1987), in which inmate Nick Nolte liberates himself literal-

ly and spiritually by becoming a playwright, to such dreary offerings as *Stir Crazy* (1980), *Penitentiary* (1980), *Penitentiary II* (1982), *Reform School Girls* (1986), and *Tango & Cash* (1989). Two big-budget star vehicles, *Lock Up* (1989) with Sylvester Stallone and *An Innocent Man* (1989) with Tom Selleck, were of minor interest. The former film is notable chiefly for Donald Sutherland's performance as the most evil, sadistic warden brought to the screen in recent years. Before it degenerates into a banal revenge melodrama, *An Innocent Man* is one of the few Hollywood films to acknowledge the existence of racist gangs like the Aryan Brotherhood within prison walls. Still, the genre has reached the point at which there can be nothing more to shock us. The evils depicted have changed from bad food and solitary confinement to homosexual rape and drug dealing inside the prison, but the message remains the same as in the earliest films—the prison system needs to be reformed.

While the indictment of the penal system is a valid message worth repeating, most of Hollywood's prison films have been as limited in scope as actual prisons are confining. The best films in the genre have tried to use their setting metaphorically—linking life in the prison to life in the outside world. One hopes future filmmakers will follow the examples of Fritz Lang, Stuart Rosenberg, and Robert Aldrich. Otherwise, the prison film genre is likely to remain a victim of confinement, trapped in a cell of tired clichés.

—Peter Roffman and Beverly Simpson

RECOMMENDED BIBLIOGRAPHY

Crowther, Bruce. *Captured on Film: The Prison Movie*. London: Batsford, 1989.

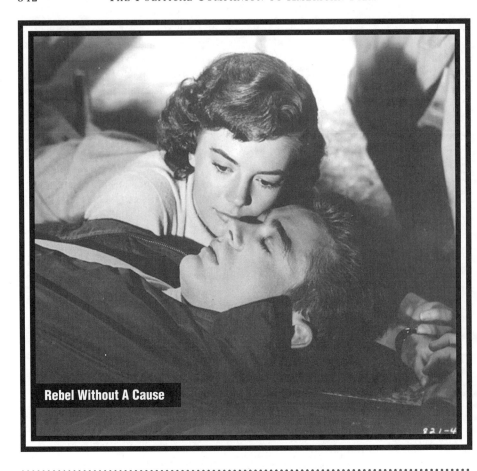

Rebel Without A Cause

The Rebel Hero

By dictionary definition, a rebel "rises in opposition to authority"; to rebel is "to resist, oppose or be disobedient to someone having authority or rule." Certainly, history supports this definition with real-life rebels whose actions saved nations, gained independence, and overthrew tyrannical governments.

Hollywood, however, espouses a different definition of the rebel. Since no Hollywood film could realistically endorse open rebellion against American society, Hollywood rebels are passively rather than actively disobedient. From John Garfield in the Thirties, to Montgomery Clift, James Dean, and Marlon Brando in the Fifties, to Jack Nicholson and Richard Gere in more recent films, the Hollywood rebel's essential characteristic is his lack of action. He may be a catalyst to upheaval, but he is seldom an activist himself. Sensitive, innately intelligent, he wants desparately to be

accepted by society, but due to some inadequacy within himself is unable to reconcile himself to the Establishment. James Dean's Jim Stark is a rebel literally "without a cause," who wants only to "belong" but finds himself perpetually at odds with the society he is desperate to join. Marlon Brando's rebellion against anything and everything in *The Wild One* (1954) manifests itself not in the form of an insurrection but in the form of an escape—he runs away from society, hiding behind his gang and his motorcycle. Indeed, Brando seems to have a greater quarrel with a rival gang member than with establishment society.

Although Hollywood's rebels often have a chip on their shoulders, usually due to an underprivileged childhood or an unhappy family life, their main goal is not to change society, but, in the words of one John Garfield character, to find a place to "hang their hat." Their success or failure to do so is a metaphoric comment on American society: a society which can tolerate and embrace its rebels, or a place which ultimately crushes the outsider.

The rebel hero originated in the Thirties, a logical successor to such stock Depression figures as the gangster antihero and the numerous social victims who paraded through Thirties films. The gangster was Hollywood's first prototype for the rebel hero. A far more subversive figure than later rebels, the gangster was a classic individualist who, like the traditional patriot hero, believed in the goals of the American Dream of success. The gangster refused to accept Depression poverty, but did not run away or become a sensitive outcast—he simply moved outside the law to achieve his goals. His immediate success is a covert rejection of the system and his inevitable downfall is less an acknowledgement of the system's triumph than a statement of the utter impossibility of achieving the American Dream during this bleak period. When the gangster faded from Hollywood screens, he was replaced by a more passive figure—the social victim. Unemployed WWI heroes, children of

the slums, ex-convicts, and dispossessed farmers became standard Hollywood characters, tramping across the country in search of ever-elusive jobs, occasionally turning to crime in desperation. Although these characters had plenty of reasons to quarrel with the system, they seldom did, and were quickly reconciled to society with the promise of a job and a place to "hang their hat."

The most poignant social victims were portrayed by Henry Fonda in Fritz Lang's *You Only Live Once* (1937) and John Ford's *The Grapes of Wrath* (1940). In Lang's film, Fonda is Eddie Taylor, an ex-con who has learned his lesson and wants to go straight. But a combination of prejudice against ex-cons and bad luck turn Fonda into a murderer, hunted down and finally killed by the cops. Although Fonda is angered by society's refusal to give him a chance to redeem himself, he is not at war with society. Rather, it is society that is at war with him. In *The Grapes of Wrath*, Tom Joad (Fonda) returns from prison to find that his family has lost their farm and is heading to California to look for work. Expecting to find the Promised Land, the Joads instead find a harsh world of economic exploitation, of casual laborers, and discrimination against "Okies." A more politicized figure than Eddie Taylor, Tom becomes involved in a strike against the farmowners and eventually kills a strikebreaker in a scuffle. Although *The Grapes of Wrath* somewhat mutes Tom's radical politics by contrasting him with his more conciliatory, conservative Ma (Jane Darwell), he is the only Hollywood rebel who actually rebels politically.

The other major social victim of Thirties cinema is John Garfield, generally acknowledged as the prototype for later screen rebels. Garfield's characters are the urban version of Tom Joad, products of the Depression slums, who are continually on the wrong side of the law, but who yearn to live a productive life within society. In *Dust Be My Destiny* (1939), Garfield plays a vagrant who wants to settle down, but,

unjustly accused of murder, becomes a fugitive, relentlessly pursued by the police. Likewise, in *They Made Me a Criminal* (1939), he is a boxer framed for murder, hounded by an obsessive policeman. But Garfield's persona differs significantly from Fonda's characters. Unlike Eddie Taylor or Tom Joad, both of whom are quick-tempered but otherwise well-adjusted, Garfield is a troubled figure, as much a victim of his own insecurities as society's persecution.

Garfield's alienation, his innate inability to conform to "straight" society, make him the logical predecessor to Fifties rebels such as Montgomery Clift's Sgt. Prewitt in *From Here to Eternity* (1953). Prewitt is a perfect example of the Fifties rebel, a non-conformist in the most conformist society of all, the army. An ex-boxer, he comes into conflict with a superior officer by refusing to represent his unit in a boxing tournament. Prewitt's stance eventually leads to his desertion from the army, and he is killed while attempting to return to his unit during the Japanese attack on Pearl Harbor. Prewitt's rebellion is a personal one, based on his abhorrence of boxing's violence, and does not represent a genuine criticism of the military. His attempt to return to his unit testifies to his deepest desire—to be accepted by his personal society, the army.

In *East of Eden* (1955) James Dean continues his *Rebel Without a Cause* (1955) role as a young man desperately seeking the love of his father. Relentlessly frustrated, he finds a way to punish his mother, secretly employed at a local brothel, and his brother, Adam, their father's favorite son. Yet by hurting these two cherished members of his family, Cal has actually turned his rebellion inward against himself, while his father, unloving, representative of establishment society, escapes penalty.

Unlike Depression rebels, Fifties rebels were less social victims than prey to their own emotional fragility. It is not poverty or a broken home that drive Sgt. Prewitt and

Cal Trask to rebel, but an inner anguish, an intense, unfulfilled need to be understood. Their rebellion is ultimately directed against themselves, not society. Sixties rebel heroes like Peter Fonda and Paul Newman combined the qualities of Thirties and Fifties rebels, reacting against social injustice for purely personal reasons in ways that are ultimately self-destructive. In *The Trip* (1967) and *Easy Rider* (1969), Fonda's hippie outcast simplistically attributes his rebellion to society's lack of social and political integrity. But his rebellion is not political; instead he drops out, taking to his motorcycle and self-destructive drugs. Paul Newman's *Cool Hand Luke* (1967) is a similarly quixotic character, arrested for a minor crime and sent to a prison where he comes into conflict with the brutality of both prison guards and inmates. Luke's fearless confrontation with sadistic authority is heroic but meaningless. His fatal refusal to "communicate" is as much a product of his own need for martyrdom as it is of society's evils.

While Fonda and Newman may have little political motivation, their anti-establishment stance makes them outcasts. Like earlier rebels, they differ significantly from the traditional hero who confronted social evil and vanquished it. Newman's loser is as far removed from Gregory Peck's confident crusading hero—e.g., *To Kill a Mockingbird* (1962), *Captain Newman, M.D.* (1963)—as Garfield was from a Jimmy Stewart or a Gary Cooper. In the Seventies, however, it became increasingly difficult to distinguish rebels from traditional heroes. Sylvester Stallone's hard-luck boxer Rocky begins as a rebel, unable to fit in no matter how hard he tries, but ends up a winner. Seemingly alienated, Stallone is really Horatio Alger dressed up as Marlon Brando. Through hard work and training, he lifts himself above his impoverished roots to challenge for the world title. Similarly, John Travolta's Tony in *Saturday Night Fever* (1977), is a cocky, ethnic version of James Dean's troubled teenager, at odds with his parents' values

and the dead-end prospects of his life. But unlike Dean, Travolta's rebellion brings him not to the brink of self-destruction, but rather to the dance floor, where he finds both his self-confidence and his communality with society.

Only one Seventies actor comes close to the rebel archetype—Jack Nicholson, the cantankerous psychiatric patient of *One Flew Over the Cuckoo's Nest* (1975) and the irresponsible nomad of *Five Easy Pieces* (1970). In *Cuckoo's Nest*, Nicholson incites a group of hospital inmates to some in-home rabble-rousing, much to the chagrin of the dour authority figure, Nurse Ratchett (Louise Fletcher). The consequences are unfortunately tragic, as one patient commits suicide and Nicholson is lobotomized. Even Nicholson, the most rebellious of the Seventies protagonists, doesn't quite fit the mold of the classic rebel. He is a far cockier, confident figure than the fragile Montgomery Clift or the fatalistic Garfield. While these rebels sought to be accepted by society, Nicholson seeks nothing from anyone, and seems content to merely display his charming arrogance and strutting self-confidence. But he is too cynical and irresponsible to be a hero. Allowed to go his own way in *Five Easy Pieces*, he abdicates all responsibility toward family and friends. When given the chance, Nicholson, in true rebel fashion, runs away.

It seems that Nicholson may be the last of the adult male Hollywood rebels for a while. Except for the troubled teenagers in such films as *The Outsiders* (1983), *Rumble Fish* (1983), and *Pump Up the Volume* (1990), the most convincing and sympathetic rebel figures since Nicholson aren't heroes but heroines: namely *Thelma & Louise* (1991). These two friends, portrayed respectively by Geena Davis and Susan Sarandon, combine characteristics of everyone from the Thirties victims through *Cool Hand Luke*. Like Henry Fonda's Eddie Taylor in *You Only Live Once*, the two women are innocent victims. Louise is presumably haunted by a past

rape, while Thelma is a victim of sexual stereotyping, forced by her domineering husband into the role of the submissive, stay-at-home wife. Like John Garfield's screen character, they are also the victims of incredibly bad luck. Heading off for a harmless weekend outing, they stop off at a bar for a couple of drinks. A tipsy Thelma gets flirtatious with a male customer who then tries to rape her. Louise, who, like many of the Fifties rebels is tormented by her past, kills the would-be rapist, and the two friends take to the road, fugitives from the law.

As they flee, the women come to revel in their newfound freedom. As outlaws, no longer governed by the rules and regulations of (male-governed) society, they realize just how constricted their past lives have been. At one point, Thelma voices what could be a credo for a new generation of rebels. Holding a police officer at gunpoint, she suggests that the policeman be sure to treat his family real well; otherwise they could turn out to be just like her and Louise. There is, of course, no specific political agenda to the two friends' rebellion. Like Brando's motorcyclist, they are rebelling against anything and everything. And like Paul Newman's Luke, they are doomed from the start. There is no way that Thelma and Louise can escape their massive police womanhunt; their journey to freedom is also a journey towards death.

Thelma and Louise fit the rebel mold far better than most of the male heroes of the Eighties and early Nineties. In recent years, there have been lots of heroes who are either in conflict with or out of step with society, but few bona fide Hollywood rebels. Kevin Costner's Civil War vet who turns his back on white society in *Dances With Wolves* (1990) is just a little too sincere and heroic to be a rebel, while James Woods's former radical idealist in *True Believer* (1989) and his muckraking journalist in *Salvador* (1986) are too cynical and psychotic. Similarly, Matt Dillon's *Drugstore Cowboy* (1989) is too blank, Robert De Niro's *Raging Bull* (1980) too

crazy, and Val Kilmer's Jim Morrison in *The Doors* (1991) too hedonistic and self-destructive.

The current direction of rebel heroes is epitomized by the films of Richard Gere. In *An Officer and a Gentleman* (1982), Gere plays a typical Eighties punk, an alienated misfit from the wrong side of the tracks. When he is accepted into an Air Force training program for pilots, Gere seems headed for success, but he cannot stop acting like a loser. His petty thievery brings him into conflict with his tough superior (Lou Gossett, Jr.) and he rejects the love of the traditional good woman (Debra Winger). Finally, threatened with expulsion from the military, he straightens himself out and becomes a winner. The military succeeds in making a man of Gere, something it failed to do with Montgomery Clift in *From Here to Eternity*.

Miles from Home (1988) reverses the plot of *An Officer and a Gentleman* with Gere beginning as a winner and ending up a loser. When the bank forecloses on his once successful Iowa farm, Gere strikes back in classic rebel fashion. He torches his house and crops as a symbolic gesture, a protest against society's lack of compassion for the small farmer's economic woes. With his younger brother as an accomplice, Gere embarks on a minor crime spree. The press portrays him as a modern Jesse James or Robin Hood, a folk hero who steals from the rich and gives to the poor. But the film pulls its punches, demonstrating that the heroic image is undeserved. Gere's behavior becomes increasingly erratic and self-destructive until he loses the companionship of his brother and the audience's sympathy. In the end, he seems less social hero than sociopath.

Miles from Home's portrait of the rebel is consistent with the trend in rebel films. Since the Fifties, Hollywood has increasingly emphasized the psychological causes of rebellion over the political causes until finally, in the Eighties, rebellion is treated as an aberration. Where previous rebels were idealists, Gere's rebellion is portrayed as a self-defeating sickness. We sympathize with him only because, like Debra Winger, we see the potential that his rebelliousness masks. While Gere triumphs over his sickness in *An Officer and a Gentleman*, he fails to do so in *Breathless* (1983), where his antisocial posturing turns him into a cop-killer, or in *Internal Affairs* (1990), where he's a cop who kills, or in *Miles from Home*, which leaves him permanently on the lam from the law. In the first two films, Gere's character is almost entirely reprehensible. He is a charming madman whose death is finally beneficial to society. In *Miles from Home*, he is a good bad guy. He desperately craves the societal acceptance he gets when the press portrays him as a hero, but his insanity finally overtakes his sense of social justice and negates his heroic aspirations.

Always uncomfortable with the rebel hero despite his box office appeal, Hollywood at first sought to turn him into a passive figure whose rebellion was metaphorically political. While the heroines of *Thelma & Louise* are idealistic, the male rebel, at least in Richard Gere's films, has been deprived of his idealism. A film like *One Flew Over the Cuckoo's Nest* suggested from a critical viewpoint that society would go to any lengths to suppress rebellion—that it would even institutionalize the nonconformist, calling him insane. *Breathless* and *Miles from Home* actually treat the rebel as though he is a madman. For the moment in Hollywood, there are no rebel heroes, only heroines.

—Peter Roffman and Beverly Simpson

RECOMMENDED BIBLIOGRAPHY
Morella, Joe and Edward Z. Epstein. *Rebels: The Rebel Hero in Films*. NY: Citadel, 1971.

Ritt, Martin

(March 2, 1914 – December 8, 1990)

As much as any major American filmmaker, Martin Ritt infused his films with a heartfelt, simple (though rarely simplistic) humanism. His most typical characters are men and women, black and white, Jew and Gentile, who transcend all superficial barriers, becoming aligned out of the desire for love and companionship or to fight a common enemy.

And that enemy is usually racism or capitalism: Ritt's heroes and heroines are underdogs, otherwise average, unremarkable working people who wish only to live their lives peacefully, and with dignity. They must come together to battle those who would deny them these most rational and reasonable of needs. As in real life, they occasionally fail. As in real life, they occasionally succeed.

Norma Rae (1979), featuring Sally Field as a poor Southern factory worker slowly won over to the concept of unionization by Ron Leibman's labor organizer, is perhaps the model Ritt feature. There's an exemplary feminist heroine here, a woman who through the course of the scenario gains self-confidence and self-respect, and takes control of her life. She learns not to whisper but to defiantly yell that little magic word—NO—to those who would exploit her. Refreshingly, Norma Rae is neither pampered middle-class housewife nor spoiled princess but a blue-collar worker laboring for her family's survival in an unglamorous workplace. Her mentor is a New Yorker and a Jew, whose ways are as foreign to her as if he's just emerged from a spaceship. Ritt does not have these two ever so chicly hopping into bed. Instead, they develop a friendship, a mutual respect. In *Norma Rae*, a woman and a man relate intimately, but not sexually. They become involved, but in ways far more lasting and profound than simply between the sheets.

Back in 1961, in *Paris Blues*, Ritt presented black and white characters intermingling easily and freely. But the roots of prejudice had to be exposed and explored before the races could fraternize on screen. In his first directorial credit, *Edge of the City* (1957), Ritt depicts the somber realities of the falsehood of the idealized American melting pot. Here, an African-American (Sidney Poitier), a jovial, honest blue-collar worker, befriends a white man (John Cassavetes), a confused army deserter. While *Norma Rae* ends in triumph, the finale in *Edge of the City* is tragic: the black man dies at the hands of a vicious racist coworker (Jack Warden). Without films like *Edge of the City*, in which African-Americans were portrayed as saintly martyrs, there could have been no *Paris Blues*—and no *A Soldier's Story*, *The Color Purple*, *Boyz N the Hood*, or *Jungle Fever*.

Ritt has had a major (and too-often overlooked) role in the evolution of the black in American cinema. By the post-*Sweet Sweetback/Shaft/Cotton Comes to Harlem* Seventies, African-American characters could be conceived in worlds all their own. Ritt in no way abandoned African-American characters: his *Sounder* (1972) is a pointed, poignant drama about a Depression-era Southern black family struggling to overcome prejudice and adversity. If Ritt does somewhat romanti-

cize his protagonists here, they still are all unmistakably real.

Not all of Ritt's male-female pairings are as platonic as in *Norma Rae*. But his most intriguing sexual couplings are in no way conventional. In *The Great White Hope* (1970), James Earl Jones's Jack Jefferson is a boxing champ, a proud African-American, a superstar when those of his race mostly were sharecroppers. His mistress is no bubbling brown sugar, but rather a white woman (Jane Alexander). The heroine and hero of *Stanley & Iris* (1990) are a working-class widow (Jane Fonda), and a loner (Robert De Niro) who is plagued by his illiteracy. Even in one of his least issue-oriented films, *Murphy's Romance* (1985), Ritt unites a couple who by society's rules should not be relating romantically or sexually: a young woman (Sally Field) and a man (James Garner) who's old enough to be her father.

Perhaps Ritt's most personal film is *The Front* (1976). The director's professional roots were in the Group Theatre, a fact which tellingly reveals the basis of his esthetic. Like so many of his generation, Ritt was robbed of his career during the reign of Joseph McCarthy. *The Front* (scripted by Walter Bernstein, with a cast including Zero Mostel, Herschel Bernardi, Joshua Shelley, and Lloyd Gough—all fellow blacklistees) is a comedy with dire overtones. As memorable as is Woody Allen's nebbish who puts his name on blacklisted writers' scripts, there is Mostel's knowing portrayal of a fat funnyman who fatally fails in his battle against the poison of the blacklist.

The Front, and ultimately the career of Martin Ritt, is an ode to the memory of the John Garfields, the Philip Loebs, the Mady Christians, the J. Edward Brombergs: those whose political leanings were based on a concern for humanity, and who paid for those beliefs with the loss of their lives. If Ritt is no great visual stylist, and his adaptations of Faulkner (excluding *The Long Hot Summer*, 1958) have been less than successful, he has throughout his career elicited award-caliber performances from his casts. More importantly, from his explorations of race relations in *Edge of the City* and so many other films, through his examination of the hardships of the overworked and underpaid in *The Molly Maguires* (1970) and *Norma Rae*, and in his depiction of multidimensional heroines in *Norma Rae*, *Cross Creek* (1983), and his final feature, *Nuts* (1987), Ritt's career has been remarkably consistent.

—Rob Edelman

RECOMMENDED BIBLIOGRAPHY

Higham, Charles. *Celebrity Circus*. NY: Delacorte, 1979.

Reed, Rex. *Valentine and Vitriol*. NY: Delacorte, 1977.

Whitaker, Sheila. *The Films of Martin Ritt*. London: British Film Institute, 1972.

Norma Rae

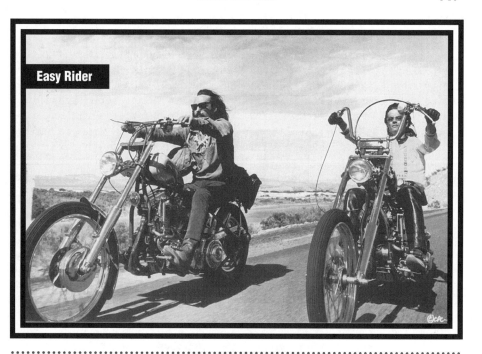

Easy Rider

Road Movies

D uring the summer of 1991 one of the most riveting films on the screen was Ridley Scott's *Thelma & Louise.* Most of the controversy centered around the strong characterizations of the lead women interpreted by Geena Davis and Susan Sarandon in an uncompromising script by Callie Khouri.

But as experts and rednecks, single men and married women traded blows as to whether the film was a feminist tirade or another female macho revenge movie, Khouri made it clear that, for her, it was a road movie told from a woman's point of view. Her point is worth considering. For the road movie has a long history in American cinema and it is a history predominantly told from the male perspective.

Walt Whitman captured much of the spirit of young, democratic America in "Song of the Open Road" when he said he wished to "know the Universe itself as a road, as many roads, as roads for traveling souls." America has grown up on the road since the pioneers began heading west. Nowhere has this restless, wandering spirit been more aptly captured in the twentieth century than in a variety of American films that treat the open road. Whether the travelers search for home, love, themselves, God, kicks, or whether they're just on the run, the road as a theme is deeply bound up with the American psyche.

Chaplin, the Little Tramp, became loved the world over as the outsider whose misadventures were interwoven with the open highway. As early as *The Tramp* (1916), Chaplin closed his film with what

became part of his trademark. His back to the camera, doing his inimitable walk, Charlie headed off down the road, alone, in long shot. So much was this image a part of his screen persona that the ending of *Modern Times* comes as not only a happy ending but also a pleasant shock: the Tramp goes off down yet another highway but this time joined by his love, Paulette Goddard. For Chaplin the highway is for outsiders in search of security and love, and yet he is always forced (or chooses, as the case may be) to move on.

The Thirties saw the effects of the Depression reflected in various kinds of road movies. Paul Muni gave a memorable performance as James Allen, a World War I vet out of work who is forced to become a criminal in the strong social drama, *I Am a Fugitive from a Chain Gang* (1932). Hollywood generally suggested during this period that many of the hoboes, drifters, migrant workers, and homeless were common people who had hit on hard times. John Steinbeck's novels provided valuable material for cinematic adaptation in *Of Mice and Men* (1939), which focused on migrant workers, and *Grapes of Wrath* (1940), which portrayed the road life of thousands of Okies on their bitter odyssey to California. In both films the highway is a place where strangers become unexpected friends or where the oppressiveness of the times and the pressure to survive may lead to crime.

Other films, however, saw the hobo in darker terms. In the 1946 adaptation of James M. Cain's *The Postman Always Rings Twice*, the highway and *film noir* blend as Frank Chambers (John Garfield) and Cora Smith (Lana Turner) find that the lure of the open road leads not to escape but to a spiraling dead end.

In contrast, Frank Capra found the highway and the roadside as an amiable location for Americans to forget their social differences and to discover instead their basic humanity. *It Happened One Night* (1934) equalized newspaper reporter Clark Gable and spoiled rich kid Claudette

Colbert while spinning a romantic fable of love on-the-road (including the justly famous hitchhiking scene) as set against the rigidity of the city. Similarly, Capra romanticizes hoboes in *Meet John Doe* (1941) as Gary Cooper and Walter Brennan appear off the road only to be suddenly swept to false fame by a Nazi-like newspaper tyrant out to subvert democratic ideals. It is only when Doe meets the common people again that he decides to live up to the hoboes' idealistic illusions of him.

With *Sullivan's Travels* (1941), Preston Sturges wrote and directed a tale of the open road that is entertaining and yet much more realistic and socially satirical than Capra's simplistic populist formula. Sturges employs double-edged satire in his tale of a Hollywood director, tired of making mere entertainment, who disguises himself as a hobo and hits the road to come into contact with "real life."

What looks like a publicity stunt at first quickly becomes a cruel and harsh reality once John L. Sullivan (Joel McCrea) becomes caught up in crime and punishment on the road in a sequence clearly derived from *I Am a Fugitive from a Chain Gang*. In the end, Sullivan decides to return to Hollywood to make entertainment after seeing prisoners laugh during a Mickey Mouse cartoon. Having exposed both social injustice and Sullivan's inflated sense of what a "social injustice" film might be, Sturges appears to retreat into a justification of Hollywood as a medium of escape from reality rather than as a possible source of images that can help individuals confront their lives.

Bob Hope, a transplanted Englishman like Chaplin, became a film star through his road narratives. In *Road to Singapore* (1940), *Road to Zanzibar* (1941), *Road to Morocco* (1942), *Road to Utopia* (1945), *Road to Rio* (1947), and *Road to Bali* (1952), he teamed his uncomplicated verbal wit with the crooning of Bing Crosby and the good humor of Dorothy Lamour to produce films in which the words "Road

to..." became synonymous with entertainment for an America under the pressures of World War II. As opposed to Chaplin's comedy drawn from everyday life and social injustice, Hope's humor portrayed the open highway as one leading to the pleasurable teamwork of his trio caught in exotic locations.

It is a curious fact that the Bible of the beat generation, Jack Kerouac's *On the Road* (1955), has not been touched by Hollywood except in *Heartbeat* (1980) which treated Kerouac's experiences while writing the book, but with little of the book itself. While a new subculture was restlessly zooming east and west and south across the border during the Fifties, filmmakers tended to ignore youth and showed the road as an extension of suburbia in such films as Lucille Ball's *The Long, Long Trailer* (1954) or as pure fantasy entertainment in *The Solid Gold Cadillac* (1956).

In the Sixties, the road film came into its own. Film producers began to cater to a youth-oriented audience and young filmmakers were suddenly recruited and encouraged to shoot realistic stories on locations. The open highway became a familiar image for a new generation made up of restless youth who, unlike the hoboes of the Thirties, *chose* to be on the road. In short, the new American cinema, which began in the late Sixties with Arthur Penn's *Bonnie and Clyde* (1967), reflected much of the feeling of the times—the violence of Vietnam and youth's disaffection with Establishment values. The stories became ones about wanderers searching for truth, kicks, drugs, and a new sense of self.

In many ways, the quintessential road film involves the outlaw couple as represented in *Bonnie and Clyde*, Steven Spielberg's *Sugarland Express* (1973), and Robert Altman's *Thieves Like Us* (1974), the latter a remake of Nicholas Ray's *They Live by Night* (1959). Each of these films, and many others, concerns a young man and woman in love with each other but isolated from society, in trouble with the law,

and carried away initially at least by the lure of a life of freedom on the go. Many of the films in this group have a kind of archetypal resonance and documentary atmosphere since they are often based on actual events and characters.

"We used to be goin' *to*; now we're runnin' *from*," says Bonnie to Clyde before Penn's film moves toward its fateful ending. What starts out as journey and an adventure in these films, often ends in a violent chase. To a generation of Americans that often felt similarly caught between going to and running from, Penn's outlaw couple became sympathetic heroes despite their violent deaths. Penn was well aware of the entanglement of Bonnie and Clyde, the actual couple, with myth on many levels. There is the myth of the freedom of the open road (Bonnie wants to start a new life; Clyde simply wants to find better ways to rob banks) in which the couple believes, and there is the romantic myth that the newspapers and thus the public builds up about them. Finally there is Bonnie herself who captures their life in her "Ballad of Bonnie and Clyde" which not only immortalizes them (she sends it to be published in a local paper), but predicts their violent end. The organization of the film into episodes punctuated by a catchy banjo tune makes the entire experience of this couple on the road appear as a ballad or as a myth.

While many films of this pattern such as *Dirty Mary, Crazy Larry* (1974) starring Peter Fonda and *Bobbie Jo and the Outlaw* (1974) starring Marjoe aimed no higher than the drive-in circuit, there is at least one other major film about outlaw couples of note: Terrence Malick's *Badlands* (1973).

In stark contrast to Warren Beatty and Faye Dunaway's romantic good looks in *Bonnie and Clyde*, Martin Sheen and Sissy Spacek are well handled by Malick to convey a more ordinary couple on the run. Malick based his film on the exploits of the famous mass murderer Charles Starkweather, crafting a film that is both

chilling and lyrical. Kit's gratuitous killings come from an individual so cut off from society (he is a garbage collector as the film opens) that violence and speed appear to be his only proof of existence. Perhaps even more chilling is Holly, his female accomplice, whose dull monotone voice-over narration mirrors the endless, flat Western landscape. She passes no judgements, makes no objections, even to the murder of her father, and is able to part with Kit in the end without any expression of emotion. Contrasted to the story is Malick's rich visual style that makes *Badlands* what has been called one of the few sustained works of romantic irony in American cinema.

Toward the end of the film, three images capture Malick's ironic tension. Kit spins a pop bottle in the desert to determine which direction they should go and then he drives off in the opposite one. Second, Malick's framing of the car in long shot, as it travels across the open spaces under a large sky *without a road* visually expresses the lost romanticism of the couple without the need for dialog. Third, at night, Sheen and Spacek dance cheek to cheek in pitch dark in the middle of the desert illuminated only by the headlights of the car as the radio plays a Nat King Cole song. Without overstatement, this and the other images accumulate in our mind as instances of the isolation, loneliness, and self-absorption of these two outsiders on the run to nowhere. Instead of the lively ballad and myth structure Penn uses in *Bonnie and Clyde*, Malick has emptied his frame and narrative to concentrate on the actual experiences of his couple within their landscape.

At least since Mark Twain's *Huckleberry Finn*, male couples on the road and on the run have been a part of our literature and cinema. *Easy Rider* (1969), *Scarecrow* (1973), *Two-Lane Blacktop* (1971), *Thunderbolt and Lightfoot* (1974), and *Midnight Run* (1988) are just a few of many films presenting male camaraderie on the highway. These films, like many road films, are especially close to the Western in derivation, trading in the horse for the car or truck, but employing the same basic Western, Southwestern, or Southern settings, and embodying many of the patterns and values of traditional Westerns with an important switch: as in the outlaw couple films, the male couple road films also favor the outsider, the outlaw, the disenchanted. It is worth noting that these films came out at the same time as the buddy Westerns such as *Butch Cassidy and the Sundance Kid* (1969) and *Pat Garrett and Billy the Kid* (1973).

What Jack Kerouac's *On the Road* was to many in the Fifties, *Easy Rider* was for many in the late Sixties. An imprecise film with a muddled effect, Dennis Hopper's film nevertheless made drugs and hard rock music an indelible fixture in the American road experience as presented on film. Peter Fonda as Captain America decked out in his red, white, and blue colors was meant, according to Fonda, to be a condemnation of a generation taking an easy ride on American freedom. But his line at the end—"We blew it"—is almost indecipherable, given Fonda's withdrawn and glazed-over performance.

Monte Hellman's *Two-Lane Blacktop* never lived up to the advance publicity it received, but it does stand out as a film that relentlessly focuses on the road with little time spent off of it. James Taylor and Dennis Wilson drift around the Southwest in a hot '55 Chevy making a living challenging small-town guys to drag races. Instead of the thrills and speed offered by the Fifties drag-racing films, Hellman's work turns out to be almost a silent movie: two drifters who prefer to speak through action rather than through words. And yet the action—the races and their travels—appear as an endless series of repetitions, an impression reinforced in the freeze-frame ending of yet another road race about to begin.

A chilling variation on the buddy road film was the unexpectedly popular *Henry: Portrait of a Serial Killer* (1987). John

McNaughton's taut narrative and ice-cold perspective leave a strong impression on audiences as Henry and his psychotic roommate wander the highways and byways and streets of America, murdering without reason and without emotion. *Henry* is as far from Walt Whitman's "Song of the Open Road" as one could possibly get. McNaughton shows the highway as one that can lead to unexpected violence and coldblooded death.

Finally, John Hughes's *Trains, Planes and Automobiles* (1986) turns the road film inside out with a suburban Yuppie twist. Instead of running away, Hughes's hapless males (John Candy and Steve Martin) are trying to get home to suburbia for Thanksgiving. Instead of outlaws, we have company men who find inconvenience and delay rather than freedom and thrills on the road.

At its purest, the road film focuses on a lone driver and his car. Films such as *Thunder Road* (1958), *The Last American Hero* (1971), and *Vanishing Point* (1971) all represent a peculiarly American myth and dilemma: the doomed wedding of a misplaced nineteenth-century romanticism with twentieth-century technology. The protagonists have grown up in traditional America, but they are restless to live out a romantic impulse towards "freedom" which isolates them from the law, from the society they knew, from any meaningful future, and even from themselves.

Thunder Road is a prototype. It stars Robert Mitchum as Luke in a story by Mitchum about a moonshine runner in the Southern mountains. Luke is a man caught between the mountain way of life he has known and the fast-moving city life, much in the *film noir* tradition, of danger and crime that he has come to know. As a loner-outlaw with an appreciation for his roots, Mitchum feels no shame, only confusion about his calling. Speaking of his ancestors, he says, "They just figured that whiskey makin' was one of the basic rights of free men. I don't remember anything dark or shameful. I just recollect the dog-wood and laurel."

As in a *film noir* or a Western, the isolated antihero of these road films cannot accept the security of a steady relationship and cannot resist the temptation of profane love. "I'm a whiskey man," says Mitchum as he leaves his hometown girl and his Memphis woman to make his final run, which will end in a fireball death as federal tax officials scatter oil and nails across his route.

The fireball ending of so many of these films becomes a troubling metaphor suggesting the conflict between individual impulses based on romantic and traditional values as they clash with those of an impersonal law. *Vanishing Point* fits the pessimistic mode of these films as Vietnam vet Kawalski (David Newman) races his snow-white Charger across the Western deserts in a West that has become a zany, sad, surrealistic nightmare. His demise is sudden and violent. In long shot we see his car go up in flames as it hits a California border roadblock. Death is certain, but the ambiguity remains: those in rebellion against a highly technological society depend on the technology of the automobile (cycle-vantruck) to live out their fantasies. The road film captures the tension and no-win, no-exit dilemma these characters face, without offering the transcendent compromises suggested by Robert Pirsig in *Zen and the Art of Motorcycle Maintenance..*

Families have also taken to the road in American films. John Ford's impressive rendering of John Steinbeck's *Grapes of Wrath* (1940) opens with a young Henry Fonda standing at a crossroads and ends with Jane Darwell as Ma speaking of the enduring power of "we the people" while what is left of the family continues its long trek down a highway crowded with other migrant families. Documentary, mythic, and personal drama blend as Ford gives visual immediacy to Steinbeck's epic of a nation on the road without a future, having lost their land and their past.

As in other road films, these disenfran-

chised individuals become both outcasts and outlaws as they struggle to survive and fight to save some semblance of family structure. Martin Scorsese's *Alice Doesn't Live Here Anymore* (1974) is representative of more contemporary films that show what happens to broken families—a mother and son in this case—when they take to the road. Despite its romantic ending (Alice meets wealthy and handsome Kris Kristofferson), Scorsese's film is less a genre film than a neorealistic slice of life on the road.

The bike film quickly became a subgenre of its own soon after Marlon Brando zoomed into a small California town with his cycle buddies and took over in *The Wild One* (1953). Bike films are more closely related to gang films, but, like other road films, they too reflect a concern for isolated characters in rebellion against the law and society. Peter Fonda, for instance, is branded in many people's memories as the laid back representative of the Sixties counterculture for his role in such bike films as *The Wild Angels* (1966) and *Easy Rider*.

Many of these films were made by companies such as American International Pictures and were seen as exploitation films made to capture a youth market. The Sixties saw many films of this type hit the screen and disappear quickly, including *The Wild Rebels* (1967), *Wild Wheels* (1969), *Angel Unchained* (1970), *The Angry Breed* (1968), *Black Angels* (1970), *The Cycle Savages* (1969), *Hell's Angels on Wheels* (1967), and *Naked Angels* (1969). The spirit of raw rebellion in such works contrasted with less angry bike films such as Elvis in *Roustabout* (1964) and Robert Redford in *Little Fauss and Big Halsy* (1970).

It was, of course, inevitable that Hollywood would pick up on the popularity of truckers and their colorful CB radio lingo. Compared to the hot car films previously mentioned, trucker films as a subgenre have tended to emphasize humor and good spirits. Isolation is overcome by

CB communication and teamwork among truckers in pursuit of a common goal which replaces the mere restless wandering of the earlier films. *Citizen Band* (aka *Handle With Care*, 1977), *White Line Fever* (1975), and Sam Peckinpah's *Convoy* (1978) are worthy examples of this phenomenon.

Comedy and the American highway have traveled together since Mack Sennett realized how funny a car chase scene could be. But it was a large leap from the slapstick of the Keystone Kops to the pathos of Chaplin's Tramp wandering alone down a winding highway.

The comic road film took on new life in the Seventies as stunt driver-turned-director Hal Needham and actor Burt Reynolds teamed to make two of the highest grossing films in Hollywood at that time, *Smokey and the Bandit I* and *II* (1978, 1980). Unlike the pessimistic road films of the late Sixties and early Seventies, Burt Reynolds's films emerged as carefree good ol' boy movies about a guy who swigs Coors beer, grabs his love on the run, and takes life as it comes. He is, like his predecessors, an outlaw and an outsider, but he is not counterculture, and the law he offends is defended by the ineffectual likes of Jackie Gleason.

Smokey and the Bandit I and *II* also represent what happens to a genre when it begins to enter its mannerist period: works of parody and comedy of mixed modes appear. The Reynolds films combine the hot car genre with the trucker CB film, thus assuring a broader box office appeal to the comedy.

But parody tends towards excess and, with Reynolds's predictable performance in *Cannonball Run* (1981), the road film degenerates into strained farce. Finally, John Schlesinger's *Honky Tonk Freeway* (1981) carries the road film to its furthest limits. Much of the freshness of earlier models came from the fact that they were low-budget films in the Roger Corman mold that could afford to experiment and include scenes that larger budgeted films

would shy away from. But as a $32 million film, *Honky Tonk Freeway* overkills its theme that in America today *everybody* is on the road. Schlesinger strains for significance in a film that resembles Altman's *Nashville* put on wheels and sent roaring down the highway towards a small Florida town where a diverse cast of characters finally wash up.

The road film is inextricably linked with America's love of the automobile and the promise of change, thrills, speed, and freedom that it offers. As long as there are cars, vans, trucks, and bikes, the road film will be a part of American cinema. From Chaplin's lone Tramp to Thelma and Louise sailing defiantly off the canyon cliff in their car towards their inescapable death, the cinema continues to reflect the restless spirit of a nation founded by travelers who have not yet settled down. As *Thelma & Louise* suggests—in its breathtaking cinematography of the American landscape, in its witty dialog between two women who are "fed up," and in its refusal to give in to contrived "feel good" resolutions—the road film is now poised to offer further reflections on the American experience, but now through women's eyes as well as men's.—Andrew Horton

Robeson, Paul

(April 9, 1898 – January 23, 1976)

P aul Robeson's work in cinema was always secondary to his work as a concert singer and even as a theater actor. His entire film involvement, not always in leading roles, totals only a dozen motion pictures, many of them marginal productions. Nevertheless, his work greatly broadened the cinematic boundaries for black Americans and was integral to his overall achievement as a socially engaged artist.

Commitment to social activism was a Robeson family tradition. After earning athletic and academic laurels at Rutgers, Robeson enrolled in the Columbia Law School with the goal of using the law to advance the civil rights of black Americans. Although he was to graduate with honors in 1923, Robeson never followed a legal career, for he had already begun to explore the artistic and political opportunities offered by acting. In 1922 he starred in the Harlem YMCA revival of *Simon the Cyrenian*, a play focused on the spiritual growth of an African rebel who speaks with Jesus on the day of the crucifixion.

Later that same year, Robeson appeared in the Y's production of *Taboo* (which soon traveled to England under the title *Vodoo*), a drama set on a Southern plantation with dream sequences involving Africa. Robeson's acting in the YMCA sponsored plays brought him to the attention of Eugene O'Neill who immediately cast him in a New York-London revival of *The Emperor Jones* and as the lead in the original production of *All God's Chillun Got Wings*, in which Robeson is a lawyer married to a white woman.

Robeson's initial film was made during this same period. The vehicle was *Body*

and Soul (1924), a silent film by the legendary Oscar Micheaux, who made feature films for black audiences. Unlike most of his counterparts, Micheaux expressed an unusual degree of racial consciousness and often dealt with controversial topics. In *Body and Soul*, Robeson was a sometimes virtuous, sometimes contemptible minister. Micheaux usually cannibalized his own work, using parts of old films in new projects; but *Body and Soul* is one of the few Micheaux films relatively intact. As such it has become an important title in the history of independent black filmmaking, but for Robeson the film was a cinematic dead end that did not lead to his entry into the commercial industry. Robeson would not make another film until the Thirties when he was already famous as a concert artist.

The singing career that would make him world famous had begun in Greenwich Village in 1925 with a program of black spirituals. Even at this early date, Robeson's goal was to link the music of black America to its African roots and then to show the formal similiarities between African music and the music of Europe and China. To this end, he learned to sing in a score of languages and performed on every continent. His first popular success was in *Show Boat* (1928). The show's most memorable song, "Ol' Man River," was written by Jerome Kern and Oscar Hammerstein with Robeson in mind. The musical's success, first in New York and then in London, made Robeson a theatrical celebrity on both sides of the Atlantic.

The trips to London to perform in *Vodoo, The Emperor Jones*, and *Show Boat* had convinced Robeson that, although far from ideal, Great Britain's racial climate was healthier than America's. He became an expatriate and did not again resume residence in the United States until 1938. His acting was so well-received in London that he was asked to star in *Othello*, becoming the first black to play the Moor on the English stage since Ira Aldrige in the 1860s. Robeson would revive the role

on Broadway in 1943 and at Stratford-on-Avon in 1959. His preparation for the role included a thorough study of Shakespearian intonations so that his performances had linguistic as well as racial authenticity.

Borderline (1930), Robeson's first talking picture, was released the same year he first played Othello. The film had been shot in Switzerland by Kenneth McPherson, a figure in the cinematic avant-garde. The interest for Robeson was that the film's plot revolved around the interaction of a white couple and a black couple who meet in the Swiss Alps. Robeson sang in the film and enjoyed playing opposite his wife Essie. Critics noted that one of the film's innovations was to project the black and white couples as equals, but most interest in the film concerned its formal qualities. *Borderline* had limited exposure to the general public.

Robeson's first popular film was the United Artists release of *The Emperor Jones* (1933). O'Neill had been writing a screen version of his play since the advent of talkies, and he had vowed not to sell screen rights if Robeson were not guaranteed the lead. As it was, O'Neill did not write the film version, but he did approve the shooting script and helped secure the star role for Robeson. The film had an unusual release pattern in New York City, opening downtown to mainly white audiences at the Rivoli and uptown to mainly black audiences at the Roosevelt. The downtown response was lukewarm, but in Harlem more than 200,000 tickets were sold, with many shows having standing room only. Robeson had become a superstar in the black community. Even if Brutus Jones was no racial role model, black audiences appreciated Robeson's creation of a complex human being. The urban audience could easily identify with a character transformed from country bumpkin to city slicker. Jones's corruption when he became dictator of a Caribbean island was as understandable to them as his earlier rebellion when victimized on a chain gang.

One racially charged sequence shot for the film was ultimately deemed too controversial to be included in the final cut. In this scene, Jones defies and then kills a white guard who tries to force him to beat a black inmate who has been caught trying to escape. Even in a class-conscious Depression America, the image of an oppressed black prisoner killing a sadistic white guard was beyond the limits of liberalism. What was remarkable was that the producers ever considered the scenario a possibility.

Shortly after the release of *The Emperor Jones*, Robeson accepted an offer by Alexander Korda to play an African in *Sanders of the River* (1933). Robeson already had developed personal friendships with students Jomo Kenyatta and Kwame Nkrumah, men destined to lead postwar African liberation movements. He hoped to upgrade the usual negative image of Africans, but the final cut of *Sanders* rendered his portrayal as the typical stereotype. Robeson was so disillusioned that he turned down subsequent film offers by Korda and vowed to gain greater script control on future projects.

Three subsequent Robeson films also dealt with Africa—*Song of Freedom* (1936), *King Solomon's Mines* (1937), and *Jericho* (1937). The most conventional but most widely seen of the trio was *King Solomon's Mines*. Among the film's fringe benefits for Robeson was that he obtained changes in the script that enhanced the stature of his character and that, while on location, he arranged for tutoring in the Efik language. He found that the inflection and rhythm of Efik and Chinese were related, strengthening his conviction that music was a form of universal communication.

Song of Freedom had a plot that presaged the *Roots* phenomenon of the Seventies. Robeson played Zinga, a London dockworker whose bass voice wins him the patronage of a concert impresario. As Zinga becomes a famous singer and comes into contact with highly educated admirers, he learns that a medallion passed on in his family identifies him as African royalty. Feeling that Africa is his true homeland, Zinga abandons Europe to return to his native soil. His ambition is to bring Western technology to his people in a form that will not destroy indigenous culture.

Jericho (also shown as *Dark Sands*) has a similar theme. In this instance, an American student named Jericho is on board a troop ship hit by U-boats during World War I. In a scene recalling the omitted footage in *The Emperor Jones*, Jericho defies and then accidentally kills a white officer who orders him to abandon men below the decks of the sinking ship. Jericho saves the men but can avoid court martial only by fleeing in a small boat. He is stranded on the shores of North Africa where he is found by a tribe of Tuareg. His Western skills soon catapult Jericho to a leadership role of the kind Zinga envisioned. Through force of arms, Jericho is able to unite various tribes in a pan-Saharan unity that saves them from economic and political ruin. The film's original script called for a contrite Jericho to return to the U.S. for trial, but Robeson wrought changes that left Jericho as a successful North African leader.

Another aspect of Robeson's political sensibility can be seen in his only major Hollywood venture, *Show Boat* (1935). His key scene is a wharfside rendition of "Ol' Man River," accompanied by stark sequences of black workers bent under heavy work loads in situations illustrating social injustice. Powerful as these images were, particularly for Hollywood, the song's message was one of perpetual suffering and endurance. Through the years Robeson was to alter the lyrics to remake the song into a cry of rebellion. For "Get a little drunk and ya lands in jail," he would substitute, "You show a little grit an' you lands in jail," and rather than ending with, "I'm tired of livin' and scared of dyin'," he would thunder, "I must keep fightin' until I'm dyin'." *Show Boat* provided the basis from which these and other militant depar-

tures evolved.

Show Boat was noteworthy in other ways. Although a musical with a heavily melodramatic plot, major themes dealt with the issues of black and white identity, racial intermarriage, and racially biased laws, with the film's sympathy entirely against racism. Several shots isolate Robeson's face to reveal that his character's apparent laziness is actually a conscious withdrawal of efficiency and that his surface good humor is a mask for profound rage.

Robeson did not again venture to Hollywood until 1942 when he undertook *Tales of Manhattan*, primarily because of its all-star cast which included Ginger Rogers, Henry Fonda, Cesar Romero, Rita Hayworth, Edward G. Robinson, Charles Laughton, and Ethel Waters. While consoled that the film exposed conditions in the American South to some degree, Robeson was disappointed that its major black storyline had childlike adults singing their way to spiritual redemption but not financial profit or social justice.

Robeson was far more satisfied with two films completed in prewar Britain, *Big Fella* (1938) and *Proud Valley* (1939). *Big Fella*, based on Claude McKay's *Banjo*, again has Robeson as a docker. This time he is as involved in class problems as he is in racial issues. Class problems are projected even more militantly in *Proud Valley* where Robeson's itinerant worker is adopted by a Welsh miners' chorus. The core of the film depicts the struggle of miners against coal operators, but in the wake of Nazi aggression in Europe, the film's conclusion was tailored to emphasize the needs of a united democratic nation, a change which sapped the film's vitality. The same kind of change marred the American-made *Native Land* (1941), which featured Robeson in a voice-over narration.

During the war years, Robeson's life was increasingly dominated by political concerns. Even though he was never a member of the Communist Party, Robeson was a man of the left. He made his first of

many visits to the Soviet Union in 1934, sang to the Spanish Loyalist forces in 1938, and planned to make a film with Sergei Eisenstein on the life of Haitian revolutionary Toussaint L'Ouverture. With the defeat of fascism, Robeson boldy declared the time had come for the end of colonialism in Africa and the end of Jim Crow in America. He insisted that friendship with the U.S.S.R. was necessary, possible, and desirable. If blacks were to fight for freedom anywhere, he thought they should begin at home by fighting for their full rights as citizens. Infuriated by Robeson's public statements and his involvement in radical movements such as the Progressive Party, conservative politicians had Robeson called before committees investigating internal subversion. Some of his concert appearances were disrupted by violent demonstrations and many others were simply canceled. The Establishment press turned against him, the U.S. State Department revoked his passport, a blacklist came into being, and the most famous black man in America quickly became a virtual nonperson. Robeson was forced to expend all his energies in legal and political struggles to secure his right to travel and to regain access to the public. An eight-year effort to regain his passport succeeded in 1958. Robeson immediately embarked on a worldwide tour during which he was tumultuously greeted in country after country, but his revived career was soon cut short by severe illness. From the early Sixties until his death in 1976, Robeson was to be a kind of living legend. His rare public appearances generated incredible excitement but at the same time he was not physically able to participate in the civil rights movement he had done so much to spawn.

Like many maverick film careers, Robeson's became more influential with the passage of time. However limited the immediate impact of the films, they came to be seen as exemplary works by subsequent filmmakers, intellectuals, historians, and political activists. *Song of Freedom* was

uniquely honored in 1950 when it opened Ghana's annual independence celebration. During his years of internal exile, individuals who would soon make a mark in the film industry came to him for personal counsel, the most notable being Harry Belafonte and Sidney Poitier. As the Sixties got into high gear, militants spoke often of the man who had chosen to star in foreign and independent films rather than accept cameo casting in Hollywood fluff. Robeson was seen to be a great forerunner in the attack now leveled at the Tarzan and Stepin Fetchit mentality of American mass media. Three documentaries reintroduced his work to a new mass audience. These films used lengthy clips from his feature films, footage of his stage work, and interviews in which he elaborated his views of music and politics. A year before his death, Robeson was asked if he wanted to retract any of his political positions or if he felt politics had been a burden. His response can stand as an esthetic epitaph: "I went where I wanted to go. I said what I wanted to say."—Dan Georgakas

RECOMMENDED BIBLIOGRAPHY

Davis, Lenwood G. *A Paul Robeson Research Guide*. Westport, CT: Greenwood Press, 1982.

Duberman, Martin B. *Paul Robeson*. NY: Ballantine Books, 1990.

Foner, Philip S., ed. *Paul Robeson Speaks: Writings, Speeches, Interviews, 1918–1974*. Larchmont, NY: Brunner Mazel, 1978.

Robeson, Paul. *Here I Stand*. Boston, MA: Beacon Press, 1988.

Robeson, Susan. *The Whole World in His Hands: A Pictorial Biography of Paul Robeson*. Secaucus, NJ: Citadel Press, 1981.

Sayles, John Thomas

(September 28, 1950 –)

J ohn Sayles is a wide-ranging talent who writes sprawling, vivid political novels (*Union Dues* and, most recently, *Los Gusanos*, about Miami's Cuban exile community), creates television shows (*Shannon*), directs Bruce Springsteen music videos, writes screenplays for Roger Corman B-movies (*Piranha*), has received a MacArthur "genius" grant, and makes low-budget, independent films.

Like John Cassavetes, Sayles's ability to work outside the studio system and Hollywood genre conventions has provided a model for other American independent filmmakers whose works are now regularly finding their way into movie theaters.

Sayles's films usually center around communities—the Sixties radicals of his first film, *Return of the Secaucus 7* (1980); the Harlem bar denizens of *The Brother from Another Planet* (1984); the miners in *Matewan* (1987); and the ballplayers in *Eight Men Out* (1988). And from *Secaucus 7* on, most of his films are informed with a clear political and social perspective—the vision of a genuinely political man who tries to avoid reducing and personalizing political conflict into a struggle between good and evil people. Inherent in Sayles's

films is a keen awareness of both the abuses of American society and history, and the role that class, ethnicity, gender, and race play in determining them. Sayles's point of view is usually neither sectarian nor schematic, rarely shaping his films in accord with pat political formulas. At their best, his films are dominated by a consciousness of the complexity and ambiguity of the process necessary to achieve some semblance of social justice.

In his first film, *The Return of the Secacus 7*, a low-budget work (made for about $40,000), a group of Sixties activists get together for a reunion in the late Seventies. The group fit no Sixties stereotype—they were neither hard-line left ideologues nor hippies. In Sayles's words, "They were the people who went to the marches, not those who planned them"—strongly committed, issue-oriented activists (VISTA rather than Progressive Labor or Weatherman) who also liked to hang out and smoke grass. By the time of the reunion, most have accommodated to Seventies reality—they have become teachers, doctors, folk singers, and speechwriters for liberal Washington politicians—but the political culture of the Sixties still maintains a powerful hold on their lives.

Sayles's first film had little camera movement, needed a great deal more editing, and was generally very raw on a technical level. Still, it was a fresh, authentic, and open-ended film made by a director who understood the Sixties from the inside. Sayles captured the period's consciousness, language, and humor without either being reverential or indulging in parody, always lacing the memories with a touch of irony. *Secaucus 7* also displayed Sayles's most striking gift as a writer and director, his wondrously attuned ear and observant eye for the way a wide range of people speak and behave, augmenting his central characters with pointed depictions of a "straight" liberal visitor and two working-class townies.

In his second film, *Lianna* (1983),

Sayles's visual style remained functional and uninspired. But his narrative—involving a tentative, insecure housewife and mother who comes to terms with her lesbianism, leaving her cynical academic husband and children for another woman—aroused some controversy. At the London Film Festival it elicited a hostile response simply based on the prescriptive notion that men shouldn't write about women, let alone gay women. The film, however, did attract large gay audiences in the United States. It also demonstrated Sayles's willingness to explore, in an unsensational manner, subjects that mainstream Hollywood usually avoids.

In the same year, Sayles directed *Baby, It's You,* his first venture for a major studio, and a film on which he did not have final cut. The film centers around the relationship of a popular, upper middle-class Jewish girl, Jill (Rosanna Arquette), and a sharp-dressing, working-class boy, Sheik (Vincent Spano), who is obsessed with Frank Sinatra. Once they leave high school, their relationship breaks down— Jill strenuously struggling at Sarah Lawrence to become hip, and Sheik in Florida on the way to nowhere. The central characters of *Baby, It's You* are much less interesting than Sayles's ability to use them to illuminate how social class and class culture work to separate people—a seemingly self-evident truth, but a social reality that American cinema has usually dealt with either by ignoring class differences altogether or reducing them to superficial differences of diction and manner.

The Brother From Another Planet is an episodic, wry, and ironic fable about a black extraterrestrial slave (Joe Morton) who escapes his planet and ends up in Harlem pursued by two white bounty hunters. This sweet, mute, web-footed alien is first greeted in Harlem more with bewildered hostility than with casual amiability. Along the way, Sayles deftly captures aspects of Harlem's ethos without indulging in stereotyping. He's especially

good at evoking the range of conversational styles of a group of Harlem bar patrons, especially of two frightened, white Midwesterners who get off at the wrong subway stop and end up drinking beer and comically straining to make small talk with the black people at the bar.

Matewan, dealing with a coal miners' strike in West Virginia in 1920, and *Eight Men Out*, based on the 1919 Chicago White Sox baseball scandal, were two films Sayles long wanted to make, but whose productions were stalled because they were commercially risky. *Matewan*'s protagonist is an ex-Wobbly union organizer, Joe Kenehan (Chris Cooper), who is sent to the mining town to coordinate the efforts of striking miners. Joe is a pacifist who is able to prevent violence between the strikers and the black and immigrant workers hired to replace them. He is less successful, however, in convincing the miners not to retaliate against the company's armed guards and strike breakers— violence which culminates in the "Matewan massacre."

Matewan's *mise-en-scène* is richer and more conscious of light and landscape than any other of Sayles's works—probably the result of Academy Award-winning cinematographer Haskell Wexler's work on the film. And Sayles has made a film profoundly sympathetic to collective action and community feeling which, in the main, avoids transforming the miners into members of a heroic working class.

Eight Men Out was a less successful work—both critically and commercially— the public preferring their baseball and Black Sox to exist more in the realm of *Field of Dreams*-like fantasy than in a plodding treatment of baseball as an exploitative business. Sayles's players are victims, dim provincials who are divided between their love of the game and their hatred of the team's miserly owner. But the film neither provides a textured, realistic evocation of the baseball milieu, nor does Sayles attempt to stylistically turn the scandal into myth. It's an intelligent but uninspired

work.

One of Sayles's boldest films was the recent *City of Hope* (1991), an ambitious and flawed (too many soap operatic and melodramatic elements) work which sets out to create an urban mosaic out of life in a decaying, changing New Jersey industrial city dominated by dark, desolate alleys and seedy neon-lit streets. It's also a city where the aging, weakening, and totally corrupt white power structure is under attack from a growing black and Hispanic population who want their share of political representation and power.

City of Hope follows, often with a rapidly moving hand-held camera, the intricate, overlapping paths of three dozen of the city's inhabitants, including white working-class cops and housewives, druggy rock musicians, middle-class professors, a homeless man, and a number of thoroughly cynical ethnic politicians. The black characters range from street kids and self-styled community leaders to an honest, ethical, ex-professor/councilman, Wynn (Joe Morton), who must compromise some of his ideals to become politically effective.

Sayles has made a pulsatingly energetic film which captures the visceral edginess and babel of diverse voices of his fictional city. He also perceptively portrays how urban institutions—like a corrupt political machine and its police department—function, without ever shearing them of their social complexity. Some of the city's police are sleazy, contemptuous, and racist, but others are sympathetic and thoroughly professional while working at an extremely difficult job. And while depicting the black community's grievances about their city government's neglect and malignancy as totally justified, Sayles can evenhandedly portray black activists as demagogically distorting events to create community rallying issues, and black street kids behaving in an insidious and destructive manner.

City of Hope is a politically subtle and sophisticated film, although it has little of

the visual imagination of Spike Lee's portrait of an inner-city block in *Do the Right Thing*. Sayles, as always, is more interested in focusing on his characters talking and relating than in shaping a vivid and socially revelatory urbanscape. It remains, however, one of the most trenchant films about America's contemporary urban problems and tensions.

Sayles's latest film, *Passion Fish* (1992) is a well-meaning but dramatically flat work. It centers around the wary, predictable relationship of two women—a self-pitying paraplegic and ex-soap opera star, May-Alice (Mary McDonnell), and her sharp-tongued nurse, Chantelle (Alfre Woodard), who has just gotten out of detox. Sayles constructs entertaining riffs about soap operas and acting, and there are idiosyncratic and nicely-observed secondary characters, but the central relationship never carries any emotional resonance.

Though John Sayles is no Ingmar Bergman when it comes to portraying human relationships, he has produced a uniformly intelligent body of work which directly and honestly confronts social issues and realities that mainstream Hollywood has either evaded or adulterated.—Leonard Quart

RECOMMENDED BIBLIOGRAPHY

Sayles, John. *The Anarchists' Convention and Other Stories.* NY: Pocket Books, 1980.

——— *Thinking in Pictures: The Making of the Movie* Matewan. Boston, MA: Houghton Mifflin Company, 1987.

· ·

Schrader, Paul

(July 22, 1946 –)

I n *Hardcore*, the gospel according to Paul Schrader is read chapter and verse by the transported Calvinist "pilgrim" Jake Van Dorn (George C. Scott). Using the acronym TULIP, he explains the cold doctrine of the Dutch Reformation Church to his tour guide through hell, "Venusian" porn actress Niki (Season Hubley).

Van Dorn recites his catechism by the letters—the total depravity of man, unconditional election, limited atonement, irresistible grace, and the preservation of the saints—and affirms his belief in an omniscient, angry God who knows in advance the names of the saved and the damned. "Wow, then, it's all worked out, it's fixed," says a flummoxed Niki. "I'll admit it's a little confusing when you look at it from the outside," Van Dorn patiently allows. "You have to try and look at it from the inside." To which the streetwise Magdalene replies, "If you look at *anything* from the inside it makes sense. I mean, you should hear perverts talk. A guy once almost had me convinced to let his German shepherd screw me."

Getting screwed, both cosmically and in the more prosaic sense, is Schrader's recurrent concern. Throughout his own pilgrim's progress, from critic and scholar—*Transcendental Style in Film: Ozu, Bresson, Dryer*—to white-hot Hollywood screenwriter—*The Yakuza* (1975), *Taxi Driver* (1976), *Obsession* (1976), *Rolling*

Thunder (1976), and *Raging Bull* (1980)—
to writer-director-auteur—*Blue Collar*
(1978), *Hardcore* (1978), *American Gigolo*
(1980), *Cat People* (1982), *Mishima* (1985),
Light of Day (1987), *Patty Hearst* (1988),
and *The Comfort of Strangers* (1991)—
Schrader has wrestled with the sacred and
the profane. Drawn to and repulsed by the
seamy backside of urban alleys and
urbane styles, he is an existentialist with a
Calvinist conscience. No other director
has more convincingly combined a full-
blown assault on the moral vacuum in con-
temporary America with an unblinking
exposure of full-frontal nudity. He walks a
line between prurience and puritanism, an
apostate who still yearns for the apoca-
lypse.

Hardcore nakedly exposed Schrader's
private demons. In an urgent errand into
the wilderness, a Midwest businessman
journeys to the California mean streets in
search of his missing daughter spotted in
an 8mm porn film. Embedded in the deep
structures of American mythology (Indian
captivity narratives, the fiery sermons of
the first Great Awakening, the violent
redeemer of the frontier, John Ford's *The
Searchers*) and foregrounded against the
modern wasteland of what was once a vir-
gin land, Van Dorn—framed unforgettably
before a huge billboard advertising *Hustler*
magazine ("Think Pink")—assumes a
heroic stature. He is truly a pilgrim wan-
dering in a desert of temptation, playing in
a cosmic drama where every detail is
invested with spiritual meaning. As he
walks the streets of L.A., through massage
parlors and brothels, peep shows, and
porn sets, he sees the Puritan dream of a
City on a Hill has become a Sodom in the
sun. Disgusted, he is also amazed and
somehow reassured by the visible witch-
craft sprung up from—where else?—hell
itself. Of course, like Lott's wife, Schrader
can't resist getting—and giving us—an
eyeful, but (remarkably) the film's verbal
and visual explicitness never titillates. Just
as the matter-of-fact obscenity dulls the
power of the word, the camera's clinical

gaze desexualizes the skin shots. First per-
son p.o.v. shots down purple hallways and
into private rooms notwithstanding,
Hardcore is about spirit, not flesh.

In 1981 James Monaco approvingly pre-
dicted that "Paul Scrader with the help of
his brother Leonard is in the process of
graduating from religion to politics." For
the committed theologian, however, any
transfer of allegiance can be only a demo-
tion. Schrader's apocalyptic vision is decid-
edly one of divine intervention, not politi-
cal action. In settings and scenarios
charged with polemical potential—the
assembly lines of *Blue Collar* and *Light of
Day*, the returned Vietnam veterans of
Rolling Thunder and *Taxi Driver*—the
Marxist decor remains purely incidental.
Steeped in the same Calvinist background
as Van Dorn but seduced by the graven
images of the cinema (Schrader reportedly
did not see a movie until he left home),
this leopard is unlikely to change his
spots: even *Cat People* is about moral
regeneration as much as physical transfor-
mation, about caging up the passions
unleashed by the flesh.

Along the road to a Damascus experi-
ence, Schrader has been uncompromising.
In his directorial debut, *Blue Collar*, he
refused to romanticize the working class,
the labor movement, or American blacks,
or to provide reassurance that fidelity to
the commandments has an earthbound
reward. Likewise, the dark *Light of Day*
was impossible to market despite a press-
book's worth of exploitable hooks—a
Bruce Springsteen title tune, a bankable
teen idol lead, a rock 'n' roll heart. But the
celebratory trajectory of the backstage
musical was deflected by a family whose
troubles hit a little too close to home, a bar
band whose realistic future was a little too
grim. Brilliantly playing off the warm sit-
com persona of Michael J. Fox as the
Good Son and the runaway delinquency of
rocker Joan Jett as the Bad Daughter,
Schrader constructed a hurt but holy
nuclear unit with a fundamentalist matri-
arch of unshakable faith (Gena Rowlands)

at ground zero. Though the resentful daughter waits "til the last minute to deliver the unkindest cut, Mom defeats her with a devastating, deathbed blast of Christian foregiveness. As for the dueling siblings, only in the exhilaration of rock 'n' roll can Jett's anger and Fox's hopes come together.

American Gigolo illustrated the twisted consequences of working in a twentieth-century form with a seventeeth-century outline. A fortuitous mass market misreading made it Schrader's most successful box office film and a touchstone for *fin-de-*Seventies excess. Tooling down the freeway to Blondie's buoyant corporate rock, matching Armani shirts and ties to the music of Smokey Robinson, Julian Kaye (Richard Gere) came to epitomize style in an era which mirrored his own vacuous narcissism. If in *Hardcore* the gaze ultimately rejected the pleasures of porn, in *American Gigolo* the camera lovingly caressed the name-brand vanities of the compleat consumer—gravity boots, sports cars, the best cuisine, and the latest in Euro-trash. And to many Americans, a life of chicly empty materialism seemed just fine, thank you. Maybe Schrader gauged his audience all too well. After all, a Puritan culture can resist sexual enticements, but it's helpless before material comfort.

Conversely and perversely, Patty Hearst, herself wrenched helplessly from material comforts, is positively transformed by deprivation and isolation. Trapped in a closet, her tormenters' dark outlines hovering over her, the California girl comes face to face with the serpent in the garden. "Like sin?," asks Patty when Cinque, the Grand Inquisitor from the Symbionese Liberation Army, identifies himself. In Schrader's moody and modulated retelling of Seventies-style revolution-mongering, a pitch-black cell, torture by degrees, and trial by fire becomes a crucible for a martyr without a cause. During the climatic eye-to-eye close-up, Nastasha Richardson's blank stare and flat tones

finally ignite with passion and knowledge. Having already suffered through her dark nights in the Weather Underground, the designated scapegoat for the intergenerational warfare of the Sixties refuses to be nailed to the cross. The vapid British couple in *The Comfort of Strangers* is less fortunate— suffering nothing but boredom and learning nothing at all, they are preemptorily sentenced to a death in Venice.

Ironically, this man of the West seems to have found some peace and solace by turning to the East, substituting for the Westerns of John Ford the austere domestic melodramas of Yasujiro Ozu, and for the strict acronyms of John Calvin the ineffable transcendence (or is it transcendent ineffability?) of the Zen koan. In Schrader the twain occasionally meet. A scene cut from the stateside release of *The Yakuza* replays the exchange in *Hardcore*: the assimilated ex-GI Robert Mitchum explains the Japanese concept of honor to the amoral young hood Richard Jordon, another system that makes no sense from the outside. Unlike the whore Niki, the hood has a chance into buy into the honor system and give his life—and death— meaning. Eastern philosophy, apparently, offers a way out of the inside-outside box of Western duality. No wonder Schrader was attracted to the esthetics of Yukio Mishima and his own search for "a harmony of pen and sword." Aided mightily by a score from Philip Glass, *Mishima* is an extraordinary work, an inspired meditation on the Zen qualities of emptiness, silence, and stillness. No bio-pic, the "life in four chapters" takes as its operating principle Schrader's comment on Ozu: "Ritual in Oriental art is not structured around a cathartic event (like the blinding of Oedipus, for instance), but is cyclic, with little rise and fall, revealing the timeless Oneness of war and nature." Though the chapters wind together in the final reel, Mishima's notorious *seppuku* is less a climax than a final unity of esthetics and action—for Mishima and *Mishima*. Like a rock garden, the placement is perfect even

when the contents are crackpot.

Back in the West, though, the ritual of the violent redeemer can end only in cathartic violence, not cyclical unity. In this intimation, Schrader found natural soulmates in two Italian Catholics, Martin Scorsese and Robert De Niro, with whom he designed the most explosive characters in postclassical Hollywood cinema, Travis Bickle and Jake La Motta. That the former was a paranoid assassin and the latter a raging brute is not reassuring. In *Taxi Driver*, the violent redeemer rides again through the sewage and hellish fog of the city streets, offering this time an affectionless narration whose signature lines seeped into all kinds of dark imaginations, in punk rock albums, in the mind of an all-too-real punk assassin. "Someday a real rain will come and wash all the scum from the street," predicts Travis—and if it doesn't, this weatherman might just help pour it on.

Like Travis, Schrader sometimes seems as if he wants to shoot his way out of the grime of earth. But under the weight of an angry God, neither style nor vision can ever be truly transcendent. For the Calvinist, to presume moral and esthetic perfection is to mock the Holy Spirit, an unpardonable sin. From inside the TULIP, as Van Dorn puts it, all our works are as filthy rags in the sight of the Lord.

—Tom Doherty

RECOMMENDED BIBLIOGRAPHY

Jackson, Kevin, ed. *Schrader on Schrader.* Boston, MA: Faber and Faber, 1990.

Schrader, Paul. *Transcendental Style in Film: Ozu, Bresson, Dreyer.* Berkeley, CA: University of California Press, 1972.

Schulberg, Budd

(March 27, 1914 –)

Scion of one of the first movie moguls, B. P. Schulberg, and raised in Hollywood during the peak of the silent era, Budd Schulberg, Jr. has had a lifelong involvement with motion picture production. His writing has included novels about filmmakers, film scripts, novels made into films, and Hollywood memoirs.

Woven into all of Schulberg's work, whether directly about film or not, has been a passion for social change which has drawn him into fierce political controversies.

Schulberg's first work on Hollywood scripts dates from the mid-Thirties, right after he graduated from college. Laboring in the assembly-line conditions then prevailing at the studios, the fledgling author received dialog, story, or screenplay credits for five films released between 1937 and 1941. The most important of these was working on the story and screenplay for *Winter Carnival* (1939). Although the film was a lightweight college romance, Schulberg's original cowriter on the film was F. Scott Fitzgerald, who was then struggling to rehabilitate his writing career and life. The two men traveled to Dartmouth, which was to be the setting for the film, but Fitzgerald's alcoholism and instability transformed the transcontinental junket and the days at the college's

snow carnival into a public scandal. Schulberg would write movingly of these misadventures in *The Disenchanted* (1951), a novel which portrayed the dying Fitzgerald as a supremely gifted but tragic personality.

Schulberg's connection with Fitzgerald led to a lifelong fascination with the plight of writers who have had enormous early success followed by commercial and critical neglect. In *The Four Seasons of Success* (1972) he dealt with this kind of situation by discussing his personal relationships with six such writers—William Saroyan, John Steinbeck, Nathanael West, Sinclair Lewis, F. Scott Fitzgerald, and Thomas Heggen. The essay on Saroyan, which deals with Saroyan's brief career as a Hollywood scriptwriter, contains some of Schulberg's most humorous writing and offers important insights into Saroyan's character.

During the period Schulberg was earning his first screen credits and mixing with Hollywood-based writers, he joined the Communist Party. He was attracted by the party's mobilizations against fascism and by its leading role in the creation of the Screen Writers Guild. His membership proved to be short-lived with the major point of alienation being artistic freedom. The party considered most of Schulberg's writing too individualistic and was especially critical of the outline of his first novel. Schulberg left the party and Hollywood in 1939 to go to Vermont where he wrote what became the best-selling *What Makes Sammy Run?* (1941). The central storyline of the novel is the Hollywood rise to power of the manipulative and amoral Sammy Glick. Figuring prominently in the chronicle is the bitter struggle to establish the Screen Writers Guild.

Publication of *What Makes Sammy Run?* was to earn Schulberg calumny from both supporters and opponents of the guild. Industry conservatives felt his exposure of the Hollywood infighting was extremely harmful to their public image. Many a conservative producer's door

became permanently closed to any script carrying the Schulberg name. The Communist Party, on the other hand, considered the book insufficiently laudatory of those who had built the guild, and the book was subsequently denounced in *The Daily Worker*. One consequence of this response was that Schulberg became a cofounder with Arthur Koestler of The Fund for Intellectual Freedom, an organization whose aim was to rally support for writers persecuted because they did not follow the official line of their government.

Following the success of his first novel, Schulberg became involved in the world of prize fighting and at various times held shares in different boxers. His sympathy for exploited fighters led to the writing of *The Harder They Fall* (1947), a tough-minded novel of underworld fight impresarios, fixed bouts, and abused athletes. The novel was purchased by Columbia Pictures and became a successful 1956 vehicle for Humphrey Bogart who played a disillusioned sports columnist who becomes enmeshed in corruption. Schulberg wrote the screen adaptation of the novel but did not work on the actual script. His continuing interest in boxing led to several retired fighters appearing as actors in *On the Waterfront* and a 1972 book on Heavyweight Champion Muhammad Ali.

When the House Committee on Un-American Activities (HUAC) turned its attention to Hollywood at the end of the Forties, Schulberg chose to be a cooperative witness. He defended his decision as being totally consistent with his political life for nearly a decade. Neither his former membership in the Communist Party nor his criticism of the party had been a secret. Opponents of HUAC were not impressed. They argued that, whatever one's political differences with the Communist Party, cooperation with HUAC was debasing and unethical, striking at the various rights of freedom of speech and association that Schulberg had always supported.

Emotions generated by the HUAC investigations were still relatively strong

On the Waterfront

when Schulberg scored his greatest film success with the story and screenplay for *On the Waterfront* (1954). Various critics then and later charged that the emphasis on testifying before a federal crime commission, an act which is central to the moral development of Terry Malloy in *On the Waterfront*, is a thinly disguised attempt by Schulberg and director Elia Kazan (another "friendly" HUAC witness) to justify their response to HUAC. Schulberg has vehemently denied that this is true, asserting that the flesh-and-blood stevedores upon whom the film is based happened to be facing this particular choice and that to leave it out would have meant distorting reality. Speculations on why he chose to give a Catholic priest such a prominent role is explained by the circumstance that two priests working in Hoboken were crucial to the reform movement in the longshoremen's union.

The debate over Schulberg's motives in scripting the film points up the unusual influence he had on the film's ultimate form. Kazan has always credited Schulberg as a full cocreator. Schulberg did all the research for the film, scouted locations in New York and New Jersey, wrote the screenplay, helped negotiate the financing, and was on the set for consultations. He has cited this creative process as a model

of how all motion pictures should be made. He feels the screenwriter should be equivalent in stature and power to the stage playwright, with the relationship to the film director akin to that of stage playwrights to stage directors. This would mean that producers and directors would have to consult with writers on proposed changes in dialog, character, and settings. Such a relationship would revolutionize Hollywood's notion of a writer's role in filmmaking and is a rebuke to the school of criticism which sees film as primarily a director's medium.

Schulberg has further argued that film scripts should be published as works of literary merit. He elaborated that view and his vision of the screen playwright in an essay which accompanied the published script of *On the Waterfront* issued as part of the Screenplay Library by Southern Illinois University Press in 1981. The essay also tells of how difficult it was to find commercial backing for *On the Waterfront* and how the film came very close to never being made at all.

The Schulberg-Kazan team was reformed in 1958 to create *A Face in the Crowd*. The film was based on short fiction by Schulberg and starred Andy Griffith as a television phenomenon. Although the film got excellent reviews, it was not a

commercial hit. Temporarily abandoning film projects, Schulberg began to adapt some of his work for the stage. He published a libretto for *What Makes Sammy Run?* in 1961 and a stage version of *The Disenchanted* in 1962. Later in the decade, efforts by Schulberg and Kazan to do a film about Puerto Rican political activists failed to find financial support. A subsequent Schulberg idea for a film about Robert Kennedy had a similar fate.

Renewed direct involvement in political change by Schulberg was set off in 1964 with the uprising in the Watts section of Los Angeles, the first of what proved to be increasingly violent urban insurrections by black Americans. Immediately after peace was restored, Schulberg and friends set up a writer's workshop in the community to encourage black writing. One outcome of their efforts was publication of *From the Ashes—Voices of Watts* (1967). Eventually the workshop idea was transferred to New York City. Renamed the Frederick Douglass Creative Center, the workshop holds classes in all writing genres but is most concerned with cinema, the stage, and television.

The distillation of the mature Schulberg's political views are found in two novels, *Sanctuary V* (1969) and *Everything That Moves* (1980). *Sanctuary V* is set on a fictional Caribbean island indistinguishable from the Cuba of Fidel Castro. The main character is a highly placed revolutionary who has become unhappy with the authoritarian direction of the revolution and is forced to flee into exile. *Everything That Moves* describes the creation of a national teamsters union by a Jimmy Hoffa-type character who is one part idealist and two parts crook. Neither of the novels enjoyed the kind of critical or commercial success accorded earlier Schulberg works.

Although none of his several film ideas and scripts reached the screen in the Sixties or Seventies, Schulberg retained a keen interest in the medium. He has explained his relatively meager film credits by saying that after the Thirties, because of his income from writing in other fields, he never had to take on hack jobs in Hollywood and would only work on projects that were intellectually stimulating. This special relationship with Hollywood is evidenced in *Moving Pictures—Memories of a Hollywood Prince* (1981), the first in a projected series which is to be partly autobiography and partly a historical account of the industry. *Moving Pictures* relates how as a child Schulberg used movie sets as play areas, interacted with Hollywood luminaries as "aunts" and "uncles," and heard films being discussed morning, noon, and night. The memoir, which culminates with Schulberg going off to college, takes pains to underline the achievements of Budd Schulberg, Sr. and other film pioneers the authors thinks have been unjustly treated. Throughout the volume there is a focus on the travails of the screenwriter and the agony of trying to make quality films in Hollywood. The biting prose and fierce views of the book indicate that even more controversy is sure to be engendered by the second volume, which will deal with the volatile Thirties.—Dan Georgakas

RECOMMENDED BIBLIOGRAPHY

Schulberg, Budd. *Moving Pictures: Memories of a Hollywood Prince.* Lanham, MD: Madison Books, 1981.

——— *On the Waterfront: The Original Screenplay.* Hollywood, CA: Samuel French, 1988.

——— *What Makes Sammy Run?* Cambridge, MA: Robert Bentley, Inc., 1979.

——— *Writers in America: The Four Seasons of Success.* Lanham, MD: Madison Books, 1982.

2001: A Space Odyssey

Science Fiction Films

More than in any other genre, the roots of the science fiction film lie in the very earliest movies made, notably in France and England. Of course, as genre, the science fiction film would only be born much later, as movies developed through technology and as an art-enter-tainment medium, beyond mere titillating novelty.

Yet these early roughhewn efforts are quite interesting politically; their quick production time, low costs, short lengths, and the increasing demands by audiences allowed the filmmakers to play with various themes, technological advances, and cultural-political elements and fads that would please their mostly working-class viewers. The films thus closely reveal audience attitudes, interests, and life-styles of the period. Along with the penny-dreadfuls and tabloids, which filtered these same ideas, the films are a rich source of information about urban working-class and lower-class life.

For instance, not long after Henry Ford set up the assembly line and pioneered modern industrial production, George Smith's *Making Sausages* (1897) satirized the notion: live dogs, cats, and, for some obscure reason, a lone duck are fed into a long Rube Goldberg-like contraption which at its other end spews out butcher shop-ready hams, bacons, and sausages. The Britisher J. Stuart Blackton added a political element: in his *Work Made Easy* (1907), the factory boss sets up a ray that makes inanimate objects move by themselves through the assembly line and also speeds up the movements of his workers.

In one of the movies' first instances of pre-union strife, the enraged workers join together, organize, and destroy the ray. A 1909 Edison film, *The Wonderful Electromagnet*, may have been a direct response to the church's denunciation of the movies as immoral, which prompted many local laws that closed the theaters on Sundays: the film features a giant magnet with the power to attract people; in one scene Edison shows a crowd being dragged by the magnet against their wills into church on a balmy Sunday morning.

Cultural fads also came under fanciful scrutiny by the early filmmakers. There was a rash (so to speak) of films dealing with alchemy and hair restorers, youth elixirs, and other patent medicines. Scientific discoveries such as the X-ray and electricity and inventions such as the microscope quickly became filmic fodder. Early filmmakers seemed entranced with miraculous surgeries and with robots and mechanical toys coming to life. These early films were all broad comedies, mostly satirical in nature, essentially innocent, although a surprising number of them dealt with grisly goings-on more worthy of the horror film, and many of them ended in death and destruction, perhaps following the popular media which also preached distrust of the ideas they presented and played with. Certainly the "inventors" in the films were portrayed as eccentrics quite deserving of public ridicule and perhaps served as forerunners of the cinema's later stock "mad scientists." These early movies were really only short sequences with no story or character development beyond the presentation of types. And with that came instances of fairly grotesque racism.

The one theme that would pave the way to initiating the sci-fi film as a recognizable genre was air travel. In the American cinema, following mostly the French model, the earth was first visited by Martians in *Message from Mars* (1913), in which the peaceful visitor criticizes our destructive, selfish way of life. More to the political point, Maxwell Karger's 1921 remake got more vociferous: the visiting Martian takes up with a rich man and shows him the effects of his evil ways. Clearly reformed, the man saves a poor woman tenant from the flames when one of his slum tenements burns down.

One of the first topical applications of air travel, however, involved war, not surprising, perhaps, since it seems an international axiom that military technology will latch on to all new ideas and develop them for destructive purposes. Among a slew of mostly British pre-WWI sci-fi-oriented preparedness films was *The Flying Torpedo* (1916), produced by D. W. Griffith, which in showing Americans repelling an Asian attack on the West Coast was clearly prescient, including the type of weapon fantasized here, of Pearl Harbor.

The Teens also saw a number of futuristic projections, interesting for their attitudes towards women, especially regarding the contemporary furor over women's suffrage. Laemmle's *In the Year 2014* (1914) takes place in a time in which women have the vote and have also taken over the business world. Set in 1950, *Percy Pimpernickel, Soubrette* (1914) reverses the sex roles as well as standard melodramatic conceits; its climax has Percy, babe in arms, driven from his home into the rain by his domineering wife.

Another politically interesting sci-fi film of this period was an early "disaster movie." The Kalem Company's *The Comet* (1910) was probably inspired by the 1909 passage of Halley's Comet, which created a sensation in the popular press. In this film rich people have the perils of the situation explained to them by scientists, and they take measures to protect themselves. The unprepared and panicking poor, on the other hand, bear the brunt of the comet's destruction as it passes near the earth. The film pointedly uses religion as a palliative and retrograde force for the poor people facing impending doom.

The Twenties was an important period for science fiction, if mostly in Germany,

including such Fritz Lang classics as *Dr. Mabuse* (1922), *Metropolis* (1926) and *Woman in the Moon* (1929). Sci-fi elements merged with routine melodramas and adventures, chiefly in the multichapter serial, which became a hugely popular cinematic genre. Many of these featured wealthy villains and dictators bent on world domination who are fought and foiled by stalwart heroes. Once again, as they will in each decade afterward, women take their lumps in the Twenties. Maurice Elvey's *High Treason* (1929), set in 1940 and attempting to cash in on Lang's *Metropolis*, offers a resolutely silly plot in which the brink-of-war world is divided between a "United Europe" and a "United America," uneasily refereed by a Peace League composed entirely of women. Their solution to world tension? Assassinate one of the two leaders, and peace will result. And in John Blystone's misogynist comedy *Last Man on Earth* (1924), an epidemic has killed all males over age fourteen, and women rule worldwide. One lone man turns up immune to the disease, and the film follows his adventures, culminating in his fathering twins in a personal effort to save *man*kind from such female domination.

The fortunes of the political sci-fi film plummeted in the Thirties. For the most part, science fiction continued to fuel only the serials, which featured by now stock fascist-like villains and dictators, such as Killer Kane in *Buck Rogers* (1939), Ming the Merciless in the various *Flash Gordon* epics, and the colorful urban evil-doers of the *Dick Tracy* serials. Feature-length films often featured protagonists with God complexes, like Dr. Frankenstein in *Frankenstein* (1931), in which the innocent villagers suffer death and destruction via the acts of an upper-class fellow with the resources to play with life and death instead of getting a real job, and the idealistic antihero in *The Invisible Man* (1933) who degenerates into a fascist lunatic. The pre-Production Code *Dr. Jekyll and Mr. Hyde* (1932), directed by Rouben

Mamoulian, is the best of several versions, explicitly dealing with the novel's Victorian code of morals in which sex and eroticism are activities a gentleman and respected physician must leave his society to find on lower-class streets.

Given the political situation in Europe, the theme of fascism erupted by metaphor and allegory in several films of the Thirties. Erle Kenton's *Island of Lost Souls* (1932) ends with a revolt of formerly human, now genetically mutant people against their Godlike scientist ruler. *The Mysterious Dr. Satan* (1940) has a would-be dictator create an army of robots to ensure his march to world domination.

A new cycle of preparedness films, again mostly British-made, got under way, echoing those of the Teens, except that now few were pacifist oriented. *Men Must Fight* (1932), set in 1940, predicted WWII and went so far as to show the destruction of the Empire State Building. Not surprisingly, with most science fiction tied to war themes, racism entered the fray, starting with the first of the Fu Manchu films, *Mask of Fu Manchu* (1932), with novelist Sax Rohmer's "Yellow Peril" theme intact. The same can be said for *Fighting Devil Dogs* (1938), with U.S. Marines fighting for the American Way of Life in the Far East. A 1935 serial, *Lost City*, has its villain, from his headquarters in Africa, brandishing a machine that can turn blacks into whites, and, for a dastardly evil punishment, vice versa!

The Thirties curiosity item has to be *It's Great To Be Alive* (1933), directed by Arnold Werker. All the world's men are killed by an epidemic called "Masculitis," and women come into power. When one surviving man is discovered he is kidnapped by gangsters who plan to take him to New York and auction him off to rich women. Rescued by the police, our hero is ordered to travel around the world, sharing his unique "gift" equally, in true democratic fashion, but he opts for the American Way: monogamy, with his girlfriend. At film's end they produce a set of

male twins. Werker has great fun with the skewed sexuality here: his business-women, gangsters, and police are all "mannish" women, although he shies away from any hints of lesbian activity in this delirious comedy, a loose remake of the 1924 *Last Man on Earth*.

Continuing the decline of the Thirties, politically oriented science fiction practically disappeared in the Forties. In a world beset by war, comic book heroes found their way to the screen, mostly in serials, ferreting out and defeating a slew of fascistlike criminals, despots, and mad scientists. These heroes were led by the three Captains: *Captain Marvel* (1941), *Captain Midnight* (1942), and *Captain America* (1944). Most of these films were simple-minded, overt war propaganda. *Batman* (1943) battled a nefarious dictator directing an army of zombies in an attempt to steal American radium for the Axis Powers. The third of Universal's Invisible Man installments, *Invisible Agent* (1942), finds the hero taking the serum to become an Allied spy. In the wacky comedy *The Boogie Man Will Get You* (1942), Boris Karloff, parodying his stock mad scientist horror roles of the Thirties, strives to create a superman for the Allies as his part of the war effort. *King of the Mounties*, a 1942 Republic serial, took the daring step (as the U.S. was not yet in the war), perhaps because it was set in Canada, of specifically identifying its villains as German, Japanese, and Italian. This is a patriotic stew of scientists working on a device to detect a new, "undetectable" Axis plane before it starts bombing the country as a prelude to invasion. The decade's darkest vision was the idiosyncratic Arch Oboler's *Strange Holiday* (made in 1942 but released only in 1945). Oboler, the Grandma Moses of American filmmaking, follows a man returning from a hunting trip to discover that America has become a fascist police state with an entirely complacent population. The sole relevant space-themed film of the decade was the Republic serial *The Purple Monster Strikes*

(1945). Despite its affectionately lurid title, this film, which involves a Martian who takes over a famous scientist to prepare the way for full-scale invasion, looks presciently ahead to the two great sci-fi themes that would soon appear: alien possession and the threat of outer space invasion (as opposed to earthbound ones, like the worldwide fascist threat just ended, or at least put on hold for awhile, by WWII).

And then came the Fifties.

If the science fiction genre as a whole had so far foundered without thematic or political bases, the Fifties provided them with a vengeance. The main theme is paranoia, as the postwar Forties American superiority-complacency was battled by anxiety, largely brought about by the political turnabout of Russia from ally to demonic enemy and instilled chiefly by exuberant religious and political propaganda. Thus the perception of communism's rise and the birth of such Fifties media-popularized conceptions as the "Iron Curtain," the "Cold War," or the Forties extended "Fifth Estate," all embellished and surrounded by the rise of nuclear weapons and the kind of right-wing political backwash symbolized and fueled by Joe McCarthy. The decade is by far the most interesting politically for the sci-fi film.

The decade started quietly enough with the (now) documentary-like *Destination Moon* (1950), in which the U.S. must beat the Russians to the punch to establish the moon as a "strategic military base." The film's hurry-up sequel, *Rocketship XM* (1950), set a more characteristic, if still innocent, note for the decade in its downbeat ending, in which the returning U.S. expedition crashlands on earth, killing the astronauts.

With space travel thus established, it wasn't long before the earth was visited by others. These aliens were mostly emotionless and evil, just like the commies across both oceans, as in Pal's *The War of the Worlds* (1953). *Earth vs. the Flying Saucers* (1956) added an unintentional but subver-

sive political angle by having the aliens destroy most of Washington, D.C.'s familiar landmarks, all worldwide symbols of democracy. Surprisingly, a handful of these "invasion" films featured aliens who were friendly, not bent on soulless destruction. They came to us for help in *It Came from Outer Space* (1953) and *This Island Earth* (1955), and we met them with hostility. *The Man from Planet X* (1951) arrives to ask scientific help to save his planet from freezing, and we respond by bombing him. Some appear on earth to help *us*, as in *The Strange World of Planet X* (1957), in which aliens help us repair a hole in the earth's ionosphere brought about by one of our nuclear mishaps. Some arrive to pose a warning to us for the safety of the universe—*The Day the Earth Stood Still* (1951), *The Star Creatures* (1956), *Space Children* (1958), *War of the Satellites* (1958), and *The Cosmic Man* (1959). These largely pacifistic aliens want us to stop our morally immature experiments in space travel and nuclear weaponry because our petty meddling now threatens not just our own planet but also the basic peacefulness of the entire universe.

The Fifties are notorious (and beloved) for their low-budget junk. In *Teenagers from Outer Space* (1959), humanlike aliens stop over en route home to graze their lobsterlike livestock, and they incur our military wrath. In the sheer silliness category, this rivals the decade's champ, *Zombies of the Stratosphere* (1952), in which Martians invade earth to destroy it in order to "move" their own planet into earth's thus vacated orbit, resulting in a better climate for them.

With the country's slouch to the right, several invasion films carry conservative religious messages. *The Day the Earth Stood Still* is largely a Christ allegory, although the emotionless visitor, backed up by Gort, his super death-ray-wielding robot, leave earth by blackmailing us: live in peace or Gort will return. *The War of the Worlds* ends in a church, with a voice-over indicating that it was our faith in God that

saved us more so than the bacteria which infected the aliens' bloodstreams. In *The Conquest of Space* (1955), the last of the Fifties "realist" space pictures, a space station commander refuses orders to send an expedition to Mars, which he perceives as a blasphemous search for God. In *When Worlds Collide* (1951), when it is discovered that a planet will replace earth in its orbit, survivors are democratically chosen by lot to voyage to the surviving planet on an expedition financed by a symbolically wheelchair-bound right-wing industrial magnate. The movie features a Noah's Flood-like devastation and ends as an Edenic vision of the new world. *Red Planet Mars* (1952) carries the theme to outrageous lengths. An American couple receive a TV signal from Mars which an ex-Nazi scientist, in league with some Russians, attempts to use to topple capitalism. His plan backfires: in a panic caused by the broadcast, Russian peasants revolt and establish a priest-run monarchy (!). At film's end, another TV signal arrives, and this time it's God himself talking. The film's underlying religious fervor and anti-Russian hysteria can be seen as a reaction to the Fifties phenomenon of Billy Graham and his groundbreaking use of the TV medium to further his message.

Red Planet Mars largely initiated the second major sci-fi Fifties theme: the Red Scare. Our politicians, media, and religious leaders told us communism was on our doorstep, poised to invade. The response from sci-fi was heavyweight. Several films used the theme in a quite literal sense, starting with *The Flying Saucer* (1950), perhaps spawned by initial reported UFO sightings in the U.S., in which an American scientist privately builds the titular contraption which is promptly captured by Russian agents. The scientist explodes it by remote control; morally shaken, he gives his secret to the U.S. government for safer development. Similarly, *Tobor the Great* (1954) has commies capture a scientist's homemade robot, but he manages to shoot it (and the villains) into outer space

when he realizes his inability to control it. In the notorious *The Whip Hand* (1951), an ex-Nazi scientist and communist agents use a small Minnesota town to develop and test a powerful germ warfare weapon. *The 27th Day* (1957) has evil, "pacifist" (only in the sense that they cannot kill) aliens giving capsules capable of destroying all life on earth to individuals from five different countries, hoping that we will destroy ourselves. The plot devolves into an East-West confrontation as the British and American recipients give their pellets to the U.S. government which successfully releases them against the Russians, who have fudged their chances by unsuccessfully torturing to death their recipient who has refused to give his pellets up. Only one such picture is actually set in an Eastern Bloc country: *The Gamma People* (1956), in which a scientist attempts with gamma rays to create a race of geniuses but winds up with goonish zombies—an unsubtle interpretation of communism. A Nazi-like scientist creates a race of zombies to carry out his will in both *Creature with the Atom Brain* (1955) and *The Unknown Terror* (1957). In the marvelously paranoid *Invasion U.S.A.* (1952), people in a bar learn via a TV newscast that the Russians have launched an atomic attack; they all die horrible deaths as they attempt to reach their homes. Later they awake back in the bar, merely victims of a collective hypnosis, and decide that the feared U.S.-U.S.S.R. clash is inevitable, so we should attack first.

For the most part, however, the subversive Us vs. Them menace of communism was dealt with in sci-fi by metaphor. Perhaps "they" wouldn't invade us physically; far more dangerous was the possibility that, if we didn't remain morally and politically straight, communism would creep up on us unseen and take us over in our very homes. Thus, *Plan 9 from Outer Space* (1956), *The Invisible Invaders* (1959), and two Roger Corman quickies, *It Conquered the World* (1956) and *Attack of the Crab Monsters* (1955), sent us aliens with the power to take over human minds

and souls without altering physical appearance, intelligence, or memories. The misguided scientist turns against his besieged Arctic station crew because of his fascination with the "no emotions" *The Thing* (1951), the decade's first and still best invasion movie, which firmly established all the elements of the genre. He dies trying to make friends (i.e., appease it), and allows it to reproduce itself within the station. One man shrinks into infinity after contact with a radioactive mist in Jack Arnold's superb *The Incredible Shrinking Man* (1957); another zooms beyond giantism in the consummately silly *The Amazing Colossal Man* (1957). *Invaders from Mars* (1953) metaphorically portrays the destruction of the American nuclear family as aliens take over a boy's mother and father and other citizens of a sleepy American town. On the flip side, a family's love defeats the titular "negative-god" alien in *Beast with a Million Eyes* (1956). The American institution of marriage is corrupted in *I Married a Monster from Outer Space* (1958) as a wife discovers her newlywed hubby has been taken over by an alien. Like a good commie spy, the humanlooking, X-ray-eyed alien in *Not of This Earth* (1956) dispatches earthlings to his home planet for their blood supply.

The key film here is Don Siegel's classic *Invasion of the Body Snatchers* (1956), which interestingly can be read as both left-wing anti-McCarthy *and* right-wing anti-communist tracts. Here seeds from space land on earth and grow into duplicates of humans, assuming the individuals' memories and intelligence but minus emotions and free will. In this film the very efficiency of American industry, agriculture, industrial planning, transportation, and even small-town folksiness is called into question and subverted as now-alien farmers grow the pods, and police, politicians, and truckers efficiently send them all over the U.S., delivering them to families and friends of the next victims. So, people go to sleep one night and wake up...different. And they never know what hit them.

The Fifties' third major thematic development was the monster film. Unlike the "Red-under-the-bed" propaganda films, the monster movies are less insidious because more explanatory: we can at least *see* what we're fighting, even if we don't quite believe it. In several films the monsters threatening human civilization can be seen as metaphors of communism and are representative of the paranoia accompanying the emergence of nuclear energy and weaponry.

Unlike alien invaders, the monsters at least belong to the earth. Most films used insects, harmless, even unnoticeable in their normal state, but now exploded in size, a rebellion by Nature. They are created in most cases through the effects of A- and H-bomb testing. In a complacent nation that had conquered all its frontiers, they came from the earth's, or America's, forgotten places: from the Arctic lumbered dinosaurs (*Beast from 20,000 Fathoms*, 1953, and *The Giant Behemoth*, 1959) and a praying mantis (*The Deadly Mantis*, 1957); from the jungle swarmed wasps (*Monster from Green Hell*, 1958); from the Florida swamps crawled *The Giant Leeches* (1959); from the ocean depths emerged an octopus (*It Came from Beneath the Sea*, 1955), caterpillars (*The Monster That Challenged the World*, 1957), and *The Creature from the Black Lagoon* (1954, although here we're technically guilty of invading *his* home); and from the desert, that favorite spawning ground (where the U.S. did most of its atomic testing) came grasshoppers (*The Beginning of the End*, 1957), *Tarantula* (1955), *The Black Scorpion* (1959), and ants (*Them!*, 1954). Mankind even had to confront its most valuable organ, now running amok, in the brain-spinal cord creatures of *Fiend Without a Face* (1957). Radioactivity itself was a creeping, formless menace in *The Blob* (1958), in which teenagers—who had become the near-hysteric villains of j.d. films throughout the decade—band together to save their home town.

For all the decade's furor over nuclear power—we thought atom-hydrogen bombs were the ultimate weapon, and, for a while, we owned all of them—the Fifties remained shockingly naive of and bereft of knowledge about it. Thus, in *The War of the Worlds,* military men, futilely using an A-bomb against the invading Martians from a few hundred yards away, simply brush the white radioactive ash from their clothes. Hollywood fashioned a comedy vehicle for Mickey Rooney in *The Atomic Kid* (1954), in which he is caught in an atomic blast and simply glows for awhile. The only other film of the decade, along with *The War of the Worlds*, in which the nuclear bomb proves ineffective is *Kronos* (1957); the giant alien robot simply absorbs the H-bomb's energy and becomes more powerful.

Other sci-fi films delved into sociological-political criticism of Fifties America. *Forbidden Planet* (1956) sets up a parallel civilization aimed at delivering a warning: the Krels became fascinated with technological power, eventually freeing themselves from material limitations, but their obsession ultimately destroyed them as their nightmares became uncontrollable physical reality. In *Donovan's Brain* (1953), a scientist saves a power-mad industrialist's brain which slowly takes control of him, a trenchant comment on the Fifties growth of the military-industrial complex. In *20,000 Leagues Under the Sea* (1954), Captain Nemo, a misguided Victorian-era pacifist, tries to end war by destroying all the world's warships; the final destruction is his own vessel, the submarine Nautilus, a mushroom cloud prophetically rising over it. Stalwart Americans find an enslaved race underground in *The Mole People* (1956) and help lead a revolution against their masters. In the comedy *The Twonky* (1953), a philosophy professor is stalked by his robot TV set which he eventually destroys to preserve his free will. The decade began (*Five*, 1950) and ended (*On the Beach* and *The World, the Flesh and the Devil*, both 1959) with downbeat postnuclear-war

visions of a desolate, dying world, with its few survivors wallowing in guilt and despair and repeating the same behavior which on a larger global scale led to the world's destruction. Also postnuke, in *World Without End* (1956) American astronauts pass through a time warp and land in 2058 in time to help the remnants of civilization survive by overthrowing autocratic leaders.

Not surprisingly, women fared poorly in the Fifties. With a perfect Freudian élan, women were either powerful leaders but man-hating predators—ruling the moon in *Cat Women of the Moon* (1953), ruling Mars in *Devil Girl from Mars* (1953), ruling a moon of Jupiter in *Fire Maidens from Outer Space* (1956), ruling Venus in *Queen from Outer Space* (1958, in this one all the women wear bathing suits and masks!)— or blithering, defenseless victims—*The Mysterians* (1957) and *Mesa of Lost Women* (1953). In the latter, a crazed scientist attempts to surgically make women "more ferocious." Women turned up as mutated monsters in *The Astounding She Monster* (1958), *Voodoo Woman* (1957), *She Demons* (1958), *Terror from the Year 5000* (1958), and *Attack of the 50-Ft. Woman* (1958). Two *Donovan's Brain* rip-offs featured scientists trying to create the "ideal" woman, starting with the head and searching for a perfect body to attach it to, in *The Brain that Wouldn't Die* (1959) and *The Head* (1959); in the latter, the head of a hunchbacked nurse is stitched onto the body of a stripper. On the scant positive side, the U.S. president is an intelligent woman in *Project Moonbase* (1953); there's a feisty woman entomologist in *Them!*, a resourceful wife in *I Married a Monster from Outer Space* and girlfriend in *The Brain from Planet Arous* (1958). But at their best, women were damned with faint praise in the Fifties: the flyboy hero's girlfriend, for example, comes up quite innocently with the solution of how to kill the creature in *The Thing*. After hearing it described as an "intellectual carrot," she says, "What do you do with a carrot? You boil it!" In the Fifties, women were considered at their best in the kitchen.

During the Sixties the monster movie frequently evolved into "revenge of nature" pictures, some ecologically minded, as in *The Birds* (1963). For the most part these films featured not radioactively infected behemoths but normal-sized animals and insects. The Sixties also saw the rise of horror elements in sci-fi films, a development increasingly rampant up through the present, begun by *The Awful Dr. Orloff* (1962) and George Romero's classic *Night of the Living Dead* (1968), the latter perhaps the first of the human takeover movies untainted by Fifties Red Scare propaganda, which slowly died during the Sixties.

One of the dominant characteristics of Sixties sci-fi was determined by the emergence of James Bond in 1963's *Dr. No*, who was quickly followed by such cut-rate imitators as Matt Helm and Our Man Flint. These films all featured a cultured, unflappable, sexually supercharged, technologically flamboyant action hero who stands as a lone defender of democracy against an equally cultured but megalomaniac villain out to rule the world. The sci-fi films evolved into quite an international stew, with the Chinese for the first time popping up as villains in *Project X* (1967), and later, following the U.S. political stance, as saviors (from the Russians) in *The Chairman* (1969), in which a surprisingly unlikable American Nobel Prize winner goes to China to steal an agricultural formula. Before that, however, in *Dimension 5* (1965) and *Battle Beneath the Earth* (1967), Chinese communists and their spies are actively working in the U.S.

Invasion from outer space also continued in Sixties films, now with more of an international flavor: the U.S. and Russians joined forces to defeat alien invaders, or deal with other fanciful emergencies, in *The Bamboo Saucer* (1968, against the Chinese again, who are investigating the same crashlanded saucer that the Americans and Russians are) and *Mission*

Mars (1968) and *Marooned* (1969), both dealing with space rescues. There's a smoothly functioning, fully international crew in *12 to the Moon* (1960), which investigates moon men threatening to freeze the earth. As in the Fifties, there were also more Sixties pre-*E.T.* friendly aliens, misunderstood by most earthlings, such as those in *They Came from Beyond Space* (1967).

Perhaps not surprisingly for the Sixties, several overtly pacifist films, the first so clearly themed since the Thirties, appeared: Edgar Ulmer's *Beyond the Time Barrier* (1960), in which a man in post-nuke 1971 travels back to 1960 to proselytize against nuclear weapons; *First Spaceship on Venus* (1960), in which earth sends an international crew to Venus to discover remnants of a civilization that fell prey to its own internal political dissensions and was ultimately destroyed by its own nuclear weapons; and *The Flight that Disappeared* (1961), a political fantasy in which three scientists who have invented a super bomb are put on trial by future generations with the result that one of the scientists destroys the bomb's plans.

Paralleling most other genres in the Sixties, the sci-fi film turned to youth themes as Hollywood discovered that potent market. Most of these, as in the Fifties, were exploitation drive-in fodder which exploited fear of the suddenly vocal Sixties youth, like *Village of the Giants* (1965), a Wellsian rip-off in which giant teenagers terrorize a small American town, or *Dr. Frankenstein on Campus* (1967), in which a teen hero discovers he's a computer-generated cyborg. On the same level but interesting politically and sociologically was *Wild in the Streets* (1968), in which a rock star becomes president and banishes everyone over thirty-five to internment camps where they are force-fed LSD. Never more than half serious, the film is a wild parody of the post-Fifties family unit, American life, and teen culture, and ends with the self-satisfied prez, having relaxed into a fat, happy lifestyle not unlike that he earlier destroyed, confronted by a disgruntled ten-year-old demanding a new, younger revolution. The year 1969 saw the first major film of sci-fi specialist David Cronenberg. In *Stereo*, set in the near future, scientists, judging sex to be "polymorphous perversity," test adolescents by surgically removing their powers of speech in order to study their thus intensified latent telepathic powers. It's a confused and confusing picture, although it looks forward to Cronenberg's later and continuing skein of "sexual plague" sci-fi-horror films.

Following the youth movement in general, Sixties sci-fi took "distrust" as the operative word in regarding mainstream social and political institutions. For the first time in sci-fi, for example, big business, that mainstay of the American notion of progress and way of life (especially in Fifties films), came under attack. In John Sturges's *The Satan Bug* (1965), a corrupt billionaire businessman murders a scientist and plants a deadly virus in Los Angeles to blackmail the U.S. A similarly schizophrenic right-wing Texas millionaire invades the U.S.S.R. in *Billion Dollar Brain* (1967); he thinks the place is ripe for another revolution which would thus end the Cold War. In John Frankenheimer's *Seconds* (1966), an aging businessman undergoes a commercially available but expensive rejuvenation process then, missing his wife and family (whom he must abandon because of his new identity) and the relaxation of middle age, regrets his decision, but learns too late the process cannot be reversed. He causes trouble for the huge, faceless corporation and so is killed, his body recycled for parts for other youth-seekers. This is an emblematic Sixties film, a paranoid warning hymn to the corruption of Big Business, which looks ahead to the Seventies and Eighties.

Technology is the culprit in several of the Sixties' best SF films. Kubrick's *Dr. Strangelove* and *Fail-Safe* (released within months of each other in 1964), the former

satirical and the latter realist, are twin explorations of the political-human ramifications of depending on technology to design a system assuring that nuclear war will never take place. Both films end in nuclear destruction. In *Colossus: The Forbin Project* (1969), Russian and American computer technology completely bypass their helpless human designers-operators and decide to try to outsmart each other with nuclear strategy in a game that almost turns real. Kubrick's landmark *2001: A Space Odyssey* (1968) did more to spark the sci-fi genre than any previous film. Here, the bland, robotlike humans are ironically set off against the (for once apt phrase) majesty of space in which the most "human" character, the computer HAL, disintegrates as if in human emotional breakdown. It is no wonder that Kubrick's debased humans, dwarfed by but dependent on candy-colored technology, look outward for the answers to life, following the black monoliths, rather than seeking inward, which the powerfully ambiguous ending hopefully reestablishes.

Such social criticism was a mainstay of Sixties sci-fi. One of the more lively satires was Theodore J. Flicker's *The President's Analyst* (1967); when the titular character suffers a nervous breakdown and disappears into a (parody) middle-class American family, he is pursued by a stew of FBI, CIA, Russian, and Chinese agents and ultimately discovers that the telephone company actually runs America, using a fleet of robots who implant telephone receivers in everyone's brain. On the serious side, *Panic in the Year Zero* (1962) examines an American family taking to the wild hills to avoid a coming nuclear holocaust.

And how did women fare in the Sixties? For the most part, the age-old (particularly Fifties) dichotomy holds true: women are either victims—usually surgically, as in *The Awful Dr. Orlock* (1962) and *Atom Age Vampire* (1960)—or male-shrivelling aggressors (*The Leech Woman* and *The Wasp Woman*, both 1960). A new wrinkle

combines in cunning fashion the victim-aggressor stance: women are aggressors but only as the tools of a guiding man, as in *The Blood of Fu Manchu* (1968) and the two Dr. Goldfoot films, *Dr. Goldfoot and the Bikini Machine* (1964) and *Dr. Goldfoot and the Girl Bombs* (1966), which titles pretty much tell all. The softcore porn movie added two relevant titles as well: *Zeta One* (1969) and the redoubtable Russ Meyer's *Kiss Me Quick* (aka the Kubrickian *Dr. Breedlove*, 1964). In both films alien males invade earth looking for women to take back home. In the Meyer film, they don't even have to round up real and possibly "flawed" ones; a scientist simply runs off a batch of busty robots for them. Similarly themed, *Mars Needs Women* (1966) provides one of the decade's most positive images of women: this time, the victims of women-hunting aliens manage to fight off the invaders.

The Seventies saw the sci-fi film continue in respectability and popularity, and the genre responded with four huge hits—*Superman* (1978), *Star Wars* (1977), *Close Encounters of the Third Kind* (1977), and *Star Trek* (1979)—although all four largely ignored political elements. *Star Wars* (and its sequels) influenced the genre immensely, although for our purposes, it actually set it back. The film's mixture of self-reflexive, genre-mixing elements (including samurai films, Westerns, Thirties serials, WWII pictures, etc.) necessarily included an evil, proto-Nazi-like dictator against which the heroes fought the good democratic fight. And it became *de rigueur* for the various rip-offs and imitators, sometimes adding James Bondian elements, including *Message from Space* (1978), *Starcrash* (1979), *The Humanoid* (1979), *The Amazing Captain Nemo* (1978), and *Warlords of Atlantis* (1978) to include this cartoony political Us vs. Them situation.

Hollywood increasingly pandered to youth, its main audience. Corman's self-parodying *Gas-s-s-s* (1970) featured a titular substance that kills off everyone over

the age of twenty-five. The latently flower-powered *Glen and Randa* (1971) followed a teenaged boy and pregnant girl (who later dies) on their search for safety through a postnuke wasteland. Perhaps the toughest exploration of the youth theme was another of Peter Watkins's "future documentaries," *Punishment Park* (1971) in which U.S. authorities have set up detention camps for political dissidents and protestors (mostly against the continuing Vietnam War). In what is clearly aimed at bringing that war home to America, Watkins has the camp internees choose between three-year jail terms or entering the Park, where they will earn their freedom if they can survive three days of being hunted by the military.

The Seventies saw a shift in the point of view of sci-fi: the source of fear and paranoia became earthbound rather than extraterrestrial invasion. The complexity of American life prompted filmmakers to turn to government, technology (increasingly including computers), and big business as, at best, unknown quantities determining the American life-style, and, at worst, out-and-out threats to life. The monster movie became the revenge-of-nature picture; several of these films emphasized ecological points, such as *Phase IV* (1973), but most functioned as nonpolitical escapism—there is a wonderful image in *Frogs* (1972): during a raid on a family, one of the hopping, chubby predators lands smack in the middle of a birthday cake decorated as an American flag.

Fear of the government (and attending military force) sparks *Piranha* (1978), written by John Sayles, which featured a deadly strain of the fish developed by the government for use in Vietnam. Romero's *The Crazies* (1973) has a plane carrying a new germ warfare weapon crashing into Middle America, causing the population to become vampires, which the military (who pointedly are more crazy than the rather benign victims) must come in to eradicate. The fear of technology running amok fuels several films. In *The Andromeda Strain* (1970), the hero must defeat a sealed-off laboratory institute's fail-safe system which is accidentally triggered as scientists attempt to identify a virus which has killed off most of an American desert town. The white-on-white *THX-1138* (1970), directed by then-neophyte George Lucas, offers a fearsomely dehumanized future. When a just-before-launch spaceship, in *Capricorn One* (1977), is found to be unsafe, the government decides to fake the trip, using the mass media, especially television, so as not to lose face. A major city hospital induces coma in patients to provide body parts for "real" emergencies and research in the post-Watergate paranoid *Coma* (1978). *The China Syndrome* (1979), commercially aided by the real-life Three Mile Island nuclear plant disaster which occurred as the film was released, exposed nuclear technology weaknesses. In *The Terminal Man* (1974), a psychotic has a tiny computer implanted in his brain to "correct" his behavior, but when it malfunctions, it turns him into a violence freak who must be destroyed. The heroine in *Demon Seed* (1977) is held prisoner in her own home by her husband's supercomputer he has programmed to run the house (he/it also wants progeny). A Nazi geneticist (Josef Mengele) has created Hitler clones who are now coming of age in middle-class homes worldwide in *The Boys from Brazil* (1978). Finally, pollution from all this advanced technology, from nuclear reactors to industrial wastes, inspired a new type of "right-thinking" monster movie, represented best by John Frankenheimer's *Prophecy* (1979), in which mercury poisoning from a Maine lumber mill causes animal life to mutate; the hero is an EPA scientist aided by an American Indian. Other such films include *Doom Watch* (1972), which obnoxiously exploits the real-life thalidomide poisonings, *Empire of the Ants* (1977), *Day of the Animals* (1977), and *The Living Dead at the Manchester Morgue* (1974). Somewhat cynically, in *The End of the World* (1977), aliens from the planet Utopia intend to

destroy earth because it is irredeemably polluted, and a bunch of scientists who discover their presence ultimately agree with and join them!

The pollutants were created, in part, by big business and helped by government for the "good" of the American economy, and a number of sci-fi films explored this fear. The detective hero in *Soylent Green* (1973) finds the Soylent Corporation processing human corpses into synthetic foods in an overpopulated future. A corporation's plans to create mutant bees in order to market their super-abundant honey backfires (they escape) in *The Bees* (1978). In the otherwise innocent Disney fable *The Million Dollar Duck* (1971), a gold egg-laying bird results in world economic crisis as the price of gold plummets and, spurred on by businessmen, the government closes in on the family. In *Rollerball* (1975), one company runs the U.S. and controls the population mostly via a televised, violent pro sport in which athletes are crushed if they become too popular and thus potentially dangerous. The cosmetics industry is roasted in Cronenberg's *Crimes of the Future* (1970), in which a line of dermatological products cause men and women to develop into primitive states. Ditto *Blue Sunshine* (1977), in which a marketed LSD-like drug turns users into psychotic killers.

The Seventies thrived on social criticism. Bleak future worlds were presented in *Z.P.G.* (1971), set in an overpopulated twenty-first century in which having babies is declared illegal. In 2274, in *Logan's Run* (1976), people live in an ordered but pleasant existence until age thirty, when they are "renewed" (i.e., killed). In a pair of *Planet of the Apes* sequels, *Conquest of the Planet of the Apes* (1972) and *Battle for the Planet of the Apes* (1973), human society is satirized through use of the simian equivalent which evolved from the humans' former housepets and servants. A pair of comedies, *Sleeper* (1973) and *Americathon* (1979), offer a negative future behind the laughs (in the latter, American Indians col-

lectively call in their debt, thus bankrupting the U.S. government).

Paranoid psychosexual plagues among repressed populations drive two Cronenberg films, *They Came from Within* (1974) and *Rabid* (1976). Romero's zombies satirize rampant consumerism as they wander through a glittering shopping mall in which humans are holed up in *Dawn of the Dead* (1978). The 1978 remake of *Invasion of the Body Snatchers* skewers pop psychiatry ("Urban life makes people unhuman"). In *Death Race 2000* (1975), a murderous, transcontinental Death Race is a mediacized-political national event, scored by the number of people run down by the drivers; at the end, realizing he's exploited, the hero cruises over the U.S. president as his final victim. The American family unit is upended in two Larry Cohen pictures: *It's Alive* (1973) and the sequel *It Lives Again* (1978) in which lovey-dovey parents beget a monster child (interestingly, in the latter film, the parents' emotional turmoil is heightened when they discover that the clawed thing, however hideous, responds to their love). Similarly, in another Cronenberg epic, *The Brood* (1978), the family becomes a metaphor for evil as women give birth to children who are products of their own neuroses; these children of rage are monsters. Cohen's *God Told Me To* (1976) features a Second Coming, except that He is a demon, and the deities fight it out Von Dankian-like on New York City streets to the befuddlement of a staunchly Catholic cop.

Postnuke worlds are explored in *No Blade of Grass* (1970) and Altman's *Quintet* (1979) in which life has become an intellectual but deadly game, like a combination of charades and Clue, and the ecologically oriented *Silent Running* (1971), in which all of the earth's greenery survives only in huge, Noah's Ark-like space barges. Most of these films divided the holocaust survivors into two camps: good people who carry on the residue of civilization and bad people who try to destroy it further, as in *The Ultimate Warrior* (1975),

Bakshi's animated *Wizards* (1977), and *A Boy and His Dog* (1975), in which the good people live underground frozen in a dreamy but dull and impotent Our Town-like existence. Boorman's playfully perverse *Zardoz* (1973) creates a new group: intellectual eternal lifers who are so bored they yearn for a death they cannot have.

Two Seventies films stand out here: Kubrick's chilling *A Clockwork Orange* (1971), a dark study of free will in a world controlled by a violent youth culture pandered to by the media and politicians; and Nicolas Roeg's *The Man Who Fell to Earth* (1976), a startling visual adventure of an alien who lands on earth seeking help for his family dying on his home planet, only to become the pawn and finally the victim of big business, politicians, the military, and government.

If the decade was downbeat politically, it was downright nasty to women, despite (perhaps because of?) the gains of women's liberation throughout the Seventies. The wife of a computer wiz is trapped in her automated home by her husband's intellectual toy and raped by it in *Demon Seed*. A scientist creates a woman in *Embryo* (1976), helplessly begins a sexual affair with her, and eventually kills her out of remorse (for *his* weaknesses and guilt). The titular *Goldengirl* (1979) is a woman athlete of modest skills who is converted by drugs and psychological experiments into a super athlete; a business conglomerate "buys" her and markets her off to the 1980 Moscow Olympic games (the film was made to cash in on the real Games, which the U.S. eventually pulled out of for political reasons). The decade, in sexual politics, seems summed up best by a downbeat film with (debatable) feminist yearnings: *The Stepford Wives* (1974), in which a sleepy Connecticut town's yuppie males replace their wives with "perfect" (i.e., emotionless, subservient, unaging) androids (the technical ringleader once worked at Disneyland, which is something to think about). The film's final scene, in

which the gaily dressed, empty-eyed creatures discuss recipes while wandering through a pastel-colored supermarket, is a classic image of the plight of women.

Thus far, the Eighties and Nineties have simply continued the themes of the Seventies, except by decreasing political relevancy. Like most other genres, the sci-fi film pulls its political punches. Fears introduced in the Seventies are still with us. Big business, on an increasingly global scale (and perhaps prescient, given the Japanese "takeover" of Hollywood late in the decade) is the really disturbing villain of the *High Noon* clone *Outland* (1981), *Superman 3* (1983), *Eliminators* (1986), *Simon* (1980), *Heartbeeps* (1981), the animated *The Jetsons: The Movie* (1990), in which the Spacely Sprocket Company opens a new plant that will destroy the environment of its host planet, both *Aliens* films (1979 and 1986), *The Stuff* (1985), and *The Incredible Shrinking Woman* (1981). In the latter two films, successfully marketed, FDA-approved products prove lethal. Ditto the military establishment and government in *Brainstorm* (1983), *Iceman* (1984), *Hangar 18* (1980), *Alligator* (1980), *Starman* (1984), *Short Circuit* (1986), and its sequel (1988), *Strange Invaders* (1983), and *Watchers* (1988). Most important here is the power of television, which is used for evil purposes in *Agency* (1980), *Halloween 3* (1983), and *Looker* (1981), all of which deal with the dangers of subliminal messaging. John Carpenter's *They Live* (1988) takes the theme a giant step further; the film is a savage, truly paranoid satire of increasingly consumerish American society in which not only TV but also billboards, magazines and newspapers, product labels, advertising, and even store signs carry subliminal messages, controlled by invisibly assimilated evil aliens. Dispensing with the subliminal, *Terrorvision* (1986) features a very real monster that lives in a TV set and emerges to menace a TV-addicted family. The satirical action film *The Running Man* (1987) has a world-popular, violent TV quiz show

hosted by a cruel, power-mad emcee, good-naturedly played by real-life game show host Richard Dawson. These multiple, rampant technological fears are best exemplified by a pair of David Cronenberg films: *Scanners* (1980), in which the giant "ComSec" research agency and multinational "Biochemical Amalgamated" drug conglomerate knowingly use a tranquilizer called "Ephemerol" (like a psychic thalidomide perhaps) on pregnant women when it is discovered that their children are born with the power to "scan" others' minds; and *Videodrome* (1982), in which a TV station technician locks into a pirate cable porn channel and, hypnotized by the signals, begins to hallucinate his own genetic adaptation to TV. By the time of his excellent remake of *The Fly* (1986), the truly exciting, innovating, and idiosyncratic Cronenberg has made the tragic plight of his genetically changing scientist hero, again by technological foul-up, into a primitive fear of procreation itself.

Outer space visitors? The decade's bad aliens include *Predator* (1987), *The Hidden* (1987), and the excellent sleeper *I Come in Peace* (1990), in which an alien preys on urban drug dealers, stealing their heroin and injecting it into his sporadic victims in order to collect brain endorphins, the alien's own special brand of narcotic. They seemed to be opposed, perhaps with Hollywood's eye on Reagan and Bush in the White House, by just as many good and often treacly aliens: *Cocoon* (1985) and *Cocoon: The Return* (1988)—which posed laughably grotesque space-age solutions to the increasing problems of what to do with our elderly—*Batteries Not Included* (1987), and *The Abyss* (1989), with the lowest point reached in *Space Invaders* (1990), in which a crew of cavorting Martians, picking up an earth Halloween replay of Orson Welles's *War of the Worlds* broadcast, stop off to help their friends with the "invasion.'

Nuclear technology means nuclear waste, and a handful of films exploited the menace it posed by creating monsters— *Trancers* (1985), *Nightmare City* (1980),

Slugs (1988), *Circuitry Man* (1990), *Big Meat Eater* (1982), *I Was a Teenage Zombie* (1987, toxically tainted marijuana, what else?)—although one held out for the societally good: the infected cop in *Supersnooper* (1981). New York's zero-budget sleaze specialist Troma Films hit commercial paydirt with the comic bookish *Toxic Avenger* (1986) and two sequels (1989), in which a wimp emerges from an accidental dunk in nuclear waste as a superhero; in *Part III*, he battles a lethal corporation called Apocalypse, Inc. The notable film here is *C.H.U.D.* (1984), in which the U.S. government continues, illegally, to move toxic wastes through New York City subway tunnels, mutating street and homeless people into monsters. The nasty villain of the movie, one of the foulest of the Eighties, is an EPA official.

Evil robots still plagued us, in *Chopping Mall* (1986) and *Robot Jox* (1990). Forget robots; even simple household electrical appliances run amok in Stephen King's *Maximum Overdrive* (1986), caused by a passing comet. These films decrying the evils of technology are contrasted by several protechnology pictures—including *D.A.R.Y.L.* (1985), *Android* (1982), *Making Mr. Right* (1986), and *Blade Runner* (1982), which fully humanize their synthetic "men'—and the antic family of robots in *Heartbeeps*, the self-sacrificing android of *Aliens* (1986), and *Robocop* (1987) in which a cyborg is created from a slain policeman, becoming an unerring super cop who while vainly searching for his lost human identity is a powerful force for good, eventually cleaning up the avaricious, yuppie-run company that created him. The message of a pair of 1983 John Badham movies—*Blue Thunder*, about a sophisticated surveillance helicopter used by the L.A. police and misused by a right-wing colonel to incite riots in Watts, and *The Forbin Project*-like *WarGames*, in which computer-simulated nuclear warfare is averted from becoming real only by man's plea to the *computer's* logic circuits—is that technology is basically good, as long

as it is not humanly misused.

Postnuke landscapes are explored in *Malevil* (1981), *Solarbabies* (1986), *Millenium* (1989), *The Quiet Earth* (1985), *Blood of Heroes* (1990), and *Creepozoids* (1987). The convoluted plot of James Cameron's excellent hi-tech *The Terminator* (1984) has a massively destructive cyborg (Arnold Schwarzenegger) from the future wreaking havoc on modern-day L.A. in an attempt to exterminate the woman who will eventually father the leader of the underground postnuke guerrillas who have defeated the computer system which has sent the cyborg as its last desperate chance for survival (by altering history, i.e., a retroactive abortion—is all that clear?). The film's (unseen) nuclear war was begun by the "Defense Network Computers," a kind of earth-based SDI, which uncontrollably evolved into a new order of intelligence, to eradicate its only enemy (also its creator), humanity. The inevitable sequel, *Terminator 2: Judgement Day* (1991), equally well directed by Cameron, spins the same plot, in which cyborg Schwarzenegger, by now too huge a star to play a villain, returns to protect the now adolescent future leader, who is menaced by an unkillable, shape-changing cyborg a few technological generations improved from Arnold's model. The two *Terminator* films are the genre's most fearsomely outrageous statement of the fear of technology. Perhaps the most political, if least outwardly "political," is *Testament* (1983), which shows ordinary people confronting the horrific aftermath of a nuclear attack, a quietly ferocious statement of the fact that it will be you and me who will bear the physical and psychic brunt of nuclear war, not the well-paid politicians, scientists, and military men who deal with it (or fail to) in a strategic, abstract sense.

Following the Sixties and Seventies, the most relevant political sci-fi films continued to be those concerned with social criticism, which in a few cases faced the fate of many serious themes in Hollywood, which

is to become the fodder of witless teen flicks, as in *My Stepmother is an Alien* (1988), *Earth Girls Are Easy* (1989), and *Martians Go Home* (1990), all feeble satires of middle-class white culture. More seriously, *Alien Nation* (1988) attempted a new view of racism, in which an alien species (read blacks and Hispanic-Americans) is attempting to assimilate itself into white urban life. Dealing with the same theme was *Enemy Mine* (1985), in which the sole survivors of warring armies, one white American, one alien, are forced to coexist, stranded on a barren, environmentally hostile world. In *Total Recall* (1990) Arnold Schwarzenegger throws in with the Martian underground to overcome their tyrant leaders, eventually restoring breathable air to the planet. It should be noted that the zombies in Romero's third *Dead* picture, *Day of the Dead* (1985), are starting to civilize themselves. The superb *Blade Runner* presents a garish Times Square-ish Los Angeles dominated by Japanese corporate influences and at the mercy of a giant business conglomerate, one of whose products, androids, have become renegades seeking, then demanding, increased life spans. The "official" version of Orwell's *1984* (1984) proved a stultifying, grayed-out but faithful version of the novel, although its themes were more forcefully explored in *Brazil* (1985), Terry Gilliam's nihilist satire of future life, in which the government torturers are genial family men and one's sole recourse to life and love is through dreams.

And what is there to say about women in Eighties and Nineties sci-fi? A pair of nerd kids computer-generate their ideal woman (from *Playboy* centerfolds) in *Weird Science* (1985) while a nerdier kid creates a body for his dead girlfriend's brain from parts of 42nd Street prostitutes in *Frankenhooker* (1990). A nutty scientist attempts to clone his wife, dead for thirty years, from her preserved cells, except he lacks a willing female body. *Lifeforce* (1985) unleashed a plague of female space

vampires. *The Incredible Shrinking Woman* does so through a piteous middle-class materialism. An aging actress, in *Rejuvenator* (1988), mostly a remake of *Wasp Woman*, needs increasing doses of brain serum from her victims to restore and maintain her youthful appearance. Women are raped by aliens and give birth to monsters in both *Inseminoid* (1980) and *XTRO* (1982). There were, however, strong women characters in both *Terminators, The Abyss*, and *Aliens*, in which, fifty-seven years later, Ripley (Sigourney Weaver) takes a squad of soldiers back to Planet LB 246 and winds up again the sole survivor, her protective maternal instincts aroused by a little girl, battling the "mother" of the aliens. Susan Seidelman's interesting *Making Mr. Right* (1987) put a delightfully vengeful spin on the battle of the sexes, as the heroine winds up by choice with a robot as her perfect mate—i.e., the solution to the age-old problem of finding a good man is to make one. Perhaps the best Eighties film on women is Lizzie Borden's independent, radical feminist *Born in Flames* (1983), an angry, controversial allegory in which the U.S. is autocratically ruled by "The Party" against which dissident women party members, guerrillas, and the underground "Women's Army" unite to wage a war of terrorism.

And so continues, in danger of losing the war, the political sci-fi film into the Nineties. Overall, sci-fi is booming, but necessary costs of production, unadventuresome pandering to proven, ever more youthful audiences, and production gambles predicated largely on what has succeeded in the past has brought us to mostly avoidance of social and political issues and pure escapism in a safe, cartoony parade of Supermans, Star Treks, and Star Wars and purposeless remakes (*The Thing, Invaders from Mars*, etc.). The only sure thing is that horror elements continue to increase, reaching perhaps gross-out apotheosis in Stuart Gordon's two loose H. P. Lovecraft filmizations: *Re-Animator*

(1985) and *From Beyond* (1986), both of which reveal a Cronenberg-like distrust-revulsion of the human body.

For the most part, political and social issues and themes are only baldly used, seldom explored, for the exploitation of the fear they arouse. It is no wonder that sci-fi writers, especially those whose novels have been filmed (and the list includes Ray Bradbury, Harry Bates, Michael Moorcock, Theodore Sturgeon, Fritz Leiber, Clifford Simak, Philip José Farmer, Harlan Ellison, Frederick Pohl, and the late Philip K. Dick) form a vociferously single-minded group in their denunciation of, or exasperation with, the contemporary sci-fi film. Nor is it surprising that the most directly political sci-fi films, no matter what decade, have been those made by independent filmmakers, whether the budget is in the millions (*2001*) or thousands (*Born in Flames*).

One theme in the genre embodies the Nineties: confusion about rampant technology, poised between fear and increasing dependence, especially regarding computers, and the ominously unknowable figure of the android/cyborg (i.e., *Terminator* vs. *Robocop*). These are strictly earthbound fears; as sophisticated technology creeps ever more securely into our homes, the poor alien from outer space or giant radiated bug from the desert are clearly no match. As Pogo once observed: "I have met the enemy, and he is us." All of which, simply, fittingly, ironically, brings the politically oriented sci-fi film right back to its roots, to the earliest films of the nineteenth century.—David Bartholomew

RECOMMENDED BIBLIOGRAPHY

Justice, Keith L. *Science Fiction, Fantasy and Horror Reference: An Annotated Bibliography of Works about Literature and Film*. Jefferson, NC: McFarland & Co., 1989.

Kuhn, Annette. *Alien Zone: Cultural Theory and Contemporary Science Fiction Cinema*. NY: Routledge, Chapman and Hall, 1990.

Marrero, Robert. *The Fantastic World of Science Fiction Movies*. RGM Publications, 1987.

Palumbo, Donald. *Eros in the Mind's Eye: Sexuality and the Fantastic in Art and Film.* NY: Greenwood Press, 1986.

Parish, James P. and Michael R. Pitts. *The Great Science Fiction Pictures.* Metuchen, NJ:

Scarecrow Press, 1977.

Penley, Constance, Lynn Speigel, and Janet Bergstrom, eds. *Close Encounters: Film, Feminism and Science Fiction.* Minneapolis, MN: University of Minnesota Press, 1990.

Scorsese, Martin

(November 17, 1942 –)

Marty Scorsese is a New York-born, -raised, and cinematically educated filmmaker. Almost all his films project variations on the same personal themes and obsessions: violence as an expression of anger and alienation that can't quite be articulated; the social world as a projection of his darkest fears; relations between people (almost always men) where the capacity for loyalty and betrayal often coexist; and a quest for some variety of personal transcendence.

That holds as true for his epic, *The Last Temptation of Christ* (1988), as it does for his realist-cum-expressionist evocation of the world of "the boys" in New York's Little Italy in *Mean Streets* (1973).

From his low-budget, self-conscious *Who's That Knocking at My Door?* (1969) through *The Last Temptation* (1990), Scorsese's work is characterized by passion and manic energy. In *Who's That Knocking?* his protagonist J. R. (Harvey Keitel) is split between his sexual desires and the lingering hold of his Italian Catholic guilt. It's a lighter, less powerful version of his *Mean Streets* (1973) where J. R. turns into Charlie (played again by Harvey Keitel)—a guilt-ridden numbers-runner who absurdly wants to be both a Franciscan saint and a manager of a night-club.

Charlie is a glad-hander who inhabits a claustrophobic world bound by a narrow set of social codes, obligations, and relationships. Scorsese carefully limns the ash cans, clothes lines, and San Gennaro Festival crowds of Little Italy, but uses these gritty images as background decor. His aim is neither a detailed neorealist exploration of everyday neighborhood life nor a sentimental fantasy about a warm, humane ethnic community out of *Moonstruck.*

Mean Streets is a frenetic and chaotic work, one mainly interested in looking at both the male-bonding rituals of "the boys'—primarily punks and petty thieves—and Charlie's relationship with his alter ego Johnny Boy (played flamboyantly and brilliantly by Scorsese's alter ego Robert De Niro). Passive Charlie feeds off outsider Johnny Boy's manic, violent behavior which ultimately puts him at odds with the world he lives in. It's an original film whose overly baroque, expressionist flourishes don't detract from its powerful evocation of a community where banality, destructiveness, and loyalty coexist.

In *Alice Doesn't Live Here Anymore*

(1974) Scorsese made a glossier, less personal film about a thirty-five-year-old waitress and aspiring singer, Alice (Ellen Burstyn), who, after her husband's death, sets out with her son to create a life on her own. She fails but ends up in the understanding, strong arms of a rancher (Kris Kristofferson) out of popular myth. The film does not pretend to be a feminist work, but it contains affecting moments of women friends emotionally connecting with each other.

Taxi Driver (1976), cowritten with Paul Schrader, is a return to a more violent, hallucinatory variation on the vision of *Mean Streets*. Travis Bickle (Robert De Niro) is a Vietnam vet and New York City cab driver who, isolated behind his partition, often drives pathological and squalid passengers around the nightmarish and beautifully grotesque city streets. Bickle is a complex mass of contradictions—fusing an almost waiflike innocence with a paranoid murderousness. He's a walking time bomb, an alienated, frustrated, porn theater habitué who carries "bad ideas in his head." He also acts as a surrogate for some of Scorsese's own devils—an inarticulate man who has demons gnawing at him that he is unable either to purge or understand.

The New York summer Bickle sees in his rear-view mirror is a neon-lit, sweltering, ominous hellhole filled with junkies, pimps, and twelve-year-old hookers. Bickle is enraged by it all, and wants to cleanse the city of its human filth. The film has much more to do with Scorsese's richly textured personal fantasies about damnation and redemption and his virtuosic love for the ambiance of *film noir* than with any critique of urban disintegration and the corruption of American culture.

Scorsese may vividly use New York imagery and speech, but his obsessions are more esthetic and psychological than social or political in nature. For example, *New York, New York* (1977), his nostalgic recreation of the iconography and themes of Forties and Fifties musicals—big bands, glittery night spots, going on the fabled "road," and the drive for success—is on one level an expression of Scorsese's passion for music and film genres, in this case old pop standards like "Taking a Chance on Love" or the Kander-Ebb hit "New York, New York," singers like Peggy Lee and Judy Garland, and films like *A Star is Born*. On another level, it is a film about an intense, solitary, virtuoso jazz musician, Jimmy Doyle (Robert De Niro), and the self-destructive behavior which engulfs both his career and his relationship with Francine Evans (Liza Minnelli), the accommodating, sweet, successful band singer he loves.

In typical Scorsese style, the actions of De Niro (who dominates the film) are abrupt and stormy, and whenever his will is countered he alternates between tyrannical rage and sullen vulnerability. The nature of these dark emotions is never made clear, and they also fail to mesh with the film's loving reconstruction of the Hollywood musical, leaving *New York, New York* an exciting and ambitious if not fully realized film.

Raging Bull (1980), for which De Niro won an Oscar for Best Actor, combines naturalistic and expressionistic scenes, in powerfully evoking middle-weight champ Jake La Motta's macho rage. The film is shot in a luminous black and white, in the tradition of Hollywood boxing films like *Body and Soul,* but develops around a minimal narrative—dropping a great many details and explanations. The emphasis is on La Motta's animal fury itself rather than on its possible psychological or social determinants, both the boxing and the Italo-American neighborhood worlds being merely sketched. La Motta's brutishness is a given—pathologically jealous of his wife, and having a penchant for fighting out of the ring (beating up his loyal wife and brother) as much as in it.

The power of the film resides in De Niro's performance and Scorsese's directorial genius. De Niro captures every physical and psychic nuance and speech rhythm of La Motta's inarticulate, uncontrolled,

and paranoid behavior. Scorsese brilliantly stylizes the boxing sequences—using tight close-ups, slow motion, and high-decibel sound to convey the violence (which seemingly both fascinates and repels Scorsese) of the ring—and intercuts to crowd reactions and flashing cameras to create the ringside environment. Despite the film's transcendent moments—its striking set pieces and emotional orgies—it lacks a certain amount of coherence.

In the films that followed—*King of Comedy* (1982), *After Hours* (1985), *The Color of Money* (1986)—Scorsese continued to create variations of his earlier work. In *The King of Comedy,* De Niro is Rupert Pupkin, a madman and aspiring comedian who obsessively attempts to impose his fantasies on the world. Here, as in *Taxi Driver*, the film ironically concludes with the lunatic transformed into a media celebrity through a criminal act.

In *After Hours* a relatively conventional, Upper East Side data processor goes out for a night in a Soho which in many ways resembles a comic nightmare variation of *Taxi Driver*'s New York. It's a much slighter film than the latter, and the protagonist, Paul (Griffin Dunne), lacks both the edgy compulsiveness and sense that the world exists as an extension of his psyche that most of Scorsese's central figures convey.

The Color of Money is a big-budget Hollywood movie with Paul Newman and Tom Cruise playing out Scorsese's usual male-bonding rituals. It is an impersonal, anonymous film, however, more a star vehicle than a work characterized by Scorsese's usual emotional energy and dynamic editing and camera movements.

Scorsese's *The Last Temptation of Christ,* based on the novel by Nikos Kazantzakis, took fifteen years to get to the screen. Its esthetic and intellectual strengths and weaknesses were obscured by the controversy the film aroused. Scorsese (who once trained for the priesthood), made a deeply felt religious film which enraged the born-again Christians,

the intolerant, and the fanatical who tried to both repress and literally destroy the work (a theater in Paris showing the film was set on fire). His Christ is an intense, tormented figure (Willem Dafoe), not the bland, sterile Christ (Jeffrey Hunter) of earlier, conventional epics like *King of Kings* (1961).

Scorsese's version gives us a working-class Christ who fuses the human and the divine; he's a man with doubts, fears, and desires who through mortal struggle achieves divinity. His Christ becomes angry, wavers in his calling, and triumphs over the devil's final temptation—a seductively serene sexual and domestic life—to affirm his painful godhead on the cross. It's clearly a vision which maddens all those who want their Christ to be sanctimonious and asexual, enveloped in a divine halo.

All of Scorsese's characteristically nervous, tense style and virtuosity is on display in *The Last Temptation of Christ.* The camera tilts, zooms, pans, and tracks and provides many striking, high overhead shots. Scorsese's Christ has an intimate, love-hate relationship with the most beloved and courageous of his Apostles—Judas (Harvey Keitel). This revisionist version of the Judas-Christ relationship fits right into Scorsese's obsession with buddies who continually both complement and betray each other.

The Last Temptation is a personal work which, stylistically and thematically, is unmistakably a Scorsese film. What feels tedious and doesn't quite jell in this naturalistic-surrealistic vision of the Gospels is probably inherent in any attempt to construct, for a contemporary audience, a narrative built on parables, miracles, and voice-overs of the devil. In addition, although Scorsese's working-class Apostles are close to the spirit of the original disciples, their thick, New York accents often seem egregious and unintentionally absurd.

Scorsese followed *The Last Temptation* by contributing the strongest segment, "Life Lessons," to *New York Stories* (1989);

the other two sections were directed by Woody Allen and Francis Coppola. In "Life Lessons" Scorsese provides a convincing and knowing portrait of a painter (Nick Nolte) totally and selfishly consumed by his need to produce works of art.

In *GoodFellas* (1990), Scorsese constructs an unsentimental portrait of the sleazy, banal, brutal world of Mafia foot soldiers who have the moral awareness of slugs. These are ordinary men with limited sensibilities, who inhabit a casually murderous universe where criminal activity is as normal as breathing. Scorsese avoids judging his characters or providing social or psychological explanations for their behavior. Instead he centers the film on the life and point of view of a second-rung hood, Henry Hill (Ray Liotta), who provides a perceptive, quasianthropological commentary on the mob's codes and mores.

Although *GoodFellas* is less stylized and expressionistic than *Taxi Driver*, it makes no pretense at being a social document. Scorsese self-reflexively uses freeze frames, narration, and a sound track saturated with songs ranging from "Sincerely" to "Gimme Shelter" to create some emotional and esthetic distance. It's a formally heady work, but one devoid of epiphanies; just a richly detailed, sometimes grisly comic portrait of violent men who exult in their version of the American Dream.

In his remake of the 1962 thriller *Cape Fear*, Scorsese succeeds in demonstrating to the Hollywood money men that he can make a crowd-pleasing genre film. It's a thriller, however, which contains elements of a more personal and imaginative work. Its hero-victim, Sam Bowden (Nick Nolte), is a womanizing lawyer with a fragile marriage, and its villain, Max Cady (a tattooed, Bible-quoting Robert De Niro) is a larger-than-life, expressionist monster, who the film intimates is Bowden's *doppelgänger*. Despite these suggestive strains, and Scorsese's sly mockery of some of the formal devices of the thriller, the film is essentially a mechanical, impersonal, stylish

exercise—dependent on violent shocks and climaxing in an interminable battle between an evil Cady and a victorious Bowden.

Except for a few commercial forays, Scorsese is a director who has consistently and courageously pursued his own cinematic style and vision. His films are not given to luminous, painterly compositions or to tightly plotted narratives, but they have a keen eye for atmospherics, an ear for the syntax and cadences of his characters, a powerful, tense rhythm, and a sense of immediacy and emotional volatility. Intensely kinetic camera movements help shape a world which is dominated by the tortured consciousness of his often isolated, angry central figures. Scorsese's protagonists live on the margins and often see the world from an angle that puts them at odds with the rest of society. Although the films carry no explicit political or social critique, the perceptions and actions of characters as apparently dissimilar as Travis Bickle and Christ radically break from conventional social or religious codes and inveigh against the corruptions of society.

With all his formal boldness and raw, pulsating energy, Scorsese's work, at times, lacks a sense of a governing intelligence. Still, there are scenes in almost every one of his films that knock one out, that have great force and passion. Nevertheless, there is a gnawing feeling that there is a fragmented quality about some of his work, that the privileged moments—emotional and esthetic—carry more weight than the whole. Scorsese is nevertheless a genuine auteur whose best films have both a hallucinatory power and darkly comic perspective on the lives and psyches of men who are either alienated, murderous, or disaffected. In Scorsese's America, obsessive and turbulent behavior is the norm.—Leonard Quart

RECOMMENDED BIBLIOGRAPHY

Ehrenstein, David. *The Scorsese Picture: The Art and Life of Martin Scorsese*. NY: Birch Lane Press, 1992.

Ebert, Roger and Gene Siskel. *The Future of the*

Movies: Interviews with Martin Scorsese, George Lucas, and Steven Spielberg. Kansas City, MO: Andrews and Mcmeel, 1991.

Kelly, Mary Pat. *Martin Scorsese: A Journey.* NY: Thunder's Mouth Press, 1991.

Kolker, Robert Phillip. *A Cinema of Loneliness.: Penn, Kubrick, Scorsese, Spielberg, Altman.* NY:

Oxford University Press, 1988.

Keyser, Les. *Martin Scorsese.* NY: Twayne Publishers, 1992.

Pye, Michael and Lynda Miles. *The Movie Brats.* NY: Holt, Rinehart and Winston, 1979.

Thompson, David, ed. *Scorsese on Scorsese.* Winchester, MA: Faber and Faber, 1989.

A Corner in Wheat

Owing to the advance in the price of flour

Silent Films

More than 30,000 features and shorts were produced by the American film industry between 1896 and 1928. More than eighty percent of these films, however, no longer exist, and this fact, coupled with the inadequate documentation on films of the period, makes the historian's task doubly difficult.

It is nevertheless clear that filmmakers during the silent period seemed more willing to deal with controversial subject matter. Censorship and moral pressures applied to early filmmakers were more concerned with violence and suggestive sexual matter than with anything else. A study of the policies of the National Board of Review of Censorship of Motion Pictures, which was founded in June of 1909 and which was later to become the National Board of Review, reveals that the Board found nothing objectionable in films dealing with birth control, capital punishment, and socialism, provided they were not shown in a "crass, crude, and commer-

cial manner."

Filmmakers were quick to take advantage of the liberal attitudes of early public and private censorship boards. *Traffic in Souls* (1913) is little more than an entertaining yet sleazy story of prostitution and white slavery, but because it was "inspired" by the Rockefeller White Slavery Report and the New York District Attorney Whitman's investigation of vice, it ran into few censorship problems. The early filmmaker also understood the makeup of his audience. He realized that most filmgoers came from the working-class, immigrant population. Such an audience would prove a willing box office booster for films such as *The Italian* (1915), which featured George Beban as a poor Italian immigrant, an innocent victim of the New York political bosses. Audiences witnessed themselves and their life-styles depicted in such films.

Labor disputes were the subjects of many early films; the best known, of course, being D. W. Griffith's *Intolerance* (1916), with its depiction of a long, drawn-out strike and its effects on the workers of the community, possibly based on the 1914 strike against the Colorado Fuel and Iron Company. The factory owner, with his various charitable activities, is obviously a characterization of John D. Rockefeller, whose Rockefeller Foundation owned shares in the American Agricultural and Chemical Company, the subject of another bitter strike early in 1915.

The film industry had been producing motion pictures concerned with strike actions for many years previous. Some were comedies, such as *How the Cinema Protects Itself Against Strikes* (Eclair, 1911), which utilized trick photography to move sets around and to costume actors, or *Cops on Strike* (Pathe, 1909), which had prisoners released from jail to arrest the striking policemen. The majority were melodramas, often with romantic subplots, and the industry showed no particular favoritism towards either management or labor. *The Strikers* (Eclipse, 1909) had a strike agita-

tor proven a coward by the young boss; in *The Long Strike* (Essanay, 1911), the son of the president of the company falls in love with one of the striking workers; *A General Strike* (Gaumont, 1911) showed "the desolation and destruction" that such a strike would cause; in *The Strike at the Mines* (Edison, 1911), the manager of the mines saves a worker who tries to defend himself against the strikers; in *The Right to Labor* (Yankee, 1910), the strikers, because of an unreasonable manager, turn to anarchy; and in *The Long Strike* (IMP, 1912, and not to be confused with the Essanay film of the same title), a striker is wrongly accused of shooting the factory superintendent. Vitagraph's *Capital vs. Labor* (1910) depicted mob violence at work in a strike and had a young minister calm the striking workers and persuade the capitalist to grant concessions. *The Moving Picture World* commented, "Perhaps the picture will have a salutary influence during this season when strikes pervade the air and from almost every section of the country comes talk of industrial complaint."

It was D. W. Griffith who directed what is probably the most discussed early short to deal with capitalism and labor, *A Corner in Wheat*, based on Frank Norris's short story, "A Deal in Wheat," and the same author's novel, *The Octopus*. The film contrasted the farmer growing the wheat for a small return with the speculators cornering the wheat market and garnering vast profits at the expense of both the farmer and the purchaser. It was one of many American Biograph productions directed by D. W. Griffith between 1908 and 1913 in which a social consciousness was evident.

One of the most impressive docudramas concerned with labor unrest is the last chapter, episode twelve, entitled "Toil and Tyranny," of the 1915 Pathe series, *Who Pays?* Director-to-be Henry King leads a strike action against the wealthy "boss," who has been driving his workers harder and harder. In retaliation, the "boss" forecloses on the company-owned homes of the strikers, to the horror of his somewhat

spoiled daughter, played by Ruth Roland. After the wife of the Henry King character has died from starvation and illness, he takes a gun to kill the "boss," but instead, accidentally, shoots the daughter. As the wealthy capitalist is left with his dead offspring and King is dragged off to jail, a title asks, "Who pays?" Thankfully *Who Pays?* survives in its entirety, but the same is not true of the 1914 All-Star Feature Corporation film version of Upton Sinclair's novel, *The Jungle*. A faithful rendition of the original work, *The Jungle*'s producers were forced to create their own stockyards and canning factories because of the refusal of owners to cooperate in any way with the film. Upton Sinclair appeared in the last reel of the feature and also spoke at each performance of the production's initial New York run. *The Moving Picture World* reported, "The vivid distinction shown between the employer and the employed and the wide and bridgeless chasm that yawns beneath the selfish and arrogant rich and the dependent poor contains much that is of human interest."

Child labor was also of concern to some early filmmakers. Thanhouse produced a two-reeler in 1912 titled *The Cry of the Children*, which illustrated the horrors of children working in the mines, while Edison released two major anti-child labor one-reel productions, *Suffer Little Children* (1909) and *Children Who Labor* (1912). Edison also produced two shorts—*The Price of Human Lives* (1913) and *The Temple of Moloch* (1914)—endorsed by the National Association for the Prevention of Tuberculosis, which vividly demonstrated why the death rate from TB among unskilled laborers was seven times higher than that among the professional classes. The one item which early film producers neglected to admit was that one major area of child exploitation was in the nickelodeons, where children worked (often without pay) as sales attendants and entertainers.

Women's rights offered early fimmakers endless opportunities for ridicule, with one-reel shorts such as *A Militant Suffragette* (Thanhouser, 1912), *Oh, You Suffragette* (American, 1911), *Bedelia and the Suffragette* (Reliance, 1912), *Leah, the Suffragette* (Cines, 1912), *For the Cause of Suffrage* (Melies, 1909), *The First Woman Jury in America* (Vitagraph, 1912), and *When the Women Strike* (Lubin, 1911). Typical of the plotlines of these films was that for *A Day in the Life of a Suffragette* (Pathe, 1908), in which a group of militant suffragettes are forced to spend the night in prison and next morning meekly follow their husbands back home to their domestic duties.

There were some pro-female emancipation films, however, notably *The Senator and the Suffragette* (Edison, 1910), in which the suffragettes win a senator over to their cause; *A Suffragette in Spite of Himself* (Edison, 1912), in which an opponent of women's rights unknowingly walks around with a "Votes for Women" placard pinned to his coat; and *Was He a Suffragette* (Republic, 1912), which had another oponent of the cause forced to march in a suffragette parade. In 1912, Reliance produced a two-reel short titled *Votes for Women*, in which a senator with opposing views is won over to the suffragette cause by his fiancée, and which closes with a suffragette parade down New York's Fifth Avenue. The scenario was the work of Mrs. Mary Ware Dennett, Mrs. James Lees Laidlaw, and Mrs. Frances Maule Bjorkman of the National Women's Suffrage Association, and the production also included appearances by the president and vice-president of the association, Dr. Anna Shaw and Jane Addams, as well as many other prominent suffragette leaders.

The most important suffragist production of the Teens was the four-reel 1913 feature, *Eighty Million Women Want—?*, produced by the Unique Film Company, and including scenes at suffragette headquarters, featuring Mrs. Pankhurst and Mrs. Harriet Stanton Blatch of the Women's Political Union. *The Moving*

Picture World reported, "Those who have looked upon the Votes-for-Women movement as the last refuge for old maids and cranks are due for a most pleasant surprise and agreeable disillusionment. The heroine of the story, though a staunch enough suffragette, is womanly from top to toe, and both she and the hero look and act their best when they gaze upon the marriage license, which forms the finale of the story."

From productions such as *Eighty Million Women Want—?*, it was but a short time before the film industry was producing features titled *Should a Woman Divorce?* (Ivan, 1914), which asked the public to judge the moral issue raised. By 1917, the New York Woman's Suffrage Party was able to produce the two-reel *Woman's Work in War Time*, illustrating "what the women of the country are doing and will do as their share of the war's work."

Two films from 1921 depicted women seeking political office. In *Man—Woman—Marriage*, Dorothy Phillips runs against her politically corrupt husband for the U.S. Senate and wins, and, in flashback, dreams of women's roles through the ages. In *Woman's Place*, Constance Talmadge is the Women's Political League candidate for mayor, but she loses to her corrupt fiancé, who gets the women's vote. He becomes an honest politician, however, and fills his political appointments with women. Women also dominated *The Last Man on Earth* (1924), set in 1954, in a world peopled exclusively by women after an epidemic of "masculitis" has killed off all males over fourteen, except for one.

Long before women were given the vote, one woman director was demonstrating an extraordinary concern for social and moral values in her films, and that woman was Lois Weber (1881–1939). There is little question that no other director active in the American silent cinema so consistently expressed personal beliefs and used their films to urge social change as did Lois Weber. As early as 1911, Weber's *The*

Martyr depicts the sorry lot of motherhood. She was concerned, as the title of a 1913 lecture given by Lois Weber indicates, with "The Making of Picture Plays That Will Have an Influence for Good on the Public Mind." *The Jew's Christmas* (1913) was concerned with racial and religious prejudice; *Hypocrites* (1915) presented an attack on hypocrisy in the church and in daily life, with an additional strike against political corruption; *Jewel* (1915) and *A Chapter in Her Life* (1923) were both preachments for the philosophy of Christian Science; *Where Are My Children?* (1916) advocated birth control and opposed abortion; *The People vs. John Doe* (1916) was a treatise against capital punishment; *The Blot* (1921) argued for fair wages for the teachers and clergymen who "clothe men's minds." In her time, Lois Weber was never fully appreciated by either the public or the critics, and she was vilified by editorials such as that in the June 1918 issue of *Theater Magazine*, which accused her of using motion pictures to sell "dirty propaganda." Today, she is largely ignored by both historians and feminists.

It was not until the outbreak of the First World War in Europe that American filmmakers fully realized the political potential of the motion picture. Prior to America's entry into the conflict, on April 6, 1917, filmmakers worked with political figures to sway the American populace for or against the allied cause.

Preparedness, with its implication that the country must be ready to fight against German aggression, was propagandized in films such as *The Flying Torpedo* (1916), *Defense or Tribute* (1916), *The Fall of a Nation* (1916), and *The Battle Cry of Peace* (1915). The last was the most important and influential of the bunch, taking as its basis Hudson Maxim's book, *Defenseless America*. It was produced by the Vitagraph Company, under the guidance of its cofounder, J. Stuart Blackton, an Englishman who did not become an American citizen until after the film's com-

pletion, leading to unsubstantiated accusations that the British Embassy in Washington had funneled funds to the filmmaker. Aside from its stars, Norma Talmadge, Charles Richman, and Harold Huber, *The Battle Cry of Peace* utilized 25,000 National Guard troops, along with 800 members of the Grand Army of the Republic, and boasted Theodore Roosevelt as its most ardent supporter.

The film opens with Hudson Maxim delivering a lecture illustrating America's lack of preparedness for war, and then gets down to the story of a prominent "Peace at Any Price" supporter whose actions lead to America's fall to suspiciously German-looking invaders, who bomb New York and Washington and embark on a wholesale campaign of rape and desolation. The Daughters of the American Revolution arranged for a special screening of the feature in Washington, D.C., but President Wilson declined an invitation to attend.

On the opposing side, the pro-Wilson forces offered Thomas Ince's religious allegory, *Civilization* (1916), which had Christ return to earth in the body of an inventor responsible for a submarine used to sink ships carrying innocent women and children. The returned Christ shows the king who is waging the war what his belligerence has caused and the king hastily sues for peace. President Wilson endorsed the production which, happily as it transpired, could, with some subtle editing, be transformed into an anti-German film, which was so done when America eventually entered the war. One should never be surprised at what a little political pressure and the promise of extra income could do to an American film producer's ethics.

There were few basically anti-British films produced in those years immediately prior to American entry into the conflict. "The Liberty Boys" series was one, and the best known is *The Spirit of '76* (1917), produced by Robert Goldstein, which showed British atrocities during the revo-

lutionary war, and which had the misfortune to open some months after America's declaration of war with Germany. Goldstein was indicted on three counts of espionage, namely that he "willfully and unlawfully attempted to cause insubordination, disloyalty, mutiny and refusal of duty on the part of the military and naval forces of the United States." For his account of the American revolution, Goldstein served one year in jail and was fined $5,000.

Among the literally dozens of anti-German films produced during this period, the most notable are *The Little American* (1916), in which America's sweetheart, Mary Pickford, is threatened with rape by a lecherous Hun, *Arms and the Girl* (1917), *Firefly of France* (1918), *The Hun Within* (1918), *The Prussian Cur* (1918), *The Claws of the Hun* (1918), *My Four Years in Germany* (1918), *The Kaiser, the Beast of Berlin* (1918), *Lest We Forget* (1918), and *The Heart of Humanity* (1918). D. W. Griffith, who had advocated tolerance and peace in *Intolerance*, did his part for the war effort with *Hearts of the World* (1918).

In the early years of this century, American filmmakers openly criticized the Czarist regime of Nicholas II in films such as *The Nihilists* (American Biograph, 1905), *Russia, the Land of the Oppressed* (Defender, 1910), *The Russian Peasant* (Kalem, 1912), and *Beneath the Czar* (Solax, 1914). However, the 1917 uprising in Russia, the tales of bloodthirsty revolutionaries and the "nationalization of women" which filtered through to the West, together with the industrial disputes which followed the First World War and the rise of the Industrial Workers of the World (IWW), brought about a marked change in the cinema's attitude towards revolutionaries.

Nine "Red Scare" films were released during 1919 and 1920, including *Bolshevism on Trial*, *The Red Viper*, *The Right to Happiness*, *Lifting Shadows*, and *Dangerous Hours*. The Department of Labor set up a motion picture section, under David K.

Niles, "to combat Bolshevism and to teach Americanization through the medium of the picture." Producers were urged to indulge in "constructive education" rather than "destructive propaganda," and to depict their film heroes in the mold of a "strong virile American, a believer of American institutions and ideals."

Probably the best of the "Red Scare" cycle—from a cinematic point of view— was Thomas H. Ince's production of *Dangerous Hours* (1920), based on the story, "A Prodigal in Utopia," by Donn Byrne. Directed by Fred Niblo, it depicted a young college graduate duped into collaborating with a group of Bolsheviks fomenting a shipyard strike. It also featured a sequence showing life in Russia, a terrifyingly vivid portrayal of pillage and rape. The manager of the General Motors works in Saginaw, Michigan, purchased 5,000 tickets to enable his staff to witness the dangers of the red menace.

As late as 1923, Fox released the two-reel *Red Russia Revealed*, comparing the well-fed leaders, Lenin and Trotsky, and the well-fed Red Army with the poor of Petrograd and Moscow, in lines for fuel and bread. "Poverty and plenty, weakness and power, ignorance and intelligence, stalk hand-in-hand through these two reels, a strange mixture vibrant with all the pathos and drama of a great human tragedy," reported *Motion Picture News*.

When the American silent cinema looked around for a group to hold up to ridicule or persecution, it was the Church of Jesus Christ of Latter Day Saints—the Mormons—which seemed best suited to the industry's needs, and literally dozens of films were produced, not only in the United States, but also in Great Britain and Denmark, depicting helpless young women being taken as slaves to Utah. Strangely, the Ku Klux Klan held little interest for filmmakers. In 1913, Sidney Olcott had directed Gene Gauntier in *In the Clutches of the Ku Klux Klan*, released by Warner's Features, which had the daughter of a newspaperman, who

attacked the Klan, held captive by the group until rescued by a Klan member in love with the woman. D. W. Griffith's *The Birth of a Nation* glorified the original Klan, but although it most assuredly helped to reestablish the KKK in America, it did not bring about an immediate flood of Klan films.

With the growth of the second Ku Klux Klan in the Twenties, a couple of films were released depicting the organization in a negative light—*Knight of the Eucharist* (1922) and *The Mask of the Ku Klux Klan* (1923)—but both of these productions were chiefly concerned with the Klan's anti-Catholic stance and ignored its blatant racism. The Klan was depicted as an honorable organization in *One Clear Call* (1922), *The Fifth Horseman* (1924), and *The Mating Call* (1928). In addition, the Columbus KKK produced its own feature, *The Toll of Justice*, released in the fall of 1923, which was advertised as "The picture that every red blooded American should see—Do away with the underworld—Clean our country of filth—Protect pure womanhood." The KKK had no problems in marketing the film, under its own auspices, in twenty-one states.

In the Teens, American filmmakers displayed at least a passing interest in politics and social reform. They were not afraid to exhibit a political view, albeit more often than not the view of the political establishment. In the Twenties, the film industry adopted an attitude that politics had little place in the entertainment of the masses. Political corruption played a part in the stories of many dozens of films, but it was there simply as a plot contrivance, not because filmmakers were adopting a political attitude. Outside of the industry, a number of groups such as the Labor Film Service attempted to produce films presenting a left-wing viewpoint of the labor movement, the Communist Party in America, police repression, and so on, but these groups were doomed to failure because the exhibition outlets were exclu-

sively controlled by the major studios. Critics and historians would tell us that the film industry had grown up, but it had come to an apolitical, covertly proestablishment maturity.—Anthony Slide

RECOMMENDED BIBLIOGRAPHY

Brownlow, Kevin. *Hollywood: The Pioneers.* NY: Alfred A. Knopf, 1979.

—— *The Parade's Gone By.* NY: Crown Publishers, 1968.

—— *Behind the Mask of Innocence: Sex, Violence, Prejudice, Crime: Films of Social Conscience in the Silent Era.* NY: Alfred A. Knopf, 1991.

Butler, Ivan. *Silent Magic: Rediscovering the Silent Era.* London: Columbus Books, 1987.

Everson, William. *American Silent Film.* NY: Oxford University Press, 1978.

Slide, Anthony. *Early American Cinema.* NY: A. S. Barnes, 1970.

··

The Small Town in American Cinema

Hollywood's image of the small town has undergone many dramatic changes over the years. From the sunny, apple pie image of Andy Hardy's small town to the unprecedented violence of *Walking Tall*'s southern burg, the small town has been the focus of filmmakers, both conservative and liberal, who seek to state their views on American life.

During Hollywood's "golden years," the small town represented all the basic rightwing American values—the glorification of home and motherhood, community, Puritan love, and the work ethic. More recently, it has been the target of liberals who see it as one of the last outposts of racism and political corruption. In either case, the town has been treated symbolically. For better or worse, Hollywood has always considered the small town the heart and soul of America.

During the Depression years, the small town was portrayed as a beacon for the rest of America, a veritable paradise. In Andy Hardy's[1] town, there is no poverty, families are stable, and although Andy is a mischiefmaker, things always turn out fine in the end. The most pressing issues facing Andy are whether Judy will be his date for the prom or whether the high school show will go on. That small towns underwent extreme hardships during the early years of Andy Hardy's popularity, that many rural teenagers were heading for the cities to look for work because their parents couldn't afford to feed them, seemed to escape most filmmakers' notice. According to most Hollywood films of this time, unemployment and hard times were purely an urban experience. The classic portrait of Depression city life is the aptly titled *Dead End* (1937). As this film so vividly demonstrates, there is no hope for the city dweller, no way out of the filth and poverty of the big-city slum. The slums not only cause frustration for the film's heroine, Drina (Sylvia Sidney), but are turning her younger brother Tommy and his pals into violent hoods. The Dead End Kids

idolize gangster Baby Face Martin (Humphrey Bogart) who "lives off the fat of the land" and ridicules the all-American values of hard work and Christian morality. Despite Drina's efforts, it seems inevitable that Tommy will become a gangster, unless he can somehow be removed from the slum environment. Throughout *Dead End*, this solution hovers as an impossible dream. Drina hopes that some day a rich benefactor will take her to the suburbs or a town, where it's clean and friendly and Tommy would surely grow up to be a nice kid.

This dichotomy between town and city provided a convenient interpretation of America's woes. One of the most frequently cited causes of the Depression was corruption. Crooked politicians, businessmen, and gangsters were robbing America blind. As Hollywood would have it, the city was the breeding ground of this corruption. The cure for the Depression was a return to the basic American values of the small town.

The city/country theme developed into two variations: the films either brought the townsfolk to the city to teach its inhabitants a lesson or brought the cynical city-dweller to the country to have his faith in America restored. The first variation, classically represented by Frank Capra's *Mr. Deeds Goes to Town* (1936), brings an innocent to the metropolis where he is immediately set upon by sharpies. Coming from a place where everybody is friendly and honest, he naturally trusts the city people who, in turn, exploit and betray him. In *Mr. Deeds*, Gary Cooper's naive millionaire wants to use his fortune to help those less fortunate than himself. He comes up with a plan to solve the Depression by giving each deserving family "ten acres, a horse, a cow and some seed." His greedy city relatives attempt to have him committed before he can give his fortune away. But Deeds, providing a classic argument for laissez-faire capitalism (there will "always be leaders...and followers" and it's up to the leaders to give the followers a hand)

convinces the judge that he's "the sanest man that ever walked into this courtroom." Charity, Capra suggests, should be left up to the individual citizen. If more people like Deeds would live up to their moral responsibilities and help the poor, there would be no need for such governmental intervention as welfare or social security. The political implications are obvious. Just as Drina's hopelessness represents the failure of the political system, so Deeds's triumph represents its justification.

The second variation, represented by *Boys Town* (1938) and *They Made Me a Criminal* (1939), involves the city dweller's confrontation with the country. The simplistic *Boys Town* suggests that if city slums cause delinquency, then the answer is to simply move the kids to the country. Armed with his faith that "There's no such thing as a bad boy," Father Flanagan (Spencer Tracy) takes slum tough Mickey Rooney to his model "town" to reform him. There, a snarling, nasty Rooney quickly forgets the wounds of his impoverished city childhood and reverts to his more familiar Andy Hardy persona.

In *They Made Me a Criminal*, John Garfield portrays a New York boxer on the run from a phony murder rap. Garfield is a Dead Ender grown up and embittered, who has never been lucky enough to come under the aegis of a Father Flanagan. Hounded by the cops and relentless bad luck, Garfield has always been in the wrong place at the wrong time until he comes to a rehabilitation ranch for juvenile delinquents. Away from the city, the adult delinquent falls in love with a nice social worker who changes his belief that life is a "sucker game." The small town/country atmosphere helps unmake him a criminal.

King Vidor's *Our Daily Bread* (1934) offers an interesting variation on the city dweller's move to the country, proposing that cooperative farms where hungry, unemployed city dwellers can grow their own food may be the answer to hard times. Though it has socialist overtones, Vidor's cooperative is really a revamped version of

Deeds's ten acres. What Vidor's characters are seeking is not a new form of existence but a return to past forms of achievement. In a key speech, Vidor's protagonist compares the co-op members to America's Pilgrim forefathers:

> When they arrived on this continent, what did they do? Stand around and beef about the unemployment situation?...No. They set to work to make their own employment, build their own houses, and grow their own food...What we've got to do is help ourselves by helping others.

There is almost a sense of nostalgia, of retreat that characterizes Vidor's film and many others of this period. The city—cold, impersonal, corrupt—is the shape of *Things to Come* (1936) and the farm community is the America We Knew which is rapidly fading into oblivion. As the past-tense title of John Ford's *How Green Was My Valley* (1941) indicates, the valley is no longer green, its way of life has given way to the industrialized city. With the advent of WWII, even Frank Capra began to have doubts about the efficacy of small-town values in the modern world. In films such as *Mr. Smith Goes to Washington* (1939) and *Meet John Doe* (1941), the triumph of his hick hero over the forces of big-city corruption became increasingly tenuous. By the postwar *It's a Wonderful Life* (1946), arguably Capra's masterpiece, the corruption has spread from the city to the small town and Capra's hero himself begins to question his values. Although George Bailey (Jimmy Stewart) wants to see the world, he never leaves his home town of Bedford Falls because of his sense of responsibility to his family, friends, and community. After a lifetime of battling the evil Mr. Potter (Lionel Barrymore), George finds his company, the Bailey Building and Loan, on the verge of bankruptcy, about to be seized by Potter's bank. The Building and Loan is dedicated to the preservation of a way of life, to allowing families to own a private home. If the company fails, these families will have no choice but to live in Potter's high-rise tenements. The town is in danger of becoming exactly like the city.

It is only through divine intervention in the form of George's guardian angel Clarence (Henry Travers) that George and his town are saved from self-destruction. Clarence answers George's despairing exclamation that he wishes he'd never lived by showing him exactly what Bedford Falls would have been like if George hadn't existed. In a powerful, frightening nightmare sequence, George wanders through a town renamed Pottersville, a seedy, garish imitation of the city replete with nightclubs, hookers, and neon signs advertising good times. With nobody to counterbalance Potter's evil, the world based on family and community has been raped by the forces of greed, cynicism, and progress. George awakens from the nightmare convinced that his life has been worthwhile. There is a happy ending as all the little people he's helped over the years give George the money he needs to save the Building and Loan. The myth of small-town America is reaffirmed, but George's despair is more convincing than his rebirth. *It's a Wonderful Life* is Capra's last stand—only through fantasy can Bedford Falls's virtue be preserved.

Not surprisingly, some filmmakers reacted against the sanctimonious clichés about small towns proferred by such films as the Andy Hardy series. As early as the mid-Thirties, Fritz Lang's *Fury* (1936; see also *They Won't Forget*, 1937) voiced a dissenting opinion about the "goodness" of small townsfolk. In *Fury*, the myth of the friendly, tolerant small town is revealed as a fraud. According to Lang, the small town is rife with the kind of frustration and boredom that can lead to violence. When a big-city visitor is arrested on suspicion of kidnapping, the townsfolk channel that frustration against him. A crowd gathers around the local jail to see that "justice" is done. Their anger soon erupts into mob violence as they surge forward, overcome the guards, and set fire to the jailhouse. In a sequence every bit as frightening as

George Bailey's nightmare, the mob watch the trapped prisoner burn, their faces grinning with almost orgiastic delight as they listen to their victim's screams for help.

Gradually Lang's view of small-town life came to be commonplace in Hollywood films. By the time Capra made *It's a Wonderful Life*, the Depression had ended and with it much of the rationale for the city/country conflict. As America emerged from WWII as the world's most powerful nation, there was no longer the need to focus on big-city corruption as a cause of the Depression, nor to hold up small-town values as its antidote. The war changed America's image of itself—and with it the image of the small town. Andy Hardy's town—and its values—had little meaning to an increasingly urban audience's life-style.

In the postwar years, with the gradual breakdown of the studio system and corresponding rise of independent filmmakers, Hollywood briefly adopted a more realistic and liberal approach. Previously, politically conservative studio bosses had censored discussion of the persecution of minorities. Where Lang could make only oblique reference to the racial motivations of most lynch mobs, a number of filmmakers now directly linked racism to lynching. In *The Lawless* (1950), *Intruder in the Dust* (1949), and *Bad Day at Black Rock* (1955), the small town is portrayed as a place seething with hatred, ready to explode against its Chicano, black, or Japanese residents. In *They Made Me a Criminal*, the beleaguered Garfield finds sanctuary in the small town. But the moment war veteran Spencer Tracy arrives in Black Rock to present the medals of his dead Japanese-American buddy to his family, you know he's in for trouble. The small town no longer represents what is good in America but rather the opposite: it is the haven for its most dangerous and reactionary elements.

Given the extreme conservatism of the McCarthy era, any attack on small-town bigotry could be intepreted as a covert attack by liberals on the McCarthyites who would again hold up the town as the "true" America. Certainly many critics have offered this interpretation of Fifties films like *High Noon* (1952) and *Storm Center* (1956) in which the protagonists take a stand against their cowardly or bigoted neighbors. Conversely, Leo McCarey's reactionary *My Son John* (1952) equates communism with the city and holds up town as the answer to treasonous urbanites.

Despite such throwbacks as *My Son John*, the image of the town and city had flip-flopped. The town now seemed as corrupt and evil as the big city was in Capra's day. In Phil Karlson's *The Phenix City Story* (1955), a small town is overrun by gangsters, while the town in Arthur Penn's *The Chase* (1966) resembles a Southern, modern variation on Pottersville. Here all the big-city evils have emerged in the small town. As in *Dead End*, the children have been twisted by the corrupt atmosphere. A group of teenagers watch uncaring as an escaped convict is shot by a trigger-happy resident while attempting to give himself up to the police. In later films, the corruption is awesome. When Buford Pusser (Joe Don Baker) defeats the forces that would destroy his town in Phil Karlson's *Walking Tall* (1974), his life has also been destroyed. His wife has been murdered by mobsters and there is nothing left for him. Yet despite Pusser's heroics and sacrifice, the evil has still not been vanquished as the mobsters come back to haunt the hero in sequels to the original film.

Other films downplayed the violence and corruption of small-town life, preferring to emphasize the small-mindedness of the townsfolk. The town in William Inge's *Picnic* (1956) is so set in its ways that it cannot tolerate the presence of an intruder (William Holden) and ultimately forces him out of town. In *Rebel Without a Cause* (1955) and *East of Eden* (1955) James Dean plays an alienated rebel against middle-class America. Sensitive and introspective, Dean is unable to grow or even survive in the stultifying atmosphere in which

he was raised. In *The Wild One* (1954) the townsfolk are so dimwitted that Marlon Brando's nihilistic motorcycle gangleader seems attractive by comparison. Asked what he's rebelling against, Brando sneers "Whaddya got?" But when Mary Murphy, the typical "good girl" looks at her dreary life and her unattractive suitors, she has to admit that Brando has a point. She is sorely tempted to get on the back of his bike and ride out of town forever.

The only way the residents of *Peyton Place* (1957) can ward off boredom is through illicit sex and alcohol. Others, too timid to leave or indulge in such pleasures, suffer for most of their lives. The small town has taken another guise—it is not so much a place of violence and corruption but a place of confinement, restriction, and frustration. These small towners are a much more civilized breed than those of *Fury*, attempting only to survive in the town with some dignity.

This is not, of course, always possible. The ultimate indignity of small-town life is spinsterhood. The climactic moment of George Bailey's nightmare occurs when he encounters his wife who, in his absence, became an old maid. When she recoils with horror at his approach, George realizes just how important his existence has been. This is only a nightmare in Capra's film but for many later heroines it was a fact of life. In Tennessee Williams's *Summer and Smoke* (1961), Geraldine Page plays the minister's daughter, demure on the outside but seething with frustrations inside. Her purgatory in the town is outlined in the film by her routine life—year after year she sings in the bandstand, gives music lessons, and puts up with a psychotic mother who, it is implied, has gone mad through the frustration of being a minister's wife in a small town. Rosalind Russell's portrayal of a bullying, hysterical teacher trying to railroad a reluctant bachelor into marriage in *Picnic* provides an interesting contrast with Russell's earlier role as the liberated big-city news reporter in *His Girl Friday*

(1940). Where the urban woman is able to find a good job and a good man (Cary Grant, no less), the small-town schoolmarm remains frustrated on all levels. Likewise, Katharine Hepburn, the Forties symbol of liberated womanhood, always a sophisticated urbanite, is a lonely country spinster, aching for love in *The Rainmaker* (1956).

By the early Seventies, the Hollywood town was not merely oppressive but decaying. *The Last Picture Show* (1971) details, in drab black and white, the slow, boring stagnation of a small Texas town near its death. With the closing of the only movie theater, there are not even any Hollywood-manufactured dreams to sustain the few remaining citizens.

The Last Picture Show and *Walking Tall* notwithstanding, with the advent of the Seventies, Hollywood's interest in the small town as a political and social symbol began to wane. In *American Graffiti* (1973), the small town is an important backdrop to the film's many subplots. But the film takes no strong positions on either the goodness or evil of the town. Although the hero knows his future is in the city, he is reluctant to leave his hometown. If college and later the city offer him the opportunity to fulfill himself as a writer, he will never again find the companionship, the closeness of his earlier life.

During the Eighties, Hollywood's interest in the small town perked up considerably. According to Emanuel Levy's definitive study, *Small-Town America in Film* (Continuum, 1991), there were nearly a hundred films during the decade that dealt with small-town life, almost double the number of the previous ten years. There is, however, no discernible trend in these films. Some are critical of the town while others revere it. Still others take the middle ground where the city and the country seem to meet, and the characters who populate each are not really distinguishable.

Costa-Gavras's *Betrayed* (1988) depicts a farm community seething with racial hatred, and Dennis Hopper's *The Hot Spot*

(1990) presents a Texas town where adultery and criminal intrigue are just about the only entertainment available. Bill Forsyth's superb *Housekeeping* (1987) suggests that most small towns are too small-minded to tolerate nonconformist behavior. On the other hand, numerous films of the Eighties and early Nineties celebrate the eccentricities of the small town. *Steel Magnolias* (1989), for example, portrays a lively, warm-hearted place where a group of idiosyncratic, occasionally nutty women (Sally Field, Daryl Hannah, Shirley MacLaine, and Dolly Parton) get together to dish dirt, crack jokes, and support one another through the bad times. *Welcome Home, Roxy Carmichael* (1990) concentrates on the coming of age of Dinky Bosetti (Winona Ryder), a gloomy misfit of a girl who yearns to escape to more exotic climes. Dinky prides herself on being different, refusing to wash her hair or conform to any of the social mores of her dull Ohio hometown. Like most of the populace in her community, Dinky is obsessed with the impending homecoming of one Roxy Carmichael, the one woman who had the courage to go out into the world and make something of herself. The difference is that Dinky believes that Roxy is also her real mother and is coming to take her away from her drab life. The resolution of the film is rather standard: Dinky discovers Roxy isn't her mother at all, finds a boyfriend, and decides life in the town isn't really so bad. Still, the film makes some trenchant observations on the role of celebrities like Roxy, movie stars, and Hollywood movies in general. These people, these movies, fill the empty places in the lives of average small-town folks and disconnnected souls like Dinky Bosetti.

In *Welcome Home, Roxy Carmichael* and *Steel Magnolias*, the oddities of the townsfolk are harmless, even endearing. In other films, particularly Jonathan Demme's *Something Wild* (1986) and David Lynch's *Blue Velvet* (1986), the weirdness is anything but comforting. Demme's film reverses past patterns of migration, followings its protagonists, Lulu Hankel (Melanie Griffith) and Charlie Driggs (Jeff Daniels), from the city to the country. Lulu is a charmingly strange, slightly kinky girl who takes Charlie, an uptight accountant, to a sleazy motel, handcuffs him to a bedpost and helps him discover his wilder, previously repressed sexuality. Lulu is wild and quixotic, but not the least bit dangerous. When she takes Charlie back to her hometown, however, they encounter Lulu's psychotic ex-husband Ray. Ray harasses the couple, then forcibly takes Lulu away from Charlie. What begins as a voyage of liberation and self-discovery becomes a horrible nightmare. In earlier films like *They Made Me a Criminal*, a trip to the country symbolized a return to older, better values. In *Something Wild*, the return to the town is anything but enriching. For once, the city, even the dreaded metropolis of New York, is no more frightening than its rural antithesis.

David Lynch's *Blue Velvet* is as much a commentary on Hollywood's vision of the small town as it is on small-town life itself. For Lynch, suburban bliss is represented by Frank Capra movies and *Leave It To Beaver* reruns. His own clean-cut hero, Jeffrey (Kyle MacLachlan), is no Mr. Deeds, but rather a peeping tom. Before trying to rescue a damsel in distress, Jeffrey hides in her apartment and watches her undress. Of course, the damsel, a beautiful nightclub singer named Dorothy (Isabella Rossellini), is hardly a symbol of purity herself. When she discovers her voyeur, she demands that he too undress, then puts a knife to his genitals. Nor is the innocent heroine quite as guileless as she was in the films of the Thirties. The sweet, virginal Sandy (Laura Dern) finds her jock boyfriend boring in comparison to the slightly perverse Jeffrey. Instead of going to see him play in the big football game at the local high school, Sandy would rather play amateur detective with Jeffrey, delving into the mysterious and dangerous world that Dorothy inhabits.

The main body of *Blue Velvet* depicts Jeffrey's encounter with the powerful and Satanic figure of Frank Booth (Dennis Hopper) who has kidnapped Dorothy's husband and child and uses their safety to blackmail her into becoming his sexual slave. Jeffrey is both intrigued and repulsed by Frank, a man who becomes sexually aroused by calling Dorothy "Mommy," sucking on a canister of helium, and then punching her in the face. Where the typical small-town melodrama depicted an uncomplicated battle between good and evil, in Lynch's confused world, the hero must first battle his own evil impulses before confronting those of others. While *Blue Velvet* eventually gives us the expected "happy ending" in which Dorothy is freed and Jeffrey and Sandy will find their own wonderful life together, much of the film resembles an updated, eroticized version of George Bailey's nightmare.

A few films in the Eighties (*Places in the Heart, The River, Country*, all 1984) nostalgically decry the decline of the small farm and the values it stood for in America. *Field of Dreams* (1989), *Sweetheart's Dance* (1988), and *Mystic Pizza* (1988) make the country seem like the ideal place to raise your children. A couple of inconsequential movies, *Baby Boom* (1987), in which neurotic urbanite Diane Keaton finds peace and happiness in the country, and *Out of Bounds* (1986), in which naive farm kid Anthony Michael Hall comes to L.A. for a visit and is thrust into an urban nightmare, do recall the old city/country dichotomy. Far more typical though, is a film like *Independence Day* (1983), which seeks out the middle ground. Here the town is hardly the happy haven of American values portrayed in the Andy Hardy films. Nor is it completely overrun by the violence and depravity of *The Chase* or *Blue Velvet*. *Independence Day*'s heroes are townsfolk, but so are its villains. The two protagonists eventually leave the small town for the city, but they will live a life there not all that different

from the one they left. It will merely be against a bigger backdrop. Although *Independence Day* has its political points to make, the location of the film has little bearing on its politics.

Less bizarre than *Blue Velvet* but still a highly imaginative look at suburban America is Tim Burton's *Edward Scissorhands* (1990). This modern-day fairy tale tells what happens when a friendly "monster" whose hands are five-fingered, foot-long blades arrives in a small Florida suburb. This incredibly pale creature, known as Edward (Johnny Depp), is not at all threatening. Rather he is gentle and creative, something of an artist. At first, he is greeted warmly by the suburbanites. They are amazed at his dexterity. In a matter of minutes, he is able to turn their garden shrubbery into odd and beautiful sculptures. He is also a brilliant hairdresser and the neighborhood's female residents line up to get Edward to cut their hair. In the suburban wasteland of tract homes and banal lives, Edward is able to add a touch of mystery and individuality.

Typically, Edward's artistry soon becomes the object of commercial speculation. A woman named Joyce (Kathy Baker) is so impressed by her new hairdo that she decides to open a hair salon for Edward. But Joyce also has sexual designs on Edward and when he rebuffs her, she claims that he tried to attack her. The people who were so enthusiastic about his arrival start to wonder if Edward really is a monster, and when he's innocently implicated in a burglary, they decide he must be expelled from the town. *Edward Scissorhands* can be read as a morality tale about what happens to the artist in a world where art is valued only as a commercial commodity. It can also be interpreted as a story of a conformist society which is unable to accept anyone who does not fit community standards of looks and behavior.

Although *Edward Scissorhands* is set in a small suburb, one doubts that city dwellers, if confronted with a character

like Edward, would react with less pettiness. For the most part, in contemporary Hollywood films, the city and country have become difficult to distinguish. As the city/country comparisons begin to fade, the town has lost much of its political significance. *Edward Scissorhands*'s community seems to symbolize the intolerances of society ar large, urban or rural. In films like *Independence Day* and *Something Wild*, the location is essentially irrelevant. Either place can be good or bad, friendly or unfriendly. At least for the time being, the small town has become depoliticized.
—Peter Roffman and Beverly Simpson

RECOMMENDED BIBLIOGRAPHY

Levy, Emmanuel. *Small-Town America in Film: The Decline and Fall of Community*. NY: Continuum, 1991.

MacKinnon, Kenneth. *Hollywood's Small Towns: An Introduction to the American Small-Town Movie*. Metuchen, NJ: Scarecrow Press, 1984.

[1] Beginning in 1937, MGM produced fifteen Andy Hardy films starring Mickey Rooney. The series includes *Family Affair* (1937), *Love Finds Andy Hardy* (1938), and *Andy Hardy's Double Life* (1942). The series was given a special Academy Award in 1942 for "furthering the American way of life."

Spielberg, Steven

(December 18, 1947 –)

I n 1988 the Academy of Motion Picture Arts and Sciences swallowed hard and presented Steven Spielberg with the Irving Thalberg Memorial Award. Sharing both a phenomenal success rate and a surname suffix with MGM's fabled boy genius, the conspicuously, not to say scandalously, un-Oscared Spielberg was a natural choice for a face-saving consolation prize.

Against expectations—would he be sycophantic or sardonic?—his acceptance speech enlivened an otherwise turgid evening. Thalberg, noted Spielberg, grew up immersed in the literature of his time, the great novels of the Victorian era and the vivid characters of turn-of-the-century drama. From literature Thalberg acquired a grasp of character, dialog, and narrative that served him well in shepherding to completion so many soon-to-be classic Hollywood productions. By contrast, Spielberg recalled a boyhood spent spellbound before the "literature" peculiar to his time—motion pictures and television.

That background gave the present generation of filmmakers a natural eye for images, but a tin ear for language and a paltry gift for storytelling. We must therefore, this least bookish of filmmakers told his colleagues, rediscover our "romance with the word."

Despite the apparently heartfelt advice to the printlorn, Spielberg long ago pledged his own troth to the image. He shows no indication of straying from his first love. Replete with sharp graphics and visceral thrills, scarce in memorable dialog or reflective soliloquies, his work is infinitely richer visually than verbally, his

eye for depth of field exquisitely more sensitive than his feel for depth of character. (Besides reptilophobia, Indiana Jones is an empty Stetson.) The trademark Spielberg shot is a freeze-frame for the Age of the Image: a wide-eyed child, bathed in soft-focus light, gazing rapturously at a cinematic marvel—a space ship, an alien creature, a gleaming treasure trove. Mirroring the passive look of the audience, the on-screen spectator celebrates in-theater spectatorship, the viewer looking in wonder at a look of wonder. For Spielberg, beauty is truly for the *eyes* of the beholders, his creative challenge to divert the sense of sight with a cinematic sleight of hand faster than rapid eye movement. In a telling gesture, a pretty coed mooning over Professor Indiana Jones says it with her eyelids: "LOVE YOU" written in eyeliner.

That sight-sensitive tack is Spielberg's distinctive, unmistakable imprint, an auteurist signature that identifies everything save vision as peripheral. The adjectival form evokes a unique style, sensibility, and Southwest scenery: to be "Spielbergian" is to be of the movies, in the movies, and, above all, at the movies. For consistent exponential profitability and sheer world-class popularity, Spielberg demands a special class of superlative: in motion picture history perhaps only Charles Chaplin outpoints him in adjusted box office gross and imagistic dissemination. Beginning with *Jaws* (1975), Spielberg piloted an astonishing, unprecedented series of megahits: *Close Encounters of the Third Kind* (1977), *E.T., The Extraterrestrial* (1982), *The Color Purple* (1985), *Hook* (1991), and, in collaboration with George Lucas, the only other industry name warranting coequal linkage, the Indiana Jones series, *Raiders of the Lost Ark* (1981), *Indiana Jones and the Temple of Doom* (1984), and *Indiana Jones and the Last Crusade* (1989).

When not personally directing outright cultural landmarks, Spielberg produces them at a less-than-amblin' pace: the terrif-

ic airwavey horror film, *Poltergeist* (1982), credited formally to Tobe Hooper but certifiably Spielbergian in tone and technique; Joe Dante's *Gremlins* (1984); and Robert Zemeckis's *Back to the Future* (1985) and *Who Framed Roger Rabbit?* (1989). Against these standards, the failure of *Empire of the Sun* (1988) to return negative costs seems less an executive indulgence than a long-term investment in research and development. In a charmed and charismatic career, only two lapses confirm fallibility—the lachrymose "Kick the Can" episode from the ill-fated quartet comprising *Twilight Zone: The Movie* (1983) and his one full-tilt lemon, the noncomedy *1941* (1981). In a business where the deadly sins thrive, the scale of Spielberg's success is almost beyond envy.

His perennial theme is his constant subject, the movies. The standard observation about the new generation of Hollywood powerhouses—Spielberg/Lucas/Landis—is that where the old "job of work" boys of the studio era—Ford/Hawks/Walsh—were men's men, standup guys who knew the masculine rites of soldiering, business, and sports, the "movie brats" were slim-boned, pale, and undernourished, devotees of the moviehouse and not the locker room. Atop the Hollywood hill, their ascendancy was (in an industry catchphrase that itself became a major motion picture) "the revenge of the nerds." Art is always mimesis, one step removed from reality, but the Spielbergian art was one step further beyond—filtered through other, predecessor art: Saturday afternoon serials, Warner Bros. cartoons, Walt Disney fantasies, John Ford Westerns, Hitchcock thrillers, and studio system classics.

Spielberg's one feature-length homage is *Always* (1989), an indulgent remake of the Victor Fleming-directed, Dalton Trumbo-scripted *A Guy Named Joe* (1943), a wartime melodrama whose themes of loss, sacrifice, and reconciliation were more alien than E.T. to the go-go, me-me Eighties. (The director originally planned

to retain the wartime setting but fast-forwarded the chronology after *Empire of the Sun* floundered at the box office.) For the blazing glory of fighting Nazis, Spielberg substituted the glory of fighting blazes, for the Battle of Britain, he served up Yellowstone National Forest *flambeau*. Though otherwise faithful to a fault to its source (whole dialog exchanges, gestures, and camera placements are devotedly replayed), *Always* is most striking when Spielberg departs from the sacred text and injects some inspiration of his own. Two scenes are magical. In one, a raving old wino picks up ectoplasmic commentary from the dead pilot played by Richard Dreyfuss and functions as a sort of skid-row "channeler" for him. The other portrays the out-of-body experience of a stricken bus driver, who crosses the veil to stand beside Dreyfuss for a moment before revival and return to life. To its credit, the film *knows* it's lost in space and time—one character delivers a soliloquy about the anachronistic ethos of the fire fighters, another imitates John Wayne—but this wry self-knowledge can't hide a basic, debilitating fact: without the Second World War, this airy trip can never really soar.

Where the recalcitrant postmodern artist rebels against the mediation of experience by pop cult pap, Spielberg exults in it. And more: he seeks to enhance it, to move from mediation to melding. Only too willing to suspend disbelief, to exchange real space for reel space, he invites us to break down the frame and merge into the screen. In *The Sugarland Express* (1974), the hero gleefully serves up sound effects for a Road Runner cartoon; in *Close Encounters* and *Poltergeist* living room spectators caress the video screen; and, best of all, E.T. and Elliot inhabit not only each other but also the John Wayne and Maureen O'Hara of John Ford's *The Quiet Man*. The "special edition" rerelease of *Close Encounters* in 1980 had an advertising tagline that played to the penetrating gaze, urging audiences to experience the thrill of "being inside." The logical extension of the impulse to merge three- with two-dimensional life is *Who Framed Roger Rabbit?*, where computer technology makes a seamless match between celluloid animation and animate humanoids.

The accumulated references, homages, and rip-offs in Spielberg's work comprise a veritable guidebook to classical film style and motion picture history, but two debts to two very different Hollywood brand names are most fully exposed. From Alfred Hitchcock, Spielberg took a working principle: if the camera is an extension of sight, then the gaze is all. The most purely cinematic and coldly calculating of the Hollywood auteurs, who claimed the creative process was finished the day shooting began, Hitchcock bequeathed a cagey, premeditated technique alternately fluid—sailing smoothly and bird-like down from on high to settle outside a window—and jarring—slicing through space and disorienting perspective with rapid-fire shot/reverse-shot editing.

Jaws, of course, is Spielberg's esteemed honors project, a virtuoso performance in which the the pupil not only played the master's score to perfection but took off on exhilarating riffs of his own. The structure (modulating moments of high horror with long passages of excruciating suspense) and technique (the "ticking bomb" school of suspense mongering) were public domain, but never had the lessons been recited so prodigiously.

Paring down Peter Benchley's narrative to pure bones—shark eats man—Spielberg worked against lateral expectations and shot up from the dark underside. The featured kills—highlighted by incisor-like editing and the Herrmannesque strings of John Williams's angina-inducing sound-track—were almost a relief after the red herring water sports witnessed from a shark point of view. When the shark hunter Quint quiets a chaotic city council meeting by running his nails down a blackboard, he offers a synecdoche for the nerve-ending tingles sent out throughout

the film. Exhibitors fondly recall *Jaws* as the number one popcorn selling feature of all time.

From Hitchcock, too, Spielberg learned what not to show, to conceal the goods and prolong the close encounter. In the TV movie *Duel* (1972), his first major project, the forbidding eighteen-wheeler pursuing hapless accountant Dennis Weaver takes on a hulking bestial quality—exhaust fumes billowing, looming in pursuit in the back frame or in the rear-view mirror, driven by a disembodied force never shown. A still more spectacular payoff for orthodox Hitchcockian technique was the famous decision to withhold the shark from view until the last third of *Jaws*. Having privileged and soothed the spectator, the results of withholding visual information can be discombobulating. Like the master, Spielberg places obstacles in the line of sight to accentuate visual interest and reinforce perspective: in *Jaws*, strolling bathers obstruct the line of sight to the beach; in *E.T.*, the opening glimpses of Carlo Rimbaldi's creature are murky, obscured by darkness and forest; in *The Color Purple* Mister sits at the porch behind a newspaper that hides his face and directs our gaze.

In the wake of *Jaws*, Spielberg was for a time labeled "the New Hitchcock"—he had, after all, done for whole oceans what his mentor had done for the shower alone. But as his next film ("written and directed by Steven Spielberg") made evident, this director looked upon visual encounters of whatever kind with none of the prurient joy and consuming dread of Hitchcock's shamefaced voyeurism. Hitchcock makes his viewer a complicit Peeping Tom. For the Anglo-Catholic Victorian, visual pleasures are always guilty. For the suburban American boomer, they are a birthright. Spielberg has a healthier attitude toward the gaze: his viewers look straight on, wide-eyed, innocent, soaking it all in. Hitchcock sees through a keyhole, Spielberg through a big motion picture screen.

From Walt Disney—or, to do him credit, with Disney—Spielberg shares a fairy tale sensibility. At once wondrous and horrible, impenetrable and transparent, fairy tales are deep structure windows on the unspoken and unspeakable rigors of growing up. Unlike real children, who know very well terror, pain, and chaos, Spielberg can be childish in the worst sense, his trips into Disneyland all hope and affirmation, wish-fulfillment and gratification. *Variety*'s one-liner about *E.T.*—"the best Disney film that Disney never made"—was only partly right. The children in Spielberg's toy-infested bedrooms go through nothing like the terror of Pinocchio, flailing and kicking, turned into an ass, or Bambi, orphaned by gunshot. When the hunter comes to the forest in *E.T.*, it is with only the best of intentions.

Perhaps harking to the critical carping, the exasperated cries for mature growth in an artist of breathtaking technical facility, Spielberg took up two efforts of ostensibly substantial seriousness, *The Color Purple* (1985) and *Empire of the Sun* (1988). Both films dealt with race and violence, tropes the director of the Indy series knew up close. That *The Color Purple* looked more like *Song of the South* than *Hallelujah*, that even the juke joint scenes evoked Norman Rockwell more than William H. Johnson, might have been expected: the ahistorical fantasy land of Alice Walker's novel suited Spielberg's own Technicolored sense of the past. Naturally, too, the radical lesbianism of the novel was toned down: Spielberg's finely attuned antennas for mass-audience taste need no Production Code to signal it. In an explicit era, Spielberg's sexual discretion is another link to his classical Hollywood sensibility. Typically, the lovers in *The Sugarland Express* are diverted from closure by a cartoon at an adjacent drive-in and, appropriately, it was violence, not nudity, that made this boyish director responsible for the PG-13 rating, a signpost for kids too young to make the R cut. His target audience is usually male, on the cusp of adolescence.

Empire of the Sun was more satisfying—he owns the franchise on boyhood fantasy. J. G. Ballard's memoir of a boy's life in a Japanese internment camp is a fairy tale darker than anything in Uncle Walt's wonderlands. Though even in a wartime prison camp a Spielbergian youngster is going to have a private space with pop culture accoutrements littering his bunk, Spielberg captures much of the horror of childhood abandonment and transference of filial affection. At the close, when the flash from the atomic bomb shimmers on the horizon in gorgeous chiaroscuro, the boy gazes up and—what else?—looks spellbound, riveted by the industrial light and magic that ended the Second World War.

At first blush, then, it seemed appropriate—inevitable?—that the former *wunderkind* whose motto was deemed a petulant "I won't grow up!" would take on Anglo-American culture's favorite tale of arrested development. Though J. M. Barrie surely promised a more congenial match than J. G. Ballard, going out on the limb for *Hook* (1991) was nonetheless a calculated and defiant stance. Appearances and advance billing aside, the kids are part of the scenery here: this is, in every sense, an adult's movie. *Hook*'s hook is to reverse the child-parent trajectory and thus redirect the whole emotional energy of the Barrie tale. The point of identification—the point of the story—shifts from the children's yearning for liberation and self-assertion to the adult's movement towards parental involvement and self-sacrifice. *Hook* isn't about a boy who won't grow up but a father who won't pay attention. The original Wendy, Michael, and John wanted Mom and Dad to let up a little: hence the lure of flight with Peter. Their yuppie-spawned descendants, Maggie and Jack, want their Dad to attend school plays and cheer playground exploits. He (and they) have to be dragged kicking and screaming into Never Neverland. What better comment on contemporary family dynamics—and Spielberg's sure ear for the vox populi

and perfect pitch to same—than the transformation of a classic escapist fantasy into an ode to parental duty?

That Spielberg has evolved out of the Peter Pan syndrome is telegraphed in the unspoken imperative from his revisionist *Hook*: clap if you believe in fathers. Whatever the Never Neverland backdrop, his main arena of action is the familial drama, the narrative movement the completion of a father-son axis. Although manifest as early as *The Sugarland Express*, nuclear family solidarity, especially a desperate yearning for the lost patriarch, has become the dominant theme of his later work—Elliot and E.T., Short Round and Indy, Indy and his father, Shug and the Minister, Jim and Basie. In *E.T.*, the most striking presence is the absent father, wafting around the garage in the aroma of aftershave on an old workshirt. In revamping *The Color Purple*, as venomously an antifather tract to come from the pen of woman, even the villainous Mister and the intolerant Minister are redeemed. Characteristically, Spielberg is distracted from the sisterly bond between Cellie and Nettie and bestows the climax on the clinch between Shug and her father.

Though reared on the tube and ascendant during an era of videotape ancillary marketing, Spielberg has insisted upon the theatricality of his movies, generally shooting in Panavision and demanding the "letterbox" format for the video versions. Significantly, even the made-for-TV *Duel* was an overseas theatrical hit. The horizontal planes (and plains) of his landscape of choice, the American Southwest, can only be contained by a 2.35 aspect ratio. His *mise-en-scène* makes adroit and dramatic use of widescreen space, whether purely for visual impressiveness (Indy's whip cracking across the full length of a Panavision screen) or for shout-out-loud impact (in *Close Encounters* a foregrounded TV screen transmits a picture of Devil's Tower against a backgrounded living room sculpture of same). Likewise, the widescreen vistas enhance his artier

efforts at chiaroscuro. He favors beams of criss-crossing light from cars or flashlights: the entire Texas Highway Patrol massing for geometrically coordinated pursuit in *The Sugarland Express*, the "collision lights" from alien spaceships zooming over the Indiana roads in *Close Encounters*, and flashlight-bearing patrols entering the woods at dusk in *E.T.* Similarly, his Hitchcockian suspense scenes play best in a packed movie house. There is a tension in a theater during a good movie that you can cut with a knife, Spielberg once said.

He wields the celluloid blade with palpable delight, teasing the audience en masse before plunging in for the thrill: the shark looming into the frame seemingly inches away from Roy Scheider's hand in *Jaws*; the levitating headlights behind Richard Dreyfus's truck in *Close Encounters*; the intestinal illumination that signals vitality as a mourning Elliot closes the coffin lid in *E.T.* Spielberg wants to levitate the audience—not the solo viewer in the living room, but the congregation before the screen. Like his mentor, the new master of suspense knows also when to count down the ticking bomb and when to trip the ignition for maximum shock. In *Always*, the engine explosion that suddenly kills pilot Dreyfuss is a foreseeable setup and a total ambush.

Elsewhere the tumblers can fall too neatly into place. Spielberg has educated his audience too well and increasingly they're a step ahead of him. The second Indiana Jones film was already baroque in its acrobatic assembly of creepy crawling creatures, expendable Third World extras, and can-he-top-himself chase sequences.

The film's opening scene—in which a tuxedoed Harrison Ford scurries through a bedlam of legs, gunplay, and overturned tables at a Shanghai nightclub after a MaGuffin—is Rube Goldberg, not Irving Thalberg, filmmaking.

In the end reel, Spielberg's own father figure may be neither Thalberg, Hitchcock, nor Disney, but Bruce the mechanical shark. The director is compelled to rush forward, afraid that if he stops cruising, the film will die. No wonder he's always seemed like a swimmer in search of the shore. In the Indiana Jones series alone he's been able to embrace whatever god proves serviceable: Jehovah (*Raiders of the Lost Ark*), Kali (*Indiana Jones and the Temple of Doom*), and Jesus (*Indiana Jones and the Last Crusade*). If Spielberg is on a spiritual quest, it's for the deity who sends off the best special effects. But then the moviehouse has always been his preferred temple of worship.—Tom Doherty

RECOMMENDED BIBLIOGRAPHY

Ebert, Roger and Gene Siskel. *The Future of the Movies: Interviews with Martin Scorsese, George Lucas, and Steven Spielberg.* Kansas City, MO: Andrews and McNeel, 1991.

Kolker, Robert Phillip. *A Cinema of Loneliness.* NY: Oxford University Press, 1988.

Mott, Donald R. and Cheryl M. Saunders. *Steven Spielberg.* NY: Macmillan Publishing Co., 1988.

Pye, Michael and Lynda Miles. *The Movie Brats.* NY: Holt, Rinehart and Winston, 1979.

Von Gunden, Kenneth. *Postmodern Auteurs: Coppola, Lucas, De Palma, Spielberg and Scorsese.* Jefferson, NC: McFarland and Co., 1991.

North by Northwest

Spy Films

Most often they are two-fisted heroes in trench coats and slouch hats who uncover and, usually in ninety minutes or less, destroy the enemy spy network. Although recent movie spies still wear the traditional trench coat favored by Humphrey Bogart, there's been a big change.

Nowadays it isn't always certain for whom the top-billed star is working, and far worse is the grim possibility that the ostensible "good guys" may be no different from the "bad guys." Even that perennial favorite, James Bond, was once called to task by critics for the cold-blooded ease with which he dispatched his opponents. Still, there is something about spies and secret agents that attracts audiences, whether it's the filmed "entertainments" of Graham Greene, the coldly impartial tales of the Cold War by John le Carré, or the detailed adventures by Len Deighton. The modern spy novel and film also have an

inherently political nature, a tradition that dates as far back as Eric Ambler's first books and Fritz Lang's first spy film, *Spione* (*Spies*, 1928).

In the late Twenties and early Thirties, gentlemanly concepts of statehood and foreign policy were challenged by the avowedly proletarian regime in the Soviet Union and plebeian but ruthless dictators in Rome and Berlin. Fritz Lang based *Spies* on a real incident involving the Anglo-Russian trade talks in London. Scotland Yard discovered that the All-Russian Cooperative Society, ARCOS, was a nest of spies and raided their offices. This inci-

dent, as well as the morbid atmosphere of post-World War I Berlin, contributed to the characterization of the master spy, Haghi, as a respectable banker who physically seemed an amalgam of Lenin, Trotsky, and Walther Rathenau, Germany's enigmatic and doomed foreign minister. Haghi's spies were everywhere, and his headquarters—honey-combed with armed couriers, transmitters, and operatives—was hidden inside the bank's immense office building. The elaborate secret headquarters was an element that was to appear again and again in subsequent spy films, reaching technologically fantastic limits in the James Bond films.

While villains like Haghi seemed unconquerable (he is defeated only because one of his vamp-like spies falls in love with the hero), some authors and film directors focused on normal, middle-class protagonists who found themselves drawn into the maze of espionage and counterespionage. Eric Ambler's first novels featured such characters, while the non-heroic protagonist was a key to Alfred Hitchcock's most successful pre-Hollywood films, *The Thirty-Nine Steps* (1935) and *The Lady Vanishes* (1938). While the former retained elements of the earlier tradition of the gentleman-turned-adventurer of the Twenties, the latter feature was much more relevant. Not only were contemporary international crises—including the 1938 Austrian *Anschluss* and Munich peace conference—used as the butt for an extended joke, but the film also climaxed with a shootout between besieged Britons and a squad of enemy secret police. *The Lady Vanishes* not only made Hitchcock famous worldwide, but also prompted his screenwriters, Frank Launder and Sidney Gilliat, to further mine the espionage lode in other films, adding larger and larger doses of comedy to the finished alloy. When the real shooting started on the Polish-German border, many films returned to the gimmicks and plot contrivances of Lang's silent melodramas. *Sabotage Squad, Sealed Cargo, Secrets*

of Scotland Yard, Nazi Agent, International Lady, Secret Agent of Japan, Nazi Spy Ring, and *Secret Enemies* were all wartime spy thrillers featuring enemy agents almost immediately identifiable, secret transmitter rooms festooned with banners, and a natural instinct for their audience's perception of the way spies *should* look and act. Despite accents as thick as sausage and plots thinner than watered beer that predominated in most films of the period, several films did hint at the moral ambiguity and the technological complexity that characterized the spy's world.

Long before the U.S. was a combatant power in World War II, *Confessions of a Nazi Spy* (1939) was made and released by Warner Bros., a studio that had pioneered the socially relevant feature film and was willing to criticize Nazi Germany. The film probed the various motives that led some Americans to spy for Germany and the methods by which they were discovered. American neutrality in the first two years of the European war was also examined in Hollywood in two films that used espionage as their basic plot device, *Watch on the Rhine* (1943) and *Casablanca* (1942). The Paul Lukas-Bette Davis feature was an intriguing examination of the character of the anti-Nazi German, an American wife and her politically naive relatives, while the Humphrey Bogart-Ingrid Bergman film was to provide a much more attractive image of American neutrality.

As the difficult terrain of modern warfare was revealed to Americans in the days after Pearl Harbor, some spy films were given a background comprised of real-life espionage experiences and the actual tools of the trade. *The House on 92nd Street* (1945) was a quasidocumentary film that mixed fictional and newsreel footage to relate its account of successful counterespionage, actually an amalgam of several real incidents. *13 Rue Madeleine* (1946) offered a detailed chronicle of how spies were recruited and trained, and its plot involved a ruthless enemy agent who was not only charming but also had no dis-

cernible accent. More frequently, however-er, filmmakers' ideas of how spies worked owed a great deal more to the "cliffhanger" serial. A serial like *Spy Smasher* (1942) revived popular interest in a "death ray" that could knock planes out of the sky, while elaborate, underground submarine pens were featured in *Don Winslow of the Coast Guard* (1943). Often as melodramat-ic, if not as derivative of the science fiction plots of the late Twenties, were the "occu-pation dramas" in which freedom-loving citizens easily bested their Nazi occupiers, although some films did try to suggest the varying levels of resistance and collabora-tion among the citizenry. *The Moon is Down* (1943) and *This Land is Mine* (1943) even hinted at differences of opinion among the German occupiers.

The simplistic characterizations and far too apparent intrigues were soon shunted into the Cold War with its unclear borders and diffuse foes. In some films realistic details of counterespionage efforts against the wartime enemy, buttressed with abun-dant documentary footage from the FBI, seemed aimed at reassuring audiences that future spies would not get very far in the next war. This reassurance was des-perately needed by a nation going through the convulsions of a spy fever intensified by the changing map of postwar Europe, revelations about a Canadian spy network, and fears of communist subversion. Today, the actual details of tactics on both sides of the spy war are better known: the Soviet use of longterm agents like Philby and Maclean; the American attempt to orga-nize resistance networks in Eastern Europe and the Ukraine modeled on wartime groups; and the internal purges—slanderous in America, murderous in Russia—that rocked both sides.

Hollywood followed where Washington led: *Walk East on Beacon* (1952), *My Son John* (1952), *Pickup on South Street* (1953), and *Big Jim McLain* (1952). The filmmak-ers were not alone; popular historians like Kurt Singer and novelists like Stanley Baron recounted tales of communist ruth-lessness. As the spy panic and Korean War gave way to talk of peaceful coexistence and trade fairs in Moscow and New York, the spy films also reflected the "thaw" in the Cold War. Alfred Hitchcock's *North by Northwest* (1959), famous for its on-loca-tion shots and sly humor, was the first major spy film to ridicule the foundation of the spy war. Not only does the advertising executive hero get himself mistaken for an American spy, but that "spy" is actually the fictional creation of the American intelli-gence community in order to bait a trap. The American spy masters, headed by a patrician-looking Leo G. Carroll, are open-ly amused that their nonexistent lure has taken on human form. Loath to save the hero from the murderous hands of the opposition, headed with upper-class aplomb by James Mason, the American spy chief moves only when it appears that a trusted counterspy is endangered. The coldblooded ruthlessness on *both* sides is almost lost amid the fast-paced action, unusual sets, and sexual innuendoes that made the film so popular.

Hitchcock's former partners, Launder and Gilliat, had also parodied some Western illusions about Eastern Europe in *State Secret* (1950) which featured a thor-oughly debonair and cynical secret police chief, played by Jack Hawkins, who makes ironic jokes about his own chances for sur-vival in a thinly disguised communist dicta-torship. The Cold War continued in many films and books, with the Chinese commu-nists occasionally substituted as a far more exotic enemy than the Russians. Nevertheless, *North by Northwest* indicated that the Cold War morality couldn't be taken quite so seriously anymore.

The parody of the spy film was not totally new to Hollywood. During the war years, popular comedy teams like Laurel and Hardy and the Bowery Boys were pit-ted against enemy spies in slapstick fea-tures, while comics like Bob Hope and Jack Benny traded wisecracks with the character actors who traditionally por-trayed Nazi agents.

In the Sixties a rather different kind of spy burlesque became immensely popular in a series of films based on the successful novels by Ian Fleming. Lt. Commander James Bond, Royal Navy, code-numbered 007, first appeared in *Dr. No* (1962). Bond owed a certain debt to his literary forbears of the Twenties with whom he shares a taste for expensive living and a cultivated disdain for his bureaucratic superiors. Despite the aristocratic tastes, Bond, as played by Sean Connery, is no modernized Leslie Howard, but rather a hardened agent as familiar with karate as with fine wines. Likewise, Dr. No. (Joseph Wiseman) owed a great deal to Fritz Lang's Haghi. His island laboratory and disguised armored truck would not have seemed out of place in *Spies*. Even Dr. No's mechanical hand seems an echo of another Fritz Lang character, the mad scientist Rotwang in *Metropolis*. Indeed, the James Bond films developed a penchant for increasingly bizarre secret laboratories and bewilderingly complex machines, including cars that could fly, swim, and destroy anything on the road. In fact, in the over two dozen James Bond films during the last thirty years, Agent 007 has become almost indistinguishable from his lethal hardware.

By the mid-Sixties, however, other films began to appear that viewed the spy war quite seriously and presented a somber image to audiences. By this time, many books and articles about the Central Intelligence Agency had been published, including Allen Dulles's apologetic *The Craft of Intelligence*, which discussed American political intervention in the Caribbean and the use of former SS agents in Europe as soon as the guns had cooled. One complex intrigue involved Noel Field, a former State Department employee, who had given information during the Thirties to a communist spy network. Field, fearful of being called before a congressional committee, fled to Hungary where he was promptly arrested and implicated in a series of purge trials that convulsed Eastern Europe's communist leadership. Whether Field was a mere pawn used as a convenient link by the Stalinists or "marked" by the CIA to cause such turmoil is still uncertain. The American public showed a growing interst in the details and amorality of the spy, especially as told in the fiction of a young Englishman, David Cornwell, who wrote under the pen name of John le Carré.

Le Carré's *The Spy Who Came in from the Cold* was filmed by Martin Ritt and Paul Dehn in 1965 and soon changed almost every spy film that came after it. It also drastically affected the way people thought about spies. While Hitchcock, Launder, and Gilliat may have giggled behind the back of official morality, Ritt and screenwriter Dehn depicted the travesty of justice by which real spies work and die. While all spy films, even comedies, presuppose an audience's familiarity with the basic terrain of potential foreign conflict, Ritt's film graphically stripped that confrontation of any decency or conscience. "Our" side was as willing to betray innocents, to abuse its adherents and to countenance injustice, as the convention used to have it, as much as "their" side. The general rule of spycraft—that appearances must be deceptive and goals obscured—was now carried over into the movies, which is as close as most Americans ever got to real spies and "controls.'

In Michael Winner's *Scorpio* (1973), the ironies came thick and fast since the ostensibly sympathetic hero, a CIA maverick, is revealed only at the climax to have been a double-agent working with the Russians. Scripted by David Rintels, *Scorpio* drew a vicious portrait of the CIA whose loyal officers were willing to murder every sympathetic character in the film to get at their quarry. Even memories of World War II were tinted with a grim fatalism. *The Counterfeit Traitor* (1962) recounts the lonely horror of posing as a Nazi sympathizer and the dread of discovery. In reaction to this despondent view, a

number of spy films in the Seventies treated espionage as an exercise in buffoonery. Treachery and murder were set amidst comic situations in *Casino Royale* (1967), *S*P*Y*S* (1974), *The Tall Blond Man with One Black Shoe* (1972), *La Cage aux Folles II* (1980), and *A Pain in the A*** (1974).

A curious inverse relationship seemed to develop between the spy film and real-life espionage, as if the silliest idea of a scriptwriter soon became a facet in the clandestine war. The schemes talked about in the CIA for killing Castro included a poisoned wet-suit, an exploding clam, and chemically treated cigars. Vetoed by less eccentric CIA officers, they sound like props for a James Bond film. The merger of the fantastic and the actual has a real basis; many spy novelists and scriptwriters had once played a part in the spies' war. Graham Greene, Paul Dehn, and Somerset Maugham, whose novel *Ashenden* had been filmed by Hitchcock with the title *Secret Agent*, had all been intelligence officers during the war years. Is it any surprise that world politics occasionally takes on the aspect of a bad spy film?

One Hollywood film that attacked the CIA in fairly strong terms was Sydney Pollack's *Three Days of the Condor* (1974). Based on a novel by James Grady, the film featured a curious variation of the non-heroic protagonist, a CIA employee who only reads about spies until he discovers that the entire staff of the bogus "historical research institute" for which he worked has been machine-gunned to death. Fearful for his life and distrusted by the CIA higher-ups whose appetite for counterespionage has been whetted, the hero must discover why a professional assassination team is after him and why his CIA superiors seem reluctant to help him. By the film's end, the hero is ready to go public with the information he has discovered of a conspiratorial clique within the CIA. The idea of renegades within the intelligence community was not rare in 1974; some critics felt the entire CIA was a source of irrationality and instability.

Some filmmakers, not content to deal with fiction, grappled with one of the most controversial events of recent American history, the assassination of President John F. Kennedy. *Executive Action* (1973) and *The Parallax View* (1974) both give disheartening views of the possible conspiracies behind political murders, albeit in wildly contrasting styles. While David Miller's *Executive Action* speculated on the machinations of a plot fueled by petrochemical funds, sparked by right-wing fanaticism, and engineered by ex-CIA specialists, Alan Pakula's *Parallax View* envisaged an anonymous organization that efficiently marketed assassinations as if they were a season's fashions. Miller's view was a traditional one of a group of malcontents with the wealth and influence to change a government by a pinpoint application of force. Pakula's saw an apparatus that seemed to have no real political interest or ideas but which was not only able to silent potential witnesses but could also incorporate would-be enemies into its seamless plots. This vision was mirrored in a number of European films during the Seventies and Eighties. *Le Secret* (1975) and *Escape to Nowhere* (1974) were modern morality tales with equal doses of James Bond and Franz Kafka. Both were pessimistic fables of the individual's frailty in the face of thugs armed and sent out by the modern state. Even the less paranoid *Le Dossier 51* (1978) provided a chilling image of a world where all private secrets could be known and a lover was a potential spy. In all these films it appeared that the spy's coldblooded sacrifices and ruthless tactics during the war years had been perfected during the Cold War with a computer's amorality only to be unleashed on the unwary and unsuspecting and, especially, on the innocent.

With today's changing landscape of international politics, the intricacies of the spy war have turned domestic. After all, filmmakers and novelists must face the prospect of obscure Third World locations replacing the famed sites of European capi-

tals as the setting for future tales. Innocent, homegrown victims are featured in films like *The Whistle Blower* (1986) and *Hidden Agenda* (1990) or tele-series like *Spyship* and *The Edge of Darkness*, where they fall vulnerable to murderous cabals with all the panoply of government ministries.

Divided loyalties and frantic fears are the two ingredients that dominate the modern spy film. Two-fisted heroes still exist on the screen, but audiences today know them to be as far from reality as Flash Gordon's sputtering spaceship is from an intercontinental ballistic missile. Even the most rational and humane spy master must carry out assignments without recourse to idealistic principles or democratic majorities, since what the spy does is beyond the normal dictates of Soviet or American legality. Most people who enjoy the works of le Carré or Greene

understand this and the novelist or film-maker is thus able to dramatize the moral dilemma of the spy asked to obey repellent orders. The spy who has personal convictions, who is an idealist, is doubly tormented, since he can never know where his path may lead or who his true friends are. Tortured by doubt, invested with secret powers, yet ironically part of a faceless organization, the spy is an apt symbol for a world in which the war of espionage must remain a secret.—Lenny Rubenstein

RECOMMENDED BIBLIOGRAPHY

Langman, Larry and David Ebner. *Encyclopedia of American Spy Films*. NY: Garland Publishing, Inc., 1990.

Parish, James Robert and Michael R. Pitts. *The Great Spy Pictures*. Metuchen, NJ: Scarecrow Press, 1974.

Rubenstein, Leonard. *The Great Spy Films*. Secaucus, NJ: Citadel, 1979.

Stallone, Sylvester

(July 6, 1946 –)

For the baby boom generation, Sylvester Stallone has become as much of an icon of the American right wing as John Wayne had been for their parents. As Rocky Balboa, Stallone personified the American underdog living out the Horatio Alger myth of material success through hard work, brute strength, and single-minded determination.

As John Rambo, Stallone personified the anger of confused Vietnam veterans betrayed by their government and defeated in a complex political arena through no fault of their own. In *First Blood* (1982), Rambo worked out his hostilities towards those who represented the small-minded attitudes of small-town America, bringing his survival skills into play to maintain his

integrity. In the Rambo sequels—*Rambo: First Blood Part II* (1985) and *Rambo III* (1988)—he came to symbolize the American White Knight, achieving singlehandedly first a victory in Vietnam by rescuing American soldiers officially listed as "missing-in-action," then, in the second sequel, fighting the communists, almost singlehandedly, in Afghanistan.

Both of these Stallone personae were created by canny marketing, psychologically designed to fulfill a perceived need in an increasingly uncertain world. The Rocky character reasserted the myth that the individual could still succeed in a stratified society that had lost its sense of individual worth. Rocky's career became a victory of the underclass, celebrating the value—and the ethic—of the Common Man. If nothing else, Rocky was the ultimate democratic hero.

Rambo was another strong individual, even more laconic than Rocky, a man of action and instinct, whose heroic adventures seemed for many to reclaim American innocence, purity, and sanity. Rambo's brute strength reasserted national values positively in a changing world in which many Americans had reasons to feel insecure both socially and politically. This cartoon *Obermensch* became an icon of the idealized American and of national strength and purity. Of course, his political ideals were cartoonish and potentially anarchic and fascistic, but his films reassured viewers who wanted to see complicated international affairs explained in simplistic terms.

As Rambo, Stallone revived the American Dream in terms understandable to the unsophisticated and inarticulate Common Man. In what seemed to be a world without winners, Rambo, like Rocky, was a winner. As a survivalist, Rambo was a twentieth-century frontiersman, the avenging marshal of the Western, a latter-day manifestation of Dashiell Hammett's "Continental Op," brought in to clean up corruption and restore order, an extension of the Western hero into urban culture. In Rambo there is the suggestion of Native American blood, a primitive warrior, a "natural" hero. Rocky, too, bears the stamp of the ethnic hero, a second-generation immigrant living out the dreams of success. The two characters combine major strains of the American experience.

The immense popularity of Rocky and Rambo can be explained and understood in these terms. Popular film, like popular literature, gives an instant mirror image of the society that produces and consumes it. Clearly, the success of the Rambo sequels in particular helps to define the spirit of Ronald Reagan's America.

At the time *Rambo: First Blood Part II* was released, Stallone told *The New York Times* he did not "work these things out intellectually." Instead, he explained, "I go by intuition, my emotions. I'm not political. I'm not well versed in politics." He also asserted, however, that "you can't squelch patriotism," and his patriotic credo would seem to be a political one: "The strongest feelings a man has are his religion, his feelings for his loved ones, and his love for his country." He admitted: "I love my country. I stand for ordinary Americans, a lot of them. They don't understand big, international politics." That Stallone, a man "not well versed in politics," would presume to interpret international tensions, even on the simplistic and superficial level of *Rocky IV* (1985), would seem to constitute a huge contradiction.

The linchpin of Stallone's dizzy success was the original *Rocky* (1976). To that point Stallone had found work as an actor in small roles. He played a hoodlum in *Bananas* (1971), for example, followed by a larger role in *The Lords of Flatbush* (1974), for which he also wrote some dialog. Thereafter, he got several roles during 1975 in films as weak as *Capone* and *Death Race 2000* and as strong as Neil Simon's *Prisoner of Second Avenue* and the remake of Raymond Chandler's *Farewell, My Lovely*. His Sicilian ancestry helped to typecast him, as, perhaps, did the fact that he was born in the Hell's Kitchen neighborhood of New York City, even though his family later moved to Silver Spring, Maryland, in the suburbs of Washington, D.C.

Stallone wrote a handful of scripts during his early years as an actor before finding the inspiration for *Rocky*, after having seen the Muhammad Ali-Chuck Wepner fight on closed-circuit TV in Los Angeles,

which Wepner lost by a TKO. United Artists offered to buy the script, first for $75,000, and finally for $315,000, but Stallone held out for the starring role, working for scale and ten percent of the net. Stallone believed in the project and its dramatic potential, despite studio reservations. Henry Winkler, Stallone's costar in *The Lords of Flatbush*, once noted, "He has an uncanny sense of what's dramatic."

Rocky won Oscars for Best Picture of 1976 and for John Avildsen's direction. Stallone himself directed the three sequels of 1979, 1982, and 1985, films that earned money, but hardly any critical acclaim. In 1978 Stallone also directed and starred in a wrestling picture, *Paradise Alley* (1978), and was directed by Norman Jewison in *F.I.S.T.* (1978), in which he played a Jimmy Hoffa-type labor leader. *F.I.S.T.* was a relative failure, perhaps because of a negative attitude that had developed nationally towards labor unions, perhaps because of Stallone's one-dimensional performance.

Beyond *Rocky*, Stallone's next huge success was *First Blood*, directed by Ted Kotcheff, followed by *Rambo: First Blood Part II*, directed by George P. Cosmatos, and *Rambo III*, directed by Peter Macdonald. But not all of his projects enjoyed the popular success of his political *Rambo* series. In 1984, for example, he was foolishly directed by Bob Clark in the idiotic *Rhinestone*, in which he played a New York cabbie turned into a hillbilly singer by Dolly Parton. Then, in *Over the Top* (1987), he was seduced by Cannon Films, for a record salary of $12 million, into playing a burly, dimwitted truck driver, an Everyman of the Road, whose dominant passion was winning an arm-wrestling championship, intent on gaining custody of his son and pitted against the devious designs of his wealthy but sinister father-in-law.

Stallone did better with action-adventure features during the post-*Rocky* period. *Nighthawks* (1981), directed by Bruce Malmuth, pitted Stallone against an inter-national terrorist played by Rutger Hauer, but the film was more about violent confrontations in New York than about the politics of terrorism. And after *Rambo II*, Stallone made another picture with director George Pan Cosmatos, the police thriller *Cobra* (1986), an imitation of the *Dirty Harry* unconventional cop motif. *Cobra* was a law-and-order vehicle in which Marion Cobretti (the Stallone character) remarks to a criminal, "You're a disease. I'm the cure." Comedian David Letterman turned that tag-line around by saying, "Stallone is a disease. Acting lessons are the cure." *Cobra* did exploit a political notion, however, in that Cobretti ends up fighting a neofascist group of killers, but it was about as subtle as the axe murderers that lumbered through its plot.

That is Stallone's major problem as a serious actor. When faced with a "serious" role, his instinct leads him to performances that tend to be hamfisted. That's why the opening of *Rambo III*, which presented a Zen Rambo trying to find inner peace in a Buddhist monastery, was so risible. Stallone acts best when he acts on instinct. His performance in *Rambo III* was therefore appropriate. The overstated cartoon politics of the film, which was rendered anachronistic by the new era of *Perestroika*, Ronald Reagan's peace mission to Moscow, and the Soviet announcement that Russian troops would be withdrawn from Afghanistan, made the film look absolutely foolish by the time it was released. *Rambo III* did poorly at the box office and was rushed into the video market. Yet two months after its release, Peter Hoffman, president of Carolco Productions, which had invested $63 million in *Rambo III*, announced that plans were under way for *Rambo IV*.

Even so, Rocky may prove to be more enduring than Rambo. Rocky perfectly personified a Republican myth that promises monetary rewards for hard work and initiative, success that even the stupid can achieve in the Land of the Free. This

simpleminded materialist ideology dominates Stallone's early work. The more bellicose ideology of his later work appeared to have reached its risky limits with *Rambo III*.

As the Reagan era became the Bush era, Stallone experimented with new roles. In *Lock Up* (1989) he played a convict in a tough prison controlled by a sadistic warden (Donald Sutherland) who bore a grudge against Frank Leone, the Stallone character. The actor then shifted direction and image in 1989 in *Tango & Cash*, which was a crass cross between *Lethal Weapon* and *Batman*, with Jack Palance playing a cartoonish criminal mastermind. Stallone's Ray Tango was a straight-arrow cop in Beverly Hills, who dresses well and plays the stock market on the side, a sort of well-groomed Republican icon who was also a man of action. His partner Gabe Cash (Kurt Russell) was as scruffy as Tango was meticulous. The plot was absurd, the direction uninspired. In 1991 Stallone experimented again with comedy, something of a surprise since *Rhinestone*, his first foray into comedy in 1984, was a disaster. *Oscar*, directed by John Landis, which was far more successful than *Rhinestone* had been, cast Stallone as Snaps Provolone, a Depression-era hood attempting to reform himself and go straight. Part of the appeal here was in the supporting cast, which included old-timers Kirk Douglas, Don Ameche, and Yvonne DeCarlo.

Moving into the Nineties, as the Soviet Union was crumbling, Stallone's most successful picture was *Rocky V*, which did its best to keep Balboa out of the ring. The Soviet contender had beat his brains out in *Rocky IV* and doctors had warned him not to fight again, so Rocky becomes a trainer and tutors a streetfighter from Oklahoma who wants to become the next "Great White Hope." It was directed by John G. Avildsen, the architect of Rocky's initial screen success, and it marked a return to the gritty streets of Philadelphia. In 1991 Stallone told *Parade Magazine* that it was time for a career change because he thought the Rocky formula had become too predictable, though the actor must know the time will come when he is simply too old for Rocky. "So it's time that I go back to my real nature," he added, "which is what you see in front of you." Other sequels have had problems sustaining more than five installments, though conceivably Rocky could go for a sixth; but even if Rocky does carry the champ into the year 2000, Stallone will likely continue as the American Everyman.

—James Welsh

RECOMMENDED BIBLIOGRAPHY

Gross, Edward. Rocky *and the Films of Sylvester Stallone*. Las Vegas, NV: Pioneer Books, 1990.

Stone, Oliver

(September 15, 1946 –)

" Tohn Ford made Westerns. I make Vietnamers," Oliver
Stone has said. The description is a good one, for Stone
makes Vietnamers in the same way that Ford made
Westerns—with utter seriousness, as an exploration of
the meaning of America and of manhood.

Even in films not concerned with the war itself, such as *The Doors, Salvador,* and *JFK,* Stone chronicles an America haunted by that conflict, torn by its moral and political implications, and suffering the still-festering wound he believes it gouged in the national character.

No one would have guessed from the first two movies directed by Oliver Stone—two horror movies, *Seizure* (1974) and *The Hand* (1981)—that he would become Hollywood's preeminent political filmmaker. He seems to option every big topical story, and he turns out impassioned spectacles about decisive aspects of American history. The era that concerns him most is the decade of his youth, the Sixties, and thirty years later he still takes it seriously as a time of widespread self-discovery, liberation, and revolt against—one is tempted to drag a phrase out of the counterculture deep-freeze—the death culture. He openly challenges American policy in *Salvador* and *Born on the Fourth of July,* and in *JFK* suggests that the military and intelligence communities staged a coup d'état with the murder of John Kennedy.

As if that weren't noteworthy enough, these very qualities have made Stone the most famous Hollywood director since Alfred Hitchcock or Steven Spielberg. Indeed his weighty, assaultive, idea-laden movies serve as a kind of counterweight to Spielberg's elevation of the kiddie matinee to billion-dollar blockbuster status.

Though Stone told *Playboy* magazine in 1988 that *Platoon* was not the definitive movie about the Vietnam War but merely "a white Infantry boy's view," the fact is that the movie did give the war its definitive dramatic shape in American pop culture. *Platoon*'s success ushered in a whole new wave of movies about the experience that Hollywood and the rest of the country had repressed. Offscreen, it ignited new respect for the Vietnam veteran.

With *JFK* Stone put movies on the national agenda, stirring up unprecedented national debate over the nature and significance of film. *JFK* precipitated congressional action on the opening of secret files concerning the Kennedy assassination. Though *Platoon* and *Salvador* had also agitated pundits and policymakers, it's safe to say that *JFK* generated more coverage on the political pages of newspapers and magazines than any other movie in history.

Oliver Stone first drew attention for his screenplays, and it is instructive to see how easily his ideas and approach to situations can be tipped over into racism and exploitation by directors who share his fondness for the inflammatory detail, but not his political judgment in framing a conflict. *Midnight Express,* the story of an American naïf's transforming ordeal in a Turkish prison, won Stone a screenplay Oscar. As directed by Alan Parker, it traffics in clichés about barbaric Turks and plays coy, as Stone has admitted, with homosexual love.

Scarface, directed in 1983 by Brian De Palma, is a white-flight movie that substi-

tutes one swarthy gangster for another: a Cuban Marielito for the Italian of Howard Hawks's 1932 original. For all its posturing and swagger, the movie is really about what frightened suburbanites imagine to be their own fate should they venture into the city. In this movie the city is Miami, which cocaine kingpin Tony Montana memorably calls a "big pussy waiting to be fucked."

Year of the Dragon, a Stone screenplay about Asian-American gangs, became a Michael Cimino movie in 1985. As might be expected from the humorless director of *Heaven's Gate*, it deteriorated into a feverish, panicky exchange of power symbols (including the rape of a girlfriend) between two men: a tormented Vietnam vet and a cool young Asian mobster. I've always wondered what these three movies would be like if Oliver Stone had had the chance as director to temper and refine the stark contrasts he drew as a writer between white Americans and the ethnic strangers with whom they clashed.

The movies Stone has directed have followed a common pattern first seen in *Midnight Express*: the ordeal and testing of a young man. In *Salvador* (1985) it is the news photographer Richard Boyle, a factual character in a movie that announces with its first scene that some characters have been fictionalized. Boyle staggers through the carnage of El Salvador's civil war, an ordeal that ends in crushing defeat on an Arizona highway with the loss of his lover to the Immigration police.

Platoon (1986) takes a young recruit, based on Stone himself, through the crucible of warfare in Vietnam. In *Wall Street* (1987) Charlie Sheen, *Platoon*'s star, successfully navigates the temptations of Wall Street, i.e., Reagan's every-man-for-himself version of America. *Talk Radio* (1988), on the other hand, finds Eric Bogosian's abrasive talk DJ the loser in a battle with his own conscience and ambition, and a victim of the dimly felt but lethal forces he has unleashed among his listeners.

Born on the Fourth of July (1989), again based on biography, charts the forcible transformation of war hero Ron Kovic into a war protester. Jim Morrison's spritual odyssey is the subject of *The Doors* (1992), and in *JFK* (1992) the assassination of John Kennedy is an educational experience in the largest sense of the word for prosecutor Jim Garrison.

So you might say that Oliver Stone and his surrogate heroes are out looking for America and their place in it, desperately trying to relocate the honorable land of John Ford, the democratic vistas of Frank Capra, the hallowed halls of justice traversed by Stanley Kramer. Stone is in that lineage and shares some of their strengths and failings, but he seems less willing than any of the others to settle for or manufacture bright, shining lies. That's what makes him unique in a distinctively American filmmaking tradition. That and the gorgeous excess of his emotions, which are a continual affront to the essential repressiveness of American pop culture and its explicators in the press and the academy.

That excessiveness is at the heart of Stone's movies and their success. *Platoon* was not the first movie about the Vietnam War, of course, but it presented combat with a degree of grubby, horrific detail heretofore unseen in movies. In fact, as *Salvador* before it had indicated, *Platoon* demonstrated that Stone's stylistic gift was a curious contradictory blend of spatial and temporal realism with symbolic, sometimes allegorical story and gesture. The dirty surfaces and chaotic, lived-in time (which Stone achieves through stylized, staccato editing) support stories of operatic emotion and import. This incongruous mix has explosive results in Stone's hands. His movies usually suffer when any of its elements are omitted, as in *Wall Street*, where empty glamor drowns an overdressed fable of greed. It's the most Hollywood of his "mature" movies and the dullest.

In *Platoon*, the story's symbolism is baldly stated in the young hero's narration.

Chris Taylor, the college dropout who volunteered for Nam (as Stone the Yale dropout did) finally explains in retrospect that he is the child born of two fathers locked in mortal combat. The scarred Barnes, whom he eventually kills, is death and darkness; the sacrificed Elias, who is likened to Christ in words and images, is light and life. In fact, their struggle "for possession of my soul," a struggle of light and darkness, serves Stone as a visual metaphor for battle itself. Full-scale war comes to the platoon ultimately as a matter of lights sweeping the nighttime forest and as details illuminated by gunfire, breaking up this potential Garden into shards of the visible and the unseeable. Barnes, poised to kill Chris with his pack shovel in the battle's climax, dissolves into a light that blanks the screen.

Elias and Barnes symbolize other oppositions as well: dope vs. alcohol, Motown vs. country, white vs. black, redneck vs. city boy, even pretty vs. scarred. Tom Berenger plays the death-dealing sergeant with a pronounced rural, sort-of-southern accent. Twice he taunts Chris to kill him, and after he has shot Elias and left him for the VC, he confronts Elias's mourners with the startling statement, "I am reality." That is the despair and the beast in humankind that Stone has spent so much of his movie time repudiating, and the war against it launches *Platoon* beyond questions of specific policy mistakes.

Stone packs all of his experience in the war into this story of a 1967 engagement on the Cambodian border. You've got friendly fire, a My Lai atrocity, fragging, and, when an American tank finally rolls in at dawn to pick up survivors, you've got a guy taking ears for bounty, another sporting a Mohawk haircut, and a U.S. tank topped with what appears to be a Nazi flag. What you don't have is the explicit discussion of American policy that studded *Salvador*.

The closest thing to criticism of this specific war, instead of War, is Elias's admission, after Barnes and company plunder a village, that he no longer believes in what he's doing. "What happened today is just the beginning. We're gonna lose this war...We been kicking other people's asses for so long I figure it's time we got ours kicked." The unsettling appearance of the "rescuers," U.S soldiers finally indistinguishable from the marauders of history, hints at what is to come.

Platoon is "dedicated to the men who fought and died in the Vietnam War." By keeping it on ground level, Stone was able to tap a growing sense of guilt in America, on both sides of the aisle, about what the war did to the enlisted men who fought it and the ignominy they suffered on their return (soon to be the subject of another Stone opus, *Born on the Fourth of July*). *Platoon* put the war back on the front burner in this country and also served as a platform for those who wanted another chance to justify the war as well as the warriors.

The videocassette of *Platoon* sports a lead-in commercial for Chrysler with Lee Iacocca somberly claiming, as he stands by one of his corporation's jeeps, that this movie is a memorial "not to war but to all the men and women who fought in a time and in a place nobody really understood. Who knew only one thing: they were called and they went. It was the same from the first musket fired at Concord to the rice paddies of the Mekong Delta...That, in the truest sense, is the spirit of America." Iacocca may be unintentionally correct about the spirit of America, but to link the war with the American Revolution is to legitimize it. And, of course, there were those who understood the time and place; they were called war protesters, and Stone repatriated them in *Born on the Fourth of July*.

Stone himself has repeatedly denounced America's military interventionism, but, as a way of explaining the debacle of Vietnam, *Platoon*'s images and drama played into that fear of alien cultures that also tainted Francis Coppola's *Apocalypse Now*. Both movies (and a num-

ber of others, such as *The Deer Hunter*) find horror in the "inhuman" jungle, with its material deprivations and physically oppressive atmosphere, and in the profound "corruption" of ancient Asian societies, such as Vietnam's.

It is a reaction of the new world to the old. Young American boys are driven mad by such contact, we see, and are left to deal with it on their own by a morally bankrupt military. So *Platoon* and *Apocalypse Now* are against the Vietnam War, but for reasons that might not help us avoid another one.

Nevertheless, Stone is preoccupied with the cautionary tale that Vietnam presents to the American psyche. *Salvador*, released in 1985, a year before *Platoon*, is set thirteen years after the events recorded in *Platoon*, when the U.S. is again embroiled in the internal affairs of a small nation torn between left-wing rebels and a ruthless oligarchy. A penniless, desperate news photographer, Richard Boyle, who describes himself as a good-hearted person who has weaseled around a lot, returns to El Salvador to make a buck, and gets in over his head, rather like America in general.

Salvador excels at capturing the sudden violence and relentless chaos of a society unbalanced by outside agitators (not Nicaraguan revolutionaries but the United States military). Stone also nails the personality of the American interventionist, both the gung-ho military type and the smoother plainclothes diplomat. He even captures with both sympathy and contempt the kind of liberal who can be manipulated by these two. Michael Murphy, a specialist in well-groomed cowardice, plays American ambassador "Tom Kelly," an idealistic Democrat on his way out as Ronald Reagan takes office. He is the one who ultimately releases military aid so that the army can beat back the climactic rebel offensive. Tanks roll over the peasant cavalry, and Boyle watches most of the good guys fall.

Salvador is explicit in blaming American paranoia about communism for the wreckage of this tiny country. There's no question where Stone's loyalties lie, for he draws the military with inhuman villainy. Not that you can reasonably take an even-handed approach to death squads, but it is painful to watch Stone cram the Salvadoran right into one-dimensional caricature when he has taken such pains to show just how complicated is the destructiveness of the American presence. Even Boyle, after all, is a kind of ugly American who gets people killed because he's not paying attention, or worse.

Like the liberal whose well-meaning attitudes rest on a bedrock of racism, Stone reflexively reaches for the racial epithet to shoot back at his enemies, picturing the Salvadoran bad guys stereotypically as greaser *bandidos* who relish their sadism. A tiny detail makes it perfectly clear. As departing ambassador Tom Kelly, a classic liberal, screws up his courage to save Boyle from a squalid execution at the border, he ends his threat to the Salvadoran army by spitting out the words, "You got that—*amigo*?"

Stone also gooses up the murder of Archbishop Oscar Romero, moving it from a chapel into the main sanctuary of the cathedral so that hundreds can scatter when the assassin, in Stone's version, spits on the proffered communion wafer (!), and then shoots the activist prelate. This is tasteless melodramatic license, which helps Stone rub our noses in the flesh-and-blood results of our government's policies. Americans have avoided that for too long, so it's understandable that Stone also wants to include the infamous factual rape and murder of four American nuns, and does so by showing them stripped and degraded, cutting away only as the trigger is pulled.

As this episode demonstrates, however, Stone has tended rather thoughtlessly throughout his career to use women as signifiers rather than subjects. The creature who comes in for the greatest derision in *Salvador* is a shallow female

American television reporter, a blonde airhead with a savage obliviousness to the suffering around her. Her opposite number is Maria, the understanding Salvadoran lover whom Boyle gets out of the country. She holds all that the future might mean for him.

Daryl Hannah is less noticeable than the postmodern furniture in *Wall Street*, just another deluxe trapping of wealth for our rising young stockbroker. Ellen Greene, an unusually strong presence in *Talk Radio*, is really there to gauge how low Barry Champlain can go. Women serve mainly to desert and confine the paraplegic vet of *Born on the Fourth of July*, and Sissy Spacek, as Mrs. Jim Garrison in *JFK*, keeps score of her husband's true credibility in discovering who killed the president and stole the country. Meg Ryan, playing Pamela Courson to Val Kilmer's Jim Morrison in *The Doors*, was dismissed by many observers as nothing more than a hippie housewife; she represented vividly but somewhat too obviously the capitulation to monogamy and domesticity that Jim resists throughout the movie.

Like women, the Vietnam War itself has taken on a more mythic than realistic presence in Oliver Stone's films. It is the backdrop to Jim Morrison's rebellion and death wish in *The Doors*. It is the itch that American foreign policy seeks to scratch in *Salvador*, and the horror Richard Boyle hopes will not recur. Even *JFK* finds its ideological pivot in Vietnam policy, for Stone and screenwriter Zachary Sklar discover that Kennedy's desire to end American involvement is a prime motive for his murder. All those spooks and generals just cannot imagine that their paranoid fantasies will evaporate so easily and so they take steps to remove the irritant.

Stone sees in Vietnam something more devastatingly personal than the divisive, costly, mendacious effort that critics of Cold War foreign policy discerned in it. Why the war has stuck in our craw is not entirely evident even to Stone, it seems,

but his movies suggest understanding the war may unlock the secret of What Went Wrong. The Vietnam War may not be big enough to hold that answer, but the alternatives are almost unthinkable for most Americans, a questioning of the very political project that America has always been (we thought).

It is also for Stone the prime defining experience for his generation of men, and he rightly sees in it the paradigmatic rite of passage for our boys. It is this aspect that occupies *Born on the Fourth of July*, whose mournfully nostalgic credit sequence lays out all the terms of the discourse. The boys at play "turn the woods into a battlefield and dream that some day we would become men." The Fourth of July celebration gives us a look at the war heroes who flinch even at firecrackers and stare blindly into the coming generation of soldiers. But no one notices. And the boy's mother dreams he speaks to a crowd saying important things, even as Kennedy, on the television, talks about fighting every foe of liberty.

The movie, a spritual sequel to *Platoon*, makes painfully clear how the rituals of patriotism murder us, but even while it guts our fondest collective memories of small-town American warmth and love, it clings to a notion that the political process can still set things right again. Kovic becomes an activist and fulfills his mother's dream by addressing the Democratic convention. "One man can change the country," Stone told an interviewer a few years ago. His movies continue to assert that, even when political justice begins to seem irretrievable, in *JFK*.

In his most recent, most reviled, most disrespected, and best movie, Stone comes perilously close to the abyss both in style and content. The armature of the movie is a legal detective story, which becomes a *Citizen Kane*-style postmortem on the life of a Johnnie we hardly knew. On the all-too-conventional shoulders of Boy Scout Jim Garrison rests a kaleidoscopic portrait of American government in

action. Garrison uncovers the shadowy presence of the military and the CIA, of merciless industrial interests combined with ambitious politicians in a plot to kill a president who takes American ideals seriously. As seriously as Oliver Stone does.

Stone's previous films have provided a window on a furiously kinetic reality, sometimes bringing actual newsreels to life, as *Salvador*'s credits do, making use of maps and frequent identifying tags on the screen, and recreating documented incidents with a melodramatic, almost De Millean buzz. *JFK*, however, breaks on through to the other side; it uses all those techniques, but it subverts melodrama with its pyrotechnic editing of varied film stocks, frame sizes, and processes into a starburst narrative. The seamless reality of Hollywood narrative explodes, and the viewer confronts the speculative nature not only of film but also of history.

More like a hallucination than any of Stone's previous movies, even *The Doors, JFK* is another long dark night of the soul which draws the audience into its final indictment. Kevin Costner as Garrison looks into the camera to say to us, "It's up to you." Stone has used this before, in Archbishop Romero's most famous homily, recreated in *Salvador* as a prelude to his murder. The camera settles squarely on him and he looks *at us* to ask, "We are poor. You in Washington are so rich. Why are you so blind?"

That question—why?—the one that X tells Jim Garrison is the most important, remains to be answered. In *Salvador*, it might all just be Reagan's fault; his election in 1980 is the engine that drives the worst excesses of American policy during the events of the film. In *Wall Street*, there are again, as in *Platoon*, two fathers to choose from, rapacious Michael Douglas as the reptilian Gordon Gekko and union

man Martin Sheen, the character's and the star's natural father. In *Born on the Fourth of July*, Ron Kovic can turn to the Democrats after the Republicans have overturned his wheelchair at their convention. *Talk Radio*, Stone's most misanthropic movie, finds both the darkness and the light in the central character, as does *The Doors* —and Jim Morrison does have finally the humor and the grounding in life's little realities to suggest going out for tacos just before (im)mortality claims him.

In *JFK*, however, the possibility that *Platoon*'s Sergeant Barnes was right about America's (and humankind's) heart of darkness—"I am reality"—looms large. Perhaps the whole thing, the great experiment, is a lie, after all. The conspiracy posed is so vast, so effective, that it seems Stone can think of no real way to salvage the political process. He falls back disappointingly on a nuclear family heading into the sunset, reviled but immaculate. It's a retreat, and possibly a dramatic compromise, a sop to the relentless, rigid siege of the right, the mantra of "family values." But even with that flaw and with its allied problem, a questionable use of gay libido to illustrate the perfidy of the conspirators, *JFK* is the most significant Hollywood film in many a long cold year, confirming that its creator is the screen's leading interpreter of the political and psychological conundrum we call America.—Pat Dowell

RECOMMENDED BIBLIOGRAPHY

Stone, Oliver and Richard Boyle. Platoon *and* Salvador: *The Original Screenplays*. NY: Vintage Books, 1987.

———— and Zachary Sklar. JFK: *The Book of the Film: A Documented Screenplay*. NY: Applause Theater Book Publishers, 1992.

Strand, Paul

(October 16, 1890 – March 31, 1976)

P aul Strand is better known—and rightly so—as a still photographer than as a filmmaker. In the history of photography, he is one of the acknowledged masters, while in the history of the cinema his status is not nearly so exalted. Yet he played an important role as an independent filmmaker, especially in relation to non-Hollywood political cinema.

At the heart of Strand's work in both film and photography lies a tension between politics and esthetics, between a commitment to social reform and a devotion to beauty. These two tendencies suggest the two crucial early influences upon Strand's photography. He was introduced to the camera by Lewis Hine, his teacher at the Ethical Cultural School in New York City and a photographer devoted to social issues: Hine's famous photographs of children working in the mills and mines helped pass the child-labor laws. But what made Strand's reputation as a still photographer—when he was still in his twenties—was the patronage of Alfred Stieglitz, an elitist and an esthete who was the leading advocate of photography as an art. In 1916 Stieglitz awarded Strand a show at 291, his famous avant-garde gallery; the following year, he devoted the two final issues of *Camera Work*, the most important photographic magazine of its time, to Strand's photographs.

Stieglitz described Strand's work as "brutally direct...devoid of all flim-flam....the direct expression of today." One group of early images, greatly admired by Walker Evans among others, consisted of harsh, hidden-camera portraits of people on the New York streets. They cut through the artificiality of studio portraiture. Another early indication of Strand's attitude toward society appeared in an image showing Wall Street employ-

ees rushing to work in front of the massive façade of the Morgan Trust Company building, described by Strand as resembling "a giant maw." In 1922, he wrote an essay attacking what he called America's idolatrous relationship with "a new Trinity: God the Machine, Materialistic Empiricism the Son, and Science the Holy Ghost."

Strand regarded the camera as a unique contribution of science to art and, like Stieglitz, saw his work as serving spiritual ends in a philistine society. If some of his photographs were overt social criticism, others were studies bordering on abstraction, as Strand explored the formal innovations of European modernism. As a whole, Strand's early photographs helped to revolutionize art photography, giving it a clarity and force it previously lacked, bringing it out of the dreamy, soft-focus world of the pictorialists and into the modern age.

Strand began his career as a filmmaker by working on medical films. His first real film, *Manhatta*, made with the painter and photographer Charles Sheeler in 1921, was a study of New York City: the images combine with quotations from Walt Whitman to pay tribute to the urban scene, America, and modern life. The following year, Strand bought an Akeley camera, and for roughly eight years he worked as a free-lance motion picture cameraman, mainly shooting documentary footage for

newsreels.

In 1932 Strand went to Mexico, where he was named the chief of photography and cinematography in the Department of Fine Arts in the Secretariat of Education. This led to his next major film project, *Redes* (American title *The Wave*), filmed in a small fishing village in 1934. Strand supervised the production and was the cinematographer; the scenario was written with Henwar Rodakiewicz, who at the start of the filming was in charge of directing the actors but then turned over his duties to the young Fred Zinnemann. *The Wave* was released in 1936 (1937 in the U.S.).

Strand admired Flaherty, and, like him, regarded documentary as more than instruction or recording of fact. Unlike Flaherty, however, Strand wanted to present a struggle against economic and social oppression, rather than purely natural forces. *The Wave* tells the story of fishermen battling middlemen and corrupt politicians; with typical proletarian wisdom an old man says, "We work—they take" and "The big fish eat the little fish." *The Wave* ends with one fisherman a martyr and another converted to the cause and taking over as leader. His final words are: "If we stand together, nothing can stop us."

Except for its more optimistic conclusion, *The Wave* is not unlike Visconti's *La Terra Trema*. In fact, with only two actors who were not villagers—one a professional, the other a university student—*The Wave* anticipates neorealism, which Strand applauded when it appeared (he collaborated on a book on an Italian village with Cesare Zavattini, novelist and scenarist of *Bicycle Thieves*). *The Wave* was originally conceived as but the first of a series on the production of wealth that would show miners, ranchers, and farmers as well as fishermen—in effect an epic survey of the working class. Unfortunately, when Cardenas became President of Mexico the project was shelved. (Visconti envisioned *La Terra Trema* as the first part of a trilogy that would include miners and shepherds; De Sanctis completed a comparable trilogy, but with melodramatic and sexual elements that represented a kind of falsification.)

In 1935, Strand joined Nykino ("New York Kino," *kino* being Russian for cinema), led by Leo Hurwitz, which was the product of a splinter group in the Film and Photo League. Like the other members of Nykino, Strand was deeply influenced by Soviet filmmakers such as Eisenstein, Pudovkin, and Dovzhenko. With the leaders of the Group Theatre, Harold Clurman and Cheryl Crawford, he toured the Soviet Union. He met Eisenstein, who held a few clips of *The Wave* up to the light and remarked that it was obvious Strand was a still photographer, not a filmmaker. It is true that for all their concern with montage and movement, Strand's films demonstrate a care in composition, lighting, and framing that make each shot a self-contained unit, suggesting a still-camera orientation (one wag called *The Wave* "the most beautiful strike ever filmed").

Strand was offered work on two Soviet projects, including one of Eisenstein's, but because of complications did not stay. Upon his return to the U.S. in 1935 he served as a cinematographer on Pare Lorentz's *The Plow That Broke the Plains* (1936), produced for the Resettlement Administration. Hurwitz and Ralph Steiner also worked on that film; along with Lionel Berman, Ben Maddow, Sidney Meyers, and Willard Van Dyke, they formed the nucleus of Frontier Films, a nonprofit left-wing motion picture production group formed in 1937 as an outgrowth of Nykino, with Strand as president.

Frontier disbanded in 1942, a casualty of personal conflicts heightened by political differences, financial difficulties, and a political climate transformed by the war. But it succeeded in producing eight films, beginning with *Heart of Spain* (1937), edited by Hurwitz and Strand, and including Elia Kazan's first film, *People of the Cumberland* (1938), as well as a film produced by Henri Cartier-Bresson.

The Frontier films took different forms.

The first films were relatively straightforward documentaries about the Spanish Civil War and Japanese aggression in China. The last film, *Native Land* (1942), photographed by Strand and directed by him and Hurwitz, was a feature-length film employing fictionalized reenactments of civil liberties violations. There were episodes on vigilante violence, including the brutality of the Ku Klux Klan, but *Native Land*'s main emphasis fell on antiunion activities by big business—everything from labor spying to the Republic Steel Massacre. The final montage, including shots of the flag and the Statue of Liberty, is accompanied by the statement that "There was never a moment in our history when Americans were afraid to stand up and fight for our rights."

Native Land now appears very much a work of its time. In its use of patriotic symbols, its poetic-didactic-moralistic narration (written by Ben Maddow and spoken by Paul Robeson), its Marc Blitzstein score, and its attempts at a "dialectical" style of montage and narrative construction, *Native Land* epitomizes much of the left filmmaking from the Thirties. If those elements at times make *Native Land* appear stilted or dated, overall it remains powerful and moving.

The swing to the right during the McCarthy period distressed Strand. Although he was apparently not in any danger—friends such as Hurwitz were harassed and blacklisted—he left the United States in 1950 to do a book on France and settled there, in Orgeval, near Paris, returning to the U.S. only on rare occasions. He worked on a series of projects in the Hebrides, Ghana, Egypt, Italy, Morocco, Romania, and in France itself, where he concentrated on traditional customs and took exquisite nature photographs in the garden of his home.

If Strand's turn from filmmaking marked an end of sorts to his political activism, he never surrendered his radical beliefs. In the Thirties, he was far to the left, especially in relation to Spain, yet he was at the same time a staunch supporter of the New Deal. In 1943 he was chairman of a committee supporting Roosevelt, editing a pro-New Deal photographic exhibition held in New York City; in 1945 he was one of 250 scientists, artists, and writers who were the guests of the President and Mrs. Roosevelt for the inauguration. Living in France meant that he was less directly involved in American politics, but in 1965 he proved that his radicalism was not a thing of the past. Invited to a reception at the White House by President Johnson, he was among those artists and writers who refused to attend in protest over the administration's policy in Vietnam.

The photographic achievements during the last period of Strand's artistic life were substantial, if not particularly adventurous. But Strand's long exile from America, his inability to move beyond a world view rooted in the Thirties, and, of course, the cessation of all film work, are a representative and sad testimony to the fate—with only a few exceptions—of independent political filmmakers and filmmaking in America from World War II until the Sixties.

—Robert Silberman

RECOMMENDED BIBLIOGRAPHY

Alexander, William. *Film on the Left: American Documentary Film from 1931 to 1942.* Princeton, NJ: Princeton University Press, 1981.

Campbell, Russell. *Cinema Strikes Back: Radical Filmmaking in the United States 1930–1942.* Ann Arbor, MI: UMI Research Press, 1982.

Strand, Paul. *Paul Strand: Sixty Years of Photographs.* NY: Aperture Press, 1976.

Sullivan's Travels

Sturges, Edmond Preston

(August 29, 1898 – August 6, 1959)

t first glance, Preston Sturges appears the ultimate enemy of the political film, Hollywood's greatest champion of escapism. Throughout his career, Sturges thumbed his nose at misguided intellectuals and do-gooders who thought they could change the social order through charitable acts, or—even more ludicrously—through their movies.

In *Sullivan's Travels* (1941), his most overt commentary on the relationship of politics and film, Sturges's misguided alter ego, big-time Hollywood comedy director John L. Sullivan (Joel McCrea) decides to make a serious film. "O Brother Where Art Thou?" was to realize the medium's sociological and artistic potentialities. But when Sullivan goes out into the "real world" of Depression poverty and prison farms, he learns that the poor have no interest in "deep-dish" movies, that they know all they need to know about human suffering and would much rather see escapist comedies and Walt Disney cartoons. As Sturges would have it, the greatest gift Sullivan can offer his public is to make them laugh and temporarily forget their troubles.

But if Sturges is antagonistic to the film community's liberal segment, he is no champion of crass commercialism. *Sullivan's Travels* continualy pokes fun at the cigar-chomping studio brass who rant and rave that "O Brother" will die in Pittsburgh and plead with their star director that a picture's got to have a little sex in it. While Sturges himself was a master of knockabout farce (*The Palm Beach Story*, 1942) and romantic comedy (*The Lady Eve*, 1941), he refused to cater to the low-brow tastes of the studio bosses. At the same time, however, he was too cynical to believe in the possibility of social change. The director's great comedies of the Forties are neither escapist fluff nor serious social commentary; rather, they are

pungent satires which poke fun at Hollywood's and America's most revered myths.

Because Sturges was a director of comedies, he could often say things which no serious director would dare to broach. Produced at a time when most Hollywood filmmakers were producing patriotic paeans to our great democracy, Sturges's great wartime comedies, *Hail the Conquering Hero* (1944) and *The Miracle of Morgan's Creek* (1944), lambasted home-front America for its phony hero worship and its commercialized patriotism. Mixed in with the slapstick comedy, absurd plot twists, and eccentric characters (with equally eccentric names like Kockenlocker, Ratzkiwatzki, and Woodrow Truesmith) are hilarious jabs at American mother worship, the institution of marriage, and even the Virgin Birth. Sturges even went so far here as to suggest that political elections are controlled by a corrupt party machine—a forbidden subject during the wartime propaganda blitz against America's antidemocratic enemies.

The Great McGinty (1940), made in the prewar period, is a savage attack on American politics, surely one of the most cynical films ever to emerge from a major Hollywood studio. In this highly original variation on the archetypal Horatio Alger rags-to-riches story, an unemployed slum tough, McGinty (Brian Donleavy) catches the attention of a powerful political boss through a unique display of initiative. Offered two dollars by the party machine to vote illegally for their candidate, McGinty shows up at thirty-seven polling booths under different names to earn himself seventy-four dollars. Quickly McGinty becomes a favorite of the boss, rising through the ranks from henchman to political candidate, finally getting elected as the state's governor. As long as McGinty remains crooked and cynical his horizons are limitless, but when he decides to use his office for the public good he is doomed. For "one crazy moment," egged on by the banal, liberal sentimalities of

his wife, McGinty challenges the all-powerful party machine and as a result loses everything—his power, his fortune, and even his wife.

No one escapes the wrath of Sturges's cynicism. McGinty offers no hope for social change since the only way to achieve and maintain power is through a corruption that negates the possibility of meaningful reform. But while he despairs of the system, Sturges also ridicules idealists who refuse to see this reality. McGinty may be corrupt but he is ingenious and unpretentious in his venality, a far more likable figure than the sappy wife who laments the plight of the poor without having the foggiest notion of what poverty is really like.

Other Sturges films are only slightly less sardonic. *Christmas in July* (1940) examines the American obsession with success, the national belief that money makes the man. Sturges's hero, Jimmy MacDonald (Dick Powell) is the exact opposite of McGinty, a man who is desperate for success but completely lacking the drive necessary to achieve it. Instead of working his way to the top, Jimmy foolishly enters contests in the hope of striking it rich through luck. Jimmy also lacks skills—his entry in the Maxford House Slogan competition is awful: "If you can't sleep at night, it's not the coffee, it's the bunk." The film develops into a chaotic comedy that flip-flops so often on the subject of success that the only viewpoint confirmed by *Christmas in July* is Sturges's ambivalence toward it. While his hero is grudgingly granted a dignified end, throughout the film Sturges allows him to be mercilessly manipulated by events. First, a practical joke causes Jimmy, his girlfriend, and his employer to believe that he has won the Maxford House contest. Jimmy is suddenly possessed of a social and professional prestige he never dreamed of, and which, of course, he doesn't deserve. When the hoax is discovered, he is thrust cruelly back into the world of nonentities—his lofty status at

work and at home dematerializes—and he is back to being a failure. Here Sturges gives Jimmy a chance to learn something from his experience. As his foreman Mr. Waterbury put it, "I used to think about $25,000...And then one day I realized I was never going to have $25,000. [But] I'm not a failure. I'm a success. And so are you if you earn a living, pay your bills, and look the world straight in the eye." But Jimmy refuses to accept his faults and settle for the contented life of a Waterbury, and he takes the news of his loss hard. Accordingly, Sturges allows him to be manipulated even further. He is named winner of the contest again—this time it's for real—but only due to the efforts of one inept juror who finally wears down his colleagues with his foolishness.

Sturges returned again and again to the theme of the great American obsession with success. The theme is present even in his earliest screenplays for other directors—*The Power and the Glory* (1933), *Diamond Jim* (1935), *Easy Living* (1937). *Mad Wednesday* (1947) is perhaps his most eloquent meditation on the subject, a look at what has happened to *The Freshman,* the eager-beaver Twenties go-getter portrayed by Harold Lloyd, twenty years later. After inadvertently gaining a potentially powerful company position, Harold Diddlebock tries to follow all the obvious success ethic platitudes, but finds himself twenty-two years later in the same spot from which he started. By adhering to the success formula, Harold has lost his ability to think for himself and can speak only in the language of platitudes ("Every man is the architect of his own future," "The power of positive thinking," etc.). Here Sturges attacks both the success ethic and the man who lives by it. Like Jimmy, Harold's desire for success only exposes him as lacking in ability, while the success formula itself has helped turn him into an ineffectual boob.

It is difficult to discern through his twists, turns, and flip-flops in plot exactly what Sturges's attitude toward the success ethic is. McGinty is corrupt, and deserves to be rich. Jimmy is honest, and doesn't deserve to be rich. McGinty momentarily forsakes his corruption and winds up poor while Jimmy becomes wealthy by an absurd stroke of luck. But John L. Sullivan's universal law runs as a constant thread in Sturges's films: "Stay put. As you are so shall you remain." Sturges does not side with the rich man, nor does he attach any particular value to being poor. The point (and it is underscored by *Sullivan's Travels*) is that the deeds of the socially conscious can do nothing to change a world governed by chance. Chance is all-powerful: it can work for you and make you a millionaire, or it can just as easily work against you and make you a pauper again.

Sturges's films are some of the funniest and most entertaining to come out of Hollywood. In that sense, he is an "escapist"; indeed, none of his films can be categorized as the plodding, solemn commentary of an "O Brother Where Art Thou?" But the inherent cynicism of his commentaries on success (*Christmas in July, Mad Wednesday*), politics (*The Great McGinty*) and almost every other established American institution make it impossible to deny that Sturges is, in his own way, one of Hollywood's most political filmmakers.

—Peter Roffman and Beverly Simpson

RECOMMENDED BIBLIOGRAPHY

Curtis, James. *Between Flops: A Biography of Preston Sturges.* NY: Limelight Editions, 1982.

Dickos, Andrew. *Intrepid Laughter: Preston Sturges and the Movies.* Metuchen, NJ: Scarecrow Press, 1985.

Henderson, Brian, ed. *Five Screenplays by Preston Sturges.* Berkeley, CA: University of California Press, 1985.

Jacobs, Diane. *Christmas in July: The Life and Art of Preston Sturges.* Berkeley, CA: The University of California Press, 1992.

Spoto, Donald. *Madcap: The Life of Preston Sturges.* Edited by Brian Henderson. Berkeley, CA: University of California Press, 1985.

Sturges, Sandy, ed. *Preston Sturges by Preston Sturges: His Life in His Words.* NY: Simon and Schuster, 1991.

Trumbo, James Dalton

(December 9, 1905 – September 10, 1976)

Authors sometimes become famous in genres they do not pursue or prefer. Dalton Trumbo did not initially intend to be a screenwriter. He started his writing career in the Thirties as a journalist and in 1935 published *Eclipse*, his first novel. It was a modest success. A year later, his *Washington Jitters*, a satire of political bureaucracy, also got fair reviews.

His antiwar novel *Johnny Got His Gun* (1939) received the dual honor of a National Book Award and serialization in *The Daily Worker*. For Trumbo, the path was clear—he was going to be a novelist. Even after the failure of his last complete novel, *The Remarkable Andrew* (1940), he never abandoned the form. He wrote screenplays to support his "serious writing," and soon became the highest paid writer in Hollywood's history. Had his lucrative career not been held up by the blacklist, he might have been free to pursue his goal.

Trumbo was seldom secretive about his political activities. While a member of the Communist Party and on the council of the Screen Writers Guild, he edited the radical magazine, *The Screen Writer*. He wrote speeches for liberal candidates in California, like Will Rogers, Jr. When the House Un-American Activities Committee (HUAC) summoned him in 1947, he refused to give names of other suspected communists. Along with other members of the Hollywood Ten, HUAC cited him for contempt of Congress and sentenced him to ten months in a federal prison. In 1953, he maintained that HUAC attacked Hollywood "to destroy trade unions, to paralyze antifascist political action, and to remove progressive content from films."

Although the Committee couldn't find any communist doctrine in Trumbo's films, it may have sensed their content. *Kitty Foyle*'s eponymous working-class heroine painfully discovers the fallacy of marrying across class lines. She is fresh to her superiors and the upper-class women she waits on, and angrily confronts her brahmin in-laws. Despite its occasional swipes at the rich, *Kitty Foyle* (1940) was no further left than other New Deal-era films, like *The Grapes of Wrath* (1940) and *Our Daily Bread* (1934). Trumbo's wartime films *Tender Comrade* (1943), *A Guy Named Joe* (1943), and *Thirty Seconds Over Tokyo* (1944) extol collective action and steer away from the racial stereotypes of many war films of that era. Ironically, the same U.S. government that had commended the latter two films for their "patriotism" seriously listened to testimonies of people like Lela Rogers, Ginger's mother. She claimed that in *Tender Comrade* her daughter had been given "communist" lines like "Share and share alike. That's democracy."

During the blacklist years, Trumbo wrote B-movie scripts, seldom receiving more than five percent of his former fees. In one eighteen-month period, he produced twelve scripts for producers such as the King brothers and developed a reputation for quick turnarounds and free rewrites. He wrote under many pseudonyms, such as Sally Stubblefield, Les Crutchfield, and Arnold Schulman, and often doctored scripts that other writers

had written. In 1956, the year that the Academy barred blacklisted artists from receiving awards, his screenplay for *The Brave One* won the Academy Award under the pseudonym Robert Rich.

In 1949, Trumbo knew that he was facing hard times, so he tried to make money at "serious writing." He had his black comic play, *The Biggest Thief in Town*, produced. It received bad reviews and closed after a short run in Boston and Philadelphia, although British audiences liked it enough to give it a two-year run. He returned to scriptwriting, believing it "hack work" he had to endure to support his family. Even after he'd broken the blacklist with *Exodus* (1960) and *Spartacus* (1960), he never changed his opinion.

Was it really hack work? Unfortunately, much of it was. *The Sandpiper* (1965), *The Last Sunset* (1961), and even *The Brave One* (1956) are forgettable, if not downright awful films, and Trumbo knew it. After hustling for thirteen years, he seemed organically incapable of turning down a script offer. But even some of his flawed films—*Exodus*, for example—contain scenes that are still effective today.

When Otto Preminger asked him to write the screenplay, Trumbo readily agreed. It didn't matter that some members of the left criticized Leon Uris's novel for its Zionist politics; Trumbo felt his accreditation in the film could possibly break the blacklist. He was right.

Even though the film's pace is sluggish and its casting often ludicrous, the screenplay has several powerful scenes that show Trumbo's skill with characterization. A hardened Jewish terrorist cracks when his commander forces him to confess his humiliating job at Auschwitz. The young woman, Karen, finds her catatonic father in a hospital in a silent, brilliantly restrained scene. When the British bar the Jews from leaving Cyprus, the refugees take a stand, and the resulting confrontation is more effective than the superficial action scenes that end the film.

Not surprisingly, Trumbo's best post-

blacklist films portray a rebellious individual struggling (and losing) against a hostile social system, as in *Spartacus, Lonely Are the Brave* (1962), *The Fixer* (1968), and *Papillon* (1973). But in other films, he seemed out of sync with his audience's needs. His political screenplays lack subtlety and are often clotted with exposition. In the JFK assassination film, *Executive Action* (1973), the characters break up the narrative to expound conspiracy theories. *Johnny Got His Gun* (1971), which he wrote and directed, was a box office and critical failure because its powerful antiwar message never quite balanced its unrelieved gloom. It could have used humor or ironic distance (which the book also lacked) or even the raw energy of his World War II films.

When Trumbo did use irony, he often applied it heavy-handedly. In a scene from *Exodus*, the Jewish commando Ari, disguised as a British officer, baits an anti-Semitic British officer. "These Jews," he says, standing nose-to-nose with him, "You can smell them a mile away."

While Trumbo's sense of humor failed him (or was curbed) in many of his films, his letters, pamphlets, and novels are rife with acid wit, even shameless sarcasm. Sometimes he used these literary tools to persuade or shame political opponents, but more often he just used them to entertain. His satiric novel, *Washington Jitters*, is about a sign painter whom a journalist mistakes for a powerful federal bureaucrat. Passing ingenuously through a web of confused assumptions, subterfuge, and misapprehensions, he becomes a feared and revered figure, much like Chance Gardiner in Jerzy Kosinski's novel, *Being There*. It doesn't matter that the politicians are caricatures, or that the novel's ending is anticlimatic—its absurd discussions and plot twists effectively deflate official pomposity and intellectual pretension.

The letters published in *Additional Dialogue: Letters of Dalton Trumbo, 1942–1962* are as acerbic as *The Letters of Sean O'Casey*, and perceptive as those in *Anton Chekhov's Life and Thought: Selected Letters*

and Commentary. Additional Dialogue shows how he used wily humor and hyperbole to survive during the blacklist. To stave off creditors, he complained vociferously about product quality, and referred to the phone company as "the thuggery." He wrote exuberant, Rabelaisian letters to his children, advising them about sex. In 1958, he outlined a wild scheme to Albert Maltz to expose the identity of Robert Rich on national TV (it never happened). When asked by the editor of *The Nation* for a list of topics for an article, he supplied thirty ideas, several of which are witty aphorisms that stand on their own.

17. Again: the acquiescent American. His marvelous and meek acceptance of shoddy workmanship, bad telephone service, involved tax forms, community drives, official pomposity, absurd laws, stop lights at three in the morning on silent and deserted street corners. There are practically no acts of rebellion.

The correspondence exhibits his many facets, perhaps more incisively than any autobiography might have. Trumbo never wrote literary criticism, but a letter to fellow blacklistee Ring Lardner, Jr. about his novel *The Ecstasy of Owen Muir* shows he knew its rules: "The involvement of passion in the process is extremely important. Without passion, which is to say anger, you are likely to present the author with your findings in a humble and apologetic fashion." The letters also reveal contradictory sides to his personality. When approached by director Herbert Biberman to write an independent script in 1951 (presumably *Salt of the Earth*), he declined for monetary reasons. "I am...not interested in pamphlets, speeches, or progressive motion pictures. I cannot...hypothecate even a month for any project that does not contain the prospect of an immediate and substantial sum." He could not stick to this resolution. Five years later, he wrote *The Devil in the Book*, a pamphlet supporting the fourteen California Smith Act defendants.

Trumbo never stopped writing what he considered legitimate fiction. He spent his last sixteen years working on the curious novel *The Night of the Aurochs* (published posthumously), a psychological study of an unrepentant Nazi named Grieben. It survives today as ten complete chapters, a synopsis, and scattered notes—an eloquent, confused fragment that tells as much about Trumbo's style of work as his changing beliefs on evil. Grieben reminisces about his youth in Germany and his evolution from a Nazi sympathizer to a commandant at Auschwitz. The opening chapters poignantly show his sexual awakenings and attitude toward women. Trumbo's notes reveal plans to show how German mysticism, not political economy, fashioned men like Grieben and gave birth to the "irrational" anti-Semitic Nazi state. His friend Michael Wilson was so impressed with the work, he wrote:

I wish some way could be found to prevent you from taking on more film work until you have finished the novel. It would be folly to rely on your own character for this essential discipline, because the mere jingling of coins triggers a conditioned reflex in your arthritic write [*sic*] hand.

Despite Trumbo's strengths and weaknesses as a screenwriter, he should be commended for refusing to cooperate with the witch hunters, while colleagues like Elia Kazan and Edward Dmytryk caved in to them to preserve their careers. Trumbo paid dearly for his courageous stand throughout the Fifties and probably realized it prohibited him from writing the masterpiece for which history would remember him. Although he was proud of *Johnny Got His Gun* and a handful of competent screenplays, his letters imply he felt unfulfilled, as if he'd been denied the mantle of a Hemingway or Dos Passos. He never realized that in revealing himself through these intense, quirky letters, he'd written an eloquent testimony, if not the masterpiece itself.—Peter Bates

RECOMMENDED BIBLIOGRAPHY

Cook, Bruce. *Dalton Trumbo*. NY: Scribner, 1977.

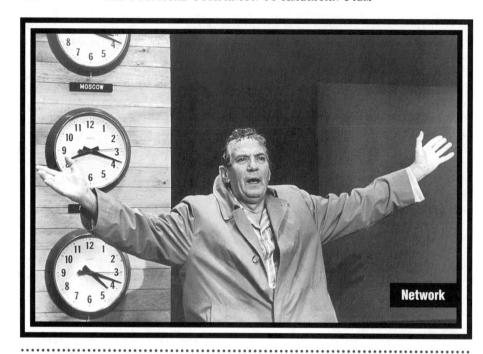

Network

Television as Seen by Hollywood

O n February 3, 1929, less than five months after General Electric's experimental station WGY in Schenectady, New York, broadcast the first televised program in America, it presented a brief televised talk by famed movie director, D. W. Griffith. In his short speech, Griffith hailed the new invention as "this last miracle of miracles."

Although this wasn't the first time someone from the film industry had encountered television, it would probably be the last time that the new medium would be so unabashedly and unambiguously embraced by anyone from the older medium. Indeed, the future relationship of the television and film industries would be marked by ambiguous feelings of love/hate that exist to this very day, a relationship whose ambivalence would also be reflected in television's image in Hollywood films.

By the Thirties successful experiments with television had already been conduct-

ed in England (1923) and the United States (1928). It was therefore no surprise when, shortly thereafter, at least three major films of the decade featured television in their scenarios. In William Cameron Menzies's *Things to Come* (1935), television made a brief appearance as one of the typical technological breakthroughs achieved by the advanced civilization of the "Airmen" following their reconstruction of the neo-Stone Age society left in the wake of a world war.

In contrast to *Things to Come*, in which television only briefly figures, it was prominently featured in the equally futuristic

Transatlantic Tunnel (1935). Not only is it seen as a means of interpersonal communication (as in *Things to Come*), it was also seen as part of a communication network and transportation system cementing an Anglo-American alliance whose hegemony would insure world peace.

Not everyone, however, was so cheerfully optimistic about the coming of television. Charlie Chaplin, in *Modern Times* (1936), for instance, envisioned television in diametrically opposite, even Orwellian, terms. As the film opens we see a factory boss laying aside his comic strip, flicking a switch, and giving orders into a huge television screen for a speedup of the assembly line. Similarly, in another scene, Charlie, on a break from the line, lights a cigarette, only to be interrupted by the telescreen which orders him to quit goofing off and to get back to work. In *Modern Times*, then, television is seen as "Big Brother," not only invading the workers' privacy but also buttressing and sustaining the authoritarian and hierarchical structures of the workplace.

Although none of these early film portrayals of television was exactly clairvoyant, they nevertheless did illuminate some of the shared assumptions and ambivalences toward the new medium. If these films are inspected for clues as to the thinking of filmmakers about television, for example, they reveal that none of them anticipated television becoming an entertainment medium (perhaps a matter of wishful thinking). Instead they emphasized its advantage for interpersonal communication. On the other hand, they seemed divided over whether television could help to achieve progressive goals such as world peace, or instead serve as a new and more oppressive tool of industrial society.

Far from clearing up this ambiguity, the films and filmmakers of the Forties generally exhibited a marked indifference to television. This lack of concern extended into the early postwar years and may even have accounted for the somewhat benign, if not benevolent, attitude taken toward television in films produced as late as 1951. For example, in *The Day the Earth Stood Still*, that year's science fiction hit, when the world witnessed the first encounter between earthlings and the alien Klaatu and his robot Gort, it watched the event on its TV screens.

Another typical example of this early head-in-the-sand attitude toward the new medium was the situation at MGM in the mid-Fifties, when Adolph Green and his collaborator Betty Comden went west to work on the musical, *It's Always Fair Weather* (1955). At a Hollywood luncheon, Green reported, "One of the chief executives got up to make a speech about the divorcement [*the forced divestiture of theaters from the studios*—A.A.] ruining the movie business. But television was never mentioned—these people weren't on the planet at all. They just didn't know."

Possibly as a result of their shock over this obtuseness, Comden and Green wrote a script for *It's Always Fair Weather* in which television played a major role. The film deals with the post-World War II reunion of three GI buddies who unfortunately now learn they can't stand one another. Their problem is compounded by the fact that a TV producer has gotten wind of the reunion and scheduled the three to appear on her program, "Midnight with Madeline." This not only allowed Comden and Green to create a lighthearted spoof of the then hit TV series, "This is Your Life," but also enabled them to satirize both the banality of TV programming and its enthrallment to advertising.

This good-natured twitting of TV, however, was but a brief moment in the Fifties relationship between TV and the movies. By the mid-Fifties, Hollywood seemed to have caught on to the menace of television, and good-natured satire gave way to vitriolic attacks. Perhaps symbolic of this changing consciousness was a scene in *The Man in the Grey Flannel Suit* (1956), in which broadcasting executive Tom Rath

(Gregory Peck) comes home to find his youngest child sitting mesmerized in front of the family TV set. That same year (undoubtedly motivated as much by anti-communist as by anti-TV feeling), the British produced a film version of George Orwell's *1984*. The "Big Brother" potential of TV was also on the minds of director Elia Kazan and novelist Budd Schulberg who, following their success with *On the Waterfront* (1954), decided to tackle the issue of television in *A Face in the Crowd* (1957).

A Face in the Crowd, however, is no more simply an anti-TV film than *On the Waterfront* is simply a film about labor racketeering. In their new film, Kazan and Schulberg gave visual embodiment to some of their fears (albeit embroidering them with some of the intellectual assumptions of many left-wing but non-communist intellectuals of the Fifties) about the influence of mass culture on American society in general, and of TV's potential to aid right-wing populist movements in particular. As Kazan says in the preface he wrote to the published script, he and Schulberg "talked of how much more powerful Huey Long would have been had he had TV at his disposal...and the synthetic folksiness that saturated certain programs and excursions into political waters by these I-don't-know-anything-but-I-know-what-I-think guys." Out of these conversations and Schulberg's short story, *Your Arkansas Traveler*, was born the character of Lonesome Rhodes (Andy Griffith). Discovered by a reporter looking for voices for her "A Face in the Crowd" show, he parlays a crafty folksiness with a gift of gab and a cynical brand of iconoclasm into political and cultural power of almost Hitlerian dimensions.

The best parts of the film, however, are not given over to fleshing out the worst fears of Dwight MacDonald and Daniel Bell, but to Kazan and Schulberg's uncanny depiction of how politics and show business intersect in America. Illuminating this aspect of the film are moments like

Lonesome's advice to a particularly rigid and humorless political candidate as to how to be natural and popular on TV— including injunctions such as keep your lips closed, make fun of yourself, and get a pet. The film also gives us a slight whiff of the proletarian resentment that lingers with Rhodes no matter how high he climbs. Rhodes's animosity toward the high and mighty eventually begins to include everyone, something which ultimately causes his undoing, when his girlfriend and mentor (Patricia Neal) deliberately leaves him on the air (when he thinks he's off), thus exposing his megalomania and viciousness to the American people.

While just this kind of pulling the plug on TV might have been on the minds of many Hollywood producers during the period, being anti-TV was not the primary virtue of *A Face in the Crowd*. Indeed, it would set the standard by which the best films about TV would be judged, because it wasn't as much about TV as it was about American culture and politics. Thus, in a film like John Frankenheimer's *The Manchurian Candidate* (1962)—where TV sets are ubiquitous, Medal of Honor winners turn into communist-controlled assassins, right-wing senators are communist dupes, and "Mom," the *ne plus ultra* of American goodness, is a Stalinist agent— television is merely the most technologically advanced and omnipresent illusion-making element in a system permeated by illusion.

In contrast to this early-Sixties view of television as just another source of illusion, by the late Sixties, in films like Haskell Wexler's *Medium Cool* (1969), it had become the ultimate source of reality. Set against documentary footage of the riots at the 1968 Democratic National Convention, *Medium Cool* shows TV cameraman John Cassellis (Robert Forster) interviewing a group of black militants who tell him to put the film on the six o'clock and eleven o'clock news, then it will be "real.'

The question of whether TV provided

an accurate picture of American life, or was a crazy mirror distortion of it, seemed less important than the fact that by the late Sixties it was unquestionably a major—if not the most powerful—force in setting the national agenda. As a result, television, along with minorities, students, and intellectuals, came in for some of the blame for the turbulence of the decade. This blaming the messenger mentality found no greater exponents than Paddy Chayefsky and Sidney Lumet in their black farce, *Network* (1976). Biting the hand that once fed them, Lumet and Chayefsky took on not only TV news and the ratings system, but also took potshots at multinational corporations, the terrorist left, and what was in store for us if we became what we beheld.

Indeed, it is this latter effect of TV that Chayefsky and Lumet seem most vociferous about. The character who comes in for the most savage treatment in the film is TV producer Diane Christenson (Faye Dunaway) who would sell her soul for a "thirty share." One character describes her as "the television generation. She learned life from Bugs Bunny. The only reality she knows is from her TV set."

The film's gallery of grotesques also includes anchorman Howard Beale (Peter Finch) who, after an on-air nervous breakdown, is turned by his ratings-starved network into the "Mad Prophet of the Air Waves." Shouting slogans like, "I'm mad as hell, and I'm not going to take it anymore" (soon to be adopted in real life by proponents of California's tax-cutting Proposition 13), he becomes a national phenomenon, and the mouthpiece of a corporate oligarch who soon has him presenting messages like, "Is dehumanization such a bad word?"

Not content to attack broadcasters alone, Chayefsky and Lumet also took on the left through the equally fantastic conceit of having the network plotting with a Symbionese Liberation Front-type group to assassinate Beale on the air when his ratings fall (thereby creating the image of

the first person to be killed for low ratings). *Network* reflects TV in a funhouse mirror wherein everything has gone startlingly awry.

Having both started their careers in early TV, Chayefsky and Lumet contrive to keep their own skirts clean, and in the process also allude to TV's "Golden Age," a time when the television industry was decent, humane, and creative. Consequently, we get the character of news chief Max Schumacher (William Holden) who, although he has a winter passion fling with Christenson, still manages to cling to his humanity and remind us of the integrity-filled and presumably bygone days of Edward R. Murrow.

Unfortunately, what Chayefsky and Lumet don't point out is that while for some the Fifties might have been a "Golden Age," for others, in the words of blacklisted Hollywood Ten screenwriter Dalton Trumbo, it was "The Time of the Toad." It was an era when director Martin Ritt and screenwriter Walter Bernstein, who later collaborated on a film about the blacklist in TV, *The Front* (1976), were themselves blacklisted.

In *The Front*, Woody Allen, in his first straight role, plays the two-bit nebbish Howard Prince, who fronts for a group of blacklisted TV writers. Soon, as a result of his brilliant success, Prince is not only the recipient of fame, fortune, and the love of a beautiful young female scriptreader, he is under suspicion by government witch hunters of being a communist. Despite *The Front*'s success in depicting the oily villainy of the blacklisters—including references to some real-life blacklist tragedies—one never gets a true sense of the terror of the era, nor the truly corroding influence it had on the art and artists of the period. Throughout the film, in fact, one senses that the blacklist Ritt and Bernstein really wanted to deal with, but didn't (or couldn't), was not the one in TV but the one in Hollywood. With its Sixties-bred contempt for McCarthyism and red-baiting, *The Front* succeeds less in evok-

ing that terrible period than in making us wonder what television might have been like had it been born in the Sixties instead of the Fifties.

It mattered little when TV was born, suggested Hal Ashby's *Being There* (1979), based on the novella by Jerzy Kosinski, because of far greater concern was the present danger of the medium turning us into a nation of videots. No one seems able to see through the banality and simple-mindedness of the nearly catatonic Chance the gardener (Peter Sellers) who is mistakenly metamorphosed into Chauncey Gardiner, a national guru. By the end of the film, this cathode ray Candide, whose sole worldly experience has been his garden and his TV set, has not only succeeded in charming a dying billionaire, his sex-starved wife, and a rather dense president of the United States, he is even being considered presidential timber himself.

After this bleakest of bleak views, Hollywood's view of television in the Eighties began to improve. Indeed, perhaps taking a cue from a late Seventies film like *The China Syndrome* (1979), which depicted Jane Fonda and Michael Douglas as a muckraking TV broadcast team who uncover safety violations and hazards at a nuclear plant, television began to take on a more positive image in films. Although *Tootsie* (1982) is only indirectly about TV—a role in a TV soap opera is the job for which unemployed actor Michael Dorsey (Dustin Hoffman) must masquerade as a woman—screenwriter Larry Gelbart and director Sydney Pollack (both of whom had earlier worked in TV) contrive to give us a behind-the-scenes glimpse of the world of daytime drama. Although the form is gently twitted here and there—a character killed off because the actor asked for a raise, a has-been actor who lusts after all the young actresses—soap opera was nonetheless treated with the respect for the enormous influence it exerted on American women. Consequently, just as Michael Dorsey got in touch with his femininity in *Tootsie*, film-

goers may likewise have sensed how much of a force for social change this most maligned of TV forms could be.

If this wasn't a rosy enough view of TV, one had to go no further than Richard Benjamin's *My Favorite Year* (1982) for an even jauntier and cheerful view. Again set in TV's "Golden Age" (which was fast becoming the favorite movie cliché for good television), *My Favorite Year* was supposedly drawn from an incident in the life of Mel Brooks when he worked for the legendary *Show of Shows*. Aspiring comedy writer Benjy Stone (Mark Linn-Baker) is given the unenviable task of keeping his show's guest star, former film swashbuckler Alan Swann (Peter O'Toole), sober and relatively chaste before the show. Swann, of course, is a mass of contradictions, who can simultaneously charm the *kishkes* out of Benjy's Jewish mother, or turn practically catatonic at the thought of meeting his estranged daughter, or, more disastrously for Benjy, appearing on live television.

My Favorite Year includes amiable and wonderful send-ups of figures from TV's "Golden Age" like the Sid Caesar imitation of Joe Bologna as King Kaiser, or the pusillanimous head writer Sy Benson (Bill Macy). Nonetheless, it is O'Toole's characterization of the besotted buffooneries of the Errol Flynn-like Swann that carries the picture. Despite his declaration that "dying is easy, comedy is hard," Swann does eventually rise to the occasion and helps Kaiser defeat a bunch of hoodlums who invade his show and try to keep him off the air, thus vindicating himself and, without missing a subtext beat, signaling the symbolic reconciliation of film and television.

That reconciliation is quite evident in James L. Brooks's *Broadcast News* (1987). Although the film is critical of broadcast journalism, it is no over-the-top jeremiad like *Network*. Perhaps this is the result of its being written, produced, and directed by the highly esteemed television writer-producer Brooks (*The Mary Tyler Moore Show, Taxi*) rather than the work of a disillusioned pioneer of TV drama like

Chayefsky. Thus, Brooks looks at TV news critically, but lovingly. Although he attacks all-powerful anchormen, lower reporting standards, and the trend toward style over substance in TV news, he ultimately accepts its basic values. Therefore, anyone looking for a sharp critique of TV news won't find it in *Broadcast News*.

What they will find is a good-natured romantic comedy which features an affair between the dimwitted sportscaster-turned-anchorman Tom Grunick (William Hurt) and a principled but driven news producer, Jane Craig (Holly Hunter), who loves but doesn't respect him. Complicating matters is Jane's other would-be lover, the brilliant, quirkily self-conscious TV reporter, Aaron Altman (Albert Brooks), who sees Tom as the embodiment of all that he and Jane have come to despise about TV news. Unfortunately, it's the love affair and not the changes in the newsroom that gets most of the attention.

This benignancy aside, TV's image in Hollywood films today remains ambiguous. For every *My Favorite Year* there is a *Being There*. In the end, this ambivalence is probably an accurate reflection of a society that has still not made up its mind about a medium that it alternately damns as the "boob tube" or hails as the means for the creation of the "global village."
—Albert Auster

The Unfriendly Hollywood Nineteen

As conservative reaction to the New Deal grew in intensity, so too did congressional investigations of institutions purveying anything classifiable as New Deal liberalism or harboring anyone classifiable as a New Deal liberal. The Federal Theatre Project fell before the guns of the right, but the motion picture industry twice repelled the invaders.

During the latter stages of World War II, however, a Trojan horse, in the form of the Motion Picture Alliance for the Preservation of American Ideals, determined to bleach the "red" out of Hollywood, opened the industry gates to FBI and House Committee on Un-American Activities investigators. On May 9, 1947, committee chairman Parnell Thomas (D-NJ) and committee member John McDowell (R-PA) held hearings at the Biltmore Hotel in Los Angeles. Two dozen members of the alliance and several studio bosses appeared.

Four months later, on September 21, forty-four subpoenas were delivered in Hollywood, inviting the recipients to appear in Washington, on October 20, to testify about "Communist Infiltration of the Motion Picture Industry." Nineteen of the subpoenaed immediately announced their hostility to HUAC and were labeled "unfriendly" by *The Hollywood Reporter*. All were men, all had been politically active on behalf of liberal and radical causes, all were determined to destroy HUAC, only four were not communists.

During the month between the subpoena and the hearings, they met regularly with their lawyers to develop a strategy that would allow them to refuse to cooperate with the committee and not lose their jobs and go to prison in the process. The lawyers made it clear that noncooperation

of any sort would earn them contempt citations and a long legal battle, but they were certain that the liberal balance on the Supreme Court promised ultimate vindication. A few of the Nineteen argued for outright refusal to answer, based on the protection of the First Amendment. A few others held out for full candor. The first was rejected because it would give the studio executives a cause to blacklist; the second because it left the witnesses with a significantly weakened legal position. (At that time, the Fifth Amendment could not be used selectively by a congressional witness; if a witness was candid about his or her activities, he or she could not legally refuse to answer questions about the activities of others.) They agreed that each would prepare an opening statement informing the public about the dangers of HUAC, and they would not directly answer questions about their political beliefs and activity, but would use such questions as a further forum for criticizing the committee.

The committee, however, knew how to arrange a show trial. It cleverly arranged the schedule of witnesses for maximum contrast of friendly and unfriendly, treated the former with kid gloves and the latter with iron fists, allowed only one-and-a-half of the opening statements to be read, and had a committee investigator appear after each unfriendly witness to read a list of his "subversive" activities and organizations. The unfriendly witnesses reacted angrily to this treatment, adding to the spectacle when several were literally dragged from the witness chair shouting their opposition.

Nevertheless, the Nineteen's strategy seemed successful. HUAC had been exposed as unfair and malicious, and the media publicity was so negative that Thomas adjourned the hearings after the testimony of only eleven unfriendly witnesses. But, on November 24, victory turned to defeat when the expected news of contempt citations from the House of Representatives was joined by the unex-

pected news that the motion picture executives had convened at the Waldorf-Astoria to begin a blacklist.

So was born the Hollywood Ten.

Alvah Bessie (1904–1985) had been a journalist and a volunteer for the Loyalist side in the Spanish Civil War. He did not enjoy great success in Hollywood, although one of his five screenwriting credits, *Objective Burma* (1945), earned him an Academy Award nomination. He wrote five novels, edited an anthology on Spain, and produced three autobiographical books (*Men in Battle, Inquisition in Eden*, and *Spain Again*).

Herbert Biberman (1900–1971) had studied to be a dramatist. He came to Hollywood in 1933, but was not a success, earning only five writing, three directing, and two producing credits prior to 1947. He was the organizing force behind the Ten's fight to stay out of prison and the efforts of several blacklisted artists to make *Salt of the Earth* (1954), which he directed. He wrote a fascinating account of that experience (*Salt of the Earth*, 1965).

Bertolt Brecht (1898–1956), one of the most significant dramatists of the twentieth century, came to the United States in 1941 to find a refuge from Hitler. His stay in Hollywood earned him one screen credit, for the screen story of *Hangmen Also Die* (1943), and a subpoena. He was the eleventh unfriendly witness called to testify. He denied membership in the Communist Party, left the witness stand without a contempt citation, and quickly returned to Germany.

Lester Cole (1904–1985) began his screenwriting career in 1932. He was a cofounder of the Screen Writers Guild and the recipient of thirty-five screen credits prior to 1947. He was about to receive a producing contract from MGM when the subpoenas arrived. His movie career never recovered. He wrote six black market scripts, including *Born Free* (1965). His memoir, *Hollywood Red*, was published in 1981.

Richard Collins (1914–) became a

friendly witness on April 12, 1951, informing on twenty-three people. His Hollywood career spanned three decades, 1939–1960, but none of his eighteen credits merit comment.

Edward Dmytryk (1908–) was the only member of the Ten to recant. He began his movie career as an editor, then moved into the directing ranks, churning out B-films at Columbia and RKO. By 1944, with *Murder, My Sweet*, he had become one of RKO's favored young men. *Crossfire* (1947), the industry's first important film attacking anti-Semitism, earned him an Academy Award nomination. Unwilling to face the loss of his career, he decided, while in prison, to do whatever was necessary to clear his name. The process included his reappearance before HUAC, where, on April 25, 1951, he informed on twenty-six people. He had four directing credits in 1952, and worked steadily thereafter. His work is not distinguishable from that of the average studio director. (See his memoir, *It's a Hell of a Life but Not a Bad Living*, 1978.)

Gordon Kahn (1902–1963) never appeared before HUAC. In 1950, fearing arrest by the gang of government agents hovering around Hollywood, he fled to Mexico, where he lived until 1955. Prior to that he had been a relatively successful B-film writer, producing scripts for Republic and Universal. He also wrote the first important account of the Hollywood Ten, *Hollywood on Trial* (1948). During the blacklist, he wrote, under a pseudonym, magazine articles and episodes for the *Robin Hood* television series.

Howard Koch (1902–) also did not appear before HUAC, but his association with radical causes put him on the graylist between 1947 and 1951, and the blacklist for most of the Fifties. He had been one of Hollywood's best screenwriters during the Forties, working on films such as *The Letter* (1940), *Sergeant York* (1941), *Casablanca* (1942), and *Letter from an Unknown Woman* (1948). He received two Academy Award nominations and one

award. He received no American credits between 1951 and 1964, but did work in Europe, where he lived between 1952 and 1956. (See his memoir, *You Must Remember This*, 1981.)

Ring Lardner, Jr. (1915–) won Academy Awards on both sides of the witch hunt: *Woman of the Year* (1941) and *M*A*S*H* (1970). He was a highly paid screenwriter, but one who talked constantly of leaving Hollywood because his best work was not reaching the screen. During the blacklist years, he wrote a novel, a play, and scripts for several television series. He began to write movies under his own name again in 1965. Since then, he has written several more scripts, a second novel, and a family memoir, *The Lardners: My Family Remembered*, 1976.

John Howard Lawson (1894–1977); see separate essay.

Albert Maltz (1908–1985); see separate essay.

Lewis Milestone (1895–1980) was born in Russia and emigrated to the United States in 1917. His Hollywood career began in 1925, and he directed forty movies. His best work occurred between 1930 and 1936, when he directed *All Quiet on the Western Front, The Front Page, Rain, Hallelujah, I'm a Bum,* and *The General Died at Dawn.* He was very active on behalf of radical causes during the Thirties and Forties, but was not gray- or blacklisted, even when, in 1948, he tried to hire Lardner to write a script for him.

Samuel Ornitz (1891–1957) was the oldest member of the Ten, in terms of age, membership in the Communist Party, and service in Hollywood. He earned twenty-one screen credits between 1928 and 1945, mostly on low-budget films. He had been a social worker in New York, and had written three novels before coming to Hollywood. *Haunch Paunch and Jowl* (1923) was one of the classic coming-of-age novels about Lower East Side Jewish people. He corrected the proofs of his last published work, *Bride of the Sabbath*, while he was in prison.

Larry Parks (1914–1975) was the lead-off witness when HUAC resumed its assault on Hollywood, in April 1951. He tried to travel a different route than the Ten, testifying about himself but not about others. The committee refused and Parks finally capitulated, informing on twelve people. He had, however, destroyed his career; coerced, agonized cooperation was not acceptable to studio executives. An actor with forty screen credits and an Academy Award nomination for *The Jolson Story* (1946), Parks appeared on screen only three times after 1951. His career was limited to night clubs and summer stock.

Irving Pichel (1891–1954) did not belong in this group. He was a liberal, who signed petitions and attended meetings, but did not join organizations. He had a busy career in Hollywood (fifty acting and thirty-six directing credits) and with the Pasadena Playhouse. He could have saved himself much grief by cooperating with HUAC, but he was a strong supporter of the Nineteen's position. He was graylisted in 1951, but cleared in 1953.

Robert Rossen (1908–1966) began his career as a dramatist and came to Hollywood in 1934. He was a writer, then a director, and finally a producer-writer-director. His work tended toward the moody and overserious, and the results were inconsistent. Among his better efforts were *Body and Soul* (1947, director), *All the King's Men* (1949, writer-director), and *The Hustler* (1961, writer-direc-tor). He received screenplay Academy Award nominations for the latter two. Blacklisted in 1951, when he refused to inform, he reappeared before HUAC in May 1953, and provided the committee with fifty-four names.

Waldo Salt (1914–1987) would have been the Hollywood "Eleventh" had the hearings not been adjourned. But he was treated as though he had appeared: Dore Schary fired him immediately after the hearings ended, but not, said Schary, "for political reasons." He worked for Warner Bros. and Columbia before his refusal to answer HUAC's questions, in April 1951, placed him firmly on the blacklist. He did some black market movie scripts and wrote for several television series until, in 1962, he became one of the first blacklis-tees to write movies under his own name. He later won two Academy Awards— *Midnight Cowboy* (1969) and *Coming Home* (1978).

Adrian Scott (1912–1973) was the only producer among the Hollywood Nineteen. He had come to Hollywood in the late Thirties, as a writer, earning five credits by 1944. He produced six pictures for RKO prior to 1947, including the widely acclaimed *Crossfire*. His producing career never revived. He wrote for television and spent a large portion of time in England during the blacklist years.

Dalton Trumbo (1905–1976); see separate essay.—Larry Ceplair

Van Peebles, Melvin

(August 21, 1932 –)

An essay on Melvin Van Peebles is, essentially, an essay on one film, the title of which is as full of jive as its creator: *Sweet Sweetback's Baadasssss Song* (1971). The film is a milestone of a sort, in that it reflected African-American life and African-American anger like no other before it.

For years, it was one of the top-grossing independently produced features, proof that a filmmaker can reap profits while working outside the Hollywood studio system. Even more impressively—although some might prefer distressingly—the film almost singlehandedly created the black exploitation genre of the Seventies. But most significantly, it was directed, produced, and edited by an African-American, and its appeal rested in the fact that it was made strictly for African-American audiences.

Van Peebles, born on Chicago's South Side in 1932, grew up in an America in which those of his race were routinely denied opportunities for self-expression and professional advancement. He had to trek off to Europe to establish himself, as a composer, novelist and, finally, a filmmaker. His initial feature, *The Story of a Three-Day Pass* (1967, and based on his own novel, *La Permission*), predates Spike Lee's *Jungle Fever* (1991) as a chronicle of an affair between an African-American man and white woman.

Clearly, Van Peebles had set out to make films which expressed his own racial consciousness. His next film, *Watermelon Man* (1970), portrays a white middle-class bigot who wakes up one morning to find his skin turning black. Finally, with his third film, his rage and frustration at being a person of color in a white-dominated society spilled over into a daringly profane, groundbreaking diatribe against white America: *Sweet Sweetback's Baadasssss Song.*

In *Sweetback*, the title tells all: the film unfolds completely within a black milieu and from a totally black point of view, with Van Peebles evoking a militant sensibility unallowable in a Columbia or Paramount production. He stars as Sweetback, a pimp and stud, an outsider populating a gritty landscape of violence and sex. The character beats up a pair of white policemen, mashing their heads with their own handcuffs. He wins a sex stamina contest against a Hell's Angels hoodlum. (Van Peebles, in fact, claimed to have come down with gonorrhea after filming this "love scene.") Ultimately, he survives by outwitting the "honky" world and making it across the Mexican border at the finale. A message then appears on screen: "WATCH OUT. A BAADASSSS NIGGER IS COMING BACK TO COLLECT SOME DUES."

Van Peebles does glorify the unsavory aspects of inner-city street life, and his hero is a shoddy role model; the film cannot unfairly be condemned as a reverse-racist diatribe in that it depicts African-Americans as "bad" and whites as fools, with nothing in between. The lead character is no hard-toiling black man, attempting to integrate into society on white terms. He may be impotent with regard to politics and power, but he is a sexual being to the bone as he almost literally cums in the face of whitey. In his world, black men are pimps and drug dealers, black women are whores, but whites of both sexes are

fools. He plays out the fantasies of the ghetto populace in that he outwits the system, survives, and, in the spirit of the times, warns white America that he—and those like him—will no longer accept powerlessness and abuse.

Herein lies the film's appeal. It may not have been the first feature to focus on racism in America. Prior to *Sweetback*, a new type of racial film hinted at the premise that African-Americans and whites were irreparably different. Among them are *Shadows* (1961), *Take a Giant Step* (1961), *A Raisin in the Sun* (1961), *The Cool World* (1963), *Nothing But a Man* (1964), *Black Like Me* (1964), *Dutchman* (1967), and *The Learning Tree* (1969). Several were independently produced and distributed, and were concerned with exploring the experience of being black in America or depicting the obstacles threatening African-American survival. But none expressed the unadulterated anger and alienation that is a byproduct of racism as vividly as did Van Peebles in *Sweetback*.

Unsurprisingly, the film was either ignored or critically roasted in the white media, and condemned by many in the African-American community. Audiences, however, loved *Sweetback*. Shot for $500,000 and released without the support of a major studio publicity machine, it grossed $14 million. At one point it was the nation's number-one box office attraction, even outearning *Love Story*.

And it spawned an entire cinematic genre. During the Seventies, feature films produced specifically for African-American audiences constituted almost a Hollywood sub-industry. Such films as *Super Fly* (1972), *The Legend of Nigger Charley* (1972), *Black Caesar* (1973), *The Spook Who Sat by the Door* (1973), *The Mack* (1973), *Black Belt Jones* (1974), *Foxy Brown* (1974), *Mandingo* (1975), and *Drum* (1976)—all descendants of *Sweet Sweetback*—were violence-laden potboilers in which African-Americans were caricatured as supercool studs and ghetto goddesses. These films toy with the collective

frustrations of their audiences; at their worst, they elevate pimps and pushers to folk hero status. Ultimately, their characters are as stereotypical—and as demeaning—as any role assigned to Stepin Fetchit or Butterfly McQueen.

But there also were *Cotton Comes to Harlem* (1970), *Shaft* (1971), *Sounder* (1972), *Lady Sings the Blues* (1972), *Black Girl* (1972), *Uptown Saturday Night* (1974), *Cooley High* (1975), *Let's Do It Again* (1975), *The Bingo Long Travelling All-Stars and Motor Kings* (1976), *A Piece of the Action* (1977), and *A Hero Ain't Nothin' But a Sandwich* (1978). These films present their characters as heroes or heroines in nonmessage entertainments, or attempt to deal with the African-American experience in a serious, humanistic manner.

But after *Sweetback*, it was not until Spike Lee's *Do the Right Thing* (1989) that another film which etched such a raw, honest portrait of African-American rage would have so graphic an impact on the nation's consciousness. As for Van Peebles, he went on to tackle the Broadway stage in the Seventies with the musicals *Ain't Supposed to Die a Natural Death* and *Don't Play Us Cheap*, as well as act in and script the made-for-television movie *The Sophisticated Gents* (1981). Interestingly, he also became a stock commodities trader, cashing in on the Eighties stock-market boom with the publication in 1986 of the self-help guide *Bold Money: A New Way to Play the Options Market*.

Other than a barely seen film version of *Don't Play Us Cheap* (1973), Van Peebles's sole post-*Sweetback* directorial credit is *Identity Crisis* (1989): a crude, messy pseudo-farce in which the spirit of a white, stereotypically effeminate fashion designer is mysteriously transferred into the body of a black, stereotypically superhip rapper (played by Van Peebles's actor-director son Mario). The latter overacts outrageously, and the film is excruciating, offensive and, ultimately, boring.

If anything, *Identity Crisis* is evidence that Van Peebles's consciousness has not

evolved with the times; certainly, his embracing Wall Street is proof that he will choose to jive to survive. This same ethic may be found in son Mario's first feature as director, *New Jack City* (1991). The film contains a clear, anti-drug message as it chronicles what happens when a police detective (played by the younger Van Peebles) recruits a pair of maverick cops (Ice-T and Judd Nelson) to overthrow a crack-selling drug kingpin (Wesley Snipes). There may be controversial, provocative commentary that drug laws may be responsible for contemporary lawlessness as much as Prohibition caused mayhem during the Twenties. There may be a wry commentary on the manner in which movies impact on their viewers; this villain's role model is, tellingly, Tony Montana, the coke-snorting drug kingpin

in *Scarface* (1983).

But the film is not above offering its share of stylish, needlessly graphic bloodletting; it is shot in a style that's as hyperactive as a junkie in need of a fix. Despite its good intentions, *New Jack City* too often succumbs to the temptation to be a formula entertainment, and revels in the violence that it is purporting to condemn.

Still, Melvin, and now Mario, Van Peebles remain important figures in the contemporary American cinema, and the quantity or quality of their work will never lessen the impact and importance of *Sweet Sweetback's Baadasssss Song.*

—Rob Edelman

RECOMMENDED BIBLIOGRAPHY

Van Peebles, Melvin. *No Identity Crisis.* NY: Simon and Schuster, 1990.

Vidor, King Wallis

(February 8, 1894 – November 1, 1982)

K ing Vidor was a man of conscience and commitment, willing to take chances on projects considered offbeat by commercial Hollywood standards, but he was also able to maintain his reputation as a dependable director during a career that spanned nearly a half century and produced more than fifty feature films.

He was born in Galveston, Texas, the son of Charles Shelton Vidor, a lumberman, and started his career shooting newsreel footage in Texas. In 1915 he married Florence Cobb Arto, a girl from Houston, and the two of them drove to Hollywood in a Model-T Ford to seek their fortunes. Florence Vidor found roles working for Vitagraph and, later, Famous Players-Lasky and went on to become a major star during the Twenties. Her husband took what work he could get, wrote screen-

plays, and finally directed his first motion picture, *The Turn in the Road,* in 1919. His first work was done at his own studio, Vidor Village, where he built his reputation and began directing for Metro-Goldwyn-Mayer.

Vidor's breakthrough picture was *The Big Parade,* which he directed for MGM in 1925, a tremendously successful film about World War I that grossed over $25 million and made John Gilbert a star. In 1924 Vidor divorced his wife Florence and

married Eleanor Boardman, who starred with James Murray in Vidor's next and perhaps most remarkable success, *The Crowd* (1928), a realistic film about an ordinary man trying to survive with his family in an uncaring world. *The Crowd* was a unique American precursor of Italian Neorealism, and despite industry predictions to the contrary, it eventually made a profit and earned Vidor his first Academy Award nomination. A second Academy Award nomination followed in 1929 for *Hallelujah*, another innovative picture that featured an all-black cast, and a third in 1931 for *The Champ*. Although two more Academy Award nominations were to come for Vidor's direction of *The Citadel* in 1938 and *War and Peace* in 1956, King Vidor never won an Oscar until 1979, when the Motion Picture Academy granted him a Special Oscar for his career achievements.

In 1950 the Screen Directors Guild included two of King Vidor's pictures, *The Big Parade* and *The Crowd*, among the ten best directorial achievements of the previous half century. After his second marriage to Eleanor Boardman ended, Vidor was married to a writer, Elizabeth Hill. He retired in 1959 after directing *Solomon and Sheba* and taught graduate courses in cinema at UCLA.

After his retirement, looking back over his career, Vidor was justly proud of his social trilogy of films that examined the lives of ordinary Americans at war, in the city, and on the land: *The Big Parade* (1925), *The Crowd* (1928), and *Our Daily Bread* (1934). In the first of these films, Vidor's intent was to show how a man's life can be changed by his exposure to war. The central character, John Apperson (John Gilbert), goes to war not out of patriotism or idealism, but simply because he is expected to go. The young man's father and his girlfriend make it clear that he has no alternative to serving in World War I. After an obligatory sequence that dramatizes the young man's experiences in basic training, he is sent to France,

where he meets a French girl (Renée Adoree), before being sent to the trenches, where he is motivated to take heroic action after one of his comrades is wounded in no man's land and unable to get back to the safety of the trench. In attempting to rescue his friend, Apperson himself is wounded and loses a leg. When he returns home, mutilated, he discovers the girl he left behind was worth leaving behind, and, finding himself an embarrassment to his family, he decides to go back to France to find happiness with Renée Adoree, who has waited faithfully for his return. Vidor does not glorify war in this picture and manages to bring a sense of realism to the way he films the action, particularly the "big parade" sequence that shows a long caravan of men and equipment moving toward its fate at the front.

Vidor's masterpiece, however, was not *The Big Parade*, but *The Crowd*, which he originally wanted to call *The Mob*. *The Crowd* was conceived as a follow-up to *The Big Parade*, which portrayed the Great War from the vantage point of a single participant. In *The Crowd* Vidor intended to put on display a single member of the "mob," a man of the masses, Mr. Mediocre, in Vidor's words, a "common punk." Vidor's wife, Eleanor Boardman, played the wife of her husband's "average American." To cast the role of his average American appropriately, Vidor avoided established stars and sought out an unknown actor, James Murray, who "looked the part." In fact, Murray himself made few films after *The Crowd* and drifted into obscurity, eventually becoming an alcoholic.

The original idea for Vidor's scenario was to trace an ordinary man's life from birth to death, undercutting popular expectations and demonstrating that the great American ideal of equality of opportunity does not necessarily insure success. Like Louis Armstrong, Vidor's central character, John Sims, was born at the turn of the century on the Fourth of July, 1900.

Unlike Louis Armstrong, however, John Sims had little personality, small charm, and no talent. As a young man John believes in the American way: "All I want is an opportunity," is his motto. This cliché is purposefully laced with irony in Vidor's film. John Sims is a cipher picked out of the "crowd" by Vidor's camera in an impressive tracking shot that moves up an office building in the city and through the window of an office suite, where it selects Sims working at Desk No. 137.

John meets Mary in the city; the two romance on Coney Island, get married, and travel to Niagara Falls for their honeymoon. They bear two children, one of whom, a baby girl, is later run down by a truck on the very day John comes home from work with the good news that he has won a slogan contest. Grief-stricken, the man cannot keep his mind on his work thereafter, quits his job, and is unable to find a better one. After a descent into urban squalor, John finally finds work as a clown for an advertising agency. He has had his opportunity and failed to make the most of it. Vidor picks this undistinguished fellow out of the crowd, tells a story of misery, disappointment, and blighted dreams, then deposits him back into the crowd at the end, when he takes his family to a music hall and breaks up laughing at a clown act. *The Crowd* was Vidor's last silent film. Part of it was shot on location in New York City by a camera hidden in the back of a truck for some of the street scenes, attempting to capture the authenticity of city life and putting the actors in contact with real people. Vidor was ahead of his time in his realistic approach to filmmaking, in his treatment of ordinary people, and in his ironic presentation of the American Dream.

The Crowd is so impressive because it takes a hard, unsentimental look at American idealism and family life. Vidor does not concern himself with easy solutions or happy endings in *The Crowd*. The director changed his approach, however, when he returned to John and Mary Sims

in *Our Daily Bread* in 1934, a film about Depression America "Inspired by Headlines of Today," as a subtitle proclaims. This time one finds John and Mary without children and represented by different actors. Tom Keene's John Sims is out of work, less self-confident, and more sympathetic than James Murray's John Sims had been in *The Crowd*. This time, Sims wants only "a chance to work" at a time when jobs were scarce. John and Mary move out of the city and buy a rundown farm on the outskirts of a town called Arcadia.

Other unemployed poor-but-honest souls gravitate to the Sims homestead, which is eventually transformed into a collective farm. Like others during the Thirties, Vidor experiments with radical solutions to the nation's economic plight. When the commune is founded, the question of governance and decision-making for the group is discussed in a public forum. When one man seriously suggests "immortal democracy" as the ideal form of governance, he is quickly and rudely shouted down: "No! It's that kind of talk that got us here in the first place!" The commune is a utopian microcosm. All trades and professions, as well as various ethnic groups, are represented.

The commune rides through several crises. When the local sheriff attempts to sell the farm at public auction, the capitalists are intimidated out of bidding. Louis, an ex-convict, turns himself in so that the farm will benefit from the $500 reward placed on his head. John has a crisis of leadership and starts to run away with a floozy hairdresser named Sally; but he ultimately returns to Mary and the farm to supervise the digging of a badly needed irrigation ditch. Clearly, this experiment in communism can succeed only if all of the communal farmers work together.

Our Daily Bread represents the embodiment of a social ideal, derived from a naive faith and trust in one's fellow man and a selfless belief in universal brotherhood necessary for the formation

of a utopian community. What the film was to suggest about property and its proper use is secondarily communistic, despite the communal ethic that governs behavior in the film. Vidor is a romantic idealist: he cannot escape the urge to make an affecting story of love, marriage, and honest labor. The film is consequently uplifting and sentimental in a way *The Crowd* was not. The human instincts it displays are positive and enduring, the ending a "happy" one, perhaps a sop to the psychological demands of the time.

As Vidor constantly stresses the sharing and generous nature of his communal farmers, it becomes increasingly difficult to accept *Our Daily Bread* as a serious propaganda effort. Nonetheless, there is an affecting sincerity about the film which must be judged more for what it offers as a social document than as a work of realistic filmmaking. The ditch-digging montage at the film's climax, however, is as fine an example of editing as can be found in the American cinema. It is, finally, Vidor's skill at organizing images that gives *Our Daily Bread* its credibility, not his manipulative presentation of characters, and not his social thinking.

When King Vidor died, he left behind him two books of memoirs—*A Tree is a Tree* (1953) and *King Vidor on Filmmaking* (1972)—and interviews, such as the one with Richard Schickel published in *The Men Who Made the Movies* (1975). Later films included Ayn Rand's *The Fountainhead* (1949), though Vidor did not "agree entirely with Ayn Rand's approach," and such large-scale efforts as *Duel in the Sun* (1947) for David Selznick, and *War and Peace* (1956) for Dino De Laurentiis.

King Vidor peaked during the Twenties, when it was possible to undertake such an experimental film as *The Crowd* at MGM, with the support of Irving Thalberg. In order to make the last picture of his American trilogy about War, Steel, and Wheat, *Our Daily Bread*, but lacking Thalberg's support on this project, Vidor raised production money himself "by mortgaging everything I had," and with Charles Chaplin's help, got the film released through United Artists. Vidor put his salary on the line for Nicholas Schenck in order to make his first sound picture, *Hallelujah*, shot on location in Tennessee and Arkansas, without the advantage of portable sound equipment. According to Richard Schickel, "the doomed director" in *Crazy Sunday* was partially modeled on King Vidor, and F. Scott Fitzgerald considered Vidor to have the only "interesting temperament" of those directors Fitzgerald had encountered in Hollywood.—James M. Welsh

RECOMMENDED BIBLIOGRAPHY

Denton, Clive and Kingsley Canham. *The Hollywood Professionals: King Vidor, John Cromwell, Mervyn LeRoy*. South Brunswick, NJ: A. S. Barnes, 1976.

Dowd, Nancy and David Shepard. *King Vidor*. Metuchen, NJ: Scarecrow Press, 1988.

Durgnat, Raymond and Scott Simmon. *King Vidor, American*. Berkeley, CA: University of California Press, 1988.

Kirkpatrick, Sidney D. *A Cast of Killers*. NY: Dutton, 1986.

Lang, Robert. *American Film Melodrama: Griffith, Vidor, Minnelli*. Princeton, NJ: Princeton University Press, 1989.

Platoon

Vietnam War Films

Blue Thunder (1983), an action-adventure thriller, features Roy Scheider as a Los Angeles police helicopter pilot. Scheider's character happens to be an ex-GI who had fought a decade or so earlier in the rice paddies of Vietnam. He is, as the reviewer in *Variety* so pointedly noted, "a Vietnam vet who, for once, is portrayed as a hero."

Now that the Vietnam War no longer remains the lead story on each evening's news, films about Vietnam and its aftermath do serve one valuable purpose: they are a means by which the American public may be reminded that 57,000 of the nation's youth died in a war they really had no business fighting. Beyond this, however, and relating more specifically to the content of each film, the depiction by commercial filmmakers of Vietnam-era soldiers, or of the American scene back when the president was Lyndon Johnson or Richard Nixon, has for the most part been simplified and distorted. While the essen-

tial nature of practically all Vietnam War films not made by John Wayne or before the Tet Offensive is that of hopelessness, with distressingly rare exception Hollywood's portrayal of Vietnam has been, like the war itself, sorely misguided.

The most celebrated Vietnam films to date include Michael Cimino's *The Deer Hunter* (1978), Hal Ashby's *Coming Home* (1978), Francis Coppola's *Apocalypse Now* (1979), Oliver Stone's *Platoon* (1986) and *Born on the Fourth of July* (1989), and Stanley Kubrick's *Full Metal Jacket* (1987). These are neither the first nor the only features that attempt to explore America's

longest, most controversial war and only military defeat. Hollywood had employed Vietnam as a backdrop for standard action fare as early as two decades before most Americans had ever heard of Ho Chi Minh. Usually, in their scenarios, a stalwart American would uncover some evildoing, or outwit his nefarious Asian adversaries. In *Saigon* (1948), featuring Alan Ladd and Veronica Lake, Air Force veterans fly to that city and expose a smuggling plot. In *A Yank in Indo-China* (1952), a couple of Americans assist French and native allies battling communist guerrillas.

Marshall Thompson is the hero of a couple of Grade B melodramas, *A Yank in Vietnam* (1965) and *To the Shores of Hell* (1965), while Burt Reynolds, in *Operation CIA* (1965), discovers a Vietcong plot to dump nerve gas in the central air conditioning system of the American embassy. The only potentially interesting feature, *The Ugly American* (1963), adapted from the William J. Lederer and Eugene Burdick book and starring Marlon Brando as the American ambassador to an Asian country, is nothing more than a muddled melodrama.

The two most representative films of the era are Samuel Fuller's *China Gate* (1957) and Joseph L. Mankiewicz's *The Quiet American* (1958), both products of the McCarthyite Fifties. *China Gate* is an action drama in which foreign legionnaires blow up a communist ammunition dump. It is a fascinating curio, the depiction of a Vietnam torn between godless communism and a wonderful Christian tradition in which peasants thrive materially and spiritually. (Rather than featuring Asian performers in the leads, Angie Dickinson plays "Lucky Legs," a Eurasian saloonkeeper, while Lee Van Cleef is Major Chan, a communist "war lord.") *The Quiet American* is a bastardization of Graham Greene's fine novel. In the original, an idealistic young American contributes "economic aid" to Vietnam via terrorist bombings. But in the film he's a private citizen, not a United States government employee,

an innocent framed by the communists.

Then, in the mid-Sixties, came Lyndon Johnson's escalation of the war. While Hollywood celebrated the exploits of American GIs in dozens of features released during World War II and, to a lesser extent, Korea, Vietnam remained virtually absent from American movie screens. After all, Americans would not pay to see movies about a war that was brought into their living rooms every evening by Walter Cronkite. Sadly, at its height, only one Hollywood feature even dared to deal with Vietnam: *The Green Berets* (1968), a vapid, laughably absurd melodrama of saints (the righteous Americans, led by John Wayne) versus sinners (the dastardly commie VC). In its essence, *The Green Berets* is just a formula Western set in Asia rather than Wyoming or Arizona, with Aldo Ray's Green Beret Sergeant Muldoon replacing Victor McLaglen's U.S. Cavalry Sergeants Mulcahy in *Fort Apache* (1948) and Quincannon in *She Wore a Yellow Ribbon* (1949) and *Rio Grande* (1950).

Three years after the signing of the Paris Peace Accords, America's escapade in Vietnam still remained taboo in Hollywood. Feature films directly addressing Vietnam were considered box office poison because the wounds of the war were still too raw. The nation had to pause, and decompress, before accepting cinematic explorations of its meaning. Then, in the late Seventies, came a spate of Vietnam-related films, most of which depicted the war as a nightmare, a mismanaged, half-hearted effort rife with demoralized, stoned-out soldiers and corrupt, pig-headed commanders.

By this time, the war had come to be regarded as a mistake even in conservative circles. America had, after all, lost. Blame had to be placed. *The Boys in Company C* (1978), for example, is crammed with finger pointing. In the film, soldiers die while transporting a top-priority convoy of beef and Jim Beam whiskey for a general's birthday party, and level an "enemy" village inhabited by women and children. Officers

are more concerned with body counts than with actually winning the war, and one even arrogantly sputters to a subordinate, "These people die at my command." Their South Vietnamese counterparts conspire to smuggle heroin to the United States in the body bags used for corpses. Nevertheless, there is no real depth here, no real exploration of the who, what, and why of Vietnam. The two most famous late-Seventies features actually set in Vietnam are *Apocalypse Now* and *The Deer Hunter*. Despite their artistic merit, and their Cannes Golden Palms and Academy Awards, both are laden with stereotypes and inaccuracies. The former is more a reworking of Joseph Conrad's *Heart of Darkness*, with technically incorrect battle scenes and undisciplined GIs. Robert Duvall's Colonel Kilgore is a cartoon caricature: a warmonger with a Civil War hat, bugle, and surfboard; while the various soldiers are off in their stoned-out worlds. The visuals may be sumptuous, but the core of the film is empty and artificial.

The Deer Hunter, the epic saga of three Ukrainian-American steelworkers and their experiences in Southeast Asia, does attempt to define the meaning of nationalism and honor. The result, however, is far too ambiguous. The finale, which sums up the tenor of the film, is exasperatingly unclear. In it, the remaining characters sing "God Bless America." Are they doing so halfheartedly—they have, after all, just buried one of their own—or are they reaffirming their faith in their country? Additionally, the Vietcong are portrayed as comic strip villains, one-dimensional sadists and goons.

While Vietnam veterans have not been as absent from the screen as GIs in combat, their lot also was stereotyped to the point of absurdity. The celluloid warriors of the World War II era, in which America was united behind an inarguably just cause, returned home winners and liberators. They came back to their families and communities, readjusted to life in civvies, and went on to happy-ever-after futures.

Any vet with problems had to be physically disabled: blind John Garfield in *Pride of the Marines* (1944); handless Harold Russell in *The Best Years of Our Lives* (1946); paralyzed Marlon Brando in *The Men* (1950). Each spurns his girl out of apprehension, yet she stands by him in hopeful finales.

World War II vets remain heroic even after trading in their uniforms for business suits. In a representative scenario, *The Big Hangover* (1950), Van Johnson plays an ex-soldier with working-class roots who's been looked after by his country in that he's been able to attend law school on the GI bill. He does have one dilemma: his experiences in combat have made him allergic to liquor, and he becomes blotto after a few sips of wine. Otherwise, he is clean-cut, ambitious yet idealistic and, ultimately, noble. He is hired by a prestigious law firm but, in the final reel, forsakes this conservative, hypocritical organization for a lower-salaried, people-oriented position. Of course, in the process, he wins wealthy, desirable Elizabeth Taylor.

Vietnam veterans on celluloid have never been so idealized. From such exploitation fare as 1971's *Chrome and Hot Leather* ("Don't Muck Around With a Green Beret's Mama! He'll take his chopper and ram it down your throat!"), *The Visitors* (1972), *Welcome Home, Soldier Boys* (1972), *The Zebra Force* (1977), and *The Exterminator* (1980) to the three *Rambo* films (released in 1982, 1985 and 1988) and *The Big Chill* (1983), Vietnam vets have been characterized, at worst, as killing machines, crazed Charles Manson clones, motorcycle-riding rapists and thugs or, at best, as aimless, impotent drug dealers or suicidal depressives. Typical is the vet protagonist in *The Stunt Man* (1980), a fugitive from justice described by David Denby as "a seedy Vietnam veteran with fear in his eyes." "You wanna get home for Thanksgiving," he says, "you better figure the guy comin' at ya is gonna kill ya. Learned that from the gooks." He also notes, "I don't know nothin' about Germans. Where I was, we only raped

gooks."

In *Rolling Thunder* (1977), William Devane stars as an emotionally deadened ex-POW who returns home after wasting away for eight years in a prison camp. He finds an America as violent as the country he has just left: he sees his wife and son senselessly murdered by thieves and, with his former cellmate, sniffs out the killers. The film concludes with a lengthy blood-bath in a Mexican brothel. One plot device in *Rolling Thunder* serves to symbolize a particularly odious celluloid myth: even the Vietnam vets who are heroes remain pow-der kegs, itching to explode. This vet's hand is at one point mashed by a mechani-cal waste-disposal unit, and he in a per-verse way seems to thrive on the pain. After all, his years in the prison camp have whetted his appetite for this sort of thing. His mangled hand is replaced by a hook, which he sharpens into a very lethal weapon.

Even when the Vietnam vet is a profes-sional good guy back on his home turf—the New York City cops played by Sylvester Stallone in *Nighthawks* (1981) and Mickey Rourke in *Year of the Dragon* (1985), and Chicago police detective Steven Seagal in *Above the Law* (1988)—his main life skill is killing, the art of which he honed while serving in Southeast Asia. Only now, he is killing criminals instead of commies. "When I was overseas," observes Seagal's character, an ex-CIA agent, "I saw things that stayed in front of your eyes like they were burned in." He employs the same deadly tactics he used in Vietnam when he's swept up in an elaborate interna-tional covert operation scheme.

During the Sixties, when Vietnam was still winnable, a great and honorable American adventure, cinematic villains often were depicted as hypocritical hippie types who had somehow managed to shirk military service. It was a time when wear-ing long hair was in itself a political state-ment, and anyone embracing the counter-culture was automatically suspect. The movies reflected this perception. In

Coogan's Bluff (1968), the heavies are pot-smoking, acid-tripping "love children" who really would love to inflict violence on sher-iff Clint Eastwood. But less than a decade later the war was lost, and moviemakers were not concerned with the reasons why. Someone had to be blamed, and veterans (rather than State Department policymak-ers or military strategists) were the most convenient scapegoats. In *The Enforcer* (1976), the third Dirty Harry film, Eastwood tangles with the Peoples' Revolutionary Strike Force, a Symbionese Liberation Army clone whose leader, as he tersely notes, "was in Vietnam, likes com-bat."

Coming Home, while well-meaning and not without its merits, remains a film with a far-too-simplistic point of view. The hero, Luke Martin (Jon Voight), is a sensitive, spirited vet who has turned against the war. He may be paralyzed, but he needs no pity. At the finale, he tells a class of high school boys, "You're gonna remember all the films, and you're gonna think about the glory of other wars and remember some patriotic feelings and fight this turkey too....It ain't like it was in the movies. And now I have to tell you that I have killed for my country, and I don't feel good about it because there's not enough reason for it."

Coming Home is a product of an antiwar activists' idealized view of the Vietnam vet-eran. The paraplegic only can heal emo-tionally when he publicly rejects the war. And in doing so he gets the girl, who is played by no one less than Jane Fonda. The character of Martin's counterpart, Bob Hyde (Bruce Dern), is a gung-ho Marine officer who sums up his Vietnam experi-ence by observing that "my men were chopping off heads, that's all they were into," and returns to find that his wife has been cheating on him. Her excuse is that he has "seemed so far away" since he came back; when he acts like a man deceived, he is told by Martin that "I'm not the enemy. Maybe the enemy is the war." But Bob Hyde just doesn't quite get it. He remains uncommunicative, and a chauvinist. While

Martin lectures in high school, Hyde drowns himself à la Norman Maine in *A Star is Born*. He is, ultimately, just another Vietnam veteran as victim.

Stanley (1972), a third-rate thriller released when many vets actually were coming home, is an especially disturbing fabrication. It's the story of Tim (Chris Robinson), a handsome young vet who lives in a shack in the Florida Everglades with his pet rattlesnakes. He has dubbed his favorite Stanley, and purrs to the rattler that he is its only human friend. He also philosophizes, "I think the only beauty in the world is when man isn't there." Not surprisingly, he sics Stanley and the other snakes on anyone who irks him, before Stanley turns on him and he is consumed in flame.

This character perhaps epitomizes the cinematic Vietnam vet. He is antisocial. He cannot relate to other human beings. He gets "tremendous headaches" as he kills. *Stanley* is, simply, a bad movie. It is overscored, overacted, and cornily melodramatic. But it contains one distressing truth: the unfortunate characterization of its Vietnam veteran protagonist is the norm, not the exception.

Not *all* Vietnam films of the time were so vacuous. *Who'll Stop the Rain?* (1978) and *Go Tell the Spartans* (1978), both of which played only briefly in first-run theaters, are far more realistic in dialog and situation than other, better known films. In the former, an adaption of Robert Stone's *Dog Soldiers*, young, confused Michael Moriarty buys heroin in Vietnam and tough, principled Nick Nolte becomes compromised as he smuggles it into the United States. The point: people become corrupt because of circumstances; the initiators of war do not suffer, while those sent to fight bleed and die.

Go Tell the Spartans is set in 1964. Burt Lancaster stars as the commander of an advisory group camp in rural South Vietnam, a career soldier and veteran of two wars who already is beginning to question America's involvement in this one. He

sees the war firsthand, the real Vietnam experience, and learns early on that, for America, it will not be a matter of victory but of survival. *Go Tell the Spartans* does not oversimplify, or enlarge beyond the truth. It puts forth one pertinent question: why were we in Vietnam?

Overall, though, an understanding of the folly of Vietnam has been best depicted on celluloid via documentary. As a record of life on the front line, Pierre Schoendorffer's *The Anderson Platoon* (1967) is a superior chronicle of soldiers fighting, living, and dying. From a point of view of issues, politics, and morality, or the experiences of those who actually served in Vietnam, the real truths of the war are most successfully explored in Emile de Antonio's *In the Year of the Pig* (1969), Michael Rubbo's *The Sad Song of Yellow Skin* (1970), Joseph Strick's *Interviews with My Lai Veterans* (1971), Peter Davis's *Hearts and Minds* (1974), Glenn Silber and Barry Alexander Brown's *The War at Home* (1981), and Bill Couturie's *Dear America* (1988).

These films movingly and successfully reveal the political or experiential reality of Vietnam. *The War at Home*, for example, is a brilliantly edited, year-by-year collage of the growing antiwar movement in Madison, Wisconsin. It features such images as a 1964 LBJ for president television spot promising to keep the peace—on October 21st of that year, the President declared, "We are not about to send boys nine or ten thousand miles away from home to do what Asian boys ought to be doing for themselves"—followed by Americans arriving and fighting in the rice paddies to the accompanyment of Barry Sadler's Top 40 hit, "Ballad of the Green Berets."

If documentarians were concerned with exploring the truths of Vietnam, Hollywood filmmakers were soon to be portraying the war in an appalling, revisionist manner. It was back to Cowboys and Indians in *Uncommon Valor* (1983), with Gene Hackman whipping some vets into shape to sneak into Laos and successfully rescue

American POWs. The Asians fall like Apaches attacking the cavalry in a John Wayne Western and America can now be proud, can regain its honor, can actually, incredibly, "win" the war. Similar scenarios followed in *Missing in Action* (1984), starring Chuck Norris, and *Rambo: First Blood Part II*. And, in *Rambo III*, John Rambo even finds a new war. This one may be set in Afghanistan, but it's against the same, tired old enemy: one-dimensional commie swine who claim they "try to be civilized" as they smack their prisoners of war senseless.

Perhaps inspired by the phenomenal popularity of Rambo—*Rambo: First Blood Part II* opened in a record-breaking 2,074 first-run moviehouses in May 1985, which was, ironically, the tenth anniversary of the fall of Saigon—the movie industry's movers and shakers thought it good business to produce a number of big-budget features set in Southeast Asia. The key titles from this period are *Platoon* and *Full Metal Jacket*. As in *The Boys in Company C*, each attempts to define the war by vividly establishing a time and place. Each is a brutally realistic war drama, crammed with sights, sounds, and details. From a dramatic perspective, *Platoon* and *Full Metal Jacket* are startlingly effective, and stunningly acted. From a political perspective, however, neither offers a point of view beyond the concerns and motivations of its characters.

Platoon is the story of Chris (Charlie Sheen), an eighteen-year-old college dropout who arrives in Vietnam. His platoon is divided into two camps: those who follow Sergeant Barnes (Tom Berenger), a psychotic, morally degenerate killing machine, and those who follow Sergeant Elias (Willem Dafoe), a combat veteran who nevertheless has managed to maintain a sense of compassion and humanity. Chris is initiated into the ways of war; eventually, Barnes murders Elias, and Chris becomes determined to put a halt to Barnes's tyranny.

Full Metal Jacket is the story of a group of Marines who have volunteered for Vietnam combat. The film's first lengthy section depicts their boot-camp training, presented as a dictatorship run by the maniacal, foul-mouthed drill instructor (Lee Ermey, who appears in a not dissimilar role in *The Boys in Company C*). He praises two ex-Marines who became noted murderers—mass-murderer Charles Whitman, and alleged presidential assassin Lee Harvey Oswald—and whips his charges into a unit of dehumanized killers. Once in Vietnam, the men—including the film's most sensible character, played by Matthew Modine—exhibit a complete lack of humanity, an appalling disregard for human life.

Both *Platoon* and *Full Metal Jacket* are more concerned with the plights of their characters within the framework of their individual experiences. The same can be said for a less dramatically successful film like *Casualties of War* (1989), which focuses on one American patrol and its brutal treatment of an innocent Vietnamese girl; and *84 Charlie Mopic* (1989), an otherwise fascinating and cinematically original work about a unit on patrol, which is shot from the point of view of a filmmaker accompanying the unit and subjectively recording the action.

The various individuals in all these scenarios undergo horrific experiences. As such, each film might be labelled as "antiwar." Yet their creators fail to either offer an overview of the war or place their characters within a global framework. In so doing, they ignore the questions that are the keys to their characters' experiences. What about this particular war? How did America come to be involved in Vietnam? War might be hell, but is American involvement in this specific war worth the hell that these characters endure?

If these films are apolitical, *The Hanoi Hilton* (1987) is a throwback to the jingoistic mentality of *The Green Berets*. Its scenario chronicles the plight of American POWs suffering years of confinement in Hanoi's Hoa Lo Prison. The Vietcong captors are stereotypically sadistic, shifty-eyed

Asian trash; despite their situation, the captives win out in a revisionist manner simply because they're Americans.

At this time, so many Hollywood films were dealing in one way or another with Vietnam that a number were able to transcend the Vietnam War film genre, using the setting only as a backdrop. In *Don't Cry, It's Only Thunder* (1982), GI Dennis Christopher and doctor Susan St. James run a makeshift orphanage. *Purple Hearts* (1984) depicts doctor Ken Wahl and nurse Cheryl Ladd falling in love and lust amid the rice paddies. *Hamburger Hill* (1987), which does capture the day-to-day reality of men in war, is basically a rehashing of the classic World War II combat film. *Off Limits* (1988) is a standard action thriller about a couple of cop heroes whose turf happens to be Saigon, rather than inner-city New York or Los Angeles. *Bat 21* (1988) is a rescue thriller chronicling the fate of an Air Force intelligence officer trapped behind enemy lines. *Flight of the Intruder* (1991) records the heroics and problems of Vietnam-era flyers; it plays like a Fifties military drama that was "filmed in cooperation with the United States Air Force." *Good Morning, Vietnam* (1987) is primarily a vehicle for the off-the-wall comic antics of Robin Williams.

There is one fascinating sequence in *Bat 21*, which is otherwise a routine genre film. The officer (Gene Hackman), tired and hungry, arrives at a small hut, the abode of a Vietnamese family. No one is home, so he helps himself to some water and rice. Enter a peasant, who panics and attacks the American with a machete. The officer defends himself and, in the process, kills the peasant while sustaining a gash on his leg. Seconds later, the peasant's family—including one young boy whose body has been disfigured by napalm—arrive on the scene. They can only look on in shock at the loss of their loved one. And the officer can only mutter, "I'm sorry," and hobble off into the forest with the sobs of the dead man's kin ringing in his ears.

This scene, as much as any in the history of the Vietnam War film, succinctly expresses an apologetic point of view of America towards the Vietnamese. The American "accidentally" comes upon the hut, and "accidentally" kills its inhabitant. All he can do is humbly apologize. But he's been wounded, too, and he stumbles off dazed, into the wilderness. The word "mistake" might be substituted for the word "accident" here. Furthermore, the American's state of mind, and his realization that he no longer wishes to kill, parallels the changing American consciousness during the Vietnam War years.

And despite its focus on Robin Williams, *Good Morning, Vietnam* does offer an irreverent, perceptive antiwar message. Williams is cast as Adrian Cronauer, a military disc jockey who arrives in Saigon in 1965 to brighten up the airwaves for the bleeding and dying boys. Cronauer, as did many of his fellow countrymen, honestly if naively believes in the American presence in Vietnam. "We're here to help this country," he says at a pivotal point in the film.

Cronauer initially is not a political creature. Essentially, he's a good, kind person whose irreverence results from his desire to "have fun." He's a humanist, and a believer in truth, but slowly the truth of Vietnam becomes clear. Cronauer is like the thousands of young men who went off to Vietnam convinced they had right on their side, only to return home disillusioned and virulently antiwar.

During the late Eighties, a number of films did attempt to deal with Vietnam veterans more honestly and compassionately. *Born on the Fourth of July* is similar to *Good Morning, Vietnam* in that its hero is a real person: Ron Kovic, who was paralyzed while in combat, and who is transformed from idealistic flag-waver to eloquent antiwar spokesperson. *In Country* (1989) may feature a shell-shocked, reclusive vet (Bruce Willis), but he is sympathetically rendered; additionally, the scenario focuses on the attempts of his niece (Emily Lloyd), whose father was killed in Vietnam, to understand the war. *Jacknife* (1989)

chronicles the plight of a pair of veterans who served together in the war, and what happens when one begins to date the other's sister. These vets may all have "problems," but they deviate from the well-worn veteran-as-psycho cliché, and this is rare and refreshing.

A pair of independently made features also seriously deal with troubled vets. *Ashes and Embers*, groundbreaking in its own modest way it that it was released back in 1982, poignantly tells of an African-American vet struggling to understand and cope with his frustration and rage. He must come to terms with his participation in the war, and his role as a black man in America. *Sons* (1990) is the story of a baby boomer who grew up with a "track record of being a winner." He then went off to Vietnam, where he lost his arm and his belief in the American Dream. The film is at its best during the vet's moving conversations with himself, in which he talks of his war experiences, his feelings and needs, and of how he is acutely aware of his failures. Both *Ashes and Embers* and *Sons* are made with an emotional honesty rarely found in Hollywood films.

At the same time, all of these films do focus on veterans who are alienated from the mainstream. We still rarely in films see characters whose status as Vietnam vet is of little or no consequence to their roles in the story. And given the nature of Vietnam, perhaps we never will.

Films like *Sons, Ashes and Embers, Jacknife, In Country,* and *Born on the Fourth of July* also serve as sobering reminders of what the legacy of the war against Saddam Hussein might be if American military strategy had been as inept as it was in Vietnam. One would imagine that many a Vietnam vet—particularly those who were bloodied by the war psychologically, if not physically—must have felt a special pain upon hearing George Bush, in the exaltation of victory, proclaim that America can now "put Vietnam behind us.'

Gardens of Stone (1987) is the sole mid-to-late-Eighties Vietnam film not focusing on Vietnam veterans that comments on the grander scheme of the war. James Caan plays a troubled career Army sergeant, a combat veteran who, like his counterpart in *Go Tell the Spartans*, loves the service but despises the war. Symbolically, his current job is to oversee the men assigned to an elite corps that presides over Arlington Cemetery's Tomb of the Unknown Soldier, and escorts the coffins of Vietnam's fallen to their final resting places.

For anyone who lived through the Vietnam War, *Go Tell the Spartans, Gardens of Stone, Hearts and Minds,* and even *The Deer Hunter* and *The Boys in Company C* will revive long-buried memories and feelings. They will be uncomfortable, even painful: Chicago in 1968, perhaps, or Kent State, or Nixon watching quarterbacks and cheerleaders while thousands pleaded for peace at his White House doorstep, or the war coming alive, day after day, year after year, on TV's evening news.

An occasional stirring of these memories and feelings is necessary, even healthy, because the Vietnam experience must never become a few paragraphs buried in history books. On one level, of course, the war must be laid to rest. The president of the United States is no longer named Johnson or Nixon, and a whole new set of national priorities exist. Still, as with the Holocaust, it remains imperative that young Americans, who might assume that the Tet Offensive is the latest strategy of the Los Angeles Rams, learn about Vietnam so that the same mistakes of purpose and policy will not be repeated. For this reason alone, we must never allow ourselves to "put Vietnam behind us."

—Rob Edelman

RECOMMENDED BIBLIOGRAPHY

Adair, Gilbert. *Vietnam on Film: From* The Green Berets *to* Apocalypse Now. NY: Proteus, 1981.

Anderegg, Michael, ed. *Inventing Vietnam: The War in Film and Television*. Philadelphia, PA: Temple University Press, 1991.

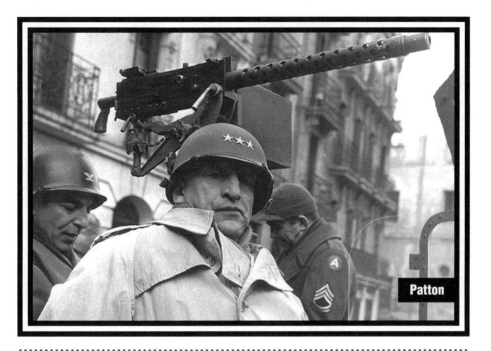

Patton

The War Film

For decades the war film has been a staple of the Hollywood economy. Whether it's a B-movie with clumsy, make-believe tanks or a big-budget spectacle with foreign armies rented and outfitted in period uniforms, war films draw audiences and make money. That they are not being churned out today at the same rate as in previous years is a matter of economy and changing audience tastes.

It is not easy to reproduce the effects of full-scale modern warfare without inflating production budgets. Some of the props are also increasingly difficult to find since few armies are still equipped with 1940–'45 weaponry. Audiences, too, have changed; the taste for heroic violence and gunplay seems sated by detective, horror, and thriller films. Perhaps the war film has also been entrapped by an intrinsic dilemma—how to display warfare accurately without diminishing its heroism or glory. Ironically, the technological progress that made the motion picture industry a reality also served to reduce the element of valor in modern warfare. In 1914, newsreel cameramen cranked away at lines of gorgeous guard-regiments on dress parade, the popular image of military valor and pride, while the machine guns, heavy artillery, mortars, and poison gas that would reduce regiments to squads in mere minutes were just waiting to be used.

Most war films deal with the events or methods of World Wars I and II, the Korean War, and the Vietnam War. These

were the first fully modern wars, including combat cameramen from whose footage Hollywood filmmakers could model their feature films. The basic categories into which most war films fall are the Embattled Platoon, the Battling Buddies, the POW Escape, the Preparedness Film, the Service Comedy-Musical, the Battle Epic, the Strain of Command, and the Antiwar Film.

The Embattled Platoon film, which portrays the tensions between members of a combat unit, owes its origins to the First World War, with its emphasis on the diverse ethnic and class makeup of the American Expeditionary Force. Among the films exploring this theme were *The Pride of New York* (1917), *For the Freedom of the World* (1918), *Doing Their Bit* (1918), and *The Lost Batallion* (1919, which incorporated documentary footage shot by the Signal Corps). An important corollary in these films was the contrast between the decadent rich man's son who initially ignores the war and the eager volunteer from the working class. Written by Lawrence Stallings and directed by King Vidor, *The Big Parade* (1925) is probably the most famous silent feature film dealing with what was then called the Great War. The film's three major characters were drawn from three distinct social classes: Jim (John Gilbert), an industrialist's idle son; Bull (Tom O'Brien), a pugnacious Irish bartender; and Slim (Karl Dane), a tall construction worker who most easily adapts to battlefield conditions. The sole survivor is Jim, but not until after he has fallen in love with a French farm girl, made a short speech denouncing the war, and been badly wounded. Vidor's film was also notable for its even-handed treatment of the Germans. In contrast to the other films produced during the war years—including *The Hun Within, Claws of the Hun,* and *The Kaiser: Beast of Berlin*—Vidor dared show a young German soldier just as fearful as his American opponent.

Made with a naturalist patina that earned high critical praise and long box office lines, *The Big Parade* benefited not only from Vidor's careful study of actual combat footage and his use for some scenes of regular army units on maneuvers, but also from a small army of veterans who served as extras and technical consultants. Despite the realistic touches in the film, few of the corpses glimpsed on the battlefield were American.

The Battling Buddies film, in which two rivals fought each other as much as they combatted the Germans, owes its origins to *What Price Glory?* (1926) and *Wings* (1927). The latter film also featured that aspect of the war that had captivated public consciousness—the "dog fights" between wildly painted biplanes, a form of battle more pleasant for the home front to contemplate than the dreary slaughter in the trenches. The air war also had the advantage of appearing as if heroism and skill were all-important, with any real discussion of the aeronautical merits of a Fokker triplane supplanted by the theme of mental strain on the commander. In *The Dawn Patrol* (1930), the contrast between the antics of the boisterous aces and the grim-faced squadron commander who had to send out raw pilots to face the "Flying Circus" was attributed to the demands of leadership. This theme became increasingly popular in later films when Spitfires and Flying Fortresses had replaced Spads and Sopwith Camels.

The Antiwar Film emerged as a reaction to World War I. Its complex network of causes, the military blunders, the homefront hysteria, and the magnitude of suffering provided countless themes to filmmakers. The initial spate of antiwar films appeared about ten years after Armistice Day, but as early as 1915 films such as Thomas Ince's *Civilization*, sanctioned by President Wilson, attempted to convince Americans of the waste of the war. The most effective antiwar films, however, grew out of the experiences of veterans. The best known of these films, Lewis Milestone's *All Quiet on the Western Front* (1930), the saga of a group of German

schoolboys based on the Erich Maria Remarque novel, is essentially a character study of an idealistic volunteer who becomes disillusioned both with the war and the society that made it possible.

All Quiet on the Western Front and other antiwar films such as *Journey's End* (1930), *The Case of Sergeant Grischa* (1930), and *The Man I Killed* (1932), seemed to have had an impact on audiences, since few films glorifying modern combat were made throughout the early and mid-Thirties. Audience demand for heroic violence during those years was satisfied by a number of historical melodramas that blended romance, chivalry, and valor in old-fashioned campaigns in the Crimea and India, on the high seas, and the American frontier. Errol Flynn and John Wayne starred as experts with rapier and six-gun long before they donned khaki and steel helmets. By the late Thirties, however, the real smell of war in the air was wafting towards Hollywood from the far corners of China and Spain. A number of espionage dramas drew on these historical events—including *Blockade* (1938), *The Last Train from Madrid* (1937), and *The General Died at Dawn* (1936)—but the films that featured the real sinews of war were the Preparedness Films.

The Fighting 69th (1940) and *Sergeant York* (1941) both used an individual's reconciliation with the demands of warfare, in the former a coward and in the latter a pacifist, as an object lesson for a neutral America. Another species of Preparedness Film featured the equipment of the coming war, even if not a single shot was fired in anger. Amid the routines of training in a peacetime army, classic love triangles competed for audience attention with aircraft carriers in *Flight Command* (1940), aircraft in *I Wanted Wings* (1941), and power dives in *Dive Bomber* (1941). Close cousins were the films that drew on the plight of beseiged England—*Mrs. Miniver* (1942), *A Yank in the R.A.F.* (1941), and *International Squadron* (1941). Although commercially successful, the Prepared-

ness Films were criticized for contributing to a form of war mongering. Any concern over that charge disappeared in the pall of smoke rising over the remnants of the Pacific Fleet at Pearl Harbor.

A number of espionage melodramas with the word Pacific in their titles were rushed into exhibition in early 1942, but the most characteristic films about the war were those based on the Embattled Platoon theme. It was only too appropriate for both American and English filmmakers to offer rousing paeans to the perfectly integrated or socially heterogeneous squad that fought to the last man and round against Japanese or German divisions. *Wake Island* (1942), *The Way Ahead* (1944), *Bataan* (1943), *The Immortal Sergeant* (1943), and *Air Force* (1943) are typical in that the true facts of immediate defeat are blended into episodes of such self-sacrifice that the unpleasant outcome of the actual fighting could be eclipsed by the bravery depicted on celluloid.

One unusual film, *Sahara* (1943), featured a truly Allied set of characters: several Britons, an Australian, a Free French soldier, a Sudanese, and even a sympathetic Italian POW. What united them was the American tank commanded by Humphrey Bogart. That in mid-1942 there were no American troops in the western desert campaign didn't seem to bother anyone, though similar inconsistencies in other films did anger the slighted parties. *Sahara* was released soon after the battle of El Alamein, so a reference to it in the closing dialog lent the film topicality. The incidents of the real war were often fashioned by Hollywood into feature films that banked on audience interest in a closer look at the history happening around them. At least two films, for example, were made concerning General Doolittle's daring daylight raid on Tokyo in April 1942, *The Purple Heart* (1944) and *Thirty Seconds Over Tokyo* (1944).

Every branch of the armed forces seems to have been singled out for its own film—the submarine fleet in *Destination*

Tokyo (1943), an amalgam of several different wartime episodes; the Merchant Marine in *Action in the North Atlantic* (1943); and even the naval engineers in *The Fighting Seabees* (1944). This last film starred John Wayne who played a series of wartime roles, including a Flying Tiger pilot and a PT-boat commander. His most famous role, as a U.S. Marine sergeant, came after the war in *The Sands of Iwo Jima* (1949). These performances established Wayne as the idealized American soldier (a later attempt to make him into an anti-Nazi German in *The Sea Chase* was thoroughly unconvincing). Wayne's filmed heroics have become part of American male mythology, and reports from Vietnam recall sad examples of how unrealistic it was of young soldiers to try to emulate John Wayne.

The Embattled Platoon films did not all deal in platitudes or morale boosting. Lewis Milestone's *A Walk in the Sun* (1945) stylishly recounted one unit's routine assignment, the taking of a farmhouse a few miles from their landing beach. The dialog, delivered in a series of monologs, explored a few basic themes—that the war would outlast each of them and the growing realization that their mission would be deadly. Despite a studied theatrical quality in the interior monologs and lighting, Milestone eschewed stupendous action scenes in favor of dramatizing the everyday war as experienced by common infantrymen. Another film which focused on the GI's war emulated combat newsreels in showing the dreary anonymity of modern war, the enemy seen only as corpses or POWs. *The Story of G.I. Joe* (1945) used a war correspondent as its narrative device, but both films tried to detail the banal quality of the war unlike the run-of-the-mill movie which tended to stress the highly strategic nature of combat. *Gung Ho!* (1943), *Back to Bataan* (1945), and *Objective Burma* (1945) may have been slanted in this way because the war in the Pacific was seen almost exclusively as an American theater of operations

(although Burma was in the British sphere of operations).

Even the Battling Buddies theme was renovated for the new world war in *Crash Dive* (1943) and *Flying Fortresses* (1942), but the theme that was to receive enhanced filmic treatment was the plight of the commanding officer. Both *Twelve O'Clock High* (1949) and *Command Decision* (1948) showed the hardships encountered by air crews sent over German-occupied Europe, but most of the screen time was devoted to portraying the emotional strain on the squadron commanders. These films can also be seen as highly subtle propaganda, since the real issues raised in them, the high casualty rate and the emergence of the Luftwaffe jet plane, were very real problems during the war. That only long-range fighter escorts could protect bombers, or that Hitler's personal meddling curtailed the efficacy of the German jet, were not the issues depicted on neighborhood theater screens. The corollary fact that the American military might be subject to careerist corruption was hinted at in these films, but always resolved with happy endings.

A relatively new theme appeared in the POW Escape films, a genre that British studios had produced for decades. The POW film had several obvious advantages: it could account for the years of defeat and withdrawal, yet still match our side against the foes; it highlighted the psychological and moral strength as well as cleverness of the captives; it did not need expensive displays of hardware and special effects; and it provided a tribute to that longing for the all-male, public-school spirit prevalent in England. While Renoir's *The Grand Illusion* (1937) was set in a POW camp, later films never tried to equal its universal concerns and themes. *The Wooden Horse* (1950) and *The Colditz Story* (1957) began the trend. The British movies stressed the preparations and stratagems, while American filmmakers tended to emphasize the escape itself, as in *The Great Escape* (1963), *Von Ryan's Express* (1965), and

Victory (1981).

Perhaps the most noteworthy POW film from Hollywood was Billy Wilder's *Stalag 17* (1953), a skillful blend of escape tale, spy story, and spoof. In addition to the espionage element (one of the POWs is a German agent) and the comic episodes (including a satire on Hitler and the POWs' efforts to visit a women's camp), Wilder's screenplay included a solid dash of disillusionment, since the apparent hero (William Holden) admits he is motivated by self-interest. Traces of bitterness could be seen in increasing numbers of American war movies throughout the Fifties, one of the legacies of a new kind of war in Korea.

Still wreathed in the euphemism of a "police action," the Korean War was unusual for most Americans—it lacked the obvious justification of a Pearl Harbor, pitted two dictatorships against each other on either side of a demarcation line, was clouded with political rhetoric, and vacillated wildly between apparent victory and impending disaster. During the war few films were made that did much more than repeat the clichés of embattled units or heroic military nurses. *Retreat, Hell!* (1952), *Battle Circus* (1953), *One Minute to Zero* (1952), and *Submarine Command* (1951) added little to the standard formulas, but *The Steel Helmet* (1951), made very early in the war, included some unusual elements. Directed by Sam Fuller from his own screenplay, this traditional tale of a forlorn platoon included a barbed conversation between a tough sergeant and a black medic about the recent integration of American Negroes into combat units. Fuller also featured a captured North Korean officer who unsuccessfully tried to win over both the medic and a Nisei veteran. With the war ended by a negotiated peace, in itself a novelty for most adult Americans, a number of films began to explore the tragic side of war, and a few, its corrupting influence.

The Bridges at Toko-Ri (1954), a tribute to the Navy pilots and their helicopter res-cue teams, also seemed aimed at the home front unaware of the dangers faced by the pilots or the reasons for them. Even the Embattled Platoon films like *Men in War* (1957) and *War Hunt* (1962) depicted the personal corruption of war—how some men find the ultimate gratification in combat. A more detached criticism was seen in Lewis Milestone's *Pork Chop Hill* (1959) in which a unit is decimated not in order to win a battle, but rather to gain a bargaining chip to be used in the peace negotiations. This despondent view of war, though it became more familiar after Korea, soon found expression in films made about the two world wars.

A devastating portrait of cynicism among high-ranking officers and criminal incompetence in a company commander was the major theme of Robert Aldrich's *Attack!* (1956). Written by James Poe, *Attack!* contrasted the skill and sacrifices of the enlisted men and their junior officers with the double-dealing and cowardice of their superiors; not surprisingly, the film received no cooperation from the Department of the Army, a trend that was to grow in the next two decades. Eventually, one film, Carl Foreman's *The Victors* (1963), reduced the American role in World War II to an episodic series of petty corruptions and daily brutalizations. Ironically, the former wartime foes fared much better than ever before in the movies made in the late Fifties and early Sixties—a result of growing sophistication among filmmakers and audiences and a realization of the importance of postwar Germany and Japan. *The Desert Fox* (1951), *The Young Lions* (1958), *The Enemy Below* (1957), and *A Time to Love and a Time to Die* (1958) offered perhaps oversympathetic portraits of wartime Germans, while Litvak's *Decision before Dawn* (1951) was deemed too critical by many Germans. Although not as fast in hitting the screen, relatively even-handed films about the Japanese also soon appeared, including *The Bridge on the River Kwai* (1957), *The Long and the Short*

and the Tall (1961), and *Yesterday's Enemy* (1959).

The Sixties and Seventies also witnessed a new type of war movie, a curious blend of all the previously existing types melded onto a quasidocumentary base— the Battle Epic. Whether *The Longest Day* (1962), *Midway* (1976), *A Bridge too Far* (1977), or *Tora! Tora! Tora!* (1970), the general outline of a battle or campaign is chronicled, often from the gunsights of both sides, with an occasional focus on one character in each sequence to give the bones of history dramatic flesh. Often actual documentary scenes are copied (*Tora! Tora! Tora!*), actual combatants' accounts used for the narrative (*The Longest Day*), and hatred of the enemy played down (*Midway*), but the scope of the film usually creates an emotional flatness, despite the presence of any number of recognizable stars in a series of cameo performances.

One film which borrowed some of these techniques, but maintained its focus on one key character, was Franklin Schaffner's *Patton* (1970). Although superb as a graphic portrait of the soul of a military professional, *Patton* is far too narrow as a chronicle of modern war. The battles are seen almost exclusively from Patton's viewpoint with very little hint at the real costs or logic of his victories. *Patton* is an excellent example of the Strain of Command war movie, with fine performances and a script designed to reveal the complexity of Patton's personality. As a portrait in heroic dimensions, the film had enormous appeal, from the millions of moviegoers who made it a commercial success to President Nixon, who was reported to have viewed it repeatedly.

While audiences thrilled to George C. Scott's Patton rushing to aid the defenders of Bastogne, real fighting and dying was going on in Southeast Asia. Like Korea before it, the war in Vietnam not only combined traditional and guerrilla warfare, but also called into question the basis for American involvement to an extent unseen seen the Filipino insurrection of 1900. The

first and for many years only Hollywood film to deal directly with the war was John Wayne's *The Green Berets*. Released in 1968, this film was basically an update of the Embattled Platoon formula but with a skeptical journalist on hand who by the film's end is convinced of the importance of the U.S. role in Vietnam. Although *The Green Berets* was among the top ten grossing films of the year, Hollywood shied away from Vietnam for another decade.

Go Tell the Spartans, *The Boys in Company C*, and *The Deer Hunter* were all released in 1978. While the element of service comedy, with the enlisted men more ready to confuse their officers than to confront the enemy, was the main theme of *The Boys of Company C*, at least until the climactic moment of truth, *Go Tell the Spartans* did have a pointed criticism of the war. Directed by Ted Post from Wendell Mayes's screenplay, the film was an Embattled Platoon movie, but with a marked resignation towards the tragic plight of fighting a cruelly confusing guerrilla war. Unlike some films that tried to convey a pacifist message, this film was specifically anti-Vietnam War—"This is a sucker's tour…I wish I could give you a better war," laments the army commander (Burt Lancaster) to an eager volunteer. Post's film is an expression of liberal regret that never seemed to find its audience.

The most unusual of this group of films was *The Deer Hunter*. With almost no battle scenes and none of the military details that characterize war films, Michael Cimino's controversial feature is an extended study of character in the most extreme situations, not just battle, but also psychological torture at the hands of murderous Vietnamese captors. In its effort to transcend the traditional war film, *The Deer Hunter* may be a tribute to the heroic man (Robert De Niro) who acquits himself superbly before, during, and after the war, but it too often degenerates into the operatic and cryptic. Francis Ford Coppola's *Apocalypse Now* (1979) is frankly enigmatic

in its blend of spiritual journey, character study, and spectacle. Though both Cimino and Coppola's films shatter the conventions of the traditional war film, it remains unclear what their legacy will be.

The comic variant of the Antiwar Film also enjoyed great popularity during the Vietnam War years. Released the same year as *Patton, M*A*S*H* (1970) ironically shared some features with its apparent polar opposite. If *Patton* is an ode to the warrior's leadership in war, the Ring Lardner, Jr. screenplay as directed by Robert Altman is a snobs' view of war as a vulgar, ill-managed event. The protagonists are not high-ranking commanders, nor are they simple enlisted men, but rather surgeons drafted during the Korean War. Angry at their loss of freedom and what they see as the idiocies of regimented life, they engage in all the rebellious horseplay they can get away with due to their officer rank and medical skills. This is different from the hijinks common in service comedies like *Francis* (1950) or *See Here, Pvt. Hargrove* (1944). In the earlier films, the top brass was either outwitted or outflanked by clever use of the army's own regulations and traditions. In *M*A*S*H* the protagonists use their status to win. Although some may discern a subtle subtext that criticizes war, the protagonists' most apparent reaction to the mutilated and dying soldiers brought before them is a cool indifference or humorous bantering between them as to which grade of thread is best for stitching up wounds. Set in an ostensible Korea, the film was seen by its admirers as a commentary on Vietnam and spawned both a hit television series and other Elliot Gould-Donald Sutherland vehicles.

A far less detached approach about World War II was featured in the screen adaptation of *Catch-22*. Mike Nichols's screen version of Joseph Heller's novel did only half as well at the box office as either *M*A*S*H* or *Patton*, yet it is a remarkable combination of lampoon and condemnation. The recurring image in the film hearkens back to a literary theme common in the literature of the First World War—the apparently lightly wounded man who is dying from a far worse injury unknown to the comrade who is helping him. This is exactly how Kat dies despite Paul's efforts in *All Quiet on the Western Front*. Measured against this imagery, the antics of Yossarian (Alan Arkin), the bombardier who would rather drop his bombs harmlessly into the sea, or the schemes of Minderbinder (Jon Voight), the boyishly ruthless entrepreneur, were threads in a tapestry both comic and tragic.

War comedies fall easily into two categories: those that make fun of the details of army life and those that satirize war itself. The bullying sergeants, pompous officers, and adolescent subalterns who plague the hapless recruits until they accidentally become heroes at the front were established conventions by the Twenties in films like *Private Izzy Murphy* (1926, the title alone a joke on the heterogenous platoon theme), *Spuds* (1927), and *Behind the Front* (1926). The origins lay in Chaplin's 1918 feature *Shoulder Arms*. These service comedies continued into the Thirties and Forties with Ollie and Stan or Bud and Lou as the hapless recruits. The most notable exception to this tradition was the Marx Brothers' *Duck Soup* (1933), an anachists' delight, a total send-up of government, diplomacy, and warfare. Few films have ever approached its cynical absurdity. "There must be war," complains Groucho, "I've paid a month's rent on the battlefield," or the antics of Harpo and Chico as spies for both sides. Following the musical extravaganzas of the war years, the postwar service comedies were more polished renderings of the old traditions, but *Mister Roberts* (1955) and *No Time for Sergeants* (1958) did not break significant ground. One group of films which did were not based on either past or current wars, but on the next and probably last world war.

Stanley Kubrick's *Dr. Strangelove: Or How I Learned to Stop Worrying and Love the Bomb* (1964) depicts the literally mani-

acal start of the war. Written by Kubrick and Terry Southern from a novel by Peter George, the film is a curious blend of tradition and satire. While those sequences about the B-52 bomber and its crew mistakenly ordered to attack Russia are an uncomfortable tribute to war film conventions—the ethnically mixed crew, the strain of their mission and the struggle to avoid being downed—the sequences involving the leaders, both military and political, are black comedy. Psychotic Air Force generals, war-happy Pentagon officers, indecisive civilians, and former Nazi scientists provide a senseless chorus while the bomber hurtles toward its target. A later film that tried to picture the aftermath of war, *The Bed-Sitting Room* (1969), is frankly absurd. Directed by Richard Lester, it postulates a debris-strewn London peopled by survivors unwilling to change their beliefs or habits despite the destruction around them. A commercial failure, its jokes may have been too arcane and its style, derived from the BBC's *Goon Show*, not suitable for a film.

Thirteen years after the American military withdrew from Vietnam, two naturalistic and well-received films about that war were released—Oliver Stone's *Platoon* (1986) and Stanley Kubrick's *Full Metal Jacket* (1987). Formally, they are not that different from many other graphic war films, but they do stress the strain of combat for the enlisted man, the way earlier films exposed the demands of high command.

Released a season earlier, *Platoon* received more attention because it uses a conceit, a metaphor to show the plight of America in an imperial war. The idealistic young recruit is torn between two views of war—the terror of combat personified by a tough, disfigured sergeant who is quite willing to kill peasants to extract information and the camaraderie of men-in-arms typified by a pleasant and pot-smoking sergeant who can be as brave as his polar opposite in battle. Stone has deepened and perhaps even muddied his metaphor by

having one officer practically murder the other shortly before a harrowing night battle. There is also a quality of homoeroticism that confuses the real, brotherly love that can develop among combat soldiers.

Kubrick's *Full Metal Jacket* is much more lucid, almost clinical, in its treatment of a Marine Corps combat correspondent, a soldier burdened with a camera and cynicism as well as his combat gear. The film's first half is devoted to the training of recruits, that half-mad series of endless rituals that are not at all that mad, since they prepare a group of individuals to act instantaneously as a group to certain stimuli and to follow orders quickly and well. Still, the change is massive and abrupt, too much so for one lad who, rifle in hand, goes mad.

The ironies of war in Vietnam are fully explored: the ease of sex and drugs; the apparent absence of any fighting South Vietnamese Army (though following the U.S. withdrawal, they did fight and die and lose for two years); the racial antagonisms and the very sharp differences between the combat troops and the chaps "in the rear with the gear." Kubrick's film is, in many ways, a cool tribute to the ethos of the professional soldier who does his job as best as he knows how, wherever or whenever he is called to fight. Indeed, the one Marine Corpsman who knows what to do when his squad is pinned down by a sniper is a minor and unpleasant character. Guerrilla or irregular warfare is not new—the Roman legions had to fight a series of them for centuries—and has never been popular among the troops, the generals, or the public expected to pay for them. The British, too, took the better part of two centuries to get used to them. Now, in the last quarter of the twentieth century, the American public has learned the price of empire.

Imperial troops don't fret over their consciences or wear peace symbols on their helmets, as does Kubrick's ironic hero, but cynical or battle-crazed, patriotic or truculent, a soldier must know how to kill an enemy as tough as he and probably

as well-equipped and perhaps a lot more motivated to take risks.

Despite a recent spate of films on the Vietnam War, and a seemingly endless series of mindless, grade-B action movies with war backgrounds, the classic war film genre is today definitely on the wane. War films will doubtless continue to be made because stories of men in combat have captivated audiences since the days of Homer. After the black humor of Kubrick, the baroque pretentiousness of Coppola, or the inflated posturings of Cimino, however, it is difficult to believe that audiences will be able to accept the conventional war film formulas of the past. Perhaps today's moviegoers have learned the wisdom of Robert E. Lee's dictum: "It is well that war is so terrible, or we should get too fond of it."—Lenny Rubenstein

RECOMMENDED BIBLIOGRAPHY

Basinger, Jeanine. *The World War II Combat Film: Anatomy of a Genre.* NY: Columbia University Press, 1986.

Dick, Bernard F. *The Star-Spangled Screen: The American World War II Film.* Lexington, KY: University Press of Kentucky, 1985.

Suid, Lawrence. *Guts and Glory: Great American War Movies.* Reading, MA: Addison-Wesley, 1987.

Wayne, John
(Marion Michael Morrison)
(May 26, 1907 – June 11, 1979)

E verybody thinks they know all about John Wayne and politics. But in Wayne's case, as in so much of the history of Hollywood, the obvious is not the most instructive. True, Wayne was unique among his generation of Hollywood personalities in successfully translating his politics into screen projects.

During the very years when he spent much of his time working to see that other Americans (those left of the Cold War's right-leaning center) kept their politics out of movies, he managed to make heroes out of HUAC and its investigators in *Big Jim McLain* (1952), pulled a fast one on the Chinese communists as an escaped political prisoner who helps a whole village flee to Hong Kong in *Blood Alley* (1955), and extolled the virtues of old-fashioned, die-for-your-country virtue in *The Alamo* (1960). This last was the magnum opus which all who knew him agreed was the summation of his philosophy, and it showed a very simple, uncluttered love of country and civics textbook ideals, with patriotism measured in violence inflicted and suffered, rather than a free marketplace of ideas.

At the height of the Vietnam War, Wayne, with all deliberate speed, recast that struggle as World War II in *The Green Berets* (1968), which embarrassed even the army when its script dwelt enthusiastically on illegal forays into North Vietnam. At the Department of Defense's request, the script was made vague with respect to such facts. *The Green Berets* went on to widespread condemnation by film critics, like Wayne's previous polemical productions. And, yes, the final scene features

the sun setting in the East (locations, being what they are, are not reality). But, unlike its brothers, this Wayne manifesto enjoyed a big box office success.

Ironically, these films (Wayne's cherished and most personal) are not where he made his political mark on American life. Nor is his strident public persona in the Sixties and Seventies—the patriotic right winger slapping around a bunch of traitorous East Coast cowards and the youth they have corrupted—the Wayne who will endure. His legacy is the vivid and complex set of movie roles in films directed by John Ford and Howard Hawks—*Stagecoach* (1939), *They Were Expendable* (1945), *Red River* (1948), *The Quiet Man* (1952), *The Searchers* (1956), *Rio Bravo* (1959), *The Man Who Shot Liberty Valance* (1962). And there are a few memorable performances in the films of others: *The Sands of Iwo Jima* (1949), *True Grit* (1969, in which Wayne symbolically reconciled with a morally accusing young-er generation and was rewarded with his only Oscar), and *The Shootist* (1976), his last film, which closes, as Wayne insisted it should, with his surrogate son's repudiation of the gun that had made the old man's fame and fortune.

Nearly all of these are Westerns and war stories, the two defining genres of American manhood, which Wayne stamped with his own indelible image. Through them, Wayne became a haunting figure in the dreams of American men. Abbie Hoffman, of all people, wrote once that Wayne was an "almost perfect father figure." Wayne's influence can still be felt—*Die Hard*, the popular 1988 action movie that tried to reclaim America for white male heroics, featured a terrorist-gangster of a favorite Wayne stripe, the effete intellectual run amok, who issues a challenge in his name.

Shakespearean Brit Alan Rickman played Hans Gruber in *Die Hard*, and spit out these fighting words to the movie's cop hero (Bruce Willis, called, with Wayne echoes, big John McClane): "Who are you? Just another American who saw too many movies as a child? Another orphan of a bankrupt culture who thinks he's John Wayne, Rambo, Marshal Dillon?" (It's a nice series of begets delineating American macho, for the Marshal is still John Wayne, who was offered the television role, and suggested they try his stunt double, James Arness, instead.)

Big John answers mockingly that he's always been partial to Roy Rogers ("I like those sequined shirts"), but, as you might expect, action speaks louder than words, and *Die Hard*'s answer in that tongue is unequivocally, yes, he is John Wayne. In one form or another, the question crops up in most personal chronicles of the Vietnam War, too, and in the idioms of professions where violence is standard operating procedure. On the movie screen in 1992, Harrison Ford's vacationing Jack Ryan in *Patriot Games* was compared to Wayne for intervening in a terrorist attack. "I just got mad," he explains. The Duke would understand, for his temper was his most admired movie asset.

Likewise Wayne remains a lightning rod for dissenters, for everybody from feminists, who identify him as America's antediluvian macho ideal, to Native Americans, who see him as the great symbolic Indian fighter of the frontier's genocidal expansion. These views are not incorrect, but they are not complete. Wayne's film record reveals something more complex than the traditional American hero of of both right- and left-wing myth. His special appeal and resonance for mid-century America lie in his peculiar postion as a transitional figure in the troubled postwar path of masculinity.

Wayne is no unblemished citizen-hero like James Stewart or Henry Fonda in the Thirties, but neither is he the loose cannon on society's deck represented by Clint Eastwood, his heir apparent in the Sixties. Wayne, like Clark Gable, is the man who can't quite settle down to play the game, and his best movies reflect his uneasy truce with the demands of community.

More often than not he never quite makes it into the fold—the essential image is Ethan Edwards framed in the doorway in the closing shot of *The Searchers*, forever outside the home to which his vile and violent skills have returned his Indian-captive niece, Natalie Wood.

Ethan Edwards certainly reinforces the legend of Wayne as Indian fighter, but Ford paints that as the man's biggest flaw, a blind racism that almost causes him to slay his own flesh and blood—surely a mortal sin in Ford's catalog. Indeed the story of *The Searchers* charts its small, bittersweet joys in Edwards's softening, in his comprehension of a cavalry massacre upon a defenseless Indian village, for instance. He treats Native American tribes in the high Ford mode as alien nations, brutal but proud, in a kind of backhanded admiration.

Even as far back as *The Big Trail* (1930), in his first starring role, as a wagon scout, Wayne credits his Indian friends with teaching him everything he knows, and blames much of the warfare between settlers and Indians on broken treaties. That doesn't keep him from killing Indians, however, when the plot contrives it, and it usually does. In most of his movies Manifest Destiny requires that Indians get out of the way, their fiercely beautiful culture, as he appreciates it, obsolete in the face of white settlement. War films often bring him into contact with other less restless or already conquered tribes; Wayne can be found treating the Filipinos, the Hawaiians, the Vietnamese, et alia, like the happy campers Dan Quayle wishes them to be.

Inner contradictions such as these may be just what makes a major movie star. Take Wayne's stance toward women. It is basically the separate-but-almost-equal paternalism of John Ford, laced with an impulsive sexuality that occasionally turns dangerous, especially when there's no Ford around to turn down the heat. In a potboiler like *Wake of the Red Witch* (1948), the piratical captain and pearl thief

Wayne plays first enters the story (chronologically, that is, via flashback) on a floating cross, set adrift by islanders who are irate about his sexual adventures. Thwarted in love when it finally strikes him, Wayne goes into a monumental sulk and for a moment advances on his beloved (Gail Russell) with the threat of rape— here understood as a case of uncontrollable desire—unmistakable in his eyes. Her unfazed devotion brings him to his senses just in time. An unleashed Wayne was utterly convincing in such films, just as he seems right at home stammering and blushing while he courts the girl in countless programmers and in some of his major films as well: The Ringo Kid, the role that established Wayne in *Stagecoach* in 1939, is too naive to perceive that Claire Trevor is a prostitute.

Yet Wayne, bounding between these extreme masculine poses, also helped to give Ford's *The Quiet Man* one of the most mature romances of the Fifties. There are the usual Fordian trappings of coy flirtation and mock-domination. "Here's a good stick to beat the nice lady with," offers a passing auntie during their epic spat, as he drags his runaway bride home, but Wayne and Maureen O'Hara engage in a surprisingly frank dialog about the balance between power and sexuality in marriage. Her oafish brother refuses the couple her rightful dowry, feeling tricked by the community (as he was) into marrying off his unpaid housekeeper. She insists her new husband demand the money long set aside for her, even to the point of fighting the brother for it.

A former boxer sworn off the ring, Wayne refuses, and she locks him out of their bridal bed. In a curious turn on the usual Wayne dilemma, he is stigmatized for too little violence instead of too much in *The Quiet Man*. He does, of course, answer the call to arms (or fists), but only when it is abundantly established that the marriage is a transaction in which she is a partner. He must pay respect to her symbol of independence (the dowry), just as

she must make sure it remains symbolic. When her brother grudgingly hands Wayne the money rather than take back the bride, she opens the boiler door for Wayne to toss it in.

Such complexity is usually reserved for Wayne's relationships with men, which are more commonly filial in essence than comradely. He is forever an errant son, seldom in fact but more in function in *The Shepherd of the Hills* (1941), *They Were Expendable*, *Stagecoach*, *Angel and the Badman* (1947), and *Wake of the Red Witch*. Or else he is the demanding father figure, in *Sands of Iwo Jima, Red River, The Cowboys* (1972), *She Wore a Yellow Ribbon* (1949), *Wake of the Red Witch, In Harm's Way* (1965), *Big Jim McLain, Rio Grande* (1950).

Sands of Iwo Jima, Wayne's most famous war movie—but not his best, that honor goes to *They Were Expendable*—featured the outcast warrior with crying-in-your-beer intensity. The Marine sergeant goads and beats his green recruits into shape, for their own survival, as the services are always reminding us. His own life is a shambles, he is separated from his real son, and his surrogate sons hate his guts until they toughen up. But Wayne can't even enjoy that camaraderie; he's shot dead by a sniper while resting up from the hard-fought victory. Our only consolation, and his legacy, is transforming his severest young critic into a perfect jarhead in Wayne's own image, as he takes command and his mentor's place.

In *They Were Expendable*, John Ford's bright, shining lie about the honor of war and American teamwork, Wayne played the other side of that equation. Rusty is a junior officer on PT-boat assignment in the Philippines. He signed on for the small craft, unproved in combat, in order to get his own command. Right away his fatherly commander (Robert Montgomery) is asking, "What are you aiming at—building a reputation? Or working for the team?" It's a litany in this elegiac tribute to those left behind to the tender mercies of the enemy as the American command evacuated only "important" personnel. As the PT command is moved further off the archipelago and ultimately decimated and scattered, Rusty learns by the quiet sacrifice of others. But even at the last moment, in a scene Wayne insisted be included, he wants to give up his seat on the last plane out to a man whose number was just one too late. Montgomery stops him with the same reminder. "Rusty! Who you working for? Yourself?" For Wayne the answer is always no; it would be up to Clint Eastwood, in a different era shaped by a different war, to say yes.

Even with Howard Hawks, where the code of professional is far more singular and entrepreneurial, Wayne had to be reined in. *Red River* found him a self-made man, who had lost the love of his life by trying to keep her safe on a wagon train while he staked out a ranch for them both. With his adopted son (Montgomery Clift), an aging Wayne, desperate to sell his cattle during the post-Civil War depression, undertakes a near-impossible cattle drive to the railhead. As obstacles mount on the trail, he becomes a Draconian boss. When he threatens to hang dissenters (about the equivalent of what Wayne's Motion Picture Alliance was doing offscreen), Clift disarms him and ejects him. The rest of the drive is haunted by his oncoming revenge, which turns out in typical Hawks fashion to be an affectionate fistfight that even a pretty girl can see through. Just another rite of passage into true male bonding.

There was often in Wayne's roles a festering resentment, a sense of something taken from him—in *The Searchers* it was the woman he loved, victory in the (Civil) war he had fought, and finally the family he cherished from afar. In *Liberty Valance,* too, he carried a chip on his shoulder for history's snub, and in the Ozark drama, *The Shepherd of the Hills*, he raged over his mother's death, her abandonment, the curse that kept him apart from normal folk. And he sought to kill the father who had caused these calamities.

Wayne onscreen was frequently bereft of any traditional family, precisely because he pursued his profession too well. The Yankee cavalry officer of *Rio Grande* burned down his southern wife's plantation on orders—end of marriage, until she follows her teenage son to Wayne's frontier outpost and rediscovers their love in the midst of his illegal forays into Mexico pursuing renegade Indians.

Wives simply got fed up and left long before the beginning of *In Harm's Way, Sands of Iwo Jima*, and *The Horse Soldiers.* And the implication always is that a price must be paid for liberty's eternal vigilance. Wayne exemplifies, so the myth would have it, an American warrior unfit, by his very devotion to the cause of freedom, for normal family life. In *The Man Who Shot Liberty Valance*, wherein Wayne's crusty frontier rancher cleaned up the territory but lost the girl and the glory to a greenhorn lawyer, the bitterness of this burden—the domestic version of the white man's burden—finally overwhelmed the honor of it. In private life, Wayne's devotion to his career was generally credited with sinking his three marriages.

It is ironic that the ideal soldier never went to war himself. The standard biographical line has been that he tried to enlist for World War II three times, failing the physical because of an old football injury. The most recent biography of Wayne, however, suggests he simply made use of the draft exemption available to any thirty-four-year-old father of four and so chose to pursue his career instead.

It's certainly a plausible scenario. When World War II broke out, Wayne had just hit the big time in *Stagecoach*, after toiling ten years in B-movie obscurity, The absence of many male box office stars gone to war gave him an even greater opportunity to consolidate his stardom. He had seen how easily fame could slip away after his first big break, a starring role in a major epic, *The Big Trail*, in 1930, and, as a typical Hollywood workaholic, he would be unlikely to take another chance on

falling back into the second rank.

The war made Wayne a star, you might say, because he *didn't* fight in it, and afterwards, when his own bandstand brand of patriotism hardened during the McCarthy era, perhaps he was making up for a kind of cultural war profiteering. He remained on the annual list of the top ten box office stars for a record twenty-five years, from 1949 to 1974, right through the era of his most right-wing and conspicuous offscreen political activism. Although Wayne once said he had been a socialist in college, it seems unlikely he joined any party. He was active in the G.O.P. and George Wallace asked him to run as vice-president on the Independent Party ticket in 1968. Wayne declined.

Wayne's politics were indisputably right wing, but not monolithic. Late in life he made conservative enemies by supporting Jimmy Carter on the Panama Canal treaty. He summed up his conservatism by saying, "I think government is the natural enemy of the individual, but it's a necessary evil, like, say, motion picture agents." Anarchist leftists need draw no hope of an ally however. Wayne was deeply distrustful of the "eastern press" and modern-day liberals who had, to his mind, distorted the Jeffersonian tradition. In this respect he was not unlike the character he played in the now-obscure pre-Civil War drama, *Dark Command* (1940). Here the antiintellectual, paranoid Wayne persona had its first full-blown airing. An illiterate drifter, Wayne wanders into volatile Lawrence, Kansas, in 1859 as a shill for an amiable snake oil salesman. His natural courage and ambition get him into the race for sheriff, running against an intellectual schoolteacher, Cantrell (Walter Pidgeon). Like all the intellectuals Wayne has known, Cantrell is unstable and dangerous. "I'm sick of doing what's right and getting nowhere," Cantrell tells his mother when he loses the election. Mom is posing as his housekeeper so that her educated son won't be shamed by his humble provenance. "Beaten out of it by an ignorant

cowhand who can't even write his own name," he wails, and soon turns to gun-running, slave-hijacking, and pillage under the guise of fighting for the South, à la the real-life Quantrill. Even Wayne can't stop this guy; in the end, his own mother shoots him down.

Dark Command is probably Wayne's only foray into gun control (he tries to arrest Cantrell for transporting "unlicensed firearms"). Despite his loudly proclaimed antiregulatory frame of mind, however, he was eager to interfere in other lives during the red scare. Wayne was a founder, charter member, and president of the right-wing Motion Picture Alliance for the Preservation of American Ideals, which undertook to weed out communists from the film industry.

The Alliance operated an active blacklist. Wayne later denied that fact thus: "The only thing our side did that was anywhere near blacklisting was just running a lot of people out of the business." Wayne was berated himself for being soft on communism by his comrades when he made sympathetic moves toward a recanting Larry Parks; Hedda Hopper slapped some of the red-baiters' peculiar sense back into him. Contradictions, always contradictions.

Wayne's appeal did not depend on his politics, I suspect, but rather on the poetics of his presence, the way in which he played out a certain small mythic tragedy recognizable to men and women of the postwar world, who would find the terms of their agreement with society changing radically in the next twenty-five years. Wayne lived to see that, and almost howled in protest throughout the Sixties, which made his screen persona seem antiquated and irrelevant. He turned down the role of Dirty Harry, it has been said, and yet by the mid-Seventies he too was making brusque, mechanical tough-cop movies: *McQ* (1974) and *Brannigan* (1975), in which his character is viewed as something of an embarrassment even by his own police department. Wayne succumbed to cancer, which he had survived more than a decade earlier, on June 11, 1979.

In retrospect Wayne in his prime was a more tragic figure than we ever imagined at the time. So many of his films dealt with one man teaching another the rules of this difficult contract that was their heritage, and yet there was no one on screen willing to succeed him in that duty. Eastwood took the mythic step Wayne always drew back from, and Stallone is but a caricature, wearing out his welcome after only a few years as box office champ.

Wayne touched something deeper. He played out a modern American dilemma, dramatizing a changing moment in masculine myth. On the verge of revolt, he would come to the end of each story finally ready to accept good-naturedly (and with a sense of its cost) the birthright of American men at arms: deference from the young, from people of color, and from women; bragging rights to the world's best-armed empire; and a manifest destiny for the man who does his job. Along with that came loneliness, mortality, and that hearth forever just out of reach. That was the bargain, about to be broken by history, whose politics struck deep.—Pat Dowell

RECOMMENDED BIBLIOGRAPHY

Boswell, John and David Fisher. *Duke: The John Wayne Album: The Legend of Our Time.* NY: Ballantine Books, 1979.

McGhee, Richard D. *John Wayne: Actor, Artist, Hero.* Jefferson, NC: McFarland and Co., 1990.

Shepherd, Donald and Robert Slatzer with Dave Grayson. *Duke: The Life and Times of John Wayne.* Garden City, NY: Doubleday, 1985.

Stacy, Pat with Beverly Linet. *Duke, A Love Story: An Intimate Memoir of John Wayne's Last Years.* NY: Atheneum, 1983.

Wayne, Aissa with Steve Delsohn. *John Wayne: My Father.* NY: Random House, 1991.

Wayne, Pilar with Alex Thorleifson. *John Wayne: My Life with the Duke.* NY: McGraw-Hill, 1987.

Zmijewsky, Steven, Boris Zmijewsky, and Mark Ricci. *The Complete Films of John Wayne.* Secaucus, NJ: Citadel Press, 1983.

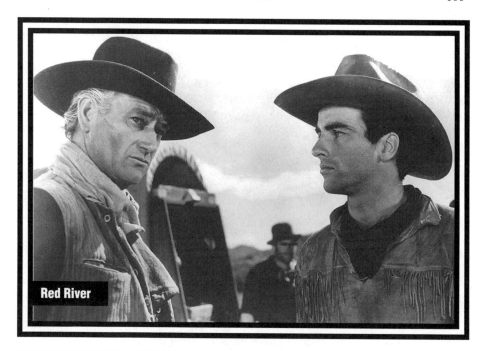

Red River

The Western

The Western hero belongs to no social class. He's not Polish or Italian, Irish or Scotch or British, and only in a spoof like *Blazing Saddles* (1974) could he ever be black. His loyalties transcend narrow distinctions of race, nationality, or class, as in his person he represents an ideal of the species. He's tall, fair, muscular, and straight-backed, an embodiment of courage and fortitude, selflessness and iron determination.

He must be physically large and powerful enough to make his presence felt, as he is in that famous last shot of *The Great Train Robbery* (1903) where a mustachioed desperado aims his gun at us.

Yet the Westerner need not be an unrelenting, stubborn, unfeeling man, the image John Wayne perpetuated. In his many incarnations, the Westerner has been sensitive and gentle, if also a sometime killer of men. In *The Last Trail* (1927) Tom Mix dons an apron. Will Banion in *The Covered Wagon* (1923) is gentle and even fashions a doll for a child. At the end of the film, passively he buries his head in his woman's shoulder; for his life's work, he has chosen not gunfighting, but farming.

So does Clint Eastwood's Josey Wales (*The Outlaw Josey Wales*, 1976) who would like nothing better than to be a family man once more. "What do you say to the war being over?," Josey is asked by his last antagonist at the end of the film. "I reckon so," says Josey. Having suffered and survived, Josey wishes only to have returned

to him the simple joys of domesticity denied him by Quantrill's Raiders in the brutal first sequence of the film. McCabe in Robert Altman's *McCabe and Mrs. Miller* (1971) may indeed have killed Bill Rountree with his pearl-handled Derringer, but he is also a loving man who can tell a woman, "I ain't never tried to do nothing but put a smile on your face."

From *Shane* (1953) to his reincarnation as Eastwood's Preacher in *Pale Rider* (1985), the Westerner is sexually pure, if not innocent, and so is able to fight for justice unburdened by guilt, ambivalence, or conflicting loyalties. The Preacher rejects the advances of beautiful fifteen-year-old Megan because it wouldn't be right to bind her to him; his lovemaking with her mother Sarah (Carrie Snodgress) has been freely chosen by both of them.

But the Westerner must be unencumbered by domestic ties that would lessen his effectiveness. If John Wayne as Tom Dunson was to build that ranch in *Red River* (1948), he had to do it alone, and so his woman conveniently is killed at the beginning of the film; only the next generation, the post-Civil War generation, that of Matthew (Montgomery Clift), can afford the luxury of fulfilled sexuality.

Yet from the old Hopalong Cassidy horse operas to *Silverado* (1985), male friendship has flourished in the Western. At the moral moment in which men are afforded the opportunity to express their best selves, they are able to reach out most successfully, not to women, but to each other. The Westerner knows that only another man, one as righteous as he, of course, can understand him. Knowing each is willing to risk everything, at moments of danger they will defend each other.

The loner, it turns out, makes the best friend, so the Western has produced its famous pairs—Hopalong Cassidy and Gabby Hayes, the Lone Ranger and Tonto, *Butch Cassidy and the Sundance Kid* (1968), and *Pat Garrett and Billy the Kid* (1973). It doesn't even matter if the heroes

are technically villains, since a good man misunderstood may be perceived as an outlaw, a not unlikely occurrence in communities where there is no "law." Even seeming antagonists like Wayne and Jimmy Stewart in *The Man Who Shot Liberty Valance* (1962), or Wayne and Henry Fonda in *Fort Apache* (1948), one just and fair, the other a narrow-minded racist, are brothers in their courage, legends in the struggle for our national identity, the great subject of this genre.

In some Westerns this bond of male friendship excludes the love of women and suggests an infantile sexuality. In others, from *The Virginian* and *Stagecoach* (1939) to *My Darling Clementine* (1946), the Westerner willingly faces the challenge of heterosexual love amid the dangers of the barbarian setting. The earlier the Western, the more politically benign the era in which the film was made, the less likely women are to be excluded. Tom Mix always winds up with a woman, if, with Tony the Wonder Horse, they wind up a threesome. Mix did not reject the claims of heterosexuality to go off with a buddy in search of adventure which may be less about justice than a simple evasion of male adulthood.

In the turbulent Sixties the Westerner did not settle down with a woman and there were few women characters in any film genre. By the late Seventies, Josey Wales does commit himself to bliss with Sondra Locke, having defeated the last of his antagonists, just as the marshal of *High Noon* (1952) went off with his bride as soon as the smoke had cleared.

The Westerner is intelligent without being burdened by an Eastern education that would conflict with his reflexive ability to act without hesitation. In the Western that education is associated with ineffectuality and a garrulous spirit; silence accentuates the manhood of the Westerner. As William S. Hart, one of the Western's earliest prototypes noted, "The bigness of the West makes men quiet; they seldom talk unless they have something to say. The

altitude clarifies their brains and gives them nerves of steel." "Shoot first and do your disputin' afterward," Hart says in *Hell's Hinges* (1916). "It seems to me I've got to stay," is all Gary Cooper says in *High Noon.*

The enduring charm of the Westerner derives from this image of male power being raised through repeated incarnations to the status of a folk legend. Like Paul Bunyan or Davy Crockett, he is a man of whom not one takes advantage. As a man of action, he brings the comfort of patriarchy to both men and women, this physically powerful male who from John Wayne to Clint Eastwood does "what he has to do." He is free of greed and materialism. John Wayne lives for years fueled by his cause in *The Searchers* (1956); he burns down his house when he loses the woman he loves in *The Man Who Shot Liberty Valance* (1962) because he knows he has lost everything that matters. If Montgomery Clift drives those cattle to Abilene with such steadfastness and determination in *Red River* (1948), it is not to make money for himself and John Wayne. He wants to pay his men. But more, he is motivated by the concept of progress and the economic fulfillment of the new land to bring food to the people of America then and thereafter.

This attractive, manly figure stands at the center of our most enduring film genre, a form we recognize at once by its icons: the gun and the railroad, which stands for progress, and the coming of civilization, always seen as a mixed blessing; the schoolmarm and the whore, the two poles of female identity the genre has found acceptable; the marauding Indians (sinister without cause); the cattle forever waiting to stampede; the covered wagon; the ramshackle town presided over by jailhouse and saloon; the open land resisting settlement, that pristine landscape of rocks and blue sky, the endless vistas of our manifest destiny; the villain in black wedded to greed and stubbornly inaccessible to reason; and the cowboy and his faithful steed, emblem of the hero's inexhaustible sexuality, who has earned a kiss from Westerners as early as Tom Mix and as recently as Kevin Kline.

Set in the historical past, usually just after the Civil War, the Western is rarely an accurate rendering of America's history. "When the legend becomes fact, print the legend," John Ford quite properly has a reporter instruct in *Liberty Valance*, for the task of the Western is much greater than the telling of somebody's mere "truth.'

The plot of the Western draws not on what actually happened in our history, but on the meaning of what happened. Westerns appeal so much to us also because they are explorations in search of who we are, dramas in which America's soul, the national identity, hangs in the balance. Epic in its scope, the Western is taken seriously because the fate of its protagonists becomes the fate of our nation. In building legends and perpetuating myths, at times the Western seems to ratify a sanitized version of American history. The genre does not often indict the mine owner, the banks, or the railroads nor does it often include the point of view of the Indian nor acknowledge that the small farmer didn't have much of a chance, the Homestead Act of 1862 notwithstanding. But that doesn't matter since we look to the Western not for objective truths, but for our strengths—as a nation and as individuals.

The Westerner embodies the myth that we can perpetually start over in this new land to be shaped by our own measurements. It asserts that we can bury the past, just as the American experiment was a revolt against the antidemocratic institutions of the Old World. In a recent Western like *Silverado*, the heroes are ex-cons. A mysterious past haunts *Shane*, John Wayne in *The Searchers*, and Eastwood in the Spaghetti Westerns. But so long as the frontier remains open, a man, exemplifying selflessness and pride, may create himself anew.

The Western has been so enduring a form in our culture because it offers nothing less than the Platonic ideal of justice. Its hero is a man willing endlessly to risk his life to protect that ideal against the inevitable challenges goodness and righteousness repeatedly face in this world.

The Westerner exists to preserve life, to make real Hobbes's quixotic notion of the social contract, an ideal for which every day on the frontier men fought and died. This was the motive for Robert Altman's McCabe, who dies at the hands of the conglomerate come to deprive the small entrepreneur of his dreams as it was for John Wayne in every one of his major films, as it was for *Shane* and as it was for Gary Cooper in his youth as *The Virginian* (1929) and in his maturity as the marshal in *High Noon*.

The Western opens on the premise that settlement was good. From *The Iron Horse* (1924) and *Cimarron* (1931) to *Red River* (1948), *Shane* (1953), and *Giant* (1956), the genre assumes that it was good to settle America. It has been the duty of the genre to participate in the myth of the free settlement of the West, in the half-truth that free land was there for the claiming. It has chosen to ignore that the railroads already owned much of the land. And the euphoria of *Cimarron* notwithstanding, let alone that Homestead Act, small farming never really had a chance.

But the Western is not about the narrow truths of economics, nor economic progress, nor the practicalities of settlement. With a hero larger than life at its helm, the Western depicts how a man can become his best self, how he can most successfully express his perfect freedom. The answer lies in his commitment to an unending pursuit of justice.

This is why *The Virginian* (1929) is so important a landmark in the genre. For here, to serve justice, the hero must hang his best friend. In the Western the end justifies the means. To preserve the possibility of fair settlement of the West, cattle rustling must be a capital offense. Steve,

although he was enlisted by the far more evil Trampas, must pay and the hero must act as an agent of that retribution.

Yet the Virginian is not tainted for having hanged his best friend. All he need do is succeed in the iconic showdown with Trampas. The schoolmarm from the East, about to become his wife, attempts to dissuade him, but to no avail. Killing Trampas avenges Steve; the community has been preserved, secure in its property, and the hero has been rendered free to marry.

In what is still the most interesting essay written on this genre, "Movie Chronicle: The Westerner" (1954), Robert Warshow says that the Westerner fights for "his honor," which makes him "the last gentleman." But if he were fighting for anything less than justice, if his honor were connected with anything so trivial as a personal sense of self, we would not admire him so much.

The image of the Westerner has been so irresistible because this hero risks his life through violence for the only thing worth fighting for: the survival of the community—the nation—which translates specifically and visually in these films to a small group of individuals braving the unknown. The issue was never the empty freedom of the virgin landscape, although no art form ever found its fulfillment in more perfect an imagery, but in what a good and honest man could do with that freedom.

The Westerner is needed so urgently because the law either does not yet exist or has already been corrupted. Liberty Valance rampages unimpeded until Tom Doniphon (Wayne) simply shoots him down. As in *Silverado*, a reprise of the genre in all its iconic splendor, the lawmen are in the pay of the rich villains who would rather kill anything that moves than yield an acre of the open range to settlement.

Warshow saw moral ambiguity in the image of the Westerner because he was a killer of men, in his violence a mirror image of his adversary. But the experience

of watching most Westerns doesn't bear this out. Shane remains the light (the good, the true) to the dark of Wilson (Jack Palance); Doniphon's violence belongs to a higher order than that of Liberty Valance, as certainly does the reluctant violence of McCabe.

The Western resides within a Manichaean philosophy, absolute distinctions between good and evil, as it does in a dualistic portrayal of women: the schoolteacher from the East represents the necessary incursion of civilization in all its rigidity. The free woman of the frontier is the one who has sacrificed her virtue.

In the classic Western, it was only Howard Hawks in *Red River* who granted this "loose" woman played by Joanne Dru the respect she deserved. In *High Noon* Katy Jurado, the woman who understands the marshal, must give way to the prissy Quaker Grace Kelly, who, if she turns to violence to save her man's life, does so only as a last resort. John Ford dehumanized women, fixing them on a pedestal of insipidity and ignorance. He kills off the woman Wayne loves in *The Searchers* (she was inaccessibly married to his brother anyway), and, to everyone's relief, we see little either of Vera Miles or the kidnapped Natalie Wood. Women are a nuisance whom men risk their lives to protect.

Yet it may be that Ford's view was the appropriate one. Love and sexuality become irrelevant in the corrupt world the Westerner must set right. Implicitly, by illustrating how almost hopeless settlement was, how fraught with danger and barbarism, the Western challenges the myth of the unequivocal rightness and value of the idea of Manifest Destiny. The struggle may have been inevitable, but the price was a high one.

This Hallie (Vera Miles) recognizes at the close of *The Man Who Shot Liberty Valance*. Settlement and progress, epitomized by that railroad, have cost us our real men. The cactus rose she places on Tom Doniphon's coffin with such tenderness suggests her understanding that his style of manhood was infinitely preferable to the pale version, the "real" rose offered by her husband Senator Stoddard (James Stewart), the man who did *not* kill Liberty Valance. Hallie's sadness reappears as the profound loneliness of Mrs. Miller drowning her sorrows in opium, as many frontier women did, after the death of McCabe.

The Western is also America's assertion that the highest value resides in the individual. There is a strong antipopulist strain that runs through this genre in its insistence that the individual is the greatest good. The hero is forced to do "what he has to do" because the group either cannot (*Shane*) or will not (*High Noon*) fight for itself. In the more benign Westerns, the community is simply too weak to defend itself; in the angrier ones, it is too selfish and cowardly to do so.

Ironically, the villains in most of these films are very well organized and function successfully in groups, whether the evil is economically structured in a mining company or a ranch, or resides in a desperate band of outlaws with no social connections. There is usually a strong, smart leader, followers, and a plan. In the Western, the villain is rarely a loner. The Western acknowledges that, given our commitment to laissez-faire economics, the uncontrolled competition for limited resources returns the worst of us to barbarism, Hobbes notwithstanding.

Without self-consciousness the Western suggests that if we are able to survive, it will not be because we will struggle together, but because a leader will guide us, help us, and save us. The Westerner, so strong, sexual, and appealing as a loner, also reflects in his person a profound lack of faith in the community. In a society characterized by an ideology of democracy, its most powerful and characteristic cultural expression, the Western film, has been both elitist and antidemocratic.

There is also a spurious character to that elitism. The Westerner has been a hero we have burdened with extremes of

behavior the community is not willing to assume for itself; it has expected him to take on the role of vigilante, if necessary, to preserve the sanctity of home and hearth and human life, as Eastwood does in *The Outlaw Josey Wales* no less than in the Dirty Harry films. It has been willing for him to behave barbarically only then to demand that he discreetly disappear once the fighting is over.

The best example of this motif can be found in *A Fistful of Dollars* (1964), not surprisingly an adaptation of Akira Kurosawa's *Yojimbo* (1961), since Kurosawa learned about the contract between hero and town from John Ford Westerns. Here evil can be overcome only by the demolition of the entire town of San Miguel, which was never worth saving anyway.

The Eastwood version of the Westerner has replaced that offered by John Wayne as one more suitable to our era. Eastwood allows himself to be enlisted in the eternal battle for justice like other Westerners before him while remaining aware that there are few who have earned the right to be so nurtured and protected by the hero. Told to make himself at home in *A Fistful of Dollars*, he replies that he "never found home that great."

He is all the more noble because, in the image which evolved from the Sergio Leone Westerns, he enters the fray without any illusions whatsoever. "Everybody knows nobody ever stood in the street and let the heavy draw first," Eastwood has said, "It's him or me. To me that's practical, and that's where I disagree with the Wayne concept...I do all the stuff Wayne would never do. I play bigger-than-life characters, but I'll shoot a guy in the back. I go by the expediency of the moment." In his sensibility, as in the grandeur of his physical person, Eastwood becomes what we would like to be, had we the courage to defy the institutions to which we cravenly conform. "The kind of thing I do is to glorify competence," Eastwood has explained.

No Western bears the illusion that the

battle for land and resources would be fair or easy. Mythic, or barbaric, defenders (and here Warshow was prescient) must be enlisted on the community's behalf. There have been "anti-Westerns" like *The Ox-Bow Incident* (1943) and *The Left-Handed Gun* (1958) which have acknowledged this ambiguity and been uneasy before violence. Usually they were allegories about topical issues of the era in which the film was made. *The Ox-Bow Incident*, actually about lynching, is a Western without a hero, while *The Left-Handed Gun* offers William Bonney (Billy the Kid) as a demented psychopath.

The Wild Bunch (1969), an unintentional anti-Western, suggests that the violence of the hero belongs not to his quest for justice, but to his nature as a man. *Little Big Man* (1970) humanized the Indian at last. But these films are finally less interesting and make fewer claims on our loyalty than the classic type. For whatever other themes it undertakes, the Western must record, justify, and make palatable the perpetual American struggle for economic breathing space.

Despite all the myth-making and the heroes larger than life, the Western is always tragic. Battles may be won, but the war is inevitably lost, the hero defeated. Finally, the Western must admit that the Westerner, however attractive and powerful an individual, cannot prevent the spread of the conglomerates to the outposts of the frontier.

McCabe is told he must sell out to Harrison Shaughnessy, "one of the most solid companies in the United States." Monopoly capitalism comes early to the West to squeeze out the supposedly free small entrepreneur who would grow rich from his own sweat and imagination. Mrs. Miller (Julie Christie), more intelligent than McCabe, tells him, "They'll do something awful to you...they'd as soon put a bullet in your back as look at you." But McCabe doesn't want to sell out. He talks to a lawyer, who tells him about the rights of the "little guy" and "the very values on

which our country is built." No matter, the law is nowhere to be found when Harrison Shaughnessy sends its Enforcers to Presbyterian Church, the town McCabe has built.

McCabe puts up a good fight in one of those iconic showdowns which began as early as the Western itself. But not even the Westerner, except perhaps in his incarnation as God paying a visit to earth—*High Plains Drifter* (1973) or *Pale Rider* (1985)—can "bust up trusts and monopolies." In the bleak, snowy wilderness of the Pacific Northwest, the last frontier, there are no lawyers, courts, or newspapers; there are only men with guns.

The tragedy goes still deeper. Even when he brings justice to the frail community, symbolized by those pathetically unattractive, grubby sodbusters of *Shane* (1953), the Westerner is hastening his own obsolescence. The greater the degree of law and order he creates, the more swiftly does the frontier disappear before his very eyes. And with the onrush of civilization comes injustices which he cannot redress.

This, of course, is the characteristic moment of the Western, that transitional time when the old lawless ways have been set at bay and the new civilization of school and church have not yet been fully entrenched. It is the moment at which all great Westerns are set and it is accompanied by an inevitable poignancy. Sometimes the sadness of his demise is addressed by the hero himself. In *Tumbleweeds* (1925) William S. Hart removes his hat in homage to his own end. "Boys," he tells the assembled cowboys, "It's the last of the West."

As the ultimate emblem of his nobility, the Westerner participates in the creation of a society in which he can play no role. Nowhere is this betrayal by history more dramatically rendered than in that image of the plain coffin in which Tom Doniphon has been laid to rest at the end of *The Man Who Shot Liberty Valance*. That cactus rose also represents his innocent bewilderment before this defeat by history. And it stands as well for his natural freedom, that high casualty of civilization and progress.

Such a world where men could be free was, of course, the Garden of Eden fantasy. So it should not be surprising that the Western insists that its passing, lawless anarchy and all, was not a wholly good thing. That we cannot allow it quite to disappear accounts once more for the resilience of the genre. As Claire Trevor and John Wayne (The Ringo Kid, another ex-con) set out for his ranch at the close of *Stagecoach* (1939), Doc (Thomas Mitchell) cannot resist the perfect irony which so epitomizes the tragedy lurking behind the action in all Westerns: "Well, they're saved from the blessings of civilization."
—Joan Mellen

RECOMMENDED BIBLIOGRAPHY

Buscombe, Edward, ed. *The BFI Companion to the Western*. NY: Macmillan Publishing Co., 1988.

Brownlow, Kevin. *The War, the West, and the Wilderness*. NY: Alfred A. Knopf, 1978.

Everson, William K. *A Pictorial History of the Western Film*. NY: Citadel Press, 1969.

Kitses, Jim. *Horizons West*. Bloomington, IN: Indiana University Press, 1969.

Lenihan, John H. *Showdown: Confronting Modern America in the Western Film*. Urbana, IL: University of Illinois Press, 1980.

Sennett, Ted. *Great Hollywood Westerns*. NY: Abrams, 1990.

Thomas, Tony. *The West That Never Was*. NY: Carol Publishing Group, 1989.

Tuska, Jon. *The American West in Film: Critical Approaches to the Western*. Westport, CT: Greenwood Press, 1985.

Medium Cool

Wexler, Haskell

(February 6, 1922 –)

Haskell Wexler has balanced an impressive career as a cinematographer of quality Hollywood features and a producer-director-photographer-writer of politically motivated fiction and documentary films.

His involvement with *The Bus* (1966), *Brazil: A Report on Torture* (1971), *The Trial of the Catonsville Nine* (1972), *Introduction to the Enemy* (1974), *Underground* (1976), and *Target Nicaragua: Inside a Covert War* (1983) displays a clear committment to political activism. Indeed, a healthy number of his mainstream credits explore such socially oriented themes as race relations (*In the Heat of the Night*, 1967); rebellion against institutional dictatorship (*One Flew Over the Cuckoo's Nest*, 1975); the Great Depression depicted through the sensibilities of Woody Guthrie (*Bound for Glory*, 1976); the folly of Vietnam (*Coming Home*, 1978); and union organizing and busting (*Matewan*, 1987).

The most intriguing credits on Wexler's filmography, however, are the two fiction (or, as he might call them, "fusion of fact and fiction") films he scripted and directed: *Medium Cool* (1969) and *Latino* (1985).

The first is a vividly original drama, filmed partially on the streets of Chicago during the 1968 Democratic National Convention. *Medium Cool* pungently mirrors the America of 1968: a nation at odds with itself in one of the most dramatic years of its history. Furthermore, the film serves as a landmark indictment of the role of television and mass media in desensitizing individuals to real feeling and real emotion.

Wexler accomplishes this in the film's opening sequence. A television news cameraman, John Cassellis (Robert Forster), happens upon an automobile accident and an injured—maybe even dying—woman. Every second is precious to her survival. Certainly, the logical (not to mention humane) action would be to seek out immediate assistance. But Cassellis, a true media animal, first films the scene. He shows no feeling, no compassion. He knows that this "hot" footage will play well

on television, and so his immediate instinct is to scoop the competition. He observes and records, rather than becomes involved in the event. This cameraman has become a slave of his technology.

Medium Cool focuses on the consciousness-raising of Cassellis as he commences a relationship with Eileen Horton (Verna Bloom), a welfare mother from Appalachia. Similarly, *Latino* chronicles the consciousness-raising of Eddie Guerrero (Robert Beltran), a Chicano Green Beret, a career soldier "advising" the U.S.-backed Contras in their war against the Sandinistas in Nicaragua. Eddie exists in a military rife with racism and sexism. Anglo soldiers casually utter the word "spic" in Eddie's presence; El Salvador and Nicaragua are referred to as "spic country." Eddie has been programmed to ignore these wisecracks. He is expected to follow orders and fight, not to think.

Like Cassellis, Eddie is blind to the oppression around him, a cog in a system that's insensitive to human needs. And, like Cassellis, he becomes involved with a woman, Marlena (Annette Cardona), a Nicaraguan, who serves as a catalyst in his life. Slowly, Eddie begins to question American foreign policy which dictates U.S. presence in her country. Eddie's relationship is not encouraged by his comrades: in his macho world, women are not the equal of men, and can never be their true companions. Yet, in both *Medium Cool* and *Latino*, the women possess the wisdom and compassion. It is the women who are the mentors of the men.

John Cassellis and Eddie Guerrero may become sensitized, but both their stories end in tragedy. Eddie ultimately cannot act, is unable to transcend his personal history, his thirty-four years as a macho Latino. For this, he is doomed. And, as the violence that was a part of Chicago in 1968 plays itself out, Cassellis's world crumbles before him. His car crashes, the woman he's come to love is dead, and he's seriously injured. A passing motorist stops to photograph the accident, and then drives off.

Wexler's message is like a sock in the gut: open your eyes to the reality of the world around you before it swallows you up.

While *Medium Cool* is unique in its blending of fictional characters within a real, evolving event, *Latino* is ultimately a left-wing soap opera. Some of the dialog between Eddie and Marlena is unbelievable, even laughable. Their words sound like paragraphs read off a page, not conversation between real people. At the finale, Marlena pops up in the village that Eddie and his Contra companions are raiding. Talk about plot contrivances: *Latino* yearns for a leaner, more cohesive, more sensible script. Additionally, Wexler is guilty of reverse-Ramboism: his Sandinistas are, to a person, holier-than-thou workers who happily sing in the fields when not fighting the good fight. At the same time, the Contras all are superficially inhuman, sadists playing out a John Wayne fantasy. They attempt to earn the hearts and minds of the peasants by shooting them in the back, torturing them, throwing them in urine- and feces-filled pits. There's no subtlety, just sensationalism. Wexler preaches to, rather than informs or enlightens, his audience.

Latino is proof positive that good politics do not necessarily make good art. Nevertheless, *Medium Cool* remains one of the outstanding films of its period both in content and execution, with its point of view as relevant today as in 1968. While one can lament that sixteen years passed between these films, which may account for the staleness of *Latino* as a cinematic work, Wexler's life and art may still be celebrated because he has remained steadfastly true to his politics and values.

—Rob Edelman

RECOMMENDED BIBLIOGRAPHY

Zheutlin, Barbara and David Talbot. *Creative Differences: Profiles of Hollywood Dissidents.* Boston, MA: South End Press, 1978.

Wilder, Samuel "Billy"

(June 22, 1906 –)

" I am Scheherazade," Billy Wilder says, defining his own style with typical wit and precision. Survivor, storyteller, trickster, closet romantic, a macho male with a surprisingly androgynous heart—Wilder is one of the most complex, clever, and deceptive of Hollywood auteurs. There is always more going on in his films than at first meets the eye.

Wilder is a passionately political filmmaker but not an ideologue. His films are moral parables, but he disdains didacticism as assiduously as he avoids obvious artiness. A writer-director who excels at transforming ready-made commercial material into metaphorical private statements, he likes to work against the grain of traditional genres. Paradoxically, his comedies are often darker than his tragedies, and his tragedies illuminated by an essential upbeat energy and optimism.

The ur plot of Wilder's films is *Cinderella*, as reshaped by the masquerade traditions of the Viennese carnival (*Fasching*) and the complex disguise plots of Von Hofmannstahl and Molnar, among others. Like Molnar (*The Guardsman*), Wilder uses role-playing to explore the relationship between behavior and emotional knowledge and to argue for a larger and more flexible definition of personality.

In Wilder's films there is always a crucial connection between the art of acting and the art of living. Trying on a new set of clothes often involves trying out a new set of feelings as well—as Jerry/Daphne discovers in *Some Like It Hot* (1959). Over and over again, Wilder's characters are able to move toward a richer emotional life by first acting out that life in cynical pretense. Thus Georges Iscovescu in *Hold Back the Dawn* (1941), who at first only pretends to love Emmy Brown in order to get an entry visa to the U.S., ends up by

falling in love with her for real. Hard-boiled Chuck Tatum finds himself weeping and bleeding for poor, sweet Leo Minosa, whom he initially sets out to exploit. Even steely Phyllis Dietrichson goes through a sudden Damascus conversion, just before Walter Neff shoots her to death in *Double Indemnity* (1944). Wilder's cynics are often really not cynics at all but apprentice lovers who have to practice an emotion before they can feel it.

Wilder's scenarios are dialectics of innocence and experience which begin by pairing off opposite human types—a Saint and a Shit, a Virgin and a Whore. Masquerade then bridges the dichotomy, moving antithetical characters toward each other onto common ground. Through role-playing and disguise, the excessively innocent learn how to protect themselves and the excessively protected learn how to let go and enjoy their vulnerability. Whether the story ends in a love match or in a gunshot, the essence of Wilder's narrative style is movement, transformation—the *Cinderella* story.

Wilder restores the crude vitality and anger which Disney bowdlerized from *Cinderella*, originally a peasant story of revenge and underdog one-upsmanship. In Wilder's version, the passive victim and the transforming Fairy Godmother are often recombined into a single powerful Trickster. Wilder's Cinderellas are survivors on the make—gigolos, con artists,

filmmakers down on their luck. They cannot afford to be sentimental about poverty. They are often forced to lie or manipulate their identities simply in order to survive—Susan Applegate in *The Major and the Minor* (1942) or Jerry and Joe in *Some Like It Hot*.

Wilder's identification with the Trickster is, in part, an expression of his heritage as a European Jew. Although he tends to side with the proletarian underdogs against the plutocrats and aristocrats, he offers no brief for social revolution—or even social reform. (Frank Capra's wonderful little populist towns are nowhere on Wilder's map.) Wilder's politics are descriptive rather than prescriptive. He understands the pathology of power, especially the stylistic connnection between Puritanical repression and dictatorial oppression, that is, between a desire for excessive self-control and a need to control others. But his stories also tend to suggest that you can't beat them without joining them. That moral is illustrated very directly in *The Apartment* (1959) in which C. C. Bud Baxter at first tries to make himself into a carbon copy of J. D. Sheldrake, the Nazi-in-a-gray-flannel-suit who runs the ruthlessly impersonal insurance firm for which Bud works. In the end, Bud stands up to Sheldrake—but not to lead a revolt. He tunes into love and drops out of the rat race altogether.

Like Bud, Wilder's protagonists usually transcend their class rather than represent it. They do not change the world; they change themselves. In the end, the bravest of them achieve a kind of separate peace which allows them to cope more sanely and joyously with a hypocritical and essentially crazy society. For Wilder and for his characters, living well is the best revenge.

Wilder is regarded as a cynic primarily because he is openly intolerant of sentimental American Puritanism and refuses to be solemn about virginity ("I don't mind being called vulgar. It just means I'm on the side of life"). Wilder is a romantic, not in the Harlequin tradition but in the Lawrencian tradition. For Wilder, sexual passion is one of the few sacral experiences in a profane world, and thus the American cult of innocence is not only silly but genuinely obscene.

Wilder's films contain much more emotion than at first meets the eye, but the emotion is often bizarrely displaced. Big feelings are rarely contained in big speeches but, rather, in small, silent subtexts conveyed by gestures and fetishized props. This semiotic gamesmanship is especially apparent when Wilder approaches material that is emotionally loaded for him—the Holocaust, for instance. At first glance, he seems to be a completely secular filmmaker whose painful personal experience as a Jew (his mother was murdered in Auschwitz) is mysteriously absent from his art. But it is not absent; it is merely disguised—well-hidden by being hidden in plain sight.

In a typically reticent way, all of Wilder's films of the late Thirties through the early Fifties display a ritual religious subtext. The fedoras which Wilder's males, like Wilder himself, habitually wear indoors, are yarmulkes in disguise; Walter Neff's confession into the hollow horn of his dictaphone announces the High Holy Days (*Double Indemnity*); Rommel's dinner table question and answer game and the spilled salt on the map of Egypt perversely commemorate the Passover Seder in *Five Graves to Cairo*; *Lost Weekend* is built around a masochistic joke whose punchline is: Yom Kippur. This sequence culminates in *Ace in the Hole*, in which Wilder manipulates the imagery of the Christian passion play in order to act out a private crucifixion—with real nails.

Wilder's greatest strength as a director, his ability to engineer the structure of his films both above and below the waterline, is also his greatest weakness. In *The Emperor Waltz* (1948), for example, the tension between Paramount's polite public intentions and Wilder's private angst show too clearly. The result is an odd, almost surreal film—the real "Springtime for

Hitler." Wilder's 1964 farce *Kiss Me, Stupid* was a more definitive disaster. The film's complex double entendres ultimately work to celebrate the joys of married love, but the Legion of Decency, and most viewers, found it merely obscene—a failure which limited Wilder's ability to raise money for future independent productions and prematurely truncated his career.

In the end, Wilder was probably a little too clever for his own good—and, paradoxically, too cautious. Because he needed to make movies the way Don Birnam needed his next drink, the threat of being cut off from his supply of celluloid shaped many of the important esthetic choices he made in his career. Most of his best work is based on original material, but, especially after the commercial failure of *Ace*, he apparently felt safer when he adapted other people's texts to new purposes. He was haunted by the fate of Von Stroheim, haunted by the fear that one day the corporate money men would take his camera away. Ultimately, that fear became a kind of self-fulfilling prophecy.

With typical survivor's wit, Wilder turned even this final failure into art. His last great film, *Fedora* (1979), is another Cinderella story, but this time the game goes awry, trapping the tricksters forever behind their masks. One of the most poignant moments in the film comes when Antonia, disguised as her star-mother Fedora, pleads desperately with Theo,who supplies her with the drugs to which she is addicted. He offers them to her, but she has no cash, so he snatches them back—hidden inside three boxes of Kodak film.—Nancy Steffen-Fluhr

RECOMMENDED BIBLIOGRAPHY

Dick, Bernard F. *Billy Wilder*. Boston, MA: Twayne Publishers, 1980.

Madsen, Axel. *Billy Wilder*. Bloomington, IN: Indiana University Press, 1969.

Poague, Leland. *The Hollywood Professionals, Vol. 7: Billy Wilder and Leo McCarey*. NJ: A. S. Barnes and Co., 1979.

Seidman, Steve. *The Film Career of Billy Wilder*. Boston, MA: G. K. Hall, 1977.

Sinyard, Neil and Adrian Turner. *Journey Down Sunset Boulevard: The Films of Billy Wilder*. Ryde, England: BCW Publishing, 1979.

Zolotow, Maurice. *Billy Wilder in Hollywood*. NY: G. P. Putnam's Sons, 1977.

Wilson, Michael

(July 1, 1914 – April 9, 1978)

Word for word, Michael Wilson may well have been the most successful screenwriter in Hollywood history. He received credit for fourteen films between 1941 and 1969. Five consecutive studio movies he wrote or cowrote, between 1951 and 1962, received major screenwriting nominations or awards.

A Place in the Sun (1951) won Academy and Screen Writers Guild awards; *Five Fingers* (1952) won Academy and Guild nominations and a Mystery Writers of America award; *Friendly Persuasion* (1956) won an Academy nomination and a Guild award; *The Bridge on the River Kwai* (1957) won an Academy award; and

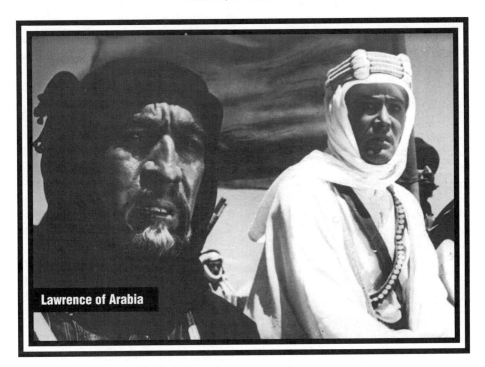

Lawrence of Arabia

Lawrence of Arabia (1962) won an Academy nomination and a Royal British Writers Guild plaque. Five of the films he has written—*A Place, Kwai, Lawrence, The Sandpiper* (1965), and *Planet of the Apes* (1968)—ranked in the top ten grossing films of their release year.

Yet it is for the movie that has never received formal distribution in the United States, nor recovered its costs, that Wilson will best be remembered. *Salt of the Earth* (1954) remains the one film made by Hollywood artists that realistically depicts the nature of class and sexual struggle in American society: Chicano mine workers against bosses and police; Chicano women against the paternalism of their husbands. In his studio work, Wilson, a dedicated Marxist, never tried to do more than treat his assigned topics honestly and humanly, knowing that to attempt more could lead to termination. *Salt*, on the other hand, a movie made by artists blacklisted from the studios, was, in Wilson's words, "obviously tendentious, was designed to be, is very class conscious, and makes no attempt to disguise its Marxist point of view."

Wilson was born in McAlester, Oklahoma. He was a "dedicated, zealous young Catholic" and an avid reader. He attended the University of California, majored in philosophy, began to write, and very slowly became radicalized. He joined the tiny, virtually inactive campus Communist Party branch in the spring of 1937, and then left for Europe to make himself into a professional writer; he was, during that year, "still a very immature, hopelessly romantic young man," tempted by the Spanish Civil War.

He returned to Berkeley a "dedicated Marxist-Leninist," and instead of pursuing his graduate work, threw himself into CP organizing and educational activity. Soon after he began a series of short stories on minority workers, his brother-in-law, Paul Jarrico, encouraged Wilson to try screen-writing. "My reactions were those of a literary snob," Wilson remembered. "I looked down my nose at movies even though I liked going to them." When Jarrico pointed out that Hollywood paid the kind of money that supported "real" writing, Wilson made the move, arriving in

June 1940.

He earned five unremarkable credits, including three Hopalong Cassidy movies, before enlisting in the Marines in 1941. He fought in the Pacific, and earned captain's bars, but his writing production was minimal and he could not, then or later, resolve his "role as an artist in the [communist] movement."

Back in Hollywood, at war's end, Wilson wrote for Liberty Films and supported a militant brand of communism. He wondered why it took the House Committee on Un-American Activities so long to get him, but, on September 20, 1951, he appeared, cited his First and Fifth Amendment privileges, and joined the blacklist. He scraped together a meager living cowriting black market scripts with Dalton Trumbo, at $3,000 per job.

The feeling of political isolation and ineffectiveness was harder to bear than the economic limitation. To break through the cultural barrier erected by the witch hunters, Wilson and several other blacklistees produced *Hollywood Quarterly*, a periodical devoted to Marxist critiques of movies and television. The circulation was tiny, but the effort was important for its writers and editors. The articles were qualitatively far superior to the usual communist criticism. Wilson wrote three brilliant articles: "Conditioning the American Mind: War Films Show Vicious Over-All Policy"; "Hollywood's Hero: Arrogant Adventurers Dominate Screen—Goodbye Mr. Deeds"; and "Hollywood on the Brink of Peace: New Trends Visible—If You Squint."

It was, however, his script for *Salt of the Earth* that represented Wilson's major challenge to the blacklist era. In a nontalky, nonpreachy manner, nicely balancing simple but eloquent narrative with realistic dialog and artfully composed group shots, Wilson depicted the awakening and unfolding of women's consciousness within the context of a labor strike. The script is not innovative or radical in structural terms, but Wilson executes his themes in such corruscatingly clear manner that the shortcomings of the finished film are less obvious.

In 1956, Wilson left the Communist Party and moved his family to Europe, where they lived for eight years. While there, he cowrote *Bridge* and *Lawrence*, but his name did not appear on screen again until 1965. Between then and his death, on April 9, 1978, Wilson wrote many scripts, but only three were produced: *The Sandpiper* (1965), *Planet of the Apes* (1968), and *Che!* (1969). He felt "completely ashamed and humiliated" by the filmed version of his script for *Che!*, remarking that he "should have known better than just to think that one could do an honest picture about Guevara in a stronghold like Twentieth Century-Fox." At the time of his death, he was working with Marlon Brando on a television history of Native Americans.

Michael Wilson was a literate and witty writer. No particular theme or style links together his output, but there is a leitmotif in his Hollywood work: five of his films (and all his *Hollywood Quarterly* articles) concern war. *Friendly Persuasion*, *Bridge*, and *Planet* are critical of militarism, while *Lawrence* and *Che!* treat wars of liberation in favorable terms.

The militant in Michael Wilson never died. In 1976, he told the Writers Guild, when it voted him its Laurel Award for Screen Writing Achievement: "I foresee a day coming in your lifetime, if not in mine, when a new crisis of belief will grip this republic...If this gloomy scenario should come to pass, I trust that you younger men and women will shelter the mavericks and dissenters in your ranks and protect their right to work."—Larry Ceplair

RECOMMENDED BIBLIOGRAPHY

Biberman, Herbert. *Salt of the Earth: The Story of a Film*. Boston, MA: Beacon Press, 1965.

Corliss, Richard, ed. *The Hollywood Screen-Writers*. NY: Avon, 1972.

Wilson, Michael. *Salt of the Earth*. Old Westbury, NY: The Feminist Press, 1978.

Terms of Endearment

The Women's Film

Atearful Irene Dunne bathed in half-light, eternally wait-
ing for her married lover in *Back Street* (1932)… Stoic
Claudette Colbert and daughters Jennifer Jones and
Shirley Temple facing bad news amid a bustling
wartime train station in *Since You Went Away* (1944)…

Terrified Ingrid Bergman menaced by
suave Charles Boyer in the claustrophobic
Victoriana of *Gaslight* (1944)… Coura-
geous Jane Fonda gazing lovingly at
Vanessa Redgrave in *Julia* (1977)…
Determined Sally Field harvesting cotton
with bleeding hands in *Places in the Heart*
(1984)… Joyous Whoopi Goldberg reunit-
ed with her long-lost sister in an idyllic
field of flowers in *The Color Purple*
(1985)… Crusading Sigourney Weaver
obsessively protecting her beloved moun-
tain gorillas amid the breathtaking natural
beauty of *Gorillas in the Mist* (1988).

These memorable stars and images are
the essence of the "Women's Film." A sta-

ple of the Hollywood studios from the
Thirties to the early Fifties, films within
this genre ranged from critically acclaimed
classics to their D-grade clones. World
War II and the rise of Rosie the Riveter
stimulated the full flowering of the
women's film. With the demise of Rosie
and the emergence of the feminine mys-
tique and the television age, the genre
declined. A trickle of women's films, how-
ever, were produced in the Fifties and
Sixties. With the rebirth of feminism, the
spirit of the genre has now reemerged
since the mid-Seventies in the United
States and Europe in a small but significant
number of woman-oriented films focusing

on issues such as motherhood, career, female bonding, divorce, and sexual violence. And the classic women's films—which immortalized stars like Bette Davis, Katharine Hepburn, and Joan Crawford—endure in revival houses, in college film courses, and on cable and network television, as well as home video.

No one really knows whether the term "women's film" (aka "woman's film," "women's movie," "women's picture") originated from studio publicity departments, critics, or fans. Whatever its roots, however, "women's film" characterizes a classic Hollywood genre produced primarily for female audiences and expressing a wide range of popular character types, psychological motifs, and narrative structures.

In the studio era, women directors and producers like Dorothy Arzner—*Christopher Strong* (1933), *Craig's Wife* (1936), *Dance, Girl, Dance* (1940)—and Ida Lupino—*Not Wanted* (1949), *Outrage* (1950), *The Bigamist* (1953)—were few and far between. Hence, most classic women's films were produced and directed by men such as George Cukor, Mitchell Leisen, and Douglas Sirk. Many of these films, however, reveal the feminine influence of stars, screenwriters, editors, art and set directors, and fashion designers. Many screenplays authored by men were adapted from popular fiction written by and for a female readership. The literary roots of the women's film can be traced to nineteenth- and twentieth-century American and British sentimental and Gothic fiction. Separation and loss, dependence and independence, victimization and vengeance—these were themes long popular with women (particularly middle-class women) across the life cycle. Silent features such as *Way Down East* (1920) and *Sunrise* (1927) sensitively dramatized the trials and tribulations of female characters. Radio soap operas promised the possibility of an endless "woman's narrative," importing convoluted tales of suffering and sacrifice into the kitchens, parlors, and bedrooms of homemakers, factory workers, secretaries,

and executives across America. It required the marriage of sound and image, however, and its unique power to capture the rich texture of the interpersonal world, to create the women's film. The maternal martyrdom of tragicomic Stella Dallas, first loved by female readers in Olive Higgins Prouty's novel, then enjoyed in Henry King's 1925 silent film (and later as a radio soap) reached its dramatic culmination in King Vidor's 1937 classic sound film. The narrative conventions of the women's film framed and interpreted the conflicts and contradictions at the heart of the American female experience in the twentieth century.

First of all, women's films focus on women—and their emotional concerns—in a culture that clearly does not. Titles often highlight the names of heroines: *Kitty Foyle* (1940); *Mrs. Miniver* (1942); *Jane Eyre* (1944); *Mildred Pierce* (1945); *Rachel, Rachel* (1967); *Alice Doesn't Live Here Anymore* (1975); *Norma Rae* (1979); *Mrs. Soffel* (1984); *Yentl* (1984); *Clara's Heart* (1988). Or they refer explicitly to the female sex or the maternal role: *Marked Woman* (1937); *Woman of the Year* (1942); *Adam's Rib* (1949); *An Unmarried Woman* (1978); *The Good Mother* (1988).

Second, and quintessentially, women's films often dramatize a crisis or moral dilemma facing the heroine(s). As Molly Haskell notes in *From Reverence to Rape: The Treatment of Women in the Movies* (1987), these crises involve a complex interplay of traditional and modern life options. Rarely simple, never abstract, these conflicts are riddled by ambivalence and loss. The women's film heroine typically finds herself:

• Sacrificing her own security for the right cause—personal, political, or religious: Bette Davis, as antifascist Sara Muller, bravely faces her husband's probable execution by Nazis in *Watch on the Rhine* (1943): "It doesn't pay in money to fight for what we believe in."

• Opting for illicit love over respectable marriage: Irene Dunne, as mistress Ray Schmidt, gives up an executive job and a

marriage proposal in *Back Street* (1932) to try to become "the one woman in a million who's found happiness on the back streets of any man's life."

• Surrendering her out-of-wedlock child for adoption by a conventional family for its "own good": Olivia de Havilland as Josephine Norris, a single businesswoman whose son knows her only as "Aunt Jody" in *To Each His Own* (1946): "Thursdays and every other Sunday—those were the days I lived for."

• Choosing her own fulfillment over her duty to a controlling parent: Bette Davis as wealthy, middle-aged Bostonian Charlotte Vale experiences a psychological rebirth in *Now, Voyager* (1942): "Sometimes tyranny masquerades as mother love."

• Ending a love relationship for her career: June Allyson as headstrong Joe March asserts to Laurie (Peter Lawford) in *Little Women* (1949): "I loathe elegant society and you hate my scribbling, but I can't get on without it."

• Opting for housewifery over career: Katharine Hepburn as superwoman reporter Tess Harding embraces a born-again domesticity in *Woman of the Year* (1942) after spouse Sam Craig (Spencer Tracy) rages: "The 'woman of the year' is no woman at all!"

• Reevaluating in mid-life the choices made in youth: Shirley MacLaine as Dee Dee, ex-dancer turned mother and dance teacher asks old friend (Anne Bancroft), world-famous (and still single) ballerina in *The Turning Point* (1977): "Tell me, Emma, what's it like to be you now?"

• Facing death with dignity rather than despair: Bette Davis as dying young socialite Judy Traherne in *Dark Victory* (1939): "I've died a thousand times. When death really comes, it will come as an old friend, gently and quickly."

• Leaving an abusive husband to pursue her own dreams: Whoopi Goldberg as Celie, an impoverished, black Southern woman, in *The Color Purple* (1985), angrily retorts to Mister (Danny Glover), as she departs: "I'm poor, black...I may even be ugly. But, dear God, I'm here...I'm here!"

The majority of these films cannot be termed feminist. But the genre embodies a key feminist assumption: that women can and should make choices about their lives. Although conservative endings defuse the independence of many a women's film heroine, these characters are far from mere objects or prisoners within a male symbolic order, as some psychoanalytically oriented feminist critics suggest. The fact that these heroines are typically depicted as active subjects may be as important as the content of their life choices. Furthermore, many of the classic compromise endings such as that of *Woman of the Year*—girl meets boy, girl loses boy, girl reunites with boy, girl abandons career—are often "tacked on" by directors, simple unconvincing resolutions to complex dilemmas.

As a genre, women's films differ thematically from male-oriented cinema such as Westerns, war and crime dramas, reflecting a cultural gender gap. Classic Westerns, for example, often dramatize a fear of intimacy (especially with women) and an obsession with individuality, duty, and male bonding. "A man's gotta do what a man's gotta do" is the stock message often delivered to a sorrowful woman (and children) by a lone cowboy galloping off into the dust. In contrast, women's films emphasize emotion and interpersonal attachment, often expressing a dread of separation from loved ones, whether female kin, friends, spouses, or children. Usually set indoors, women's films are dialog rich and rarely violent. Masculine dramas, often shot outdoors, are marked by sparse dialog, repressed feelings, and a surplus of action (often violent).

Female- and male-oriented cinema also contrast in their presentation of moral dilemmas. For heroes of the classic Western, justice is an abstract ideal, necessitating the suppression of emotion. On the other hand, for women's film heroines, justice is a relational ideal whose complexity

reveals itself in conflicting strong interpersonal bonds. The moral discourse of the classic women's films produced during the studio era foreshadows the analysis of contemporary psychologist Carol Gilligan in *A Different Voice* (1982):

> This (feminine) conception of morality...centers moral development around the understanding of responsibility and relationships just as the conception of morality as fairness (masculine) ties moral development to the understanding of rights and rules. (p. 19)

Narrative pleasure, for this genre's primary audience, derives from a vicarious female bonding, the identification of women in the audience with their counterparts on the screen. Although the female audience is divided by class, age, race, and sexual preference, as well as other social and psychological factors, the themes of women's films connect with a broad range of feminine experience, and offer multiple and complex points of identification. While dominant Hollywood codes may seek to privilege specific definitions of womanhood over others, audience research indicates that diverse women utilize women's film conventions in ways that speak to their own experience.

Although women's films differ in theme, as well as in visual and narrative style, they share a mood of intimacy and interiority. Women's films can be characterized as films about faces. The extensive use of close-ups (often extreme close-ups) establishes a sense of intimacy and identification with each major female character. In addition, the camera often frames the feminine world in the collective intimacy of the medium shot: sisters, mothers, daughters, and friends gazing into each others' eyes, arms linked, and hands clasped. Women's films can also be described as films about houses. The dominance of domestic sets, classically rambling Victorian homes with elegantly sweeping staircases, chintz curtains, and plushly upholstered furniture, signifies the middle-class familiar essence of the genre. Offices often possess a domestic flavor as well, women's desks

proudly displaying photos and knickknacks similar to those that might adorn the mantelpiece at home. Women's films are also films about voices, female narrative voices whose sisterly and maternal tones invite identification with the protagonist and guide viewers through the maze of flashbacks and flashforwards punctuating many of these films.

The women's film is a genre whose shifting boundaries are difficult to draw. Movies that look, sound, and feel as different from one another as *Little Women*, *Mildred Pierce*, *The Snake Pit*, *Adam's Rib*, *All That Heaven Allows*, *Girlfriends*, *Yentl*, *The Color Purple*, *Desperately Seeking Susan*, and *Gorillas in the Mist* might all be considered women's films. Many movies that appeal to a wider audience, such as John Ford's classic Depression chronicle of the Joad clan, *The Grapes of Wrath* (1940), Woody Allen's seriocomic fable of Manhattan sophisticates *Hannah and Her Sisters* (1986), and Costa-Gavras's cautionary tale of right-wing extremism, *Betrayed* (1988), incorporate elements of the women's film genre. Unlike other Hollywood genres (horror, science fiction, Westerns, crime, comedy) which are delineated by theme, setting, and/or mood, the women's film has adopted its identity from its primary audience. Market research from the studio era shows that many of its fans tend to identify their favorite features differently than film critics and scholars, not by genre or by director but by star(s), a Joan Crawford, Bette Davis, or Katharine Hepburn movie, rather than a George Cukor, Mitchell Leisen, or Irving Rapper film.

THE INFLUENCE OF THE PRODUCTION CODE

Women's films come in a variety of narrative shapes, sizes, and forms. Romantic and maternal melodramas have historically dominated the genre, with "career girl" features, *film noir*-inspired Gothics, "female buddy films," and social problem dramas providing a critical edge of contrast. For all

women's films produced during Hollywood's Golden Age (approximately 1930–'50), however, no influence proved so powerful as that of the Production Code whose taboos shaped the countours of American cinema from the mid-Thirties to the early Sixties.

In the early Thirties, the advent of the sound era, women's films such as Dorothy Arzner's *Christopher Strong* (1933) and Ernst Lubitsch's *Design for Living* (1932) openly dramatized controversial themes such as romantic triangles, unwed pregnancy, and nonmarital sex. This era was short-lived, however. Pressured by a national movement for censorship and fearful for its continued existence, Hollywood adopted the Production Code in 1934.

The Code established rigid guidelines for the filmic portrayal of sexuality ("Excessive and lustful kissing, lustful embraces, suggestive postures and gestures are not to be shown"). Separate beds for spouses and very pregnant women with twenty-four-inch waists became the order of the day. Unconventional behavior, such as extramarital relationships, could be portrayed but only in the most moralistic manner. Homosexuality was virtually banned from the screen.

For women's films, however, Code restrictions proved contradictory. While the Code distorted and repressed female sexuality on screen, it also opened space for the portrayal of more independent, assertive, and career-oriented heroines. The screwball comedy owes some of the vitality of its pent-up sexual energy to the Production Code. Also, the Code, like many systems of censorship, was not an impermeable barrier. Rather, it functioned more like a fence which producers, directors, screenwriters, cinematographers, and stars slipped under, over, and around. American movies of the Thirties, Forties, and Fifties spoke a double language as ambiguous dialog, suggestive gestures, and dances evolved to subvert the Code. The fantastic plot conventions of Gothics such as *Dragonwyck* (1945) and the narra-

tive excesses of melodramas like the ever-popular *Madame X* (1937; 1965) may also be seen as creative adaptations to Code commandments. Directors like Douglas Sirk often parodied the Code by treating controversial issues as they pleased and then attaching a didactic conclusion to placate censors (as in *Imitation of Life*, 1959), encouraging audiences to find these endings contrived and ridiculous.

ROMANTIC AND MATERNAL MELODRAMAS

For many critics, scholars, and fans alike, "women's film" is synonymous with the romantic or maternal melodramas. Star-crossed love, mysterious and unrequited passion, lifelong obsession—such are the emotional hallmarks of classic romantic melodramas like *Wuthering Heights* (1939), *Letter from an Unknown Woman* (1948), *The Story of Adele H.* (1977), and *Mrs. Soffel* (1984). These films indulge the madness, ecstasy, and despair of total romantic engulfment. Often historical and exotic settings provide ideal backdrops for compelling tales of women consumed by their own passions. Palatial mansions, windswept moors at dusk, and dimly lit Victorian garrets are particularly evocative environments for these fantasies. Extreme close-ups, voice-over narration, and emotionally overwrought musical scores (by such masters of melodramas as Alfred Newman, Max Steiner, and Franz Waxman) envelop viewers within a tortured intimacy with heroines whose unfulfilled longings and solitude comprise their universe.

For millions of female fans, the haunting and ethereal Catherine Earnshaw (Merle Oberon) in Wiliam Wyler's *Wuthering Heights* was the melodramatic heroine par excellence since her impossible passion for Heathcliff knew not even the limits of the grave. In Max Ophuls's *Letter from an Unknown Woman*, the pallidly lovely Lisa (Joan Fontaine) is obsessed by Stefan (Louis Jourdan), a musical Don Juan with whom she had a brief affair

which produced a son (unknown to Jourdan). Ten years later, she is devastated to learn that the man whose image is burned into her memory has no recollection of her. François Truffaut's *The Story of Adele H.* vividly chronicles the lifelong obsession of Adele (Isabelle Adjani), Victor Hugo's daughter, with Lt. Pinson (Bruce Robinson), a young military officer whom she briefly dated. While Adele relentlessly pursues the lieutenant across the globe, he remains steadfastly indifferent. Since Pinson seems an eminently forgettable character, one senses that Adele is obsessed with either a projection of her own desire or the need to avenge his disinterest in her. No amount of rejection deters Adele, as she sacrifices her youth and musical talents to the pursuit of Pinson, first following him to Canada, and finally to Barbados. Adjani's distraught beauty embodies the tragedy of unrequited passion, as she grows older, shabbier, and crazier, in the never-ending quest for the elusive lieutenant.

In Gillian Armstrong's *Mrs. Soffel*, an affair with a prisoner (Mel Gibson) promises to release a frustrated warden's wife (Diane Keaton) from a future of marital boredom and meaningless charity work. The somber blue tones of turn-of-the-century Pittsburgh provide the perfect contrast to the fiery intensity of Kate Soffel's emotions. As the proper Victorian wife and mother, Kate distributes Bibles to the prisoners, presenting a reserved image, her girlishness and crown of curls suggesting her vulnerability and sensuality. After she falls in love with prisoner Ed Biddell, and aids his escape, her face takes on a postcoital kind of glow, her flowing tresses symbolizing freedom from her priggish husband and the "lady bountiful" trap.

These heroines are all in their twenties and thirties, yet they seem eternal adolescents, swept up forever in an emotional maelstrom. Lisa first meets Stefan as a teenager, and Kate Soffell mourns the loss of her own youth to the duties of wifehood and maternity. Furthermore, these women are radically alone, having cut themselves loose from the moorings of family, friends, work, or community that might restrain the intensity of their doomed passions. And, predictably, their desire never dies, but they usually do, either literally or figuratively. Catherine Earnshaw's finest moment of grand passion occurs on her deathbed, Lisa melodramatically expires at the end of *Letter...*, and Adele H. persists in fantasizing about the infamous Pinson for forty years in an asylum until she dies at eighty-five. Kate Soffel's lover is killed, and she spends the rest of her days in prison, reading and rereading his love poetry, watching other women distribute Bibles and blankets to the incarcerated.

It is easy to dismiss romantic melodramas like these as unadulterated masochism, the warped dreams created by male-dominated studios for female audiences. Clearly this interpretation may be somewhat true. These classic plots simply don't work as well when the heroine has a stronger sense of self or a career or cause to which she is committed. (Imagine a remake of *Letter...* with Sigourney Weaver as a love-obsessed neurosurgeon!) Female audiences cast the final vote at the box office, however, and it may not solely be masochism that draws women to this theme. Heroines like Lisa, Adele, and Kate are paradoxically conformists and rebels at the same time. Existing in a surreal world of impossibly heightened emotions, they at once control and are controlled by their feelings. (The fact that *Mrs. Soffel* and *The Story of Adele H.* are based on real-life women adds to their fascination for audiences.) Refusing to settle for respectability or cynicism, they passionately embrace the ideal of romantic love—no dirty diapers, clogged sinks, or nagging husbands for these heroines. Because their love is either doomed (as in *Mrs. Soffel*) or unrequited (as in *Letter...* and *The Story of Adele H.*), they are radical risk-takers, opting to struggle endlessly for their cause despite insurmountable odds. Pauline Kael, in *When the Lights Go Down* (1980), interprets the

obsession of Adele Hugo as a "feminine revolt" against conventional marriage and family life, pushing the cult of romance to its limit and beyond. Heroically mad, these heroines live for the intensity of their own emotions, hence commanding our attention and negating their own invisibility. In the unrequited love films, the inevitable male forgetfulness, betrayal or absence is the ultimate metaphor for a heterosexual politics of love in which overcommitted women and undercommitted men daily play out these same themes on a more mundane, but equally painful plane. For gay male audiences, the surplus emotionality of these films may symbolize a life "on the edge," redefining the cultural boundaries of masculinity. Al LaValley suggests in "A Gay Take on Straight Movies" (*American Film*, Spring 1985) that urban gay men, lacking more sensitive media images of either their own sex or sexual preference, sought models within the emotionally overwrought performances of melodrama actresses. The history of camp and the history of the romantic melodrama are intricately interwoven.

Other women's films utilized conventions of the romantic melodrama to challenge the sexual double standard or probe social issues. In Curtis Bernhardt's *My Reputation* (1946), headstrong widow Jessica Drummond (Barbara Stanwyck) insists on her right to love again despite the protestations of her grown children and her mother. Likewise, suburban widow Carrie (Jane Wyman) in Douglas Sirk's *All That Heaven Allows* falls passionately in love with a much younger man, "free-thinking" gardener Rock Hudson, much to the dismay of her bridge-set friends and Freudian social worker daughter. In Elia Kazan's *Pinky* (1949), the "doomed love" theme dramatizes the tensions in postwar race relations. In the title role, Jeanne Crain is cast unconvincingly in that inimitable Forties stereotype, the "tragic mulatto," who chooses to commit herself to building a nursing school for young black women rather than risk what seemed the

impossible: an interracial marriage.

While few classic romantic melodramas have been produced in the Seventies and Eighties, threads of the subgenre continue to weave themselves through films as diverse as *An Unmarried Woman*, *Sophie's Choice* (1982), and *Black Widow* (1987). And, doubtless, we haven't seen the last remake of *Wuthering Heights*.

THE MATERNAL MELODRAMA

At the movies, 1984 was the year of the rural heroine. In films like *Country, The River*, and *Places in the Heart*, resilient farm women struggled against the cruelty of nature and the impersonality of bureaucracies to maintain their farms and families. What critics often overlooked in praising the performances of actresses like Jessica Lange, Sissy Spacek, and Sally Field, is their historic debt to their cinematic foremothers: the maternal heroines of Thirties and Forties women's films. Traditional, strong, resourceful, these women serve as the emotional bedrock for families, communities, and societies in crisis. Ma Joad (Jane Darwell), with her plump, lined face and iron-gray hair challenged dominant Hollywood codes of beauty and set the tone for these movie matriarchs in the concluding monolog of *The Grapes of Wrath*:

> Man, he lives in jerks. Baby born and a man dies and that's a jerk. Gets a farm and loses a farm, and that's a jerk. Woman, it's all one flow, like a stream, little eddies, little waterfalls, but the river it goes right on.

Flourishing during World War II, many of these films were "coming-of-age" chronicles in which home front became battlefront and wives and mothers rose to the challenge of war. Rosie the Riveter and her homemaker sisters flocked in ever-increasing numbers to watch Greer Garson in *Mrs. Miniver* disarm a young Nazi in her kitchen or Bette Davis confront a fascist "friend of the family" in her mother's lavish drawing room in *Watch on the Rhine*. Assertive and courageous, these heroines challenged the boundaries of traditionalism. Often unsung for their efforts in

defense, women viewers were at least able to celebrate their own achievements by identifying with the bravery of housewife-turned-welder Ann Hilton (Claudette Colbert) in *Since You Went Away*, or the courageous group of war nurses in *So Proudly We Hail* (1944). For American women adopting new (and often confusing) roles in wartime, these films may also have provided asurance that a gain in social power need not spell a loss of femininity. Hollywood, buffeted by the winds of both conservatism and change, crystallized those tensions within the narratives of women's films.

As the female experience evolved in wartime, however, so did the maternal drama. Several popular mid- to late-Forties films with a historical setting depicted a traditional mother as the muse for a career-oriented daughter. In turn-of-the-century San Francisco, Katrin Hansen (Barbara Bel Geddes) gains confidence as a writer through the inspiration and counsel of her mother Marta (Irene Dunne) in *I Remember Mama* (1948). Marmee (Mary Astor) in *Little Women*, set during the Civil War, suppresses her anxiety to provide unconditional love and support for the authorial explorations of iron-willed daughter Jo March (June Allyson). In this cycle of films, assertion for others transforms itself in the next generation into assertion for self; the private commitment to family evolves into a public commitment to work. The "feminism" of these films is a gentle one, however, and does not demand the breakup of families, the transformation of society, or the displacement of men. Charting a middle course, this vision of womanhood appealed to the traditionalism of the studios and some of their audiences, while subtly, but powerfully, expressing more egalitarian ideas.

The optimism and joy of these films is counterbalanced by the tragic mood of another cycle of maternal dramas. "Don't look like Stella Dallas" was a piece of advice often delivered to young American girls growing up in the Forties and Fifties.

Stella (Barbara Stanwyck) was the over-baubled and bangled heroine of King Vidor's 1937 screen classic of the same name. Dedicated selflessly to the upward mobility of her daughter Laurel, working-class Stella could not see the ridiculous image she presented in "high society." Perceiving herself as a handicap to Laurel, Stella convinces her grown child that she has little time for her. In the memorable last scene, a bedraggled Stella, unbeknownst to Laurel, stands outside in the rain, watching her daughter's society wedding from behind an iron gate. Joy and sadness merge as Stella gains her greatest wish, but only at the expense of her bond with her only child.

Likewise in *To Each His Own* (1946), directed by Mitchell Leisen, Jody Norris (Olivia de Havilland) also takes pleasure in watching from afar as her illegitimate son grows to manhood. True to Code standards, Jody "pays" for her "indiscretions" with World War I flyer Bart Cosgrove (John Lund), later killed in action. Through a series of complicated plot conventions, Jody's infant son is adopted by an old beau and his wife who had recently lost their own first child. Although Jody escapes into executive success at the Lady Vyvyan Cosmetics Company, her motivations for achievement are strictly maternal. Yet her dreams of regaining custody never materialize. In middle age, however, she finally is able to take advantage of one last chance to be more than an aunt to her soldier son.

Both films conclude with a wedding scene. *To Each His Own* allows viewers the joy of vicarious wish-fulfillment; Jody gets a chance to dance at her son's wedding! *Stella Dallas* creates a tangle of emotions as audiences identify both with Stella's joy and sadness at separation from Laurel. Despite the contrast in endings, both dramas stress both the joy and pain of maternal sacrifice and self-abnegation. For Depression and war era women who crossed the boundaries of traditional morality or who were forced to love or parent at a distance, these films conveyed

sympathy and understanding. For the Depression mother with an alcoholic husband, the soldier's wife with an illicit lover, or the defense worker bearing her lover's child, if Barbara Stanwyck, Bette Davis, or Olivia de Havilland could still look themselves in the eye, perhaps so could they.

Maternal dramas declined in the postwar era. "Transition" films such as *Mildred Pierce* narratively linked occupational success with maternal failure at the same time that the dominant themes in American popular culture counseled women to return to domesticity. Popular American cinema shifted its attention to the multiple issues confronting returning vets in films such as William Wyler's *The Best Years of Our Lives* (1946). Television soap opera, drama and situation-comedy heroines, for the most part, couldn't hold a candle to the earlier generation of movie mothers.

The late Seventies and Eighties have witnessed a slight resurgence of the maternal drama. In contemporary movies like *Terms of Endearment* (1982) and *Mask* (1984), the contradictions of the subgenre endure, albeit in more modern form. Widow Aurora Greenway (Shirley MacLaine) and her married daughter Emma Horton (Debra Winger) have a "hip" relationship in James Brooks's *Terms of Endearment*. After all, it's not every fifty-year-old grandmother that would laughingly confess to her daughter that "Sex is fan-fucking-tabulous!" Though the dialog is smack out of the Eighties, the modern veneer of this film glosses a traditional core, a narrative that might well have been produced in the Fifties. Neither Aurora nor Emma has any significant interests or commitments outside the realm of romance, home, and family. The ideal wife and earth-mother, Emma follows the philandering Flap Horton from one boondock university town to another with minimal complaint. In one scene, Emma's Texas warmth and naïveté contrast to the cool, slick, superficial polish of the Manhattan career women who casually discuss abortions and sexually transmitted diseases over lunch. And,

shades of Bette Davis in *Dark Victory*, a thirty-ish Emma dies of cancer, leaving Aurora to renew the maternal cycle with her three young grandchildren. Likewise, Cher as biker mom Rusty Dennis in *Mask* is modern: single, youthful, and sexually active. In addition to coping with son Rocky's fatal and disfiguring disease, she has a serious drug problem of her own. Yet Cher, like Emma and Aurora, is a hip version of Ma Joad, eternally on call for the emergencies of others, never having the time, space, or power to define her own priorities.

FEMALE BUDDY FILMS

Sister of the maternal drama, films of female bonding and competitition provided their audiences with commentary on the possibility of love and community among women. *Little Women* (1933; 1949), the classic parable of sisterhood, presents a range of feminine choices represented by conformist Meg, rebel Job, opportunist Amy, and ethereal, self-sacrificing Beth. Despite their conflicts, the March sisters always return to the family cameo for mutual support, nurturance, and understanding. In *Stage Door* (1937), a group of aspiring and impoverished actresses (Lucille Ball, Katharine Hepburn, Ann Miller, and Ginger Rogers) who live together in a rooming house provide sisterly support and experience sisterly conflict. A World War II female surrogate family in *Tender Comrade* (1943) sees its members through crises of birth and death. The group of "hostesses" (Code for prostitutes) courageously bond together in *Marked Woman* to testify against their gangland boss and see justice done in the murder of another woman.

As compared to groups, female dyads were depicted in women's films as both supportive and competitive. From Bette Davis and Miriam Hopkins in *Old Acquaintance* (1943) to Anne Bancroft and Shirley MacLaine in *The Turning Point* (1977), a close woman friend can inspire a complex mixture of pride and jealousy. In a world of constricted female options, each

friend's life symbolizes a path not chosen.

After a period in the Sixties and early Seventies dominated by Newman and Redford, "female buddy" films reemerged in the late Seventies. Some critics, such as Kathi Maio in *Feminist in the Dark* (1988), identify 1977 as a high point in contemporary Hollywood representations of women. Claudia Weill's *Girlfriends* (1977) depicted the strains in a postcollege friendship of two young women, one a struggling photographer, the other an ambivalent poet. With a low-budget, black-and-white-realism, the film traces a relationship that begins as roommates and evolves as Sue (Melanie Mayron) pursues her career more seriously and Ann marries and has a child. *Julia* (1977), based on Lillian Hellman's *Pentimento*, flashes back to an incident in the intense friendship of Lily (Jane Fonda) and Julia (Vanessa Redgrave). Inspired by Julia's bravery, Lily decides to risk her life by transporting funds to antifascists in Germany. *Personal Best* (1980) delicately explores what had previously been tabooed in women's films through the depiction of a sexual friendship between two young women athletes. Donna Deitch's film adaptation of a Jane Rule novel, *Desert Hearts* (1987), captures beautifully the passion and class tensions in an unlikely Fifties Reno romance between the prim, divorcing academic Vivian (Helen Shaver) and her younger out-of-the-closet lover, casino worker Cay (Patricia Charbonneau). The influence of the female buddy films could also be seen in popular prime-time TV series of the Eighties such as *Kate and Allie* and *Cagney and Lacey*. No longer could Newman and Redford remain unchallenged.

"CAREER GIRL" MOVIES

When asked to recall their favorite old-movie heroines, many contemporary women may mention Rosalind Russell in *His Girl Friday* or Katharine Hepburn in *Adam's Rib*. Yet the Forties array of wisecracking reporters, acid-tongued lawyers, and super-competent executives were preceded by much more stereotypical working-girl heroines from the Depression era. Rosalind Russell, star of over twenty "working-girl" features, commented:

Except for different leading men and a switch in title and pompadour, they were all stamped out of the same Alice in Careerland. The script always called for a leading lady somewhere in the 30's, tall, brittle, not too sexy. My wardrobe had a set pattern: a tan suit, a gray suit, a beige suit and then a negligee for the seventh reel, near the end, when I would admit to my best friend that what I really wanted to become a dear little housewife.

Rarely did Thirties women's films feature a heroine who attained both professional and maternal success, or displayed traits of leadership and competence as well as warmth and nurturance. In *Dr. Monica* (1934), the title character (Kay Francis) is a successful obstetrician, yet predictably cannot bear children. Through a series of melodramatic plot conventions, Monica winds up both delivering and adopting her husband's illegitimate offspring. Likewise, executive Ruth Chatterton in *Female* (1933) is supercompetent, yet hostile and sexually frustrated. At the opposite end of the spectrum, heroines in the helping professions—in films like *Night Nurse* (1931) and *The White Angel* (1936)—were often cast in an occupational variation of the maternal role.

A cycle of popular Forties "career-woman comedies," however, recast this pattern significantly. Focusing on the dilemma of femininity versus achievement, "screwball women's films" such as *His Girl Friday* and *Adam's Rib* fuse hyperactive comedy with a narrative centering on a competitive and sexually charged relationship between the heroine and her male lover and colleague. In Howard Hawks's *His Girl Friday*, motormouth reporter Hildy Johnson (Rosalind Russell) must choose between bland, rural domesticity (and marriage to insurance agent Ralph Bellamy) and frenetic, male-dominated urban journalism (and remarriage to editor Cary Grant). Attorney Amanda Bonner (Katharine Hepburn) in George Cukor's *Adam's Rib* finds her duty to client Doris

Attinger (Judy Holliday) at odds with her loyalty to her spouse Adam (Spencer Tracy), representing the opposite side in a domestic violence dispute. Quintessentially verbal, these comedies became sparring matches in a rapid-fire battle of the sexes.

Although generally the mood of Forties career-woman features was more egalitarian, the most regressive women's film of the decade also dramatizes the femininity-achievement conflict. In Mitchell Leisen's Freudian-inspired musical *Lady in the Dark* (1944), perhaps the esthetic disaster of the decade, troubled magazine editor Liza Elliott (Ginger Rogers) realizes her true desires on the analytic coach. In asking Dr. Brooks, "Well, what's the answer?," he smugly replies, "Perhaps some man who will dominate you." For Forties women in transition, "career woman" films—from the "feminist" *Adam's Rib* to the antifeminist *Lady in the Dark*—provided a dream canvas upon which to project their own concerns about femininity and achievement.

In contemporary American cinema, few films would be termed "working woman" dramas. The Seventies and Eighties, however, have generated some memorable portrayals of dedicated working women, often based on actual biographies. *Marie* (1985), a close cousin of the made-for-TV movie, features Sissy Spacek as heroic Marie Ragghianti, who blew the whistle on state government corruption and risked her own life in the process. *Gorillas in the Mist* (1988) cast Sigourney Weaver in a more complex characterization as Dian Fossey, whose zeal to save the endangered mountain gorillas of Rwanda bordered on a dangerous obsession. In addition, a few excellent contemporary dramas have been produced, drawn from the real-life struggles of blue-collar women. In Martin Ritt's *Norma Rae* (1979), based upon the life of union organizer Crystal Lee Jordan, Sally Field portrays a Southern textile worker, a single mother and veteran of failed relationships and backbreaking work. Playing the role without makeup, Field portrays a complex woman, neither proletarian heroine nor sexual object. Yet the film recalls the romantic tension of the screwball comedy by departing from Jordan's narrative to inject a quasiromantic interest with an urban Jewish union organizer. In *Silkwood* (1982), Meryl Streep stars as the doomed environmental activist whose maturity and conviction are sometimes undercut by an adolescent prankishness. Gritty and realistic, both films depart radically from the "domestic and gleaming" set conventions of classic women's films.

FILMS OF SUSPICION AND DISTRUST

This Gothic subgenre peaked in the mid-Forties, as World War II came home to the American screen in the language of *film noir*. Shadowy lighting, tilted camera angles, twisted, ambiguous narratives—these were the cinematic legacy of German Expressionism and the psychological stamp of a world gone awry, a world unsure that it would ever again know normalcy. Crime dramas such as *Double Indemnity* bore the mark of *film noir*, with narratives classically featuring a jaded, down-and-out detective, a mysterious murder, and an evil woman. GI fears were thinly masked as *femmes fatales*. The women's film, too, was colored by *noir*, in dramas of terrified women and murderous men.

"Don't trust your husband" is the recurrent theme of a popular cycle of *noir*-influenced women's films such as *Gaslight, Suspicion,* and *Sleep, My Love* (1948). Other features such as *Rebecca* (1941), *Shadow of a Doubt* (1943), *Notorious* (1945), *The Spiral Staircase* (1946), *Jane Eyre* (1944), and *Sorry, Wrong Number* (1948), while differing somewhat in narrative, also share elements of this cycle. Gothic melodramas merged with *film noir* to produce uniquely feminine cine-dramas of suspicion and distrust.

The following composite plot is classic in this subgenre: After a whirlwind courtship, a rich, naive, and sheltered young woman marries a somewhat mysterious but charming man. At first he seems

the ideal spouse, loving, sensitive, and protective. Yet his civilized facade masks a brooding rage. After the "honeymoon" (which may last from a month to a few years), his behavior shifts. Clue upon clue begin to appear, leading the woman to suspect that her husband plans to murder her or drive her insane. As the audience experiences her emotions through a fish-eye lens or a dark, claustrophobic interior, they know that her initial joy has turned to terror and confusion. Her home has become not a secure haven, but a prison. These films (Cukor's *Gaslight* is the most famous) are marked by a disquieting cycle of climax and anticlimax, suspicion, and relief. Will he murder her? Or is she only imagining this horror? Often the audience knows more than the heroine, recognizing the danger she suspects and bonding more closely with her in vicarious terror. The filmic narrative asks and reasks these questions with mounting anxiety until the conclusion, which often proves the woman's fears to be well-founded.

The popularity of this subgenre peaked from 1944 to 1948. The postwar culture of consensus discouraged overtly subversive sentiments on the part of female moviegoers. During and immediately after the war, these Gothic films provided female viewers an opportunity to vent their fears of male betrayal and violence within the safety of narratives offering the distance of an historical or foreign setting. In contemporary cinema, occasional films like *Coma* (1978), portraying a young female doctor (Genevieve Bujold) victimized by an evil, male-dominated medical empire, or *Jagged Edge* (1985), depicting a defense attorney (Glenn Close) terrorized by her suave client-lover (Jeff Bridges), provide the same kind of narrative release for women's fears of male violence. Yet perhaps the "naming" of crimes of violence against women has finally opened narrative space for the dramatic portrayal of rape in films such as *Extremities* (1987) and *The Accused* (1988), incest in *Nuts* (1987), and wife-battering in made-for-television movies like *The Burning Bed* (1984) and even lavish neo-studio productions such as Steven Spielberg's *The Color Purple* (1985).

Strong mothers, loyal sisters, wise-cracking reporters, terrified wives—these classic characters have remained enduringly popular with American female audiences since the Thirties. The future of the women's film is difficult to predict. It is unlikely, however, that the genre will ever return to its strength in the studio era. While individual motion pictures might be typed "neo-women's films," we are unlikely to see the full resurgence of the genre in more modern garb. The "lost audience" of mature adults has never returned to the movies en masse, and film producers and directors often orient themselves to the perceived desires of white, largely male viewers under twenty-five. The popular cycle of "slasher" films, in which young women are brutally victimized in distinctly adolescent *mises-en-scènes*, is testimony to a powerfully contemporary cultural current of misogyny.

Yet at the same time, contemporary feminism has stimulated a small but significant resurgence of the women's film genre in features such as *Frances* (1982), *Tell Me a Riddle* (1980), *Sophie's Choice* (1982), *The Color Purple* (1985), *Out of Africa* (1987), *Crossing Delancey* (1988), and *The Good Mother* (1988). These films can, to varying degrees, be characterized as postfeminist. That is, they reflect the social changes wrought by feminism and the personal and political concerns articulated by the movement. While many of these contemporary features are still produced and directed by men, more women have entered the arena of motion picture production, creating a wide range of films impossible to type or classify as a whole. American directors Donna Deitch, Joan Micklin Silver, Susan Seidelman, and Claudia Weill, as well as Australian Gillian Armstrong and Canadian Patricia Rozema have successfully struggled to create memorable films centering on women.

Yet, as popular culture, contemporary

women's films address a broad audience, and, in so doing, sometimes dilute and defuse more radical themes. Nonetheless, the contrast, as well as continuity, with earlier generations of women's film heroines is important to note. One can see shades of Katharine Hepburn in Sigourney Weaver's performances in *Aliens* (1986) and *Gorillas in the Mist*, though Weaver's characters no longer feel obliged to apologize for their work-oriented personas. Although Whoopi Goldberg as Celie appears in slave stereotype garb in the first half of *The Color Purple*, she emerges in midlife into an angry and dignified character that Hattie McDaniel, Ethel Waters, and Butterfly McQueen never had the opportunity to portray in the studio era. Susan Seidelman's *Desperately Seeking Susan* (1984) is a distinctively New Wave feature, a postmodern fable with the unpredictable Madonna as a send-off of cultural constructions of womanhood. Some neo-women's films such as *Extremities* and *The Accused* take on issues of sexual violence tabooed by both the Code and dominant culture of the studio era. *Children of a Lesser God* (1986), through the acclaimed performance of Marlee Matlin, depicted a deaf woman, not as an object of pity, but as a proud survivor and bearer of a rich cultural tradition. Several women's films of the Eighties such as *The Trip to Bountiful* (1985) and *The Whales of August* (1987), featuring stars of the Thirties and Forties, dramatize the life crises of older women, reflecting the influence of the gray media lobby and changing national demographics. While bonding between women remains an important focus of this cycle of contemporary films, some features dramatize the tensions between women in a post-feminist era. Rationalist psychiatrist Jane Fonda clashes sharply with the assertive yet mystical Mother Superior (Anne Bancroft) in *Agnes of God* (1985). The yuppie feminist lawyer (Kelly McGillis) in *The Accused* experiences a cultural chasm separating her from the experience of her client (Jodie Foster), a young waitress victimized

in a gang rape.

Many films, however, echo age-old ambivalence about "having it all." In *An Officer and a Gentleman* (1982), Debra Winger is cast in a Reagan-era stereotype: a factory girl swept off her feet (literally) by her military prince. Winger's government-agent heroines in both *Black Widow* and *Betrayed* are also vulnerable, unable to set emotional boundaries between themselves and their evil prey. Diane Keaton in *The Good Mother* portrays a young divorcée whose love affair threatens her custody of her only daughter. While some narrative space has opened for the portrayal of women of color, lesbians, older women, and women with disabilities, the majority of contemporary Hollywood heroines are, like their counterparts in the studio era, white, heterosexual, middle-class, able-bodied, and less than middle-aged. Choice and constraint continue to frame the filmic universe for contemporary stars such as Cher, Glenn Close, Sally Field, Jane Fonda, Whoopi Goldberg, Holly Hunter, Diane Keaton, Jessica Lange, Marlee Matlin, Sissy Spacek, Meryl Streep, Sigourney Weaver, Oprah Winfrey, and Debra Winger.

The classic women's films endure as popular entertainment and as rich source material for understanding the collective experience of American women. Neither the top-down mythology of the film industry nor the bottom-up collective unconscious of American womanhood, women's films represent a dynamic, a power relationship and struggle between men and women within and outside the studio.
—Andrea S. Walsh

RECOMMENDED BIBLIOGRAPHY

Doane, Mary Ann. *The Desire to Desire: The Woman's Film of the Forties*. Bloomington, IN: Indiana University Press, 1987.

Fischer, Lucy. *Shot/Countershot: Film Tradition and Women's Cinema*. Princeton, NJ: Princeton University Press, 1989.

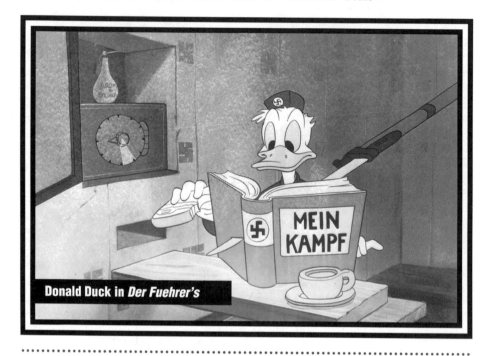

Donald Duck in *Der Fuehrer's*

World War II Animated Propaganda Cartoons

During World War II, government contracts were welcomed by Hollywood animation studios for practical as well as patriotic reasons. With revenue from foreign markets cut off by the war, training films for the armed services and propaganda shorts aimed at the home front saved a number of cartoon shops from closing.

The quality of the films was maintained because drafted personnel who were key staff animators, layout, or background artists were often excused from overseas duty. They served their country by using special skills considered too valuable to be wasted in combat.

One of the busiest of the cartoon factories was Warner Bros., which used Bugs Bunny to sell war bonds (*Any Bonds Today?*) to the folks at home, and produced a series of *Private Snafu* training

shorts for viewing by the armed forces only. (The name "Snafu" is based on a military acronym for "Situation Normal, All Fucked Up.") Private Snafu, a hapless nitwit of a soldier, uses slapstick antics and barracks language to warn combat-ready troops of the dangers of malaria, venereal disease, spies, infantry "blues," and so on. About twenty-five *Snafu* shorts were produced between 1942 and 1945, written mostly by Ted Geisel (later known as Dr. Seuss) and directed by Warner's staff car-

toon directors Chuck Jones, Friz Freleng, Bob Clampett, and Frank Tashlin.

War-related propaganda also found its way into many Warner shorts intended for general theatrical relase. *The Draft Horse* (1942) features a super-patriotic but physically inept plow horse who fails a rigorous Army induction exam. The rejected "4-F" horse happily ends up knitting "bundles for bluejackets," an example of the importance of unity and support from the home front for the troops on active duty.

The trademark iconoclastic humor of the Warner cartoon filmmakers attempted to diminish the perception of the enemy as a superpower. In *The Ducktators* (1942), a manic Orwellian takeoff, the public images of Hitler, Mussolini, and Hirohito are punctured when the leaders of Germany, Italy, and Japan are portrayed as farm fowl trying to dominate a barnyard.

Hitler's hyperventilated style of public speaking was often a target for cathartic cartoon clobberings, literally in *Daffy Commando* (1943) when Daffy Duck takes a large mallet to *Der Fuehrer*'s head. In *Russian Rhapsody* (1944), Hitler personally flies a bombing mission to Russia, but is foiled by a team of tiny, violent gremlins (caricatures of the Warner cartoonists). In *Herr Meets Hare* (1945), shape-shifting Bugs Bunny imitates both Hitler and Brunhilde to confuse Goering; finally captured, Bugs frightens Hitler with a Stalin impression.

The zeal of the Warner cartoonists to symbolically destroy hated individual foreign enemies often spilled over to general attacks on entire ethnic groups: the cultural and physical differences of the Japanese proved to be irresistible targets for merciless racist slander.

The very title *Bugs Bunny Nips the Nips* (1944) conveys the flavor of a film in which the American Rambo-rabbit singlehandedly destroys a Japanese military base, while addressing its grossly caricatured soldiers as "slant-eyes," "monkey-face," and "bowlegs." *Tokio Yokio* (1943) contains a series of poisonous sight gags exploiting

the assumed inferiority of the Japanese mind and physical form: bucktoothed, squinty-eyed runts bow constantly and scurry about, accidentally blow themselves up, stick needles in each other (to simulate a warning siren), and generally make themselves look ridiculous.

Movies of the period, animation and live action, mirrored and reinforced America's racist attitudes and distrust of foreigners and the exotic, feelings which were exacerbated to paranoiac extremes by the war. The dehumanization of an entire people is a necessary step on a path that leads to American internment camps for Japanese citizens and, ultimately, the destruction of two Japanese cities by the atomic bomb.

America's prejudice against African-Americans manifested itself in segregated barracks for black and white soldiers. Animated films of the period reflect and reaffirm America's rampant Negrophobia in films such as Warner's *Coal Black and de Sebben Dwarfs* (1942), a gaudy, breathlessly paced parody of Walt Disney's *Snow White and the Seven Dwarfs* (1937).

Coal Black is as technically brilliant and as ideologically flawed as D. W. Griffith's *Birth of a Nation* (1915), the grand live-action leap forward in film art that dragged one foot through a dung pile of bigoted imagery. *Coal Black* exploits every cliché, derogatory image of blacks, from the fat mammy narrator, to zoot-suited Prince "Chawmin," a cowardly gambler with dice for teeth. The heroine, "So White," is a scantily-clad, oversexed camp follower capable, it is implied, of satisfying the erotic needs of an entire army platoon. The seven dwarfs are uncoordinated bumblers, and, of course, there is a shuffling Stepin Fetchit caricature.

All of these images of blacks were accepted and expected by the white majority audiences of the time, and it must be said that the director of *Coal Black* (Bob Clampett) had no axe to grind in using them. His direction is deft and exhilarating, and one recent critic found his carica-

ture of blacks "affectionate...ironically, the racism of *Coal Black*...is directed against the Japanese, the scapegoat enemies of World War II. Accordingly a billboard advertises: "We rub out anyone for a price: midgets, half-price; Japs, free."

One could argue that a cartoon character such as wimpy Elmer Fudd is a negative exaggeration of whites; however, inferior images of whites are always contrasted with positive ones, such as Bugs Bunny, a Caucasian surrogate who is resourceful, clever, quick-witted, energetic, self-aware, and intelligent. He is a hero, one with dignity and a dimensional, multifaceted personality. Blacks had no such surrogates in Hollywood cartoons of the period.

The busiest animation studio during the war years belonged to Walt Disney. In 1943, for example, ninety-four percent of all film footage produced by Disney was under government contract, and between 1942–'43, Disney exposed over 204,000 feet of film, more footage than any Hollywood studio, live action or animation.

The Disney studio turned out an unprecedented amount of training films, with titles such as *Four Methods of Flush Riveting* (1942), *Aircraft Carrier Landing Signals* (1942), *Air Masses and Fronts* (1943), *Your Job in Germany* (1944), *Something You Didn't Eat* (1945), and *Insects as Carriers of Disease* (1945).

Disney's propaganda shorts for theatrical release to the home audience were more intentionally educational than those from other studios. The shorts use humor to attract attention, but the message is punched home with darker imagery, which manipulates emotions by utilizing all the skills perfected by Disney storypeople and animators in the production of the feature-length cartoons (i.e., *Snow White, Pinocchio,* 1940, and others).

Two anti-Nazi shorts, *Chicken Little* and *Education for Death*, both from 1943, have endings that are unusually grim and hopeless for Disney. "Virtually no other films in the entire Disney oeuvre can match these

two shorts for sobriety and pessimism," notes Richard Shale.

One of the earliest and most popular of the general audience entertainment-informational shorts was Disney's *The New Spirit* (1942) produced for the Treasury Department and distributed free to 12,000 theaters. Bosley Crowther of *The New York Times* called it the "most effective of the morale films yet released by the government," and the short proved so popular that a sequel was ordered—*The Spirit of '43* (1943).

Both films star Donald Duck, whose volatile personality suited the times; by the early Forties, he and his temperamental squawkings eclipsed in popularity the comparatively bland Mickey Mouse. In *The Spirit of '43*, Donald is urged to pay his taxes ("Taxes to beat the Axis" is the rallying slogan); to do otherwise, it is strongly suggested, is both unpatriotic and un-Christian. Donald's choice to either spend his money drinking in a saloon or contribute to the war effort is a struggle couched in symbols of Western mythology—a good (angelic) conscience tugging against a bad (devilish) one, imagery often used in earlier Disney shorts such as *Donald's Better Self* (1938), and others.

"Good" is here represented by an older, bearded duck wearing a plaid kilt, speaking in a Scottish brogue. According to an ethnic stereotype, Scots are thrifty, and bagpipes are heard on the sound track whenever the Scottish duck appears. "Evil" is a zoot-suited, key-chain-twirling duck with a Hitler-like mustache who makes his entrance in a devilish puff of smoke. His theme music is jazzy, and both jazz and the zoot suit were associated with blacks, a race whose culture was considered inferior and one to be shunned by whites. Further moral attitudinizing is demonstrated by a squeamishness toward sensual pleasure and recreational drugs (alcohol); the barroom is seen as a nest of sin.

Donald obviously makes the "right" choice when he punches the evil duck to the sound effect of a bomb explosion, and

we fade into the hard-sell section of the film.

Although Donald disappears for the second half of *The Spirit of "43*, the result of his taxpaying is seen in a series of tableaux of busy factories turning out multitudes of guns, boats, bombs, and aircraft. (The budget for *Spirit of "43* was tight, so while Donald is animated in the usual full, fluid Disney manner, the backgrounds are black; in the second half, movement is kept to a minimum—time- and labor-saving techniques, such as sliding cels and dynamic camera moves, set the imagery in motion.)

To the sound of an incessant "Voice-of-God" narrator—a patriarchal voice of authority—anthropomorphic ships, airplanes, and submarines are destroyed easily by American-financed bomb and missiles. This is a cartoon version of war, for no carnage is shown. The enemy vehicles of war are described as "birds of prey" and "evil destroyers of freedom and peace," while on the screen we are shown machines with faces, not men. There is no blood, no mutilation of human flesh, no death. An ultimate enemy machine—big, black, wearing a German helmet and a devil's horns—shoots fire and smoke as the camera moves in close. A Technicolor explosion reduces the monster to a broken toy, steel helmet askew. Disney's imagery suppresses facts and distorts the reality of war in order to sell an idea: it is the essence of propaganda.

The final scene is a long camera pull back from a sky filled with red, white, and blue clouds forming an American flag, as an endless parade of U.S. tanks trundle over the horizon. A heavenly choir hums "The Star Spangled Banner," as the booming voice-over assures us that "Taxes will keep American democracy on the march!" This ending recalls the finale of *Fantasia* (1940): after the big, black devil is forced back into Bald Mountain by the ringing of church bells, Schubert's "Ave Maria" is heard as a procession of worshippers walk through a forest of trees resembling stained-glass church windows. Both *Spirit of '43* and *Fantasia* use religious symbols, visual and aural, to define good and evil and assure us of the triumph of the former over the latter.

"The great psychological song of the war," according to Oscar Hammerstein II, came from the Disney short *Der Fuehrer's Face* (1942), originally titled *Donald Duck in Nutzi Land*. In this pointedly anti-Nazi film, the irascible duck awakes in a world filled with swastika symbols—the twisted cross of Fascist Germany is seen on clock faces, in the shapes of buildings, and even in trimmed trees and shrubbery.

A German band booms out the title song, complete with Bronx cheer: "Ven Der Fuehrer says, 'Ve iss der Master Race,' Ve Heil! (razz), Heil! (razz), Right in Der Fuehrer's face."

Spike Jones's version of the song sold over a million and a half records, making *Der Fuehrer's Face* one of the most popular songs of the war years; the film won an Oscar in 1943 as Best Animated Short.

In Nutzi Land, Donald breakfasts on wooden toast and "aroma of bacon and eggs" (sprayed from an atomizer). He works at a Chaplinesque assembly line in a munitions factory where the pressure of constructing shell casings at an ever-increasing pace causes him severe distress. Donald's mind cracks and in a surreal dreamworld he himself becomes a bomb shell. After literally exploding, he wakes, wondering if the nightmare was true. A shadow of an outstretched arm appears on the bedroom wall as a Nazi salute and Donald starts to return it ("Heil, Hit...") but realizes it is cast by a statuette of the Statue of Liberty, which Donald embraces, quacking happily, "Am I glad to be a citizen of the United States of America." *Der Fuehrer's Face* uses broad cartoon humor to make its points about the differences in the quality of life under fascism and democracy. Food rationing, for example, is seen as a small sacrifice for Americans considering the nonfood substitutes that supposedly constitute a German

diet.

Disney was the only studio to produce three propaganda features, including two proposed by Nelson Rockefeller of the Office of Coordinator of Inter-American Affairs (CIAA) as part of the "Good Neighbor Policy": *Saludos Amigos* (1942) and *The Three Caballeros* (1943). Barbara Deming wrote of the latter:

Walt has indeed wrought something monstrous. And the art critic may well turn away in dismay. But the psychoanalyst, or the social analyst—the inquirer into the mythos, the ethos of the times—may, on the contrary, well look twice. For *The Three Caballeros* is not Disney's private monster, his personal nightmare. It is a nightmare of these times.

So convinced was Walt Disney that air technology could win the war for America, he personally financed the feature *Victory Through Air Power* (1943). It was a grand patriotic gesture, for the film has none of the timelessness or commercial value of his other animation features and, indeed, it has never been rereleased theatrically since its debut. In the film, Major Alexander de Seversky, author of the 1942 book of the same name, explains his controversial and unproven theories with the aid of animated charts and maps. There is an amusing "History of Animation" animation sequence and a cartoon finale featuring a dynamic battle between a giant American eagle and a sinister black octopus, whose gigantic tentacles strangle the Pacific Islands.

James Agee, writing in *The Nation*, questions Disney's method of imparting information:

I only hope Major de Seversky and Walt Disney know what they are talking about, for I suspect an awful lot of people who see Victory Through Air Power are going to think they do...I have the feeling I was sold something under pretty high pressure, which I don't enjoy, and I am staggered with the ease with which such self-confidence, on matters of such importance, can be blared all over a nation, without cross-questioning...I notice, uneasily, that

there are no suffering and dying enemy civilians under those proud promises of bombs: no civilians at all, in fact.

The profound role women played during World War II—leaving the home to take on jobs in factories and offices vacated by men serving overseas—was not addressed in most of the animated cartoons of the period. In *Spirit of "43*, for example, no women appear on screen, although the Hitler-duck forms the shape of a female body in midair to tempt Donald, and the film's narrator refers verbally to "his and her" taxpayers. The hundreds of workers shown in factories making armaments are faceless and sexless, although a high percentage were in actuality "Rosie the Riveter" and friends. When female characters did appear in animated films of the period, they were cast in roles supporting male characters and as the usual mother-slut-witch clichés.

Two Warner Bros. shorts hint grudgingly of the real roles women successfully took on to aid the war effort. *The Weakly Reporter* (1944) is a "newsreel" barrage of sexist gags about the WACS and working women; in *Brother Brat* (1944), a woman war factory worker hires Porky Pig to baby-sit her monstrous child. She suggests Porky use a book on child psychology, but this approach fails and Porky is a shambles when the woman returns home from the night shift. She promptly shows Porky the correct way to apply psychology to a child: by using the book to spank the brat across his backside. The film thus reinforces the stereotype that a woman's place is in the home, where she excels at parenting. Soon after the war, live-action films, songs, and advertisements began a propaganda campaign to reinforce a "homebody" image of women that would push "Rosie" out of the factory and the office in order to leave men's work to the men.

—John Canemaker

Zanuck, Darryl

(September 5, 1902 – Deember 22, 1979)

D arryl Zanuck was the producer most frequently associated with the Hollywood social problem film. In the early Thirties, as production chief at Warner Bros., he was directly responsible for the films which gave the studio its reputation as the "socially conscious studio."

He actually wrote the story for the hilarious, corrosive satire of the electoral process, *The Dark Horse* (1932), and oversaw production of Hollywood's most despairing portrait of Depression America, Mervyn Leroy's *I Am a Fugitive from a Chain Gang* (1932). Later, as head of Twentieth Century-Fox, Zanuck continued to make socially conscious films, the most prominent of which were *The Grapes of Wrath* (1940), *Gentleman's Agreement* (1947), *The Snake Pit* (1948), *Pinky* (1949), and *No Way Out* (1950).

While many Hollywood producers were merely administrators, overseeing the budget and hardly involving themselves in creative decisions, Zanuck exerted a tremendous personal influence on his films, and hence on the direction of the mainstream Hollywood political cinema. According to his official biographer, Mel Gussow (*Don't Say Yes Until I Finish Talking*), Zanuck "was involved in every foot of film that came out of his studio, not just in the conception and casting, but in the day-to-day construction. The movies that came out of the studios he ran clearly represented his taste." Despite this personal involvement in all of his films, an overall examination of his work reveals no clear political viewpoint. Instead, the politics of his films range from the radical (*Fugitive*) to moderate liberal (*Gentleman's Agreement*) to populist (*Grapes*) to the reactionary (*Tobacco Road*, 1941). Like most Hollywood producers his concerns were essentially commercial and the politics of his films usually reflected the political mood of the American public. At the height of the Depression, with twenty-five percent of the country unemployed, Zanuck recognized that optimism wouldn't sell, hence the despair of *Fugitive*. Later, as the country moved toward prosperity, his films reflected a less radical viewpoint, suggesting that most social problems could be easily overcome.

The producer himself readily admitted that his chief aim was always commercial, not political. His major input to a film was at the writing stage, where he attempted to construct story elements which would bring out entertainment values—exciting action, appealing characters, and interesting situations. The many interoffice memos quoted in Gussow's biography reveal the priority of "elements of suspense and tension" over those of "significance" in a Zanuck film. Writing about Kazan's direction of *A Tree Grows in Brooklyn* (1945), Zanuck expresses his fear that in "his searching for illusive moods and inner motivations there is the danger that we may talk ourselves into a…story that is emotionally magnificent but lacking the true elements of entertainment that will appeal to the masses."

Following this line of thought, Zanuck humanized his problem pictures, giving the message a strong basis in story and character. But this drama often homogenized the message, eliminating any subtleties or ambiguities. As Peter Viertel put it, "He would very often take the nuance off

the picture and leave the fast and violent." Zanuck's real aim was entertainment and box office, and anything too "cerebral" or challenging was considered counterproductive.

The strain between entertainment and message is most evident in *The Grapes of Wrath*. Zanuck played up the story of the family and played down the politics of the larger predicaments: "In *Grapes of Wrath* we had to make a very vital decision... whether to tell the story of the Okies as a whole or the story of one isolated family." The choice was essentially the right one, for in centering sympathy on the Joads the film does give an emotional weight to its protest against their victimization. Unfortunately, this also led to the exclusion of the broader social context, removing most of John Steinbeck's more pointed comments and radically changing the ending. Ma's sentimental curtain speech was added at Zanuck's insistence because such an "upbeat" finale was in keeping with family drama.

If entertainment value and box office appeal were the cornerstone of Zanuck's approach to filmmaking, an explanation for his predilection for social themes is in order: surely less controversial storylines could have been treated with equal doses of dramatic tension and been equally successful. Zanuck would have disagreed. He learned the commercial value of the problem film while at Warner Bros. in the early Thirties. There, realism allowed for low-budget pictures and topicality brought a certain degree of built-in publicity. While Zanuck's Fox films were no longer low-budget, he continued to make movies which generated enough controversy to heighten public interest and foster a studio image of social responsibility. With *Grapes of Wrath*, Zanuck exploited the popularity of the book and encouraged notoriety around the shooting, proclaiming the screen's contribution to the betterment of society. In a *Saturday Evening Post* interview, he described *Grapes* as "a stirring indictment of conditions which I think are a

disgrace and ought to be remedied." At the same time, he bowdlerized any explosive implications. The final irony, pointed out by Michael Mok in *The Nation*, was that the premiere was attended by the very trust companies, banks, and moneyed interests that "tractored the Joads, and thousands like them, off their farms," and were "about to wax still richer from the profits by a dramatization of the agonies of those unfortunately shiftless and stupid people."

Zanuck tries to reconcile the contradiction between social concern and commercial appeal by rationalizing "that the box office counts, not because it determines profits, which is important, but because we fail unless we can get a maximum turnout for those pictures which guide and enlightened the public." Producers must dress up their message in "the glittering robes of entertainment...Without entertainment, no propaganda film is worth a dime."

Zanuck's high-minded defense of profits in the name of social significance is more than a little self-serving. Yet *Pinky, Gentleman's Agreement*, and *The Snake Pit* are solid melodramas, while *Grapes*, for all its compromise, remains a stirring depiction of the Okies' plight, Zanuck's most successful blend of high drama with social comment. It and *I Am a Fugitive from a Chain Gang* are among the most socially significant films ever to come out of the Hollywood studios. If Zanuck's comments fail to convince one that the softening of political themes is necessary to get a message across to the masses, one must still appreciate the consistent quality of his socially conscious films.

—Peter Roffman and Beverly Simpson

RECOMMENDED BIBLIOGRAPHY

Gussow, Mel. *Darryl F. Zanuck: "Don't Say Yes Until I Finish Talking."* NY: Da Capo Press, 1980.

Harris, Marlys J. *The Zanucks of Hollywood: The Dark Legacy of an American Dynasty.* NY: Crown Publishers, 1989.

Mosley, Leonard. *Zanuck: The Rise and Fall of Hollywood's Last Tycoon.* Boston, MA: Little, Brown, 1984.

Notes on Contributors

ALBERT AUSTER is an Assistant Professor of Communication at SUNY, College at New Paltz, and is coauthor with Leonard Quart of *American Film and Society Since 1945* and *How the War Was Remembered: Hollywood and Vietnam.* He has also contributed to *The Journal of Popular Film and Television, Television Quarterly,* and *Cineaste.*

DAVID BARTHOLOMEW is Film Specialist for the New York Public Library's Billy Rose Theatre Collection at Lincoln Center. Formerly he was NY Editor of *Cinefantastique* and the trade magazine, *Film Bulletin.* He is also a free-lance writer, critic, and editor, and is Acquisitions Consultant for Vestron Video and Vestron Pictures.

PETER BATES has published in *Cineaste, Jump Cut, Film Quarterly, American Book Review,* and *Radical America.* He lives in Boston where he also writes computer manuals, reviews, and short stories. He is now at work on a young adult novel.

JOHN CANEMAKER has, for more than a decade, designed and directed animation for numerous projects, including the Academy Award-winning documentary, *You Don't Have to Die,* the IBM/PBS series *The Creative Spirit,* the feature film *The World According to Garp,* and Yoko Ono's *John Lennon Sketchbook.* An internationally recognized authority on animation history, he is author of four books, including *Winsor McCay: His Life and Art, Treasures of Disney Animation Art, The Animated Raggedy Ann & Andy,* and *Felix: The Twisted Tale of the World's Most Famous Cat.* Mr. Canemaker heads the animation program at New York University's Tisch School of the Arts.

LARRY CEPLAIR teaches history at Santa Monica College and is the coauthor of *The Inquisition in Hollywood: Politics in the Film Community, 1930-1960* and author of *Under the Shadow of War: Fascism, Anti-Fascism, and Marxists, 1918-1939.*

THOMAS DOHERTY is Assistant Professor of American Studies at Brandeis University, the author of *Teenagers and Teenpics: The Juvenilization of American Movies in the 1950s,* an Associate Editor of *Cineaste,* and Contributor to *Cinefantastique.*

PAT DOWELL was a Senior Editor of *American Film* and has written film criticism for *The Washington Post, The Washington Star, In These Times, Cineaste, The Army, Navy* and *Air Force Times* and National Public Radio.

ROB EDELMAN is a Contributing Editor of Leonard Maltin's *Movie and Video Guide* and Director of Programming of Home Film Festival, which rents select videotapes by mail throughout the country. He has written for numerous publications, including *The New York Times, The Washington Post, The New York Daily News, Premiere, Variety, American Film, Cineaste, Video, The International Film Guide,* and *Filmmaker,* among many others.

PAUL ELITZIK teaches literature and writing at the School of the Art Institute of Chicago and has written film criticism for *Cineaste.*

PATRICIA ERENS is Professor of Film Studies at Rosary College in River Forest, Illinois, and the author of several books, including *The Jew in American Cinema*, and is editor of *Sexual Stratagems: The World of Women in Film* and *Issues in Feminist Film Criticism.*

MARK FINCH is the Exhibitions and Festival Director for Frameline, a San Francisco-based distributor of lesbian and gay films.

DAN GEORGAKAS is an Editor of *Cineaste* and teaches at the Harry Van Arsdale School of Labor Studies, SUNY. He is coauthor or coeditor of *The Cineaste Interviews, In Focus: A Guide to Using Films, Solidarity Forever: An Oral History of the IWW* (based on the documentary, *The Wobblies*), *The Encyclopedia of the American Left*, and the forthcoming *The Immigrant Left.*

DOUGLAS GOMERY is an Associate Professor at the University of Maryland, College Park, the author of *The Hollywood Studio System* and *Shared Pleasures: A History of Movie Presentation in the United States.*

FOSTER HIRSCH is Professor of Film at Brooklyn College of the City University of New York, and is the author of more than a dozen books, including studies of *film noir*, Woody Allen, Laurence Olivier, film acting, and the Actors Studio.

ANDREW HORTON is Professor of Film and Literature at the University of New Orleans. He has written widely for film journals in the U.S. and Europe, and is author or editor of numerous books, including *Comedy/Cinema/Theory, Modern European Filmmakers and the Art of Adaptation,* and *Inside Soviet Film Satire: Laughter with a Lash.*
He is also an award-winning screenwriter whose credits include *Something in Between* and *The Dark Side of the Sun.*

KAREN JAEHNE has written for numerous publications, including *Variety, Film Quarterly, Film Comment, Cineaste,* and *Positif.* She is coeditor of *Magill's Encyclopedia of Foreign Film,* has worked as an independent film producer, and is presently at work on a book on Greek cinema and its obsession with Greek history.

DANIEL J. LEAB is Professor of History at Seton Hall University and Managing Editor of *Labor History.* His books include *From Sambo to Superspade: The Black Image in American Film* and *A Union of Individuals: The Formation of the American Newspaper Guild.* His articles and reviews have appeared in *The New York Times Book Review, The Times Literary Supplement, The Journal of Contemporary History, Cineaste,* and *Political Science Quarterly.*

JOAN MELLEN is Professor of English at Temple University where she teaches film as well as literature. She is the author of numerous books, including *Women and Their Sexuality in the New Film, Voices from the Japanese Cinema, Big Bad Wolves: Masculinity in the American Film, The Waves at Genji's Door: Japan Through Its Cinema,* and *Bob Knight: His Own Man.* Her biography of Kay Boyle will be published in early 1994 and she is presently working on a dual biography of Lillian Hellman and Dashiell Hammett.

RICHARD PORTON is an Editor of *Cineaste* and has written for numerous other publications, including *Film Quarterly, Motion,* and *Persistence of Vision.* He is currently working on a study of the relationship between film and anarchism.

LEONARD QUART is a Professor of Cinema at the College of Staten

Island/CUNY, and the Graduate Center/CUNY, an Editor of *Cineaste*, coauthor of *How the War Was Remembered: Hollywood and Vietnam* and coauthor of the revised and expanded second edition of *American Film and Society Since 1945*.

BURNS RAUSHENBUSH is a novelist and poet and he has also written film criticism for several publications, including *Cineaste*.

MARK REID is an Associate Professor in the African-American Studies Program and the English Department at the University of California-Davis. He is the author of *Redefining Black Film* and is coeditor of *Le cinéma noir Américain*. He is currently writing a book on post-Negritude in African-American culture.

PETER ROFFMAN is coauthor, with Jim Purdy, of *The Hollywood Social Problem Film*, and has written for numerous publications, from *Cineaste* to *The Hockey News*, and is currently a Contributing Editor to *Graffiti* magazine.

LENNY RUBENSTEIN is a former longtime Editor of *Cineaste*, is coeditor of *The Cineaste Interviews*, author of *The Great Spy Films*, and a contributor to *World Film Directors* and *The Motion Picture Guide*.

THOMAS SCHATZ is Director of Graduate Studies in Radio-TV-Film at the University of Texas in Austin, the author of *Hollywood Genres: Formulas, Filmmaking and the Studio System, Old Hollywood/New Hollywood: Ritual, Art, and Industry,* and *The Genius of the System: Hollywood Filmmaking in the Studio Era,* and has written for numerous publications, including *Wide Angle, Cineaste,* and *Premiere*.

ROB SILBERMAN is Director of Film Studies and Associate Professor of Art

History at the University of Minnesota and has written on film, photography and art for numerous publications, including *Cineaste, Burlington Magazine,* and *Art in America*.

BEVERLY SIMPSON is a free-lance writer based in Toronto who has written for *The Toronto Star* and *Cineaste*.

ROBERT SKLAR is Professor of Cinema Studies at New York University, Contributing Editor of *Cineaste,* the author of several books, including *Movie-Made America: A Cultural History of American Movies, F. Scott Fitzgerald: The Last Laocöon, City Boys: Cagney, Bogart, Garfield* and *Film: An International History of the Medium,* the editor of *Prime-Time America: Life On and Behind the Television Screen* and *The Plastic Age: 1917-1930,* and has written for numerous publications, including *The New York Times Book Review, The Nation, Cineaste, Horizon, Emmy,* and *American Film.*

ANTHONY SLIDE is an independent film scholar who has authored or edited more than fifty books on the history of popular entertainment over the past twenty-three years. Among his best known works are *Early American Cinema: The Films of D.W. Griffith, The American Film Industry: A Historical Dictionary,* and *Nitrate Won't Wait: A History of Film Preservation in the United States.* He is also a filmmaker, lecturer, and editor of the Scarecrow Press Filmmakers series. In 1990, Slide received an Honorary Doctorate of Letters from Bowling Green University, at which time he was hailed by Lillian Gish as "our preeminent historian of the silent film era."

ROBERT STAM is a Professor of Cinema Studies at New York University, the author of *The Interrupted Spectacle, Reflexivity in Film and Literature,*

Subversive Pleasures: Bakhtin, Cultural Criticism and Film, the coauthor of *Brazilian Cinema*, and has written for numerous publications, including *Film Quarterly* and *Cineaste*.

DR. NANCY STEFFEN-FLUHR is Associate Professor of English at the New Jersey Institute of Technology, where she teaches a course in science fiction and science fiction film. She is presently completing a book on the films of writer-director Billy Wilder.

ANDREA WALSH is a Research Fellow at the Mary Ingraham Bunting Institute, Radcliffe College, and has previously taught at Clark University, Cornell University and State University of New

York at Binghamton. She is the author of *Women's Film and Female Experience, 1940-1950* and has written widely on film, television, aging, and popular culture.

JIM WELSH, an Associate Professor of English at Salisbury State University in Maryland, edits *Literature/Film Quarterly*, now in its twenty-first year of continuous publication. He is the author of *Peter Watkins: A Guide to References and Resources* and coauthor of *Abel Gance* and *His Majesty the American: The Cinema of Douglas Fairbanks, Sr.*

R. T. WEST is a free-lance writer living in Oregon.

Index, Names

Adair, Peter, 176
Adjani, Isabelle, 488
Adler, Nathan, 135
Agee, James, 19, 190, 279, 500
Akerman, Chantal, 83
Alda, Alan, 266
Aldrich, Robert, 340-341, 459
Alexander, Jane, 348
Allegret, Yves, 21
Allen, Woody, 9-12, 81, 219-221, 248, 265-266, 348, 388, 435, 486
Allyson, June, 485, 490
Alter, Robert, 219
Althusser, Louis, 79
Altman, Robert, 13, 16, 184, 204, 264, 305, 351, 461, 470, 472
Ameche, Don, 62, 416
Ames, Leon, 287
Anderson, Judith, 173
Anderson, Madeline, 5-6
Andersson, Bibi, 273
Andrews, Dana, 139, 209
Angelopoulos, Theodoros, 315
Anger, Kenneth, 173

Araki, Gregg, 177
Arkin, Alan, 461
Arlen, Richard, 62
Arliss, George, 36, 217
Armstrong, Robert, 96
Arnold, Edward, 36, 50, 53, 131, 323, 325
Arquette, Rosanna, 360
Arthur, George K., 172
Arthur, Jean, 325
Arzner, Dorothy, 263, 484, 487
Ashby, Hal, 436, 447
Asner, Ed, 255
Assante, Armand, 255
Astaire, Fred, 86, 278, 282-287
Astruc, Alexandre, 31
Atkinson, Brooks, 170
Autant-Lara, Claude, 21
Avalon, Frankie, 227
Avildsen, John, 415
Axelrod, George, 155
Baby Peggy, 60
Bacall, Lauren, 266
Bacharach, Burt, 215
Bacon, Lloyd, 62, 285

Baker, Joe Don, 398
Bakhtin, Mikhail, 83
Bakshi, Ralph, 221
Ball, Lucille, 351, 491
Balsam, Martin, 100
Bancroft, Anne, 223, 261, 298, 485, 491, 495
Bankhead, Tallulah, 212
Barry, Joan, 58
Barrymore, Lionel, 36, 53, 397
Barthes, Roland, 76, 182
Barzman, Ben, 218
Bates, Alan, 158, 252
Baudry, Jean-Louis, 79
Baudry, Pierre, 76
Baxter, Anne, 264
Baxter, Warner, 281
Bazin, André, 17, 31, 74, 178, 204
Beatles, 290
Beatty, Warren, 14, 99, 272, 304, 316, 318, 351
Beckett, Scotty, 61
Bedelia, Bonnie, 331
Beeson, Constance, 174
Bel Geddes, Barbara, 490
Belton, John, 191
Beltran, Robert, 477
Belushi, Jim, 230
Benjamin, Richard, 219, 265, 436
Bennett, Joan, 263, 310
Benny, Jack, 410
Berenger, Tom, 419, 452
Bergman, Ingmar, 152, 264, 362
Bergman, Ingrid, 62, 320, 409, 483
Berkeley, Busby, 281, 284-285
Berman, Lionel, 160, 424
Berman, Pandro, 215
Bernardi, Herschel, 348
Bernstein, Elmer, 215
Bernstein, Walter, 348, 435
Bertolucci, Bernardo, 315
Bessie, Alvah, 198, 438
Best, Willie, 308
Biberman, Herbert, 198, 431, 438
Blackton, J. Stuart, 369, 392
Blakely, Susan, 133
Blankfort, Michael, 260
Blitzstein, Marc, 162, 425
Bloom, Verna, 477
Blore, Eric, 173, 282
Blue, Carroll, 6
Bluth, Don, 221
Boardman, Eleanor, 444
Boetticher, Budd, 183, 304
Bogarde, Dirk, 252
Bogart, Humphrey, 64, 97-99, 138-139, 225, 366, 396, 408-409, 457
Bogdanovich, Peter, 290
Bogosian, Eric, 418

Boisset, Yves, 315
Bolger, Ray, 285
Bologna, Joe, 436
Bonaduce, Danny, 61
Bond, Ward, 148, 151
Bonet, Lisa, 46
Borden, Lizzie, 384
Bourdieu, Pierre, 76
Bourne, St. Clair, 5
Bow, Clara, 175, 298
Boyer, Charles, 483
Brando, Marlon, 89, 99, 132, 167, 227, 233, 235, 255, 289, 304-306, 327, 342-344, 354, 399, 448-449, 482
Braudy, Leo, 85, 182
Brecht, Bertolt, 80, 438
Brice, Fanny, 279
Bridges, Jeff, 39, 92, 494
Bridges, Todd, 61
Briggs, Joe Bob, 121
Broderick, Matthew, 256
Bronson, Charles, 298
Brooks, Albert, 437
Brooks, James L., 436
Brooks, Mel, 222, 436
Brown, Barry Alexander, 451
Brown, Jim, 45-46
Brown, Rowland, 35
Bujold, Genevieve, 125, 494
Burke, Billie, 263
Burnett, Charles, 8, 49
Burns, George, 60
Burstyn, Ellen, 386
Burton, Tim, 401
Byrne, Gabriel, 102
Caan, James, 86, 92, 454
Cage, Nicolas, 91
Cagney, James, 38, 95-98, 225, 278, 281, 286
Caine, Michael, 39
Caldwell, Erskine, 161
Candy, John, 353
Cantor, Eddie, 62, 279
Canudo, Ricciota, 75
Capra, Frank, 50-53
Cardona, Annette, 477
Carpenter, John, 207, 211, 381
Carr, Alexander, 217
Carradine, John, 209
Carroll, Noel, 207
Cartier-Bresson, Henri, 161, 424
Cassavetes, John, 264, 308, 347, 359
Cassidy, Hopalong, 470, 482
Chabrol, Claude, 32
Chandler, Jeff, 165, 296
Chapin, Lauren, 61
Chaplin, Charles, 54-59, 129, 217, 403, 446
Charbonneau, Patricia, 492

Charisse, Cyd, 298
Chayefsky, Paddy, 435
Chenzira, Ayoka, 6
Cher, 491, 495
Chevalier, Maurice, 280
Christie, Julie, 14, 252, 264, 474
Christopher, Dennis, 453
Ciment, Michel, 254
Cimino, Michael, 64-65, 152, 275, 418, 447, 460
Clark, Bob, 211, 415
Clark, Susan, 126
Clayburgh, Jill, 264
Clement, René, 21
Clift, Montgomery, 123, 167, 263, 342, 344-346, 466, 470-471
Close, Glenn, 265, 494-495
Clouzot, Henri-Georges, 21
Clurman, Harold, 170, 424
Cobb, Lee J., 99, 327
Coburn, Charles, 36
Cogley, John, 198
Cohen, Larry, 121, 380
Cohn, Harry, 202, 215
Colbert, Claudette, 51, 263, 350, 483, 490
Cole, Lester, 31, 198, 438
Coleman, Gary, 61
Collins, Kathleen, 7
Collins, Richard, 67, 438
Comden, Betty, 287, 433
Comolli, Jean-Louis, 78-79
Connery, Sean, 256, 276, 411
Coogan, Jackie, 60, 62
Cooper, Chris, 361
Cooper, Gary, 52, 124, 153, 241, 263, 298, 344, 350, 396, 471-472
Cooper, Meriam, 202-203
Cooper, Miriam, 192
Coppola, Francis Ford, 85-93, 204, 229, 275, 460
Corman, Roger, 85, 206, 274, 354, 359, 374
Cosby, Bill, 46
Cosmatos, George Pan, 415
Costa-Gavras, 313-314, 316, 320-322, 399, 486
Costner, Kevin, 101, 299, 317, 345, 422
Coutard, Raoul, 313
Crawford, Broderick, 323, 326
Crawford, Cheryl, 424
Crawford, Joan, 96, 212, 484, 486
Cronenberg, David, 211, 377, 382
Crosby, Bing, 131, 289, 350
Crouse, Lindsay, 64
Crowther, Bosley, 19, 29, 326, 498
Cruise, Tom, 387
Cukor, George, 215, 484, 486, 492
Cummins, Peggy, 98
Curtis, Tony, 99, 308
Cushing, Peter, 208
Da Silva, Howard, 162

Dafoe, Willem, 387, 452
Dailey, Dan, 288
Daley, Robert, 257
Dalton, Darren, 90
Daly, Tyne, 126
Dane, Karl, 456
Daniels, Jeff, 400
Danning, Sybil, 341
Danson, Ted, 266
Dante, Joe, 403
Darro, Frankie, 225
Darwell, Jane, 343, 353, 489
Dash, Julie, 7
Dassin, Jules, 137, 340
Davidson, Max, 217
Davis, Bette, 132, 212, 263-264, 409, 484-486, 489, 491
Davis, Geena, 345, 349
Davis, Joan, 62
Davis, Ossie, 8, 46, 247, 331
Davis, Peter, 451
Day, Doris, 264, 266
De Antonio, Emile, 103-107, 451
De Havilland, Olivia, 212, 271, 485, 490-491
De l'Iglesia, Eloy, 176
De Laurentiis, Dino, 446
De Lauretis, Teresa, 82
De Mille, Cecil B., 148
De Niro, Robert, 64, 101-102, 167, 265, 290, 311, 345, 348, 365, 385-386, 388, 460
De Palma, Brian, 108-110, 212
De Rochemont, Louis, 27, 30
De Saussure, Ferdinand, 75
Dean, James, 167, 227, 230, 342-344, 398
DeCarlo, Yvonne, 416
Dehn, Paul, 411-412
Deitch, Donna, 492, 494
Delluc, Louis, 75
Derek, John, 226
Deren, Maya, 174
Dern, Bruce, 159, 312, 450
Dern, Laura, 400
Devane, William, 450
Dickinson, Angie, 448
Diller, Barry, 72
Dillon, Matt, 90, 229-230, 345
Disney, Roy, 113-114
Disney, Walt, 62, 110-115, 200, 285, 403, 405, 426, 497-498, 500
Dixon, Thomas, 115-117, 337
Dmytryk, Edward, 137, 194, 431, 439
Doane, Mary Ann, 82-83
Doherty, Thomas, 119, 248
Donen, Stanley, 183, 284, 287
Donleavy, Brian, 427
Douglas, Kirk, 156, 218, 238, 416
Douglas, Michael, 39, 171, 329, 422, 436

Dourif, Brad, 272
Dreyfuss, Richard, 219, 404
Driscoll, Bobby, 60-63
Duke, Bill, 247
Dumont, Margaret, 268-269
Dunaway, Faye, 99, 351, 435
Dunne, Griffin, 387
Dunne, Irene, 483-484, 490
Dunne, Philip, 242, 260
Duras, Marguerite, 83
Durbin, Deanna, 132, 284
Durgnat, Raymond, 18
Duvall, Robert, 231, 449
Dwan, Allan, 149
Dyer, Richard, 173, 176
Eastwood, Clint, 64, 123, 128, 184, 322, 450, 464, 466, 469, 471
Ebert, Roger, 49
Eco, Umberto, 75
Eddy, Nelson, 283
Edison, Thomas, 200
Edwards, James, 308
Eisenstein, Sergei, 74, 135, 358
Eisner, Michael, 72, 115
Elkins, Stanley, 41
Ellen, Vera, 288
Elvey, Maurice, 371
Emerson, John, 35
Epstein, Phil, 215
Esmond, Car, 28
Esposito, Giancarlo, 247
Eszterhas, Joe, 171
Everson, William, 191
Ewell, Tom, 264
Fabian, 227
Fairbanks, Douglas, 34-35, 129-130, 200, 287, 298
Fanaka, Jamaa, 8
Farmer, Frances, 131-133, 273
Faye, Alice, 287
Fellowes, Edith, 61
Fetchit, Stepin, 44, 308, 359, 442, 497
Feuer, Jane, 82
Field, Sally, 331, 347-348, 400, 483, 489, 493, 495
Fields, W. C., 103
Finch, Peter, 435
Finney, Albert, 262, 266
Fischinger, Oskar, 112
Fishburne, Larry, 231
Fitzgerald, F. Scott, 365-366, 446
Flaherty, Robert, 144-146
Fletcher, Louise, 272, 345
Flicker, Theodore J., 378
Flitterman, Sandy, 82
Flynn, Errol, 167, 287, 294, 457
Fonda, Henry, 123, 140, 149, 183, 340, 343, 345, 353, 358, 464, 470

Fonda, Jane, 261, 305, 331, 348, 436, 450, 483, 492, 495
Fontaine, Richard, 174
Ford, Francis, 293
Ford, Glenn, 226, 229-230
Ford, Harrison, 40, 407, 464
Ford, John, 21, 65, 147-152, 178, 181, 203, 253, 274, 294-296, 298, 302-303, 343, 353, 363-364, 397, 403-404, 417-418, 464-466, 471, 473-474, 486
Foreman, Carl, 153-154, 215, 218, 236, 459
Forster, Robert, 434, 476
Foster, Jodie, 60, 495
Fox, Michael J., 363
Fox, William, 200, 215
Frampton, Hollis, 33
Frankenheimer, John, 155-159, 211, 311, 320, 340, 379, 434
Franklin, J. E., 8
Freed, Arthur, 203, 215, 280, 284-285, 288
Freedland, Thorton, 285
Freeman, Joseph, 135
Freeman, Morgan, 230
Freund, Karl, 206
Friedkin, William, 171, 175
Friedrich, Su, 177
Fuller, Samuel, 33, 164-166, 448
Funicello, Annette, 227
Gable, Clark, 51, 263, 350, 464
Gance, Abel, 89, 192
Garbo, Greta, 256
Garcia, Andy, 39
Gardenia, Vincent, 109
Gardies, René, 76
Garfield, John, 137-140, 167-171, 334-335, 339, 342-343, 345, 350, 396, 449
Garland, Judy, 61, 284-287, 290, 386
Garner, James, 348
Garrett, Betty, 288
George, Dan, 299, 306
George, Susan, 303
Gere, Richard, 40, 91, 342, 346, 364
Gerima, Haile, 7-8
Gershwin, George, 282, 286
Getino, Octavio, 33
Gibson, Mel, 49, 488
Gilbert, John, 443-444, 456
Gilliam, Terry, 185-189, 383
Gilliat, Sidney, 409
Glass, Philip, 364
Glover, Danny, 47, 49, 485
Godard, Jean-Luc, 20, 80, 83, 305
Goddard, Paulette, 57, 298, 350
Goetz, William, 215
Gold, Mike, 244
Goldberg, Whoopi, 47, 49, 483, 485, 495
Goldman, William, 215

Goldstein, Robert, 393
Goldwyn, Samuel, 194, 215, 225
Golino, Valeria, 159
Gossett, Jr., Louis, 47
Gough, Lloyd, 348
Gould, Elliott, 13-14, 219
Grant, Cary, 36, 98, 131, 140, 320, 399, 492
Gray, Billy, 61
Greaves, William, 5
Green, Adolph, 287, 433
Greene, Graham, 148, 282-283, 320, 408, 412, 448
Greenstreet, Sydney, 141, 143
Grey, Joel, 290
Griem, Helmut, 290
Grier, Pam, 46
Grierson, John, 19, 31, 144-145
Griffith, Andy, 367, 434
Griffith, David Wark, 190-193
Griffith, Melanie, 40, 400
Griffith, Richard, 19, 23
Grote, Alexandra von, 176
Guardino, Harry, 100
Gunn, Bill, 7
Guthrie, Arlo, 228, 306
Hackman, Gene, 88, 451, 453
Haley, Jack, 285
Hall, Anthony Michael, 401
Halperin, Victor, 210
Hamer, Rusty, 61
Hamlin, Harry, 176
Hamlisch, Marvin, 215
Hammer, Barbara, 174
Hanet, Kari, 76
Hannah, Daryl, 400, 421
Harryhausen, Ray, 209
Hart, William S., 470, 475
Harvey, Laurence, 155, 311
Haskell, Molly, 82, 183, 262, 484
Hawkins, Jack, 410
Hawks, Howard, 97, 132, 139, 202, 271, 418, 464, 466, 473, 492
Hawn, Goldie, 222
Hayden, Sterling, 195
Hayes, Gabby, 470
Haynes, Todd, 177
Hayworth, Rita, 358
Heath, Stephen, 76, 78, 80
Hecht, Ben, 203, 214-215, 217, 324, 328
Hellman, Lillian, 199, 218, 305, 492
Hellman, Monte, 352
Hepburn, Audrey, 175, 263
Hepburn, Katharine, 173, 241, 255, 263, 399, 484-486, 491-492, 495
Herrmann, Bernard, 215
Hersholt, Jean, 96
Hickman, Darryl, 61

Hill, Walter, 228
Hines, Gregory, 47
Hirsch, Judd, 256
Hitchcock, Alfred, 271, 404, 409-410, 417
Hoffman, Dustin, 219, 256, 262, 265, 303, 306, 332-333, 436
Holden, William, 125, 301, 326, 398, 435, 459
Holliday, Judy, 38, 218, 493
Hollinshead, Jr., Richard M., 118
Hood, Darla, 60
Hooper, Tobe, 403
Hope, Bob, 327, 350, 410
Hopper, Dennis, 91, 231, 352, 400-401
Hopper, Hedda. 468
Horne, Lena, 44
Horton, Edward Everett, 173, 282
Howard, Trevor, 299
Howe, James Wong, 158
Howell, C. Thomas, 90
Hubley, Season, 362
Hudson, Rock, 158, 264, 266, 489
Hughes, Howard, 26, 200, 202, 204
Hughes, John, 16, 353
Hunter, Holly, 437, 495
Hunter, Jeffrey, 387
Hunter, Tab, 227
Hunter, Tim, 230
Huppert, Isabelle, 253
Hurwitz, Leo, 135, 160, 162, 424
Huston, Anjelica, 92
Huston, John, 128, 137, 143, 203, 271, 275
Huston, Walter, 34, 36-37, 39, 51, 96, 324
Ice-T, 443
Ince, Thomas, 293, 393, 456
Iscovescu, Georges, 478
Iwerks, Ub, 111
Jackson, Kate, 175
Jackson, Samuel L., 247
Jacobs, Lewis, 19, 34, 135
Jaffe, Sam, 215
Jarrico, Paul, 67, 481
Jerome, V. J., 67
Jessel, George, 217
Johnson, Don, 155, 158-159
Johnson, George, 3
Johnson, Noble, 3
Johnson, Van, 62, 449
Johnston, Eric, 194
Jolson, Al, 279, 283
Jones, Anissa, 61
Jones, James Earl, 276, 348
Jones, Marcia Mae, 61
Jourdan, Louis, 487
Julien, Isaac, 176
Jurado, Katy, 473
Kael, Pauline, 17, 23, 28, 32, 46, 126, 303, 488
Kahn, Gordon, 195, 439

Kalin, Tom, 177
Kanfer, Stefan, 198
Kanin, Garson, 215
Kanin, Michael, 241
Kaplan, Jonathan, 228
Karger, Maxwell, 370
Karloff, Boris, 206, 209, 211, 372
Karlson, Phil, 398
Kasdan, Lawrence, 152, 256
Katzenberg, Jeffrey, 72
Kaye, Danny, 218
Kazan, Elia, 153, 161, 232-235, 272, 304, 327, 367, 424, 431, 434, 489
Kazan, Lainie, 223
Keaton, Buster, 21, 55, 145
Keaton, Diane, 10, 401, 488, 495
Keeler, Ruby, 281
Keene, Tom, 445
Keitel, Harvey, 385, 387
Keith, Brian, 166
Keller, Marthe, 159
Kelljan, Bob, 208
Kelly, Gene, 183, 218, 284, 286-289
Kelly, Grace, 153, 473
Kempton, Murray, 198
Kenton, Eric, 371
Kern, Jerome, 279, 286, 356
Kibbee, Guy, 325
Kidd, Michael, 288
Kilmer, Val, 346, 421
King, Charles, 280
King, Henry, 390-391, 484
King, Jr., Woodie, 5-6, 8
King, Perry, 229
King, Stephen, 239, 382
Kline, Herbert, 161
Kline, Kevin, 265-266, 471
Knight, Shirley, 86
Koch, Howard, 195, 439
Koningsberger, Hans, 315
Korda, Alexander, 200, 357
Kotto, Yaphet, 47
Kracauer, Siegfried, 23-24, 74
Kramer, Stanley, 45, 235-236, 418
Kristofferson, Kris, 65, 354, 386
Kubrick, Stanley, 215, 228, 237-240, 288, 447, 461-462
Kuchar, George, 174
Kuntzel, Thierry, 76
Kurosawa, Akira, 123, 474
La Cava, Gregory, 22
Ladd, Alan, 62, 139, 141, 448
Ladd, Cheryl, 453
Laemmle, Carl, 200, 215
Lahr, Bert, 285
Lahti, Christine, 256
Lake, Veronica, 142, 448

Lamour, Dorothy, 350
Lampson, Mary, 106
Lancaster, Burt, 156-158, 298, 316-317, 330-331, 340, 451, 460
Landis, John, 416
Lane, Diane, 90-91
Lang, Fritz, 32, 43, 139, 250, 310, 321, 339, 341, 343, 370, 397, 408, 411
Langdon, Harry, 51, 55
Lange, Jessica, 133, 489, 495
Lansbury, Angela, 155-156, 311
Lardner, Jr., Ring, 67, 137, 194, 197-198, 241-242, 253, 431, 439, 461
Larkin, Alile Sharon, 7-8
Lasky, Jesse, 215
Laughton, Charles, 358
Launder, Frank, 409
Lawford, Peter, 485
Lawson, John Howard, 197, 243-244, 439
Lean, David, 219
Lee, Canada, 170
Lee, Christopher, 208
Lee, Joie, 247
Lee, Spike, 8, 48, 223, 245-249, 249, 309, 318, 362, 441-442
Leigh, Vivien, 235
Leighton, Margaret, 252
Leisen, Mitchell, 484, 486, 490, 493
Lemmon, Jack, 38, 99, 320
Lenz, Kay, 125
Leone, Sergio, 123, 222, 245, 331, 474
LeRoy, Mervyn, 96-97, 249-252, 446, 501
Leslie, Joan, 97
Lester, Richard, 462
Lévi-Strauss, Claude, 181
Levinson, Barry, 220-221
Lewton, Val, 202-203, 206, 212
Leyda, Jay, 19, 161, 252
Lincoln, Abbey, 308
Linn-Baker, Mark, 436
Liotta, Ray, 102, 388
Litvak, Anatole, 215, 271
Lloyd, Emily, 453
Locke, Sondra, 125-126, 470
Loew, Marcus, 202, 215
Loos, Anita, 35
Lorentz, Pare, 162, 424
Losey, Joseph, 137, 154, 218, 252-254
Love, Bessie, 280
Loy, Myrna, 62
Lubitsch, Ernst, 215, 279, 487
Lucas, George, 204, 274, 379, 389, 403, 407
Lukas, Paul, 409
Lumet, Sidney, 22, 255-257, 435
Lund, John, 490
Lupino, Ida, 97, 484
Lye, Len, 112

Lynch, David, 400
MacCabe, Colin, 78, 80
Macchio, Ralph, 90
MacDonald, Jeanette, 283
Macdonald, Dwight, 19, 21, 334
MacLachlan, Kyle, 400
MacLaine, Shirley, 124, 175, 400, 485, 491
MacMurray, Fred, 140
Macy, Bill, 436
Maddow, Ben, 160, 162, 218, 424-425
Magnani, Anna, 255
Maio, Kathi, 492
Malick, Terence, 351
Malmuth, Bruce, 415
Maltin, Leonard, 61
Maltz, Albert, 68-69, 137, 241, 258-260, 431, 439
Mamet, David, 109
Mamoulian, Rouben, 279-280, 371
Mankiewicz, Herman, 215
Mann, Anthony, 183, 304
March, Fredric, 37-38, 156
Markopoulos, Gregory, 173
Marsh, Mae, 192
Marshall, E. G., 305
Marshall, William, 208
Marx Brothers, 267-269
Martin, Steve, 353
Marvin, Lee, 165-166
Mason, James, 410
Matlin, Marlee, 495
Mature, Victor, 183
Mayer, Louis B., 43, 194, 202, 215, 288
Mayron, Melanie, 492
Mazursky, Paul, 220-221
McCarthy, Andrew, 159
McCrea, Joel, 225, 231, 350, 426
McDaniel, Hattie, 43, 308-309, 495
McDonnell, Mary, 362
McDowell, Curt, 174
McDowell, Malcolm, 228
McGillis, Kelly, 495
McGovern, John, 272
McGraw, Allie, 302
McKee, Lonette, 46
McLaglen, Victor, 448
McLaughlin, Sheila, 133
McQueen, Butterfly, 442, 495
Mead, Taylor, 174
Melies, Georges, 206
Melnick, Daniel, 291
Merrill, Dina, 157
Merrill, Gary, 263
Metz, Christian, 75, 182
Meyers, Sidney, 160, 424
Micheaux, Oscar, 4-5, 246, 356
Michelson, Annette, 19
Midler, Bette, 222-223

Miles, Vera, 473
Miles, William, 5-6
Milestone, Lewis, 253, 439, 456, 458-459
Milius, John, 89, 274-278
Milland, Ray, 140, 326
Miller, Ann, 288, 491
Miller, David, 317, 412
Miller, Marilyn, 279
Mineo, Sal, 173, 227
Minnelli, Liza, 290, 386
Minnelli, Vincente, 284, 287
Mitchell, Thomas, 169, 475
Mitchum, Robert, 353, 364
Mix, Tom, 469-471
Monaco, James, 363
Monroe, Marilyn, 38, 99, 263
Montand, Yves, 38, 254, 313-314, 320
Moreland, Mantan, 309
Morgan, Helen, 279
Moriarty, Michael, 451
Morrow, Vic, 60, 226
Morton, Joe, 360-361
Mostel, Zero, 218, 348
Mulvey, Laura, 82-83
Muni, Paul, 95, 218, 249, 339, 350
Munshin, Jules, 288
Murdoch, Rupert, 72
Murphy, Audie, 298
Murphy, Eddie, 48
Murphy, Mary, 227, 399
Murphy, Michael, 264, 420
Murray, Don, 264
Murray, James, 444-445
Nelson, Judd, 443
Newman, Alfred, 215, 487
Newman, Paul, 275, 304, 329, 331, 340, 344-345, 387
Niblo, Fred, 394
Nichols, Bill, 104
Nichols, Dudley, 310
Nicholson, Jack, 101, 167, 239, 265, 272, 306, 342, 345
Noiret, Philippe, 312
Nolan, Lloyd, 98
Nolte, Nick, 39, 255, 341, 388, 451
Norris, Chuck, 47, 452
Nowell-Smith, Geoffrey, 33
Nunn, Bill, 247
O'Brien, Margaret, 62, 287
O'Brien, Pat, 95, 102, 225
O'Brien, Tom, 456
O'Hara, Maureen, 263, 404, 465
O'Sullivan, Maureen, 268
O'Toole, Peter, 436
Oates, Warren, 303
Oberon, Merle, 487
Oboler, Arch, 372

Odets, Clifford, 132, 170
Olin, Lena, 332
Olmos, Edward James, 230
Ornitz, Samuel, 439
Ottinger, Ulrike, 176
Ozu, Yasujiro, 364
Pabst, G. W., 270
Pacino, Al, 34, 100-101, 167
Page, Anita, 280
Page, Geraldine, 125, 399
Pakula, Alan, 320, 412
Palance, Jack, 416, 473
Pangborn, Franklin, 173
Parker, Alan, 417
Parkerson, Michelle, 6
Parks, Larry, 440, 468
Parks, Sr., Gordon, 7
Pasolini, Pier Paolo, 75
Passeron, Jean-Claude, 76
Patten, Luana, 62
Peck, Gregory, 344, 434
Peckinpah, Sam, 124, 300-304, 354
Penley, Constance, 83
Penn, Arthur, 184, 228, 304-306, 351, 398
Penn, Sean, 101, 229, 231
Perkins, Tony, 272
Pesci, Joe, 102
Peters, Bernadette, 128
Peters, Jean, 98, 166
Pichel, Irving, 440
Pickford, Mary, 129-130, 200, 298, 393
Pidgeon, Walter, 310, 467
Plato, Dana, 61
Platt, David, 135
Pleynet, Marcelin, 79
Poe, James, 459
Poitier, Sidney, 45, 48, 307-309, 347, 359
Polanski, Roman, 212, 273
Pollack, Sydney, 215, 320, 330-333, 412, 436
Polonsky, Abraham, 137-138, 141, 197, 333-336
Pontecorvo, Gillo, 314
Porter, Cole, 282, 286
Potamkin, Harry Alan, 135, 336-337
Powell, Dick, 141, 427
Power, Tyrone, 27, 298
Praunheim, Rosa von, 176
Preminger, Otto, 215, 218, 260, 430
Presley, Elvis, 227, 290, 298
Price, Vincent, 211
Prochnow, Jurgen, 158
Pryor, Richard, 48
Puzo, Mario, 86-87
Quarry, Robert, 208
Rabe, David, 15, 109
Raft, George, 95, 99
Rainer, Luise, 132
Rainer, Yvonne, 83

Rains, Claude, 250, 320, 325
Randolph, John, 158
Ray, Satyajit, 22
Reagan, Ronald, 72, 127, 322, 329-330, 414-415, 420
Redford, Robert, 275, 305, 330-332, 354
Redgrave, Vanessa, 483, 492
Reed, Carol, 320
Reed, Oliver, 312
Reichert, William, 320
Reisz, Karel, 28
Renoir, Jean, 107
Resnais, Alain, 254, 313
Rettig, Tommy, 61
Revueltas, Rosaura, 25
Reynolds, Burt, 184, 340, 354, 448
Reynolds, Debbie, 264
Rich, Matty, 9, 49
Richards, Jeffrey, 149
Rickman, Alan, 464
Riefenstahl, Leni, 190
Rigg, Diana, 312
Rimbaldi, Carlo, 405
Rintels, David, 411
Riskin, Robert, 51, 203
Ritt, Martin, 12, 347-348, 411, 435, 493
Ritter, Thelma, 164
Rivette, Jacques, 20
Roach, Hal, 51
Robbins, Jerome, 288-289
Robertson, Cliff, 166, 272
Robeson, Paul, 44, 59, 162, 355-359, 425
Robinson, Andy, 126-127
Robinson, Bill, 43
Robinson, Bruce, 488
Robinson, Chris, 451
Robinson, Earl, 161
Robinson, Edward G., 35, 95, 97, 99, 138, 141, 149, 179, 195, 358
Rocha, Glauber, 33, 76
Rodakiewicz, Henwar, 424
Rogers, Ginger, 280-282, 284-285, 358, 491, 493
Rohmer, Eric, 20, 32
Rollins, Jr., Howard, 47
Romero, Cesar, 358
Romero, George, 121, 184, 207-208, 211, 376
Rooney, Mickey, 61, 286, 375, 396, 402
Rosenberg, Stuart, 340-341
Ross, Herbert, 80
Ross, Katharine, 298
Ross, Steven J., 71
Rossellini, Isabella, 400
Rossen, Robert, 250-251, 334, 440
Rotha, Paul, 19
Roundtree, Richard, 47-48
Rourke, Mickey, 64-65, 90, 450
Rowlands, Gena, 363

Rozema, Patricia, 494
Rozsa, Miklos, 215
Rubbo, Michael, 451
Rubin, Benny, 217
Ruiz, Raul, 83
Russell, Gail, 465
Russell, Harold, 449
Russell, Kurt, 416
Russell, Rosalind, 263-264, 399, 492
Russo, Vito, 172, 175-176
Ryan, Meg, 421
Ryan, Robert, 141, 165, 316
Ryder, Winona, 230, 400
Salt, Waldo, 195, 440
Sandler, Barry, 175
Sandrich, Mark, 285
Sarandon, Susan, 345, 349
Sarris, Andrew, 17, 31-32, 43, 257
Savalas, Telly, 312, 331
Sayles, John, 359-362, 379
Schaffner, Franklin, 460
Schary, Dore, 194, 215, 218, 252, 440
Scheider, Roy, 158, 291, 407, 447
Schenck, Nicholas, 202, 446
Schickel, Richard, 190, 446
Schlesinger, John, 354
Schneer, Charles, 209
Schrader, Paul, 362-365, 386
Schulberg, B. P., 215, 365
Schulberg, Budd, 67, 153, 234-235, 327, 365-368, 434
Schultz, Michael, 48-49
Schwarzenegger, Arnold, 383
Sciorra, Annabella, 247
Scofield, Paul, 158
Scorsese, Martin, 65, 102, 184, 290, 354, 365, 385, 388-389, 407
Scott, Adrian, 194, 440
Scott, George C., 240, 309, 362, 460
Scott, Ridley, 349
Seagal, Steven, 450
Seberg, Jean, 272
Segal, George, 219, 264
Seidelman, Susan, 384, 494-495
Selleck, Tom, 341
Sellers, Peter, 436
Seltzer, Leo, 135
Selznick, David O., 200
Semprun, Jorge, 254, 313, 315
Sennett, Mack, 51, 354
Shaver, Helen, 492
Sheen, Charlie, 39, 128, 418, 452
Sheen, Martin, 89, 106, 351, 422
Shelley, Joshua, 348
Shelton, Ron, 329
Shields, Brooke, 60
Shub, Esther, 135

Sidney, George, 217, 284
Sidney, Sylvia, 225, 323, 339, 395
Siegel, Don, 125-126, 183, 340, 374
Silber, Glenn, 451
Silver, Joan Micklin, 222, 494, 263, 271
Silverman, Kaja, 82
Simmons, Jean, 289
Simon, Neil, 220-221, 414
Sinatra, Frank, 100, 102, 154, 156, 175, 260, 284, 288-289, 311, 360
Singleton, John, 9, 49, 231, 247
Sirk, Douglas, 33, 183, 484, 487, 489
Slater, Christian, 230
Smith, George, 369
Smith, Maggie, 263
Snipes, Wesley, 247-248, 443
Snodgress, Carrie, 470
Snow, Michael, 33
Snowflake, 309
Solanas, Fernando, 33
Solinas, Franco, 314
Southern, Terry, 242, 462
Spacek, Sissy, 351, 421, 489, 493, 495
Spader, James, 223
Spano, Vincent, 360
Spiegel, Sam, 215
Spielberg, Steven, 16, 47, 215, 351, 389, 402,-407, 417, 494
St. James, Susan, 453
Stallone, Sylvester, 127, 184, 341, 344, 413-416, 450
Stanwyck, Barbara, 142, 264, 489-491
Steiger, Rod, 166, 308, 312
Steinbeck, John, 233, 350, 353, 366, 502
Steiner, Max, 215, 487
Steiner, Ralph, 135, 161, 424
Stepanek, Karel, 28
Stevens, Mark, 62
Stewart, James, 36, 39, 52, 123, 167, 296, 325, 397, 464, 470, 473
Stone, Oliver, 317, 417-422, 447, 462
Strand, Paul, 160, 162, 423-425
Streep, Meryl, 265, 332, 493, 495
Streisand, Barbra, 219, 222, 291, 331
Strode, Woody, 45
Sturges, John, 377
Sturges, Preston, 202, 350, 426-428
Suber, Howard, 198
Sutherland, Donald, 13, 341, 416, 461
Sutton, Grady, 172
Talmadge, Norma, 393
Tandy, Jessica, 222
Tanner, Alain, 80
Tashlin, Frank, 183, 497
Tavernier, Bertrand, 335
Taylor, Elizabeth, 61, 264, 449
Taylor, Robert, 98-99, 296

Taylor, Rod, 263, 312
Temple, Shirley, 44, 61-62, 281-282, 285, 483
Thalberg, Irving, 202, 215, 268, 402, 407, 446
Thomas, Bob, 63, 114
Thomas, Danny, 61
Thompson, Marshall, 448
Tillman, Lynne, 133
Tourneur, Jacques, 206, 212
Tover, Leo, 271
Towers, Constance, 166
Townsend, Robert, 8-9, 49
Tracy, Spencer, 96, 241, 293, 339, 396, 398, 485, 493
Travers, Henry, 397
Travolta, John, 291, 344
Treut, Monika, 176
Trevor, Claire, 465, 475
Trilling, Lionel, 18, 20, 238
Trintignant, Jean-Louis, 313
Trumbo, Dalton, 137, 154, 199, 238, 253, 260, 316, 429-431, 435, 440, 482
Turner, Kathleen, 91, 101
Turner, Lana, 142, 169, 350
Turner, Tina, 46
Turturro, John, 247
Tyson, Cicely, 46, 309
Van Cleef, Lee, 124, 448
Van Dyke, Willard, 161, 252, 424
Van Peebles, Mario, 9, 49, 443
Van Peebles, Melvin, 8-9, 309, 441-443
Vaughn, Robert, 198
Veidt, Conrad, 172
Verhoeven, Paul, 171
Vertov, Dziga, 134
Vidor, King, 35, 37, 252, 280, 396, 443-446, 456, 484, 490
Voight, Jon, 315, 450, 461
Wahl, Ken, 453
Walken, Christopher, 102
Walker, Robert, 29, 173
Wallis, Hal B., 202
Walsh, Raoul, 274, 338
Wanger, Walter, 200
Wanger, William, 215
Warden, Jack, 347
Warner, Harry, 202, 279
Warshow, Robert, 19, 29, 95-96, 99, 150, 179-180, 472
Washington, Denzel, 247-248
Waters, Ethel, 358, 495
Waters, John, 174
Watkins, Peter, 379

Watson, James Sibley, 174
Watts, Jr., Richard, 170
Waxman, Franz, 487
Wayne, David, 173, 264
Wayne, John, 29, 123-124, 127-128, 139, 147, 150, 152, 167, 183, 263, 266, 296, 404, 413, 447-448, 452, 457-458, 460, 463-468, 469-472, 474-475, 477
Weathers, Carl, 47
Weaver, Sigourney, 40, 384, 483, 488, 493, 495
Weber, Lois, 392
Weber, Melville, 174
Weill, Claudia, 492, 494
Weiss, Andrea, 173, 176
Welles, Orson, 34, 37, 143, 202, 382
Wellman, William, 97
Wenders, Wim, 89
West, Mae, 261-262
Wexler, Haskell, 106, 361, 434, 476-477
Widmark, Richard, 98, 141, 150, 164, 166, 307
Wilder, Billy, 38, 183, 202, 215, 459, 478-480
Williams, Bert, 42
Williams, Billy Dee, 47
Williams, Robin, 188, 453
Williams, Spencer, 5
Williams, Tennessee, 232, 305, 399
Willingham, Calder, 306
Willis, Bruce, 453, 464
Wilson, Michael, 154, 431, 480-482
Winfrey, Oprah, 495
Winger, Debra. 346, 491, 495
Winkler, Irwin, 335
Winner, Michael, 411
Winters, Shelley, 209, 331
Wiseman, Joseph, 411
Wollen, Peter, 33, 76, 80
Wolper, David L., 312
Wood, Natalie, 61, 218, 227, 272, 331, 465, 473
Woodard, Alfre, 362
Wyler, William, 64, 132, 215, 275, 491
Wyman, Jane, 72, 489
Yeager, Barton, 135
York, Michael, 290
Young, Loretta, 298
Young, Nedrick, 154
Zanuck, Darryl, 202, 233, 236, 251, 501-502
Zavattini, Cesare, 424
Zemeckis, Robert, 403
Zinnemann, Fred, 215, 312, 424
Zugsmith, Albert, 119
Zukor, Adolph, 200, 215

Index, Film Titles

Abraham Lincoln, 192, 323, 333
Ada, 327
Adam's Rib, 172-173, 262, 265-266, 484, 486, 492-493
Adios Amigo, 48
After Hours, 387
Agency, 381
Air Force, 457
Aircraft Carrier Landing Signals, 498
Al Capone, 98, 328
Alexander's Ragtime Band, 287
Alias Nick Beal, 326
Alice's Restaurant, 228, 305
Alice, 11
Alien Nation, 383
Alligator, 381
Always, 403-404, 407
America, 192
America, America, 234
American Gigolo, 172, 363-364
American Graffiti, 399
American Pop, 221
Americathon, 380
Anchors Aweigh, 284, 286-287
Android, 382, 384
Angel Heart, 46
Angel Unchained, 354
Animal Crackers, 268
Animal House, 246
Annie Hall, 10, 220, 266
Annie, 291
Another Woman, 11-12
Apocalypse Now, 88-89, 92, 275, 277, 420, 447, 449, 454, 460
Applause, 279-280
Arrowsmith, 147
Assignment Paris, 30
Atom Age Vampire, 378
Attack!, 459
Avalanche Express, 335
Avalon, 221, 227
Baby Boom, 401
Baby Doll, 234
Baby Face Nelson, 22
Back Street, 483-484
Bad Boys, 229, 268
Badlands, 351-352
Bananas, 9, 12, 414
Barry Lyndon, 237-239
Barton Fink, 223

Basic Instinct, 171, 176
Bat , The, 21, 453
Bataan, 98, 457-458
Batman, 317, 372, 416
Battle Circus, 459
Beach Party, 227
Beau James, 327
Bedlam, 210, 407
Before Stonewall, 176
Betrayed, 329, 399, 486
Beverly Hills Cop, 48
Big City Blues, 6
Big Fella, 358
Big Jim McLain, 410, 463, 466
Big Meat Eater, 382
Big Wednesday, 276-277
Billion Dollar Brain, 377
Billy Jack, 296
Biloxi Blues, 221
Bird, 127
Bittersweet, 283
Black Angels, 354
Black Belt Jones, 442
Blackboard Jungle, 227
Black Caesar, 442
Black Fury, 61, 135, 162
Black Girl, 8, 46, 442
Black Robe, 300
Black Sunday, 159, 220, 311-312
Black Tuesday, 340
Black Widow, 489, 495
Blacula, 208
Blade Runner, 144, 382-383
Blaze, 329
Blazing Saddles, 222, 469
Blockade, 244, 457
Blood Alley, 463
Blood Money, 35, 39
Bloodsucking Freaks, 121
Blow Job, 174
Blow Out, 109, 321
Blowup, 109, 321
Blue Collar, 363
Blue Sunshine, 380
Blue Thunder, 382, 447
Blue Velvet, 400-401
Bob & Carol & Ted & Alice, 264
Bobby Deerfield, 332
Body Double, 109
Borderline, 356

Born Yesterday, 38, 326-327
Boulevard Nights, 228
Boys Town, 229, 339, 396
Boyz N the Hood, 231
Brainstorm, 381
Bram Stoker's Dracula, 93
Brannigan, 468
Brazil, 185-189, 383
Breathless, 305, 346
Breezy, 125
Brewster McCloud, 13
Brewster's Millions, 48
Brighton Beach Memoirs, 221
Broadcast News, 436-437
Broadway Danny Rose, 11
Broadway Melody, 280, 284, 289
Broken Arrow, 260, 296-298
Broken Lullaby, 35
Bronco Billy, 127, 297
Brother Brat, 500
Brother Orchid, 97
Brubaker, 341
Brute Force, 65, 165, 340
Buck Rogers, 371
Bull Durham, 322
Bullitt, 328
Bus Stop, 264
Bush Mama, 7
Bye Bye Birdie, 227
Bye Bye Braverman, 219, 256
C.H.U.D., 382
Cabaret, 220, 290
Caged, 340
Caine Mutiny, The, 236
California Split, 14
Cannonball Run, 354
Capital vs. Labor, 390
Capone, 414
Capricorn One, 379
Captain America, 372
Captain January, 282
Captain Kronos, Vampire Hunter, 207
Captain Marvel, 372
Captain Midnight, 372
Captain Newman, M.D., 344
Captive Wild Woman, 209
Carefree, 282, 288, 354
Carnal Knowledge, 264-265
Carrie, 108, 184, 212
Casablanca, 32, 263, 332, 409, 439
Casino Royale, 412
Cat People, 203, 206, 363
Catch-22, 461
Champion, 153, 236
Charley, 272
Che!, 482
Cheyenne Autumn, 149-150, 296

Chicken Little, 498
Children's Hour, The, 175
China Gate, 448
China Strikes Back, 160-162
Chinatown, 39, 143-144
Chopping Mall, 382
Christopher Strong, 263, 484, 487
Cincinnati Kid, The, 242
Cinderella, 114
Circuitry Man, 382
Citizen Band, 354
Citizen Kane, 22, 37, 87, 151, 262, 324
City Lights, 56
Civilization, 293, 393, 456
Clara's Heart, 484
Clockwork Orange, 228
Cobra, 127, 415
Cocoon, 223, 382
Cohen's Fire Sale, 216
Colors, 231
Coma, 379, 494
Coming Home, 440, 447, 450-451, 476
Command Decision, 458
Committed, 133
Conspirator, 27
Convoy, 300-301, 303, 304, 354
Coogan's Bluff, 126, 450
Cool Hand Luke, 340-341, 344-345
Cooley High, 442
Count Yorga, 208
Countdown, 13
Countess Dracula, 212
Country, 401
Cover Girl, 287
Craig's Wife, 264, 484
Crash Dive, 458
Creepozoids, 383
Crime School, 226, 339
Crooked Banker, 35
Cross Creek, 348
Crossfire, 218, 307, 439-440
Crossing Delancey, 222, 494
Cruising, 171, 175, 407
Cutter's Way, 39
Cyrano de Bergerac, 153
Daffy Commando, 497
Dance, Girl, Dance, 263, 484
Dangerous Hours, 393-394
Daniel, 255-256
Dark Passage, 138, 140, 143
Dead End, 225, 231, 395-396, 398
Dead Men Don't Wear Plaid, 144
Dead-Bang, 155, 158-159
Dear America, 451
Death Race 2000, 380, 414
Death Wish, 229, 331, 421
Deathtrap, 255

December 7, 147
Decision Before Dawn, 459
Deliverance, 262
Dementia 13, 85
Demon Seed, 379, 381
Der Fuehrer's Face, 499
Desert Hearts, 172, 176, 492
Desperate Hours, 64
Desperately Seeking Susan, 486, 495
Destination Moon, 372
Destination Tokyo, 259
Destry, 303
Detective Story, 141, 421
Devil's Eight, 274
Diamond Jim, 428
Dick Tracy, 371
Die Hard, 464
Dillinger, 275-276
Dimension 5, 376
Diner, 221
Diplomatic Courier, 27
Dirty Dancing, 222
Dirty Harry, 126-127, 275, 322, 415
Dirty Mary, Crazy Larry, 351
Dive Bomber, 457
Do the Right Thing, 245
Dog Day Afternoon, 22, 256-257
Dog Soldiers, 451
Donald's Better Self, 498
Donovan's Brain, 210, 375-376
Doom Watch, 379
Double Indemnity, 138, 140, 142, 264, 478-479, 493
Dr. Mabuse, 208
Dr. Strangelove, 157, 187, 237-240, 377, 461
Dracula's Daughter, 173
Dracula, 206-207
Dragonwyck, 487
Driving Miss Daisy, 222
Drugstore Cowboy, 345
Drum, 6, 98, 442
Duck Soup, 461
Duel, 405-406
Dutchman, 442
Dynamite, 243
Easter Parade, 287
Easy Living, 428
Easy Rider, 344, 352, 354
Eddie Murphy Raw, 48
Edward Scissorhands, 401-402
8 1/2, 152
Eight Men Out, 359, 361
84 Charlie Mopic, 452
Eighty Million Women Want—?, 391-392
El Condor, 46
El Dorado, 22
El Topo, 205

Elephant Boy, 146
Eliminators, 381
Embryo, 381
Enemies, 222
Enemy Mine, 383
Enter Laughing, 219
Equus, 255
Evel Knievel, 275
Every Sunday, 284
Executive Action, 311, 316-317, 412, 430
Executive Suite, 38
Exodus, 218-219, 260, 430
Extremities, 494-495
Fail-Safe, 377, 379
Fame, 291
Family Business, 256
Fancy Free, 288
Fantasia, 113-114, 499
Fatal Attraction, 125
Fatal Beauty, 47
Father's Little Dividend, 263
Fear Strikes Out, 272
Fedora, 480
52 Pickup, 155
Fighting Devil Dogs, 371
Finian's Rainbow, 86
Fireworks, 173, 325
First Blood, 413-415, 452
First Lady, 324
Five Easy Pieces, 345
Five Fingers, 480
Five Star Final, 249
Flaming Star, 298
Flash Gordon, 371
Flashdance, 185, 291
Flight Command, 457
Flying Fortresses, 456, 458
Footlight Parade, 280-281
Forbidden Planet, 375
Foreign Correspondent, 320
Fort Apache, 148-149, 294, 448, 470
Fort Apache, the Bronx, 46
42nd Street, 280-281, 285, 383
48 Hours, 48
Four Daughters, 167-168
Four Friends, 306
Foxy Brown, 46, 442
Frances, 133, 273, 494
Frankenhooker, 383
Frankenstein, 206, 209, 371
Freaks, 206, 210
Friendly Persuasion, 480, 482
Fright Night, 176
Frogs, 379
Full Metal Jacket, 237-239, 447, 452, 462
Funny Face, 289
Funny Girl, 219, 291

Funny Lady, 291
G-Men, 96
Gaily, Gaily, 328
Garbo Talks, 256
Gaslight, 483, 493-494
Gay USA, 176
Gentleman's Agreement, 170, 218, 233, 307, 501-
 502
Getting Straight, 228
Ghost Dad, 309
Ghost Town, 298
Ghost, 49
GI Blues, 290
Giant, 472
Gigi, 289
Gimme Shelter, 290, 388
Girl Crazy, 286
Girlfriends, 492
Godzilla, 210-211
Golden Earrings, 334
Goldengirl, 381
Good Morning, Vietnam, 453
Good News, 279, 445
Goodbye, Columbus, 219-220
GoodFellas, 101-102, 223, 388
Goonies, 223
Grease, 291
Greetings, 108
Gremlins, 403
Guess Who's Coming to Dinner, 236
Gums, 120
Gun Crazy, 98-99
Gung Ho!, 458
Gunman's Walk, 298
Gunn, 7, 98
Hallelujah, 280, 405, 444, 446
Halloween, 11-13, 121, 185, 207, 209-211, 381
Hamburger Hill, 453
Hammett, 89
Hang 'Em High, 124
Hangar, 18, 381
Hanky Panky, 309
Hanna K., 223
Hardcore, 362-364
Harlem Nights, 48
Harlem Sketches, 136
Harper, 98
Harvest: 3,000 Years, 7
Havana, 330-332
Heartbeat, 351
Heartbeeps, 381-382
Heartbreak Ridge, 127
Heathers, 230
Heaven's Gate, 64-65, 152, 418
Hell's Highway, 35
Hell's Hinges, 471
Hello Frisco, Hello, 287

Hello, Dolly!, 289, 291
Hennessy, 311-312
Herr Meets Hare, 497
Hester Street, 220
Hi, Mom!, 108
Hidden Agenda, 413
High Anxiety, 222
High Noon, 126, 153-154, 381, 398, 470-473
High Plains Drifter, 124, 475
High School Confidential, 119
High Sierra, 97
High Treason, 371
Hillsboro Relief Scandal, 136
Hit!, 48
Holiday, 36, 324
Hollywood Shuffle, 9, 49
Home Movies, 108
Honky Tonk Freeway, 354-355
Hook, 403, 406
Hoosiers, 322
Housekeeping, 126, 400
Humoresque, 61, 169, 216
Husbands, 264
Hush Hush Sweet Charlotte, 212
Hypocrites, 186, 392
Iceman, 381
Identity Crisis, 442-443
Identity Unknown, 62
Illusions, 7, 11, 81, 350, 410, 474
In Country, 453
Independence Day, 401-402
Interiors, 10, 65, 139
Internal Affairs, 346, 420
International Lady, 409
International Squadron, 457
Intolerance, 190-191, 338, 390, 393
Invisible Agent, 372
Irene, 172
Isn't Life Wonderful?, 191
Jabberwocky, 186-187
Jacknife, 453-454
Jackson County Jail, 341
Jagged Edge, 494
Jailhouse Rock, 290
Jane Eyre, 484, 493
Jaws, 120, 155, 184, 403-405, 407
Jeremiah Johnson, 275, 277, 298, 331
Jericho, 357
Jewel, 7, 392
JFK, 159, 311, 317-318, 417-418, 421-422
Jim Thorpe—All-American, 297
Joe Kidd, 124
Joe, 229
Joe's Bed-Stuy Barbershop, 8, 246
Johnny Eager, 251
Johnny Guitar, 18
Journey's End, 457

Judge Priest, 149, 151
Judith, 219
Julia, 261, 483, 492
Jumpin' Jack Flash, 47
Jungle Adventures, 145
Jungle Captive, 209
Jungle Fever, 9, 48, 247-248, 347, 441
Junior Bonner, 303
Kagemusha, 89
Kelly's Heroes, 127
Key Largo, 99, 138, 141, 143, 179, 296
Killer's Kiss, 238
King Creole, 290
King Kong, 206, 210
King Solomon's Mines, 357
Kismet, 289
Kitty Foyle, 429, 484
Klute, 262
Knickerbocker Buckaroo, 130
Kramer vs. Kramer, 264-265
Kronos, 207, 375
La Cage aux Folles, 412
Labryis Rising, 174
Ladykiller, 96
Latino, 476-477
Leadbelly, 7
Lepke, 220
Let's Make Love, 38
Lethal Weapon, 416, 450
Levitsky's Insurance Policy, 216
Lianna, 176, 360
Life Stinks, 222
Lifeforce, 176, 383
Lifting Shadows, 393
Lilith, 272
Lillian Russell, 287
Limelight, 57-58
Little Big Man, 294-295, 299, 306, 474
Little Caesar, 35, 95-97, 140, 251, 310
Little Nikita, 47, 309
Little Women, 485-486, 490-491
Livin' Large, 49
Lock Up, 341, 416
Logan's Run, 380
Lolita, 237-238
London After Midnight, 206
Longtime Companion, 172, 176
Looker, 381
Losing Ground, 7
Lost Angel, 62
Lost Boundaries, 45, 307
Lost City, 371
Lost Illusions, 81
Lost Weekend, 141, 479
Louisiana Purchase, 324
Louisiana Story, 144-146
Love Parade, 279

Lover, Come Back, 264
Loving, 264
M, 210, 270
Mad Max Beyond Thunderdome, 46
Mad Wednesday, 428
Madame X, 487
Madigan, 335
Magnum Force, 126, 275, 277
Make Mine Music, 113-114
Making Love, 175-176, 265
Making Sausages, 369
Malcolm X, 9, 318
Malevil, 383
Manchurian Candidate, The, 310
Man Hunt, 310
Mandingo, 442
Manhatta, 423
Manhattan, 10-11, 220, 266
Marjorie Morningstar, 218
Marked Woman, 484, 491
Marlowe, 98
Marooned, 377
Mars Needs Women, 378
Martians Go Home, 383
Martin, 208
Mary Poppins, 289
*M*A*S*H**, 242
Mask, 491
Matewan, 359, 361-362, 476
Maurice, 176
Maximum Overdrive, 382
Mayor of Hell, 225
Maytime, 283
McQ, 468
Mean Streets, 385-386
Medium Cool, 434, 476-477
Meet John Doe, 36, 51-52, 325, 350, 397
Melody Time, 113-114
Men Must Fight, 371
Merrill's Marauders, 165
Metropolis, 371, 411
Metropolitan, 284
Mickey One, 304-305
Mickey's Good Deed, 113
Midnight Cowboy, 262, 440
Midnight Express, 417-418
Midnight Run, 352
Midway, 147, 460
Mildred Pierce, 137, 140-142, 263, 484, 486, 491
Millenium, 383
Miller's Crossing, 101-102, 222
Miser's Fate, 35
Mishima, 363-364
Mister Roberts, 461
Mo' Better Blues, 9, 223, 247-249
Moana, 145
Mobsters, 101, 222

Modern Times, 56, 350, 433
Modesty Blaise, 253
Monsieur Verdoux, 19, 37, 57-58
Monsignor, 335
Monte Carlo, 279
Monterey Pop, 290
Moscow Strikes Back, 259
Mother's Day, 213
Motorcycle Gang, 119
Movie Crazy, 172
Moving, 48
Murphy's Romance, 348
Mysterious Island, 209
Mystic Pizza, 401
Nada, 311
Naked Angels, 354
Naked Gun 2 1/2, 323
Napoleon, 89, 239-240
Nashville, 13-16, 328, 355
National Hunger March, 136
Native Land, 160, 162-163, 358, 425
Native Son, 47
Naughty Marietta, 283
Nazi Agent, 409
Nazi Spy Ring, 409
Network, 256-257, 435-436
Nevada Smith, 298
New Jack City, 9, 49, 101, 443
New Moon, 279, 283
New York Stories, 93, 387
New York, New York, 290, 386
Night Moves, 184, 306
Night Nurse, 492
Night People, 25, 27-28
Nighthawks, 415, 450
Nightmare City, 382
1941, 403
Nobody Lives Forever, 168
Norma Rae, 39, 347-348, 484, 493
North Dallas Forty, 39
Northwest Passage, 293
Nosferatu, 206
Notorious, 493
November Moon, 176
Now, Voyager, 485
Numbered Men, 339
Numero Deux, 81
Nuts, 348, 494
Objective ,Burma! 438, 458
Obsession, 108
Odds Against Tomorrow, 335
Off Limits, 453
Oklahoma!, 289
Old Acquaintance, 491
Oliver Twist, 216, 219
Oliver!, 289
One Clear Call, 394

100 Rifles, 46
One, Two, Three, 38
One-Eighth Apache, 297
On the Waterfront, 234
Operation CIA, 448
Operation Secret, 30
Ordinary People, 223
Oscar, 416
Outland, 381
Outrage, 484
Outsiders, 229
Over the Edge, 228
P. J., 98
Paid, 96
Painters Painting, 105
Pale Rider, 124, 470, 475
Panic in the Streets, 233
Papillon, 263, 430
Paradise Alley, 415
Paris Blues, 347
Parting Glances, 172, 176
Partners, 175
Party Girl, 28, 99
Passion Fish, 362
Paths of Glory, 237
Patriot Games, 464
Patton, 86, 88, 309, 460-461
Patty Hearst, 273, 363-364
Pee Wee's Big Adventure, 176
Peggy Sue Got Married, 91
Penitentiary, 8, 341
Percy Pimpernickel, Soubrette, 370
Persona, 273
Phase IV, 379
Picnic, 263, 398-399
Pillow Talk, 264, 266
Pink Cadillac, 128
Pinky, 45, 151, 218, 233, 307, 489, 501-502
Piranha, 359, 379
Plane Crazy, 113
Platinum Blonde, 51
Platoon, 417-422, 447, 452, 462
Point Break, 176
Poison, 177
Politics, 324
Poltergeist, 403-404
Popeye, 15, 97
Pork Chop Hill, 459
Porky's, 120, 185, 230
Portnoy's Complaint, 220
Potemkin, 21-22, 135, 205
Power, 256-257
Predator, 382
Presumed Innocent, 223, 316
Pretty Baby, 60
Pretty Woman, 40
Private Benjamin, 222

Private Izzy Murphy, 461
Private Snafu, 496
Private Worlds, 271
Prizzi's Honor, 101, 320
Project Moonbase, 376
Project X, 376
Prophecy, 155, 379, 480
Proud Valley, 358
Psych Out, 228
Psycho, 109, 206, 210, 270-271, 319, 321
PT 109, 323
Public Enemy, 35, 95, 97, 247
Pump up the Volume, 230
Punishment Park, 379
Purple Hearts, 453
Puss 'n' Boots, 111
Q, 121
Queen Christina, 173
Quick Millions, 35, 96
Quintet, 380
R.P.M., 228, 236
Rabid, 164, 211, 380
Rachel, Rachel, 263, 484
Radio Days, 11-12, 221
Raging Bull, 345, 363, 386
Ragtime, 47, 223, 287
Rambo III, 413, 415-416, 452
Rambo: First Blood Part II, 413-415, 452
Random Harvest, 251
Re-Animator, 384
Rear Window, 183
Rebecca, 173, 493
Rebel Without a Cause, 227
Red Dawn, 276-277
Red Planet Mars, 373
Red River, 123, 263, 464, 466, 470-473
Red Russia Revealed, 394
Reds, 318
Reform School Girls, 341
Rejuvenator, 384
Repulsion, 273
Retreat, Hell!, 459
Rhinestone, 415-416
Rio Bravo, 464
Rio Grande, 149, 192, 448, 466-467
Risky Business, 185
River's Edge, 230-231
Roberta, 282
Robin Hood, 129
Robot Jox, 382
Rock, Rock, Rock, 227
Rocketship XM, 372
Rocky, 47, 225-226, 277, 344, 413-416, 491
Rolling Thunder, 362-363, 450
Rosebud, 220
Rosemarie, 283
Rosemary's Baby, 212, 273

Roustabout, 354
Rumble Fish, 90-91, 230, 345
Run, Simon, Run, 297
Russian Rhapsody, 497
S*P*Y*S, 412
Sabotage Squad, 409
Saboteur, 311
Sahara, 44, 457
Saigon, 448
Salt of the Earth, 197
Salvador, 345, 417-422
San Quentin, 339-340
Saturday Night Fever, 185, 291, 344
Scalawag, 260
Scanners, 211, 382
Scarecrow, 352
Scarface, 101, 109, 443
Scarface, The Shame of the Nation, 95, 97
School Daze, 9, 48, 246, 248-249
Scorpio Rising, 205
Scorpio, 126, 205, 411
Screwballs, 120-121
Seal Island, 114
Sealed Cargo, 409
Searchers, 183
Seconds, 158, 377, 453, 457
Secret Ceremony, 254
Secret Enemies, 409
Secret Honor, 15, 323
Seizure, 417
September, 11
Sergeant Rutledge, 150
Sergeant York, 303, 439, 457
Serpico, 257
Seven Women, 152
Shadows, 442
Shaft's Big Score, 8
Shaft, 8, 46, 442
Shane, 303, 470-473, 475
Shanghai Madness, 162
Sheriffed, 136
Shining, 239
Shock Corridor, 76, 165-166
Shock Waves, 209
Short Circuit, 381
Shoulder Arms, 461
Show Boat, 279, 356-358
Silence of the Lambs, 176
Silent Running, 380
Silver Streak, 48
Silverado, 152, 470-472
Singin' in the Rain, 203
Sister George, 174-175
Ski Party, 227
Slamdance, 176
Sleeper, 9, 12, 380
Slugs, 382, 388

Soapdish, 49, 176
Solarbabies, 383
Soldier Blue, 294
Solomon Northrup's Odyssey, 8
Something Wild, 400, 402
Sophie's Choice, 221, 489, 494
Sorority Girl, 119
Sorry, Wrong Number, 493
Sounder, 46, 347, 442
South Pacific, 289
Soylent Green, 380
Space Children, 373
Space Invaders, 382
Spaceballs, 222
Spartacus, 238, 240, 260, 430
Spellbound, 271, 273, 320
Spies, 408, 411
Spuds, 461
Spy Smasher, 410
St. Elmo's Fire, 223
Stage Door, 491
Stage Struck, 255
Stagecoach, 147-148, 182-183, 192, 295, 465-467, 470, 475
Stalag 17, 459
Stanley & Iris, 348
Stanley, 451
Star Spangled Rhythm, 286
Star Trek, 378
Star Wars, 73, 184, 378, 384
Star, 289
Starcrash, 378
Stardust Memories, 11-12
Starman, 381
State Secret, 410
Staying Alive, 291
Steamboat Bill, Jr., 145
Steamboat Willie, 112
Steel Magnolias, 400
Stella Dallas, 484, 490
Stereo, 377
Stir Crazy, 48, 309, 341
Storm Center, 398
Strange Holiday, 372
Strange Invaders, 381
Straw Dogs, 262, 300-301, 303
Streamers, 15
Streetcar Named Desire, 234
Student Bodies, 121
Submarine Command, 459
Sudden Impact, 126-127
Suddenly , Last Summer, 174
Suffer Little Children, 391
Sugarland Express, 351, 404-407
Sullivan's Travels, 350, 426, 428
Summertime, 263
Sunrise, 323, 484

Superdyke, 174
Superfly, 46
Superman, 378
Suspicion, 493
Sweet Liberty, 266
Sweet Lorraine, 222
Sweet Sweetback's Baadasssss Song, 8-9, 309, 441, 443
Sweethearts Dance, 401
Sweethearts, 283
Swingtime, 282-283
Switching Channels, 329
Swoon, 177
Sylvia Scarlett, 173
Taking Off, 228
Talk Radio, 223, 418, 421-422
Tango & Cash, 341, 416
Tarantula, 375
Target Nicaragua, 476
Target, 306
Targets, 119
Taxi Driver, 60, 311, 328, 362-363, 365, 386-388
Tender Comrade, 429, 491
Terminator 2: Judgement Day, 383
Terrorvision, 381
Testament, 383
Thelma & Louise, 345-346, 349, 355
Thieves Like Us, 13, 351
13 Rue Madeleine, 409
Thirty Seconds Over Tokyo, 429, 457
Thousands Cheer, 286-287
Three Bad Men, 147
Three Smart Girls, 284
Three Warriors, 298
3 Women, 14
Thunder Road, 353
Thunderheart, 300
THX-1138, 379
Tightrope, 125, 127-128
Time Bandits, 186-187
Tin Pan Alley, 287
Tobacco Road, 501
Tongues Untied, 176
Tony Rome, 98
Tootsie, 212, 330, 332-333, 436
Top Hat, 278-279, 282
Tora! Tora! Tora!, 460
Torch Song Trilogy, 176, 223
Total Recall, 383
Toxic Avenger, 382
Trading Places, 48
Trancers, 382
Transatlantic Tunnel, 433
Treasure Island, 114
Trial, 30-31
True Confessions, 39
True Life Adventure, 111, 114

Tucker, 39, 92-93, 138
Tumbleweeds, 475
Turnabout, 35, 173, 372
Twelve Angry Men, 255, 257
Twelve O'Clock High, 458
Twice a Man, 174
Twilight's Last Gleaming, 321
Two-Lane Blacktop, 352
Ulzana's Raid, 184, 296
Unchained, 340, 354
Uncle Tom's Cabin, 42
Uncommon Valor, 451
Underground, 106-107
Underworld USA, 165-166
Underworld, 94
Unforgiven, 128, 298
United Action Means Victory, 160
Uptown Saturday Night, 442
Vampire Lovers, 212
Vanishing Point, 353
Varnette's World, 6
Verboten!, 165
Vertigo, 108-109, 152, 182
Victim, 174-175
Victory Through Air Power, 500
Victory, 459
Videodrome, 382
Vietnam! Vietnam!, 148
Violent Angels, 228
Viva Zapata!, 233
Von Ryan's Express, 458
Voodoo Woman, 376
Wagon Master, 151
Wake Island, 457
Walking Proud, 228
Walking Tall, 395, 398-399
Wall Street, 39, 329, 418, 421-422
War Hunt, 330, 459
War Games, 382
Warriors, 228
Washington Merry-Go-Round, 324
Watchers, 381
Water Ritual #1, 7

Waterloo Bridge, 251
Way Down East, 484
Weeds, 25, 341
Weird Science, 383
Welcome Home, Roxy Carmichael, 400
Welcome Home, Soldier Boys, 449
West Side Story, 228, 289
White Feather, 297
White Flood, 160
White Heat, 98, 141
White Hunter, Black Heart, 128
White Line Fever, 354
White Palace, 223
White Zombie, 210
Wild One, The, 226
Wild River, 232
Wild Wheels, 354
Wilson, 323
Windwalker, 299
Wings, 456
Winter Carnival, 365
Winter Kills, 39, 320-321
Wise Guys, 109
Woman of the Year, 241
Woman's Place, 392, 500
Woman's World, 38
Woodstock, 290
Work Made Easy, 369
Working Girl, 40
World Without End, 376
XTRO, 384
Yankee Doodle Dandy, 286, 323
Yentl, 222, 291, 484, 486
Yesterday's Enemy, 460
Yojimbo, 123, 474
You Are There, 197
Young Frankenstein, 222
Young Winston, 154
Z, 311, 313-316, 318, 320
Z.P.G., 380
Zabriskie Point, 228
Zelig, 11, 81
Zeta One, 378

About the Editor

Gary Crowdus is the Editor-in-Chief of *Cineaste: America's Leading Magazine on the Art and Politics of the Cinema,* which he founded in 1967 while an undergraduate student in film production at New York University's Institute of Film and Television. He was Associate Editor of *Film Society Review,* published by the American Federation of Film Societies, from 1968 to 1972. He has also been professionally active in theatrical and non-theatrical film distribution since 1972, initially with the Tricontinental Film Center and Unifilm, and, since 1981, with the Cinema Guild.